VISIONING AN EQUITABLE WORLD

Reflections on Women, Democracy, Education, and Economic Development

an intellectual memoir

IRENE TINKER

INKWATER PRESS

Publisher: Inkwater Press | www.inkwaterpress.com

Paperback ISBN-13 978-1-62901-320-6 | ISBN-10 1-62901-320-X
Kindle ISBN-13 978-1-62901-321-3 | ISBN-10 1-62901-321-8

Printed in the U.S.A.

1 3 5 7 9 10 8 6 4 2

Seeking an equitable future for all, I have been joined along the way by a myriad of colleagues, friends, and family. I thank them all for their companionship and enthusiastic support. Their knowledge and wisdom added immeasurably to my own understanding of possibilities. To all of these wonderful women and men I dedicate this collection of my life's work.

TABLE OF CONTENTS

Introduction . ix

PART ONE

Section 1: Political Theory, Democracy, and Elections 3

Case studies of India's first
general elections 13

America: Melting Pot or Plural Society? . 19

The First General Elections in
India and Indonesia25

Quotas for women in elected
legislatures: do they really
empower women? 34

Assumptions and Realities:
Electoral Quotas for women53

Section 2: Education for All63

The Underprepared College Student . 66

Federal City College: How Black? 73

Reaching Poor Women in Nepal:
Do Literacy Programs Really Work? . . .92

Section 3: Population and Family Planning97

Cultural and Population Change –
excerpts . 99

PART TWO

Section 1: Activism in the Nation's Capital 115

Women in Washington:
Advocates for Public Policy 121

Letter from Canton, Mississippi - 1963 133

Radcliffe College Alumnae
Association: Alumnae Recognition
Award Irene Tinker '49 149

Section 2: Influencing Development Policy 153

Feminist Values: Ethnocentric or
Universal? . 158

Women in Washington:
Advocates for Public Policy.
My chapter on "Women in
Development" 172

A Tribute to Ester Boserup:
utilizing interdisciplinarity to
analyze global socio-economic
change. 182

The Adverse Impact of
Development on Women 197

The Making of a Field: Advocates,
Practitioners, and Scholars 211

Women in Developing Societies:
Economic Independence Is Not
Enough . 230

Nongovernmental Organizations:
An Alternative Power Base for
Women? . 239

The State and the Family:
Planning for Equitable Futures in
Developing Nations 254

Section 3: Influencing Global Policy through UN Conferences261

A Feminist View of Copenhagen267

A Personal View and Appraisal of
Nairobi .271

UN Decade for Women: Its
Impact and Legacy275

The Fourth World Conference
for Women in Beijing; the NGO
Forum in Huairou289

Section 4: Women's Roles in the Rural Economy297

Women's Roles on North
American Farms303

Women in African Development
[including citation from Rural
Sociology]307

New Technologies for Food
Related Activities: An Equity Strategy . 315

The Real Rural Energy Crisis:
Women's Time340

Women, Donors, and
Community Forestry in Nepal:
Expectations and Realities352

Section 5: Women Making Money367

Credit for Poor Women:
Necessary But Not Always
Sufficient For Change376

Alleviating Poverty: Investing in
Women's Work386

The Urban Street Food Trade:
Regional Variations of Women's
Involvement401

Street Foods: Urban Food and
Employment in Developing
Countries – Chapter 9419

Microentrepreneurs and
Homeworkers: Convergent
Categories440

Section 6: Food and Shelter in Urban Areas455

Women and Shelter: Combining
Womens Roles466

Beyond Economics: Sheltering
the Whole Woman478

Women's Empowerment
Through Rights to House and Land ...496

The Invisibility of Urban Food
Production513

Urban Agriculture Is Already
Feeding Cities516

Feeding Megacities: A Worldwide
Viewpoint521

Section 7: HERstory of Women and Development527

Developing Power Introduction:
Ideas into Action530

Challenging Wisdom, Changing
Policies: The Women in
Development Movement548

Many Paths to Power: Women in
Contemporary Asia559

Empowerment Just Happened:
The Unexpected Expansion of
Women's Organizations578

Women's Economic Roles and
the Development Paradigm606

The Camel's Nose: Women
Infiltrate the Development Project ...625

INTRODUCTION

THIS VOLUME TRACES MY INTELLECTUAL JOURNEY FROM MY 1949 RADCLIFFE COLLEGE honors thesis for political theory and comparative government, to two chapters in major reference books published in 2014, which summarize my work in the field of women and development. The topics in most of my publications concern contemporary issues and debates which began with a concern for democracy and led to my thesis on the *Political Liberalism of Jacques Maritain and Reinhold Niebuhr.* Their philosophies were so contemporary that I found my best sources were informed individuals rather than books in the library. I interviewed a Congregational minister who introduced me to Niebuhr himself. My mentor on Maritain was a Jesuit priest whom I met in the library stacks.

Similarly, when I began research for my doctoral dissertation for the London School of Economics on India's first general elections in 1951-52, I was informed that the topic was not scholarly enough for the faculty of the Delhi School of Economics where I had registered. Once again my sources were outside academia. Most useful were briefings by the Electoral Commission and discussions with the many press correspondents from all parts of India and from abroad who were covering the elections.

Indeed, for years I harbored a desire to be an international correspondent or a travel writer so I could explore the world. I soon found that obtaining travel grants for research was a better source of income than getting articles published. My record of driving from London to India was published in the British Ford magazine in return for fine-tuning the Ford Anglia for the trip, and providing a set of replacement parts; but no money. This habit of recording my travels has stayed with me: I send these letters out instead of Christmas cards. I have collected these letters and other unpublished commentaries in a separate volume.

Throughout my career I have continued to focus on contemporary topics and utilized interviews and cultural immersion rather that library research as the foundation of my writing. Ideas often led to involvement in promoting my findings in an effort to change policy. Action research increasingly dominated my life and for years I worked outside universities. Not having to meet regular classes allowed for travel abroad for study or conferences. As a result, I have spent about half my career at universities and the other half in institutions that allowed me to apply my ideas or on research grants studying new concepts in new countries.

The common thread that weaves my ideas together is a concern for individual rights for all women and men. At first I described this conviction as equality; I soon realized that most portrayals of equality used as its standard a white male. Raised to believe a woman could do everything a man could *if she tried*, I came late to the understanding of the impact of socially constructed gender roles. For years I tried to emulate men. Only later in life did I come to comprehend that equality as sameness was both undesirable and unobtainable. "If man is the measure, women will always be second class" became my mantra. I changed my call for rights from equality to *equity*: the rights of all people to utilize their own capabilities. To achieve these rights, I celebrate all forms of activism to attain that equality/equity, from political parties to non-governmental organizations, from sit-ins to marches, to lobbying.

Organization of the book:

This volume consists of two parts. Part I focuses on my early career when my academic pursuits took precedence even as my activism grew. Part II reverses those priorities as the issue of women's equality at home and abroad began to dominate my writing and my occupations.

Part I has three sections: **Political theory, democracy, and elections; Education for all;** and **Population and family planning.**

My publications on elections had their roots in my dissertation research on the First General Elections in India in 1951-52. My first academic publications were three case studies observing the actual election in former princely states. The fundamental issue addressed by studying this election with universal suffrage for all was whether a largely illiterate population could vote to support democracy. During my tenure as a researcher in the Modern India Project and the University of California Berkeley, I applied my fascination with elections and democracy to other countries. A fellowship to Indonesia to observe their first elections provided material for more publications analyzing the effect of the type of electoral system on politics. Years later, I was able to combine my interest in elections with my years of writing about women and their organizations to illuminate the debate about electoral quotas for women.

Educational issues engrossed me as a result of my experiences teaching at Howard University, after I moved to Washington DC in 1960. The combination of poor academic preparation of the students and racial discrimination made teaching difficult. As a result, I became deeply involved in trying to set up a new university that might provide an alternative path to a good degree. As Assistant Provost of the new Federal City College, I wrote several articles about our hopes and goals. I also taught courses on urbanization. This led to a fellowship to study

urban governance in Indonesia. My exposure in Indonesia to the adverse impact of economic aid on women sparked my career in this area.

Appointed as the Director of International Science at the American Association for the Advancement of Science (AAAS), my first task was to work with Margaret Mead to ensure the timely publication of a handbook for the United Nations World Conference on Population in June 1974. This immersion in population issues became the basis of several publications and was useful in my later action-research activities. Margaret Mead's initiatives at the Population Conference provided a powerful example of using UN meetings to promote issues. With her support, I was able to use the UN World Conference for Women in 1975 to propel the issue of women and international development onto the world's agenda.

Women's issues are, of course, part of elections and education, and central to population. But the focus of the women in development movement (WID) was on the economic contribution of women. While population studies concentrated on women's role in the family and on women's ability to control her fertility, they situated women in their reproductive roles. In 1973, population projects were well-funded by development agencies. Not so, those promoting women's vital role in a nation's economy. WID promoters considered it critical to emphasize the distinction between women and mothers and women as producers in order to influence national and international agencies and organizations as they formulated their economic projects and programs. The funds that flowed into these projects assisted women to organize at local, national, and international levels and inadvertently helped to fund the global women's movement.

Part II consists of seven sections: **Activism in the nation's capital; Influencing Development policy; Influencing global policy through UN Conferences; Women's work in the rural economy; Women making money; Food and Shelter in urban areas;** *and an overview chapter* **HERstory of women and development: from then to now.**

When our family moved to Washington DC in 1960, the city was roiling as the Civil Rights Movement and the anti-Vietnam War groups cooperated with or contested the invigorated Women's Movement. Drawn into these struggles, I interacted increasingly with the myriad of women's organizations in the city. The focus of my publications quickly settled on contradictions between women's goals in the US and how US aid was undermining those goals abroad.

Presenting the concept of women and development at the United Nations, I then followed how its basic themes evolved as a result of the four UN World Conferences on Women. My publications focused on the politics of these conferences. Active in UN conferences were many non-governmental organizations; I compared NGOs with women's organizations in their ability to achieve women's goals. In the final chapter in *Women and Gender Equity in Development Theory and*

Practice: Institutions, Resources, and Mobilization, a volume Jane Jaquette and Gale Summerfield edited in my honor, I illustrate how development aid actually paid for women to organize.

The adverse impact of development on women in subsistence economies was the foundation of WID. Programs introduced by the development community tended to overlook women's roles in agriculture and food production. Appropriate technology groups proposed "solutions" to food processing or energy needs that were less than appropriate. When the UN convened conferences on these topics, I was invited to present the women's responses at national and international conferences. I also attended these conferences to lobby for women's inclusion in the conference documents.

As subsistence economies became increasingly monetized, programs were introduced by economic aid agencies to assist women in earning money. Projects aimed at crafts or knitting and sewing added more to women's time burden than to their income. In response I began a major study on Street Foods, an enterprise where women were already gainfully employed in developing countries. I also wrote several critiques of micro-credit schemes.

As a professor in the Department of City and Regional Planning at Berkeley, I began to write about urban issues of housing, criticizing its gender neutral viewpoint when in fact housing both at home and abroad is utilized differently by women than by men. Urban agriculture was as overlooked as were street foods as a critical input in the urban food supply and an important source of income, especially for women.

The final section attempts to capture the *herstory* of the period from three perspectives. First is a book of memoirs, edited with Arvonne Fraser, recounting how 27 women from 12 countries helped form the global women's movement. My Introduction, "Ideas into Action," reviews the field; my own memoir reflects my upbringing and high school experiences.

The second set of articles follow the field of women in development. "Many Paths to Power: women in contemporary Asia" utilizes my years of research in South and Southeast Asia to examine the influence of culture on women's progress. The chapter I wrote for my festschrift, "Empowerment just happened: the unexpected expansion of women's organizations," provides evidence for my argument that international economic aid unintentionally funded the growth of the global women's movement.

Finally, two retrospective chapters about the WID movement and what it accomplished complete the volume. One was written for the International Development Research Council of Canada and published in a collection of economic-focused papers which are heavily referenced. Adding a chapter on women was a

frantic response by the editors when they realized that, despite their instructions to authors, women were largely invisible in the other chapters.

In contrast, the two women editors for the Oxford University Press America Handbook on *Transnational Feminist Networks* requested a readable chapter with minimum footnotes. Authors were asked to explain their original goals and explain what succeeded and what did not. Finally, the editors requested authors to write about commentaries on their approachs to WID, a request that provided me with a welcome opportunity to defend the field of women in development. I chose a provocative title for my chapter, "The Camel's Nose: women infiltrate the development project."

Presentation and editing of articles

Academic articles are over-referenced in order to prove to readers that the author knows the literature. To avoid cluttering the included articles with lengthy footnotes, I have incorporated important comments in the article and cut those meant to demonstrate knowledge of the field. Further, most articles include long lists of references. Obviously, many are repetitive. When the reference is to a quotation, I have included the bibliographic information in the text. Occasionally, when the author is an outstanding commentator on the issues at hand, I have also provided the reference in the text. These editing decisions have markedly reduced the length of the manuscript and added to the readability of this memoir.

PART ONE

SECTION I
POLITICAL THEORY, DEMOCRACY, AND ELECTIONS

M Y FIRST RESEARCH AND WRITINGS REFLECTED BOTH MY EARLY EXPERIENCES AS AN activist and the impact of a mind-expanding education at Harvard. Considering a career in law or politics, I majored in government but enrolled in or audited a wide range of courses. Entranced both by political theory and American intellectual history with its religious underpinnings, I wrote my honors thesis on *"The Political Liberalism of Jacques Maritain and Reinhold Niebuhr."* When I met Harold Laski at a professor's brunch for mostly graduate students, he suggested that I apply to the London School of Economics where he would be my tutor. Laski assumed that I would continue in this trajectory of religious thought by analyzing the work of Cardinal Newman. Instead, put off by the thought I might become a sort of Salvation Army woman, I returned to a more activist research topic of parliamentary democracy and elections, following candidates from all three parties who were contesting in one constituency during the 1950 British elections.

My fascination with politics began at age 9 when I gave out party literature at the local polling stations when Alf Landon ran for president in 1936. In high school I snuck out of the house to go to a victory [sic] party for Thomas Dewey; at college I organized the Students for Stassen. In 1948, as a *Mademoiselle Magazine* college editor, I went to the Republican convention in Philadelphia for a few days. I then spent that summer in Madison, Wisconsin, working on publicity for the National Student Association convention. While overseas in the 1950s, I became enchanted with Adlai Stevenson and campaigned for him when we moved to California and also became involved with a statewide Democratic Caucus. Later, in Maryland, I ran as a Democrat for the House of Delegates, an experience that convinced me that I was better suited to academics than politics.

When my controversial tutor, Harold Laski, caught pneumonia during the election campaign in 1950 and died, I decided to study how the British model transferred to the newly independent Republic of India. LSE was filled with students from around the world; London newspapers discussed issues from the colonies that I had never studied. At Harvard, comparative government had included Europe and dead civilizations, but only one course was focused outside this narrow view. To assuage my woeful ignorance, I drove out to India across the Middle East to experience these changing countries.

Research for my doctoral dissertation on the First General Elections in the

Indian Republic in 1951-52, with its staggered polling, allowed me to conduct case studies in five different areas of the country. In each state, I interviewed party members, electoral officials, and voters, and garnered background information from the many local and international reporters covering the story. Following the elections, I interviewed members of each party with seats in the Parliament, including members elected to seats reserved for Scheduled Castes and Tribes. Finally, I was able to talk with the Prime Minister, Jawaharlal Nehru, early one Sunday morning. Overall, my research led to a lifetime concern for minority representation and how separate electorates could sabotage efforts for compromise.[1]

I was so delighted with the experience of driving to India that I wished to share with my new husband the joys and difficulties of driving in road-less areas. In 1953, we drove from Mombasa, Kenya, to London in an Austin A40. While Mil kept the car in shape, I interviewed colonial administrators, politicians, settlers, and religious leaders about the plans for independence being pursued by the several colonial powers. In the British areas, I worried that mishandling minority demands would lead to greater divisiveness, as it had in India. Other colonial powers did not anticipate independence would come so soon. My book about this amazing drive was eventually published: *Crossing Centuries: A Road Trip through Colonial Africa.*[2] Back in the US, my involvement in the civil rights movement prompted me to write about fair representation for African Americans. A subsequent fellowship to Indonesia provided additional material for analysis of electoral systems throughout Southeast Asia.

PLANNING THE FIRST GENERAL ELECTIONS IN INDIA

Holding elections in India with its largely illiterate electorate was contentious: many skeptics predicted the effort would be a disaster. Cognizant of the many issues, the Indian Electoral Commission devised procedures which have since provided a prototype for governments with many illiterate voters. Using symbols for parties, voters could place their ballots into individual boxes which displayed the symbol. Parties selected symbols from a list vetted to exclude religious or emotive symbols. This use of symbols also solved the problem of languages: India has 15 recognized languages plus several hundred local languages. Each voter was marked with indelible ink to show they had voted, a widely copied technique to prevent double voting.

1 *Representation and Representative Government in the Indian Republic,* London School of Economics, 1954. Fulfilled requirements for the PhD; later reproduced in several collections of doctoral dissertations.

2 *Crossing Centuries: A Road Trip through Colonial Africa.* 2010. Inkwater Press, Portland, Oregon. Available on Kindle.

A second innovation was the staggering of the actual voting so that a teams of trained electoral commissioners were able to travel from one state to another. Dates for voting were adjusted in the Himalayan regions where heavy snowfall might impede access to the polls and in several states to avoid conflicts with local festivals. Thus the actual voting extended from October 25, 1951 until February 21, 1952.

This spread was ideal for my research: I was able to observe the elections in five states, interviewing both electoral officials and members of all political parties. Three of these case studies, immediately published by *Parliamentary Affairs*, were my first published professional articles.[1] I was annoyed when the British editor insisted on using my legal name: Irene Tinker Walker, acquired when I married Millidge Walker in New Delhi in February 1952.

Challenges unique to India:
Devising methods to allow illiterate voters to cast ballots became a major concern of the Electoral Commission under Chairman Sukumar Sen, who later assisted Sudan in organizing their elections in 1953 and whom I met again during my Africa road trip.[2] Many issues faced during the elections stemmed from political decisions made under the British Raj.

Princely states: The most critical issue that had to be resolved before constituencies could be delimited and the actual elections scheduled involved the very creation of the Indian Republic. Partition of the country created India and a bifurcated Pakistan: West and East Pakistan were separated by 1000 miles. Prior to the division, about 60% of the territory was comprised of 565 princely states. The several French or Portuguese enclaves, which surrounded the port cities, were integrated into India at a much later date. A map of pre-independence India somewhat resembled a Jackson Pollock painting: many tiny drops of paint but also a few large blobs. Princely states were administered differently from British India, having rajas or nawabs as hereditary rulers. Four large states had their own administration, but the small ones were overseen by the Indian Civil Service.

The first task of the independent India was to consolidate those states which had acceded to the new republic into a single geographic entity. Despite premonitions of resistance, only a few states proved troublesome. Only Hyderabad, in the center of the country, with a Muslim ruler and a predominantly Hindu

1 "The General Election in Himachal Pradesh, India," <u>Parliamentary Affairs</u> VI/3: 250-257. 1953.
 "The General Election in Travancore-Cochin, India," <u>Parliamentary Affairs</u> VI/4: 333-341. 1953.
 "The General Election in Rajasthan, India," <u>Parliamentary Affairs</u> VII/2: 242-247. 1954.

2 In December 1953, I have the Mid Week Talk on the General Overseas Service of the BBC on "The Sudan Elections." Comparing Sudan and India, I concluded that both "have proved that a well organized administration can successfully conduct the elections under the most adverse situations long strides toward their goal or meaningful self-government."

population, required armed persuasion. Observers assumed that Kashmir, with a Hindu ruler and a heavily Muslim population, would accede to Pakistan though it borders both Pakistan and India. Prime Minister Nehru was a Kashmiri Brahmin, however, and supported the Hindu ruler. Today Kashmir is divided between the two countries to the satisfaction of neither. Three wars have subsequently been fought over Kashmir and relations between the two countries and their military remain contentious. To date, Kashmir remains a distinct entity: the elections I observed in October 1951 were not part of the national elections.

As a transitional device, India created three categories of states with distinct methods of governance. Part A states were those that had been part of British India. These states all had functioning railroads and a network of surfaced roads; they had been administered by the Indian Civil Service. I selected Bombay State as my Part I case study which at that time included what is now Gujerat State. Part B states combined large princely states into a single unit; the level of modernization differed as my studies of Rajasthan and Travancore-Cochin illustrate. Part C states consisted of many small princely states or of union territories, all of which had previously been centrally administer. I studied two Part C states: Himachal Pradesh was composed of both states and union territories; Delhi was the capital and a union territory.

Minority representation: Reserved seats for the members of the Scheduled Castes and Tribes guaranteed representation to these groups. The British census of 1905 listed all the castes and tribes throughout British India: the "untouchables" and the tribes. These groups continued to be greatly disadvantage; without special provisions it was assumed they would be unable to win representation in the parliament. The double member constituencies were created so that all voters could select both a regular and a reserved candidate. A few constituencies were for three members: regular, plus but caste and tribe.

This provision was in direct response to experience in pre-independent British India, with its limited suffrage, which had responded to minority demands by creating separate lists for as many as 27 groups. Elected members had tended to act like interest groups, promoting often extreme positions. Separate representation was created for Muslims: Muslim members of the dominant nationalist party, Congress, were forced to choose whether to register as a Muslim or no. These provisions, which promoted the views of the most extreme Muslims, certainly exacerbated the tensions between Hindus and Muslims that finally led to the creation of Pakistan.

Parties contesting and elected: With no precedent to guide them, many politicians decided to run as Independents. The commission delimited 3,862 seats in the Lok Sabha, or lower house of Parliament. 85 parties plus over six thousand Independents

contested for four and a half thousand elective seats in legislatures at national and state levels. Only 39 won any seat; only 20 had seats in the Lok Sabha.

Once Parliament convened, I interviewed Members of Parliament about their experiences, including Jawaharlal Nehru early on a Sunday morning. All were trying to create a modern governmental structure while still reflecting the values inherent in the nationalist struggle, particularly those rooted in Gandhi's philosophies. The Anglo-Indian community was granted two appointed seats in this otherwise elected body. The upper house of Parliament, the Rajya Sabha, was elected by state legislators using proportional voting. A unique feature of this body is the twelve members who are appointed by the government to represent arts and literature. Back in London, I wrote up my field research plus chapters on issues of representation as my dissertation and received my PhD in June 1954.

All this material was useful in my work as a researcher for the Modern India Project at the University of California, Berkeley, from 1954 to 1957. I was co-editor of *Leadership and Political Institutions in India*, with Richard L. Park, Princeton University Press, 1959; reissued 1968. I also wrote a chapter in the book, "Decision Making in the Indian Parliament," with Norman D. Palmer.[1]

This book included most of the American scholars writing on India and thus secured my role as an Indian "hand." Throughout my career I utilized my knowledge about India and South Asia to write both about this area and as a basis of comparison with other parts of the world, especially concerning women's status. [2]

APPLYING ELECTORAL RESEARCH IN OTHER COUNTRIES:

My study of the multi-group reservations provided the basis for many of my interviews when I tried to make sense of the colonial administrations in Africa during the drive from Mombasa to London with my husband. The insights from these encounters form the core of *Crossing Centuries: A Road Trip through Colonial Africa*.

While at UC/Berkeley, I wrote two articles suggesting some form of reservations might be introduced in the American South that would allow more blacks to vote.[3] This idea was not well received. Later, when President Bill Clinton

1 Leadership and Political Institutions in India, edited with Richard L. Park, Princeton University Press, 1959; reissued 1968. "Decision Making in the Indian Parliament," with Norman D. Palmer, pp 115-136.

2 *Indian Political Leadership: Attitudes and Institutions*, RAC, McLean, VA, 1968.
 "Expanding Social, Cultural, and Intellectual Exchanges," proceedings, Second US-India Bilateral Forum. Institute of East Asian Studies, UC/B, & India International Centre, New Delhi, IEAS, Berkeley, CA, 1991.

3 "America: Melting Pot or Plural Society?" *New Frontiers* 6/2: 53-37, 1965;
 "Nationalism in a Plural Society: The Case of the American Negro," *Western Political Quarterly*, Mar., 1966.

nominated Lani Guinier to be the Assistant Attorney for Civil rights in 1993, she was pilloried for writing about a similar alternative electoral system that would allow greater representation of minorities. After the president withdrew her nomination, Lani Guinier became the first African American faculty member of the Harvard Law School. [1]

Searching for examples of promising minority representation, I researched elections in Malaya which was won by a racially inclusive party of Malays, Chinese, and Indians.[2] The following year en route to Indonesia, we spent a month in Malaya, interviewing prominent politicians and bureaucrats. I argued that the inclusive dominant political party, United Malay National Organization (UMNO), encouraged cooperation between the Chinese, who controlled much of the economy, the Indians with their plantation interests, and the rural and often poor Malay. Unfortunately this partnership has unraveled as the state privileged Malays in education and government subsidies.

In 1957, my husband and I received a joint Ford Foundation fellowship to study in Indonesia. In India, I had met a delegation from Indonesia which was observing those elections and I became interested in comparing the functioning and results of the elections in the two countries. After the parliamentary elections in Indonesia in Sept. 1955, I published an analysis with my husband.[3] The proportional representation system produced four major parties which led to institutional instability which we observed first hand. Once again I interview elected members at all government levels and including vice president Mohammed Hatta and President Sukarno.[4]

Disillusioned with the inability of parliament or the regional assemblies to function, President Sukarno declared "Guided Democracy" on July 5, 1959, and a return to the 1945 Constitution. Our co-authored article on this undermining

1 Lani Guinier,'s 1994 book *The Tyranny of the Majority* suggests two systems: cumulative voting – a system in which each voter has "the same number of votes as there are seats or options to vote for, and they can then distribute their votes in any combination to reflect their preferences" – and multi-member "superdistricts", a strategy which "modifies winner-take-all majority rule to require that something more than a bare majority of voters must approve or concur before action is taken."

2 "Malayan Elections: A Pattern for Plural Societies?" *Western Political Quarterly,* June, 1956.

3 "The First General Elections in India and Indonesia," with Millidge Walker, *Far Eastern Survey,* July, 1956.

4 Obtaining an interview with Sukarno was hardly straight forward: I was asked for a photograph to see if I was sufficiently comely. I was served a full breakfast, although it was mid-morning and I had already eaten. Sukarno sat behind an array of medicine and vitamin bottles, swallowing them with black coffee. I was trying to take notes in my lap. Finally he decided I was not of personal interest to him and let Mil join me for the rest of the interview.

of all elected bodies as well as the political parties appeared that December.[1] Mil and I authored several subsequent articles using our Indonesian research.[2] Later, I utilized my research as background for women's status in Indonesia and for a review of Indonesian non-government organizations.[3]

Two conclusions regarding democratic elections: First is the impact of the electoral system on the outcome of elections. I discuss this extensively in my work about electoral quotas and women. In Indonesia, the list system produced an unstable government and led, within two years, to President Sukarno's declaration of *Guided Democracy* which transferred control to him. In both India and Malaysia, large inclusive nationalist parties resulted in strong majority rule in the early days of their existence. Both are federated states, and soon local parties began to challenge the control of the nationalist party. Many local parties were based on identity politics and are inherently divisive.

The second conclusion is the need for a national consensus party that can unite diverse sections of the population. When Narendra Modi became Prime Minister of India in May 2014, his pro-Hindu stance frightened many Muslims. The Muslim population of India is about 14 per cent, which makes India the country with the second largest Muslim population in the world. Modi is changing his rhetoric, claiming he wishes to unite the country and sweep away old bureaucratic inefficiency and corruption. Future will tell.

Identity politics in countries without a strong democratic history, as throughout the Middle East, are tearing the fabric of the country. Syria is a terrible example. Extremist Muslims want *sharia* law and demand the unity of religion and state. Political rebels, usually Sunnis, want to replace President Bashir al-Assad who is an Alawite believer, an Islamic group close to the Shiites. Christians have fled. No inclusive nationalist leader has emerged.

DECENTRALIZATION AND URBANIZATION

As former colonial countries gained independence after World War II, they formed their first governments within the same colonial borders. These borders were often

1 "Indonesia's Panacea: 1959 Model," with Millidge Walker, *Far Eastern Survey*, Dec., 1959.

2 "Development and Changing Bureaucratic Styles in Indonesia: The Case of the Pamong Praja," with Millidge Walker, <u>Pacific Affairs</u>, Spring, 1975.
 "Indonesia: chaos and control," Op-ed with Millidge Walker, *Christian Science Monitor* 3 June 1998, p. 20.

3 "Pengaruh Pembangunan yang Merugikan Kaum Wanita," <u>Prisma</u> 4/5: 33-44. Oct., 1975.
 "Expectations of the Roles of Indigenous Nongovernmental Organizations for Sustainable Development and Democracy: Myth and Reality," <u>Institute of Urban and Regional Development (IURD)</u> Working Paper # 680, summer 1996.

arbitrarily drawn, ignoring linguistic, ethnic, or religious groupings. Since their formation, most countries have experienced unrest or war over both external and internal boundaries. Rapid urbanization has challenged administrative systems based on rural control of the indigenous population. Various methods had been adopted by the colonial power to ensure that their citizens in the colonies had the same laws as at home while applying distinct laws to the indigenous population. In Indonesia the Dutch created residential enclaves; the British carved out municipalities from the rural areas.

In India, the division of the country into Part A and B states proved inefficient so in 1956 the map was redrawn and 14 states created. Over time, divisive tendencies have raised that number to 29 states and 7 territories. As power began to shift from the civil service to elected officials, the demand for reform of local government grew both to give political parties more influence locally and also to include villagers in the development process. The first major reform was in 1957 which created a three tiered system of indirectly elected panchayats and replaced the caste based traditional panchayats.

Both the growth of local bodies and the expansion of economic development encouraged the expansion of nongovernmental organizations. These civil society groups were often supported by international funding agencies and were frequently seen as contradicting government policy. Thus, in subsequent research trips to India and to Indonesia, I studied local rural and urban governance structure as well as NGOs.[1] Mil and I published a reflection on the changing Indonesian centralized civil service.[2] My focus was increasingly how these administrative chances affected women.[3] I also began to question whether women could attain their goals in NGOs and concluded that women needed women's organizations.[4]

ELECTORAL QUOTAS FOR WOMEN

As the women's movement expanded, the recognition grew that political as well as economic and social reform was needed. At the Fourth United Nations Conference for Women, held in Beijing in 1995, this demand was crystalized in a

1 Review article for *International Feminist Journal of Politics.* Commentary on *Democratization in progress: women in local politics in urban India* by Archana Ghosh and Stephanie Tawa Lama-Rewal, International Feminist Journal of Politics: 9/2 pp. 274-277 (spring 2007).

2 "Development and Changing Bureaucratic Styles in Indonesia: The Case of the Pamong Praja," with Millidge Walker, Pacific Affairs, Spring, 1975.
 "Planning for Regional Development in Indonesia," with Millidge Walker, Asian Survey, Dec., 1973.

3 "Pengaruh Pembangunan yang Merugikan Kaum Wanita," Prisma 4/5: 33-44. Oct., 1975.

4 "NGOs: an alternate power base for women?" in Mary K. Meyer and Elisabeth Prugl, *Gender Politics in Global Governance.* Rowman. & Littlefield, 1999. pp 88-104.

paragraph in the Platform of Action recommending that 30% of all decision-making positions should be held by women. Similarly, in legislatures, one-third of all seats were to be reserved for women so that their numbers would provide a critical mass enabling them to affect the function of the body and its policy outcomes.

Although UN resolutions are not enforceable, they become a goal used by activists for lobbying. Women's growing voting power prompted many countries to institute quotas for legislative bodies. At least ninety countries have introduced some type of provision for increasing women's representation. This global rush for quotas for women in elective bodies was widely supported yet little examined, so I began a series of articles to challenge the assumptions that electoral quotas produce more women legislatures, and that women will have the political power to affect policy.[1]

I analyzed the reasons that such quotas do not consistently result in increased numbers of women elected. Much depends on the type of electoral system used in the country and how it is implemented. Few advocates of quotas understood the distinction between the list system of voting and one based on single constituencies. The most efficient method for ensuring that women are elected to legislatures is through the party list system with parties distributing the seats through proportional representation. If the list puts women and men alternatively, then a closed list will result in half of the successful candidates being women. [2]

Where quotas do result in more women in a legislature, and a critical mass of women is achieved, these women usually begin to address the patriarchal character of the body itself. But whether they support a feminist agenda is a different matter. Perhaps those issues need to be separated. More women in a legislature will warm the chilly climate, insist on childcare, and demand more family friendly meeting times. On these and many other issues of particular concern for women, women legislators often agree, and form alliances across party lines.[3] They also rely heavily on women's organizations to promote their proposals to the general public.[4]

Domestic Violence Laws: Passing such feminist bills as those addressing domestic violence challenges men to relinquish their assumed rights: <u>they seldom pass</u>. To assess how such laws have fared, I compared efforts in two sets of countries. In

1 "Democracy and representation worldwide: who gets elected and how," Inaugural lecture, 23 October 2003: Irene Tinker Lecture Series, International Center for Research on Women, Washington, DC.

2 "Quotas for women in elected legislatures: do they really empower women," 2004 *Women Studies International Forum* 27:5-6 pp 531-546.

3 "Why elect more women? For equity or policy shift?" *Electoral Insight*, Elections Canada. Web-posting Oct.2008.

4 "Power for women: the symbiosis of in and out," University of Southern California conference 2-4 February, 2001, "Gender and International Relations: from seeing women and recognizing gender to transforming policy research."

2006, Sweden and Rwanda had the highest percentages of elected women in their national parliaments. Sweden has long been admired for its social policies yet has repeatedly failed to pass a bill addressing domestic violence. Rwanda's inexperienced parliament was able to draft such a bill during its first session but without support of their authoritarian president the bill languishes in committee. To pass these bills, women must confront the ingrained cultural attitudes that not only privilege men but are embedded in the entire governmental structure.

I then considered what happened to similar bills put forward in France and India where feminists relied on social movements rather than political parties to support legislation regarding domestic violence. In France, the issue garnered national attention when Segolene Royal, during her unsuccessful campaign for the presidency of France in November 2006, announced that the first legislation she would enact if elected would be a law against violence perpetrated against women. Current pressure for passage comes from the women's movement, not from the women legislators who comprised only 18.5% in 2006.

In 1993 the Indian parliament passed legislation requiring that one third of all members of *panchayats* or local councils must be women. The dynamics of local government have noticeably changed since then. These outcomes encouraged the women's movement to agitate for more women in Parliament, then less than ten percent.[1] In 2006, the disparate women's organizations from throughout the country joined together to form the national WomenPowerConnect. Finally, after ten years of agitation, the Domestic Violence Bill became law in November 2006. Two years later, in May 2008, a bill to expend reservations for women in Parliament that had been pending for 12 years was finally sent to a Standing Committee.[2]

Joining my passions:

After the 1995 UN Conference for women with its call for legislatures to have 30% women, I was amazed at how few advocates understood the way that different electoral systems could produce different results from the same number of votes. Measures of women's status continue to count numbers of women in legislatures, rather than measure outcomes. My several articles and lectures on the quotas for women completed the circle of my research interests: combining my study of elections and electoral systems with the growth of women's power.

1 Review article for *International Feminist Journal of Politics* of *Democratization in progress: women in local politics in urban India* by Archana Ghosh and Stephanie Tawa Lama-Rewal, International Feminist Journal of Politics: 9/2 pp. 274-277 (spring 2007).

2 "Assumptions and realities: Electoral quotas for women," Georgetown Journal of International Affairs: 19/1 pp. 7-16 (winter/spring 2009).

CASE STUDIES OF INDIA'S FIRST GENERAL ELECTIONS

I ORIGINALLY PLANNED TO CONDUCT SIX case studies for my dissertation, 2 each in Part A, Part B, and Part C states. As the elections progressed, it soon became clear that the primary challenges were in those former princely states where rulers dominated and communications were limited. My case studies of Himachal Pradesh and Rajasthan, which exemplified remote areas, were the immediately published in *Parliamentary Affairs*; the editor had been observing the elections himself and asked for my manuscripts as well as the one on Travancore-Cochin.

In former British India, elections with limited suffrage had been held for years and the Indian press recorded voters and civil servants in regional and national newspapers. Realizing this, I selected the most modern city in India, Bombay, to conduct an urban study. I also studied Delhi state with its combination of rural areas, the conservative old city, and the internationally influenced New Delhi.

My selection of states to visit depended on their polling dates: I wanted to observe the actual election. The first state to vote was **Himachal Pradesh**, a small mountainous state bordering Tibet that had been formed by the merger of twenty-one minor princely

states and several British hill stations. Polling was held in the higher elevations in mid-October with ballots carried in by donkeys. The majority of voters cast ballots between November 19th and 25th. The first vote held in an area accessible by auto was at the end of the road toward Tibet at the tiny village of Narkanda.

I began my research in the state capital and former British hill station Simla. The electoral commission for the state, Captain I. Sen, explained the complicated organization of transporting ballot boxes throughout the state with an absence of roads and communication. He also arranged for me to be escorted to party offices in town by his assistant who could translate for me, if necessary.[1] I had started Hindi lessons in New Delhi, but soon learned that most areas I

1 This young man was recently married. When I had tea with him and his wife, they explained they were not ready for children and so were practicing abstinence, following Gandhi's preaching. This belief annoyed me as they were so obviously in love. I mentioned to them than Gandhi was already a father when, at 35, he decided that expending semen stole energy and so put his wife away. I felt this was unfair to her, especially since Gandhi was always accompanied by young women who massaged him daily. Compounding this debate was the fact that the candidate for Parliament in Narkanda was Rajkumari Amrit Kaur,

planned to visit spoke distinct dialects or other languages. Most of my subsequent interviews were in English.

I had arrived in Simla after visiting the Princely State of Jammu and Kashmir which had just held an election for its Constituent Assembly.[1] This plebiscite on the accession was intended to settle the issue between Pakistan and India, each claiming the state: the population is predominantly Muslim but the ruler was Hindu. Because of the continued fighting, however, the United Nations refused to accept the results and the dispute continues to impact on the relationship of these two neighbors.

Since this was the first time illiterate voters in India were able to vote, reporters from international as well as national agencies came to observe along with a team from Indonesia. On election day, I hitched a ride to the Narkanda with the BBC reporter. After checking into the local *dak* bungalow [government maintained rest house], we visited several polling stations and met a high level Congress party official

from New Delhi also observing the polls. We invited him to tea. About that time, Millidge Walker, a political officer at the American Embassy, appeared; since it was the Thanksgiving weekend, he had offered to drive to Narkanda and give me a lift back to New Delhi.

This visit resonates in my memory: as we sat out on the hillside staring toward the snowcapped peaks of the Himalayas, Mil asked me to marry him. Magical.

Mil's visit caused the Congressman to start a rumor that the Americans were in Himachal Pradesh trying to buy the election! The rumor was picked up by a reporter for *Blitz*, a weekly tabloid published in Bombay that often spun a rumor into a good story regardless of facts. This story was headlined on the back of the paper actually identifying the officer as the administrative director at the Embassy named Walker, a man who never ventured outside the capital.[2] Ironically, on the front page of the paper was a large photo of a reception held by the editor of *Blitz*, Russi Karanja, surrounded by guests including me, and General Cariappa, recently retired Commander-in-Chief of the Indian Army. I was in Bombay to observe the city elections held on January 3rd.

Travancore-Cochin, located along the tropical coast of southeastern India, was still administered by the Maharaja

the Minister of Health, who did not believe in birth control.

1 A German woman, who was driving around India and was also staying at the YWCA , offered to drive me to Kashmir and then to drop me in Simla. Because of the unrest, there were few tourists: we were able to rent a house boat which came with a cook and houseboy. As usual, I contacted the information officer of the state to learn about the elections. This Sikh official insisted on taking me back to my house boat and made clear his intention to come aboard. Instead, I pushed him and he fell into the lake!

2 We met the reporter, G. K. Reddy, a year later in Cairo where he had become a foreign correspondent for the respectable *Times of India* newspaper. He was deeply embarrassed and confirmed the practice of *Blitz* to invent stories on the least whiff of a rumor.

of Travancore during the elections. The elections were held on December 9-10 to avoid any conflict with the Hindu festival *Sabarimala* which is held yearly on January 14ᵗʰ. The contrast with Himachal could not be more stark! Tropical beaches, not snow covered mountains and an educated electorate which had voted *"just after the British withdrew from India. At that time there was only one way to vote, and that was for Congress. Everyone was a member of Congress, which was then more a movement than a political party."*

The state was smaller than Himachal, but with nearly ten million inhabitants, it was entitled to twelve seats in the House of the People, compared to three for Himachal. *"The bulk of the population is concentrated also the coast... The coastal area has the highest density of population in India, if not in the world. There is no such thing as a village, for under every few coconut trees there is a hut. Nearer the town the huts are more concentrated. The whole countryside is like a vast South Sea suburb.*

To provide employment for this multitude, there has been only slight industrialization. The coir industry ranges all along the coast both in homes and in factories. Cashew nuts are prepared for market in Alleppey. The State is a food-deficit area and there is a continual shortage of rice, the staple diet. Some rice is grown along the coast but the land is sandy and tends to be saline. Tapioca is grown up-country, and when mixed with fish provides a supplementary diet.

The bounty of nature and the overpopulation not only means large unemployment but also extensive forced leisure amount those people who are self-supporting. Thus there is no premium on the labour of children who in other parts of India often begin work at five or six. This leisure, and the large number of schools in the area, have given the State the highest literacy rate in all of India.

This emphasis on learning is probably partly due to the continuing influence of foreigners. The Moslem population is predominantly of Arab stock; there is a colony of Jews in Fort Cochin. The large number of Syrian Christians claim to have been converted by the Apostle St. Thomas. In the sixteenth century the Portuguese sent missionaries to the Malabar coast and brought these early Christians under the allegiance of the Pope. After the British came to India, large numbers of Protestant missionaries also went to the area and stabled many schools. As a result of all the proselytizing, the population today is one-third Christian.

Government schools were soon set up for the Hindu population. At the time of elections over 20 percent of the population – both boys and girls – were receiving formal education. Adult education classes were widely available.

Instead of the normal Hindu grouping of caste into four classes and the "untouchables," there are in Travancore only two major castes, the Nairs and the Eshavas. The Nairs were traditionally the warrior class while the Eshavas performed the more menial tasks... [Above these castes are] Brahmins of a special group known as Nambudris. They believed in a patriarchal system as opposed to the matriarchal system of the Nairs and Eshavas. Further, only the eldest male Nambudri was allowed to marry or to inherit the family property. Therefore

the Brahmin group remained static while the other groups multiplied.... Today the Brahmin group has largely given up orthodox Hindu practices and has tended to support Left-Wing political movements.

By the time of the elections Congress had split into rival power-hungry groups, some centered around castes or religions, other about personalities. The first elected Chief Minister left the party to head the Socialists party; Congressmen belonging to the Nair and Eshava communal associations led a revolt against what they deemed was the Christian Congress. Although these two groups joined about a month before the elections, very few former rebels were elected. All this squabbling over seats tended to push aside women candidates.

So the election fight became polarized Congress versus the Communists. The communist Party had been banned for about two years predicting the elections, after it had participated in uprisings in the Quillon-Alleppy districts. Many of its leaders and candidate, including the successful candidate to the House of the People, were "underground," while others were held in jail as detenus.[1]

These people could not stand as Communists, but registered as Independents or as members of the United Front of Leftists...

For the most part, the election was pro- or anti- Congress Party... [The left leaning candidates together won more seats in both the House of the People and the State Assembly.] *There was widespread fear before the elections, particularly among Cabinet Ministers, that the reactionary parties would defeat the Congress in some areas. Generally, the elections dissolved this fear and located the challenge where it really is – on the Left.*

Rajasthan became the largest state in the Indian Republic when eighteen princely states joined together. The contrast between Rajasthan and Travancore-Cochin is a stark as their different size and topography. Rajasthan exemplifies the romantic notion of medieval India with its palaces, its hunting parties out in the desert, and its beautiful women hidden from sight.

The need to integrate the diverse parts of this huge State is one of the most difficult tasks facing the Rajasthan Government. There is little feeling of unity: indeed many of the constituent States are traditionally enemies. Communications between the various areas are undeveloped, and during the elections the State election committee was

1 I was able to meet one underground candidate. In Delhi, I had met Sardar Panikkar, the first Indian Ambassador to China, who was born in Travancore. His daughter was campaigning for the UFL: her husband was a candidate. She arranged to meet me at a bus stop. We then wandered the neighborhood until she felt we were not being followed and could meet the candidate. After the interview I was taken back to the bus stop. While waiting, I was approached by a man who questioned me about the women; I said she merely helped me find the bus stop. From then on, I was followed. I was spooked one night when I was taking a tonga from the train to the guest

house on a peninsula jutting into the Indian Ocean. I could hear the clip-clop of another tonga behind me. Then at the reception desk, the clerk wanted to keep my passport, but I refused. After that, my movements were tracked by the Central Intelligence Bureau. During one of his official meetings with the CIB director, Millidge was asked what he knew about this American; he replied, "I'm going to marry her."

forced to rely on the radio and on aeroplanes to supervise the elections effectively. Even so, in the Jaiselmer district the polling party had to cross the desert on camel-back.

Between these desert areas in the west which border Pakistan for over eight hundred miles, to the dry plains in the east, the great majority of the population cultivates the soil. These peasants suffer from periodic droughts: in the best years they make only a meagre living, for over seventy present of the land is under the tenure of *jagidars*... the *jagidar's* income from his land is in cash...or a percentage of the crop... They were an integral part of pre-Independent society...often taking paternal interest in the well-being of their tenants. Because of this they excercise a tremendous influence over the peasants.

Under such a feudal system, education was limited. The fife percent of the population that is regarded literate is drawn almost exclusively form the ruling classes. Since about 1900, the *jagidars* have maintained their own schools—for males only. Wives of the *jagidars* are neither educated nor free: the purdah system which the Hindus copied from the old Moslem rulers still operated throughout the State.

The *jagidars* had no political organization as such, but sponsored candidates as long as they opposed land reform... seventy-nine candidates were actually *jagidars* themselves... As the returns became known, it was obvious that the *jagidars* won a moral victory. Many top-ranking Congressmen were defeated [for the State Assembly.] Congress did no better in the ventral Parliamentary contest, winning only nine of the 20 seats. The *jagidar* group won only four, but three of the six Independent members are princes.

Some forty-three percent of the electorate

went to the polls all over the State... Even more impressive, however, was the absence of disturbances. Everyone was expecting trouble. The problems involved in conducting an election over such a vast area were tremendous, added to which the tension created by the proposed abolition of the *jagidari* as well as an increase of banditry. To meet all these eventualities, Rajasthan set up a special high-powered election committee under the able direction of Mr. P. N. Shinyal. It efficient function was possibly the most important reason that Rajasthan's elections were the fiasco that many people had predicted.

The Election Control Rooms, which were housed in the State Guest House in Jaipur, deserve come comment.[1] Here the committee charted the movement of all polling parties and police detachments with military precision. Altogether there were 8,602 polling booths at 6,808 polling stations. They were

1 The election commissioner, drawn from the administration of anther state, was also housed in a palace, one of many scattered about Jaipur City. Mr. Shinyal invited me to dinner to meet his daughter who was about my age. She showed me the intricate interiors of the palace before we ate. The mother served us, but withdrew to the kitchen which the three of us ate together: a very modern thing to do. As a Brahmin, Mr. Shinyal delighted in reading horoscopes and offered to present one to me as a wedding present. I had to provide him with the exact time of my birth and/ or when the marriage was finalized. My birth certificate from Wisconsin arrived in time, and I sent him that information along with the time Mil and I became man and wife. I never heard from him; worse, his daughter, who occasionally visited New Delhi, was told she could no longer visit. For years I pondered what was in my horoscope so dangerous to the daughter. On my next trip to India, I met Mr. Shinyal again and asked about his promise. He replied: "You have a fine family now, what difference does it make?"

manned by 1,221 polling parties consisting of at least five persons each. Voting in Rajasthan started on the 4th of January and continued until the 24th. This allowed parties to shift from place to place within a given areas, conducting elections every other day. Coloured pins on a map of the State showed at a glance where every polling party was...

Detachments of the Rajasthan Armed Constabulary were placed at strategic places... A chart indicated the number of ballot boxes distributed at certain centres all over the State. Disturbances were charted [and] included: ballot box tampered with; canvassing too close to the polls; impersonation; polling party injured in a motor accident and polling postponed; bandits attacked polling party and driver killed, but voting held; ballot boxes did not arrive.

The efficiency of the election committee contrasted with the earlier errors made when preparing the electoral rolls. Most of the women had been enrolled as the "wife of" so and so. Later it was decided that this was not an adequate listing; the woman's name had to appear in full. An effort was made to correct the roll, but at election time some forty percent of women... were not able to vote due to improper listing.

For women who were properly registered, special <u>purdah</u> booths were set up wherever possible. In several instances where polling booths had to be used by both sexes, the booth was set up I a place from which women were traditionally excluded, and thus they were unable to vote. Nonetheless, more women voted that had been anticipated; it is estimated that they made up forty-eight percent of the total poll. It is significant that the women's vote was heaviest in constituencies where ex-rulers were standing.

AMERICA: MELTING POT OR PLURAL SOCIETY?

New Frontiers 6/2: 53-37. 1965

BOYCOTTS, STRIKES - PEACEFUL AND otherwise, demonstrations, all are now frequent occurrence in the United States as the civil rights movement gathers momentum. The relationship between the Negro minority and the rest of the American people is clearly a central problem of this generation, but as a problem it is hardly unique. Hindus and Muslims riot on both sides of the India-Pakistan border; the United Nations sends troops to quell the strife between Turk and Greek on Cyprus; a world gasps in horror at apparent attempts by the Bahutu in Rwanda to commit genocide on the Watutsi. Under colonial rule, and many describe the Old South as a colonial system, these groups lived in apparent harmony within their countries. Why now the vast unrest? It is obviously the result of nationalism.

The idea of nationalism has swept the world in the last half century. One needs only to remember the ease with which royalty born in one European country used to rule in another to see how recent exclusive nationalism really is. Modern nationalism emphasized loyalty to the group above all else. The group may be based upon language, religion, culture, race - any or all, it doesn't matter. What is crucial is that the group feels itself bound together and therefore distinct from other groups.

As leaders in colonial countries began to demand independence, they based their claims on nationalism: the right of the groups to give loyalty to their own leaders, in other words, the right of self-determination. The major enemy was the colonial power; the major impetus for group feeling was anti-colonialism. To stimulate a more positive nationalism the nationalist leader sought heroes from history, emphasized cultural distinctiveness from the metropolitan country, and nurtured indigenous myths.

Today many of these newly-independent countries face serious internal strife due to the very success of this stimulus to group identity. There is no absolute level at which this group identity must stop. Fervent loyalty to a group is the same emotion whether the group is identified as the Indian Republic of over 440 million or the Turkish Cypriots of a few thousand. Minority demands spring from the same feelings of group identity and the right of the group for self-determination as did earlier demands for independence. Where do you draw the line? When is this nationalism a positive force and when does it divide and disrupt the country?

Most newly-independent states have boundaries which have no relevance to ethnic, cultural or religious boundaries. Leaders of these new states are without exception engaged in nation-building...the creating of a strong myth of group solidarity which bases its outlines on the state. Many nationalist leaders have found that nation-building is easier without democracy since most groups - minority and majority - may need to be restrained while their particularistic myths are molded to fit the newly-created national ideals. Thus Ghana's Nkrumah denies rights to the Ashanti tribesmen while General Ayub Khan tries to hold together East and West Pakistan by military rule.

The problem of minority rights has obviously become more critical as the stress for government in a democracy is laid upon majority rule. If group identity or group nationalism hardens the majority and minority into permanence, the basis for the nation-state is threatened. When the United States became independent less stress was placed upon group emotion and more upon allegiance to the country as opposed the king and to an unfettered economic system. Since many Tories left after the British were defeated, the American revolutionaries led a relatively homogeneous group in terms of ideals and outlook. Nonetheless, our founding fathers, too, had to engage in nation-building to create symbols to replace the rejected king. From thirteen prickly states, from unmapped wilderness, from disparate peoples, a state

was molded, a nation created, through the help of the American myth.

Our myth is a kaleidoscope, shifting, appearing differently to every observer, yet clearly a combination of certain beliefs. To encourage national loyalty, heroes were invented or embellished: Paul Bunion or Pecos Bill are the stuff of folk tales while Washhlgton as founder of the nation was endowed with a personal myth from the cherry tree to his death. Individualism and hard work as keys to success were underscored by the Protestant Ethic and the abundance of the frontier. Later, to counter the growing ethnic variety and linguistic chaos and mold the later arrivals to a pattern, the melting-pot theory was added to the American myth.

Basically this theory holds that every immigrant melted, lost his distinctiveness, submerged himself among the American people within a generation or two. Oscar Handlin has documented this frequently painful process of culture change in his brilliant study of New York City, *The Newcomers*. Here he has shown that the melting in some cases took six to eight generations. But the Irish and Germans, Jews, and Italians, eventually did melt. Our myth goes on to say that the mold into which these various peoples melted turned out equal people. Our Constitution is permeated with the philosophy of John Locke who believed that every person was born with a *tabula rasa*, blank slate, and so must be equal. Melted and molded Americans become, via this process, not only equal, but similar: the

mold was presumed to turn out identical persons. From such philosophical assumptions came the American celebration of mediocrity and conformity, the suspicion of intellectuals and non-conformist, and minorities.

Unmelted Americans have never been treated equally. Indians were shunted off into reservations; Chinese were isolated in quaint blue-tiled ghettoes; Japanese were treated to a second-class citizenship which allowed them scant protection of the Constitution in the hysterical days following Pearl Harbor.

Free Negroes, who were among the earliest American settlers, were not accorded the right of federal voting until after the passage of the Fourteenth Amendment. We all know the constitutional provision that a slave was three-fifths of a man as far as numerical suffrage is concerned; today in the South Negroes are counted as full persons, but still are not often allowed to vote. These minorities have not melted; according to our myth of the melting pot, these groups are therefore non-American.

Here is the crux of our problem today. We honestly believe in the American myth; nothing is too hard to alter as these axiomatic values which the culture instills in us. America IS the melting pot; but we are not sure we wish the Negroes to melt. Everyone is equal in America ... that is, if they are melted Americans.

This paradox explains the ambivalence of the Northern melted American. In suburban Maryland's Montgomery County a fair housing organization to-gether with the local churches has been soliciting pledges which say that the signer believes that every person should have equal opportunity in housing. Too often, the reply is a confused: "why of course I agree, but, well, my neighbors might not like it," or "ah, er, I think Negroes should have nice houses, but, here, well, I have to think of the property values." Among the equal, everyone is equal.

The adherence of all Americans to this melting-pot myth beclouds the whole issue of minority rights. In the very long run a final solution to the relationship between minority and majority may be melting, assimilation, a solution Hawaii has achieved to a large measure. Even so, the melting point is high; assimilation will take generations. Clearly the minorities cannot be excluded from equality until they melt. The illusion of the easy melting pot needs replacing by a realistic appraisal of minority rights.

Concern for minority rights in a democracy has frequently been voiced. John Locke's equal men made all decisions by a majority; John Stuart Mill feared the Tyranny of the majority and proposed safeguards for minorities. In many ways, as F.S.C. Northup has demonstrated, the United States follows Locke and England follows Mill. In her colonies England was deeply committed to the protection of minorities.

Indians blame the concern for the minority Muslims and their rights as the seed from which Pakistan grew. Provisions in the Cyprus constitution,

insisted upon by the British to protect the Turkish minority, started the latest round of rioting on the island. Far from being the cause of dissension, the attempts at constitutional safeguards in these two instances were simply not strong enough to withstand the contradictory pressures toward group solidarity by the majority and toward group recognition by 'the minority.'

In India the myth-creation tended to emphasize Hinduism, Hindu leaders, Hindu cultures; the Muslims became increasingly uncertain of their role in an independent India. They demanded Pakistan as the price for their support of independence. The distribution of Muslims was sufficiently regional to allow the carving out of British India, an artificial state, its two wings separated by nearly a thousand miles of hostile territory. But the operation left many Hindus and Muslims on the wrong side of the border thus creating a continual irritant in the relations between the two new states.

Separation appears, then, as a possible solution to minority demands. Turkey and Greece exchanged populations in 1922 to clean up minorities in their respective countries. Cyprus, under the British, was not included in the exchange. Many observers see evaluation of the Turks as the one method of guaranteeing their lives: another exchange. Separation can also take place within a state. America's Indian reservations were such an attempt, as is South Africa's policy of apartheid or the Black Muslim's demand for a Black America.

The Turkish Cypriot demand for federation follows this line of reasoning, as the does the Ceylonese Tamil's demand for federalization on their tiny island. Quebec providence in Canada or Nagaland in India unite groups which feel themselves at odds with the prevailing national identity; they continue to demand more and more autonomy in order that their group may dominate in their own province.

Continued separation of groups already regionally located may solve the problem of minority rights; but enforced separation by exchanges leads only to bitterness. At least one million Muslims, Sikhs, and Hindus lost their lives during the partition riots in India in 1957; more die every year in the undertow of intolerance. Few believe in the efficacy of apartheid or of Black America as the solution to anything.

Removal of minorities, beyond mere exchanges, is a policy pursued in some countries and ranges from the insanity of genocide to the intimidation of white and Indian settlers in East Africa, to the economic squeeze Burma is putting on her Indians or Indonesia is putting on her Chinese. Marcus Garvey wished to remove himself and most Negroes to Africa; few Negroes favor this solution today.

What solution is left, if forced national unity cannot be engineered by redistributing groups...each to its own province or state? Just imagine a UN of thousands of Andorra-sized states! Until group loyalty can be focused upon the nation-state, the only solution to

the problem of national minorities is toleration in a plural society.

A plural society is nothing more than a society where different culture groups live territorially mixed up, where each group is free to live and speak and dress in its own way, where persons from each group participate in the realities of power in the country. Some basic consensus must be present for government to function, and undoubtedly this consensus is the base for myth-creation of nation-building. But these myths then start from diversity, not conformity, from a mosaic of types and values not from single mold.

Malaysia's example of toleration between Chinese, Indian, and Malay is a glorious light in a dark picture; the escalation of nation-building to include three new parts of Malaysia has increased the diversity in the new country, making tolerance all the more necessary. The chaos and cruelty could explode in Malaysia if intolerance and murder replaced the present compromise is frightening to contemplate. Far from, endangering Malaysia, Indonesia's confrontation policy is strengthening the bonds between the diverse units as well as the determination of various ethnic groups to make a success of their daring commitment to mutual tolerance in a plural society.

Toleration of minorities in a plural society is clearly the only solution to the building up of stable nation states; rampant nationalism can only be disruptive and divisive. America, too, needs to recognize the pluralism of her

people. For years we have celebrated the pluralism of our institutions as the guarantor of our open society. Even more of an asset - if we would but recognize it - is the pluralism of our people.

If the majority in the United States continues to insist upon the melting pot in theory but oppose it in practice, the result will be increased tension, more vocative rioting. If Negroes and other ethnic minorities cannot become melted Americans, then their only alternative is Black Nationalism. Signs of increased group consciousness are everywhere apparent. Negro writers more and more extol blackness...as a color, as a look, as a special ability to love. The cultural patterns of the Negro masses now tend to be overlooked and forgiven by the middle-class leadership of the more militant wing of the civil rights movement. Indeed, it is the Black Bourgeoisie who are being criticized for having attempted to melt. Poured into the American mold, these bourgeoisie, resembling the other melted Americans in all but the slightest facial tinge or hair texture, have simply not been recognized as equals. Alienated from the mass of Negroes and disowned by their fellow middle-class Americans, the Black Bourgeoisie was, and is, in an impossible situation. Many reacted to this unreality by emphasizing the fast life. A few looked to communism. Today many leaders of this disposed class are looking to nationalism. If a plural society is not created in which this talented class may seek recognition and power, then their only chance

of participating in American society is for the middle-class to shed its alien culture they have adopted and identify with the Negro masses.

The school boycotts are symptomatic of this trend. The more conservative leadership, realizing that the evils of slum schools are too complex for an easy solution of one-day boycotts, has begun to oppose the boycotts because they fear the growing enmity of the white middle-class. The military leadership favors the boycotts for the reasons the conservatives oppose them: enmity of the whites and the resultant solidification of the Negroes.

The more that nationalism pervades the civil rights movement, the greater the gap between the dominant melted majority and the demanding minority. Lines are more and more drawn on color, not culture. Cooperation, even communication, between the opposing groups lessens. Look at the history of Cyprus; or British Guiana; or Pakistan; or Rwanda. Raw, excessive nationalism broke down cooperation and communication between majority and minority; riots, violence and bloodshed resulted. Is that to be our history too?

Only immediate legal equality, only the rejection of the unrealistic and outmoded melting-pot theory, only the creation of a truly plural society where individuals qua individuals are equal, only these things can avoid the frightening trend toward separatism and nationalism in the United States. We believe and practice equality in religion, though religious wars convulsed Europe for centuries. Now we must learn to practice equality of group, though nationalistic wars have convulsed the world this century.

The melting-pot theory is the basis for white nationalism. Perpetuation of this myth can only lead to a continuing denial of the freedom and equality upon which this great nation of ours is based. That denial is clearly no longer tolerable.

THE FIRST GENERAL ELECTIONS IN INDIA AND INDONESIA

[summary text in italics]

THE DIFFICULTIES OF INTRODUCING UNIversal suffrage elections into the new democracies of Asia and Africa have been widely discussed, but little serious attention has been given thus far to the electoral process itself. In recent years, two of the more important Asian nations have held their first general elections in the face of tremendous obstacles. Since India and Indonesia have different colonial backgrounds, a comparison of the electoral process in the two countries should reveal both problems and solutions in holding elections in a newly independent country.

It is no simple matter to introduce full-fledged democracy into a country previously controlled by an oligarchical colonial administration. Ideally it might be expected that various forms of democratic government would be carefully examined and those most appropriate to the country slowly introduced. But in fact the expectations aroused in the citizenry by nationalist agitation have required the immediate introduction of the whole gamut of parliamentary institutions. The tendency is to turn to the former metropolitan power as a model and to imitate its institutions with a minimum of adaptation, allowing modifications to be made later. Since elections tend to become the symbol of the complete introduction of a democratic government, great emphasis is attached to the speedy holding of elections. Yet, it is not merely elections, but the type of elections, that indicate progress toward democracy....

Actually it is immensely important that elections be held expeditiously. Elections themselves are a potent education in democracy; the effect of introducing the concept not only of choice, but of a free and secret choice, to a submissive peasantry conditioned by fatalistic ideas cannot be overstated. Equally important is the understanding of democracy which follows when the detached and distant ruling group comes to the humble villager and asks for his vote. Further, the elite leadership of any independence movement, coming as it does from a narrow social group, can easily lapse into an oligarchy itself if it is not required to seek approval from the electorate. The gap between the usually Westernized elite and the more traditional villager can be narrowed through the electoral process, the villagers learning of democracy and of national issues, the leaders coming into close contact with the peasants and their problems.

Nor is it really valid to raise the question of the readiness of the illiterate

citizenry to work democratic institutions. Since nationalist agitation is normally directed against the narrow base of colonial rule, the cry for participation in government is usually one of the first voiced against the colonial power. "One man, one vote, one value" becomes a rallying call, despite the only recent equation of universal suffrage with parliamentary democracy[1]... To many Asian nationalists it seems intolerable to suggest that the base of power should be widened only gradually; they insist that all civil and political rights must be granted immediately to the new citizens. Given this attitude, it is essential that the electoral process be sufficiently simplified so that in fact the new citizens are able to use and control the parliamentary institutions and thus prevent them from becoming a mere facade behind which a clique manipulates the government.

It is a mistake to overstress the drawbacks of illiteracy in an electorate. There is no question that education, genuinely deep education and not superficial glitter, creates an electorate more able to participate fully in the process of government.[2] However, recent psychological research has emphasized that educated men will not always act, or vote, rationally. Furthermore, the increasing complexity of government makes it nearly impossible for voters to comprehend the nuances

of all legislation, and thus it becomes virtually impossible for them to give a mandate to their representative on the diverse issues with which modern governments are concerned. Instead, the voter selects his candidate on the basis of past action or on the trend of attitude which the candidate expresses. The candidate may make his stand clear by references to broad issues such as nationalization, foreign aid, neutralism, but he can also depict his position in terms of local land reform or village wells. Beyond this, any candidate is known to some extent by the company he keeps, whether he is contesting in San Francisco or in Djakarta. If the choice presented is sufficiently clear and relatively limited, then an illiterate is as capable of making an intelligent selection as is the educated man.

The simplification of the voting procedure so that illiterates may vote in secret, while putting an added strain on the administration, does not really present a major problem. Symbols are used in addition to (or in place of) the name of the party or candidate. The British seem to favor the multiple-box technique and have introduced it into India and Africa. In Ceylon and Malaya the voter is required to put an "x" on the printed ballot paper alongside the symbol of the candidate. Indonesia has the voters punch a hole in the symbol of their choice. The French prefer the symbol on-a-card technique—the voter picks up the card he prefers and puts it into an envelope which he then casts in public.

1 Problems of Parliamentary Government in the Colonies (London: Hansard Society, 1953), p. 58.

2 Sir Ivor Jennings, *The Commonwealth in Asia* (London: Oxford University Press, 1951) p. 36.

More important is the need to limit the choices presented to the voter so that he may be faced with fairly clear alternatives...The existence of a few strong responsible parties with clear trends of thought greatly simplifies the choice presented the voter. Yet one of the characteristics of party development in the new democracies has been the proliferation of parties. It is possible, by the selection of a particular electoral system and by the premium put upon party actions in parliament, to influence the development of a party system to some extent. However, the need in new nations to hold elections with utmost dispatch tends to preclude experimentation.[1] Moreover, so many other factors (such as the history of the nationalist movement, the geography of the country, the social base of the society) also have a bearing upon the party system that a multiplicity of parties in the new democracies seems likely to continue for some time. Under such circumstances it is important that the number of elective offices be limited, and that, within the limits of the electoral system adopted, all devices for limiting the number of parties be employed...

It is obvious that the national leaders in both India and Indonesia were aware of these problems when they set up the electoral systems in their countries, although their differing colonial traditions

naturally led them to different solutions of these common problems.

SUMMARY COMMENTARY:

The article details election planning in each country identifies significant issues, notes difficulties encountered, and contrasts the two systems. I list those of major interest.

Selection of the electoral system:

Since India had held limited suffrage elections in much of the country, the adoption of the single constituency plurality system was not debated. Much heat was generated by the provisions for communal seats. The British had chosen to ensure representation through separate electorates. This approach exacerbated communal tension and was instrumental, in my opinion, in the creation of the two separate states of Indian and Pakistan. Eventually, separate electorates were abolished; reserved seats for the underprivileged Scheduled Castes and Tribes were provided, but all voters in the constituency were able to cast a ballot.

Indonesia had few of India's advantages either in trained administrators or in an established electoral system. Moreover, the animosity against the Dutch which was instilled into the Indonesians during the prolonged struggle for Independence made them reluctant automatically to adopt parliamentary institutions similar to, or identified with, those of their ex-colonial master. All schemes of federalism, an obvious governmental form to adopt (given the territorial diversity of the country)

1 See, in particular, Maurice Deverger, *Political Parties* (London: Methuen, 1954) and F.H Herman "Proportional Representation and Parliamentary Democracy" in *Parliamentary Affairs,* Spring 1951.

were disliked, primarily because the Dutch had sponsored the federal plan for a United States of Indonesia...

Eventually, because of the pressure of small parties to give them some representation...and because it was the only system that any leaders had experienced, Indonesia turned at last to a modified list system of proportional representation...

One of the most inflammatory sections of the electoral law concerned the division of the country into electoral districts. The Catholic Party, supported by the Communists and others, wanted the whole country to be one single constituency; they assumed this would give greater strength to the medium-sized parties whose support was distributed throughout the country. The SOcialists advocated 37 districts in order to give greatest possible representation to minority and regional groups. The compromise figure of 16 districts –including the Dutchheld Irian Barat (Western New Guinea) - was considered to provide districts small enough to give representation to regional and minority groups and at the same time large enough to discourage small local parties.

After the squabbles over regional representation, the problem of communal representation was solved almost without argument. Eighteen parliamentary seats were set aside for minority groups: 9 for Chinese, 6 for Arabs, and 3 for Dutch...

Symbols:

As in India, symbols were used to designate parties or candidates. Although the election law prohibited the use of "the national crest or symbol of any foreign state, the pictures of any individual, or any symbol which is offensive to Indonesian conceptions of morality," the Central Election Committee interpreted this broadly, allowing parties to use a hammer and sickle despite the fact that it appears on the Soviet Union flag. Both the Masjumi and the Partai Sarekat Islam Indonesia (PSII) used variations of the crescent and star which appears on several national flags. Nor did the similarity between these two symbols produce any reaction from the Central Election Committee. To confuse matters further, one party was allowed to have different symbols in different districts. The Socialists, who used a star and a sheaf of grain in Java, used a *renchong* knife in Sumatra and a ship in the Celebes... the parties with a distinct communal base did not sufficiently consider how effectively the use of a religious or cultural symbol would limit their scope as political parties. For instance, the Catholic Party chose a rosary as a symbol: but a Hindu, however much he might like an individual candidate, would hardly be likely to vote for a rosary. Many of the Javanese parties chose typically Javanese symbols, an action not calculated to endear them to voters in the outlying districts...

While the electorate in Indonesia was only one-fourth the size of India's,

the even greater lack of trained administrators and the geographic obstacles to rapid communication presented grave problems. Regional rebellions demanded the services of many officials who would have otherwise been available. Further, the majority of administrators were Javanese who knew little of the conditions outside their own island and were often resented by the inhabitants of the outer islands. To overcome what appeared to be an insuperable shortage of administrators to conduct the elections and to involve the greatest number of citizens in the process, a pyramidal system of lay committees was set up extending down to the village (*desa*) level. Thus the major work of elections fell, not as in India on a cadre of trained men, but on village committees. Much more an act of faith than the extension of suffrage to the illiterate villager was this entrusting the conduct of the elections to the often illiterate headman and his committee... Instead of attempting to set up an impartial administrative structure for the elections, the Indonesians involved the parties hoping that they would control each other.

Registration of Voters

The first problem facing these committees was the registration as voters of all citizens over eighteen years of age or married, Since this registration was in effect a census, it was important that it be as complete as possible. Before the election law was passed, registration had been attempted on a voluntary basis, but the public had not responded. Therefore the village committees were asked to undertake a house-to-house canvass, a long tedious job particularly in those areas still torn by internal strife. In many areas this method of registration was replaced once more by voluntary registration after September 30, 1954. Complicating the difficulties of registration was the problem of citizenship, particularly with regard to Chinese resident in the country. This problem was still under consideration when the government rather arbitrarily ended further registration on September 15, 1954. Since nowhere had registration—and hence the census—been entirely completed and since almost no count had been made in the areas of West Java held by the Darul Islam insurgents or in the portions of North Sumatra and Atjeh which were in rebellion, the opposition accused the government of purposely (and) rule (43.1 million) were qualified by age or marital status, to be placed on the electoral register...

The voter then took this large ballot, which was two feet square and contained the names and symbols of all parties contesting in the district, into a small uncurtained cubicle and indicated his choice of party by punching a hole in the symbol... The size of the ballot paper made it easy to see which symbol the voter had punched...

Counting the votes was another matter. The enumeration of the ballots was begun by the village committees... and rule on the validity of the

ballots, a task for which they were not adequately prepared. Not unnaturally, decisions varied from committee to committee… if the voter wrote in the party of his choice instead of punching the symbol, his vote was set aside… The initial awarding of seats was handled by the District Election Committees once they received voting figures from the village committees. They first established a quota for the district by dividing the actual vote by the number of seats assigned to the district. Any candidate –independent or on a party list— having this total was automatically elected. The straight list vote totals were divided by the quota to obtain the number of candidates winning in each list…

The second and third allocations or votes, conducted by the Central Electoral Committee, disregarded district boundaries. All undistributed votes from the whole of Indonesia were totaled and then divided by the number of seats as yet unassigned in order to obtain a quota for the second distribution of seats. Each list or combination of lists or combination of candidates was then divided by this quota and allotted one seat for each full quota. For the third allocation seats still unassigned were given to those lists having the highest number of "remainder" votes…

When the results were finally known, two rather amazing facts appeared: despite proportional representation, nearly 85 percent of the voters had cast their ballots for one of four major parties, and these parties corresponded to definite social and traditional divisions of the society. Of the PNI support 84 percent came from Java, particularly from the bureaucracy and the aristocracy and those influenced by them. The strength of the Indonesian Communist Party was also concentrated in Java, but came from the less prosperous and generally more socially disturbed areas of East and Central Java. Neither party had much support outside Java though the PNI picked up some votes in Hindu and Christian areas where there is distrust of the Muslim-oriented parties; the Communists received some support in the plantation areas of Sumatra. The Muslim parties, Masjumi and Nahdlatul Ulama (Muslim Teachers), which were united until 1952, did not on the whole, compete for votes. The strength of the Nahdlatul Ulama was concentrated in East and Central Java while the Masjumi support came from West Java, Sumatra, and Sulawesi.

This identification of party with social groups made the creation of a single national party impossible. The Parliament, as well as most provincial and district assemblies which were elected in May 1958, were paralyzed by squabbling among the four parties and were unable to pass any legislation. Eventually, the legislatures devised a system of voting consensus on a bill –they called it suara bulat or round vote – and then listing exceptions to particular sections. Interestingly, this form of consensus voting with exceptions has been adopted by the United Nations General Assembly. This legislative impasse led to the declaration of Guided Democracy by President Sukarno in July of 1959.

CONCLUSION

In both countries the elections effectively dispensed with the more evanescent groups while still returning a wide variety of parties to Parliament. In India the exaggerating effects of the plurality system caused several panties to make alliances in subsequent elections, while two of the larger national parties united-at least briefly- into the Praja Socialist Party. On the other hand, the Indonesian system of proportional representation removes any pressure for parties to unite, but tends rather to perpetuate all but the smallest parties. As the major parties in Indonesia lose their traditional base – becoming it is hope, more secular—it would seem probable that (if Indonesia continues with the present system of proportional representation) the number of major parties will increase while few very small parties will continue. Under the Indian system there will always be scope for an independent, but the slaughter of them in the first election should discourage all but the strongest candidates from contesting in the future.

Theoretically, proportional representation assures more voice to minority groups in the country. But in Indonesia the major problem is one of minorities grouped territorially rather than of minorities in a plural society. Even with districting, regions in Indonesia have less scope and power than do the states under India's federal structure simply because (at least in the state legislature) regional interests can predominate. Yet in neither country has the relation between the center and the regions been stabilized, and in both, divisive trends are a constant threat to the unity of the country.

The elections, by emphasizing the national parliament and national problems, give prestige and importance to the nation. In both countries the weighted representation of small remote areas made unity more amenable to outlying areas. But with Muslims in Atjeh and Nagas in Assam demanding more independence from the center, it is clear that further adjustments need to be made to ameliorate regional-central relationships and that perhaps in both countries the electoral systems could be made to perform a more integrative function than they do at present. For instance, if the second distribution of seats in Indonesia were still on a regional basis (with all the remainder votes from Sumatra being put together, all those from Java, all those from Kalimantan, etc.), and if candidates could win only in regional distributions from the area in which they Jived, then regional predilections would have wider scope than they have at present. In India the reserved seats for tribals give representation to the Nagas, but the extension of full state government to Manipur, and the possible inclusion of some of the neighboring Naga areas into this border state would probably lessen the tension now felt between the local tribesmen and the men from the plains.

With the number of parties in the

field, the choice given to the voter in either country was not as simple as might be hoped. Intensive educational programs by government and parties occurred in both countries. Also in both countries the tradition of group life meant that group decisions were more frequent than in the more individualistically oriented countries of the West. This fact in itself is educational and useful, especially when coupled with the secrecy of the vote. Because of the size of districts in Indonesia, it was almost impossible for a local candidate or local issues to have any real place in the election. The choice was between national leaders and between those parties with which the local leaders had aligned themselves. Trends of the parties, because they were not localized, seemed to have had less meaning to the Indonesian voter than to the Indian voter. Hence the meaning of the vote and the meaning of the choice were clearer under the more personalized single-constituency system than under proportional representation. This may help to explain the apparent docility of the voters in Indonesia.

When India completed its elections, the lesson drawn was that whatever the obstacles, a well-trained administration could conduct elections in any country if the country were willing to pay the cost and give time. Indonesia, without sufficient administrative personnel, developed the committee system which relied on the parties and citizens to aid the overburdened administration on all levels. In the Sudan, a country with even fewer administrators than Indonesia, an international committee conducted the elections. This suggests that the problems of administration need never be considered insuperable.

Both the cadre and the committee system functioned well, though the cadre system was certainly more efficient. Distribution of materials under the committee system often broke down; this was one of the reasons that registration took so long, and that elections in some areas of Indonesia were held after September 29. Yet the constant contact between village committees and the administration was educational to both and undoubtedly impressed villagers with a sense of their village leaders' importance—if not their own-under the new Indonesian government. There was amazingly little corruption under either system. The parties, under the Indonesian committees, were put on a sort of honor system which seemed effective against cheating in the elections. Further, by involving the parties more directly in the electoral system, Indonesia's parties aided the elections somewhat more than was the case in India. Thus the pros and cons of the two systems are about evenly matched. The amazing point is that Indonesia dared to gamble its whole electoral process on the intelligence of the illiterate villager, and that the gamble paid off.

It is obvious, then, that if a newly independent country wishes to hold elections, administratively it can do so within a reasonable length of time. If

several parties and candidates are allowed to compete openly and freely for the voters' favor, the elections can be a tremendous educative process, though the electoral system chosen affects both the range of the education and the type of choice. Further, electoral systems can help eliminate central-regional or minority-majority animosities by emphasizing national unity while still giving minority groups adequate representation. During the fluid years following Independence when the people, learning to live under a democracy, are most impressionable, the electoral system selected will set patterns which can exert far-reaching effect on the country. Both India and Indonesia have introduced systems that augur well for the future.

QUOTAS FOR WOMEN IN ELECTED LEGISLATURES: DO THEY REALLY EMPOWER WOMEN?

2004 Women Studies International Forum 27:4

POLITICAL PARTICIPATION OF WOMEN IS currently a major goal throughout the global women's movement. The Fourth World Conference for Women in Beijing restated the importance of women in political as well as economic and social decision making. Representation in legislative bodies is believed essential in order for women to protect the expansion of their rights and opportunities by enshrining them in laws and constitutions. Frustrated at the slow pace of change, women are demanding special provisions to enable women to be elected or appointed to high level decision making positions, and promoting the idea that 30 % of membership is necessary to provide a critical mass that would allow significant changes in policies and procedures.

This demand for quotas has escalated in the last decade as the UN's Division on the Advancement of Women and the European Union debated the concept (Gierycz, 2001; Jaquette, 1997). The 30% target quickly became a goal at the 1995 Beijing conference. UNIFEM's *Progress of the World's Women 2000* notes that "The Beijing Platform for Action affirmed the target previously agreed upon by the UN Economic and Social Council (ECOSOC) that women should have at least a 30 per cent share

of decision-making positions" (2000:9) Such a demand would seem to be the next logical step in an empowerment process that has altered the status of and opportunities for women in every country around the world. Over 25 countries have adopted legal or constitutional quotas for women in legislatures, primarily at the national level but also at the local level.[1]

The Inter-Parliamentary Union happily tabulates the success of this pressure for numbers of women and posts results on its website (www.ipu. org). The Institute for Democracy and Electoral Assistance in Stockholm tracks elections globally (www.idea.int). The latest published date indicates that women hold at least 30 percent of the seats in ten countries, with another fluctuating based on appointive seats. As of March 2002, those legislatures with the highest percentage of

1 As of March 2000, between 20 and 30 per cent of seats at some level of assembly are to be filled by women in: Argentina, Belgium, Bolivia, Brazil, Chile, Dominican Republic, Costa Rica, Ecuador, Eritrea, Finland, Ghana, Guyana, India, Mexico, Morocco, Namibia, Nepal, Norway, Tanzania, Uganda, and Venezuela. Finland requires equal numbers of candidates of political parties; Philippines has an executive order encouraging 30 per cent representation in local elective bodies (UNIFEM 2000:76).

women are: Sweden 42.7; Denmark 38.0; Finland 36.5; Norway 36.4; Iceland 34.9; Netherlands 32.9; Germany 31.8; Argentina 31.3; New Zealand 30.8; Mozambique 30; South Africa 29.8. Another 23 countries have at least 20 percent of the seats occupied by women. These countries expand the European coverage both south and east, adding Canada, Australia, three Caribbean islands, two Central American states, four more in Africa, four communist countries, and Turkmenistan.[1]

This global rush for quotas for women in elective bodies is widely supported and little examined. Do numbers of women in legislatures in fact translate into power to implement a feminist agenda? Or is the purpose of more women in elective offices to offer exposure of more citizens to the reality of compromise and governance? Or is the idea to bring the housekeeping and nurturing skills of women into corrupt and ineffective councils, especially at local levels, so that roads are paved, schools built, and water provided? Or are women only window-dressing in legislatures controlled by a single party? Or are women considered merely a front for men unable to run for whatever

reason or for relatives who already hold power locally or nationally?

The answer to these questions depends on the justification offered for quotas. If the argument rests on the concept of equality, then numbers, not outcome, register success. However, this justification begs other questions. If equality means that all citizens should be able to participate in decision-making, why should women have a different type of access to election success than that provided for other under-represented groups? After all, women are seldom a minority of citizens; why do they need distinct treatment?

On the other hand, if the justification is based on the concept that women have distinctly different priorities in life and in governance, then the impact of women in the legislature should lead to a different outcome than would have been true in an overwhelmingly male body. Clearly the campaign to elect women launched by the women's movement expects that an increased number of women legislating will lead to a feminist agenda.

What factors increase the probability that having more elected women will result laws that enhance women's rights? Outcomes are greatly influenced by the type of electoral system. How the women candidates are chosen and by whom, how the electoral system operates, and the external support for feminist goals in the nation are all essential factors in evaluating the utility and possibility of quotas for women. Other factors that affect the ability of

1 The 23 countries: Belgium, Switzerland, Austria, Spain, Poland, and Bulgaria in Europe; Canada and Australia; Barbados, Trinidad and Tobago, and Sao Tome and Principe in the Caribbean; in Central America, Guyana and Nicaragua; in Africa, Namibia, Tanzania, Uganda and Rwanda; communist countries of Cuba, China, Laos, Vietnam; plus Seychelles, Turkmenistan,

women to alter the priorities of the legislature include the characteristics of the party system, the level of government requiring quotas, the local political culture, and the underlying social system that determines the prevailing relationships between women and men.

This article first presents various arguments for quotas. The second section analyzes the major electoral systems in current use around the world and how women candidates and feminist issues fare under them. The third section reviews problems encountered by women both as candidates and as legislators in the face of male resistance and structures. The next section addresses the question of women's power and asks whether the instituting of quotas will really make a difference in the political decisions in elected bodies by themselves. In conclusion, the essay addresses two basic questions. First, to what extent does the method of ensuring a quota and the electoral system itself strongly influence the power women members have in a legislature, and over what type of issue? Second, how does a vibrant women's movement influence both the legislature and the wider public to support a feminist agenda?

WHY QUOTAS ARE CONSIDERED NECESSARY TO INCREASE WOMEN'S POLITICAL PARTICIPATION

Despite the fact that the Constitutions in all the newly independent countries proclaim equality for women in civil matters, entitling them to vote even before some women in Europe were granted that privilege, the numbers of women in decision making positions actually diminished compared to their roles in the nationalist movements or liberation struggles. Over time, women – whether elite leaders such as Ambassador Vijaya Pandit or Judge Annie Jiaggi, or the soldiers in Eritrea or Zimbabwe – were sidelined as men reenforced patriarchal privilege and power to bolster their nationalist claims. Indeed, most women, as well as men, seemed to assume that men are the more fit to act in public spaces and to govern, women to nurture in the privacy of the home. Yet, today the voting public, disgusted with widespread mal-administration and corruption, has begun to consider women in politics as acceptable, even desirable, because they are perceived as being more concerned with outcomes than the accumulation of power.

Equality vs difference The Women in Politics committee of the International IDEA discusses quotas in their *Women in Parliaments: Gender and Democracy*. Druda Dahlerup, in her section, writes that "The core idea behind quota systems is to recruit women into political positions and to ensure that women are not isolated in political life." She notes that critics argue "Quotas are against the principle of equal opportunity for all, since women are given preference" while supporters say "Quotas do not discriminate, but compensate for actual barriers that prevent women from their fair share of the political seats. " This argument for

quotas perceives that women and men are the same. Women are half the population so it is only fair and right that women have equal representation in legislatures that make decisions over their lives. Because of historical reasons, affirmative action such as quotas may be needed to ensure that women achieve greater representation, if not parity.

Yet quotas also appeal to the idea that women's experiences are distinct; that women are different from men and bring to governing distinct and insightful attributes that encourage a more compassionate and less corrupt society. Gro Harlem Bruntlund, when she was Prime Minister of Norway, argued to the author that women needed to be in the government because of their distinct viewpoint. In Latin America, the difference argument is often referred to as maternalist, a definition that limits women's distinctive viewpoints to motherhood issues.

The essentialist argument presents a quagmire to many women scholars who have argued the society, not genes, creates the difference. Yet, current biological research is increasingly demonstrating that boys and girls are to some extent hardwired differently. Opponents of this argument that women are more attuned to women's needs recite the list of powerful women prime ministers such as Margaret Thatcher or Golda Meier; the note the economic corruption attributed to Benizer Bhutto or power grabbing of Indira Gandhi. Radha Kumar suggests that the startling number of women

heads of state is South Asia[1] can be attributed not only to dynastic politics; the dangerous power of the goddess Kali, "who came to earth to destroy demons and drink their blood," is intermixed as well (1995:59).

Thus the justification for quotas relies on two conflicting arguments: equality versus difference. These arguments suggest first that women deserve to share power in decision-making roles in government and in elected bodies as an equity concern, and secondly that women's distinct viewpoints need to be considered and that their influence is good. In practical terms, these positions are conflated and the philosophical niceties are often ignored. Indeed, if a person's gender is constructed from the

1 In Bangladesh the heads of the two major, and intensely competitive, parties are women. Both have served as the prime minister, neither espouse feminist causes, and both come from political dynasties: Khaleda Zia is a widow of an assassinated prime minister; Sheikh Hasena is the daughter of a nationalist leader. When Benazir Bhutto, daughter of another martyred prime minister, was in power in Pakistan, her ability to ameliorate the *Hudood* was circumscribed, but she supported women in their preparations for Beijing. Indira Gandhi, as India's prime minister, kept aloof from the feminist movement; after her assassination her son Rajvi became prime minister; after he was also killed, his wife Sonia –albeit an Italian by birth– was made head of the Congress Party and is being groomed for high office should the party win the elections. Sri Lanka is unique in having had both mother and daughter as leaders: Sirimavo Bandaranaika, the widow of an assassinated prime minister, was the first woman prime minister in the world. Her daughter Chandrika Bandaranaika Kumaratunga is Sri Lanka's president but was also a prime minister; her husband was also assassinated.

many facets of an individual's life, then a woman may feel equal in some settings and distinct in others. However, the debate has policy implications, according to Jaquette who ties the difference versus equality positions to how women view power and the state.[1] Yet the demand for quotas illustrates the widespread acceptance of working within the government to improve women's lives.

Proponents for quotas assert that "women leaders better represent the interests of women citizens, will introduce women's perspectives into policymaking and implementation, and help expand women's opportunities in society at large" (Mala Htun, 1998). Dahlerup suggests that such an argument represents a shift from the classic liberal notion of equality as 'equal opportunity' to the concept of equality of result (2000). Few call this a feminist agenda, but clearly the drive for quotas by the global women's movement assumes women friendly policies.

MECHANISMS TO INCREASE THE NUMBERS OF WOMEN IN LEGISLATURES

Today, quotas for women in elective office have been introduced either at national or local levels, by laws, executive orders, or party directives, in at least 45 countries. How these quotas are applied varies by the type of electoral system utilized in each country. These arrangements also influence how effective the quotas have been in increasing the numbers of women elected and whether a critical mass of women in legislatures can really make a difference.

The most efficacious method for ensuring that women are elected to legislatures is through the party list system with parties distributing the seats through proportional representation (PR). Under the basic PR method, contesting parties draw up lists of candidates for the electoral district: a country, province, or country.[2] Each district is allocated a set number of seats for the legislature. After voting, the total ballot count is divided by the available seats. If 10,000 votes are cast in an area with 5 seats, then a seat requires 2000 votes. Parties are allocated seats by their vote count. Very small parties lacking a certain per cent of the vote are usually disqualified. Since the party controls the list, they also control who from the list is selected. Unless agreement is reached that the candidates are selected by their place on the list from top to bottom, women or other minorities may appear on the list and not be selected.

The other major electoral system used for free elections is the single member constituency or first-past-the-post system (FPTP); candidates stand

1 Jane Jaquette, 2001, discusses the scholarly feminist debate which fragments the women's movement, in her view. Women candidates tend to appeal to both arguments and do not see the ideological divide that scholars perceive

2 Analyses of electoral systems list as many as 14 types that combine elements of the two basic types – proportional representation and single member constituency that is often call "first past the post" – in a variety of ways.

in a particular territorial area and are elected to represent the voters in that specific district. The winning candidate is the person receiving the highest number of votes; where three or four people are standing, the winner may not even enjoy a majority. In some countries, a run-off election between the highest two candidates is required when no candidate has over 50% of the votes. In the past, parties have often been reluctant to assign a seat to a woman under the assumption that some voters will switch loyalties to vote for a man. Gradually, where parties have become convinced of the importance of women legislators, they have adopted quotas. But the competitive nature of single constituencies, where local loyalties may be a critical as party platforms, has resulted in fewer women candidates than under the party system.

Critics of this majority rule complain about the "wastage" of votes in this system and noted how difficult it is to elect women or minorities. Some countries create multi-member districts; voters may cast all their votes for one candidate, or spread them in any manner. Under this "block system" it is easier for minorities to gain a seat since the number of votes per candidate is less. In the US, districts have often been gerrymandered to allow elections of African-Americans or Hispanics. Several countries have adopted reserved seats for women and minorities, some in addition to the general seats.

In an exhaustive analysis of electoral systems, the Institute for Democracy and Electoral Assistance (IDEA), reports that "Just over half (114, or 54% of the total) of independent states and semi-autonomous territories of the world which have direct parliamentary elections use plurality-majority systems; another 75 (35%) use PR-type systems.." Another 10% combine these two major systems. In terms of population, the plurality-majority systems represent 2.44 billion people in contract to the PR systems with 1.2 billion people. The mixed systems account for just under half a billion. "In our survey the seven countries which do not have directly-elected national parliaments constitute 1.2 billion people, but China makes up 99% of that figure" (IDEA 2002:2). Additionally, the handbook notes that elections are free in only 98 of the countries in transition; another 36 are established democracies (IDEA 2000).

All of the eleven countries with over 30% membership of women use proportional representation (PR) utilizing the party list system but it is moderated in Germany and New Zealand by a dual voting arrangement called the Mixed Member Proportional (MMP) system. Interestingly, both New Zealand and South Africa switched from the single member constituency to PR in the last decade. South Africa adopted PR in the 1994 Constitution to create an "atmosphere of inclusiveness and reconciliation" in the post-apartheid era and allow an ethnically heterogeneous groups of candidates, many of them women, to be elected. New Zealand also adopted PR to allow greater

ethnic representation while retaining a constituency base. The 1993 elections, the first under the new MMP system, resulted in more Maoris, Pacific Islanders, and women being elected. In all these instances, the high percentage of women was due to quotas established within the parties. Under regular PR, voters cast their ballots for a party rather than an individual. Candidates are expected to follow the party line, if elected. To alter party policies women must lobby within their parties with leaders who allocated the party tickets to them.

Elections for reserved seats for women in national legislatures utilizing the single member constituency system have been established in Taiwan and Uganda; Pakistan has reservations for local and national seats. Quotas for seats in local bodies are also being instituted. India passed a Constitutional Amendment in 1993 to require that one-third of all seats in local councils must be filled by women. France required parties to nominate women for 50% of mayors with the result that 48% won seats in 2001 as compared to only 9% in the national assembly which had not a quota. In the Philippines, an executive order recommends a 30% quota for seats in the *baranguy* councils.

Historical and contemporary use of reservations and quotas for women

Little attention has been given to earlier experiences with ways that representation for women has been attempted. A look at the various approaches for representations that predated the 1995 Beijing conference and the subsequent campaign for women's representation provides a useful context for analyzing contemporary efforts and their possible impact on legislation.

South Asia. Colonial India, faced with an amazing diversity of population, first utilized separate categories for representation in 1892. These lists were both for communal/religious groups and for special interests.[1] When women were given the vote in 1928, they became another special interest category: such voters were allowed two votes.[2] Under this system, about six million women were enfranchised, about one fifth of the total of male voters This system of "double franchise" continued in Pakistan until 1965, when indirect elections were instituted and the number of reserved seats reduced. Women's quotas were filled by votes of sitting candidates in the elected legislature in question, not

1 From 1892 until 1909, communal representatives were nominated. Until 1919, voters eligible to cast ballots for all special lists had a second vote for general candidates. After that, communal voters had only one vote, a system that exacerbated communal tensions and contributed to the eventual partition of India. Separate interests retained a double franchise. In the Act of 1935, twelve separate lists were recognized at the national level and fifteen in some provinces. See Tinker 1954.

2 Double voting was common in England until 1956 when the business vote, which allowed owners to vote in the constituency where the business was located, was abolished.

by popular vote. After Bangladesh (formerly East Pakistan) became independent in 1971, the indirect representation of women continued until 2002; no further provisions have been made to date for women's special representation. Indeed, with women leading the two major parties in that country, the case is more difficult to make for direct quotas for women.

The present government of Pakistan has increased the number of seats reserved for women in all elected legislatures.[1] In previous elections, women were elected by the sitting members of an elected body, a system which Farzana Bari believes allowed "the continuing domination of feudal-cum-capitalist male election in our political party structures" (2002:1). Most women in the local governments were neither vocal nor assertive, as they were often brought into the local bodies to serve the political agenda of the male members of the councils.[2]

The current system is an amalgam of both directly and indirectly elected seats. The Union Council, the lowest assembly, exists in both rural and urban areas and is made up of 26 members – General Seats: 8 men, 8 women; Workers/Peasants: 4 men, 4 women; Minorities: 1 man, 1 woman. Union Councillors elect women to the district level assemblies. In the local and district elections of 2000-2001, a total of 2,621 women competed for the 1,867 reserved seats, or one-third of seats in local governments. Anita Weiss and Farzana Bari note that "These women were no longer the complacent surrogates of male politicians of a generation ago. They were educated (the minimum education requirement to contest these elections was a matric degree, or tenth grade) and generally had a good grasp of issues that were confronting women in their constituencies (Weiss & Bari, 2002:22).

The elections in October 2002 reserved only 17% of the seats in provincial and national assemblies for women. These reserved seats were filled by separate party lists of women by province; winners were elected through a proportional representation system of political parties' lists of candidates on the basis of total number of general seats won by each political party in the National Assembly. Thus women are beholden to

1 See President Musharraf's March 23, 2000, press conference statement in Islamabad entitled
 "Devolution or Power and Responsibility: Establishing the Foundation of Democracy": http://www.pak.gov.pk/public/govt/reports/pc_Mar23.htm

2 "In a study of women union councillors conducted by Farzana Bari (1997) in six districts of the Punjab, she found the following characterized the majority of them: from rural areas; were over forty years old; more than four-fifths were married; nearly three-quarters were illiterate; forty percent had over seven children; and the majority were from fairly poor families. In nearly all of these cases, women did not make the decision to become union councillors but were rather asked by their

male relatives or other influential men of the community to put their names forward for the position, which was then determined by the overwhelmingly male-dominated union council membership" (Weiss & Bari: 20).

the party to get a spot on the list. Mixing PR with the single constituency electoral system distances women from the electoral process, according to Bari, and reinforces "their dependence on male leadership of their parties." She argues that direct elections are preferable and supports additional separate ballots for women in each province (2000:2).

India maintained special representation for both Scheduled Castes [untouchables or *dalits*] and Scheduled Tribes its 1950 Constitution. Unlike separate lists, however, all voters voted in their constituency; reserved seats meant that all candidates in that constituency had to be from the particular depressed group. Because of the presence of strong women leaders in post-independence India, no special provisions for women were thought necessary at that level. However, when a system of local elected councils, or panchayats, was introduced in India in 1959, the law provided for the nomination or co-option of women in the absence of elected women. This system was fraught with patronage; a few states rejected that system in the 1980s and introduced directly elected reserved seats for women. A national law was needed; the Constitution was amended in 1993 that required a 1/3 membership of women in all panchayats; these women were to be elected by popular vote. Furthermore, one third of all panchayats must elect a woman as chair. Attempts to institute the system of quotas at the nationallevel has thus far been unsuccessful.

Communist countries. Both communist and fascist countries utilized the corporate approach by giving representation to constituent groups within their one-party systems. USSR and Eastern European countries guaranteed seats for women in their national legislature through the mass organization for women of the communist party; these arrangements collapsed when these communist regimes fell; none of these countries have retained quotas. In China, Vietnam, and Laos (with representation of women in the legislature respectively at 21,8%, 26%, and 21.2%), women's mass organizations continue to exist, but because decision making power resides in the party, not the legislatures; the women in the mass organizations have little influence and tend to be looked down on by strong women leaders within regular party ranks.[1]

Yet a UNIFEM publication on the 1993 elections in Cambodia bemoans the lack of women elected to the communes. "Women also lost politically with the shift to democracy. Perhaps surprisingly, interviews suggested that Vietnamese socialism was generally unpopular with women, yet the socialist system has propelled many women into local leadership positions. Under the socialist system every commune council had at least two female members. By contrast,

1 Personal interviews. The Women's Federation ceased to exist for a time in China. Nonetheless the National People's Congress suggested a 30% quota; in some areas in the southern part of the country, local leadership was actually higher than that.

women standing for election in 1993 found themselves passed over in favour of men in the face of strong competition between the main contending parties.".

An exception to this generalization that democracy reduces women's representation would seem to be Bulgaria where women's representation in parliament went from 10.8% to 26.2% in the June 2001 elections. This jump occurred because the former King Simeon of Bulgaria decided to return home; when his attempt to run for President was rejected by the Constitutional Court, he ran for parliament instead. Because the election date was imminent and most politicians had joined one party list or another, the king set up a new party, the National Movement Simeon the Second (NDSV), in coalition with a little known women's party. Apparently tired both of the former communists and the neo-liberal parties, the citizens overwhelmingly elected Simeon's movement with 43% of the vote among the 138 participating parties.[1] Women and students studying abroad, many quite young, have provided new faces in the legislature; the Deputy Prime Minister who is also the Minister of Labor and Social Policy is a woman. Furthermore, 36.5 percent of the NDSV's seats in parliament were given to women. (Kristen Ghodsee, 2002).

Latin America In Argentina, under the presidency of Juan Peron, 1946-55,

women were not only given the right to vote for the first time in 1947, they were granted a share of seats through the women's branch of the party. Since the Peronist Party had three branches – men, women, and trade unions – women held 21.7% seats in House of Representatives in 1955 and 23.5% in Senate in 1954. Eva Peron herself gave visibility to women in politics; her legacy continues today, whether she is idolized or demonized.[2]

By the 1990s, when democratic governments were being promoted in Latin America and Eastern Europe, many in the increasingly influential women's movement began to demand quotas for women as the only way to ensure women benefitted from democratic rule. With amazing swiftness, 12 nations in Latin America introduced some form of quotas. "There is tremendous variation in the success of quota laws. The details of the law and the nature of the electoral system determine whether quotas get more women elected" (Htun, 2001:16). While all Latin American countries utilize the party list system at the national level, many variations

1 Only four of the 138 parties contesting the election received the requisite 5% of the vote to qualify for a seat in the parliament.

2 Gloria Bonder (1995) argues that Eva Peron continues to be a model for "women's expression of their desire for political power." Martha Farmelo (2002), studying gender issues in Argentina under a fellowship from the Institute for Current World Affairs, quotes from Eva Peron's *La Razon de mi Vida* to underline the mixed messages emanating from her own writings: that feminism means to do good for women who were born to constitute homes; but she also championed a monthly subsidy for housewives.

exist. Some use the mixed system that combines single member constituencies with large multimember districts that utilize PR. A combination of the closed list system where winners must be selected as presented to the voters, results in more women elected; for example, women must listed as every third candidate in Bolivia, every fifth in Paraguay, or placed in *electable* position as in Argentina.[1] When women are placed at the bottom, or where voters can select among candidates on the list as in Brazil, women generally fare less well unless they are very well known. This was the case in Peru where voters are allocated only two preference votes. In the 2000 election, "four of the 10 individuals with the highest number of preference votes were women...women's presence in the Peruvian Congress doubled (from 11 to 22 percent)" (Htun,, 2001:16.)

Many countries in the region have introduced quotas at lower governmental levels. Argentina extended quotas to the 21 of its 24 provinces using PR; the remaining use single member constituencies. Regardless of the version of PR used, all provinces increased the representation on women. Elsewhere, decentralization of powers plus locally elected officials has resulted in the replacement of weak or appointed mayors with stronger elected heads of

both rural and urban areas thus providing new opportunities for women throughout the region and for indigenous candidates in Andean countries.

Quotas do not only apply to national legislatures. Colombia introduced a law requiring a 30% quota for women in appointive posts in the executive branch of government. The result is that 5 of the 13 person cabinet of Alvaro Uribe are women while only 19 of the 166 members of the legislature are women; further a woman is now minister of Defense (Christian Science Monitor 28 Oct 02).

The early euphoria about the rapid introduction of quotas in Latin American has been replaced with caution by many observers. As male resistence becomes obvious, some ask why men should give up their power, seeing the increasing numbers of women on party lists as "sacrificing" men. Mala Htun and Mark Jones confront this issue, saying that "With the exception of Argentina, quotas have been a relatively painless way to give lip service to women's rights without suffering the consequences" (2002:15) Yet Argentina's current crisis reflects badly on political parties and may result in a new type of electoral system without quotas.

Africa South Africa has the highest percentage of women members in its parliament in this region. Pressure for broad representation of all groups led the framers of the 1994 Constitution to replace their former system of single member constituencies with a proportional representation for the

1 Political turmoil in Argentina in 2002 may well result in the scraping of the party list system entirely for the single member system; the impact on women is uncertain.

parliamentary level. When the April 1994 elections for parliament were conducted under proportional representation, 25% of the members were women. The percentage was increased to 29.8% women in the 1999 elections. Uganda has chosen a different approach to ensuring women are elected to parliament: Uganda has 45 districts, each with one woman elected by women. Some women have also been elected in general seats.

In Kenya and Tanzania, appointed seats in parliament are available to women, but not exclusively so. The current parliament in Kenya, consisting of 210 elected and 12 nominated seats, has 17 women members, 8 of whom were nominated, an increase from 9 women, 5 nominated, in the previous body. Kenyan women have become increasingly vocal in their demand for greater representation, bolstering their activities through the Collaborative Center for Gender and Development. An Affirmative Action bill, introduced into parliament in 1997, would require that 33% of all seats in elective legislatures at the national and local levels be reserved for women.[1] To have this result, each of the eight province would elect two women from a women's only list just preceding the general election as is done in Uganda and Tanzania. In 2001, the bill was referred to the National Constitutional Conference. Because the draft constitution proposes the mixed member proportional representation, women are lobbying the parties to make half of their candidates women in future elections, reminding them of their internal agreements to ensure that women participate in party politics. Leading this effort is the women's mobilization network which consists of women councillors, women party coordinators and party leaders.

PROBLEMS FACING WOMEN POLITICIANS

The adoption of quotas or reservations in so many countries was seen by many activists as the solution to increasing women's political participation. As with any panacea, many problems have arisen. First, even in countries with constitutional mandates for quotas through party lists, women are not always winning seats in the legislatures because of the distinct ways the elections are run. Htun and Jones write that "male resistence to quotas is increasing, especially in Latin American where interpretation of laws allows their intent to be subverted by placing women low on party lists (Htun & Jones, 2002). In Brazil, for example, the open list system allows voters to select an individual not a party; with excess votes cumulated for a second round. Thus even if a party lists a woman, she may not be elected in the first round and the party is free to select winners in the second round.

When Ecuador approved its quota

1 Maria Nzomo was the first Kenyan women to discuss the idea of a critical mass of 33% of women's seats in a paper presented to AAWARD (Association of African Women in Research and Development) in 1992.

law in 1998, the authors expected to avoid this wiggle room. The law set the minimum percentage at thirty percent with the stipulation that the quota increase in every subsequent election by five percent (5%) until the goal of fifty percent (50%) is achieved. Further, the law requires that women candidates be listed sequentially and alternately to men candidates with a quota law starting at 30% but increasing to 40% and then to 50% in subsequent elections. As a result of the quota, women's membership in the legislature jumped from 3.7% in 1996 to 13.22% in 1998 and 17.89% in 2000. Shortly before the 2002 elections, the Supreme Electoral Tribunal proposed changes to the quota law that would undermine the sequential/alternate placement on the party list through the concept of "symmetrical space" which would allow women to be placed anywhere on the list. While this change is still under discussion, the ambiguity surrounding the law encouraged parties to disregard the sequential mandate. The women's movement challenged this interpretation which the Tribunal eventually accepted after the elections during which almost all parties ignored the rule. In response to the Tribunal support for quotas, one political party introduced a bill to eliminate quotas (personal communication from Jennifer Myles, UNIFEM-Andean Region office, Oct. & Dec. 2002)[1].

In New Zealand, the MMP system was introduced to increase the number of minorities and women, but in the 2002 elections the number of women in the national legislature fell below 30%. Having compared the success of women under the single member constituency system with that of the MMP, Rae Nicholl writes "We are starting to wonder if women's representation has plateaued in New Zealand, as the results from our local government elections have shown a similar trend" (personal communication November 2002). This trend is counter that in most countries where any form of PR *increases* the representation of women. In Germany, which was the model for the MMP system, fewer women were elected when that system was extended from the federal to the state system of elections.

A rich source for listing obstacles to women's increased political participation may be found in the International IDEA publication *Women in Parliament: Beyond Numbers*. These encompass, besides the topic discussed above, the cultural and social attitudes (Shvedova), methods of candidate recruitment (Matland), and the institutional and procedural traditions in the legislatures (Karam & Lovenduski).

The cold climate for women in chambers are well known. Women elected to Congress found few women's toilets, a barber shop but no beauty shop, no access to the pool or fitness center. In England, the first female Speaker of

1 See also UNIFEM Currents of July-August 2002 unifem-currents@udp.org. For

further information on this controversy, contact unifem.ecuador@undp.org.

the House was able to avoid wearing the heavy wig, but sessions continue to be scheduled in the late afternoon and evening, a time not convenient for most women with family responsibilities. As a result, many of Tony Blair's "babes" who ran in the 1996 elections, did not run again. Such issues are more acute in developing countries. As one of the first black women in the South African parliament, Thenjiwe Mtintso writes in her essay "From Prison Cell to Parliament" that "Sitting in Parliament is a far cry from the experience of exile and imprisonment, solitary confinement and banishment, which was the price paid by many of us who dared oppose the apartheid regime." She calls parliament "a male domain... from its facilities (toilets, gym, childcare centers and so on) to its language, rules, sitting times, and attitudes" (1995:103). All of the activist women are finding parliament a difficult terrain, she complains, and sums up their apprehension by quoting her colleague Jenny Scheiner: "The post-election South African situation has within it both the seeds of women's emancipation...and the seeds of entrenched patriarchy" (1995:117).[1]

Globally, the issues of sexual harassment have reflected relationships between powerful men and women staff. In Uganda, even women members of parliament complained that the practice was rampant (Ali Mari Tripp, 2001). Clearly, in many other legislatures, the male political culture of the institution remains a major obstacle for women's power.

IMPACT OF WOMEN IN LEGISLATURES

Nonetheless, women are making a difference. They address issues of daily concern to the voters. In India, elected women at the *panchayat* or local levels of government, have focused their energies on local needs from water to schools to housing. Their main impact "seems to be on increasing effective implementation of various government programs and schemes (Neema Kudva, 2001:11). This in contrast to wide spread mis-use of funds by male leadership. In Uganda, women have tried to affect traditional clientelism at the local levels so that more resources are directed toward women's needs, often without success (Tripp, 2000:235).

While overseas data are sparse, recent research in the US supports this general position. A study of community based organizations in nine sites in the U.S. found that those community organizations controlled by women generally espouse a broader social agenda than those drop footnote: run by men. These groups expanded the narrow neighborhood focus on housing and enterprise development to encompass community participation, child and elder care, leadership training, and outreach beyond the

1 Nearly half the sitting parliamentarians did not stand for the second elections in 1999 but others helped push women's representation nearly to 30 per cent of the seats. Many felt they could contribute more doing community work. (Tripp 2001)

immediate community to networks serving battered women. In Minnesota, a 20 year analysis of women in the state legislature found that once the number of women was more that 20% and women had become senior enough to chair committees, new policies were evident. While the study does not insist such policies would not have emerged anyhow, it does document the role women legislators have in drafting and passing the laws (Minnesota Women's Campaign Fund, 2002).

The Institute for Women's Policy Research conducted a comparative study of women in electoral offices by state in the US during the 1990s included governors, various elected state offices, state legislatures, and the congressional delegations.[1] These numbers were compared with levels of women-friendly policies in the state. In addition, the analysis considered other indicators such as overall levels of women's political participation, cultural attitudes, resources available, and party strength. Importantly, the study finds that the cultural climate regarding women in politics interacts with elected women to support women policies relevant to women's lives. "Having women in elected office cannot guarantee better policy for women, but it clearly helps" (Caiazza, 2002:19).

Corruption Yet another argument

for electing women is the belief that women are less corrupt than men. Several studies show that women, confronted with corruption, opt out of electoral politics. Tripp quotes an unsuccessful candidate in Uganda who was disillusioned not only by the extent of corruption but by the way voters had come to expect politicians to hand out money (Tripp, 2000:232). Further, because women in Uganda are so alienated by the system they have less to lose by opposing it (Tripp, 2001:151).

In fact, recent studies have shown a correlation between significant rates of women in government and loweredlevels of corruption at both the national and local levels. In their extensive analysis of independent data sets, a World Bank team found that not only are women less involved in bribery, but that this finding was more robust where women were well represented not only in the legislature but also in the labor force. They further explored whether the type of electoral system used in the country affected women's propensity to avoid corruption. These authors specifically state that "we do not claim to have discovered some essential, permanent, or biologically-determined differences between men and women. Indeed the gender differences we observe may be attributable to socialization, or to differences in access to networks of corruptions, or in knowledge of how to engage in corrupt practices, or to other factors" (2001:2). Despite this caveat, the authors conclude that these gender differentials in corruption will persist.

1 This study is part of a long term research agenda on women's civic and political participation in the US. A list of available research reports is available on www.iwpr.org.

Political climate: the dilemma of in or out Many leaders of women's movements in the South have been hesitant to join the government in either elected or appointed positions for fear of being coopted by disinterested and possibly corrupt party leadership. In both Chile and Argentina, the return to democracy in the 1980s caused a split among the women who had been active in oppositional politics. Many women found it difficult to give up their autonomy which allowed the advocacy of a women's agenda. They faced a dilemma: working within the new democratic governments would mean compromise; lobbying outside would reduce them to interest groups (Jaquette, 1995).

East African women began in the 1980s to form their own organizations separate from all political parties. Their goal has not been to oust the ruling regime, as was true in Latin America, but to affect widespread political reform (Tripp, 1996). For many years, awaiting such reform, women were reluctant to get involved in politics, and often focusing on community development projects. Jaquette compares this type of "exit" strategy with the autonomy argument utilized in Latin America and concludes "..strategies of autonomy can usefully be interpreted as forms of engagement, part of a larger process of gender negotiation that is taking place at many levels, public and private" (2001:117).

In South Asia, the distaste for participation is even stronger among the educated elite. Jamila Verghese comments

about India: "The minuscule presence of women in politics can be partly attributed to the increasing criminalisation of politics. With the rampant corruption and the oppressive presence of religious fundamentalism in party politics, women are retreating into the shadows..." (1997:314) Women in Pakistan talk about the criminalization of politics, but are also aware "that if women want to see substantive changes in their lives, they must be enabled to voice their perspectives and priorities in national policies and programs. Indeed, they must be physically present in the political decision-making bodies, though the process of getting there has been increasingly wrought with corrupt methods" (Weiss & Bari, 2002:10).

This dilemma, whether to work inside of the government, or lobby outside for change, has been faced throughout the world. During the 1970s, when much legislation benefitting women was passed by the US Congress, we talked about the symbiosis of in and out: women inside the government helped us testify before House and Senate committees and told us where to appear for regulatory meetings (Tinker, 1983). A similar strategy involving the legislators as well as activists and bureaucrats is the basis for many alliances in Latin America. Yet laws can be changed; increasingly women activists call for women in positions of political power, and argue that a critical mass of 30-35% women participants is necessary in order to bring substantive differences into decision-making in terms

of content and priorities, as well as style and working climate.

Even asking for quotas has an impact, according to Mala Htun, who has written extensively about women and leadership in Latin America. She argues that the symbolic effect of having quotas must not be overlooked. "Since women gained the right to vote..., no policy measure has stimulated such an intense debate about gender equality in politics and decision-making" (Htun & Jones, 2002:15).

Further, women question the exclusive membership of many political parties which tend to represent a single class or group or area. Rigidified by the functioning of political structures with their entrenched male dominance, party loyalties divide the electorate and the parliament. In some countries women have sought alliances across parties to counter their lack of numbers in any one party. Elsewhere, women have established broad-based organizations outside traditional parties in order to lobby all parties and so have some impact on decision-making. Especially in countries where appeals for votes are based on ethnicity or religion, such coalitions of women provide a basis for civility and compromise. Such alliances bridge class and occupation, and reflect the strength of the women's movements around the world.

WHERE ARE WE NOW?

Most of these quotas are too recent for adequate analysis about the impact

of all these women legislatures. Much of what has been published is based on cursory observation and is often ideologically motivated, with the educated elite often arguing that most women are simply not able to function in elected bodies. Especially in countries where poorly educated women are being elected as in India or Africa, women's organizations have addressed this complaint by launching major programs to train women in their duties and rights, for example, in India, Philippines, Taiwan, and Uganda (Kudva, 2001; Tripp, 2001; HDR, 2002).

Decentralization of government functions is, along with elections, seen widely as a path to democracy, and to greater representation of women and minorities. Yet too often, locally entrenched male interests become, if anything, stronger as power and resources are transferred; local legislatures often pass laws that reinforce patriarchal controls over women. Efforts to introduce *sharia* law in Nigeria have led to deadly riots in many Kaduna and Abuja .[1] Decentralized power in Indonesia has led to attempts to reintroduce *adat* or customary laws (Kathryn Robinson, 2001). Summing up this point, the 2002 Human Development Report (HDR)

1 Newspapers are full of the attempts of local officials in Nigeria to impose state-based legislation stoning women for adultery, for example. Several contestants to the Miss World contest, scheduled for Abuja in October 2002, boycotted the event over a sentencing of a woman to death. Although the other contestants went to Nigeria, controversy erupted and became the cause of more riots. The contest was moved to London.

writes: "..local officials are not more immune to elite capture than officials in central government...A recent survey of 12 countries found that in only half was there any evidence - some quite limited – that decentralization empowers more people.." (HDR, 2002:67).

Quotas have been seen as one way to dilute male privilege. Yet among the staunchest supporters of quotas there is a growing realization is that numbers alone, while necessary, are not sufficient to women to make a significant difference in policy initiatives and political goals (Karam, 2002). The 2002 HDR writes that "Quotas are primarily a temporary remedial measure, and are no substitute for raising awareness, increasing political education, mobilizing citizens and removing procedural obstacle to women getting nominated and elected" (HDR, 2002:70). In Taiwan, scholars complain that the 10% quota is now seen as a ceiling (Chiang, 2000).

Htun & Jones (2002) argue that it is not quotas, but broad based political alliances that also work with women in the bureaucracy and executive, that will produce laws benefitting all women. In Uganda and Kenya, women organize across ethnic lines to support women legislators and to lobby the government (Kabira, 2001; Tripp, 2000). The Women's National Coalition in South Africa, which successfully challenged the primacy given customary law over civil law in the Constitution, crossed urban-rural boundaries as well as class and ethnicity (Kempa et al, 1995). In countries as diverse as China and Bolivia, educated elite women are trying to bridge the gap with those women striving for election by running training courses for them.

To have alliances, organizations must exist. Throughout this essay the writers assume women's organizations. But the way that organizations can impact on electoral politics or on policy clearly varies. With strong party list systems, alliances of women across parties within the legislature as well as among women in other parts of the government have produced results, especially in Latin America. Alliances among women inside government and outside are characteristic of single member constituencies where party control of the bureaucracy or even individual members has less influence.

Many countries have instituted equality of leadership positions within the party. The resultant strength of the Labour Women's Council within the New Zealand Labour Party has "compelled the party to take women very seriously since the mid-1980s," according to Rae Nicholl. She notes that "We have a very strong and popular woman Prime Minister, Helen Clark, who is now in her second term" (personal communication Nov 2002).

How to link grassroots groups to alliances or coalitions is an on-going problem that varies by country and electoral system. Ali Mari Tripp writes about this issue with great insight, adding the even more confounding problem of how to change the institutional culture. "The case of Uganda is an important one, because it brings to light a dilemma in institutional change: new

players - namely women - are brought into the game, but the rules, structures, and practices continue to promote the existing political and social interests." Women are told to play along with old rules. "This inability to tailor the rules to meet women's needs helps explain why even though the local council system has given reserved seats to women in Uganda, they have a difficult time asserting their interests in these structures." The problem is how to develop "meaningful mechanism to translate this participation into policy-making within the state" (Tripp, 2000:219).

For any pressure to exist, whether to achieve quotas, to find and support candidates, to influence policy in the legislature, or to turn out the vote, women's organizations are necessary. Women in strong party list countries will need to work within the party itself; but outside influence remains important. Women within to become candidates in FPTP systems might use their experience in women's organizations or other NGOs to achieve a nomination for a seat. Party caucuses inside the party help in obtaining nominations and in influencing policy.[1] Because women continue to be a minority in the political arena, they have tended to form coalitions across ethnic and class boundaries much more frequently than men.

Once in the legislature, a critical mass is important to begin to address the patriarchal character of the body itself. Quotas clearly result in more women in legislatures. But whether they support a feminist agenda is a different matter. Perhaps those issues need to be separated. More women in a legislature will warm the chilly climate, insist on childcare and more family friendly meeting times. On these and many other issues of particular concern for women, women legislators often agree, and form alliances across party lines. For policy to become law, even broader alliances are essential, with both women and men, so that issues can be reformulated to show their importance for the national as a whole. And for laws to be implemented and enforced, they need broad citizen support which civil society organizations can produce. Overall, women in politics practice the same networking skills that has brought the global women's movement to its powerful position today.

1 Women's power in the Labour Party in New Zealand was explained by Rae Nicholl as an important source of power. Arvonne Fraser argues that women's power grew once the Democratic Party agreed to equal delegates (personal communication).

ASSUMPTIONS AND REALITIES: ELECTORAL QUOTAS FOR WOMEN

Georgetown Journal of International Affairs: 19/1 pp. 7-16 (winter/spring 2009)

ACTIVISTS ASSUMED THAT ELECTORAL quotas for women in legislatures would provide a critical mass of women who would then be empowered to shift policies toward a more women-friendly agenda. Since 1991, at least ninety countries have some type of provision for increasing women's representation. Yet the impact of such quotas does not consistently result in increased numbers of women elected; and even in countries with significant women representatives, policy change is uneven.

Studies show that impact depends on many factors including the electoral system, the origins of the impetus for quotas, the type of democracy, political and social culture, class structure, and the strength of the women's movement.[1] This article will explore these many factors and how they reinforce or undercut efforts both to increase the numbers of elected women and to pass legislation that addresses gender equity. While numbers are easy to count, what change women legislators bring to the parliament is complex, ranging from changing the hours when the body meets to the passage of significant legislation.[2]

To illustrate the difficulties of generalization about the impact of quotas, two sets of North-South comparisons are presented. Sweden and Rwanda have the highest percentages of elected women in their national parliaments. Sweden has long been admired for its social policies yet has failed to pass a bill addressing domestic violence. Rwanda's inexperienced parliament prepared such a bill during its first session.

The second set compares national and local governments in France and India. In 2000, France passed a law requiring parity or equal status for women and men candidates in elections at every governmental level. Yet women won only 18.5% of the seats parliament in the last election. Representation of women was greater at local levels, but nowhere did the results approach parity. In 1993 the Indian parliament passed legislation requiring that one third of all

1 Mona Lena Krook, "Quota Laws for Women in Politics: Implications for Feminist Practice," *Social Politics* 15.4 (2008): 1-24. For a cross country multivariate analysis see Aili Mari Tripp & Alice Kang, "The Global Impact of Quotas: On the Fast Track to Increased Female Legislative Representation," *Comparative Political Studies* 41.3 (2008): 338-361. Accessed on line at http://cps.sagepub.com/cgi/content/abstract/41/3/338

2 See Irene Tinker, "Quotas for women in elected legislatures: do they really empower women," *Women Studies International Forum* 27:4 (2004): 531-546.

members of panchayats must be women. The dynamics of local government have noticeably changed since then. A bill to apply reservations to parliament had been pending for 12 years until it was finally introduced into the upper house in May 2008. Currently, women parliamentarians are fewer that ten percent.

The case studies illustrate the difficulties of generalizing about the impact of quotas for women either in terms of numbers or impact. Factors that enhance legislation for women are noted. The article concludes that the single most important factor is the role of women's organizations operating in an open and receptive political system.

REASONS FOR INCREASING WOMEN'S REPRESENTATION

As more and more countries adopt some form of quotas for women, the question arises why male dominated political systems would chose to do so. The most persuasive reason is altered worldview concerning women as a result of the burgeoning global women's movement which argued that significant numbers of women in legislatures was an indicator of justice. Two United Nations' documents legitimize the equal participation of women in decision-making positions. The Convention for the Elimination of All Forms of Discrimination Against Women, adopted in 1979, has been ratified by 179 counties. The Platform of Action passed at the 1995 United Nations Fourth World Conference for Women

in Beijing does not have the force of law but does provide feminists with a standard to use when lobbying their governments.

After Beijing, women pressed hard for quotas. The newly democratic Latin American countries were particularly responsive: 10 countries adopted quotas for women between 1997 and 2000; only Argentina had had quotas before then.[1] Results of these quotas after ten years show an increase in the percentage of women in lower houses with Argentina leading with 38.3 %. Yet Brazil has only 8.8% women in their legislature. The average number of seats held by women in the 11 countries is 20.5% compared with non-quota countries having 14%. Such disappointing results illustrate the limitations of quotas alone.

A second reason many governments, democratic and authoritarian alike, have adopted quotas relates to economic development. Rapid economic transformation cannot take place with half the population deprived of health, education, and jobs. In the interim, most donor agencies privilege programs for women. In countries with weak legislatures, the authoritarian leader may support more women candidates to be in step with international opinion and to ensure continuation of development aid. Such institutional changes are not

1 Argentina adopted a 30% quota in 1991; the remaining ten countries introduced quotas following the Beijing conference. Beatriz Llanos & Kristen Sample, eds. 2008. *Thirty Years of Democracy: Riding the Wave*. Women's political participation in Latin America. Stockholm: IDEA

meant to affect male control of political power, but women in assemblies where they have little power nonetheless are provided with an insight into intricacies of political power.

A third reason political leaders support the idea of more women in decision-making positions is the recognition that women's priorities are distinct from men's. Suffragists wanted equal citizenship rights with men. Many second-wave feminists argue that if man is the measure, women will always be second-class and so argue for equity rather than equality to recognize gender differences. Studies show that women legislators in the US and abroad support peace and social programs more often than men. As women's political skills grow, they also question many laws that enshrine male privilege, especially those dealing with family law.

Legislation that provides education, health care, improved job access and pay, maternity leave, and childcare were all introduced in Europe by center-left parties. Scandinavian feminists have termed such policies as state patriarchy because they do not address the power balance between women and men. In fact, most countries grant civil rights to women but few have addressed the inequities embedded in both modern and traditional legal systems. For example, as the US Congress began to respond to the burgeoning women's movement in the 1960s and 1970s by passing laws to equal pay, education, access to credit, support for women's issues eroded

when legislation to establish centers for victims of rape or domestic violence.[1]

MECHANISMS FOR INCREASED REPRESENTATION OF WOMEN

Mechanisms to ensure women's representation function quite differently in the two types of electoral systems most commonly used: the single-member constituency form used by 40% of countries and the proportional representation (PR) list system used by 31.7%. Combinations of the two types are utilized in another 13.96%. One party states are included in the 'other' category of 14.34%.[2]

Adding women's quotas to PR does not require an institutional change in the electoral system. Quota supporters assumed that including more women in each party list would result in more women being elected. Political parties, whether voluntarily or required by simply add female candidates to their lists. Since most parties are male dominated, they often rig the outcome by putting women at the end of the list

1 Two decades of accomplishments by activist women lobbying both Congress and the government are chronicled by the women themselves in Irene Tinker, ed., 1983, *Women in Washington: Advocates for Public Policy*, Beverly Hills CA: Sage.

2 International Parliamentary Union maintains a data base: www.ipu.orb/parline-e/parline-search.asp An "other" category with 14.34% includes one-party states such as China, Soviet Union, or North Korea.

or using an open list where leaders can pick and choose candidates to fill their allocated numbers. Cultural attitudes that discourage women participating in public forums and the limited number of women with political experience provide party leaders with an excuse to circumvent the intent of the law.[1] Voters cast their ballots for a party; winners are allocated based on the total popular vote. Whether women are selected from the list depends on their placement on the list and whether the list is closed. In fact, the top ten countries with the greatest number of women members elected use some form of PR and quotas do result in more women elected in all countries that use them. However, the percentage of successful women does not match the quota required in most countries due to manipulation of the lists and the lack of sanctions for ignoring the quota.[2]

Single constituency systems provide a different challenge: parties are reluctant to nominate a woman when only one candidate can be elected.[3] Instead of requiring parties to nominate women, laws specify the exact number of women to be elected and create special electoral districts for women candidates which are overlaid on the regular constituencies. Candidates run as party members and are elected either in proportion to the general vote for each party or by an only-women vote as in Rwanda, which added reservations to its PR general vote. Unique is the reservation system used for local assemblies in India: in one third of the constituencies only women may stand, though men may also vote.

Recognizing the advantages and disadvantages of these two systems, many countries have decided to combine them by having both single member districts and larger multi-member districts designed for PR. Pippa Norris explores the impact of the proposed move in the Netherlands from an exclusive PR system to several mixed alternatives.[4]

France has neither reservations nor quotas. In 2000, a constitutional law was adopted that requires parity in elections at all levels. Earlier attempts

1 Julie Ballington who headed the Women in Politics programmed at IDEA for many years, summarizes these issues in "Strengthening Internal Political Party Democracy: Recruitment from a Gender Perspective," a paper presented at the *World Movement for Democracy* workshop in Durban, South Africa, 2 February 2004, and available at www.idea.int/gender/index.cfm

2 International IDEA (Institute for Democracy and Electoral Assistance) tracks the use and misuse of quotas. This intergovernmental agency produced an invaluable handbook *Women in Parliament: Beyond Numbers* in 1998 to emphasize the many obstacles to increasing women's representation. A revised edition issued in 2005 updates statistics and adds new case studies written by women from the countries concerned. Publications are available on line at www.idea.int. Drude Dahlerup's chapter "Increasing Women's Political Representation:

New Trends in Gender Quotas" (141-153) is particularly pertinent.

3 Few countries with this system require residence in the constituency, as the US does.

4 Pippa Norris, "The Impact of Electoral Reform on Women's Representation," *Acta Politica* 41.2 (2006): 197-213.

to introduce quotas by left-wing parties had limited success so the Socialist Party introduced a quota for elections with PR and changed the plurality system to PR for national elections. In 1982, the court declared quotas unconstitutional because they violated the abstract concept of undifferentiated universalism citizenship. Women's representation in the National Assembly remained below 6% prompting demands for a new method for electing women. Parity is different from quotas: quotas provide representation for under-represented groups; parity implies that women and men have equal status under the law. Parity allows women to be equal and different.

When the court ruled the 1982 law invalid, it also argued that allowing quotas for women would encourage other under-represented groups to seek quotas as well. Peru has instituted such quotas for indigenous communities. The other 16 countries with electoral mechanisms for minorities use reservations.[1] In France, efforts to placate the large Muslim population has centered on inclusion in government in order to be consistent with the indivisibility of French citizenship.

1 Mala Htun argues that increasing women's representation is less politically difficult than giving minorities a voice because such groups demand redistribution of wealth as well as power. "Is Gender like Ethnicity? The Political Representation of Identity Groups," *Perspectives in Politics* 2.3 (2004): 429-458.

REALITIES OF QUOTA IMPLEMENTATION AND IMPACT

To illustrate the wide range of mechanisms utilized to increase women's representation in legislatures and the impact such increase has had on policies, two sets of countries will be compared. In each set, one country is from the industrialized world and the other a majority rural developing country where subsistence agriculture is widespread. Both these countries use reservations to ensure that women and other under-represented groups have representation in elected bodies. All four countries have multi-party elections, but power relations between the executive and the legislature varies. The policy impact of women's representation is more pronounced in the developing countries both because of the disadvantaged socio-economic position of women in these countries and because the European socialist parties had already introduced strong social welfare policies.

The first set of countries has the highest percentage of women members of their national parliaments: Rwanda, with 48.8% and Sweden with 47%. Both are both small centralized countries that use a PR system for voting. They differ on mechanisms for electing women.

Sweden has voluntary party quotas which have dramatically increased the proportion of women in parliament from the 14% in1971 when the two major parties began to compete for the

women's vote. The Social Democratic Party started party quotas and established a women's unit in government in 1972 while the Liberal Party created a 40% for the party's governing board. Both actions moved debate on women's issues into the parties and made a unified voice for women outside parties more difficult.[1]

Most social policy legislation such as improved working conditions and pay, affordable child care, and paid maternity – and paternity – leave drew on a socialist ideology and were passed with little input from independent feminist organizations. Dissatisfied with economic rights that perpetuated women's subordination, women turned to poetry and art to protest their invisibility. Huge fairs are held semi-annually under to umbrella of the Women Can Foundation celebrate women's accomplishments. In 1979, the first shelter for victims of domestic violence was established in Stockholm. Although the government helps finance these centers, many feminists argued that not enough was being done.[2] Legislation passed in 2003 meant to protect women from domestic violence has not been aggressively implemented

due to outdated attitudes; incidences of violence are increasing, according to a 2004 report by Amnesty International.[3] In 2005 a women's party, The Feminist Initiative, was formed to agitate for reform of rape laws, programs to address domestic violence, and for equal pay for women.[4] The party put up candidates in the 2006 parliamentary election but won just under 0.7% of the votes and no seats. Since then the leadership has splintered between moderate and radical advocates. The issue of violence not yet become a national issue, but SIDA is including the issue of domestic violence into their country programs.

Rwanda does not have party quotas; rather it utilizes reservations to ensure women's representation. The 2002 constitution provides that 24 of Rwanda's 80 member Chamber of Deputies will be elected by women's councils in each district and from the city of Kigali.[5] In the first subsequent elections held in 2003, fifteen women won seats in the general election in addition to the 24 women elected by reservation bringing the total to 39. These numbers give women a strong voice in a weak Chamber of Deputies in an authoritarian state.[6] Instability is

1 Lena Wanhnerud, "Sweden: A Step-wise Development," *Women in Parliament: Beyond Numbers* (Stockholm: IDEA. 2005): 238-247.

2 Descriptions of women's organizations and goals may be found in Gunnel Gustafsson, Maud Eduards, Malin Rönnblom,eds., *Towards a New Democratic Order? Women's Organizing in Sweden in the 1990s* (Stockholm: Publica, 1997). See also Irene Tinker, "Why elect more women? For equity or policy shift?" *Electoral Insight,* Elections Canada. Forthcoming.

3 "Men's Violence against Women in Intimate Relationship: aa account of the situation in Sweden," 19 April 2004. Stockholm: Amnesty International.

4 See the Web site of the Feminist Initiative at www.feministisktinitiativ.se.

5 Two youth representatives are also elected and a representative of the disabled is appointed.

6 Paul Kagame, a Tutsi who had led the military

a constant danger, especially following the genocide during April-July 1994. Violence against women characterized that period; many international organizations offered programs to assist women economically and psychologically. Women's Councils were set up in every district; women from the leadership of these groups were added to the Constitutional Assembly during the Transitional Government.

Rwanda is the most densely population country in Africa. Ninety percent of the people are subsistence farmers living in a patriarchal society where traditional practices such as bride price and polygamy are the norm. Elected women determined to introduce a bill that addressed violence against women. They formed a cross-party caucus and held meetings in villages and towns over a two year period utilizing their connections with the women council leaders. During these consultation it became clear that men conceptualized their relationships with daughters and mothers differently from that of wives; they revere mothers, want the best education and future for daughters, but claim cultural rights to beat their wives. In August 2006, four men joined with four women to sponsor the draft bill. This is the only legislation that originated in the parliament; other laws are developed by the president. The draft law was refered to committee but the

extensive consultation has resulted in some behavior change as villages think the parliamentary women are watching them.[1]

France and India were selected because they each have a unique approach to providing representation for women. France is number 65 in the Inter-Parliamentary Union 2008 list of women in national parliaments having 18.2%; only Greece ranks lower among European countries. How is it possible that a constitutional law mandating parity could produce such a low percentage in the national assembly yet achieve over 47% in the municipal, regional, and European Parliament elections? The latter elections use PR; years of unstable coalition governments in post-World War II prompted a switch from PR to a single member plurality system for National Assembly elections. The Parity Law specifies that if parties contesting PR elections do not have a list with 50% women, the slate cannot contest the elections. Non-compliance for the Assembly elections only penalizes the party by reducing public funding.[2]

1 Elizabeth Pearson, Elizabeth Powley editor. "Demonstrating legislative leadership: the introduction of Rwanda's gender-based violence bill." (Cambridge MA: The Initiative for Inclusive Society, Hunt Alternatives Fund) 2008: 32.

2 Extensive analysis of election outcomes and attitudes, based on extensive interviews of women, see Katharine A. R. Opello, *Gender Quotas, Parity Reform, and Political Parties in France* (New York: Lexington Books, 2006.) For an interesting comparison between the only two countries using parity ass Virginie Van Ingelgom, "Legislation on Gender Parity

invasion of Uganda in 1990, is president of this predominantly Hutu country.

Women in France were only granted suffrage in 1946 and had little input into the social policies. Most bills come from government, not the Assembly. The Parity Law hardly diminishes male political dominance. The law is silent with regard to mayors who are elected by heading the list of the winning party. Despite decentralization, mayors hold a dominant position in the districts; not only is the position seen as a stepping stone to the parliament, Assembly members can continue to be mayors!

Feminists in France have relied on social movements to create change, not political parties and have not encouraged women candidates, according to Sineau. [1] The state provided women with generous health and maternity benefits. Domestic violence has only recently been widely discussed due to inadequate statistics and a tendency to blame the victim.[2] Segolene Royal, when campaigning unsuccessfully for the presidency of France in November 2006, announced that the first legislation she would enact if elected would

be a law against violence perpetrated against women. No action has yet been taken by the current government; women's groups.

India uses the single constituency electoral system at all levels in this federal state. Voters cast their ballots in the district in which they live, but candidates are not bound by any residential condition. India provided for 12 separate lists for communal and special interest groups in 1925. Interest groups such as women were allowed two votes, but communal voters had to choose.[3] [The country has had special reservations for under-represented groups since 1935 when the British granted reserved seats in elected Provincial Councils to 12 categories, including women and religious minorities.] The separate Muslim seats exacerbated tensions between the Hindu-dominated Congress Party and the Muslim League; inability to compromise led to the creation of Pakistan when India became independent in 1947. The 1950 constitution abolished separate seats for women and religious groups. The two lowest socio-economic groups, the Scheduled Castes and Scheduled Tribes, were guaranteed parliamentary seats in areas where they were a significant population; but distinct from earlier elections, all voters in the constituency vote. This approach was replicated in the 1992 Constitutional Amendment that gave women

and Quotas: The Belgian and French Experiences." *Electoral Insight*, Elections Canada. Forthcoming.

1 Marinette Sineau , "The French Experience: Institutionalizing Parity," *Women in Parliament: Beyond Numbers* (Stockholm: IDEA. 2005): 123.

2 Dominique Fougeyrollas-Schwebel, "Violence against women in France: The context, findings and impact of the Enveff survey," presented at an Expert Group Meeting Organized by: UN Division for the Advancement of Women in collaboration with the Economic Commission for Europe (ECE) and World Health Organization (WHO), Geneva, Switzerland, April 2005.

3 Double voting was common in England until 1956 when the separate business vote was abolished.

33% of seats in the local councils or panchayats; chairs of these bodies must reflect the reservations and must rotate.[1] Efforts to increase the 8.7% of women in the Lok Sabha (lower chamber) by introducing similar reservations were stalled for 12 years; finally in July 2000, after a contentious debate, the bill was sent to a Standing Committee.

More than a million women have served as panchayat members. Hundreds of organizations, universities and agencies participated in training sessions that explained the intricacies of council and government procedures. The impact of women panchayat members has exceeded expectations, particularly in rural areas where pernicious caste and traditions have long marginalized women.[2] Women panchayat members have succeeded in reducing corruption, building roads, repairing sewers and, in the case of new public housing projects, putting property ownership in women's names. Female literacy rates have increased from 39% to 54% by using networks to reach remote areas. The World Bank reports that panchayats have become a truly equalizing factor. Low caste women's political agency operates in a non-western manner to achieve empowerment.[3] Skeptics, who argue that many women are merely stand-ins for male family members, overlook the status and self-confidence acquired by women who become public officials. Voters seem more positive: the southern state of Karnataka has actually elected a panchayat with 46.7% women, an indication that women can also win general seats.[4]

For years, most women's organizations in India focused on charitable work or development projects. Finally, in 2005, Indian women organized a national lobby, WomenPowerConnect (WPC), with full-time lobbyists in New Delhi.[5] The legislative goals of WPC are set by state chapters; national conventions listed passage of a civil domestic violence bill, passage of the 33%

1 The 73rd Amendment to the Constitution of India also strengthened the move toward decentralization by granting constitutional status to these local bodies, creating a tiered system for elected assemblies, and expanding their functions and resource base. As well, this amendment granted more powers over governmental services and projects to the three tiers of rural councils or "panchayats", at the village, block and district levels.

2 Neema Kudva & Kajri Misra interrogate feminist theory and quota literature, providing new insights for gender justice: "Gender Quotas, the Politics of Presence, and the Feminist Project: What Does the Indian Experience Tell us?" *Signs: Journal of Women in Culture and Society* (forthcoming, 2008).

3 Mauela Ciotti, "The Conditions of Politics: Low-caste Women's Political Agency in Contemporary North Indians Society," *Feminist Review*, forthcoming 2009.

4 Women members of municipal councils are well educated so activists ignored municipal elections until recently, when women's human rights groups in Delhi began recruiting and training candidates and pressuring sitting members, especially about domestic violence. Archana Ghosh and Stéphanie Tawa Lama-Rewal, *Democratization in progress: women and local politics in urban India* (New Delhi: Tulika Books, 2005).

5 See www.womenpowerconnect.org

reservation for women in Parliament, and work on gender-just budgeting. WPC helped organize by a coalition of women's organizations that lobbied successfully: the Domestic Violence Bill after ten years of agitation finally became law in November 2006.[1]

After years of focusing their energies on helping poor women through development projects or charitable activity, Indian women at all levels are beginning to use the political process to address women's concerns through government programs and laws. These efforts, aided by the rapid, if spotty, modernization in the country, are challenging the caste/class/race hierarchies that have impeded drives for greater gender equity.

WOMEN'S REPRESENTATION: NUMBERS AND POLICIES

Increasing the number of women in legislatures has multiple benefits: women learn the intricacies of politics and gain in confidence when facing their constituents. Feminists who often have viewed politics as corrupt and so preferred to maintain ideological purity outside government have begun to understand the importance of participation in government with all its messy compromises.

1 Violence against women is a huge problem throughout India. Dowry deaths – in which lower-middle class families who feel the bride's family is not providing sufficient material goods over and above the legal limits on dowry pour cooking oil over the bride and claim she died in a cooking accident – are just the most visible manifestation of women's low status.

But the political arena is still male dominated and women's influences are limited. Most quota initiatives, as well as much social policy, have historically come from the establishment, not from women's organizations. As numbers of women legislators increase, women's organizations are learning to develop a symbiotic relationship with them to enhance women's power.

Domestic violence legislation provides an example of women politicians, activists, and scholars coming together to demand an end of patriarchal privilege that have legitimized men's control over women. The starkness of patriarchy is more evident in the developing countries of Rwanda and India; women's organizations led the campaign for passage of laws against violence. Women in Sweden and France, benefiting from strong social welfare legislation, have been slower to accept the existence of domestic violence in their countries. Policies that question male privilege and seek gender justice will multiply as women's power grows.

Assumptions about the rapid impact of quotas on political agenda have been exaggerated. Clearly, however, significant numbers of women in legislatures do influence both the culture of the assembly and the attitudes of men. Coalitions of women from different parties can promote women's concerns; alliances with men are necessary to pass legislation. The importance of state policy to implement shifts in gender balance is clear from the illustrations above. Women are learning the art of politics.

SECTION 2
EDUCATION FOR ALL

U NTIL WE MOVED TO WASHINGTON, DC, IN 1960, MY ACADEMIC PURSUITS HAD largely shielded me from the pervasive sexism in society. Job hunting in the Capitol exposed rampant discrimination in hiring practices in throughout the US. I was finally offered a teaching position at Howard University: white women were presumed to have missionary impulses and so could be paid less than either the white men, who had the highest salaries, or black men. Black women were the most discriminated against.

Of greater concern to me at the time were the low academic standards pervading the university culture: tolerating plagiarism, helping graduate students write their papers, and general low expectations of student performance. I finally resigned after I began to advise my brightest students to go elsewhere. Convinced that it was possible to admit poorly prepared students to college, provide an expanded freshman year for catch-up classes, and then graduate students with an acceptable degree, I organized a group to lobby for a new urban grant college for DC, the first in this category in the country. When a planning team for Federal City College (FCC) was formed in 1967, I became Assistant Provost. The timing was not propitious. Before classes were to begin in August 1968, Martin Luther King's assassination in April provoked riots and looting throughout the city.

Higher education was also in turmoil in the 1960s, reflecting unrest around the country as activists from the civil rights movement and the Vietnam protests began enrolling in universities, and were not happy with what they saw. Around the country, innovation in higher education was taking many forms from student driven courses at Evergreen to flexible majors at Hampshire.

Academic plans for FCC resembled those in that premier urban college: City College of New York (CCNY). Open enrollment for the underprepared students would be combined with compensatory teaching to allow them to perform at the college level. The viability of these hopes was rapidly undermined as poorly prepared students, expecting to graduate in four years, demanded their rights. Standards at CCNY fell from exceptional to poor; FCC went downwards from mediocre. Neither college was able to balance open enrollment with maintaining academic standards.

During my years at FCC I wrote about how the disconnect between the expectations of the underprepared black student and the approach to teaching by

idealistic white instructors led to frustration and bitterness. Cultural differences plagued this new urban college.[1] With noted sociologist Amatai Etizioni, I wrote an article suggesting that attempts to solve the higher educational problems of black students must go beyond a focus on black studies and on compensatory education. We argued that attention should be directed on the mass enrollment of black students. The problem, we declared, is to find a system that incorporates both liberating and technical orientations to protect higher education against the hazards of open enrollment.[2]

The college opened in 1968 was the year that Martin Luther King was assassinated and much of Washington burned. The Vietnam War was tearing at the political fabric of the country. Black Nationalists were in ascendance, yet at FCC they were the strongest voice for excellence. Returning veterans also sought out those teachers who demanded more from students than merely showing up for class. Marches led by SNCC activists from Howard University and elsewhere in the often closed the campus, threatening faculty and students if they did not leave the buildings.

For three years I dedicated my life to holding onto the original premise. When a strike was called by these SNCC activists on the day of final exams, I let the students finish in my office. As I left for the day, I barely avoided a beating: I was accompanied by a black Vietnam veteran in my class who walked me out of the building. When we reached my car, he asked why I was still teaching. That day I wrote to request a year's leave, but never returned.

During that year, I tried to write a novel that captured the emotional debates of our faculty meetings to illustrate why I refer to my years at FCC as a three year sensitivity session. My efforts to encapsulate the turmoil among the students and faculty lacked evocative texture: my writing skills simply did not suffice. So I wrote an academic analysis entitled "Federal City College: How Black?"[3]

My years immersed in educational reform provided useful background as international development agencies began to value education for girls. Organizations realized that cultural obstacles, such as a girl's economic value in assisting in the farm or the issue of her safety getting to school, had to be addressed before the family would agree to send her to school. Several programs provided a stipend to the parents if their daughters attended school. Transportation to school or

1 "The Underprepared College Student", American Education, Nov., 1970.

2 "A Sociological Perspective on Black Studies," with Amitai Etzioni, Educational Record, Winter 1971.

3 Federal City College: How Black?" in David Reisman & Verne A. Stadtman Academic Transformation: Seventeen Institutions under Pressure, Carnegie Foundation for the Advancement of Teaching. NY: Mc-Graw-Hill. 1973: 99-126.

boarding schools helped protect the young women from harm. As with population programs, cultural practices inform education for girls.

Studies show that family health improved and contraceptive use increased in families whose mothers had completed at least four years in primary school. Today, enrollments in primary school are nearly equal for boys and girls, but secondary and university admissions vary globally, still influenced by cultural mores.

From the earliest development projects, teaching literacy was a high priority, but the ignorance of planners about women's work meant classes scheduled in the day were sparsely attended. When I was in Nepal on a Fulbright in 1988, I studied their new literacy programs and wrote a short commentary about a new approach that seemed to be working.[1]

1 "Reaching Poor Women in Nepal: Do Literacy Programs Really Work?" Peace Corps <u>Visions</u>, Kathmandu, Nepal, Summer 1988. Circulated within the World Bank by the South Asia lunch group before a presentation there January 19, 1989; reprinted in <u>Newsletter for the Committee on Women for South Asia</u>, Spring, 1990.

THE UNDERPREPARED COLLEGE STUDENT

THE INCREASING PRESSURE ON THE NA-
tion's colleges to open their doors
to students from all socioeconomic
backgrounds has generated knotty
problems. Not the least of these is the
presence in classes of students not ad-
equately prepared to do college work.
For too many such students the open
doorway has merely led to another
marked EXIT and framed by frustra-
tion and bitterness.

Many colleges are trying in various
ways to meet the special needs of these
underprepared students by providing
expanded counseling, remedial, or com-
pensatory programs. Among these are
the special services newly funded under
the Higher Education Amendments of
1969. All too often, however, an institu-
tion's efforts are less than successful and
too frequently create hostility and rejec-
tion. Perhaps it is because those plan-
ning the programs have not stopped to
consider, on the one hand, the identity,
problems of the underprepared student
and the subtle forces pulling at him, and,
on the other, the attitudes, conscious or
unconscious, of the faculty, administra-
tion, and trustees.

While serving as assistant provost
for curriculum development at Federal
City College in Washington, D.C., from
1967 to 1969, I surveyed the activities
of various colleges in their efforts to
deal with the problem of the underpre-
pared student. This student lacks basic
skills and his socioeconomic level has
given him a cultural heritage not identi-
cal to that of his middle class peers. His
cultural distinctiveness, whether black,
Puerto Rican, Chicano, Chinese, Appa-
lachian, Indian, or other, has provided
him with an education not readily test-
able on middle class achievement tests.
It is likely also to have given him an en-
vironment not supportive of education,
and he is probably the first in his imme-
diate family to enter college. He comes
to college having survived 12 or more
years in a middle class school system
where the general intent has been to
blur his cultural differences—to melt
him in the pot. That he has made it
through high school indicates that he
has learned to manipulate the system,
to memorize requisite material, to
behave, to survive. But the process has
not necessarily fitted him for college.

Though many whites from low-in-
come groups are also among the under-
prepared, the most challenging prob-
lems are posed by those students from
minority groups. Awareness of their
divergence from the dominant white
middle class pattern is important for
curriculum planning and for student

success in that curriculum. But two related mistakes are commonly made by educators in planning programs. The most frequent mistake is to assume that all blacks, or Chicanos, or Indians are underprepared. There are great cultural differences between the black bourgeoisie and the black laboring class. Puerto Ricans and Mexicans have differences as well as similarities, and, within each culture, the "native" group and the American-born group diverge.

Educators' second common mistake is to conclude that all minority students are politically radical. This misconception has sprung from the wide publicity given nationalist or black power advocates. But as a matter of fact, a large percentage of minority students come from those lower economic groups that view college as a means of getting ahead in the establishment. They cannot afford economically or psychologically to challenge the system. They expect their education to be a passport to a good job.

On the other hand, they are influenced to some extent by the attacks on the system mounted both by black nationalists and by middle class white students. They are seeking the security of the middle class at the very time the middle class of both black and white are questioning the whole structure of our society. For the white underprepared student this becomes a profound political problem; for the black it becomes an identity crisis as well. While the white asks himself, Do I support the American way of life or am I against it?, the black asks himself, If I accept the American way of life, where is there a place for me as a black? Or if I cannot accept it, where is there a place for me?

IDENTITY CRISIS COMPOUNDED

This identity crisis is compounded by the student's concept of success. Coming from a group in which college attendance is unusual, he views his college entry as proof that he is "making it" in the theme of the American success story. Having adapted himself to the system through his first 12 years of school, he, like any other convert, holds to the system in its pristine glory. Such a response to the dominant customs and mores is typical of rising social groups, whether they are the Sanskritized castes in India or aspirants to the black bourgeoisie.

If the college, in its efforts on his behalf, deviates from the norm the new student expects, it only makes him feel shortchanged. And because he does not know any college graduates, his version of the norm is based on his high school experiences. Thus, the more a college resembles high school, the more at home he feels. His impressions of college life are also gained from the media which seldom go into the classroom but limit themselves to the social and interpersonal relationships, usually depicting them as much more glamorous than they actually are. It may be that the frequent complaint heard at Federal City College that there is no social

life or any way to meet people reflects the popular image of college as a sort of matrimonial bureau.

What is true of social expectations is equally true of academic assumptions. The innovations eagerly sought by white students on middle class campuses—flexible scheduling, lack of attendance requirements, independent study, pass-fail marking, and the replacement of lectures with group dynamics sessions—are regarded with suspicion by minority students.

At Federal City College the unstructured classroom made most of the students uncomfortable. The faculty attempting this technique were mostly young, white, and in the social science teaching area. One student complained: "It was just rapping. I didn't learn a thing I didn't know. I didn't read anything either. But I got an A just for going and talking. Except I stayed quiet when I was in a minority. Too much hostility when you're alone." A Vietnam veteran remarked about his course on urban problems; "It was fine until the instructor asked us what we wanted to discuss. That was six weeks ago. The class just disintegrated."

NO-FLUNK RULE DEFEATED

The first-year attempt to combine the no-flunk rule with a pass—no-pass policy at FCC was not continued. Many students interpreted this permissiveness as an admission that education was a con game anyhow. Serious students complained that they were being unfairly treated. The question of continuing the system was put to a vote of students and faculty and was defeated in favor of a letter grade.

If an institution does not understand the subtle forces pulling at its new clientele it will run into other perplexing and seemingly contradictory reactions. It also needs to take a good look at itself—the cultural biases of its faculty, administration, and trustees. Educational institutions almost by definition are conservative, in that they represent the essence of the dominant society's values and concerns. Only the very self-confident institutions dare risk innovation.

Most colleges that are established for students who are trying to move up in the social strata tend to replicate the existing patterns in higher education. FCC did at first try to introduce new forms as well as new content for courses, but it has yielded increasingly to the pressure to become more traditional. This pressure comes not only from the students and the community but also from many faculty members. It is often wrongly assumed that black faculty will automatically be radical. The fact is that black faculty with established credentials have adapted to the dominant WASP (white, Anglo-Saxon, Protestant) culture, even though the culture group has not adopted them. This contradiction is readily apparent to the student, even though he may choose acculturation himself.

Radical blacks, like nationalists throughout the world, come from the

middle class. But they have rejected the accommodation made by their parents and are seeking new career patterns, generally outside the establishment. Hence, they tend to question established credentials which they see as blandishments to entice them to succumb to the system. At FCC it was a young and largely uncredentialed group of faculty that led the demand for black education. Drawing parallels to colonial education, they argued that the WASP bias in the school system is as inappropriate for blacks as, say, French education is for the Senegalese. Therefore, to precede professional instruction, they proposed a rigorous two-year course that would have as its purpose the "decolonialization of the mind."

What these proponents of a completely separate college were really saying was that they wished to change the attitudes and values of the students by an intensive course in black experience. In particular, they fulminated against the white individualism and materialism that might lead a black doctor, for example, to buy two expensive cars instead of setting up a free clinic in the inner city. Social responsibility and self-sacrifice were stressed instead. Yet, when the administration responded by granting the program increased faculty, only approximately 100 of the 2,000 students then enrolled in the college actually registered for the sequence. In disgust at the conservatism of both students and institution, the majority of the black studies faculty resigned from the college and set up a separate school: the Center for Black Education.

If most of the actors in the education drama are conservative, how can education expect to reform itself, much less make an impact on society? History shows us that over the years colleges have changed from elite institutions to broader middle class ones. The process has been slow, and, as recent student unrest has shown, the institution is fragile. Nonetheless, change is possible. The response of the colleges to the underprepared student will inevitably change the structure and purpose of higher education as much as the previous broadening has done. The direction of some of these changes may already be seen in administration, counseling, and in curriculum devised for the underprepared.

Administrative measures can help a student stay in college by not penalizing his lack of preparedness. The abolition of almost all standards, however, is patronizing and can adversely affect the student's performance, as we found at Federal City College. The lowered standards tend to suggest to the student that he is not merely underprepared, but incapable. Conversely, no relaxation of normal college requirements for a student not as prepared as his peers is unrealistic, even cruel. Rigid requirements for the underprepared can contribute to the dropout rate or to pressure for lower standards.

REDUCED PANIC LEVEL

Most colleges do relax or change their rules when applying them to the underprepared student. Minimum loads are reduced; a ceiling is often placed on the number of credit hours a student may attempt each term. Scholarships are continued even when a student is on probation. Unsatisfactory grades during the first year are often disregarded, expunged, or replaced thus allowing the student to achieve a reasonable grade point average. In some colleges a student cannot be flunked out during his first year. Along with pass—no-pass grading, these relaxations tend to reduce the panic level among the underprepared students as they compete with their better prepared classmates. Considering the high dropout rate of all freshmen, not only the underprepared, administrators might do well to consider making such provisions normal.

Student counseling services traditionally have offered support to students in fixing their career goals, relieving academic difficulties, and helping with personal and emotional problems. Increasingly, the counseling centers provide tutors for students in academic difficulty and may run self-study centers or precollege skills-training. The underprepared students need all these services, and those with variant cultural backgrounds need additional help in negotiating the alien environment. To be certain that the students know the availability of the counseling services and actually use them, these services should be built into the educational program.

Colleges have tried various approaches to meet this felt need. At the City University of New York in the SEEK (Search for Education, Elevation, Knowledge) program, the professional counselor assigned to each student is the only person who can sign the student's official papers, so the student has to meet with the counselor. Conversely, the counselor is expected to talk to the student's teachers and to see the student once a week.

At the Experiment in Higher Education, a two-year college program in East St. Louis set up under the aegis of Southern Illinois University, the counselor was made into a teacher. Keeping up with both these roles has proved difficult, especially since the early counselors were themselves drawn from the inner city and had had only somewhat more college experience than their students.

WARMED-UP HIGH SCHOOL COURSES

More usual, perhaps because it costs less, is group counseling through the medium of a required freshman course in applied psychology. In such courses the student is given a series of tests and then given his own test scores to analyze. While such an impersonal approach is of some use in self-assessment of skills, it does not offer individual assistance for skills or cultural adjustment. Most students—particularly the underprepared—seem to need someone

on the campus to whom they may turn for friendly and knowledgeable support. Since it would seem that the contact is more important than the expertise, increasing use of peers seems probable.

Most colleges have for some time provided remedial courses for students who enter with deficiencies in reading, writing, and mathematics. These courses, which are too often merely warmed-up high school courses, have frequently been extended without change or thought to the needs of the underprepared student. Devices that enable a student to study on his own and evaluate himself, or even computerized instruction, will not help a student who lacks motivation; they may even threaten a weak student. And repeating grammar courses from which he learned little in high school will not motivate a student—whatever the mechanical assistance. Reading black authors rather than Milton may help, but a serious question must be raised about whether either approach—teaching communication through English literature or through parroting of grammatical rules—is necessarily the best.

Fewer approaches to the teaching of communication include the use of such media as films and tape. Drama and song are also used. The theory is that students, if they have something to say and are not hung up on the formalism of the English theme, can communicate. Only after they are at ease with expressing ideas should they be asked to polish the sentence and phrase. Another approach is to remove communication from English courses and put it with social science or history. Motivation here comes from the regular course material.

Separate remedial courses may alienate the underprepared student from the college by making him feel second-class. There is also the possibility that, with the increasing political slant to the identity problem, separate classes may turn into cells more intent upon power than education.

There is a strong argument, then, for minimizing special remedial courses and mixing the underprepared students into the general student body, but with at least some of the additional supportive services mentioned. The demand for a broader cultural and political course content can only improve the courses for all students of minority and majority ethnic and economic groups. Mixing of students in classes will increase debate and thus further the learning process of both student and teacher. In the long run, the effect of the new student should be to point the institution's narrow cultural orientation in a pluralistic direction.

The merging of skills with content in general college courses is as useful to the average student as to the underprepared. Recognition that compensatory needs go in two directions—that, though minority students may lack an overview of WASP culture, most middle class students are woefully ignorant of other ethnic groups in their own country—will enrich general education for all college students. Neither the techniques for dealing with

skills deficiencies nor a more encompassing course content answers the student's deeply felt need for professional training. Although he enjoys the prestige and status a four-year institution bestows, the upward mobile student is often impatient with the goals of a general liberal education. If he is one of the weaker underprepared students, it may be the general and required course that is his nemesis. Motivation may again provide a key. If a student can understand why he must learn certain things, he may be more interested in learning them.

LESS PAROCHIAL PHILOSOPHY

At Federal City College the one innovation on traditional curriculum that the students enthusiastically endorsed was the introduction of field experience as an integral part of many courses. These courses are arranged in cooperation with business and industry. Students are asked to report on their actual jobs, or on volunteer work they select, or on community organization they attempt. Their analysis of their own experiment is to be based on criteria gleaned from basic readings. Through these courses, students gain insight into their current jobs or into jobs that they may have experienced previously. In career terms, even if they do not continue their studies, they have had an experience that is useable. If they do continue, they have greater understanding of the relationship between academic ideas and daily application.

Many elite colleges have been trying entire semesters of field experience. The constant interpretive element in the field experience course work would seem to be more helpful to the underprepared student who is not yet ready for independent study. Field experience course work might well be tried for all students; it has an immediacy that contradicts the charges of irrelevancy which today's students so often level at overly scholastic college courses. It may also be a method of weakening the tight time-frame now applied to higher education and facilitate a lifetime of learning and working.

When seen as a new stage in the development of the American university, the influx of underprepared students into higher education becomes extremely important. Responses to these students will affect the entire system. In particular, the recognition of cultural narrowness ought to lead to a less parochial educational philosophy, which can only strengthen the curriculum. The addition of field experience courses may also mitigate the clash between professional training and academic scholasticism leading to a better preparation for life for all students. Techniques for skills training, especially in the communication arts, will benefit all students as will the more focused use of counselors. There is great opportunity here if the colleges will really respond to the underprepared student, not merely admit him and then ease him out.

FEDERAL CITY COLLEGE: HOW BLACK?

A T EIGHT O'CLOCK IN THE MORNING OF September 1, 1968, Federal City College began its first classes. Some 98 percent of its first 2,000 students were black. The local press had been gentle with the new college and had praised its policies of open admission and selection by lottery. Thus on November 12 of that year, David Dickson, the provost and academic vice-president of the college and a black scholar of English and classical literature, confounded the city by revealing that the college was in turmoil over race.

Racial tension, racial suspicion, and racial polarization have almost blasted our lovely spring buds. . . . Our meetings display passion quite as much as reason, intimidation rather than discussion. The black or white moderates, shocked at the flight of reason, are supine while the well-disciplined and intense cadre of white radicals and black separatists neglect academic principles for revolutionary ends (Dickson, 1970).[1]

In response to the speech, the chairman of the faculty organization, a white historian, tried to institute impeachment proceedings against Dickson.

Some students issued a peremptory summons to all faculty and students to attend an interrogation of the administration; the notice was unsigned except for an upraised black fist. Even faculty who agreed to some of the charges felt the public recital of them was wrong and that Dickson should have kept criticism "in house." On the other hand, the college's white president, Frank Farner, played down the tensions within the faculty by describing them as "similar to what every college has." He blunted the impact of the talk by telling reporters that Dickson "overstated the case in almost every regard. Things are just not as bleak as he describes it" *(Washington Post*, Nov. 13, 1968). Thus Dickson was left exposed, with few open supporters, for daring to speak the truth as he saw it.

This incident was a minor skirmish in a series of battles for power and of efforts to obtain a clear sense of direction which culminated six months later with the resignation of both Farner and Dickson at the request of the District of Columbia Board of Higher Education. They were not the only college administrators who were forced out of their positions in 1969, but the crises at Federal City College were unique for other reasons. First, the college itself is unique as a black, urban, land-grant

1 Presented at the general meeting of the National Association of State Universities and Land-Grant Colleges, Nov. 12, 1968. Reported in the *Washington Post* on Nov. 13.

institution and as the first comprehensive public college in the nation's capital. Second, impetus for campus unrest there came from within the faculty and administration; students were occasionally used as accessories, but they did not initiate action. Further, the newness and fragileness of the college exacerbated all conflict because there were not yet any established stabilizing structures or procedures.

The issues behind the decision-making struggle dealt with fundamentals: who shall run the college? who shall teach? what shall be taught? From the beginning, the common theme of these issues was that the administrators, the faculty, and the curriculum were too white and that therefore change must be in the direction of black. This general proposition received little challenge. The problem was in definition. What is black? How black is black?

A NEW COLLEGE

Before the establishment of Federal City College (FCC) and its sister institution, the Washington Technical Institute, citizens of the District of Columbia had no other public opportunity for higher education except for the District of Columbia Teachers College. Few attended the five private universities within the District: only Howard, with perhaps one-fourth of its student body drawn locally, and Catholic, with about 10 percent of its students from the District, made any effort to recruit locally. Despite the fact that a legacy

for a proposed federal university was included in George Washington's will, Congress did not get around to setting up a college in its "colony" until November 1966.[1]

To District residents, the description of their city as a colony is merely a statement of fact. Bumper stickers proclaiming "D.C. Last Colony" are sold by the League of Women Voters. The District's new nonvoting delegate has joined Puerto Rico's delegate as a second-class congressman. But in Puerto Rico they at least elect their own legislature. The legislature for the District is still Congress, or more particularly, the House and Senate District of Columbia committees. Money for the college is included in the overall District of Columbia budget, which is scrutinized by the Bureau of the Budget before presentation to the District of Columbia subcommittees of the appropriations committees in both the House and the Senate, which hold hearings before recommending the budget to their respective houses for passage. The final answer to the question of who runs the college must be "Congress" until such time as home rule becomes a reality. Indeed much complaint against Dickson's speech concerned the possible effect it might have on Congress. Pressure from the District committees of both the Senate and the House finally

1 Biderman, Albert D. *The Higher Learning in Washington: A 175-YearOld Crisis,* Bureau of Social Science Research, Washington, May 1966.

forced the board of higher education to act in the black studies crisis.[1]

The board itself is a political body, responsive, particularly in the first years, more to federal than to city concerns. Technically appointed by the District mayor-commissioner, the first board was named directly by the White House. Charles Horsky, board member from the beginning and chairman of the board for its first four years, was then White House adviser on District affairs. The role appropriate to a board of a new college probably should differ from the distant benevolence of many boards of trustees; but to attempt to govern, as the board of higher education did in the spring of 1969, was neither feasible nor felicitous.

In 1968, however, until Provost Dickson gave his speech, both Congress and the board seemed remote to the power struggle at FCC. Even board members were unaware of the escalation of conflict that prompted the president, Frank Farner, increasingly to adopt a style of non-leadership.[2] Few seemed to understand the implications of Farner's early decisions concerning open admissions, low tuition, and immediate expansion both as to size and to level, although the majority of the board seemed to follow Horsky's lead

in supporting Farner and urging rapid growth. These decisions altered the character of the college from what many assumed would be a relatively small, excellent city college in the model of the old City College of New York, one that might attract out-of-state students of all colors by the depth of its urban commitment to what one observer has called "the common college." Rather than apply open admissions only to the two-year Washington Technical Institute created by the same bill, Farner chose to admit to the liberal arts college any person with a high school degree or its equivalent with no limit on the type of training or, for a time, on the size of the student body.

The need to provide post-high school education for a variety of District students had been recognized both by various study committees and by the bill itself. In order to emphasize technical training and give it the status and dignity he felt it deserved. Congressman Ancher Nelson (Republican of Minnesota) had separated the practical from the academic and had written into the bill a separate institute, Washington Technical Institute, authorized to grant certificates or associate of arts degrees.

Since the original bill had included a community college as well as a four-year standard liberal arts college with authority to set up a master's degree in teaching, the residual Federal City College was a multilevel college. It would have been possible to set up two separate campuses, one a junior college with

1 Myers, Phyllis: "What It's Like When Congress Runs a College," *CITY,* October-November 1970.

2 Mapes, M. C., Jr. *The Congressional Relations of the Federal City College,* a report prepared for the District of Columbia Citizens for a Better Public Education, Jan. 15, 1970. (Mimeographed.)

open admissions or a general curriculum, the other a more selective school. To some, such preselection bore with it elements of tracking, a political anathema in the District. Further, it was argued, particularly by Board Chairman Horsky, that such a plan might lead only to the funding of the two-year college, because Congress was a notoriously fickle body, basically antagonistic to the District. Farner and the board of higher education had thus decided not to separate the college into constituent parts, but to develop it as an organic whole.

This same concern over funding led Farner to establish a master's degree program immediately. The attitude was very much one of occupying territory left unprotected by the enemy. Yet the swift establishment of beachheads at all undergraduate levels, and the graduate level as well, was to apply to the doctrine of open admissions to all students. Indeed, a bachelor's degree was not necessarily to be required for entrance into the master's program. Philosophically, desire replaced preparation as the standard for entrance.

For consistency with open opportunity there had to be a low tuition. Since the first two years of FCC were to be equated to a community college, Farner began with a comparison of fees or tuition at neighboring community colleges. On the basis of lower average income in the District, he proposed, and the board accepted, a tuition of $25 a quarter. Out-of-state students would not be charged the cost of their instruction—few colleges do that—but the incremental cost of their attendance. Nonetheless, it was decided that such students would pay 10 times the local rate, or $250 a quarter, $750 a year. Such a charge was half again as much as the annual tuition at neighboring state universities such as Virginia ($525) or Maryland ($502) and was higher even than the tuition at nearby Howard University ($618), which is subsidized through the U.S. Department of Health, Education and Welfare. Thus, even though anyone over 21 residing in the District for three months was considered a resident, and even though no check was ever really made to verify residency, this tuition differential severely limited the clientele from outside the District while extending opportunity widely within it.

Low resident tuition and open admissions at every level resulted in a flood of inquiries which were interpreted as applications. As the number of letters expressing interest in joining the college grew close to 6,000, Farner made another political calculation. He decided to ask Congress for an increase in the size of the charter class. To dramatize the need for this action as well as to solve the problem of admission priorities, Farner decided to hold a lottery among the 6,000 applicants for the spaces available.[11] Bennetta Washington, the mayor's wife, drew the first number. This was a masterpiece of public relations. FCC was featured in all the news media in the country. Pressure began to build to open more

opportunities in the college for the eager students.[1]

The original funding request for the first year of teaching had called for a faculty of 60, already greater than estimates in the Chase report (A Report to the President, 1964). At a ratio of 1 faculty member to 16 full-time students, these instructors could teach only 960 full-time students or, it was estimated, 800 full-time and 500 part-time students for a total of 1,300 persons. Farner went to the Congress with a request for supplemental appropriations to increase the faculty size to 120 in order to accommodate 2,400 students in the initial class. Actually neither budget had in fact been passed when the school opened, but the faculty recruitment tapered off in May at slightly over 60. Although Farner had the board's backing for the larger budget, he did not finally agree to recruit more faculty until July 1968 under pressure from the faculty. This decision had a tremendous impact on the black controversy at the college, since it meant recruiting for additional faculty during the summer when most faculty would have already signed contracts.

1 Like much else in Washington, this numbers game was primarily for public relations. As applicants were processed, it became clear that many had no real intention even of applying to the college. Of the first 350 persons processed, 100 were actually traceable. Lottery numbers to 3,800 were exhausted to achieve enrollment of 2,000 heads for the first quarter, and most of the rest of the numbers were used during the winter and spring quarters to replace earlier students who dropped out.

Taken together, the decisions to combine low tuition for District residents with open admissions at all academic levels and with immediate expansion of the student body confused and complicated the curriculum thrust of the college and therefore its philosophy. The goal of quality education can be combined with open admissions at the freshman level if intense efforts at "catch-up" are made for the benefit of underprepared students. Highly structured core courses with intensive skill components were originally proposed for the incoming freshmen. But rampant growth and open admissions at upper levels made quality control almost impossible and, for many, unpalatable. The social goal of educating all comers submerged vague notions of educational standards. Such was the tenor of the times that the philosophical issues implicit in Farner's decisions were never discussed at the time within the college community either by the burgeoning administration or by the faculty committee which had co-opted student representation.

THE FACULTY

The confusion with the college—over curriculum, recruitment, and size of the student body—was compounded by power struggles that intensified as Farner increasingly avoided making decisions. This vacuum of leadership became clear to the faculty the first time they met together in late June 1968.

The total faculty which assembled

at the June convocation included 44 whites and 18 blacks. Recruitment guidelines stressed reasonable academic preparation and experience in cross-cultural teaching. A fairly high salary scale and innovative teaching possibilities were expected to attract a highly qualified faculty. Indeed, many of the faculty came from such top graduate schools as those at Harvard, MIT, Minnesota, Chicago, Yale, and Michigan. Several young whites joined as a sort of academic VISTA experience, more ready to learn, perhaps, than to be missionaries, but certain that change was good. A small but significant group, black and white, moved over from Howard, where they had been active in challenging a conservative administration. Thus, while traditional academic preparation had been stressed, the early faculty combined with their credentials an impatience with the system. Such faculty members brought with them many ideas and theories based, naturally, on their previous experiences, which had generally been at WASP colleges.

A special effort had been made to recruit black professors in order to achieve parity, but the first faculty group was only 44 percent nonwhite. There were several reasons for the lack of a majority of blacks despite commitments by the recruiters to seek out black faculty. The emphasis on an academic degree in appropriate subjects limited the pool of candidates. In areas such as creative arts and drama, where a degree was not considered necessary, the percentage of blacks was higher

than elsewhere. Those blacks offered jobs were often unwilling to take a chance on a new college; the refusal rate was considerably higher among blacks than whites. There was also a conscious effort to avoid widespread hiring of nonwhite foreigners, a practice widely followed in Negro colleges, mainly to avoid dialectical problems with underprepared students.

This early faculty, socially aware and generally privileged, quickly grasped the implications when Farner repeatedly informed them at the convocation that nothing about the college structure or curriculum was "writ in bronze." Instead of a planning session, the convocation became a staging ground for "doing your own thing." One of the first moves was to organize a faculty organization to take over the decision making which Farner had clearly abdicated. Student services and media staff were unwilling to let so much power pass to the faculty, with whom many had already had arguments at least partly because of status-perception conflict. There finally emerged an Interim College Committee which included representatives of every constituency at the college: media (library), student services, administration, faculty, and general employees.

Rather than a decision-making group, the ICC became an assembly where diverse views of the major constituencies were aired. About the only point of agreement was over the need for parking. At one particularly fruitless September meeting the chairman,

Harland Randolph, then vice-president for development, complained that "everything is so amorphous. . . . I like to have my nightmares at night. . . . Misunderstanding around this place is one of the ways power shifts."

The faculty organization was much more active over the summer. Nearly 40 faculty were already working full time, and most were at first active in the organization. When Farner's decision to increase faculty size became known, a black member of the English faculty who had formerly taught at Howard offered a resolution at a meeting on July 24 stating that all new positions in the faculty or on the staff should be filled with blacks only. There was little opposition among the group of 26 faculty present; only 2 members voted against the resolution. Farner, who was present, said he would approve the motion and pass it immediately to the board. He did this without any attempt to discuss the matter with his provost, whose job it was to recruit.

A Black Committee was formed to recruit and screen new candidates. When it reported to the second convocation on August 27, it reported having recommended the hiring of 35 educational personnel, over half of whom were faculty. Many of the additional faculty hired were part-time teachers who were graduate students at nearby universities or working elsewhere. Two had started and ran a black bookstore. Another was a radio and TV announcer. Several were community organizers with the Office of Economic

Opportunity. Very few came from academia, although one professor was lured from North Carolina despite the lateness of the recruiting effort. Another associate professor for a time continued to teach full time at another college in Maryland while ostensibly teaching full time at FCC. The racial tenor of this recruiting may be seen in the reaction of one black candidate who reacted to the interview process angrily. "They say I'm not black enough because I came with a tie on. I spent three years getting myself together, going to a psychiatrist. I know who I am. I'll not play their game."

In September the faculty numbered 106 heads—51 black to 55 white. Anyone teaching even one course had a full vote in faculty meetings. With a quorum set at half, the faculty had constant problems with attendance. Decisions were made by 35 to 40 active faculty. No wonder that it seemed to the provost and to many others as if the faculty were run by "the white radicals and the black separatists." When an issue was demonstrably racial, then the black-white militant coalition always won. To the question, who shall teach? the faculty had answered, black. In asserting their answer they had also, for the time, stated that they, the faculty, would run the college and determine what was to be taught. For much of the first year, they did.

Most of the issues considered by the faculty were not clearly racial, but there was usually an effort to define them as such in terms of shades of

blackness. Only when an issue touched upon faculty power was there anything like unanimity. The faculty voted that no one could be fired the first year, and the administration accepted it. The faculty voted that any instructor could teach any course acceptable to its own elected Educational Policy Committee. Thus ended any attempt at curriculum structure; the administration accepted it. The faculty voted to change the organizational structure by dividing the three divisions into departments and programs. Heads of divisions as well as heads of departments and programs were elected, and changed, with no consideration of rank or experience. Privileges of having secretaries, light course loads, and space went with these elected positions. Although there were attempts to alter faculty decisions, the administration eventually accepted each change—until, as we shall see, the issue of creating a separate black program came up.

On educational or political issues, the unanimity broke down. Many white teachers felt that achievement and aptitude testing was culturally biased and should not be used at FCC. Other white faculty considered grading passé: students should be given an A the first day of class. Most blacks read this attitude as patronizing, as if the whites were saying that the blacks could not equally achieve or equally learn. Black faculty, both traditional and militant, tended to demand high standards and rigorous courses. Black students complained that some white teachers merely liked

to bull; they resented everyone getting passing grades when many did no work.

In terms of course content, the majority of the faculty in the professional and physical science divisions favored traditional curricula. In social sciences and humanities there were many faculty members interested in trying to adapt the courses to what they perceived were the experiences and needs of the student body. Some of the younger white faculty tended to hold a somewhat romantic view of the students as underprivileged rejects of society whose native intelligence was waiting to be revealed. In fact, the bulk of the students were lower-middle-class Americans with typical ideas about the upward mobility inherent in a college degree, who were in college for status and jobs, not for pure education.

The kaleidoscopic nature of the faculty makes generalizations almost impossible. Faculty members preferring structure may be separated by course content into traditional and adaptive. The latter term suggests cultural, temporal, and attitudinal adaptation of the general curricula to respond to the needs of the students as perceived by the faculty members themselves. This group included those favoring the original integrated core curriculum as well as the black militants espousing black studies. Those preferring unstructured classes and free-flowing ideas were all white, although one young woman of Armenian dissent who identified herself as black could be included in this group.

On political issues faculty members were more likely to divide by race. A majority of blacks seemed to prefer avoiding any confrontation and stopped attending faculty meetings altogether. The more militant wanted to preserve their energy for their own concerns. Thus the blacks did not join whites in fighting the governmental oath required of all federal employees which eschewed union activity and queried Communist affiliation. When white faculty wished to open the college for the moratorium marches, the black students and faculty joined to countermand the offer.

The issue over Project Vault was more obscure. The black director of admissions, himself a retired army officer, originally negotiated FCC's involvement in Project Vault, a well-funded Defense Department program to help Vietnam veterans get a college degree in elementary education so they could teach in inner-city schools. Many of the white faculty objected to any affiliation with "the war machine and its tainted money." Other faculty of both races recognized the worth of the program both to the veterans and to the students they would teach. The militant blacks did not want to alienate these objecting whites, on whose votes they so often relied, or the moderate blacks with whom they were trying to cope. Generally they considered the war a white man's problem and unfair to black soldiers; one of their members was then in the midst of a court case over his conscientious-objector status. When the

vote came, those present were mostly whites, and the project was shelved.

Depending on the subject matter, then, the faculty grouped in various ways. Of course there were individuals who fit no group, and more individuals who uncertainly swung from one group to another. The fact that most of the faculty was young and relatively inexperienced and lacked structural or behavioral alternative models exacerbated the swings. That first year at Federal City College was in many ways a continuous sensitivity session demanding exploration into the meaning of middle-class-ness and racism. Many black militants exalted the four-letter word as a weapon against bourgeois pretense. Skin color became the most important factor in weighing opinions; the most damning thing that could be said of a black faculty member was that he was not black enough. Whites were automatically called racists if they did not acquiesce to the militant view. Race increasingly informed all decisions; the college, like the society, might be seen as institutionally racist. As this view of society and the college gained popularity, the black-white coalition against which the provost inveighed could carry the faculty, but only on racial issues which the less radical black faculty might dislike but would not dare oppose. An issue that was accepted as black would win, at least openly. The role of the silent black majority was pivotal in the defeat of black studies.

BLACK STUDIES

The demand for black studies escalated through three phases, from demand for courses to demand for program to demand for a college; within the college the majority opinion switched from support to rejection. Controversy over the separatist program led to a polarization between the faculty and the administration which caused the board of higher education to request the resignations of President Farner and Provost Dickson in May 1969. The board, confused and disunited, tried for a time to intervene in, and even to assume a decision-making function at, the college, tangled with the faculty, and then withdrew, leaving former Vice-President Harland Randolph as the new president.

As previously indicated, the curriculum planners assumed from the beginning that Federal City College would have courses more appropriate and more relevant to city life and to various subcultures in this country than is usual in the WASP-dominated colleges. The true test of new black subject matter is its incorporation in all courses. No one considered the short-term introduction of specifically "black" courses as contradictory to this long-term goal. During the summer hiring push for black instructors, six or seven were hired to teach courses on African antecedents, community action, and black literature, for example. Such faculty members were hired within the existing teaching divisions.

Originally the divisions were primarily to offer structured team-taught courses in their subject areas but with skills built in. Such integrated team-developed courses take much time and commitment *on the part of the faculty.* But the faculty was obsessed with politics and decided to delete the teaching of skills and revert to the usual freshman courses. As more and more courses were offered, the structure lost its form.

During that first quarter, an Educational Policy Committee was charged with the enormous task of reviewing the reordering of the college's curricula. As a committee of the active faculty, it had more flexibility than the more conservative faculty condoned. Interdisciplinary programs as well as departmental offerings were encouraged. More rigid programs were criticized, and suggestions were made to make them more flexible, but, on the grounds that any program deserved a year's trial, no programs were rejected.

Such an EPC was clearly sympathetic to an interdisciplinary black studies program. The organizer of the program was James Garrett, a 25-year-old instructor of English who had already written several black plays and had helped to set up the black studies program at San Francisco State College while he worked on his bachelor's degree. In a series of memos during the fall of 1968 various faculty members, black and white, who were interested in the topic produced course outlines for a black studies department or a black studies committee. Garrett's memos as convener of the black studies program

from the beginning seemed focused upon an interdisciplinary offering. At first the subjects were all within the humanities division and included history, literature, arts, and communications; the program was to be "geared toward the isolation and specification of information in order to include the study and expression of black life with those areas of study for which Federal City was founded."

A memo on black studies which Garrett sent to the provost on October 10 had added social science to the "suggested major areas of concentration." Eleven faculty, all black, were listed as giving courses. This memo was followed by an informally circulated ditto, which declared that "the Black Studies Program will be divided into four degree-granting areas: Arts, Humanities, Community Development, and Science and Technology." Under this proposal the degree would be in black studies with a concentration in one of the four areas. Students not in the degree program could take black studies courses as electives.

At this point some faculty began to wonder where such an all-embracing black studies program left the rest of the college, especially as it became clear that white faculty were not welcome to teach in the program. Then the final version of the black studies program, later renamed the black education program, ignited the controversy early in November. Garrett was now asking for an essentially and autonomous program with a twofold purpose

of "revolution and nation-building." He continued: "The main emphasis of Black Studies will be toward the liberation of the African world. Since education should serve to expand the minds and spheres of action of the people involved in it, Black Studies must prepare Black people for the most complete self-expression, which must, in fact, be liberation and self-determination. Black Studies will take the position that the total liberation of a people necessarily means that those people separate themselves in values, attitudes, social structure and technology from the forces which oppress them."

Students enrolled in the program were to take five mandatory courses per quarter. The first two years "have as their major focus the decolonization of the mind." During the last two years the student was expected to specialize in useful skills, whether technical, political, or cultural. While there were to be a few courses open to other students, the thrust of the program was to create a cadre of black nationalists.

To mount this program, Garrett demanded that it be allotted half the total faculty and that he be named director of the program, with complete freedom to recruit. Since the college was planning to double its size for the academic year 1969-70, half the faculty meant over 100 persons. He issued a position paper on the aims and objectives of the black studies program which emphasized that "the necessity of control is vital to every level of black *endeavor.*"

The issue was clearly power and revolution, not academic niceties.

As long as the black studies program was perceived as any other academic program at the college, decisions as to its curricula could be left to the Educational Policy Committee. When the program began to demand faculty positions far beyond its programmatic size, other faculty programs were endangered. When it ideologically demanded a separation between black studies and white studies, the very philosophy of the college was in question. Yet such was the atmosphere at the college that open criticism of the program was negligible, until November 12, when Provost Dickson gave his speech.

Why did Dickson make this speech, especially since he lacked the support of any constituency at the college outside his office? Dickson, an English scholar of Jamaican heritage and New England birth, was educated at Bowdoin and Harvard. He taught courses on Milton and the Bible at Michigan State University in East Lansing before going to Northern Michigan College as vice president for academic affairs. A sensitive man, perhaps lacking in political sophistication, Dickson became embroiled in a controversy over university expansion by supporting the rights of faculty to protect elderly residents from losing their homes to the university. This was an explosive issue for the small community, but it was played out by the rules of the game. It did not prepare Dickson for the conflicting rules, and even games, played at Federal City College.

Dickson came not merely to accept but to applaud the need for study outside his own narrowly focused Greco-Judaic classicism. He accepted the argument that black commitment might be weighed instead of academic degrees, and had agreed to hire the faculty which formed the core of the black studies program even though only one candidate held a doctorate and he was an African whose philosophical orientation soon came into conflict with Garrett's. He talked with students and ignored the expletives that offended him. When several student leaders came to his office the day after the speech, Dickson argued against hiding one's head in the sand and hoping problems will go away. He said he had given the speech because of the "paranoidal tension" at the college and hoped that putting it in the open might make it easier to deal with. Later, in response to a student reporter who asked why he had not kept his criticism "in house," Dickson replied that he thought it "very important to talk about the infancy of this youngest land grant college, this oldest perhaps of a new group of urban grant colleges." Further he stressed the importance of open discussions. "Those who deny a hearing to their fellows have no right to stay in the academic community"

Why did Dickson receive so little support? Farner's style of non-confrontation meant that he played down the situation but did not attempt to deal with it. The vice-president for financial and administrative affairs was in the process of resigning; the dean of

student services was being moved to a less visible post; the dean of community affairs ran an essentially separate operation. Harland Randolph, Farner's executive assistant, the vice-president for development, and later president, carefully avoided identification with either Farner or Dickson. Farner himself once commented that although he had hired Randolph, he never felt he was "staff of my staff."

Among the administrators outside Dickson's immediate staff, only the new dean of student services, David Eaton, openly objected to a separate black studies program and argued this view in an open student meeting during November. Undoubtedly the racial tension at the college helped explain the lack of leadership in the administration. Whites were suspect, lumped together despite their own political perceptions as racists and exploiters. As a result, many vied with each other to acquiesce to black demands. All but the most self-confident and proved blacks were likely to be chastised as white if their stance included any criticism of black studies.

Although students had been on most faculty committees for many months, the first student government elections were held during the week following Dickson's speech. About half the student body voted and selected a relatively moderate slate from among five choices. This group, the CHOSEN FEW ("We are not a black minority, we are the chosen few"), became increasingly politicized and radicalized, so that by February, when they began to

attack the administration in general but Farner and his dean of administration in particular, they were a potent force in the college. The Student Government Association tended from the first to skirt the black studies issue and leave student involvement in that controversy to students enrolled in the course. A leader of this group, Leonard Brown, was also SGA vice-president, however. Those students more concerned with education than politics did not organize for another year and therefore played no role in the black studies controversy.

As the polarization of the college grew, student attacks on Dickson took on a personal tone. Typical is this open letter printed in the student newspaper and signed "enrolled citizen." *Mr. Dickson, you seem not to understand the nature of colonialism or to accept the fact, in the first place, that this is a colonial country and that we Black people, brown people, and yellow people are colonized. . . . The ferment you see in the world today, Mr. Dickson, on the part of colonized and oppressed people is that they are revolting against the alien culture of the colonizer, and are re-discovering their own heritage and values. Mr. Dickson, you have no identity either. It's time you re-discover yourself.*

Pressure mounted among faculty members to accept the program as proposed, despite its political as well as educational implications. This memo, circulated by a white member of the Educational Policy Committee, is indicative of the psychological dilemma this program posed for many faculty: *I*

*question the notion that Federal City Col-
lege or any college can be divided in any
meaningful and final sense between Black
Studies and White Studies. It is my con-
viction that racism in America, the most
pervasive and irrational racism in Western
history, is itself the result of an even greater
evil which afflicts our nation... The program,
in its very intensity and comprehensiveness,
moves away from the opening of choices and
options, and toward a closed and absolute
evaluation of history and society.... Despite
these concerns I support the Black Studies
program . . . as the only realistic means for
Black self-confidence, community, and ulti-
mately, genuine intellectual freedom.*

Isolated within the college, the pro-
vost's office acquiesced to tacit recogni-
tion of the program by listing courses as
a separate department and, after con-
siderable negotiation, allotting 40 new
slots for faculty to the program. Dick-
son refused adamantly to recognize
Garrett as the director of the program
and instituted a nationwide search
for an established scholar who might
head it. But Farner overruled Dickson
on that issue and refused to support a
search committee.

Outside the college the black stud-
ies program triggered considerable ad-
verse comment. While some questioned
the existence of black science, others
objected to some of the activities listed
under physical development: akido,
karate, t'ai chi, kung fu, stick fight-
ing, riflery, aquatics, the African hunt,
gymnastics, dance. The *Post* picked up
the essentials of the conflict in an edi-
torial which began "Infanticide is easy."

While the rage of blacks is understand-
able, that at Federal City College is
wrong for two reasons, "One is that it
reflects an emphasis on indoctrination
at the expense of education. . . . The
other is that it will bring about the cer-
tain end of public support of the col-
lege" *(Washington Post,* Nov. 20, 1968).

While the debate raged within
and outside the college, black studies
courses were offered during both the
winter and spring quarters. Enrollment
was low. Altogether 601 students en-
rolled in all the various black courses
in the winter quarter; the number fell
to 410 in the spring. Since each full-
time student was expected to take four
courses (black studies itself specified
five courses for its majors), the actual
number of full-time equivalents (FTE)
students was between 100 and 150
out of a total of 1,500 students at the
college. On the basis of a faculty-stu-
dent ratio of 1 to 16 the black studies
program already had more faculty than
its students needed. For the fall the
program had been granted nearly 20
percent of total faculty positions, yet it
had been able to recruit only 10 per-
cent of the students. Garrett himself
complained at a faculty meeting that
"black students have to be convinced of
black studies."

As it became clear that the program
would have difficulty in recruiting stu-
dents to its rigorous course of study, the
staff reversed itself on the emphasis on
exclusivity and joined with the Student
Government Association in a memo on
April 9 which called for all students to

take a minimum of 20 credit hours in black studies. A compromise might still have been possible, but Garrett kept up his vitriolic prose.[1]

Black people are not western. They are westernized. In much the same way as one might get simonized. We are painted over with whiteness. If you think that you can go to school and get what you call an education and feel that you will not have to pick up the gun one day to protect your life from these pigs and the rulers of the pigs and the rulers of the rulers of the pigs (those are the top pigs)—the mayors who are the rulers of those pigs, and the white businessmen who are the rulers of those pigs—stop it. It won't work. You're going to have to fight. You can't escape that. It'll be like escaping life. And this white man might let you do a whole lot of things, even marry his daughter, cause he doesn't need her anymore, but that is one part of life he will not let you escape—war.

Further, black studies had become a symbol of the faculty in its demands for control. The active faculty argued that it had agreed to the black studies program and neither the administration nor the board had any right to object. Increasingly, the silent faculty began to approach both the board and Congress with complaints about Farner's unwillingness to confront the more radical faculty. The apparent inability of the administration to deal with its own faculty and the impact that a black studies program might have on congressional

funding of the college forced the board to act. A Curriculum Committee was established in April to review all curriculum offerings in order to ascertain "(1) relevance of curriculum to the needs of adult citizens in the District of Columbia and (2) satisfaction of requirements for degree and accreditations."

Each division or program prepared its statement, which was forwarded, along with comment from the provost's office, to the Curriculum Committee. An advisory panel of students and citizens heard the statements and added their comments to those of the committee and the provost. Hearings were held between May 27 and June 14 and involved over 80 community representatives and 120 students. All projected offerings were given provisional approval, with questions to be answered during the upcoming academic year.

Although scheduled, the black studies program was never reviewed. First the faculty boycotted the review when the board stopped recruiting in black studies. Then the committee "was unable to clear with Mr. James Garrett a date and time for the rescheduling." In preparation for the review the board, on March 11, had announced its criteria for black studies:

- It must be academically sound;
- It must be designed to meet the needs of a student body from the District of Columbia;
- It must be consistent with legal requirements;

1 Raskin, Barbara, "Federal City College: Militancy In Microcosm," *Washington Monthly*, April 1969.

- It must have a proper relationship to other programs of the college.

The provost's office prepared a memorandum which said that the program "is autonomous to the point of being a separate college. . . . the methods employed by the Black Studies program stress ideological conversion rather than reasoned commitment. It is clearly outside the role of a public university to provide courses of indoctrination for True Believers."[27] This apprehension was stressed in a special report on black studies sponsored by the American Council on Education: "Programs like that Federal City College proposal will unquestionably raise serious doubts about their propriety in an academic setting." The argument was not against black studies but against separatism.

The crisis reached its climax at a raucous faculty meeting on the afternoon of June 2. During the preceding weeks the active faculty had censured the board for suspending hiring for the black studies program. The vote was 38 to 1; the faculty total at that time was 106. Moderates continued to absent themselves. The faculty then demanded that the board meet with them, since on May 26 the resignations of Farner and Dickson had been announced.

On June 2, five board members were present, as were some 60 faculty and 20 students. At last there was a quorum, but no votes were taken. Garrett reiterated statements he had made the week before that the black studies program would be withdrawn if the board did not cease and desist discriminatory action. "We will not accept that b - s in good faith. They don't have to be faithful because they have the arms." Some faculty had proposed that they all resign if the black studies program were not fully supported.[1]

But no resolution was presented. Board Chairman Horsky announced that he had rescinded the prohibition against hiring for black studies. This did not satisfy the faculty. They kept closing in on Horsky demanding to know whether the board could veto curriculum, and if so, how had they the competence? Horsky was accused of "not giving one clear answer on one single question." Asked whether the board was responsible to the community or Congress, Horsky answered, "Both. If in conflict, then the board must decide." Great hooting and calling followed this remark, along with much oratory on congressional colonialism. The meeting dissolved inconclusively; the faculty was unable to focus on any positive action to solve the dilemma: either to force the board to support the program or to convince Garrett to compromise.

Garrett decided against retreat. On June 9 he circulated a statement on

1 Actually Garrett had not put forward any candidates for hiring, although he was allotted 40 slots, until the last week of April. By June, 39 candidates had been interviewed and 5 new faculty had been hired in black studies. It is possible that if the program had continued, all 39 would have been hired. Many thought this laxness about candidates indicated that Garrett never expected the program to be accepted

"The Fight for Black Education" which heralded the departure of the black studies program to the community:— *The Black Education Program can no longer remain on this plantation. It must no longer submit to the condition of dependency forced upon it. . . . As long as we are confined in Federal City College Plantation, the existence, or non-existence, or modification of Black Education will always be in the hands of the Congress of the United States.*

Nine of the black studies faculty, then numbering nineteen, resigned along with Garrett and followed him to the Center for Black Education which he set up in the heart of the inner city. Those faculty remaining at the college were distributed among the existing divisions. Many taught a course at the center and were expected to contribute a tenth of their salaries to sustain it. At Federal City, no degree in black studies has yet been proposed. While most courses in social science and humanities have substantial nonwhite materials, there is some attempt now to be less repetitive. At first, it seemed to the students that they studied the same classics, like Malcom X's *Autobiography,* in every class. The result of the year-long controversy was to leave course content up to the individual faculty. Perhaps more importantly, the controversy gave the faculty a sense of power over the administration and involved

SUMMARY

The first year of Federal City College was full of tension as the faculty and staff undertook to answer the three fundamental questions who shall teach? what shall be taught? and who shall run the college? That first year the debate was couched primarily in terms of black ideology, and in all cases black was the answer.

Blacks shall teach. The faculty hired in 1969 was with few exceptions black; almost no faculty was hired in 1970 because of budget cuts. The ability of any white to teach at the college was questioned during the Black Awareness weeks following the Jackson State College shooting in May 1970. Student government officers sat in on classes of white teachers to monitor their degree of blackness. While some white males, both faculty and students, were roughed up in the hall and several white women verbally abused, the threats of violence were not merely black-white. The militants utilized rhetoric and violence against middle-class-ness of any color. The life-style of the street corner penetrated the college: the drugs, the violence, the admiration of the con man. Intra-black rivalries erupted openly during the election of the social science division chairman by the black caucus of the division. The successful candidate, a West Indian, would have been automatically confirmed by the white members of the division. Instead he was severely beaten by two other faculty members, spent some weeks in the hospital, and never returned to the college. The faculty members guilty of the beating were eventually fired and later taken to court by the injured man.

Responding to the tension and chaos, many faculty left. The percentage of faculty holding doctorates fell from 42 percent the first year to 29 percent the second. Black degree holders were eagerly sought by other institutions. The result is increasingly a faculty typical of those at many Negro colleges: marginal in terms of the profession, with low status and low mobility. Such staff, lacking other teaching options, is generally compliant to administrative pressure. There are women (black and white), foreigners, and men without doctorates or with degrees from low-status institutions. Of course there are exceptions, notable ones. Nor does the degree automatically indicate good teaching credentials. Many young faculty are stimulating and provocative, and may be much more appropriate to the student clientele than doctorate holders. But in terms of comparability to good state colleges, excellence is further away than ever.

What shall be taught? With the emphasis on hiring black, a large proportion of the newer faculty was recruited from Southern Negro colleges and from the District school system, both havens of bourgeois conservatism. Once the black militants left the college, the trend toward the tried and proved accelerated. There have been several attempts to tighten standards, and students can theoretically be flunked out for not passing enough subjects. The chaos in record keeping, however, has mitigated the force of this regulation. Now in its fourth year, the college still lacks a freshman-year program and is unlikely to initiate one.

While the trend is toward traditional college courses and content, the effect of the first-year controversy was to free the faculty from administrative control and to focus faculty effort against the administration. Today the faculty are left largely alone to frame their own courses or to work in groups for general courses. Such flexibility results in greater choice for the student; but because this flexibility is tied to the individual faculty and is not policy, it may be an ephemeral characteristic.

The answer to who shall govern? has yet to be given After Farner left, his vice-president for development, Harland Randolph, was appointed acting president, and he was confirmed in that post by October 1969. In an attempt to impose management systems on the college, Randolph called an all-college meeting at a motel in Bowie, Maryland, in May 1970. Student government officers attended all meetings and threatened faculty members who would not agree to the reorganization plan. When Randolph refused to call off the students, several of whom were for a time on his payroll, the faculty walked out.

Randolph then attached provisions on faculty contracts giving him almost unlimited power to fire anyone he wished. The faculty refused to sign for nearly a year, until the board intervened. In January 1971 the faculty voted 123 to 50 to censure Randolph for arbitrary actions in firing his provost. In March 1971 the faculty compiled a dossier of

what they termed Randolph's arbitrary actions: over half the faculty signed the petition that he be fired. In retaliation, the faculty, except for a few with tenure, were given one-year contracts for 1971-72. The board itself voted to fire Randolph in January 1972, then reversed itself allegedly because Randolph refused to return to the college at all. The board chairman, Edward Sylvester, resigned his post over the incident and sent other board members a statement which later appeared in the press. He was quoted as writing, "Harland Randolph lacks the management capability, the administrative knowhow, and above all the integrity to produce and lead a quality educational institution. . . . His approach to the board and its members has generally lacked candor, frequently been devious and manipulative, and at times just plain lies" (*Washington Post,* Jan. 14, 1972).

The mayor's office and several congressmen are at present studying plans for reorganization of the entire higher education system within the District. Perhaps a city university will be established with various campuses serving various needs. The students have become politicized and must be given a role in any new planning. The present student government forced the resignation of those students working with Randolph and has repeatedly called for

the firing of most of the present administration on the grounds of inefficiency. One group even called for the end of the intimidation of white faculty so that the few remaining might stay.

Internally, then, the struggle for black-white has been resolved at Federal City College. Rivalry within the black group tends to follow lines according to attitudes toward Randolph. Randolph's supporters tend to be found among the most conservative blacks. On the board, however, it was the white group that most consistently supported Randolph. One perceptive black member of the faculty called this a typical white guilt reaction. Five new members, appointed in March 1972, may well alter the ambiance of the interinstitutional relationships. Any reorganization of higher education in the District would call for a completely new board; meanwhile the new members have rejuvenated the old.

The fight over black studies exacerbated friction at the college and caused faculty, administration, and board to adopt roles which have proved mutually antagonistic. A change of all the major actors in this drama is probably necessary to ameliorate the situation. One decision which is unlikely to be reversed, however, is that the college will be black. The problem still is in defining what that means.

REACHING POOR WOMEN IN NEPAL: DO LITERACY PROGRAMS REALLY WORK?

"Reaching Poor Women in Nepal: Do Literacy Programs Really Work?" Peace Corps Visions, Kathmandu, Nepal, Summer 1988. Circulated within the World Bank by the South Asia lunch group before a presentation there January 19, 1989; reprinted in Newsletter for the Committee on Women for South Asia, Spring, 1990.

E ACH COUNTRY IS DISTINCT; ITS CULTURE, religion, geography, history and politics all affect the roles and status of women. So it should come as no surprise that programs for poor rural women which have worked in one country may be less successful or produce different results in another. This seems true of rural credit programs. Nor is it surprising, though it is still discouraging, to find organizations fostering the "welfare approach" to helping poor women, teaching them unmarketable skills or training them to make poor quality handcrafts or clothes which find no market. What has been surprising in Nepal is the apparent success of a program which everywhere else has failed: functional literacy. My skeptical dismissal of literacy efforts when I arrived here four months ago has changed to cautious support.

Literacy programs for women have accompanied independence in most former colonial countries. Nationalism was based on equality between the colonial ruler and the colonized; middle class women were pushed into nationalist movements by their fathers and husbands. Literacy statistics always showed disparity between women and men. So students and educated women were mobilized to offer literacy classes for women. Often these classes were held mid-day, and the "lazy, superstitious peasant women" never came.

Time-use studies show clearly why these hard working farming women did not attend those classes: such women are heavily engaged in survival and income-earning activities for 10 to 12 hours every day. It has taken a decade of research to detail women's work in near subsistence economies and to show that poor women everywhere work longer hours than poor men. By holding on to middle class stereotypes of what women do, development planners focused programs on men which too often added to women's subsistence activities while undercutting the demand for traditional foods and crafts which they sold or exchanged.

So, the current argument goes, increased income most helps poor women. Women and children are malnourished because they are poor. Mothers spend their income on their families, while men use much of their income for their own pleasure. Women-in-development

proponents pushed donor agencies and NGOs to set up income activities for women. At first, middle class assumptions about appropriate women's work resulted in knitting and sewing projects which produced unmarketable goods. Many organizations soon abandoned such projects in favor of credit programs as it became clear that poor women know better how to make money in their villages than do urban elites.

In Nepal, the Women's Services Coordination Committee is only now slowly moving away from its emphasis on knitting and sewing. Just because a person is female does not mean that she is skilled in such activities. Indeed, men dominate tailoring in Nepal and also commonly spin and weave wool. Assuming women are skillet at this type of work has led to projects producing poor quality clothing and handicrafts around the world. This is not to say that there is not a market for limited production of good quality traditional handicrafts which employ women already skilled in their design and production. Dhaka cloth scarves, handwoven baskets, nettle-cloth fabrics can all provide income for women if the market is not flooded (as has been the case of Kenyan baskets, for example.)

In Nepal, both the Production Credit for Rural Women and the women's program of the Small Farmer Development Bank are based on this current wisdom. Their model for credit is drawn from Bangladesh's Grameen Bank, which dispenses credit through affinity or solidarity groups. Social cohesion is encouraged through group savings and joint efforts in personal uplift or community projects. Loan repayment rates are high because other group members must wait until the first loans are repaid to receive theirs. Weekly repayment schedules also encourage careful investment. Interest on loans goes partly into a group emergency fund, providing loans to members to cover the expenses of illness or marriages.

The Grameen model seems to have been changed in the Nepal programs. Groups are socio-economically stratified, and cohesion is weak. Savings efforts are abandoned and group members can all take out loans at one time; indeed they are eligible for several loans. Collateral is often demanded. In other words, groups are perceived primarily as a mechanism to dispense loans rather than as a basis for solidarity and mutual support. This trend to treat loans to the poor as just more bank loans is unlikely to produce the impressive payback rate that characterizes the Grameen Bank programs.

Nonetheless, both PCRW and SFDP do provide credit to poor women and men. Women use the loans primarily to purchase livestock despite pressures toward knitting and sewing from cottage industries officials. Income producing programs for women are moving away from these traditional activities toward producing consumer goods for local markets, especially those food items in constant demand. They grow vegetables for the urban market, produce seeds both for forestry projects

and gardens, bottle orange juic and lemon squash, run tea shops, sell sweets and other street foods...all these activities provide good incomes for industrious women and men both in Nepal and elsewhere.

All these things I expected when I came to Nepal as a Fulbright professor in January. What I did not expect to find were literacy programs. Most donor organizations have reduced the educational components of development programs to training for income projects. Poor people are too busy surviving to waste time on non-productive activities. So what are all these women doing in rural Nepal coming out six nights a week during the agricultural slack season to study? Are they really attending these classes after their long work day? Can they really become literate in six months? If not, what do they expect to gain?

Let me outline some answers I have found to these questions. Women really attend these classes, but there is a high drop-out rate and fluctuating attendance. Classes include many young unmarried women who have not been able to attend primary school; but young mothers are also attending. Estimates are that 20-30 percent of the women attend throughout the course and eventually become literate, although the course usually takes longer than six months to complete. Further, most of the women learn to write their own names and that of their village.

But more important is the education that is imparted. The teaching materials are universally regarded as superb. Readings and discussion focus on the daily life concerns of health and sanitation, family planning, agriculture, credit, and community development. Thus, while the younger women are more diligent about literacy, older women benefit from the educational content of the lessons. They all benefit from increased self-confidence and the greater respect they receive within the village. They can sign for the own loans or for citizenship applications; some can read the letters their absentee husbands write.

Women may also have more time today than the earlier statistics show. Two significant changes have come to many villages: grain mills reduced the drudgery of grinding rice or wheat or maize, and drinking water schemes have shortened the distance women must walk to fetch water. It also appears that poor households are increasingly buying fuelwood with the remittances from migrant family members. These three survival activities account for approximately half of women's daily work in most time use studies.

But what motivates these women to attend in the first place? Some must be responding to the "carrot" approach, since many organizations require literacy class attendances as a requirement for participation in training or credit programs. For others, this many be the first time in their lives when they can meet with other women regularly to discuss problems of their daily survival. Perhaps the most important reason is

the high value of education in Nepalese society. Almost no one received schooling before 1950, and there is a huge pent-up demand. Naturally boys have been given preference; girls began tending livestock so their brothers could go to school. No wonder these women flock to classes when they can. And their husbands consider literacy a legitimate achievement, one that may even raise esteem for the household.

If indeed these functional education/ literacy programs are working, then other countries must look to Nepal and learn how to replicate them. Income activities are essential to poor women, but literacy is a key to improved status for the next generation of poor women. The miserable failures of earlier literacy programs have affected more recent efforts to educate young rural women in developing countries. Nepal's programs should lead to a rethinking of this attitude, if they indeed prove successful.

SECTION 3

POPULATION AND FAMILY PLANNING

M Y YEARS AT FEDERAL CITY COLLEGE WERE AN EXTENDED SENSITIVITY SESSION, MEN-
tally and physically exhausting. I took leave after three years as assistant
provost, but never returned. Instead, I turned my focus back to Asia with a fel-
lowship, in 1972, to study urbanization in Indonesia. While this trip propelled
me into the field of women and development, it also renewed my credentials in
studies of developing countries.

I was hired by the American Association for the Advancement of Science
(AAAS) in November 1973 to find a way to produce a scholarly book on cultural
factors in population programs as stipulated in a grant given to Margaret Mead
by USAID. Originally conceived as a standard academic book of chapters written
by outstanding researchers, Mead had expected the project to be under the aegis
of the American Anthropology Association (AAA).

At that time, critics of the Vietnam War were questioning the role of anthro-
pologists in Southeast Asia and challenged Mead's support of the government.
Responding to the controversy, the board of AAA refused to sponsor the book.
Mead asked the AAAS, on whose board she sat, to accept the project. By now it
was impractical to use the previous model, so when I was hired in November 1973
and expected to produce this book by May 1974, I proposed a different type of
book, one that summarized the views of experts in the field. Three anthropolo-
gists and I interviewed more than 100 scholars in the fields of population, cultural
change, or economic development about their recent research. Teasing out new
ideas before they were published meant that our data was on the cutting edge of
population thinking. A similarly diverse committee read and critiqued the draft
report to ensure the widest disciplinary views.

My immersion in both the evolution of the field and of current theories
helped me edit the required volume and, for a time, qualified me as an expert in
the field.[1] I include below the introduction and several salient sections from that

1 Culture and Population Change, with P. Reining, W. Swidler, and W. Cousins, preface by Margaret Mead,
 AAAS, Aug 1974; reissued 1976. Prepared for the UN Conference on Population, Bucharest, 1974.

report. During this time, colleagues at AAAS and I collated articles from *Science* on population and on urbanization.[1]

Population studies were beginning to move from an emphasis on supplying women with contraceptives – and assuming they would use them, to an understanding of the many cultural factors that influence decisions to have children. Family pressure was intense to produce children, especially in religious societies. Promoting spacing of births to reduce maternal and infant mortality was gradually being accepted in some areas. The role children played in alleviating women's survival tasks was becoming less important as families moved to towns. Monetization of the economy replaced the exchange market with cash and was pushing women to earn money. Instead of investing in many children so at least one would care for their parents in their old age, families began to having fewer children, educating them for jobs outside agriculture.

These socio-economic changes altered women's status as well. As I tracked them in my research on the impact of development on women with an emphasis on economic issues, family planning began to challenge the patriarchal control of men over women's reproduction. Questions about child brides and honor killing elevated the unequal treatment of girls. At the 1994 International Conference on Population and Development in Cairo, "women's rights are human rights" became the mantra.

Population advocates thus celebrated a woman's rights to control her own body. In doing so, they confronted patriarchal dominance in the bedroom as well as in society. No wonder that this mantra continues to be challenged as it perhaps the greatest threat to men's power worldwide. The global women's movement enabled these population challengers and conflated women's economic and familial roles.

1 Population: Dynamics, Ethics, and Policy, P. Reining and I. Tinker, eds., preface by Margaret Mead, AAAS, May 1975.

 Village Women: Their Changing Lives and Fertility, with P. Reining, F. Camara, B. Chinas, R. Fanale, S. Gojman de Millan, B. Lenkerd, I. Shinohara, AAAS, 1977.

 The Many Facets of Human Settlements: Science and Society, I. Tinker and M. Buvinic, eds., Pergamon Press, 1977.

CULTURAL AND POPULATION CHANGE — EXCERPTS

Authors: Irene Tinker, Priscilla Reining, William Cousins, Warren Swidler

Preface by Margaret Mead

INTRODUCTION

Population change, whether a measured growth or decline, has no predictable or necessary cultural consequences. As long as the ratio between population and resources remains relatively constant and the societal mechanisms for distributing the resources remain unchallenged, the society and its culture will remain stable. At various times in history this balance has been disturbed either by increases in resources arising from the introduction of new food crops, new methods of farming, new technology, or access to wider markets, or by decreases in population caused by disease or war. It has also been upset either by decreases in resources brought about by invasion, exhaustion of soil, or the collapse of the wider market, or by increases in population caused by new health methods or better nutrition. When the balance is disturbed, cultural adaptations will most certainly follow.

In preindustrial societies cultural practices and constraints, generally embodied in religion through taboos, were developed to maintain a reasonable balance between population and resources. For example, pregnancies were spaced so that one child was weaned and walking before another arrived. Often this was accomplished by forbidding intercourse during the period of breast-feeding. The return of a new mother to her parents' home for an extended visit was another method. Unwanted or weak children were left to die. On the other hand, polygynous marriages were a frequent response in societies where men were dying in wars and the population was diminishing.

When land was available, a gradual increase in population—one that would not drastically alter the number of adults per child—could be tolerated; abrupt alterations of family size between generations might undercut the authority of the elders and inhibit socialization. New slash-and-burn areas could be cleared, or satellite villages set up, or tribes split. Where land was scarce, one cultural response was to limit legitimacy, often by allowing only the eldest son to marry. Land tenure and inheritance systems were changed to limit the number of heirs. Cross-cousin marriages also tended to keep resources within the kin groups. In many island societies the weaker segments of the group were forced to leave. In times of scarce resources, kinship ties were generally tightened as the "haves" struggled to hold on to what they had. Castes and guilds formed to ensure

both landed and landless of their places in the resource chain. Social mobility became increasingly limited, and marginal niches were created: the spinster, the serf, the prostitute, the beggar.

In the contemporary world one can see indications of such trends where population is outrunning the immediately available resources. Labor unions have become like guilds in some countries: only relatives of members can join. Kin networks are promoted, with food being sent to cities in exchange for clothes or children's education. Litigation over land is a widespread phenomenon. Urban migration has increased the number of marginal squatters. In some countries bands of runaway children fend for themselves, a clear indication that there are too many children per adult.

Where resources are in excess of population, the converse has been noted. Societies are more open, mobility is possible, fewer persons are assigned to a marginal existence. Kin relationships become less pressing, and marriage and legitimacy laws are relaxed. Expansion of opportunities leads to a labor scarcity, and low-status jobs are hard to fill. For example, one might think of changes in the United States that have resulted from the recent decades of affluence.

Historically, cultural adaptations have always taken place in isolation, often slowly although sometimes precipitously as with the collapse of the Harappan Empire. Today, spread rapidly by worldwide communications, technology and other modern developments have virtually engulfed most subsistence economies. The cultural implications of this fact are enormous. Not only are alternate cultural patterns available to each individual and family, but the former constraints and limitations of the enclosed cultures are no longer enforceable. Individuals and families see their worlds expanding, but they do not understand the problems of national or world balances of population and resources and so tend to maximize family or individual resources as best they can—a decision which often means expanding the family size. This response has led many theorists to suggest that only a drastically altered social structure, perhaps one requiring a redistribution of resources in a nation, could bring about the degree of population control now needed to bring resources and population again into balance.

The belief that economic development alone will somehow trigger a decline in fertility is still widely held. In Section 1 we examine the theory of demographic transition, upon which this belief is based. It is a beguiling theory because it is simple. But it fails to consider the tremendous diversity among the world's societies, many of which do not react as the theory predicts. In particular, economic development often brings a spurt rather than a decline in fertility, as many families have more children in transitional economies so that they may produce more or earn more wages and thus increase family income.

A traditional mechanism for relieving pressure on a given society has been

migration, which is the topic of Section 2. Too often it has been assumed that migrants lose all contact with their rural homes and rapidly become urbanized, especially by adopting the nuclear family pattern and so reducing fertility. Studies which are reviewed here show that changes in fertility rates vary with class and culture. Singled out for emphasis are other studies which show the prevalence of kinship networks which bind the villager, the townsman, and the city dweller into a new unity for the maximization of economic opportunity.

What happens to the family itself and to the roles of its members as they adapt to modern influences is explored in Section 3. The assumption that traditional family types will be replaced around the world with nuclear families is examined and rejected: in fact, there are more rather than fewer types of families in the contemporary world. One reason for this expansion of family types is due to the change of the family from an economic and kinship unit to solely a kinship unit. This results from the employment of individuals, not the family, in factories or on plantations. When only the man is employed, the result is to create dependency of women, children, and the elderly. Such a change has profound consequences on the well-being of women, children, and the elderly while at the same time placing an intolerable burden on the working man. The removal of women from the working force not only slows development but may encourage increased fertility; yet many aid-giving agencies

continue to assume that women's place is only in the home. It is not an accurate reflection of reality in most of the world today, and it is yet another illustration of the importance of considering the real world rather than imposing assumptions which would lead to incorrect policy decisions.

Another assumption which needs to be discarded is that population regulation is a new thing. This error arises in part from the belief that primitive societies produced the maximum number of children and that populations grew slowly because of high mortality rates. Actually few societies have reached the biological maximum of children per woman. Biological and social methods used to regulate fertility are discussed in Section 4; comments on the communication of knowledge about procreation and contraception are also included.

Because the cultural, economic, and political implications of population change are becoming evident to policymakers around the world, it is important that the population impact of all governmental decisions be considered. This is particularly crucial since, between the time a policy is implemented and the time its impact becomes apparent, there is always a lag. When this lag extends over several years, and especially when unintended consequences result, the connection between the policy and its outcome is often missed at the national level. Studies of small societies may permit the relationship to be perceived more quickly and accurately.

Therefore, Section 5 deals with the types of policies that are often contradictory to population control and warns that policymakers may be led by limited knowledge of their own heterogeneous peoples, as glossed over in macro-statistics, to institute programs at variance with their stated national goals. This section also reviews briefly some of the cultural factors which hinder population programs and suggests that concentrating only on the family or on women is too narrow a focus for successful family-planning programs. If indeed families decide to have many children in response to their perceptions of the family size needed to survive, and perhaps to improve the quality of their lives, these perceptions can be influenced. Some nations have already instituted programs which try to find economic alternatives to children. These programs focus on rewards to the mother or to the family. An untried idea would be to reward villages or other groups for reduced fertility....

Throughout the paper we have tried to show how many of the policy dilemmas facing government officials when they try to evaluate or institute family-planning programs may be due to inaccurate assumptions about the actual behavior of people. Without a clear picture of the varying responses likely from the diversity of subnational groups or economic levels within any nation, the consequences of population policies may well be unexpected, and possibly antithetical to stated national goals.

IS POPULATION REGULATION NEW?

In all societies the biological and environmental forces that affect population dynamics are channeled and controlled by an intricate web of cultural practices. Birthrates in all but one of the known human societies, for example, have been well below the biological potential of the population. The exception is the Hutterites, a small sect living mainly in Canada and the United States during the past 100 years. In striving to grow, the Hutterites achieved the highest fertility known in any social group; their experience suggests that the biological limit for the average woman approximates 10 to 12 children. Yet even in the fastest growing nations today families seldom average more than seven children. Thus some sort of fertility regulation clearly has long been characteristic of human societies.

Traditionally family size has been regulated by a combination of innate biological factors, social and ritual restrictions, and more direct means of birth control. The preferred social, ritual, and direct controls and the extent of their use have varied among societies, but modernization has subjected all traditional methods to change, often with drastic effects on fertility. The process has created a need for new and acceptable methods to replace those that have been lost or that now seem a threat to health.

The size and composition of populations are determined not only by

social regulation of birth, but of death as well, and they are affected also by migration. Membership in social groups has always involved the cultural concepts of legitimacy and eligibility. Soon after birth the acceptable newborn are given "social life," often by some form of affiliation ceremony, and are reared thereafter to perpetuate the group and its preferred traits and behaviors. The unacceptable are left to die or to be reared as outcasts.

If birth and affiliation create social life, then exclusion in its various forms brings "social death." Where a society changes slowly, the aged remain the repositories of knowledge—how to give birth, how to work resources, how to avoid illness, how to treat the dead. But where a society changes rapidly, each generation must acquire new knowledge; social death often comes quickly as the aging are excluded from full economic participation long before physical death. Physical death, in fact, may be hastened by the earlier social death. The maximum attainable human life span appears to depend ultimately on genetic limitations and probably is about 110 years. But differing rates of death and disease within populations indicate the importance of social controls. Thus the complex interplay among biology, environment, and culture must be kept firmly in mind if a useful framework is to be created for the formulation of population policies.

Biological Regulation. A woman's ability to conceive is regulated basically by the functioning of the menstrual cycle. The cycle, in turn, is regulated by other biological processes, influenced by lactation, and often conditioned by environmental factors such as nutrition and altitude. Increasingly, moreover, the menstrual cycle and its attendant biological mechanisms are becoming accessible to biomedical manipulation. Modern medical research is also reducing the incidence of diseases which interfere with the reproductive capacity of women.

Lactation, with its effect on the spacing of children, is one of the most important biological regulators of population in human societies. Research has demonstrated that women who are feeding their infants entirely by nursing are less likely to become pregnant than those who are combining partial nursing with other foods or who are not nursing at all. The introduction of powdered milk and other supplementary foods and the discouragement of nursing by modern nutrition and health programs, therefore, may increase fertility by shortening the period of low potential for conception that normally follows the delivery of a child.

In societies where nutrition is poor, the average age of menarche—the onset of puberty in girls—may be unusually late. Conversely, the steady, well-documented decline of the age of menarche over the past 150 years in modernized nations is related to improved nutrition. The evidence indicates that a girl does not begin to menstruate until the fat in her body amounts to 20 to 25 percent of total body weight. The better her

nutrition, the sooner she arrives at that condition and the longer the span of her reproductive years. Improved nutrition, in consequence, may increase fertility in societies where the age of marriage comes not long after menarche.

Environmental factors other than nutrition are also being studied for their effects on fertility. A pervasive problem in such research is that, for any given people, culture may moderate the effects of environment. A people's traditional agricultural crops and technology, for example, may influence the prevalence of malarial mosquitoes and so affect the frequency of exposure to the disease. In the real world, therefore, it is most difficult as a rule to disentangle culture and environment to the point where adequately controlled comparisons can be devised. The difficulty is eased, however, in research at high altitude. Culture does little to interfere with the physiological stresses of altitude, so that a people's adaptation to those stresses can be studied while holding culture constant. In this vein, research on a group in South America, living at 13,000 feet and above, indicates that fertility apparently is unaffected by the altitude. Infant mortality is high, on the other hand, because the newborn are small and often afflicted by heart complications. Additional research is in process on the effects of climate on fertility.

Social Regulation. Biological limitations on reproductive capacity have always been reinforced by social means of regulation. These include both ritual and social restrictions on intercourse, social acceptance of more direct methods of controlling conception and birth, and, more recently, acceptance of new forms of contraception. Incest taboo and the vast array of marriage and sexual regulations reported from all known societies forbid, limit, or specify potential marriage partners. These regulations include norms for virginity, legitimacy of various types of union, age of marriage and of consummation, widow inheritance, and remarriage of divorced or separated persons. Since the nature of most regulations is restrictive, the actual number of unions possible within a given group is always much smaller than would be possible in the absence of regulation. In many large societies access to spouses is limited by requirements that one marry within one's caste or outside one's clan; in small societies, the application of such restrictive rules to relatively few people often creates a lack of partners. Some of these problems are now being examined by computer through simulation modeling.

Once cohabitation is allowed, the frequency of intercourse is known to be subject to other social restrictions. These may include types of living arrangements, beliefs about moderation, or even anxiety about loss of semen.

Socially patterned sexual access is usually buttressed by ritual restrictions—especially, for example, clan and caste prohibitions and specifications. A very common restriction, verging on ritual, is that of banning intercourse

during a woman's menstrual period. More formal ritual restrictions include temporary periods of enforced continence to serve goals of ritual cleanliness, often in preparation for ceremonies and pilgrimages. These restrictions ostensibly meet only the requirements of ritual but have the additional effect of reducing sexual access.

The acceptance of contraception is influenced strongly both by the prevailing culture and by the woman's own reproductive history. The push to have children is very strong in many societies where a woman is not considered fully adult until she has had at least one child. The same woman, after she has borne several children or, in some places, several sons enjoys a very different status in the community. At that point she may be willing and able to accept some previously unacceptable type of contraception. In some societies men must prove their virility to be recognized fully as adults. In such a society a man may accept a vasectomy, but only after he has fathered several children.

Societies around the world have developed reproductive norms that tend to reflect the availability of resources. Where resources are limited, as among island peoples or where tillable land is scarce, legitimate marriage is permissible only for certain children, usually only the eldest son. In one area, religious ritual requires that a son preside at the cremation of a parent; birthrates in this society accurately reflect the fact that, statistically, the average family must produce 6.8 children to provide one adult son.

Alternative patterns for childbearing are more available in large, complex societies than in small, tightly integrated ones. Nonetheless, certain minimum expectations are widely held. People in the United States are still surprised that some couples might choose not to have children. Peoples elsewhere react similarly to the family that has only two children when the norm is four or five.

Reproductive norms, embodied as they are in cultural wisdom, apparently change slowly and lag behind actual behavior, which seems more responsive to new circumstances. The point is illustrated by studies in one Latin American country before and after the availability of legal, inexpensive contraceptive pills. Before the pills were available, women interviewed rejected the idea of using any contraceptive. A few years later, the same women not only were using the pill but were actively espousing its use among their friends. Similarly, predictions that black women in the United States would not use abortion clinics have not been borne out by actual behavior. Often such flips or sudden changes in behavior become quite apparent before the norms overtake them. On U.S. television, for example, advertisers continue to depict the four-child family as the norm while in fact the two-child family more truly reflects actual behavior.

METHODS OF REGULATION

Societies have used and continue to use many methods to achieve the desired number of children per family. Some methods, such as love potions and massage, were designed to increase fertility, but the intent of most has been to limit or space births. The latter techniques include abstinence, withdrawal, induced abortion, infanticide, mechanical barriers, hormones, intrauterine devices (IUDs), and sterilization. Improved methods for abortion, safer drugs and barriers, and the development of IUDs are part of many contemporary family-planning programs.

Abstinence appears in cultures widely separated in place and time, and some consider it the oldest traditional method of fertility control. Historically the practice has been implemented mainly through cultural controls such as beliefs about the frequency of intercourse, especially after the birth of a child or during menstruation.

Many peoples have practiced abstinence for various reasons. Where a society is aware of the fertile and nonfertile phases of the menstrual cycle, people may abstain consciously to avoid conception. Where a society believes that intermittent continence and celibacy distinguish man from animal, abstention may become part of religious ideology. Diverse cultures believe that sexual activity is debilitating, both physically and mentally. Thus power-renewing foods may be served and shared after intercourse. Belief in the "contaminating" effect of females is evident in postintercourse cleansing rituals. In polygynous societies, restrictions on the timing of wife visitation have limited the frequency of intercourse for many women. The pervasive existence of elaborate, institutionalized rules of continence for the many and of celibacy for some demonstrates that for centuries peoples have recognized the need to control fertility.

Another old method of fertility control is withdrawal or incomplete intercourse. It is thought to have been the primary method used in Europe during the period of rapid decline in fertility rates since the turn of the century before use of new methods of contraception became widespread. The decline, which began in Western Europe, occurred in both agricultural and industrial societies. In Eastern Europe, beginning in 1920 and before the advent of significant industrial development, the birthrate fell 25 percent in 10 years. In the same period in Portugal, the south had a markedly lower fertility than the north while not developing economically more than the north.

At the World Population Conference in 1965, induced abortion was reported to be still the world's most widely used form of birth control. The fact was confirmed in 1973 at the Brighton Conference of the International Planned Parenthood Federation. Abortion is not confined to modern, industrialized societies. Examination of a sample drawn from 350 societies has indicated that the practice is widespread

in nonindustrial and preindustrial cultures. Among the highest known rates of abortion are those estimated for Latin America. An earlier study in one country found three abortions for one live birth; in 1971, a larger study reported the rate as two abortions for one live birth. The worldwide estimate for legal and illegal abortions is 427 per 1000 live births. Undoubtedly abortion is popular because it requires no pre-planning and does not interfere with the sex act.

The availability, safety, and legality of abortion are all factors that influence a woman's acceptance of this method of fertility control. The recent legalization of abortions in the United States has had a significant and unpredicted impact on fertility rates in the country. Particularly unexpected has been the response of black women. Recent statistics from an eastern city and the West Coast show that among such women the abortion ratio—the number of abortions per 1000 live births 6 months later—is about twice as high as that among white women. One East European country, concerned over its falling birthrates, banned abortions; the birthrates shot up briefly, then sank back as women apparently turned to other methods.

A population may accept or reject abortion on the grounds of its concept of the status of the fetus at various points in its development. Many societies do not consider the fetus human until the third or fourth month of pregnancy; others consider it human at the time of "quickening," which normally occurs between 16 and 18 weeks after conception. Here, again, cultural factors have clear implications for population policy.

Infanticide is thought to be one of the earliest methods used to space children. Reconstruction of a Pleistocene population produced an estimate that infanticide was used as a spacing technique in from 15 to 50 percent of the births. Infanticide in a society is difficult to observe and discuss and is not well understood. This is especially true of the practice of actually exposing the child to die before it becomes "socially alive," as in a naming or group affiliation ceremony. Somewhat better documented is the alternative practice: neglecting over many months those infants considered unfit, for whatever reason, while at the same time seeing to the health and well-being of other children. Recent studies in South Asia where girls are seen as an expense because dowries must be provided for them, while boys are seen as laborers, indicate that malnutrition—often leading to death—is significantly higher among girls than among boys.

Infanticide is felt to be necessary in societies where breast-feeding is the only recognized source of nutrients for the very young. Such cultures display concern over the number of children a mother can nurse at the same time, the effect of nursing on a developing fetus, and constraints on the mobility of the mother with more than one infant to tend. In some societies the birth of

twins bodes ill; one or both are often left to die soon after birth. Where infanticide is practiced, female infanticide is usually the rule; where infant mortality is high, female infanticide often represents an attempt to increase the probability of having male heirs.

The use of mechanical contraceptives seems nearly as old and widespread as that of other direct forms of fertility control. Many groups in many areas have made pessaries, which cover the entrance to the womb, out of a multitude of substances. Many others have used substances that, not unlike today's foam, create an unfavorable environment for the survival of sperm. Male sheaths, made of many different materials, have been common. Mechanical means of fertility control have two advantages: they do not interfere with bodily functions, and they do not require administration or supervision by medical personnel. On the other hand, they interfere with the sex act to some degree, and they require conscious thought before intercourse. Since planning ahead is a characteristic that varies culturally, mechanical methods are sometimes entirely inappropriate.

In the past 15 years, hormones that induce infertility in women have become the most popular form of contraception. Pills are the most widely used form; they can be distributed by nonmedical personnel, although physicians prefer some degree of supervision to avoid possible side-effects. The fact that the pills must be taken daily is at best a nuisance, and at worst it can lead to pregnancy among women who forget to take them regularly. The latter problem is especially prevalent in societies where time-ordering is not stressed. The newer technique of injecting the hormones has been popular wherever it has been tried. The injections need be given only every 3 months; they are administered under medical supervision, which provides a convenient opportunity to examine recipients for side-effects and general health. Thus far, however, concern over long-range effects on fertility has kept the injection method from wider use.

Intrauterine devices, although they require clinical insertion, do not upset a woman's hormonal balances. For this reason many medical practitioners believe the devices to be safer than pills. The IUD does produce numerous physical side-effects, however. It aggravates vaginal infections and frequently increases menstrual flow. Bleeding is often excessive and even intolerable, especially if a woman's movement is restricted during menstruation as it is in some societies.

Sterilization, for both male and female, is becoming increasingly popular, especially in the United States where 10 percent of the adults are now sterilized. Except in the United States, where men and women equally utilize this method, its acceptance varies according to the cultural values attached to the sexual role. The irreversibility of the operations certainly has limited the method's use, and efforts are being

made to redesign the procedure to allow reversibility.

Because none of these methods is entirely satisfactory, they are accepted differently by different societies and economic groups. Moreover, various methods are often used by the same couple at different ages. Thus it would seem important for any family-planning program to provide a variety of types of contraceptive techniques for its clients.

The availability of methods increases their acceptability; the importance of delivery systems is discussed in the next section. It is important to note that nonclinical methods such as pills and condoms can be easily and widely distributed without immediate reference to medical services. A South Asian country used kerosene delivery trucks to deliver condoms to every village. More usually distribution is tied in with some kind of health advisory system that also serves as a communications channel.

Meanwhile, the search for new methods continues. Interest is growing in indigenous means of birth regulation in the hope that some plant or other material, when refined, may produce a better contraceptive drug or barrier. Anthropologists are studying the use of various indigenous methods, while physicians are analyzing and testing the substances used.

Biomedical technology is moving beyond the hormones used in pills and injections to mimic the natural infertility of pregnant mothers. The types of manipulation now being explored may be less culturally acceptable than oral contraceptives. Experiments are under way, for example, on chemicals capable of postponing the onset of puberty. A second possibility, genetic manipulation to produce "ideal types," may not become a reality for some time. But the ability to predetermine sex may come sooner. Already concern has been expressed in print over the potential effects of sex-determination on the ratio of female to male births. In the United States, the National Fertility Survey of 1970 indicates that, in response to preferences in order of birth, the ratio would return to normal after marked increase in male births. In any event, the ethical aspects of using these biomedical techniques need widespread discussion.

COMMUNICATION OF METHODS

In traditional societies, knowledge of sex and fertility control was communicated through specified individuals within the family or through an indigenous health system. Because of increased mobility and increasing contact among societies and individuals, and the social changes that attend modernization, these traditional communications networks have broken down. In addition, community support for traditional fertility practices disappears in the presence of alternative ways of life.

The communications problem seems particularly pressing in highly

modern societies. In the United States, for example, "old-fashioned" remedies are looked down upon, mobility and the lack of kin networks among the middle class have interfered with communication, and cultural values for many years barred open discussion of sexuality. The result has been widespread ignorance of sex and contraception, a fact that has led many school systems to introduce courses on these topics. Nonetheless, the rate of pregnancy remains high among unmarried girls in their teens. In the 1950's some observers estimated that nearly three quarters of all teen-age brides were already pregnant. A study in 1971 showed that 10 percent of all teen-age girls in the United States became pregnant out of wedlock, despite the ubiquitous birth control pills. The availability of suction abortion presumably will reduce the number of births to this group, but the need for earlier and better information about sex is obvious.

Still, knowledge of contraception may not be used by some young women. There is evidence, for example, that some teenagers purposely risk pregnancy, and conceive, for psychological reasons. A study in an eastern city in the United States shows that such young women who enter unsuitable alliances have a common family history of hostility between parents, mother-daughter alienation, and strong father-daughter attraction. Pregnancies among such disturbed women will continue regardless of birth control information.

Adult women as well as teenagers in the United States need better access to contraceptive information. Statistics indicate that American women reported one in four births during 1961-1965 to be unwanted; the figure dropped to one in seven in 1966-1970, presumably as a result of widespread use of the pill. The extensive use of abortions since they became legal would seem to indicate that many women continue to become pregnant through contraceptive failure or lack of information. Further, nearly half of all women seeking abortions in 1970-1971 had had no prior children. Clearly, the first child causes a dramatic change in life-style. The postponing of the first child, by lengthening generations, has important fertility implications. Many women who might have borne the child when abortion was illegal are now apparently utilizing clinics. Often such women exhibit high levels of anxiety over the action; clinics have responded with improved counseling. The very fact that so many women are having abortions indicates the inadequacy of present contraceptive usage.

Even more startling is the fact that, among couples using contraceptives, the methods failed to such an extent that 40 percent of all births during 1966-1970 were unplanned. The failure rate among couples who were delaying their next child was almost double that among couples who did not wish further children.

Studies have shown that mothers of unplanned children are less likely to seek prenatal care or to follow advice

on health care in general. This attitude leads to complications and higher infant and maternal death rates at birth. There are also indications that infant mortality is higher among unplanned children because, once born, they receive less-than-adequate care. The unplanned first child also may force the mother to stay home when she prefers to continue working; if she does continue to work, the child adds a new burden to her other housekeeping duties. Much of the hostility to men reflected in current American feminist literature stems from the feeling of many women that they have had to bear the burden of children while their husbands have "copped out." A frequent result of this feeling is divorce.

Changing living patterns affect attitudes toward fertility and fertility itself. In many developing countries the move to the city lessens the effects of traditional constraints on fertility. Often the connection between long-time customs and fertility is not understood; most women do not realize, for example, that their period of infertility after childbirth will be shortened if they abandon breast-feeding earlier than normal, and even if they abandon it only partially, in favor of the bottle and other foods. This type of knowledge, as well as that on newer methods of contraception, may often need to be propagated in rapidly expanding urban areas. Even where kinship and other kinds of networks exist, the information they transmit is too often wrong. Women of one minority community in the United

States were found to "test" pregnancies by taking quinine or ergot. They believed that, if the fetus did not abort, the baby would' be healthy. They did not know that quinine, taken in quantity, can cause deafness in the infant.

Establishing communications systems to transmit knowledge of reproduction and fertility regulation is clearly a high priority for any nation. Integrating such systems into traditional health services is one way to reach many people quickly. Although there is some concern that traditional healers and midwives will continue to prefer their own advice, studies show that practitioners such as these can become adept at fostering new methods of contraception and health care.

Several nations have set up or used women's clubs to popularize and distribute contraceptive pills; the governmental support that accompanies such a program has stimulated local women to organize other services—such as credit unions, sewing centers, and improved schools—for themselves and their families. This form of interaction among family planning, improved status of women, and economic development underscores the importance of considering all three activities together rather than one at a time.

In sum, it may be said again that the world's many peoples have always regulated their numbers to the degree and in the manner that they found appropriate. But the methods they have used to do so, worked out over a long time period and embodied in societal

values and behavior, are being eroded or bypassed by the modernization process. Communication of information on contraception, therefore, becomes particularly important as societies move into urban situations. Experience demonstrates that, when new and safe methods of contraception become available, their rate of adoption exceeds expectations. Still, the rate of failure of present contraceptive methods is so high that only by legalizing abortion can unplanned and unwanted pregnancies be avoided and the desired number and spacing of children be achieved.

CONCLUSION

The formulation of governmental policies must take into account the culture of the society if the policies are to have the impact intended. General developmental policies need to be reviewed to ascertain their potential for impact on population dynamics. Explicit population programs are often impeded by cultural factors, especially when a single governmental policy is applied throughout the nation. Finally, the data base upon which policies are formulated often carries with it cultural biases that must be taken into account when one is drawing conclusions from the statistics utilized. Governmental policies, then, should be established within a cultural context. Families make their fertility decisions within their immediate socio-economic environments, of which there may be many in the national context. Only by understanding the many varied environments and shaping policy to adapt to them can policymakers hope to influence such personal decisions as fertility.

A document from the Office of International Science, AAAS, prepared under the direction of its Advisory Committee on Cultural Factors in Population Programs.

PART TWO

SECTION I

ACTIVISM IN THE NATION'S CAPITAL

Washington DC in the 1960s was an exhilarating place. President Kennedy had just set up the first Commission on the Status of Women in response to increasing demands to pass the Equal Right Amendment. At the time, recommendations of the commission such as equal pay for equal work seemed tame; yet sixty years later they have yet to be fully applied. Increasingly, I was swept up in the re-energized women's movements reacting to a decade of propaganda by media and government that a woman's place was in the home: cooking, caring for the children, and serving her husband a martini when he returned from work. Meanwhile his well-educated wife was isolated in her suburban house.

WOMEN ORGANIZING TO CHANGE POLICY

Although I was aware of discrimination against women at Berkeley, I still had the mind-set of a "queen bee" because I was comparing my career with that of other women, not with men. In DC, in contrast, discrimination was rampant. I applied for a research position at the Brookings Institution assuming that since I already had a doctorate, a published book, and a post-doctoral fellowship, I would be a good candidate. Instead, I was told by the staff member, who ignored my post-graduation record, that Brookings hired Radcliffe women as secretaries and Harvard men as researchers.

As an active member of the American Political Science Association, I was appointed to the Status of Women in the Profession in 1967. Our charge was to identify obstacles that women encounter along their professional path, from graduation to work. Each member researched a particular area. I wrote "Nonacademic professional political scientists," based on questionnaires I sent to women in the federal government. I quote from the concluding paragraph: ...*women who have survived within nonacademic career ladders admit to professional discrimination and underutilization while denying personal discrimination. Only a few categorically state that they have never been aware of professional discrimination. Evidence indicates that such lack of difficulties must be an exception. Indeed, it may be self-delusion. Women are so invidiously socialized... that it is likely the women who tenaciously cling to careers feel, and are, so unusual, that they measure their progress in terms of those who have not made it rather*

than comparing themselves to their male peers. In all probability, these unique women, in an equal system, would have held positions of even greater responsibility and authority.[1]

The primary interest of the committee concerned issues faced trying to secure jobs in academia. For example, as graduate students, women were hired as teaching assistants while men worked as researchers whose names were often included in their professors' publications; women were hired at community colleges or women's universities, not at research institutions; the tenure clock made it difficult to have a family and also get tenure. Professionally, women were seldom appointed to association committees or selected to participate in the annual meetings. At my first presentation at a professional meeting, at the Association of Asian Studies, I was placed in the last panel of the last day and, as the only woman on the program, listed last.

After that experience, I helped form women's caucuses at every professional meeting I attended, or joined those already formed, with to goal of increasing women's participation both in the association and in the annual meeting. In the fall of 1972, representatives of caucuses and other women's groups met in Washington DC and formed the Federation of Organizations for Professional Women; I was elected president and provided with a long list of directives and very little budget. The membership of the steering committee included scientists, engineers, civil servants, medical professors, and union leaders: they greatly broadened my understanding of problems faced by women in all profession, especially engineers.[2] My first experience testifying before a Congressional committee was in my role as head of FOPW, claiming to speak for all the members of all the affiliates, "the marching millions." While it was doubtful most of these women had even heard of FOPW, we clearly frightened a lot of men.

Women graduate students, empowered by their activism protesting about civil rights or the Vietnam War began to demand the inclusion of women in their curriculum. Early efforts to write women's studies courses concentrated on the humanities: women's art, literature, and music existed, though male instructors seldom included their work. I was included in these early efforts, trying to include social sciences in their curriculum. The humanities base, and anti-government bias, of Women's Studies – soon expanded to Gender Studies – created a split with the women in development movement and our involvement with the government. When I became the chair of Women's Studies at the University of California/Berkeley in 1991, I had to address this issue.

1 'Non-Academic Political Scientists," *American Behavioral Scientist*: XV: 2, Nov-Dec 1971, 206-212. Issue on professional women. Reissued by Sage Publications, 1974.

2 "What's happened to Progress?" Career Guidance for Women Entering Engineering, ed. Nancy Fitzroy, Engineering Foundation, New York, 1973.

A major focus of the burgeoning women's movement was at first on opening women's access to professional programs. Trade unions were also targeted for their exclusive membership base that excluded women. Overall, the movement sought to prove how women's work was essential to a society that still categorized women in terms only of reproduction. This conditioning of scholars to overlook women's economic contributions was apparent in the Blue Ribbon Anthropology studies selected in the 1930s as premier examples of excellence. Every mention of a female in these studies was in terms of mother, maternity, marriage, etc. Not a single mention of women's essential activities in growing and processing food was included!

In the 1960s, women's organizations proliferated in DC and challenged male assumptions on issues ranging from equal rights to women's health, as well as the limitations on women in education, civil service, political parties, and labor unions.

Collectively women lobbied successfully to pass the laws and regulations to allow women to have credit cards in their own names, to own a house without a male co-signer, and for other rights today accepted as ordinary. Equal pay for equal work was declared, but quickly undermined by definitions of positions. Part-time work was accepted in principle, but difficult to achieve in practice. Breast cancer studies on male undergraduates were abandoned after women published this ridiculous approach.

We learned that regulations implementing laws were as important as passing laws. Women in government would tell us activists when a committee was discussing the law so that we could show up to influence descriptions. This symbiosis was critical to our successes.

Early lobbying efforts focused on obvious inequities in civil law. As the women's movement grew strong throughout the country, more feminist concerns were introduced. Training for "displaced homemakers" – divorced women who had assumed they married for life and had no employment skills – was acceptable to the mostly male Congress, but demands for hideouts for abused women or for rape crisis centers threated male privilege. Passage of the Equal Rights Amendment was stymied by procedural rules in the Senate.

To my delight, even Radcliffe, my alma mater, began to notice the women's movement. In 1974, I had co-founded the Wellesley Center for Research on Women with the feminist president of Wellesley College. Radcliffe had been awarding Bunting fellowships to women for some time, but they went to women with interrupted careers in any field. Even today, with Drew Gilpin Faust as Harvard's president, the Radcliffe Institute privileges scholarship over feminism and remains chary of advocacy. Still, in 1970, Radcliffe College supported a symposium on Women and Power which I initiated.[1]

1 Women and Power: An Exploratory View, proceedings from March 1979 Radcliffe Centennial Symposium, Washington D.C., Mar., 1979.

The election of Ronald Reagan 1980 blew cold wind on women's activism. Under his directive, federal legislation lost much of its power to the states. Conservatives, both women and men, began to reassert the theme that "woman's place is in the home." Women in Washington, rather than pushing forward, tried to hold on to their achievements.

To capture the exuberance of those decades and to document the success and failures, I persuaded activists to write personal histories of their actions, goals, and strategies. I include the introduction and conclusion from the resulting book along with my chapter following this narrative.[1]

MARCHES ON THE MALL

The Mall is an inviting space for marches: most demonstrators march up Pennsylvania Avenue to the Mall and congregate below the Capitol where a stage has been set up for speeches. Those of us promoting an urban grant university for the District did not march, however; there were not enough of us. Rather we visited Congressional offices where we achieved our goal: the establishment of Federal City College. Over the next decades, I frequently joined the marches against the Vietnam War and the US invasion of Cambodia. But I did not write about these events.

March on Washington for Jobs and Freedom: On August 18, 1963, perhaps 300,000 participated in this march which started below the Capitol: many buses lined every street as people from around the country poured in. Peter, Paul, and Mary were singing "If I had a hammer..." The mood was celebratory, calming fears of many that the march might turn into a riot. My black colleagues from Howard watched as I walked past, pushing my son Tjip in a baby carriage, as we headed toward the Lincoln Memorial at the other end of the Mall. They later filled in as the crowd flowed around the reflecting pool and onto the steps of the memorial. I found a grassy space under a tree not far from the podium. I was so enthused by Martin Luther King's "I have a dream" speech that I had a black and white bumper sticker on my car for many years.

In the summer of 1964, when I spent several weeks in Mississippi helping register black voters, I came to understand this fear of police for the first time. What courage it took for my hostess to open her house to whites.[2] I had bemoaned how society had repressed my black colleagues at Howard most of whom came from the "black bourgeoisie:" the educated blacks in DC who imitated white culture.

1 Women in Washington: Advocates for Public Policy, editor & author of "Women in Development," Beverly Hills, CA: Sage Publications, 1983.

2 My *Letter from Canton* describing those events was widely circulated and a block party I held to raise money for the organizers in Mississippi was featured in *The Washington Post*. I copy the letter in this volume.

In contrast, my students from the Caribbean and often referred to such men as "Uncle Toms." Black leaders of SNCC (Student Nonviolent Coordinating Committee) had often been born in the Caribbean. These cultural differences set the groups apart and differentiated them from the elite blacks who were being employed at white universities and in the government. It took several years before I recognized that women's roles were similarly socially constructed, partly because women held both ascribed as well as achieved status in society. This dual status mitigated the limitations placed on women to accept their roles as mother and wife. Recognizing how socialization represses any individual expression was a critical lesson in my later work trying to understand women around the world.

The civil rights movement's quest for jobs was significantly strengthen when President Lyndon Johnson issued the Executive Order 11246 that required all agencies receiving government grants to post an affirmative action plan for increasing the number of women and minorities in their employ. Monitoring these affirmative action plans became a focus of many women's organizations in DC, including FOPW; my first Congressional testimony exposed the inadequate response of the Brookings Institution!

To my delight, even Radcliffe, my alma mater, began to notice the women's movement. In 1974, I had co-founded the Wellesley Center for Research on Women with the feminist president of Wellesley College. Radcliffe had been awarding Bunting fellowships to women for some time, but these went to women with interrupted careers in any field. Even today, with Drew Gilpin Faust as Harvard's president, the Radcliffe Institute privileges scholarship over feminism and remains wary of advocacy. Still, in 1970, Radcliffe College supported a symposium on Women and Power which I initiated.[1] Then in 1999, at the 50ths reunion of my graduating class, I was honored with the Alumnae Recognition Award.[2]

Political activism in Maryland

In California, I had been active in Democratic Precinct politics, supported ending restrictions on housing, and became a member of the NAACP. As soon as we moved to Chevy Chase, Maryland, I organized our street into a community group and went door to door for signatures on a petition for open housing. Soon, I was participating in a coalition of neighborhood groups and townships who fought against proposed zoning on Wisconsin Avenue that would allow business to build in residential areas.

1 Women and Power: An Exploratory View, proceedings from March 1979 Radcliffe Centennial Symposium, Washington D.C., Mar., 1979.

2 Alumnae Recognition Award citation and my response, which traces my activism to my mother's involvement in women's groups, is included in this volume.

In 1965, I sought another way to influence policy by running for the House of Delegates in Maryland. The state was still using an electoral system that grouped five Delegate seats and two seats for the Senate into a single constituency. Montgomery Country, where I lived, was divided into two constituencies. Thus I was standing, not only in the liberal areas near DC, but in the rural north where conservative Southern Democrats predominated. When our slate lost, I was blamed as the left-wing radical. Indeed, I had compared Montgomery County to a developing country where rural conservatives dominated urban liberals! The campaign convinced me that my strength was in writing and organizing where I need not hedge my views.

Refocusing on international issue

My immersion into Black Nationalism at Federal City College convinced me that I was the wrong sex and wrong color to effect change in that institution. Teaching at the Education School at the University of Maryland was equally disillusioning. My venture into elective politics reinforced my decision to return to academia and to focus on the intersection of US and global issues. So in 1971 I applied for a research grant to study urbanization in Indonesia. In addition to teaching about urban issues at FCC, I had organized a DC-wide faculty seminar that compared the process of urbanization in the US and abroad. This background was pivotal when I became a Professor in the Department of City and Regional Planning at the University of California/Berkeley in 1989.

This trip to Indonesia was also a turning point in my career. Because I was asked by the US Information Service to give several talks about the US women's movement, I interviewed Indonesian women friends about their lives, not just about their careers. How this morphed into founding the field of women in development is traced in Section 2 on *Influencing development policy.*

WOMEN IN WASHINGTON: ADVOCATES FOR PUBLIC POLICY

INTRODUCTION: TWO DECADES OF INFLUENCE

Women in Washington is a celebration of the extraordinary women who have contributed their energies and skills to influence public policy on issues of particular concern to women. Outside of Washington their efforts are not as well known as they should be. The media, when it has reported on women at all, has tended to focus on the controversial and extreme in the women's movement, not on the achievements of women's organizations in the capital. Over the past decade, leaders of the more dramatic and radical wing of the women's movement have been widely quoted, even on policy issues, while women in Washington who have been deeply engaged in changing policy have been virtually ignored. Part of the reason is clearly our mode of operation. Living in Washington is an education in compromise, emphasizing pragmatism rather than ideology, at least when lobbying for a bill or trying to influence the bureaucracy.

Most of the women writing in this book have been working, professional women all their adult lives. Those of us who married continued working and many kept our own surnames. We have used our political and organizational skills in a myriad of political and community efforts. We are less angry than those women who were locked in the suburbs with families and felt used by the system. Our dedication to women's equity comes from our own struggles to be accepted fully in our professional life. In the 1960s, the "queen bee" syndrome was very much in evidence—the attitude among the few women who had high-level jobs that they had struggled and so could we. Today, Washington has the most supportive network of women's organizations of any city in the world. This is the result of the women's movement. This movement has changed our lives and, through the policies we influenced, the lives of women throughout the country.

This book was written by activist women. They define the issues that motivated their actions, analyze their responses, and evaluate their accomplishments. It is for the most part a view from outside government, from women who were active in women's organizations trying to change government policy. There are a few exceptions: Esther Peterson grew to prominence in the labor movement, then accepted appointment from President John F Kennedy to organize the President's

Commission on the Status of Women, in addition to her other duties. A staff member to that commission and later staff director for the Citizens' Advisory Council on the Status of Women, Catherine East played a pivotal role between the government and the women's movement. Fern Ingersoll bases her chapter on interviews with early feminist congresswomen, in which they recall the hostile environment of Congress before it was somewhat tempered by the women's movement.

Many other authors have worked on the inside for short periods. June Zeitlin, an activist lawyer, writes of her efforts to legitimize the issue of domestic violence and institutionalize government efforts to combat it during her inside phase as the head of the Office on Domestic Violence of the Department of Health, Education and Welfare. Mary Ann Millsap presents a study of the long and complex efforts to achieve education equity, a process she viewed as a staff member of the National Institute of Education—but also as a member of women's organizations—and as a graduate student. Arvonne Fraser and Irene Tinker accepted political appointments under President Jimmy Carter, but their chapters report on their activities within women's organizations.

What has been fascinating in editing these chapters is seeing the different interpretations given to the same activities by different observers. Like light diffracted through a prism, the authors lend distinctive coloration to particular events. We have not insisted on consistency. While there are facts about a bill's passage or the formation of an organization, there often is not consensus on the original intent of a piece of legislation or the reasons why a group was established. These different perspectives enhance the value of the book and underscore the fact that the interpretation of history is influenced by the observer.

It is important to state what this book is *not* about. It is not a story of the many women working inside government or on the staffs of congressional committees. In the male milieu of bureaucracies, it is generally difficult for women to play the role of woman's advocate on the job without undercutting their professional standing with male colleagues. As long as the number of women in decision-making jobs in the executive branch or on staff committees remains at a token level, it will be extremely difficult to change bureaucratic behavior and male chauvinist attitudes. The only woman commissioner of one regulatory agency was asked to prepare coffee for her own welcoming party!

As this book shows, however, women inside the government in mainstream positions are crucial to the success of the outside women in affecting policy. They alert women's organizations to changes in regulations, to shifts in policies, to the timing of congressional hearings. They suggest the need for letters or phone calls advocating women's interests. But if they are too open in

their support of women's issues, their effectiveness may be reduced.

Such covert activity is not required of the women working in offices assigned to cover women's issues. Too often, however, such jobs are regarded as second-class by bureaucrats, and ambitious women are warned that accepting such a posting might endanger their careers. All the more reason to recognize the leadership role provided by such women and their offices. For its first forty years, the Women's Bureau of the Department of Labor was the focal point for women in the government. Set up to protect the welfare of working women, its emphasis on protective legislation made it a long-time adversary of the women's organizations seeking passage of the Equal Rights Amendment. This controversy is thoroughly explored by Esther Peterson, Catherine East, and Marguerite Rawalt in their chapters. Nonetheless, the bureau's publications and statistics have provided most of the early data collected on women in the United States. Similarly, materials gathered by the staff of the various commissions on women have proved an invaluable resource for women on the outside trying to influence policy.

Challenges to the Civil Service that were raised by the President's Commission on the Status of Women in 1962 began to open up high-level government jobs to women who had encountered barriers due to stereotyping of jobs by sex. This effort was greatly enhanced by the creation of the Federal Women's Program, which was created as an internal governmental response to the amending of Executive Order 11246 in 1967 to prohibit discrimination against women in the awarding of federal contracts. Thanks to the Federal Women's Program, administered for many years by Tina Hobson, and to pressure from the outside by Federally Employed Women, federal employment of women has grown dramatically. In this story of women and their influence in public policy on behalf of women, these problems of the inside women are mentioned only in passing. They deserve another book.

What are women's rights?

Underlying and subtly pervading all the chapters in this volume is the debate over the elusive definition of "women's rights." Some interpret women's rights as equality for each woman as an individual citizen. Indeed, throughout the last two decades, the thrust of the women's movement has been toward dismantling the elaborate structures of discrimination that limited the types of jobs women could hold and the hours they could perform their work, imposed quotas on entrance to educational and training institutions, and treated women as minors under the law. Changes have often been accomplished through class action suits undertaken on behalf of women as citizens through individual court challenges. By the 1970s, women no longer sought protection or special privilege; they merely

wished to be treated in the same way as men with regard to employment, education, contracts, credit, social security, pensions, and insurance.

To some, this measuring of women's rights against the rights of men has been challenged as trying to make women imitate men. They argue that our laws, our bureaucracy, indeed our fundamental values are prevaded by discriminatory values of the male patriarchy. Only a profound alteration of our entire value system will ever produce the equality sought by the women's movement. In particular, the extreme individualism that characterizes the basic American value system has been criticized as giving too little recognition of social responsibilities. If men were celebrated when they imitated the individual success of Horatio Alger, women were praised for maintaining their responsibilities as housewives. The women's movement, by demanding equal independent individualism for women, neglected to consider who or what institutions would fill societal needs. This aspect of the women's movement has limited the impact of its message on women in developing countries who place a higher value on family roles.

Other women define "women's rights" differently from "men's rights," since women face conditions – such as sexual violence – that men do not. Those defining women's rights in this way believe that women will never achieve equality as individuals unless programs are established that address the different needs of women. Rape

crisis centers and shelters for victims of family violence, for instance, respond to the different needs of women. Demands for special training programs for displaced homemakers, or access to a husband's pension rights, reflect the growing concern of all women for those who chose more traditional roles only to be abandoned by their husbands. These issues touch on the inherent tension in a woman's life: to be an equal person in a male world and to be a female.

In the working world of institutions created by men, being equal tends to mean to act like a man, whether as a carpenter or as an executive. The dilemma of the professional woman is recorded in many chapters of this book: If she espouses women's issues, much less advocates them, will she be perceived as less than professional? To what extent is her support for women's issues mistaken as a demand for more jobs for women to institute or monitor women's programs? In this confusion, the substantive issues—funds for shelters for battered women or credit programs for poor women in developing countries—are viewed through lenses colored by a sense of competition for jobs between men and women.

An alternative to imitating men is to stress female differences. In the early part of the century, efforts to provide protective legislation for women and children were deemed necessary by their advocates because of what was considered the vulnerable natures of women and children. Supporters of the ERA interpreted these same regulations

as limiting women's job opportunities and income.

Perhaps the most important contribution the women's movement has made to this debate has been the questioning of stereotypes about women's roles. By doing so, it has opened up the possibility of choice—not only for women, but also for men. Looking for equitable, rather than equal, patterns for living and working is a task for the rest of the century.

For Whom Are Women's Rights?

The American women's movement, like the suffragist movement, has been primarily the result of intense activity by middle-class white women. Both movements have had as their goals greater rights for all women. The Equal Rights Amendment, when passed, will finally make women equal citizens, a process that began with the demand for women's suffrage. Many issues discussed in this book—rape, family violence, health care, and access to education, training, and employment opportunities—affect all women regardless of age, race, income, or national origin.

Some of the chapters describe efforts to serve the most disadvantaged women. It was concern for women working in sweatshops and factories that prompted labor union women to oppose early efforts for the Equal Rights Amendment, since the amendment would have wiped out protective legislation specifically designed to protect working women. Two groups discussed in this volume, Wider Opportunities for Women and the National Commission on Working Women, reach and involve pink- and blue-collar workers, assisting and supporting them in the search for job opportunities in nontraditional areas. Two of the case studies trace the efforts of Washington women to change government policies to benefit primarily low-income women. Women-in-development professionals, in conjunction with the National Council of Negro Women and many church-related groups, are seeking a shift in international development assistance so that at least some aid programs reach the incredibly poor women in developing countries. The efforts of the National Coalition for Women in Defense emphasize opening up a greater variety of job categories in the military, particularly to noncommissioned women.

Some chapters focus on issues of concern to a distinct occupational group of women: business owners, scientists, and college professors. While it is true that such women are likely to be drawn from the middle class, by comparison to men in the same categories they clearly face discriminatory practices in their professions.

Minority women have been involved individually in the many organizations and movements described in this volume, and minority women's organizations have been involved in many coalitions. Black women have long been organized; representatives of their major organizations, like those

of Catholic, Methodist, and Jewish women, have frequently testified on Capitol Hill in support of women's legislation. Asian women's groups have been particularly active on educational equity issues. Hispanic women were first mobilized on a national scale in the early 1970s with the creation of the National Conference of Puerto Rican Women, the National Mexican American Association, and the National Association of Cuban American Women. Preparations for the First National Women's Conference, held in Houston in 1977, brought increased mobilization and coalition building among minority women. In the future, the views of these minority groups will be increasingly important to the women's movement. Like the many other women's groups in Washington, they support issues and coalitions that are consistent with their own priorities, and bypass those that are less important to their membership.

Minority women's groups, along with the organizations representing the concerns of low-income and rural women, have given depth and diversity to the women's movement as it has influenced policy in Washington. They have added new vibrance to the kaleidoscope of changing patterns clustered around a variety of women's policy issues. It would be difficult to record all the groups and impossible to list all the players. This volume is a beginning. The chapters speak for themselves. It is truly an impressive story.

CONCLUSION: STRATEGIES FOR THE EIGHTIES AND BEYOND

Women in Washington have been extremely successful in raising a number of women's rights issues to national prominence. Even legislation not passed and regulations not implemented serve to mobilize women, to provide material for the press, and to catapult issues onto the national agenda. The Reagan years have been a time of regrouping, for struggling to hold onto previous gains, and for considering policy options and strategies for the rest of the century.

STRATEGIES: The strategies adopted over the past two decades have reflected both the growing strength of the women's movement throughout the country and the shifting concepts of appropriate governmental action.

The early 1960s witnessed growing federal dominance in the governance of the country. Small groups of women, working cooperatively with legislators and committee staff, were able to add women's concerns to a broad range of legislation, from civil rights to educational equity to international aid policy. Similarly, women utilized the regulatory process and judicial review to achieve equity in implementation of the laws. Executive orders were another weapon in the fight against discrimination.

As the movement grew, women's issues became more visible and controversial. Forces supporting and opposing women's issues grew in number. Marches and confrontational politics

dramatized the differences between the women's movement and the New Right on such issues as abortion and the Equal Rights Amendment.

Toward the end of the 1970s, grass roots groups concerned with women's health, the plight of battered women, displaced homemakers, among other problems, brought their demands to Washington. They remained skeptical of and often angry at the women here, seeing us as establishment women, out of tune with life outside the capital and largely unconcerned with issues of the disadvantaged. In turn, many Washington women saw these grass roots groups as politically naive and unwilling to compromise in order to achieve at least part of their goal.

Reagan's victory at the polls in 1980 ushered in a period of financial stringency as well as a return to policies based on conservative stereotypes of women's roles. The last few years have been characterized by the collision of women's expectations and the growing unwillingness of either the legislative or executive branch of government to provide funds for women's programs. As a result, grass roots and professional women are drawing closer together and devising coordinated strategies appropriate to the current political context.

The issues raised by the burgeoning women's movement have increased markedly during the last two decades. From issues centering on conditions, training, and pay of working women, we have moved to attack discrimination against women on a broad front, from

pensions to education to business to science and to championing the Equal Rights Amendment. Unequal treatment of women in the health system and by police produced powerful grass roots movements that provided havens for battered women and support groups for women seeking alternative health care.

Following the precedent of the UN World Plan of Action for International Women's Year, the range of issues championed by women enlarged considerably at the First National Women's Conference, held in Houston in November 1977. Grass roots activists, housewives, professional women, and policymakers, women from traditional organizations and from a myriad of new groups passed a National Plan of Action that went beyond issues arising from inequities for women to broad societal issues affecting all people. Thus, the plan includes recommendations relating not only to abortion but to national health programs, not only to employment rights of women but to peace and world disarmament.

Even among feminists there is debate over this strategy. The disagreement does not relate to the right of women to take stands on general national issues, but rather concerns the question of whether a women's conference is the appropriate forum for such broad issues and recommendations. Those who favor broadening the spectrum of issues on which women take a position argue that women have as much right as men to declare their stand on fundamental issues. Those who argue that women's

meetings should focus on issues germane to women suggest that if women wish to take part in a wider political debate, they should do so in a forum where their opinion and vote may have a direct impact. They also argue that limiting discussion to women's issues allows participation from a broader political spectrum and so strengthens subsequent lobbying efforts.

National reaction to these various clusters of women's issues has also varied. Women's rights to employment and educational equality were hard to deny in principle, but they continued to be subverted in practice. Occupational segregation has perpetuated lower pay for women: Today it is 59 cents for women to every dollar for men. As the economy worsened, affirmative action also came under increasing attack. Nonetheless, the gains have been enormous. Issues relating to the family have roused more opposition from the New Right than have the economic issues. The ERA, in particular, has become the symbol that divides feminists and conservatives.

Analysis of the 1982 elections suggests that women are translating their beliefs on both women's issues and societal concerns into votes. More than anything, recent elections in this country have demonstrated that there is great diversity among women's views of themselves and their lives in a society still largely dominated by men. But elections also show that many women are dissatisfied with the status quo,

and therefore continue to represent a potent force for change in the country.

TARGETS: Throughout the period covered by this book, whether small groups of women were seeking change on narrowly drawn issues or large organized groups were working on a broader front, the targets have been all three branches of government.

Many of the chapters focus on the passing of legislation, because changing the law of the land is the most visible method of signaling a shift in national attitudes. But shepherding a law through Congress is only the first step in a long process. Monitoring the executive branch as it considers how to institutionalize the new law within the bureaucracy and as it issues implementing regulations to be followed by the general public is a tedious process, lacking the glamor of lawmaking but necessary if changes are to be effected. The judicial process can also take years, as cases move slowly through the hierarchy of the courts. New administrations usually alter governmental positions, requiring the process to start. afresh. The intent of the law is a critical factor in the issuing of regulations and of judicial challenges to its implementation. For this reason the legislative history, including records of public hearings as well as committee reports, continues to be important long after the bill is passed.

Although the Founding Fathers gave the right of lawmaking only to the legislature, the executive and judicial branches implement and interpret the laws through executive orders—such

as Executive Order 11246, as amended to cover women—through regulations such as those giving greater access to sports for women and girls and through court decisions—such as that on abortion rights. The monitoring of each of these phases of policymaking requires particular skills. The expansion of women's groups in Washington is a logical result: There are independent groups that specialize in law, lobbying, research, and consulting; there are coalitions of professionals, trade associations, religious groups, and women's organizations; and there are formal and informal networks of women that connect these outsiders and tie them to the insiders. Influencing policy in Washington today is a full-time occupation for many women.

Much of the activity described in this book, however, has come from the effort of volunteers. Two decades ago women's major resources were their enthusiasm and their time. Women's groups working in Washington still have limited resources, but their skill and dedication often result in influence far greater than their slim resources might indicate. Of course, one reason for this is the continued voluntary support women and men give to full-time policymakers.

Throughout these chapters, euphoria over bills passed gives way to the drudgery of monitoring implementation. Under the Carter Administration, many departments included a significant number of women political appointees from the movement. Ironically, women activists found that friends in high places can make action more difficult: Even supportive women inside could not always deliver, but attacking them is often impossible. As a result, activists are more conscious of bureaucratic constraints that affect friend and foe alike. Access to the executive branch that led to the appointment of women has disappeared under the Reagan Administration. Most of the Reagan women appointees are drawn from conservative circles not sympathetic with the goals of the women's movement.

Members of Congress sympathetic to women's issues are playing a critical role in turning back many of the Reagan Administration's attacks on women's programs. For the time being, lobbyists on Capitol Hill admit that the best they can do is to save programs from destruction; it is, unfortunately, a time of reactive politics.

TACTICS: Wide divergence among authors is evident as to the style women should project when trying to influence policy. Do you appear ladylike, or aggressively confrontational? Do you argue rationally with a male member of Congress or approach a wife or daughter to influence the vote? Do you maintain ideological purity, or succumb to compromise? Do you alert the media that the bill is your idea, or do you hide your issue within other legislation? Do you work for consensus before pursuing an issue, or make decisions simply by parliamentary procedure? The choice of approach is highly personal and reflects the age and training of women activists.

Should groups organizing on women's issues be open only to women? The Congresswomen's Caucus initially based its membership on sex, although not all women members joined. Even so, members found that they had little common ground. In 1981, it became the Congressional Caucus for Women's Issues, with male as well as female members and greater cohesion of viewpoints.

Bureaucratically, the wisdom of separating women's concerns from mainstream issues is raised when special offices or programs for women are proposed. For years the Women's Bureau in the Department of Labor was the only agency of the government charged with looking after women's welfare. Does the existence of such an office mean that no other part of the government need be concerned with women? But if there is no advocacy office, will any other part of the male establishment pay attention to women at all? The same issue of separation or integration arises in programs designed to benefit women. In this book, some authors argue for one tactic or the other. Their choice seems to be related both to bureaucratic ambiance and to the issue at hand. Others argue the need for both tactics—one to take the heat off professional female staff and the other to influence major programming.

Employed women have clearly been disadvantaged. Does this mean they should share in governmental programs that redress past discrimination? The relationship between white women and minority women is mentioned in several chapters. Particularly critical was the debate over including white women business owners under regulations designed to provide contracts for minority firms.

Throughout the decades there has been a trend toward seeing women's issues in a wider context, one that does not set women apart or relegate women's programs to the margin. At the same time, women have demanded and secured an increasing number of women's program offices in government agencies and caucuses in professional associations and labor unions. Increasingly, women's membership groups have opened their rolls to men; but it is still predominantly women who work for women's issues. Organizationally, women's groups now encourage leadership but try to avoid hierarchy. Stylistically, women find no conflict in adopting more feminine clothes while at the same time rejecting the idea that a women should never appear aggressive. Tactics can be alternated or combined, it seems; debate over them is invested with less emotion than over strategies or over the substantive issues themselves.

Toward The End Of The Century

Palpable optimism pervades this book. Many of the authors believe a new administration would immediately implement the women's programs they describe. Others stress the importance of building constituencies throughout the nation. Still others are convinced that a

political strategy must replace the lobbying and organizational strategies as the primary method by which women attain their goals: They want more and more women in elective offices at all levels of government. Whatever the strategy, women see the Reagan years as a pause in the move toward greater equity.

Such faith in the future is strengthened by the apparent move of the United States from the industrial to the communications age. Elsa Porter, among others, pointed out that the management skills needed in this new era match women's attributes in interpersonal relationships, and this should open up many new opportunities for employment at all levels. A more pessimistic view is put forward by women scientists, who note how young women are still being counseled out of math classes and thus will lack needed preparation for the new era.

Whatever the new era is called, it is obvious that we are in the midst of a radical change in life styles and work opportunities. The women's movement itself has spurred the questioning of dominant American values, particularly the deeply ingrained stereotypes of women's appropriate roles. This self-examination of the basic institutions and values of the country provides an important opportunity to alter prevailing attitudes toward women.

In Washington, it is also clear that fundamental realignment of power is occurring within the national government and between the federal government and state and local governments.

The strategies and tactics described in this book were devised during a period of federal support for social programs that were designed to spread the good life more equitably among Americans. In a time of great prosperity it was not too difficult to argue that women should benefit fully from these programs.

Women affecting policy during the 1960s and well into the 1970s worked primarily from the outside. From a handful of women operating essentially as loners, women involved in policymaking in Washington have come to number in the thousands. They work in women-only groups, but also in trade unions, professional associations, and corporations. Their efforts are recorded and supported by a myriad of women's newsletters and magazines, as well as coverage in the media. In other words, women are now an accepted and important part of the policy-influencing community in Washington.

For the future, is this sufficient? Many think not. If government power continues to be decentralized, the role of state and local legislative bodies will increase in importance. If federal regulations and guidelines continue to be curtailed, then pressure to alter, for example, health care must be applied directly to hospitals. And if more and more health care facilities are privately owned, what are the implements for ensuring adequate care for the growing number of elderly women? Activists will have to work not only at the state and local levels but on private institutions

as well. They will have to diversify their activities without diluting their efforts.

The answer is power: the power of the press, of consumers, of voters, of research, and of pressure from all of them. These are the powerful tools of the outsiders, and the ones we women have been learning to wield with great skill, not only in Washington but around the country. The new strategy for the 1980s is to get more women inside. This means redoubling efforts to get women appointed and elected to executive and judicial posts at all levels. But most of all it means electing women to Congress, to state assemblies, and to municipal councils. Elected women have access to resources far beyond those available to outsiders. They have office staffs and newsletters; they have access to the government, corporations, and the press. More women in legislatures across the land will help balance the inside-outside network, and insiders and outsiders together will continue to affect government policy toward greater equity for women.

LETTER FROM CANTON, MISSISSIPPI - 1963

AROUND CANTON THE FLATS OF THE Mississippi Delta stretch monotonously in all directions. In August the heat shimmers across the ripening cotton fields. The landscape was deserted though in the distance billows of red dust marked clearly the path of a car churning along a back road. In contrast we sped smoothly along the new interstate highway which cuts to half an hour the 25 mile drive from Jackson north to Canton. There were seven of us packed into a rented Falcon, six adult volunteers for the Mississippi Summer Project and our driver, a Polish student from Brooklyn who had been down all summer. Public transportation is risky, he said. Last week some ministers went to Canton by bus and were met by a mob of a hundred whites. When they did try to leave in the cars of two Negro housewives, other cars blocked them front and back and kept them pinned in an alley for nearly three hours. The mob, like the housewives, had expected the ministers: all phones are tapped. So were we expected; advance notice is necessary to keep volunteers from disappearing. Should we be stopped for any reason, the car was equipped with a two-way radio so that we could notify headquarters where we were. These precautions made us tense; our nervousness, combined with the heat, made us all sweat; yet we drove with the windows nearly up...for security.

When I first heard about security regulations, lolling in a beach chair around the pool at the Sun-N-Sand Motor Hotel in Jackson, I wondered whether the old-timers were not trying to overawe the new volunteers. Up to then, at the airport, in the limousine, at the motel desk, Jackson had displayed its polite Southern charm. But later, when I paid my dinner check, after sharing a table with a young Negro volunteer, a pretty college freshman, my change was slapped down without a word. Grudgingly, the Sun-N-Sand has opened its restaurant and rooms to Negroes, but not yet its pool. There has been no "swim-in"; Mississippi has greater problems than a segregated pool. Even the fact that restrooms for the employees are still separated has not deterred the Sun-N-Sand from becoming a sort of headquarters for incoming adult volunteers: Jackson doesn't offer much choice.

The motel is only two blocks from the offices of the National Council of Churches (NCC), and of the lawyers' and doctors' volunteer groups. All three groups recruit adults to help the student volunteers and the young staff of the

project. NCC is in Mississippi because it is "committed to the cause of equal justice as a principle of the Christian faith." To help prepare the students for their Mississippi summer, NCC sponsored the two week-long orientation sessions at Western College for Women in Oxford, Ohio, and continues to run, and pay for, the orientation of the continuous stream of adults and students coming to Mississippi to help.

The Sun-N-Sand faces toward the new complex of state buildings, all gleaming white. But back behind the six-foot wooden fence, across a weedy space which is a road on the city maps, starts shanty town. The sidewalk cracks and buckles; the water from a sudden cloudburst was captured into pool in the clay soil. The narrow, wooden houses looked like trolleys up on blocks, for they were all raised off the damp ground by concrete blocks or bricks. Many homes were brightly painted and surrounded by grass and flowers; others were rotting into the sea of mud. All did have one thing in common: a front porch. From them grandmother and toddler, man and woman, watched curiously as well-dressed whites walked back and forth from the motel to the Negro business street. NCC's offices were over a store, and next to a funeral home.

Forty-four of us crowded into these offices for the Monday orientation. I was wedged in between a Methodist minister from San Bernardino, California, who said his church fully endorsed his coming and had paid his way, and a Baptist minister from Mapleton,

Minnesota, down on a week's vacation and due back to perform a Saturday noon wedding! The number of women, nearly a quarter of the group, surprised me. Most looked like earnest Mid-West women you would expect to find behind the counters at a church bazaar. It turned out that they were either minister's wives or professional church workers. One attractive young girl from Wilmington, Delaware, was driving to Texas for her vacation, and decided to take a week of her leave in Mississippi. This fact was announced in the local papers, she said, and for the three days before she left she received so many crank calls both at the church and at home that she had departed earlier than she had intended.

The only Negro woman among us was a professional singer, especially of spirituals; she had only recently returned from two years of missionary work in Ghana. "You know," she said in a jovial voice which rolled across the room, "Mississippi is still like a colony. They kept asking me in Ghana, 'When are you going to get your freedom?'"

One of the three Negro ministers was himself from Mississippi originally, and he had come South to go to his own hometown to preach non-violence. He told me later that he had been appalled at the state of siege he found. Everyone had arsenals; his own father drove with a pistol strapped to the car seat. The young men were getting restless, especially after the passage of the civil rights bill wrought no changes downtown. The minister, himself, along with two white

companions, had been refused service in a restaurant which clearly catered to interstate trade. So frightened was he at the specter of an explosion that he contrived to stay much longer than he had intended. Indeed, the needs of Mississippi are so clear that many ministers, and students, become repeaters. It even affects families; two couples had come because their children were already in Mississippi as student volunteers.

While all denominations affiliated with the NCC sent ministers during the summer, nearly half the volunteers that particular week came from the Disciples of Christ. There were a rabbi among our group, and two Catholic priests had been expected. The Catholic Bishop of Mississippi, however, had announced that no out of state priests or nuns would be welcome. The power of the hierarchy of the Catholic church, which contrasts with the dominant power of the congregation among the Protestant churches, made this order important. Instead of joining us, the two priests decided to become "tourists" and visit the several Freedom Houses around the state without their collars on.

Rev. Warren McKenna, Director of the NCC Summer Project, is a slight, dark-haired man who was on leave from his New England church. He and the permanent staff member of NCC, Rev. Arthur Thomas, are both Episcopalian ministers, and to see them driving their sports cars, one would not believe they belonged anywhere but with the Establishment. When one of the ministers kidded McKenna about his

MG, he retorted that he should know it takes two generations to support an Episcopalian minister!

Perched on his desk, so that he could survey this new batch of volunteers McKenna looked a good deal less ministerial than most of the new arrivals. "You will find," he began, "that NCC gets all the credit, and damnation, as a trainer of saboteurs. Some people even think we started the whole summer project. I wish we had! In fact we only service COFO (Council of Federated Organizations.) COFO is made up of SNCC (Student Non-violent Coordinating Committee), CORE (Congress on Racial Equality), NAACP, and SCLC (Southern Christian Leadership Conference)."

I was surprised when one minister stopped McKenna to ask what Snick and Core were. It became clear that few of the ministers had had any contact with civil rights groups before that had come to Mississippi. They had come out of a moral conviction that it was the right thing to do. It seemed that they hoped to carry back to their congregations experiences which would help their church understand and face the racial crisis.

By now the room was so packed that the air-conditioner strained and clanked trying to keep down the heat. McKenna's soft voice barely carried across the room. "We have here in the Freedom Movement eight or nine hundred of the finest people, the best kids, in the country. They are non-conformists; like you, they have gone through

a lot just deciding to come. They are idealists and have come to help. It is hard for them to understand why the ministers are here, for they have stereotypes of the church, the white church especially. Now some ministers don't know what they are doing here either. I know many of you have wished you didn't have so much administration to do, didn't have to hold committees, go to meetings. Sometimes you have felt you don't have time to do what you were ordained for. Well, here's the chance to try. Let me warn you, many of you will find it a most frustrating experience. You will be used as chauffeurs, or errand boys. If you can fit in, then you can participate. What you can't be is a minister-counselor. You can't just arrive and say to the Project, bring us your problems."

At this, an embarrassed laugh fluttered across the room. "You must be a part of the program," he reiterated. "We have found that some ministers can't relate to the young people, and are rejected. You must remember they are here to instill democracy in the state. They are super-democrats; they want to argue out every problem to consensus. Yours will at best be just one more voice."

Two young Negroes arrived in the SNCC uniform of jeans and T-shirt. Somehow a space was cleared in the center of the room for a demonstration of non-violent techniques. Arthur Cotton, who wore a red paisley print kerchief around his neck, began bluntly. "Once you've been attacked, you've lost half the battle. You must not let yourself

be victimized. Try to sense the mood of the adversary and change it. You remember how it was when you stole a cookie from your mother's cookie jar: you had a defense ready. Now for instance, one time when I was in jail, I saw the guard had a leather strap six inches wide and three feet long. There were some flies in the cell. I concentrated on them, playing with them, catching them." His hands cupped the air; we all looked for flies. "I ignored the man, and he went away."

After a moment, he continued in a strong, earnest voice. "See, for a man to hit you he has to dehumanize you first. You must try not to let this happen. This is the psychological reason for an argument, so the opponent can convince himself you are not a man. You must not react to insults. But if all fails, and you are hit...Jim, you be the attacker." With that James Travis pretended to hit Cotton who cupped his two hands before his face, fell sideways to the floor, and curled into a fetal position but with his ankles crossed.

"You must fall, and fast," Jim drawled. "The rabbi that was hurt in Hattiesburg, he didn't hit the ground. Thought he could talk, have a dialogue. Last Friday a minister was beaten in Carthage. He was hurt more than the volunteer with him because he was knocked out as he fell and couldn't curl. You know where he was hit? In a clinic. He was trying to get the doc to treat the volunteer who had an infected foot. Now you wouldn't expect that, would you?" He stopped and looked slowly around

the room. "One thing you gotta' keep in mind. You are no longer in the USA, you are in Mississippi. Down here you got only two rights: to keep quiet, and to stay healthy...or to open your mouth and take what they give."

Cotton, deciding he'd been on the floor long enough, got up and contradicted Travis. "No, you are in Mississippi, USA, but you're no longer the white middle-class that you were before you came. The red-necks call all the white volunteers 'low class niggers'. "Another thing to remember," Cotton said, "is that until the last eight months, the violence came mostly from the police. If you are arrested, ask for your phone call. They may feel like giving it, and they may not. You should call Freedom House and they'll send a lawyer. You can't be held over 72 hours for investigation. You should answer questions if they only involve you. Don't lie, but don't answer other questions."

At this point the two boys acted out a mock arrest. Among the questions Travis fired at Cotton: "What color are you; what color is Bob; are you part of the Communist bloc?" Cotton's evasive answers were polite and innocent: "I don't know; whatever you say." The interview ended with a beating.

Then they answered questions from the ministers. "No, don't run. If you do you've defeated your reason for being here, and if they catch you, you'll get it worse." "When you see someone being beaten, fall on them to take the blows when you see they've had enough. Fall on women right away." At that remark,

a young blonde woman asked in a trembling voice if women could expect the same beating as men. Travis remarked hoarsely, "They no longer consider you a woman."

Incredulity was the dominant reaction to the boy's message, as if they had been playing for the galleries. But McKenna's quiet voice confirmed their words. "Five or six people are beaten every week," he reminded us. He then introduced us to our protectors. Three different, and to some extent rivalrous, groups of lawyers were operating out of the same building. The peculiar province of minister's defense was theoretically left to the Lawyers for Civil Rights, one of the professional committees set up by President Kennedy. Since ministers were normally arrested with other volunteers, the actual scope of this group is uncertain, and its activities unimpressive. But the very existence of this high-powered group in Jackson was nevertheless important. The most active lawyer's group is that specifically set up to help the Mississippi Project by the American Civil Liberties Union, the NAACP Defense Fund. This group, the Lawyer's Constitutional Defense Committee, keeps ten or so lawyers on tap all the time. The Lawyer's Guild, first of these groups on the scene, seems now generally eclipsed by the LCDC with whom they cooperate.

A tall, gangling doctor told us of the tentative nature of their doctor's program. Since the doctor volunteers are not usually licensed to practice in Mississippi, they were spending their time

compiling information on the need for permanent staffing, on the problems of public health and the difficulties of volunteers and Negroes in receiving good medical treatment in the state.

We were sent off to lunch in shifts. Volunteers down for less than two weeks were assigned to one of the special minister's projects in Hattiesburg or Canton where all worked on voter registration. Only those down for over two weeks were assigned to regular projects. While McKenna got on the phone to arrange transport and to warn the different centers of our coming, we listened to a tape of a speech given the students in Oxford. Vincent Harding, himself a Negro minister in Atlanta, was talking on the History of the Negro in the United States, "Slavery is responsible for the basic contradiction in our nation. It set as indelible a mark on our life as did Puritanism or the Frontier...It gave a split personality to our churches. At least one slave ship was named *"Jesus"*. When he began to talk of Mississippi his words commanded full attention. "There is bitterness in the Negroes against the White Man," he said. "It is a dangerous generalization, as calling people "red necks" or "niggers". Still you are the white man. They will meet you with mixed feelings. When you come with articulated ideas, with all the answers on the blackboard, one through ten, they will hate you."

McKenna echoed his words, as he sent us off. "The staff is mostly Negro. They have done great work as loners. They've been beaten and ostracized for a number of years. This has made both Snick and Core into tight-knit groups. Now hundreds of affluent white students come. There is bound to be a conflict. Also, these people have worked down here for years. Yet it is only when the whites come that publicity and protection come too. They can't help but be a bit resentful. At one meeting a Negro minister told me, I will hate you this summer, but forgive me."

Then we were off, driving in the heavy afternoon heat, still not quite believing, not quite absorbing all that we had been told. But the Canton project radiated emotions; love and hate, fear and courage. Drawn into the group, we were no longer audience; we were on stage.

Freedom House had been shot at the night before, and everyone expected a second raid that night. A red Chevrolet kept circling the block while its six hefty occupants leered at the COFO girls. They were all beefy men, with pasty complexions which flushed red under tension. A white Ford joined the harassment. It held three red-necks and three equally puffy middle-aged women who stared at the volunteers as though they were monkeys in a zoo.

The licenses of the cars were duly posted on a list near the phone along with seven others. We were told to beware of those cars when we were out working and to hide if we were walking or be ready for a chase if we were in a car. Even more dangerous were unlicenced cars; they were looking for trouble. Again we were told not to expect

any protection from the police. In fact it is hard to know who are police, for like the old frontier, a sheriff may deputize almost anyone, and does. So any one of them could arrest any one of us, we were told. And they frequently do. Just being in Freedom House makes one liable for arrest since it is illegal in Mississippi to advocate any change in the political or social structure. Arrests become arbitrary; the police became the enemy .

Suddenly wary of Mississippi cars, I braced as a black car pulled up in the vacant lot next door. Later I learned that most COFO cars are rented; out-of-state tags are too obvious, and after a month they are illegal to use. In this car were the volunteers who had just been bailed out by the LCDC lawyer. A rabbi, two white girls, three white boys and a Negro staffer had been picked up Saturday morning for possessing registration forms for the Freedom Democratic Party. By the time bail was arranged the town's attorney managed to be out on a picnic, so the group spent the weekend in jail.

One of the girls arrested, Martha Wright, a shy young woman with pale, freckled skin and dark auburn hair, told of going on a hunger strike because the jailors would not give them any utensils to eat with. "It was a bit hard to down gruel with your fingers," laughed a hefty youngster whose grubby T-shirt was the only indication of his jailing.

Like most of the Negro homes in Canton, Freedom House had two front doors, a convenient hedge for the owner who could then rent it to one or two families. On either side were three rooms, one behind the other railroad fashion, the rear room fitted as a kitchen and having a back door which led across a tiny backyard to a storage shed. COFO rented the entire house and had blocked various doorways to cut the traffic. Only one front door was used, and this led into the office, where two phones were in constant use. A brown haired girl with serious, dark eyes handed us forms to fill out. She and another white girl were CORE staffers and had been in Canton since January setting up the office.

Most of the students sitting around in the adjacent front room were summer volunteers. A projects meeting was regularly scheduled at four on Mondays, and two students from each satellite project were there. The largest group were Freedom School teachers from the seven centers out in the "rural", and the two in town. All the teachers were white, as indeed were most of the thousand volunteers who participated throughout the hot summer months. There was a constant flow of adult short-term volunteers, mostly ministers, and one major wave of additional students in early August.

Of the original seven hundred students, only forty were from Negro schools with Howard University contributing the largest block of fifteen students. Among the white students, the largest number came from the Harvard-Radcliffe complex with Stanford taking second honors. Girls predominated as teachers since voter registration was generally the boys preserve.

But most Freedom Schools, especially in the towns, had at least one boy for safety. Schools were designed for junior-senior high students, and during their week of orientation at Oxford, Ohio, the volunteers were given materials on Negro history, the Mississippi power structure, national politics, etc. suitable for these grades.

No two schools attracted the same age group; in fact few schools attracted any students at first. The teachers found it necessary to scout the neighborhood to recruit students. At the Pleasant Green Baptist Church the volunteers taught about fifteen regulars, but there were a few more than that on the rainy day I visited their school. The classes were held in the single room of this small, white clapboard church in the middle of Canton's Negro district. Pete, one of the teachers, was just finishing a discussion of headlines, and a lad of ten was asked to point out Vietnam on the map. Then Sue, another of the teachers, read a portion of a letter from Martin Luther King and tried to draw for the students an understanding of the words. To encourage discussion, they split into two groups; six high school freshmen boys were in the older one; the larger group had girls and boys down to eight years old.

I asked Joe, a bright boy who outshone his classmates, why he came to school. "To learn about things they don't teach us in school." he replied. "There's forty-five or fifty kids in a class and even with the old, beat-up desks from the white schools, there's not

room for us all to sit. And them books we get are second-hand, and nothin' about Negro history. Now in the white schools there's only twenty-five kids in a class. They've lockers, but we don't. Ain't got no physical education either."

Joe didn't say this in resignation, but in anger; it wouldn't surprise me if he were one of the Negroes who tried to attend the white high school in the fall. He is not only bright, but a leader. "We had a boycott last spring; two thousand of us stayed out. The Board of Education said they'd take away teachers and equipment if we didn't came back; everything's based on the number of kids. And the principal (great disdain) made us come in with notes from our parents saying we wasn't to try that again." The boycott concerned the milk contract for the school cafeteria; the company which traditionally provided the milk had a very poor record for hiring Negroes and the students were protesting the renewal of the contract under the federal school milk program. After the boycott proved unsuccessful, the students simply refused to buy the milk, and cartons of milk spoiled.

Students in the rural, who met in an abandoned school house up a dusty road behind Flora, were less politically astute, but were also less hostile. In such isolated areas the impact of the schools was more obvious. Enthusiasm was so strong that classes had been shifted to evenings so that the parents could come too. Joanne Ooiman, a Denver girl going on to graduate work in history, taught the adults while a

cheerful redhead from Oregon, Sandy Watts, took on the assorted children. They lived with a local Negro family and so had been completely adopted by the community. Their major complaint was the cloud of bugs they attracted every night, for the windows had no screens. When they began the school, the windows were all boarded, and it was unbearably hot; now it was cooler, but buggy.

Two other rural schools were copying Flora and setting up evening classes in churches, both of which have since been burned. In town all projects stopped at dusk. Security required all volunteers to be home by dark, and stay there. Bombings were too easy at night, and no congregation in town was willing to risk its church by letting volunteers use it at night. This fear sharply curtailed the activities of the community centers of which Canton had two. The least structured of the projects, the centers, varied in programs and in success. All the centers had libraries amply stocked with donated books, heavy on college texts and parallel reading, but lacking in children's books or Negro novels.

Two of the adult women volunteers in Canton when I was there spent much of their time unpacking and cataloging the cartons of books inundating the small library room in one church. Guitar lessons were given to teenagers, and Sally Shidler, from eastern Washington State, used her portable typewriter to teach typing to a class of girls. One girl had been especially gifted with children and had a nursery group every

morning; when she left after five weeks the class melted away. There had been hopes to use the centers for adult lectures on child-care or citizenship or literacy, on a year-round basis, but the inability to meet at night has forced the volunteers to improvise on daytime activities for whomever comes.

This unwillingness of churches to open their doors at night has also resulted in a new project in many areas, that of building a Center. Harmony, near Carthage in Leake County, has nearly completed building their own Center. Harmony is a filling station and a cluster of churches three miles out along a dead-end country road. The houses spaced along the road look more like suburban homes near Jackson than like the typical rural shacks set up on concrete blocks off the damp earth. These Harmony homes are ranch style with brick or concrete bases. Many of the farmers of this slightly rolling terrain own their land, a fact that allows them to be more independent of the whites than the town folks and puts them on an economic plane with many poorer red-necks. Harmony lives up to its name; some years back they built a school and turned it over to the Board of Education in return for a teacher. Three years ago the building was closed, as a result of school consolidation officially. Mr. Johnson, one of the carpenters working on the new Center said the Board closed the school because "we had a good thing going. Lots of our children go on to college. They didn't like that, so they closed it." Now with

a court order to desegregate the County, there is talk of reopening the Harmony school to continue de facto segregation.

Meanwhile the school building at Harmony stood vacant. But the Board would not release the building to its builders: the Freedom Schools attracted so many students that the churches couldn't hold them, so the community undertook a second building, this one for their own use.

We drove up from Canton in an hour and arrived at noon. Under two large shade trees tables were set up; the women of the community were feeding all comers: the men hammering and sawing on the Center, the volunteers and their students from the Freedom Schools, the voter registration boys, and our carload from Canton. Fried chicken and corn bread, beans and tomatoes, Jell-O salad, kool-aide, cake or pie was the menu. Balancing the paper plates we sat on tree trunks or upended boxes and chattered with the kids. Two of the volunteers were comparing their experiences in the Peace Corps in Nigeria with their Mississippi stint. Remote as Harmony is, they felt many parallels with their Nigerian village. "It's in the cities that the difference gets you. You can feel the hostility welling up against you here if you walk down a street with a Negro. It's like a colony here, only the Negroes aren't yet fighting for their freedom, not enough. In Nigeria, much of the press for independence came from intellectuals and politicians in England. We've got to do the same thing up North; bring Mississippi into the Union."

I climbed up the wooden plank to the floor of the Center some three feet above ground. The men had resumed their work on the roof but the hot sun beat down into the Center where a large room would act as auditorium or hall. In the back was space for a library and lavatory while two smaller rooms flanked the front entrance. Mr. Johnson proudly showed me around. "You know, we have to guard it every night. The red-necks came out and stare, and hate. But I don't think they'll try anything. It's a long way back to the highway. Non-violence is all right from you people, you don't live here. Non-violence to us is just takin' and takin'. We've had enough. Next time we'll give as good as we take."

The volunteers from Canton had come to Harmony to help set up a farmer's meeting. They were part of the team investigating federal projects to find out whether federal funds were in fact being used without discrimination. These students had spent two weeks in orientation and seemed particularly well-trained. Around Canton they had encouraged the independent farmers to form an association and they had requested the various federal agencies which have programs for the farmer to give talks on the services of their agencies. Cooperation varied. The old-Mississippian who headed the FHA came easily, convinced that times were changing and he had best learn to change too: but the younger man who headed the Soil Conversation Service came only out of fear of losing his job.

Sharon Anderson, an intense blonde, was elated over the meeting. "Both men were clearly impressed with the dignified way the meeting went. You knew they had never been to such a gathering before. "Bill Carney, a co-worker, was more explicit; "The Soil Conservation man was so scared, his shirt was wringing wet from sweat. All the Negro farmers looked neat and cool." The local agent of the Agricultural Stabilization and Conservation Service agreed to come to a later meeting but was warned against it from a superior. Most adamant against any co-operation was the white County agent of the Federal Extension Service. He even ordered his Negro County agent not to have anything to do with the new group. Faced with this blatant opposition, contrary to administrative directives, the Federal projects volunteers began to follow channels upwards. Washington took interest; a phone call from the Civil Rights Commission was the morale booster of the week. Mike Peori, the Harvard graduate student who directed the unit, is now quietly confident that the new Farmer's League will survive and perhaps even elect a member of the very important committee of the Agricultural Stabilization and Conservation Services.

Less successful have been the attempts of the Federal Projects unit to investigate complaints of discrimination. Unusual in the South, Canton has a public housing scheme; it has two sections across town from each other. Local officials deny segregation; no whites apply to live in the Negro section and no Negroes dare apply in reverse. In cooperation with doctors from the Medical Committee, the unit was trying to assess the use of federal funds in clinics and was meeting with unconcealed hostility.

Two years ago an attempt had been made in Canton to form a Negro Chamber of Commerce. The Federal Project unit tried to encourage its revival using the same techniques that had proved successful for the Farmer's League: scheduling speakers from agencies which could help businessmen. It became clear that these small shopkeepers, painters and builders, were much less independent of the white power structure than were the farmers. An electrician who had been active for some years in voter registration groups said he had tried to switch a large loan he had at the local bank into Jackson in order to be free of local pressure. He had not been able to switch, and now he was deeply worried over the bank's pressures to call in the loan. Many tiny concerns made their income on the licensed but illegal sale of liquor. The police would crack down at any step they took toward change. So they all bought tickets to the luncheons, and stayed away.

One Negro who did attend the meetings was George Washington whose store, caty-corner from Freedom House which he also owns, is a favorite source of cold, soft drinks for all the volunteers. His store had prospered as a result of a downtown boycott, and

recently dynamite was found under the foundations at the time another general store in the Negro district, but white owned, was bombed. The boycott was so successful that three downtown stores had gone out of business and the Chamber of Commerce had issued a threatening letter to the Negroes, whom they called "misguided", saying that taxes on downtown profits helped to pay for town services. If the boycott continued, the letter said, then taxes on auto-use and on electricity would have to be increased.

A letter appeared to counter the threat, noting that although 71% of Canton's 10,000 inhabitants were Negroes, they hardly received half of the town's services. Further, although both races had segregated recreational centers with pools, the city-owned Negro Community Building was locked most of the time. The boycott was triggered by the town's reaction to a voter registration rally, but demands for cessation included the hiring of some Negroes as clerks. Til now Negroes were only porters or night-watchman, or teachers in the Negro schools. There is a dream that a cooperative Negro shopping center might grow out of the boycott, but the economic squeeze the whites exercise ever the Negroes has not yet been broken.

The Freedom Rides of 1960, while enjoying wide publicity for a short time, had their greatest long term effect in pushing the Civil Rights groups into COFO, and encouraging their liaison with the many minister groups which arrived in the state. In terms of local conditions, the Freedom Rides did almost nothing. The bright new airport building, completed with the aid of federal funds only a year ago, still has two sets of toilets and two snack bars. It finally got through to the officials in charge that the airport would have to be desegregated so that the separate facilities are not labeled. Also, the open expense of the observation dining room was broken up with room dividers and imitation planters, presumably to protect sensitive diners from visual reminders of the attack on the Mississippi way of life.

Non-evident techniques work only in situations where the opponent has a guilty conscience. India found this out when it tried to take Goa from the Portuguese utilizing the Gandhian techniques of *satyagraha* after eight fruitless years, Nehru finally sent in the Indian Army which completed the job in five days. The white power structure in Mississippi has no guilt complex. Sit-ins and demonstrations will only be met with retaliation. COFO decided that only inroads in the white power base would ever produce a change. As a result, the major effort at the beginning of the Summer Project was on voter registration.

By the time I arrived in Canton, however, emphasis had switched to Freedom Registration. Attempts to escort large numbers of Negroes to register were met with delaying tactics and arrests. The natural local leaders in most communities, and certainly in Canton, had already encouraged those Negroes

to register who were literate, relatively independent economically, and daring. Earlier in the summer much effort was expended for disheartening results. So tactics were changed.

In the fall of 1963 COFO had started a Freedom Vote Campaign for Governor, using, for the first time, large numbers of white volunteers, primarily from Harvard and Stanford. The next logical step was to contest the Democratic primaries. For this purpose, the Freedom Democratic Party was set up with candidates pledged to support the national Democratic ticket. Arguing that their candidates were better Democrats than the "regular" party, they sought support from both communities. The number of registered Negroes is roughly three percent of the registered electorate; clearly there was no chance of the Freedom candidates winning. It was to be an exercise of protest.

Delegates to the national Democratic convention were the next target. Late in June registered Negroes clipped the newspaper announcements of precinct meetings and went to the meetings. To the great surprise of most of these Negroes who have been indoctrinated with the glories of democracy - could they but participate, these precinct meetings either were proforma or not even held. In several places Negroes were the only persons attending and they elected themselves as delegates; in Greenville, however, equality prevailed. At the county level party meetings, however, the Negro delegates were not seated at all, or if seated, were not allowed to participate. At that point, the Freedom Democratic Party decided to hold its own party meetings at all levels, copying exactly the rules of the regular Democrats. First would come registration.

Freedom registration is on a simplified form similar to that used in most states, and like those used in Mississippi before 1954 when the new qualifications were passed requiring voters to interpret the state Constitution and be able to discourse on the obligations of citizenship! At first registration centers were set up, but the reluctance of most Negroes openly to defy the whites soon forced registration to become a house-to-house campaign.

In twos, we became Freedom precinct organizers, not only soliciting registration, but also trying to impart political education. Walking down the streets in Canton's Negro section, we were obviously of the Movement. From every porch, from every yard, came greetings, "Hi, y'all." To my northern accented "Hi," came the cheery report, "Fine." There are no sidewalks or curbs, only a ditch-gutter, overgrown in most places. The unevenness of the houses amazed me; standing next to a stucco and brick ranch house with an air-conditioned unit would be an unpainted shack on rickety piles; watermelon rinds would litter one yard next to an immaculately manicured lawn. The tattered houses were rental property and the leverage against landlords was non-existent. Nor was there any civic group which could pressure both tenant and

landlord to improve the upkeep of these shacks.

As we signed on Freedom voters and held block meetings, the disorganization of the neighborhoods became evident. The whites have never allowed organizations among the Negroes; social contact has become centered upon churches and related religious activities. Loyalty to one's church is so fierce that married couples seldom belonged to the same congregation; rather they maintained their original ties. As a result, persons on the same block did not know each other any more, perhaps less, than we know our suburban neighbors. And what they did know was attached to nicknames, a practice which must have been a safety measure at one time, but one which today makes organization quite difficult. The reliance on God's will also burdened political organization. It was quite a shock to some that the ministers came to Canton to do political, not religious, work.

Knocking on doors, I was met with unfailing courtesy. In fact, COFO warns against this courtesy, seeing it as the reflex politeness traditionally given the white Boss. The student volunteers try to encourage everyone to use first names, but for the adults, this seems inappropriate. Frequently, even when the Negroes signed registration forms, their attitude toward us remained obsequious. More often the response was one of embarrassingly profuse gratitude.

There was neither gratitude nor fawning in our relationship with our hostess, but rather a fierce pride. Mrs.

Jones (not her name) reigned over her house, and the six volunteers billeted with her, like an African matriarch. A widow four times, but unsubdued, she answered the door concealing a long knife behind her skirts. At six in the morning she did the daily shopping before the heat set in, yet she spent the hottest part of the day over a wood stove producing Southern fried chicken, rice, cornbread. She did not allow us to help with cooking, but we did the dishes, a project reminiscent of my great-grandmother's Iowa farm. Scrappings went to pigs, chickens, or dog; water was drawn from the bathtub and heated on the wood stove while we ate.

Security regulations prohibited our going out after dark, so we talked long hours on the unlighted porch. Beds were in every room, permanently, and the heaviness of furniture and wealth of drapings and bric-a-brac were straight Victorian, and most unsuited to the breathless, hot climate. Yet this modicum of material wealth marked our hostess as a member of the elite. Among her husbands had been a teacher and a preacher, and her grandchildren's pictures in graduation robes crowded the table tops.

The long quiet evenings had begun to irritate the students. After eight weeks of confinement these healthy youngsters began to violate security and visit each other at night. The staff, predominantly Negro, made no pretense at keeping security, but preached it constantly to the volunteers. The resultant antagonism had been further

widened by the dismissal of two white girls after they forged strong attachments with two local Negro men. All the tensions of the summer between staff and volunteers seemed to erupt in this tangle of race and sex. The project head, an ebony copy of Castro, seemed to want to imitate his image and assert his unquestioned authority over the volunteers whom he seemed to feel must live a monastic existence to prove their devotion to the cause. More and more the volunteers reacted by flaunting him. The morale of the Canton Project could hardly have been lower; yet no one talked of leaving. Indeed, recruiting was going on for volunteers to stay throughout the winter and many signed on. The difficult interpersonal relations only proved to each one how deep was the chasm between the races, how urgent the need to bridge it.

There are gulfs within the Negro community, too. The family with regular income still aspires to a middle-class status. The leaders and volunteers have all read Professor Franklin Frazier's ridicule of this class in the *Black Bourgeoisie*. Frazier does not use the term in a Marxian sense; rather he uses it to underscore the unreality of the imitative life of the middle-class Negro. Many reporters, unfamiliar with this important sociological study, confuse the arguments about the role of the black bourgeoisie with communist jargon. These critics seem unaware of the divergence within the Negro community between the matriarchal mass and the Victorian bourgeoisie.

The Negro church we visited the last Sunday had a congregation just beginning the climb into bourgeoisie status. This change was evident in their service as well as in their politics. Instead of rolling spirituals, the music was sung from hymnals and the urge to improvise was generally restrained. The handsome young minister began his sermon in a speaking voice which soon rose into a chant. Only at the climax of the message and, I detected, with effort, did he reach the pitch of emotion common to the lower class churches. In response to the pulsating emotion, only one woman wailed in ecstacy, though cries of "Well, well" punctuated the attempted calm. Politically the congregation was very suspicious of the Freedom Movement and clearly would have preferred COFO to stay away. We had come asking for the use of their church for a Freedom School and they voted against us.

The minister apologized sincerely. He had jeopardized his job by forcing a vote of the congregation instead of accepting the word of the deacons for it was they who controlled his job and paid him $75.00 a Sunday. He preached there only two Sundays a month, having another parish elsewhere, and supported his family with a porter job in Canton which, despite his high school education and theological training, was the only thing open to him.

Flashing his brilliant smile, he repeated, "I am deeply sorry. But you know last week they burned a church cross town. It was the same

denomination as ours and the deacons are sure the vigilantes made a mistake and were after this one. After all, they say, you volunteers have been here and not to the burned church. I frankly think the burning had nothing to do with the Civil Rights. That church is near a new irrigation program and I know the neighboring plantation has been trying to buy the church land for three or four years. I think he will get to buy it now."

We walked out into the brilliant afternoon light. The movement felt good after four hours of services. "You know I think we should cooperate with you", continued the preacher. "I feel that our church may be bombed no matter what we do. And the Movement is right. We should support it. In fact, the burnings may help the churches in the long run. Right around here are six tiny churches. Most have a minister only once a month. Many have no education, and don't understand at all the changes that are coming. We need large, strong, progressive churches. Perhaps this is God's way of helping us help ourselves."

God is very much wound up in the Freedom Movement. Though some students may be skeptics, the moral arguments in favor of freedom give the Movement wide appeal. Perhaps it is the strain of forgiveness in Christianity that has kept retaliation out of the goals of the Negro. This intermingling of political and religious motive could be seen throughout the state convention of the Freedom Democratic Party. The elected chairman, Dr. Aaron Henry, is the state leader of NAACP; the vice-chairman, Rev. Edwin King, is a white minister at Tougaloo College. After the business of the meeting, during which Mississippi Negroes formulated their greatest political challenge to the existing power structure, the entire audience joined hands to sing the many verses of, "We Shall Overcome." They hummed it during the benediction, and then repeated the stirring words: "Black and white together, we shall overcome some day."

RADCLIFFE COLLEGE ALUMNAE ASSOCIATION: ALUMNAE RECOGNITION AWARD IRENE TINKER '49

IRENE TINKER, YOUR CONTRIBUTIONS TO academia and involvement in the international community reflect the best of both the scholar and the activist. The author of many books and monographs, including *Street Foods, Engendering Wealth and Well-Being*, and *The Many Facets of Human Settlement*, you have blazed new intellectual paths in international and feminist studies. At the same time, you have tirelessly devoted your time and energy to improving the lot of the disadvantaged throughout the world, particularly women and children.

An expert on women and development, you have identified the sources of persistent inequality, a necessary foundation for the greater empowerment of women world-wide. Honored with many prestigious grants to study abroad, and drawing on your years of work with United Nations agencies, you have used these opportunities to convene international conferences, which have fostered greater communication across language and cultural divides. For the amazing vitality of your scholarship and for the scope of your international leadership in international service organizations, Radcliffe College Alumnae Association is honor to present you with its Alumnae Recognition Award.

Symposium: Women in the World: Personal Identity and Public Impact Radcliffe Symposium—June 11, 1999

Without doubt my life has been shaped by, and in some ways helped shape, the major social movement of the century: the global woman's movement. Such influence as I have had was accomplished in concert with other women, united in a myriad of organizations and research projects. My actions have been based on a profound sense of universal equality, and on the belief that individuals, alone and in groups, can influence events and world views at many levels.

My mother, by her actions, embedded these ideas in my psyche. Reacting to the unfair rules that forced her to resign as a high school physics teacher once her pregnancy showed, she raised her daughters and son as equals, never cautioning us from climbing trees or jumping out of the garage loft window. And like so many talented women of her generation, she engaged in voluntary activities through organizations she often reshaped. I tagged along on visits to new immigrants in our small Wisconsin town, or listened to the women's chorus she organized, or proudly attended the ceremony when trees were planted along a new highway

in south Jersey with funds she and her group has raised.

My enthusiasm for traveling the globe is harder to trace, perhaps from reading "Terry and the Pirates!" Classes at Harvard were not much help in learning about countries outside Europe and North America: Rupert Emerson taught a course on Nationalism in which I read Nehru's *Autobiography*; and Edwin O. Reischauer and John King Fairbank introduced their rice paddies course just before I graduated. My ignorance about the world was painfully evident when, as a graduate student at the London School of Economics, I met women and men from Africa and Asia and Latin America.

When my mentor and tutor, Harold Laski, died during the spring of my first year at LSE, I switched the focus of my doctoral research on elections and the parliamentary system from England to India. Eager to understand the many places between London and New Delhi, I found a second hand English Ford and talked two male colleagues into driving out to India with me. Unrest today makes that journey almost impossible. But there was fighting along the Afgan-Pakistan border even then. In the crowded hotel in Kabul, we were the subject of much gossip: a woman with two husbands! When a Pathan asked us to smuggle guns over the border, we feared being caught up in the struggle and stole out of the capital in the middle of the night, heading as fast as we could for Pakistan.

These adventures paled against my African drive in an Austin A40 from Mombasa back to London, after I completed my research in India. This time my newly acquired husband drove with me. Since finishing my dissertation, I have continued studying and teaching about developing countries, traveling widely and living in Indonesia, India, and Nepal for extended periods. This immersion in societies abroad reaffirmed my mother's belief in equality.

Back in the States I quickly became involved in the civil rights struggle. In California I joined protesters demonstrating against covenants that prevented Orientals from buying homes in the Berkeley Hills. Later I taught at Howard University, participated in the Mississippi summer and the March for Civil Rights in Washington, and organized academics to lobby for the first US Urban Grant university, the University of the District of Columbia.

It was from teaching a wide variety of black students, from Africa and the Caribbean as well as American blacks from both inner city and middle class societies, that I began to understand how we are all of us socially constructed. Today, in Women's Studies, we teach about how the US government encouraged women to work in factories during World War II, and how they told Rosie the Riveter to go home after the war so that her job could be taken by a returning veteran. Women's magazines of the time projected the ideal housewife as one with four children and a dog in a station wagon who kept an immaculate house and served a cold martini to

her exhausted husband when he came home from work.

The growing consciousness of how society denied most women from entrance into graduate schools for law or business or medicine but rather pushed the college educated women into the isolation of the suburbs drove the second wave of the women's movement.

Those of us in Washington, DC, who had persevered in our professions began organizing to change the legal bases for this discrimination, lobbying for equal pay, affirmative action, and the ERA (Equal Rights Amendment) –which didn't pass Congress but has largely been implemented throughout the country today. Congress was receptive to gender equality where citizen rights were concerned: a woman could now have a charge account in her own name or buy a house without a male family member cosigning. Achieving women's share of their husband's pension or social security took more persuasion.

But the male decision-makers balked at supporting rape crisis centers or abortion because these actions would undermine the patriarchal control of women in the home. Not until twenty five years later at the 1993 World Conference on Human Rights were women's rights declared to be human rights. At last, domestic violence is seen as a crime, and an "honor killing" of an adulterous wife in Brazilian is now illegal. This slogan: women's rights are human rights is unquestionably the greatest challenge to patriarchy the world has ever seen

In 1972, I returned to Indonesia to study urbanization and was asked by the US Information Service to give some talks on the US women's movement. As I thought about what to say, I tried to draw comparisons with Indonesian women, and realized that although I had met and interview many women, I had never talked to them about issues of being a woman in Indonesia. Only one book had been written about contemporary women in Indonesia, and nothing recorded about their roles in the Independence struggle.

Too quickly it became apparent that women in Indonesia were losing their relatively egalitarian roles under the pressures of rapid economic development, largely due to the biases of western economists who still saw women as servers of martinis.

Back in Washington I organized a discussion group of women active in the Society of International Development and found my observations confirmed in other countries. Women's traditional work was not counted, not valued, and frequently undercut by development programming.

In Africa, for instance, women still produce some 80% of the food grown, yet early US aid programs targeted men for agricultural training. Men then took part of their land away from women in order to raise cash crops. The men not only required their wives to weed the cash crops in addition to growing food crops, but the men kept all the profits. No wonder per capita food production in Africa has been falling for decades.

This idea that women's work and roles are undercut by development was so powerful and persuasive, that Congress added a provision to the 1973 Foreign Assistance Act and the United Nations General Assembly passed a resolution calling for the integration of women in development. Just before the First UN World Conference for Women in 1975 in Mexico City, I organized a seminar for women and men from around the world where many more examples of the differential, and too often detrimental, impact of development on women were documented. The field of Women and Development was born.

More research was needed, so I founded two international research centers, one to maintain a critical outsiders view, the other to work with agencies to implement the programs that benefitted women. We emphasized women's work—from handicraft to Street Foods; after all the development agencies talked economic development. [Notice the exquisite weaving on the Laotian jacket I am wearing.] But as we all have experienced in this country, women may demand, even achieve, equality in the workplace, but most women must do a double day of maintaining the household with little help from their spouses. And in most countries, if the marriage fails, it is the women who must leave the family home.

My recent work centers on women's rights to house and land around the world. including the rapidly modernizing command economies of China, Laos, and Vietnam where we have observed the reassertion of patriarchal control of resources even after years of nominal gender equality.

As the leading proponents of women's equality during the last forty years begin to retire, we are concerned our history, herstory, be preserved. The Schlesinger Library led the way on women's archives, but one library cannot collect everything. Through the National Council for Research on Women, I have set up an archival committee to identify and describe existing archival collections on women in this century with the goal of increasing both the scope of collections and their financial support. With that commercial, I was planning to close.

Instead, I will add another. As Radcliffe merges into Harvard, the need for women faculty becomes ever more acute. Let me commend to you the Committee for Equality of Women at Harvard for your support. Together, we women are making a difference!

INFLUENCING DEVELOPMENT POLICY

I N 1972, DESPAIRING OF MY EFFORTS TO REFORM URBAN EDUCATION, I SUCCESSFULLY applied for a grant to return to Indonesia to study urbanization. While in Jakarta I was asked by the US Information Service to give a talk about the US Women's Movement. During my two years studying elections and democracy in Indonesia, I had interviewed many women for my research and met many more socially, but I knew little about the realities of their lives. As I asked them how the changes that development was making in the country impacted on them, I was astounded to realize that the feminist goals I had been championing for equality between women and men were being undermined by the inclusion in development rhetoric of implicit values of male privilege. Indeed, at the time, professional women in Indonesia had achieved a measure of equality during the independence movement that was superior to that in the US.

Thus began an evolution in my thinking about women's rights and feminist values. Women around the world would benefit from increased equality. I believed fervently that women were men's equal; later I was convinced, by research and experience, that women and men have distinct attributes and began to argue that "as long as man is the measure, a woman will always be second class." Therefore I began to speak of "equity" instead.

As the US Women's Movement celebrated its accomplishments, there was increased skepticism abroad as to whether American values could— or should – be exported. Clearly, a strong strand of ethnocentrism has permeated much of the US women's movement, especially in Women's Studies, which seemed blind to cultural variations. My keynote address, "Feminist Values: Ethnocentric or Universal?" addressed this issue at a conference in Honolulu.[1]

Unfortunately, many development programs focused on women's concerns also became tainted by assumptions by people implementing them that other countries should follow the American model. Perhaps the most acute reaction

1 "Feminist Values: Ethnocentric or Universal?" based on a keynote address at conference on Concepts and Strategies: Women's Studies in Different Cultural Contexts, co-sponsored by Women's Studies Program, University of Hawaii, and East-West Center, Honolulu, Nov 15-17, 1982. Published in <u>Women in Asia and the Pacific: Towards an East-West Dialogue</u>, ed. Madeleine J. Goodman, U. of Hawaii Press, 1985.

came in Eastern Europe where USAID poured economic aid after the collapse of USSR. Under the Soviet system, the state provided housing, health, food, and jobs to all. As women lost their jobs, they preferred to stay home rather than take out loans to start a business. I have included discussion of these issues in my publications in Section 6.

THE CONCEPT OF WOMEN AND DEVELOPMENT

After my Indonesian experience, I began talking with other young women scholars in Washington who had recently returned from research abroad. Many had encountered similar influences as development policy promoted western culture. I proposed that we start a caucus of the local chapter of the Society for International Development and collect data on the issue. From this caucus, SID/WID, came the shorthand name of the movement. Two members of the caucus, Pushpa Schwartz and Patricia Blair, were editing the Development Digest, and began summarizing articles written by anthropologists and economists noting how modernization was affecting women. Outstanding was Ester Boserup's just published book entitled *Woman's Role in Economic Development*. The WID movement had found its scholarly base.[1] Over the years I became a close friend of Ester's and wrote a tribute to her influence on women as well as on population. [2]

Meanwhile, I visited the international office of SID in DC and prevailed on them to add two panels on WID at the next international SID conference scheduled for San Jose, Costa Rica, in the spring of 1973. Since the program had long since been set, our panels were in the evening. To my surprise, the panels drew women and men from around the world, all agreeing that women had been neglected in development planning.

Encouraged by this reception, I testified at a State Department briefing on the upcoming International Women's Year about the adverse impact of development on women. My article, based on these data, was widely published and became a mantra for the WID movement.[3] Two participants in this briefing, wise in the ways of Congress, determined that, to address this inequity, an amendment to the Foreign Assistance Act of 1952 was needed.

1 "Ester Boserup," entry in the *Elgar Companion to Development Studies,* David A. Clark, ed. 2005

2 "Utilizing interdisciplinarity to analyze global socio-economic change: a Tribute to Ester Boserup," 2003, in *Global Tensions: Challenges and Opportunities in the Economy*, Lourdes Beneria, ed. London: Routledge Press.

3 My chapter in <u>Women and World Development</u>, I. Tinker and M. Bo Bramsen, eds., "The Adverse Impact of Development on Women," was included in <u>Peace Corps Program and Training Journal</u>, Vol. IV, No. 6, 1977; translated as "Le developpement contre les femmes" in <u>Question feministes</u>, no. 6, Sep. 1979, and included in a collect of articles on women prepared for Oxford 2014.

The eventual passage of the "Percy Amendment" is a study of how laws are really passed in Congress as opposed to what I was taught. Important players included the wife of the chief of staff of the Senate Foreign Relations Committee, Mildred Marcy, and her husband, Carl, who suggested that a Republican Senator introduce the amendment. Senator Percy who agreed, although he really didn't know what the amendment meant, would have left to catch a plan home if a staff member had not rushed over to remind him to introduce the amendment: it passed easily as his colleagues assumed it was a "motherhood" amendment introduced to please a constituent. Later, members of the conference committee voted to drop the amendment until a barrage of telegrams and phone calls changed their minds. I also phoned the legislative staffer for each member to explain the amendment and emphasize that no funding was involved.[1]

USAID set up an office as the focal point for women to implement the law. In an effort to influence their priorities, I visited bureaucrats in various USAID offices, gave talks around town, and wrote about what policies the WID office should adopt.[2] CARE published a widely circulated Brief on Development Issues, included in this volume, in which I listed six myths that had been influencing agency policy, and then suggested new programs to improve women's lives.[3] My focus was on equity for women and stressed that including women would make current programs more successful.[4] My advocacy was introduced to academia when Jean O'Barr, at Duke University's Program on International Studies, invited me to coauthor *Third World Women: Factors in the Changing Status.*[5]

To support research on WID, I set up two research centers. The International Center for Research on Women was the first, in 1976, and was focused on changing development policies by identifying incorrect assumptions upon which their policies were based.[6] One of the first projects collected data on women-headed

1 My chapter giving a detailed narrative of how the law was passed is included in this volume: "Women in Development" in *Women in Washington: Advocates for Public Policy*, I. Tinker ed. Beverly Hills, CA: Sage Publications, 1983.

2 "Equity for Women and Men: A Basic Need for USAID", <u>US Development Assistance: Retrospective and Prospects</u>, CASID (Center for Advanced Study of International Development) Occasional Papers, Michigan State University, Fall 1987; published Spring, 1989.

3 "Feminizing Development: For Growth with Equity," <u>CARE Brief</u> #6. Issued in cooperation with the Overseas Development Council, Washington D.C., 1986.

4 "Policy Strategies for Women in the 80s," <u>Africa Report</u>, Mar.-Apr., 1981.
 "Women in African Development", <u>The Rural Sociologist</u> 5/5, Sept., 1985.

5 <u>Third World Women: Factors in Their Changing Status</u>, Jean O'Barr, with Shirley Lindenbaum and Irene Tinker, Duke University Program of International Studies, Durham, NC, 1976.

6 ICRW was originally set up as a project of the Federation of Organizations for Professional Women; the following year we obtained a 501-3 status and spun it off as a separate entity.

households. I had used the estimate that one-third of all households are headed by women in much of my testimony: this was a ballpark figure as are so many estimates about socio-economic change when speaking of countries with minimal data.[1] My article "Development and the Disintegration of the Family" was published by UNICEF in Geneva.[2] As the family support weakened, women generally kept the children; with lower income and more family responsibilities, the gap between female and male living standards widened with women-headed households becoming the poorest."[3]

Research at ICRW emphasized that ensuring income for men was just the first step toward addressing their multifold concerns. I highlighted this need in my chapter in *Economic Independence for Women: The Foundation for Equal Rights* entitled "Women in Developing Societies: Economic Independence is not enough."[4] This type of research assumed that bureaucrats could be persuaded to alter their programs if the data were sufficiently robust. However, when I became an implementing bureaucrat while serving as a Presidential Appointee under President Carter in ACTION, I realized that the crucial requirement for change was to get the idea to the top of the "in" box. With this in mind, I started the Equity Policy Center, EPOC, in 1978, to work *with* the agencies so that women's issues did not sink out of sight. The centerpiece of EPOC research was the series of Street Food studies explored in Section 6.

The United Nations as well as bilateral agencies set up focal points on women and development. Old and new women's organizations competed for grants to run projects around the world. Debates swirled around the best way to infiltrate the bureaucratic culture. Activists wondered whether more might be accomplished within traditional NGOs or whether feminist goals were more likely to be reached through women's organizations. Writing a chapter on NGOs convinced me that women's groups were essential so that women's concerns remained front and center. [5]

For the same reason, I vehemently opposed the "mainstreaming approach" to women's programs that became popular during the nineties. This approach was promoted by women working in women's section of development agencies

1 Details of how we arrived at this estimate are recalled in the *Camel's Nose* in Section 6.

2 "Development and the Disintegration of the Family," Assignment Children, UNICEF Quarterly Review No. 36, Geneva, Switzerland, Oct.-Dec., 1976.

3 "Widening Gap", International Development Review, Jan., 1975.

4 "Women in Developing Societies: Economic Independence Is Not Enough," Economic Independence for Women: The Foundation for Equal Rights, ed. Jane Chapman, Sage Publications, 1975.

5 "NGOs: an alternate power base for women?" in Mary K. Meyer and Elisabeth Prugl, *Gender Politics in Global Governance*. Rowman. & Littlefield, 1999. pp 88-104.

who had become discouraged by their isolation and lack of effectiveness. They argued that having a separate women's section was antagonizing the mostly male decision-makers and that abolishing these centers would make it easier to include women's issues in all programs. In effect, they were throwing out much of women's progress within these agencies. Using the analogy of Women's Studies on university campuses, I maintained in my two overview chapters, that change requires a both integration and also a strident voice for women. My views on this topic are summarized in the two retrospective chapters in Section 7.

My advocacy and scholarship on WID were so dominant in my subsequent career that I found it difficult to be consulted on any other topic. After my discouraging stint at ACTION,[1] I founded the Equity Policy Center in 1978. As a free-standing action-research center, I sought funding based on the "flavor of the month" topics such as technology or energy in order to show the importance of including women in their debates.

As an expert on WID, I with my staff wrote papers, consulted with foundations, bilateral agencies, and such international bodies as the World Bank, FAO, and ILO. It was an exhilarating time despite the constant scrabbling for money. Generous overhead on projects funded by USAID sustained EPOC. Foundations, used to paying researchers at established institutions what supported the scholars' salaries, quibbled at paying a mere 15% of operating expenses. Often I balanced the accounts by not drawing a salary. Then, after President Reagan was elected, I was blacklisted for non-competitive grants from the government because I had been a Presidential appointee. After teaching at American University and receiving a Fulbright research grant to Nepal and Sri Lanka, I was offered a professorship at the University of California Berkeley. It was gratifying to return to UCB as a full professor after having been a mere research assistant thirty years before!

At EPOC, I was writing grant proposals as we completed projects; my head was full of analytical ideas that I had not had the time to explore. At Berkeley, without having to scrounge for funding, I revisited these thoughts and explored them with my marvelous graduate students. During those nine years, I was able to publish or edit seven books, write numerous articles, and contribute encyclopedia entries, all utilizing my experiences with women's projects around the world.

1 Sexism was rampant at ACTION under Director Sam Brown; politically correct, he appointed women and blacks to visible offices, but ran the agency from his kitchen cabinet.

FEMINIST VALUES: ETHNOCENTRIC OR UNIVERSAL?

AMERICAN FEMINISM OVER THE PAST decade has had an immeasurable influence on individual attitudes and institutional policies, both nationally and internationally. Yet many foreign women scholars and leaders whose policy goals seem very similar to ours question the applicability of American feminist values to other societies. It is my purpose in this essay to disentangle the several strands of values that have been wound together in the dominant belief system of contemporary American feminism, and to examine each for its universality.

By American feminism, I mean the multi-faceted efforts by American women to redefine their roles and rights in American society. Such a broad definition obviously includes some groups that might be uncomfortable with the term "feminism," precisely because it has taken on, even for many American women, a more specific value association than "equal rights for women." Like any revolutionary movement, the American women's movement tends to be identified with the most extreme positions put forward by radical feminists. It is from such challenging ideas that the movement has drawn its strength and dynamism. However, the broad support for the movement by American

women comes from the fact that the dominant values of the movement spring from deeply held American beliefs in individual rights, equality, and justice. I will argue that the values of American feminism define the American women's movement, that the radical stance of some feminists is an issue of degree, not substance; and that it is the underlying American value system that disturbs women in other cultures, particularly in developing countries.

This essay is not meant to present an exhaustive review of American feminist theory. Rather it is a first step in linking American feminist thought to debates over the validity of current theories concerning socio-economic development, particularly as they relate to women. In the process, I will identify and examine the issues supporting, and separating, two aspects of the American women's movement: Women's Studies and Women-in-Development. Both these groups were represented at the conference "Concepts and Strategies of Women's Studies in Different Cultural Contexts," held at the University of Hawaii in November 1982, where the ideas discussed in this essay were first presented. This conference, therefore, provided an ideal opportunity to explore the values that undergird

American feminism, particularly as they manifest themselves in Women's Studies, and to reflect on their universality, particularly through the responses of the participants from the Pacific Islands and Asia.

FEMINIST VALUES

Essentially what American women have been demanding over the past decade is that women should have the same rights as men: equal opportunities for education and employment, equal pay for work of comparable value, equal access to credit and clubs, equal benefits and pensions. These demands are part of the equity revolution of the sixties which started with the Black civil rights movement but which quickly expanded to include Native Americans, Hispanics, Asians, white ethnics, the handicapped, and senior citizens. The demand for equal treatment by clearly identifiable groups was de facto an admission that the melting pot concept was not only a myth but was no longer a desirable ideal. These various groups argued that people should be allowed to be different and still receive equal opportunities and justice under American law. Their complaints illustrated the unpalatable fact that discrimination was still pervasive.

This recognition of persistent racism in the United States contributed to the condemnation of the Vietnam War, for many saw the war as racist and the military service as particularly onerous to Blacks. Mary of the same women

and men who had been actively working and demonstrating for civil rights joined the anti-war movement. Yet it seemed that in both these movements it was the men who did the leading while the women did the typing. Nor did these male leaders simply discriminate against women in job assignments; many were individually credited with the statement that the only position for a woman in the movement was prone.

"If everyone is equal, why not women too?" asked the activist women as they began to look at their own exploitation by the men in these movements that laid claim to moral rectitude. After all, they argued, the right of the individual as paramount is a fundamental American value. The search for religious liberty— the right to seek salvation of one's soul in one's own way—was responsible for much of the early European settlement of the states. And of course, each soul is equal. The connection between Calvinist beliefs and the work ethic embodied; in the White Anglo-Saxon Protestant (WASP) value system which today pervades our country has been amply documented. Briefly, Calvin preached predestination: some people were born to be saved, others were predestined to Hell. Since none but God could know who was to be saved and who not, society began to assign values to individual behavior. Good people lived simply, went to church, and worked hard. In the resource-rich new land, hard work was quickly rewarded. Imperceptibly, "rich" was added to the attributes defining good.

The ideology of our current administration in Washington is a classic example of this belief: if you are rich you are good. If you are poor, it must be because you are lazy or spendthrift, and, therefore, you are bad. "Rags-to-riches" is the WASP definition of success; Horatio Alger, the hero. Wealthy dynasties such as those of Carnegie, Rockefeller, and Kennedy are celebrated; the way their wealth was accumulated is irrelevant. Indeed, these beliefs seem to work for many Americans; our country is affluent beyond the dreams of most people in the rest of the world. We seem to others to worship materialism.

The WASP concept of the right of an individual to work hard and become rich did not seem to apply to women. The counter-culture of the sixties transferred the value of individual rights from seeking wealth to 'doing your own thing." Children of the affluent middle class were put off by the pursuit of money and material goods that characterized their parents, whose own goals were formed during the Great Depression of the thirties. These "flower children" celebrated love and nature; they turned their back on affluence...at least for a time. This strand of individualism was open equally to women and men.

EGALITARIANISM AND INDIVIDUALISM

Thus the two dominant, but overlapping, values of the women's movement, as for all Americans, are egalitarianism and individualism. As women began to organize in the sixties, they not only demanded equal rights under law, but also insisted that women have as much right to "do their own thing" as do men. Women do not need to accept a subordinate role in the suburbs, playing chauffeur to the kids and the dog. Women do not need to throw away their fine university educations on years behind the vacuum cleaner.

Indeed, much of the anger that has welled up within the women's movement comes from the feelings of exploitation voiced by well-educated suburban housewives. It was these women, rather than established professional women, who flocked to meetings in the early seventies of the National Organization for Women (NOW) with its emphasis on the consciousness-raising group. For this reason, NOW has emphasized individual values within the family more than the professional organizations founded about the same time. Groups such as the Women's Equity Action League (WEAL) and the Federation of Organizations for Professional Women (FOPW) have focused on achieving egalitarian national policies toward women, especially with regard to employment and education.

Egalitarianism and individualism are distinct concepts, however merged they may seem in the women's movement. Egalitarianism in the American context means equal rights for citizens under the law: to vote, to a job, to equal pay, to pensions, to an education. Women in Washington spent two decades, from 1960 to 1980, trying to

expand federal legislation to include women equally. During that time, as women's issues gained in visibility and legitimacy, such legislation became increasing difficult to pass. A major reason is that the issues being addressed had changed from those concerning women as citizens to issues such as those of battered women or abortion, that concern women as individual women.

Although the women's movement was demanding equal protection under law to ensure the right of every woman to have an abortion, or to leave a husband who beats her, there is a subtle difference: these issues relate directly to the family; earlier issues related simply to women's equal access to rights already accorded men. More recent issues concern private life; while equal rights under law issues generally dealt with public life. It is much easier for most men to grant public equality; treating women in the home as equal individuals is another matter. Furthermore, equality in the workplace is a basic demand of all who work. As a result, there is almost universal support for public equality for women. The current debate over women's rights revolves around issues of individual rights and roles for women within the private sphere of sex and family.

The dominant view within the women's movement is that equality and individual rights can be applied within the family. Radical feminists in the sixties denied this possibility and viewed any male-female relationship as exploitative. The logical outcome of such a view is women living apart from men, whether in lesbian relationships or not. The identification of feminism with lesbianism in the minds of many observers has continued to plague the women's movement, leading many young professional women to eschew the term "feminism," while clearly supporting the goals of the women's movement.

SEX DIFFERENCES

At the heart of the debate over equality within the family is the issue of whether women and men should be considered absolutely the same. This issue, in turn, requires consideration of the biological differences between the sexes. The easiest way to reconcile women's demands for equality in the private sphere is by emphasizing the right of each individual to make her own choices and minimizing any differences between the sexes. Equality is thus defined as equity or fairness rather than as sameness. Thus, women can bear children but men can feed them as well as women except for breast feeding. Men can cook and women clean up, or vice versa. Early movement women championed marriage contracts that laid out the division of household chores.

An alternative way of dealing with the issue of housework has been to assign economic values to each household activity, and thus prove the wage value of women's household work. Indeed, an organization was formed under the banner of "Wages for Housewives" to promote this. The idea of

paying women to stay home and attend the house and children was intended to give greater status to women's work in this sphere. Such a view can too easily be turned into a conservative justification for keeping women at home, "in their place." This reversal was illustrated recently in Italy where a neo-fascist party took up the cry of wages for housewives. Furthermore, if monetary values are given to every activity, what of love, beauty, and creativity?

As the issues of abortion and family violence drew greater attention during the sixties, the feminists had to base their claims for women's rights on their uniqueness, not on their sameness, for it is women who bear children and women who are usually beaten. Assertion of women's rights on both issues infringes on men's traditional assumptions concerning paternity and authority. To demand abortion rights or to seek shelters for battered women requires the acceptance of women's biological differences. Thus the women's movement began increasingly to reconsider women's nature and to wonder if, in insisting on absolute equality, women were not being pushed into imitating men. Women began to realize that equal access to clubs, or jobs, or universities has usually meant women's equal entry into a man's world or a male bureaucracy, and it's the women who adapt. Academic women began to recognize the male bias in curricula and set up Women's Studies courses and women's research centers. Books and articles appeared on women in the arts, in history, in science, in the corporation, or in government. One author even argued that the hope for American business was the feminization of the workplace, while another believed that female attributes were more suited to the Age of Communication than were male attributes. In all of these trends there is acceptance of the difference between men and women.

Some feminists, acknowledging women's biological differences, have argued that women are morally superior to men. Indeed, this assertion ran through the arguments presented early in this century by the suffragettes and it tends even today to undergird the women's peace movement. This can be a dangerous stance, allowing, for example, such radical religious leaders as the Ayatullah Khomeni to blame the moral ills of Iran on women for discarding the veil. Nonetheless it continues to be a pervasive belief held by both women and men.

A second set of assertions arising out of the recognition of biological differences revolves around the belief that women are by nature more nurturant than men. This concept has been used as an explanation of why the environmental movement is dominated by women. But this same belief can also reenforce conservative political insistence that women's place is in the home and that mothering is only for women.

Recognizing that any claim to moral superiority or special attributes too easily leads to a questioning of equality and provides a rationale that puts

women back into traditional roles, most leaders of the women's movement prefer to emphasize the rights of each individual woman to equality both under the law and within the family. Paternity leave and househusbands are championed. The strains of the double bind are ignored, but with few children and long working lives, the heaviest household tasks don't last too long. A couple can surely deal with equal household tasks more easily when children are no longer at home. It is within the context of children and their upbringing that the equality of husband and wife is most questioned. Solutions to the dilemma of women's work on the one hand and of household and family responsibilities on the other, are neither easy nor obvious. Simplistic solutions based on the mere assignment of "value"—often equated with cash value—to women's contributions within the family do not directly address the question of equality. They tend to presume the legitimate confinement of women's efforts to a rather stereotypic mold within the family sphere and thus propose perpetuation of inequality in both private and public lives by underscoring women's differences. Growing praise for the family, both in the United States and in the United Nations, suggests a reaction to women's demands for equality that could reverse many of the freedoms recently won by the women's movement. These are the issues that I expect to dominate debates within the women's movement during the next decade. But I do not believe that feminists will retreat from the underlying values which proclaim each woman's individual right to equal treatment.

THE INDIVIDUAL AND SOCIETY

Almost nowhere in the literature spawned by the women's movement is there serious discussion of social responsibilities of women, or of men. Indeed, the majority of persons who identify themselves as new feminists express the notion that historically, women were "conned" into providing the glue of society while men were out "doing their own thing." Hence, most American feminists eschew the whole idea of being a volunteer. To them this means playing "grey lady" in the hospital, organizing charity balls for the old folks home, or holding a fair to make money for the school. Yet the same women provide hours of volunteer help in a multitude of organizations: feminist, environmental, and political. Perhaps the pertinent' distinction is between time spent trying to change the present organization of society and time spent providing free community service.

As with family responsibilities, women today demand that men spend equal time on social support systems or, alternatively, that the government develop services to replace those previously undertaken by volunteers or the family. Clearly, in contemporary America, individual rights take precedence over societal responsibilities, whether for family or community. In the name

of egalitarianism, women now claimed the same privilege long enjoyed by men.

The emphasis on the individual as the primary building block of society can be traced back to many strands of thought that arose in Europe during the Renaissance and Reformation. Social Contract theorists such as Hobbes, Locke, and Rousseau debated the characteristics of man in the natural state and designed societal rules based on their philosophical not analytical, observations. Their projection of women's roles, however, were more "realistic," drawn up not with reference to proposed ideals of political stability, social equality and participation but descriptively, by reference to the lowest common denominator of women's social, sexual and economic functions. Contemporary women anthropologists argue that the portrayal of women's roles in primitive societies in textbooks still tends to be based on myth, not reality; women historians and theologians have shown how women lost many privileges during the so-called renaissance or rebirth of Europe; women scientists and philosophers illustrate how sexual stereotypes have conditioned biological thought and influenced experimental conclusions.

In other words, much of the thinking upon which the foundations of our contemporary industrialized society are laid is, in its essence, chauvinistic. It provided the philosophical rationale for freeing men from the hierarchy of the church-state; but by emphasizing the predominance of the individual man, it put his woman further under his control, with little channel for appeal to societal standards or rights.

The primacy of the individual over society also asserts the rights of the individual owner over land and resources. In response, the environmental movement works for preservation of our great natural heritage for future generations against immediate short-term individual gain. In other words, environmentalists are demanding a better balance between the unfettered rights of the individual or collection of individuals in a corporation and the right of society to clean water and clean air and to forests, marshes, and beaches. They are also concerned with indiscriminate exploitation of farmland, minerals, and oil. Some women environmentalists talk of the "rape of the earth," further establishing the parallel between feminist thought and environmental concerns.

In conclusion, it is clear that American feminists have utilized as the philosophical basis for their movement the fundamental American values of egalitarianism and individualism. These are verities deeply held by all American women and men. What feminists have done that is revolutionary is to insist that women should be equal to men and should have the same rights to develop their individual skills and psyches. What was once a radical challenge is today the cornerstone of the American women's movement. Indeed, opinion polls show that a majority of women and men support women's rights under law. Even conservative women base

their argument favoring the housewife role on individuals having entered into a marriage contract.[13]

While early feminists inveighed against the housewife role, activist women today are more likely to demand equal rights to social security and pensions for women who do make such a choice. And they demand better ways to collect child support payments when a man deserts his family. All of these policies continue to be based on equal individual rights. Yet by pushing these concepts to their logical extremes, feminists have revealed the weakness of a philosophy which gives unfettered rights to an individual over family or society and which interprets equality as sameness. Most feminists have chosen to ignore these weaknesses, fearing that any modification of their demands would be seen as a retreat.

EXPORTING FEMINIST VALUES

Since World War II, the United States has assumed a leadership role in the reconstruction and modernization of societies worldwide. Beginning with the Marshall Plan for war-torn Europe, the US has loaned or given money to other countries to assist in their industrialization. Economic development theory used the U.S. of the post-war era as its model of "modern." This was the period in which women were urged to give up their wartime jobs in factories or government and retreat to the suburbs. Obviously, development theory

has been exporting the male values which are anathema to the feminists. By the seventies, empirical data began to show that development too frequently was having an adverse impact on women. As this process became more widely understood, women concerned with socio-economic development agitated to have the fruits of development reach and benefit women as well as men. This group, which began to be known as Women-in-Development (WID), emphasizes cultural variation and differences among people in different countries, and so argues that development should be based on local values and needs.

In their criticism of prevailing development theory, WID adherents have found allies among adherents of two groups of early development specialists, those favoring the basic needs approach and those calling for appropriate technology. All three movements condemned the capital intensive macro-economic approach to development, which has frequently resulted in the rich getting richer and the poor getting poorer. They called, rather, for small-scale technology, village participation in planning, labor intensive enterprises, and programs that reach women. Above all, they called for adapting theories to local situations and designing projects in response to local needs as articulated by the local group.

Interest in the impact of economic development and social change on women in the developing countries has increased exponentially on American

campuses in the last 10 years. In the early days most of the Women-in-Development work was done by anthropologists; they were quickly joined by political scientists, rural sociologists, and home economists. Interest also soared among women concerned with the implementation and impact of development programs. Policy-oriented women in Washington conceived an amendment to the Foreign Assistance Act of 1973 calling for the integration of women into development programs, which Senator Charles Percy introduced. The U.S. Agency for International Development, the World Bank, and most major donor agencies set up WID offices to ensure that women as well as men were beneficiaries of their programs. Several independent research centers and consulting firms have been established both in the United States and abroad to support these efforts.

Meanwhile, Women's Studies courses expanded throughout the country and, in 1977, the National Women's Studies Association was established. This organization of academics aims to support women faculty primarily on university campuses. Because some early Women's Studies courses contained large amounts of consciousness raising and because men were often barred from the courses, some university administrators questioned the academic validity of the programs, while others thought of them as advocacy rather than substantive courses. Consequently, within the Association, great emphasis is placed on scholarship

in order to give legitimacy to the subject matter. Furthermore, because of the possible loss of academic merit for women teaching Women's Studies, only committed feminists tend to do so. This tendency exaggerates the tension between the feminist emphasis on egalitarianism and the hierarchical structure of the university. Feeling embattled, many Women's Studies faculty members, with their students, have formed closely-knit groups that presume to be the only true representatives of feminism on their campuses.

As a result, many Women's Studies professors dismiss Women-in-Development research as too applied, too hasty, and generally deficient in scholarship. They also argue that, because the funding source is often the U.S. Agency for International Development, the results are suspect or tainted. Finally, as self-appointed keepers of American feminism, they have tended to argue for the universality of their views and question the feminist credentials of those WID practitioners who argue for adapting feminist values to varying cultural situations.

In 1981, several leading WID adherents from major land-grant universities began to discuss the need for a professional association of WID specialists who would be drawn from donor agencies and consulting groups as well as from university and research centers. The Association for Women in Development was formed in May 1982 and held its first national conference in Washington in October 1983 to bring

together scholars, practitioners, and policymakers.

DEVELOPMENT THEORY AND WOMEN

The subject matter of WID is social change, whatever the cause. As critics of development theory, WID specialists question the use of GNP (gross national product) as the measure of development. Alternative measures have been attempted to get beyond availability of food, clothing, and housing, to meet basic survival needs, into more illusive standards for health, sanitation, and education.[17] These measures are much more accurate in assessing women's status in a country than is per capita income: the Arab countries provide obvious illustrations. In questioning that money is the measure of all things, WID specialists join a growing body of women and men in the U.S. who are critical of American materialism. But it is difficult to incorporate this concept into a feminism that is striving for equality with men in the terms of success as perceived in the United States: equal pay at all levels.

As critics of a development theory that argues for the universality of economic phenomena and trends, WID adherents emphasize local variability and advocate adaptation of programming to the norms of the community. This does not mean an uncritical acceptance of local hierarchies of power, but rather the recognition of alternative value systems which, while changing

rapidly as a result of modernization, may still differ from our own. In particular, this means understanding the tension between individual rights and societal or family needs in a different philosophical context. When doctrinaire feminists have visited developing countries and argued for the freeing of women from the bondage of their families, the vision evoked of the parlous state of unattached women is often considered worse than the prevailing patriarchy. Local women leaders have criticized dedicated American feminists for trying to design programs for women which assume greater individual autonomy than exists and have called these efforts counterproductive.

The point here is that development is a dynamic process; change can further exacerbate the daily struggle of women for survival, or it can ameliorate their drudgery, and provide new opportunities for education and income. Even with revolution, nations draw heavily on their cultural traditions. The tenets of American philosophy which granted unfettered rights to the individual over society are not widely held nor easily exportable.

Even more difficult to export is the idea that women and men are the same. Ivan Illich has recently provided a new theory as to why women have less status in modernizing societies. He argues that women held greater advantage in a society which preserved gender assignments of economic activity and where women and men were necessary to each other for survival. In industrial

societies, tasks are genderless, with the result that women are assigned the most lowly. This leaves only sex as the difference between men and women. No wonder this was the focus of the first attack by American feminists. As noted above, there is danger in acknowledging biological differences between men and women, lest the response be back to economic assignments by gender, in the home and in the marketplace. Yet this particular strand of feminist thought is already under reconsideration at home, making it all the more improbable that it will be adopted abroad.

We have, then, two national organizations of women concerned with research and policy: the National Women's Studies Association and the Association for Women in Development. As aspects of the women's movement, these organizations share the fundamental beliefs of egalitarianism and individualism. While they have different substantive bases, both groups also support demands for increased employment opportunities for women in their respective fields. Embedded as it is in academia, Women's Studies seeks to legitimize theory and scholarship about women; Women-in-Development, on the other hand, wants to influence policy and programming and so emphasizes pragmatic research and field experience. To this extent, the differences between the two groups is similar to those between many other organizations that divide over the academic versus the applied.

In addition, however, are the value perceptions of the two groups. Women's Studies, as the inheritor of early feminism, continues to espouse the early feminist interpretations of egalitarianism and individualism. As a group they tend to ignore criticism on the grounds that alterations of the basic philosophy will weaken the movement, and to be intolerant of those who suggest modification. Women-in-Development is founded on the premise that any theory based on national experience travels poorly; it seeks to moderate the impact of socio-economic development on women in the name of social justice. As a group, WID adherents accept local definitions of the balance between the individual and society and try to work within local definitions of women's roles.

These different approaches may be seen more clearly by referring briefly to several recent issues which have divided adherents of these two groups.

Infant formula. For some years, feminists in the United States have inveighed against the advertising campaigns of international conglomerates to convince women in developing countries to stop breast-feeding and use infant formula instead. In particular, they attacked Nestle's tactics of sending saleswomen dressed as nurses to visit newly delivered women in the hospital. Incorrect use of the formula has led to many infant deaths; sterilization of feeding bottles is obviously difficult under sanitary conditions prevailing among all but the affluent in most developing countries. Incorrect measuring

or purposeful ekeing out of the powder over long periods of time leads to malnutrition. The problem is particularly acute in Africa, where commonly inherited lactase deficiency means that babies cannot digest cow's milk and its use in formula leads to severe diarrhea. Boycotts led by American women were largely responsible for creating the publicity that led to the passage by the World Health Organization in 1981 of a set of guidelines which spelled out acceptable advertising methods.

The intent of the boycott was to stop all export of the formula to developing countries. Women in those countries were increasingly critical of this effort, for they saw no concerted attempt in the United States to prohibit the sale of the formula. They argued that women had to work to survive and they had to be able to bottle-feed their babies. Furthermore, many felt that allegations about incorrect use of the formula were attacks on the intelligence of women in their countries. They felt that instead of receiving support from women in the U.S., their interests were being subordinated to a theoretical international stand.[19]

Depo-provera This injectable contraceptive has been used in developing countries as part of the USAID-supported family planning program. It has many advantages over available methods: pills must be taken regularly, not easy even in the clock-tied U.S.; IUDs (intra-uterine devices) exacerbate vaginal infections and so are more hazardous in developing countries, where infection is more common and treatment less accessible, than in the U.S.; condom use must rely on the cooperation of husbands; diaphragms require a level of cleanliness not easy to attain. Perhaps the greatest advantage of Depo-provera is that one injection lasts three months and may be obtained on a regular trip to market; furthermore, husbands do not need to know—a not inconsiderable advantage in many male-dominated societies.

But Depo has not been licensed for use as a contraceptive in the U.S., tests reported in 1979 found the drug to be carcinogenic when taken in large quantities. There is strong opposition, particularly among a large sector of women in the health movement, to the sale overseas of this drug that is not acceptable in the U.S. itself. In addition, there is increasing concern in developed countries over the safety of chemical contraceptives in general and a widespread return to barrier methods. There is a growing worldwide demand for greater emphasis on developing male contraceptives. For all these reasons, the women's health movement has campaigned against the continued promotion of Depo in US-AID-funded programs.

On the other hand, statistics from Thailand, where Depo has been used for more than five years, do not indicate any undue hazard, according to proponents. They also point out that women in developing countries face greater risks from pregnancy than from the drug and that Depo presents no greater risk than the less effective pill.

Advocates of the drug feel that comparisons of risk between the U.S. and such countries are fallacious, that different standards must be recognized, and most particularly, that in countries where population explosion is a reality, Depo works and women like it.

This line of reasoning is winning converts, especially as retesting of the drug has cast doubt on earlier results which indicated high risk. At an international meeting in Geneva in 1980, sponsored by the international feminist journal ISIS, grassroots women's health groups decided not to pass a resolution against Depo after hearing the presentations of women from developing countries. In 1983, the U.S. Food and Drug Administration took the unusual step of arranging a re-hearing on Depo. The radical feminist Women's Health Network testified against the use of Depo, but the Women and Health Roundtable pleaded instead for careful monitoring. The FDA has not yet issued its ruling.

MULTI-NATIONAL CORPORATIONS

An economic phenomenon of the last decade has been the trend by multi-national corporations to move factories from the U.S. and other high labor cost countries to developing countries where labor costs are low and governments often grant tax advantages. Textiles and electronics have been particularly affected, industries that employ large numbers of women. Many feminists in the U.S. have condemned this movement of industries, both for the jobs lost to women here and out of concern for the women exploited in the developing countries. Multi-national corporations are said to seek a docile labor force and regulations in many free trade zones specifically prohibit union organizing of workers. Hours are long, the pay is low, and there is little job security, since management prefers to hire unmarried young women. Nonetheless, these jobs are eagerly sought after, particularly by young rural women who have few job alternatives to living in villages and working 10 to 12 hours a day at subsistence activities merely to survive. Furthermore, in most of these countries, women who marry do not usually wish to continue to work; as did the New England textile workers, they work to earn a dowry and then leave.

CONCLUSION

These three cases are prime examples of the many policy issues on which many American feminists have taken a view based on theory that does not accord with the reality of women's lives in developing countries as seen from these women's own perspective. In none of the cases is there an easy solution. It would be healthier if all women breast-fed their infants; but surely that must be an individual woman's choice. Depo-provera is by no means a perfect drug, but how can American feminists, with their demand at home of the right to control their own bodies, object to

allowing the same choice to women in developing countries? Conditions in most factories are onerous; women employees are undoubtedly exploited in the name of profits. But subsistence life is even harder; money is scarce and much needed. How can feminists who insist on equal employment opportunities object to the opening of more jobs for women in poorer countries?

I have argued that American feminism built its strength and persuasiveness on the basic American values of egalitarianism and individualism. The radical message of American feminists is that these values should apply equally to all women. In the ensuing debate it is clear that most American women and men have embraced the public application of egalitarianism: the Equal Rights Amendment has the support of the majority of citizens of the country. But equality within the private sphere of the family brought greater questioning, particularly as women began to demand legislation which was female-specific. Most Americans also support the concept of individualism. Feminists, by arguing that women have the same rights that men have, put individual women's interests before their families; or alternately, in the name of the family, they have underscored the weakness of a philosophy that does not temper individual rights with responsibilities to family and society. On the whole, American feminism

as expressed through Women's Studies has rejected any modifications to their clear stance: movements need ideology. To the extent that they claim for themselves the term "feminism," their views and values remain ethnocentric.

But the movement does not remain stationary. Indeed, the intellectual challenges posed by the feminist critique are producing some of the most exciting thinking of the century. Much of it is pointing in one clear direction: the fundamental tenets of current American beliefs must be reexamined, whether the research and ideas are coming from scientists, or theologians, environmentalists or Women-in-Development specialists. What all of these theorists and technical specialists are asking for is a reconsideration and revaluation of basic American beliefs. This requires scrutiny of the philosophical bases of contemporary industrial society, at home and abroad. In this respect, feminists are in harmony with the growing unease around the world toward the continuing export through development of these unexamined values. Change is inevitable, and necessary. But the goal should be societies where women have equal rights, where men and women can choose occupations and roles without gender limitation, where there is a reasonable balance between individual rights and support for the family, society, and the environment.

WOMEN IN WASHINGTON: ADVOCATES FOR PUBLIC POLICY. MY CHAPTER ON "WOMEN IN DEVELOPMENT"

It has been amply demonstrated that our current policy on development aid has tended to make the rich richer and the poor poorer; it is also clear that development aid has tended to have an adverse effect on women by undercutting their traditional economic activities and ignoring many of their traditional rights. Congress recognized the need to pay particular attention to integrating women into development plans when it included the "Percy Amendment" in the Foreign Assistance Act of 1973. This chapter recalls how a few women, aided by a propitious confluence of events, were able to design that amendment and have it signed into law, all within three months. The rest of the chapter focuses on the implementation of the amendment by U.S. agencies, and on its application worldwide, which has occupied the attention of the "women in development" (WI D) community since 1973. Women in development is the name given to the concept that development aid should reach and benefit women as well as men. People concerned with this particular issue focus on the impact of policy and programming on women in developing countries.

ORIGINS OF THE CONCEPT

During the 1960s, my college teaching included courses on development theory. Economists in those days saw parallels between the postwar reconstruction of Europe and the development of many countries in the Third World. It was assumed that sufficient capital applied to infrastructure projects would lay the groundwork for a "take-off" of the economy. As the gross national product increased, benefits would "trickle down" to the poorer citizens. Unfortunately, experience has proven that it was easier for these economies to take off (and in the process benefit those with resources and education) than it was to ensure that the fruits of development would reach the poor.

The development community, aware that a shift in emphasis was needed, introduced a series of amendments to the Foreign Assistance Act to provide "new directions" to the Agency for International Development (AID). They instructed AID to design programs responding to the basic needs of the poor, such as food, nutrition, health, and population information. At the time, little was said about women in any of the development theories. Assumptions were made that improved jobs for men

automatically benefited the family, that women's economic contributions were marginal, and that rural women and men were generally underemployed.

Today we know that all those assumptions were wrong. Furthermore, we knew in the early 1970s that the assumptions that these same economists were making about women in the United States were also wrong, and that the model of development used by development theorists was this country. (Let me note here that I too had never thought of women in developing countries as a separate category worthy of study.)

Political science is still a male-dominated profession; the American Political Science Association Committee on the Status of Women in the Profession, of which I was a member, had focused primarily on career opportunities for women, but not on more substantive issues. Advancement in the profession was certainly not to be gained by doing research on women. In my studies of the political process in India and Indonesia, I had interviewed women only if they happened to be politicians. It was not until 1972, when I returned to Indonesia on a fellowship, that I talked with women about their own lives. I had been asked by the U.S. Information Service to give several lectures on the new women's movement in the United States and I knew that I had to draw comparisons with women in Indonesia. The results of my random questioning appalled me. The traditionally strong role of Javanese women was rapidly being eroded. Even the women

who had participated in the independence struggle and had been rewarded with high government positions were now being pushed aside.

Back in Washington, I talked with other researchers and found that others had observed the same trends. In December 1972 we formalized ourselves as a working group of the Society for International Development (SID), a professional association of development planners. Since we were women in the development field who were already associated with SID, we began to call our group SID/WID. During the spring of 1973, we had frequent noontime meetings to develop our understanding of what was happening to women in developing countries. We learned that the AID agricultural extension programs in Africa, designed to help farmers to improve their crops, were staffed by men and aimed at men, even though the majority of farmers in tropical Africa were women. The government of Indonesia, using international funds, was encouraging large-scale textile industries, which was making it difficult for women to sell their home-crafted batiks. In Nicaragua, the government was trying to push the market women to the outskirts of town so that supermarkets could be built in the city market area. Meanwhile, family-planning doctors in Beirut treated women with such arrogance that it was no wonder the program did not have any effect.

What became clear was that economists were basically concerned with the modern sector, while most women's

activities in these countries were in the informal or agricultural sectors. Thus, their activities were not recorded in the statistics used for planning. In 1970, Ester Boserup brilliantly analyzed what little data existed in her book *Women's Role in Economic Development*, which identified broad, worldwide trends in women's work brought about by the introduction of new technologies and education.

As a result of our research and reading, we put together the first "women in development" bibliography, annotated and edited by Julia Graham Lear and Sushiela Raghavan. We also organized several panels at the SID meeting in Costa Rica in March 1973 and compared notes with participants from around the world. In June, at the invitation of Janet Welsh Brown, I participated in a Mexico City meeting jointly sponsored by the American Association for the Advancement of Science and the Mexican National Council of Science and Technology. These meetings gave us an opportunity to refine the concept of women in development and added to our growing international network. Since the United Nations had declared 1975 International Women's Year, with emphasis on equality, development, and peace, we were determined to raise the issue of the adverse impact that development was having on women and so try to change development policy.

The Percy Amendment

In September, the State Department scheduled a foreign policy conference for nongovernmental (that is, private voluntary) organizations. Virginia Allan, deputy assistant secretary of state for public affairs and the highest ranking woman in the State Department, had added many new women's organizations to the list of invitees. The purpose of the conference was to brief the audience on current U.S. foreign policy. In addition, Allan had added an agenda item concerning International Women's Year and asked Mildred Marcy to lead the presentation. Marcy had just returned from an around-the-world study tour meant to aid her in her position as head of women's programs at the U.S. Information Agency (USIA).

The official presentation took up most of the time allotted, but women in the audience wanted to continue the discussion and to participate, not just listen. They demanded and got additional time to present their views at eight o'clock the following morning. Various women's issues were brought up before a standing-room-only audience; my comments in particular related specifically to development. Marcy has since told me that this presentation was critical to her thinking about the need to include women in all aspects of development.

A follow-up staff meeting was called in Allan's office to discuss the action to be taken as a result of the conference. At the meeting, Clara Beyer, a venerable civil servant from the Department of Labor on loan to AID, asked Marcy if "something about women" could not be included in the proposed changes

to the Foreign Assistance Act. Because Marcy's husband, Carl, was chief of staff of the Senate Foreign Relations Committee, she knew its staff well and called Norvell Jones to request that a sentence on women be added to the authorizing committee report.

Marcy recalls what happened next: *I got to thinking that adding a sentence to the committee's report wasn't a very smart thing to have done. A report is just legislative history; there are no teeth in it. I had to wait in Carl's office one night rather late so I asked for a copy of the foreign aid bill and read it through. Then I sat down at a typewriter and typed up a final paragraph requiring that the New Directions mandate be implemented in such as way that it also benefited women.*

Because the president then in office was a Republican, Carl Marcy suggested that a Republican senator introduce the amendment. Scott Cohen, Senator Charles Percy's foreign relations assistant, liked the amendment. Realizing it would gain the senator support from the women's movement, he recommended that Percy introduce the amendment, and Percy agreed. Friday, October 2, 1973, was the final day for consideration of the bill. It was getting late and the debate continued. Percy, who was axious to catch a plane to Chicago, got up to leave. Bob Dockery, staff member of the Senate Foreign Relations Committee, rushed over and reminded him of the amendment and a short speech he had prepared for him earlier in the day. Percy returned, signaled for the floor, read

the amendment, and requested that the speech be entered into the *Congressional Record* without his reading it. By voice vote, the amendment was passed. The elapsed time was under five minutes. The entire bill passed later in the day.

Since the bill had already passed the House, it was sent to a conference committee to negotiate the differences between the two versions. The Percy Amendment was not in the House version. To focus some House attention on the issue, Arvonne Fraser decided that there should be hearings. An active politician and feminist, and subsequently coordinator of the AID Office of Women in Development during the Carter Administration, Fraser had also attended the State Department's foreign policy conference. Her husband, Representative Donald Fraser, was then in the midst of a series of hearings before the House Foreign Affairs Subcommittee on International Organizations and Movements concerning the international protection of human rights; he agreed to hold a session on the status of women on October 24, 1973.

Harriet Crowley, deputy assistant administrator of AID, strongly supported the Percy Amendment but was unable to present the official administration view, as one had not yet been developed. Carmen Maymi, then chief of the Women's Bureau of the Department of Labor, forcefully illustrated the problem of data collection when she noted that the rate of participation by African women in the work force was less than 5 percent! I spoke as a scholar,

as president of the Federation of Organizations for Professional Women, and as chair of SID/WID. Responding to Maymi's statistics, I reiterated the crucial need for improved data, documented the adverse impact that development was having on women, and suggested that the Percy Amendment could begin to address these problems.

Despite the hearings, the House members on the conference committee considered that the Percy Amendment was designed to placate constituents but not to be taken seriously; it was quickly dropped from the bill. Mildred Marcy was informed; she in turn called several women who had been at the State Department and congressional hearings; and the lobbying began. The conferees were amazed at the torrent of mail and phone calls urging support for the amendment and quickly put it back in the bill at the next meeting. Senator Percy himself has since remained a staunch advocate of the amendment, increasing its scope in subsequent, years and taking a similar resolution to the UN General Assembly in 1974. He also assigned Julia Chang Bloch, one of his aides on the Senate Select Committee on Nutrition and Human Needs, to oversee AID's implementation of the amendment. Bloch is currently an assistant administrator for Food for Peace and Voluntary Assistance.

Several factors contributed to the ease of passage of the Percy Amendment:

- The concept of women in development is substantively easy to understand. Reorienting foreign assistance to help the poor, which was the thrust of the "new directions" legislation, helps to make clear the importance of specifically including women.

- The amendment carried no appropriations. Foreign aid monies were attached to specific functions, such as agriculture, health, and population, so that adding the amendment did not increase the always-controversial funding level for foreign aid.

- The women who lobbied for the amendment came from mainstream or scholarly organizations. Thus, they were viewed by the members of Congress as moderate, respectable, and nonthreatening.

- Any expression of positive interest in a foreign aid issue by voters has greater impact, since most constituencies are perceived as being opposed to foreign aid.

International Networking

The lobbying, the hearings, and the State Department's foreign policy conference all combined to stimulate enormous interest in development issues among women. The State Department invited Arvonne Fraser and me to advise the U.S. delegation to the UN Commission on the Status of Women when it met in New York in January 1974. There, U.S. delegate Patricia Hutar, ably assisted by Shirley

Hendsch, a career civil servant, helped to increase worldwide awareness of the problems that development policy was causing women. Barbara Good, working in the United Nations Educational, Scientific, and Cultural Organization (UNESCO) section of the State Department, drafted a Percy-type resolution, which was passed by the UNESCO assembly at its annual meeting in November 1974 in Paris. Similar resolutions were introduced into most of the proceedings of UN agencies over the next year, from the UN Conference on Trade and Development to sessions on criminal justice.

In 1974 the United Nations also held two world conferences, one on population and one on food. At each conference, women formed an ad hoc group to draft and lobby for a resolution or a new paragraph or two to be included in the World Plan of Action that would relate women's work and responsibilities to the particular subject under discussion. The U.S. delegation at the Population Conference in Bucharest, Hungary, included Margaret Mead and Fran Hosken, later founder and editor of the *WIN Newsletter.* Page Wilson, a Washington author, drafted a similar insertion for the World Food Conference held later in Rome. Our network has subsequently added resolutions to documents passed by UN conferences on habitat (1976), water (1977), desertification (1977), agrarian reform and rural development (1979), science and technology (1979), and new and renewable sources of energy (1981).

The international focus for most women during this period was on the two UN conferences for women, one in Mexico City in 1975, and the other in Copenhagen in 1980. U.S. activities for UN conferences are coordinated through the State Department. In 1973, the State Department funded an independent U.S. Center for International Women's Year (IWY) to serve as a stimulus to nongovernmental activities. Ruth Bacon, a retired career foreign service officer, served as director. In 1974, Mildred Marcy was assigned to the State Department to serve as coordinator of the Secretariat of IWY; Catherine East became her deputy. The same staff also supported both the Interdepartmental Task Force for IWY and the National Commission on the Observance of IWY.

At the IWY Conference in Mexico City, women from every part of the world came together for the first time to discuss women's issues and to produce a World Plan of Action. While much of the official meeting was taken up by debate on generic international issues instead of the plan, women delegates in the end forced the acceptance of the World Plan of Action without completing the formal discussion.

Many more women, representing only themselves, gathered at the nongovernmental meeting, called the International Women's Tribune, to participate in a kaleidoscope of panels and workshops on women's issues. The networks formed then have been nurtured by the International Women's Tribune

Center, setup, as was the tribune, by Mildred Persinger of the Young Women's Christian Association. Many women's organizations sent members from around the world; some sponsored women from less developed countries. In particular, the National Council of Negro Women funded a group of African women who attended the tribune and then toured less developed parts of the American South.

Because there had been no experts meeting prior to the UN conference to discuss women in development, I convened a seminar on Women and World Development in Mexico City the week before the conference. Sponsored by the American Association for the Advancement of Science, and co-sponsored by the Mexican National Council of Science and Technology, the UN Institute for Training and Research, and the UN Development Programme, the seminar brought together 95 participants from 55 countries representing the academic, practitioner, and planning communities. The seminar corroborated and expanded our knowledge base, which detailed the adverse impact that development was having on women. Several participants were also members of official delegations to the UN International Women's Year Conference in Mexico City. Hence, many of the seminar recommendations were incorporated into the World Plan of Action for International Women's Year.

After the IWY Conference, the United Nations declared 1976-1985 the Decade for Women. To sustain the pressure on national governments to implement the World Plan of Action, which specified a greater role for women in all governmental activities and programs, the United Nations called a World Conference of the Decade for Women in Copenhagen in July 1980. The debate at the official conference was once again dominated by current UN controversies, which spilled over even more than in Mexico City to the nongovernmental meeting, this time called the Nongovernmental Organizations (NGO) Forum. Women were not only split over the substance of issues concerning the Middle East controversy and apartheid; they also disagreed about whether such issues should be discussed at women's conferences.

As 1985 approaches and plans are made for a UN world conference to review and appraise the progress made during the Decade for Women, questions about preferred strategy again arise. American women have taken the lead in proposing a preconference assembly where women from the developed countries could explore and address their particular concerns. At this assembly, issues of women in the industrialized countries would have equal footing with those of women in developing countries, bringing a better balance to the consideration of women in future years.

Administering the Percy Amendment

Once the Percy Amendment was passed,

AID set up a task force to recommend how best to implement the directive. Many of the questions asked then continue to be debated. For example: (1) Should there be an independent women-in-development office with its own funds? (Pro: Money is clout. Con: The rest of the agency will do nothing for women if there is a "women's fund.") (2) Should a women-in-development coordinator monitor all projects or select a few areas that make a difference to women? Also, should all projects carry an "impact statement" relating to women? (Pro: All issues relate to women as citizens and as females. Con: Women's issues are a dead end for serious professionals.)

Answers to these questions relate more to bureaucratic procedures and mentality than to substantive issues. At AID, the Office of Women in Development began largely unfunded and attached to the administrator's office. It was subsequently made a division of the planning office, where it has its own budget, as well as oversight of another $10 million. This funding was mandated by legislation in 1978. At that time, Connie Freeman of the Senate Foreign Relations Committee and Margaret Goodman of the House Foreign Affairs Committee had staff responsibility for oversight of the Office of Women in Development at AID. Still, the monies available to this office are tiny in comparison to the agency budget; all parts of AID must respond to the amendment for changes in programming to be significant. One way to require agencywide attention to women-in-development issues is by mandating periodic reports from AID to Congress on successful programming. The most recent report was submitted early in 1983.

The AID task force recommended that an impact statement be supplied for each new project in order to persuade project officers to think about the different effects that any particular program might have on men and women. Unfortunately, because of the pressure of paperwork, a pro forma response is typical. Case studies of projects that have aided women are now being prepared with funding from the current coordinator, Sarah Tinsley, who sees this process as an alternative way of convincing planners of the efficacy of including women in projects.

While women in development was conceived as a substantive issue, it is widely assumed that women are better at understanding that issue than men. For this reason, some have perceived it as an affirmative action program, a perception strengthened by the appointment of the AID equal employment opportunity officer, Nira Long, to be the first coordinator of the AID Office of Women in Development. This perception, which is still with us, has made it difficult to staff the office, or similar ones created in the regional bureaus and missions overseas, with career civil servants. The assumption that women in development must be an advocacy activity and not a substantive development issue has not yet been dispelled.

This tension between women's issues and professional outlook is, of course, not limited to international development planning.

The response of women in Washington concerned with women in development has been to create organizational support for the concept (and the office) outside of the bureaucracy. The Coalition for Women in International Development was set up in 1976 and is housed at the Overseas Education Fund. On Capitol Hill, women representatives of national religious agencies formed a subcommittee on women and development. More recently, the Association for Women in Development (AWID) has been organized to provide permanent contacts between women in Washington and those on college campuses throughout the country. The first national AWID conference, to be held in October 1983, will celebrate the tenth anniversary of the Percy Amendment.

Arvonne Fraser, the coordinator of the AID Office of Women in Development during the Carter Administration, played a significant role in developing this outside support network and in funding the many new groups of women and men interested in this field. In particular, her support for women at the land-grant universities has greatly expanded the circle of women and men aware of the need to break down data by sex if the actual impact of development programs is to be assessed.

CONCLUSION

The thrust of strategies to achieve gender equity in development planning and implementation has been aimed at current practices of bilateral and multilateral programming. While the predominant targets for change are the donor agencies, a strong constituency outside of government is a necessary component of this approach. Of great importance are the various coalitions and working groups that are constantly interacting with members of Congress and their staffs, and with economic planners at the national and international level. New information is critical in the fast-changing panorama of development, but it must be cast into a usable form if the ideas are to reach policymakers. To provide women in development with a focal point and to perform this interface function, I set up the Equity Policy Center (EPOC) in 1978.

Documentation for EPOC policy papers is derived from academic studies and penetrating insights, from anecdotes and studied observation. Constant tension exists between academics and policy analysts, between the scholarly research of one group and the applied research of the other; there is just as wide a gap between bureaucratic decision makers and policy practitioners. Standing between the fieldworker and the academic, the advocates of women in development have tried to provide a bridge between the two. To the bureaucrats, we summarize the policy implications of the growing literature

concerning the reality of the lives of women and men in developing societies. To scholars, we reflect the need for relevant studies completed in a timely manner. All three groups—practitioners, researchers, and policy analysts—will come together in our new network, the Association for Women in Development. Together, we hope to change the stereotypes that too many planners continue to hold about women.

A TRIBUTE TO ESTER BOSERUP: UTILIZING INTERDISCIPLINARITY TO ANALYZE GLOBAL SOCIO-ECONOMIC CHANGE.

ESTER BOSERUP WAS A TRULY ORIGINAL scholar who challenged many prevailing economic development theories and became the guru of the women and international development movement. As such a towering scholar, she is more often quoted than read. Most people recall one or two ideas from her works and overlook her many other insights. She wove her examination of agriculture, technology, population, and women into a unified model that strengthened her analysis of the separate disciplines. Not only does her model provide insight into current trends, but her penetrating analyses have often anticipated contemporary debates. For example, her stance that food subsidies had a negative impact on agriculture has been a recurrent theme since she wrote about Denmark during World War II. Her observations that improvements in women's health and education were perhaps the best ways of achieving family planning were noted at the UN Population Conference in Bucharest in 1974 and anticipated resolutions made at the UN Population Conference in Cairo in 1994. Above all, Boserup demonstrated the interrelationship of technology change on the farm, in cities, or in factories with socially constructed roles for women and men, children and the elderly.

Up to the end she continued to elaborate on her model of development. Only two days before her death on September 24, 1999, at the age of 89, she had completed an essay for the *Encyclopedia of Global Environment Change.* Ivan Boserup, her younger son, wrote to her friends: "She was happy she had managed to write and publish *My Professional Life and Publications 1929-1998,* where she has stated in concise form what she found most important to stress in her own and in future research within the social sciences. 'More interdisciplinarity!' could have been her last words." The cover of this intellectual autobiography reflects this mantra: it shows a circle with topics around its edges all connected by arrows: culture, environment, technology, population, occupation, family.

Before utilizing her own commentary to trace the evolution of her ideas and to discuss the impact of her work, I should like to place her writings into the context of her life and times, piecing together facts gleaned from our conversations over the years. In keeping with

her reserved, even austere, personality, Ester summarizes her intellectual journey, noting the influences of her professional work and world events on her ideas, but she characteristically omits any personal reflections about combining work and family or about being a woman in a predominantly male profession. Nor does she mention her status as the savant and theorist for those of us studying woman's role in economic development. Indeed, I think Ester was bemused by all the attention and veneration she received from global feminists.

FORMATIVE INFLUENCES

We all know that women's rights and autonomy have certainly not progressed in a linear fashion throughout history. Like the rise and fall of empires, women's roles have altered as the predominant cultures or beliefs have constructed women's lives to suit their purpose. The 1920s were a time of wrenching political changes on the European continent following World War I. Contending theories of socialism, communism, and democracy all nominally acknowledged women's equality with men. Universities were open to the talented as well as to the traditional elites; a good degree provided access to intellectual circles where women were more accepted as equals than they were among the middle and lower classes in what were still stratified societies.

Ester Borgesen was born in Copenhagen on May 18th, 1910, the only daughter of an engineer who had risen to a director of a major power company. Her father, son of a textile entrepreneur, died of diabetes when Ester was two; shortly thereafter an upheaval in the textile industry wiped out the family's investments. Further, the power company deprived her mother of her widow's pension. Desperate, her mother moved into a flat with her mother and her brother and his wife; she learned hairdressing and embroidery to support herself and her daughter. Education was valued in her family; her great-grandfather had left farming for school teaching. Encouraged by her mother and aware of her limited prospects without a good degree, Ester studied diligently and entered the university when she was nineteen. No wonder that Ester championed education for women throughout her life.

During university, she married Mogens Boserup when both were twenty-one; the young couple lived on his allowance from his well-off family during their remaining university years. In 1935, Ester graduated with a degree in theoretical economics tempered by studies in sociology and agricultural policy. Her choice of a multi-disciplinary degree presages her intellectual path. She writes:

> From the very beginning of my university study of economics, the structural problems of human societies had imposed themselves on me by the contemporary world conditions: I began the University in the autumn of 1929, when the New

York stock market crashed, and when I left we were still in the middle of the Great Depression of the thirties. Against this background, the prevailing theories of equilibrium and marginal utility seemed irrelevant and –like many of my fellow students – I looked for alternatives (1999:9).

This search for alternatives led to her membership in a socialist intellectual debating group and governed her choice of two divergent topics for the two research papers required for the degree. She wrote on the American Institutionalist School and on The Marxian Theory of Crises. Even at that young age her ideas were insightful; the paper on Marx was widely circulated and led to invitations to participate in scholarly meetings. The year following her graduation she published her first article that compared Keynes' theory of 'propensity to consume' with Marxist theory of underconsumption. Already her unconventional views were attracting attention.

Refusing to be constrained by the conventional wisdom of the day, Ester consistently looked for alternative approaches to existing problems. She worked for the Danish government from 1935 until 1947, an unsettled period that encompassed the depths of the depression, World War II with its German occupation, and the postwar recovery. As head of the planning office, she was involved with trade policies and observed first hand the effect of widespread government subsidies on Danish agriculture. When she and Mogens moved to Geneva in 1947 to work with the newly created UN Economic Commission of Europe (ECE), her work again focused on trade, much of which, as in Denmark, was in agricultural products. In later years she wrote extensively on the issues of food aid and its disastrous impact of agriculture in Africa. Also while working for the ECE, Ester began to wonder whether the low rate of industrial growth in France might be related to its low population growth. Already the interrelationships between agriculture, population, trade, and industry were churning in her mind.

In 1957, she and Mogens agreed to work with Gunnar Myrdal, a senior researcher at the ECE, on a joint project assessing the future of India that was funded by the Twentieth Century Fund. Economic development assistance was at its zenith; western models of development were in ascendancy; and India was the experiment. Few people, Indian or western, questioned the validity of the prevailing theory; indeed, most of the economists in the Indian Planning Commission were western trained.

But Ester held to her critical gaze. Traveling about the country, Ester decided that what she had learned about agriculture in the west did not fit the Indian situation. She observed women working in the fields, noted the agricultural impact of various forms of tenure, and learned about the flexibility of agricultural labor. All this made her

question many of the western-based assumptions about agricultural production, particularly the theories relating to surplus labor, population density, and migration. Such observations provoked an increasing skepticism of the entire project with Myrdal and a realization that the evaluations of the situation in India held by Ester and her husband increasingly diverged from those held by Myrdal. So after completing the chapters required by their contract, Ester and Mogens declined to continue with this long term project and returned to Copenhagen. Myrdal finally published his massive and influential *Asian Drama* in 1965.

After returning from India, Ester did not hold a permanent job again, but rather preferred to combine consultancies with her research and writing. Mining the libraries in Denmark and at the Food and Agriculture Organization (FAO), she substantiated her Indian observations and sharpened her understanding of the interrelatedness of economics, agriculture, population, migration, technology, land use, and gender roles. Explaining these relationships and their implications for women and men became Ester's life work, and interdisciplinarity became her creed.

Family life During this period, Ester also became a mother. Her daughter, Birte, was born in 1937; her sons Anders, in 1940, and Ivan, in1944. When the children were young she was able to work parttime even though no such provisions were generally available. By the time Ester went to India, Birte

had begun study of art and interior design in Switzerland, and soon married an Italian-Swiss lawyer who is now a judge on the provincial high court. Anders finished his schooling in Switzerland and then went out to India for a year before becoming a physicist; later in his life he returned to international work participating in peace research and the UN Disarmament Commission. He died in 1990 of a heart attack. Ivan had more international exposure: he was enrolled in a New Delhi school for two years and went to Senegal with his parents in1964-65; he is currently a classicist and research librarian with the Danish Royal Library. When the sons married, they made Copenhagen their home. Ester resided there until after her husband died, then moved in 1980 to Switzerland where she lived in the summer house she and Mogens had purchased when they worked in Geneva, and which was minutes away from her daughters home.

Ester seldom discussed her children and did not acknowledge any conflict between career and family. That comes as no surprise to me. I never carried pictures of my family; never talked about the problems of *au pairs* or maids with any but my closest friends. Working women simply managed; we were super-moms who believed we were equal despite the double burden. Ester was heavily invested in her career. She lived the life of a feminist, but as many young women today, she did not identify with the word. She considered her theoretical trilogy a single concept, uniting all

aspects of her research into her model of economic development. I think she was genuinely moved, and not a little surprised, by her elevation as an icon of women and international development.

THE BOSERUP MODEL

The important intellectual contributions made by Ester Boserup provided a legitimacy to the growing women in international development movement. She presented an overarching theory that addressed major debates of the day regarding economic and social development and challenged prevailing paradigms. She produced three seminal books over a period of sixteen years that announced, expanded, and detailed her concept of economic development. Much more than the gurus of early economic theory who propounded the take-off approach, she rooted her ideas in multi-disciplinary literature and field research. In doing so, she observed the roles of women in the economies of subsistence and developing societies, roles well understood locally but at the time seldom documented except by anthropologists. For many of us, her genius was the way she integrated women into her fundamental theory of economic change.

Ester Boserup's broad view of development also meant her ideas about women became influential outside the often narrow field of economics. In similar ways, Amartya Sen today breathes respectability into much research on women. Both utilized a broad range of published and unpublished reports, articles, and books written largely by women, to document their conclusions. At a time when much women's research is still regarded as marginal by the priests of academia, the importance of having these two towering scholars on our side is inestimable. The fact that both Boserup and Sen wrote chapters for my edited book *Persistent Inequalities* helps explain its continued use in universities around the world.

Boserup's model for economic development is based on extensive historical research. She argues that population densities compelled early societies to invent agricultural technologies in order to increase food production. New agricultural systems in turn required adaptations in the social structure, altering family work obligations and gender relationships. Changing agricultural methods affected the environment, as well. Increased food production, that resulted from improved technology, also fostered urbanization where social systems underwent even greater adjustment.

Agricultural change Ester Boserup first stated her development model in *Conditions of Agricultural Growth* that appeared in 1965. Rejecting the idea of static primitive societies that modernized only with exogenous technology, Boserup argues that such societies, under pressure from population growth, invent their own technologies to increase food production. More people means that existing land must be farmed more intensively as earlier

systems, so long fallow rotation is replaced with short fallow periods. These changes required more labor input into farming, though no one worked very hard. Gradually the forest became grasslands which required the application of nutrients and the turning of the soil. Long fallow systems demanded little weeding; men cleared the land and women grew the food. Women began to weed the fields as shorter fallow periods pertained. Increasing population density led to more intensive agricultural systems using animal draft power and plows, and the substitution of common land for private ownership. Under this farming system, men had to spend more time growing food although women continued to do much of the labor. These historic stages are familiar to readers of Boserup's books, as are the implications for social structure; but Ester warns these changes are not predictive of the future without study of technologies still in the pipeline (1981).

Less familiar are her theories of urbanization. Food surpluses allowed the expansion of town centers. But these surpluses might be the result of many producers rather than new technology; hence towns could grow prior to technological innovation. However, for towns to grow, they needed adequate transport for trade (1990:87). This gradualism which Boserup documented in her research into ancient, European, and American growth patterns became dislocated, she argued, with the abrupt introduction of modern technology into areas lacking requisite infrastructure or cultural receptivity. For these reasons, the introduction of modern farming techniques, such as the Green Revolution, has had very different impacts in Asia and Africa. With its limited infrastructure and sparse population, Africa benefitted little from the new technologies in comparison to Asia which had adequate transport, trained extension workers, and rural amenities. Continued low agricultural productivity in Africa led many governments to seek development agencies to provide imported food for urban areas. These staples were sold at subsidized prices, thus further reducing incentives for food production. "The assumption of inelasticity of food production...made large-scale transfer of food from industrialized to developing countries look like a desirable solution to the agricultural problems of both the developing and developed countries" (1990:281). Farmers leave the land and crowd into rapidly expanding urban agglomerations where misery reigns.

Population increase Boserup's theories about population growth also challenged contemporary wisdom. When she published *Population and Technological Change* in 1981 she reiterated the theory first presented in *Conditions of Agricultural Growth*: with the new book she sought to broaden and deepen the theory, discussing the causes as well as the effects of population increase.

In the 1960s, the theories of Thomas Malthus dominated population policy: because people were

increasing geometrically while food was increasing arithmetically, land for cultivation would soon be exhausted and starvation, wars, or pestilence would ensue. Boserup argued that Malthus saw the world as static; she believed that population densities would result in new technologies that would increase food production on lands currently in production. Dense populations were also necessary if roads, schools, and health clinics were to be provided in remote rural areas. Population growth was therefore necessary for economic development.

In the introduction to Boserup's collected essays, T. Paul Schultz remarks that Boserup in effect stood Malthus on his head. "The historical record remains sufficiently varied and uncertain, so that neither the model of Malthus nor that of Boserup explains adequately all the evidence. But the last two decades have moved the mainstream interpretation of this process in the direction proposed by Boserup" (1990:2).

Boserup expounded the importance of population growth to economic development, but she also argued that women's ability to determine "when and how often to bear children" is a decisive element in women's efficient participation in the development process (1975:26). To accomplish this, women needed access to education and health services. Active at the first UN World Population Conference in Bucharest in 1974, her views were incorporated in a consensus resolution declaring that an improvement in women's status and

educational opportunities would promote women's health as well as a reduction of birth rates. Such an approach was important "regardless of whether the over-all situation is one of strong pressure of population on resources or an insufficient population base for development (1975:26). Further, she noted how traditional methods of spacing were often discarded during economic change leading to higher fertility per woman and often increased maternal and infant morbidity and mortality ("Population, the status of women, and rural development" 1990:161-174). The importance of women's health and education to population programs was reiterated and expanded in 1994 at the Cairo UN Conference for Population and Development by a global coalition of women's organizations.

At the 1984 UN population conference in Mexico City, the U.S. population policy, influenced by Christian conservatives, did a flip-flop away from strong support for funding international family planning programs. Intellectually, US policy drew on the writings of Julian Simon and his uncritical support of technology as *the* answer to population pressures. Boserup was sometimes incorrectly associated with his views. To clarify the distinction, she emphasized that her model distinguished between endogamous technology, that was a creative way to increase food productions, and exogamous technology, that is too often introduced to cultures not yet motivated to accept the changing systems. Inappropriate or

abrupt technology often has a destabilizing impact on culture and economics. Further when modern technologies are transferred wholesale to low income countries, as happens with globalization, international trade is affected. High wage countries maintain or increase subsidies for crops and products to maintain competitiveness with lower income countries despite calls for free trade; many firms move to low wage countries "with the result that structural unemployment has become a serious problem in many high wage countries" (1999:42). These trends are at the heart of the controversies at the World Trade Organization.

A THEORETICAL BASE FOR WOMEN IN INTERNATIONAL DEVELOPMENT

Ester Boserup's book on *Woman's Role in Economic Development* was first published in 1970, five years after her *The Conditions of Agricultural Growth: The economics of agrarian change under population pressure*. When the latter book was in press, she spent a year in Senegal where Mogens was directing the UN Institute for Economic Development and Planning. Traveling widely in Africa on various UN contracts, Ester explored linkages between industry and agriculture and investigated the predominantly male migration to cities. Ester wrote that she was "intrigued by this unexpected (for me) pattern" where women grew the food and men sent home part

of their earnings, and determined to study women's roles in economic development. "Knowing that this was a controversial issue, I wanted it to be a solid study, based on official statistics." Obtaining a research grant from Denmark, she returned to Asia as Africa to interview local officials and collect case studies that more accurately reflected women's work than the usual labor statistics. She delighted in commenting that her book contained 12 figures and 64 tables, and cited 258 sources (1999:24).

Throughout her book, Boserup is interested in occupational distribution; her first sentence states: "A main characteristic of economic development is the progress towards an increasingly intricate pattern of labour specialization" (1970:15). She further emphasizes that the division of labor within the family is assigned by age and sex, and this distribution varies across regions and cultures. Criticizing generalizations made by Margaret Mead that men are the providers of food while women prepare it, she distinguishes between male and female farming systems.

Women farmers Only the first third of her book is an examination of women's roles in these various farming systems, though this is the section most often quoted as it makes women's subsistence and farm work visible. Women's economic worth is related to their status: bride price is paid where women work in the fields; a dowry is offered to convince the groom to accept a non-working wife. Where women farm and men can purchase their labor and

where land use rights can be expanded, polygamy continues. Cultural practices appear to trump religion in this regard for the most of the countries with high levels of polygamous households are in West Africa. In Muslim areas where dowry is the rule, the incidence of polygamy is largely confined to the wealthy. In these areas of male farming, upper caste/status women are in seclusion but women from the lower classes frequently work as casual laborers, an occupation that emphasizes the economic costs of female seclusion.

Boserup devotes an entire chapter to describing the loss of women's status under European colonialism. Two of her points stand out: first, the promotion of land ownership deprived women of use rights in areas of Africa and South East Asia, and second, the belief that men were superior farmers encouraged the introduction of technology and cash crops to men, especially in Africa, thus leaving women to continue using traditional low yield methods for growing subsistence crops. Both actions continue to have current repercussions. Land rights and ownership have become highly contested, especially in Africa where bride price custom continues. In countries such as Rwanda or Uganda, where wars and/or HIV/AIDS have left grandmothers as the primary providers for their extended families, women's right to control her own farm land is now being recognized. On the second point, insufficient attention to subsistence food production in Africa is a primary cause for the decline in per capita food availability throughout the continent.

Women in towns Boserup distinguishes between female and male towns as she distinguished farming systems. Female towns are centered on markets where women dominate the trade. Male towns are of two types: they may have a surplus of men in the population or they may be towns where women are in seclusion and therefore unseen. A semi-male town is one where women dominate the traditional markets while the modern sector is exclusively the domain of men. Further, most towns include migrants of ethnicities whose cultures diverge regarding women's occupations.

Market towns trade both agricultural and non-agricultural commodities. Because historically women produced many of the household products they needed, increased opportunities for trade encourages specialization. Products may originate in rural areas but trading is done in towns. Women and men also offered their tailoring and food at markets. Boserup called this activity the "bazaar and service sector" which was a more focused concept than the more widely used residual category "informal sector." Her category is more accurate, for when the International Labour Organization (ILO) studies looked at the informal sector they were searching for small enterprises that hired workers. This classification effectively screens out most women or family run microenterprises, such as street food vending, or home-based work, or urban agriculture. Boserup notes that

many women prefer such work to factory jobs because it more easily mesh with household responsibilities. This is also true of other economic activities that women can conduct from home.

The impact of higher education on women's occupations reveals continued discrimination by sex. Ester attributes the "polarization and hierarchization" of men's and women's work roles to the maldistribution of technology between them. But she also notes how the age-sex-race-class hierarchies play out differently on different groups of women and often reward some occupations while increasing discrimination against women in other (1970:140).

Broadening the audience As soon as *Woman's Role* was published, the Danish Broadcasting Company presented Boserup with a prize that entailed popularizing her book through six radio broadcasts. As a result, she was included on the Danish delegation to the UN. In 1972 she began an eight year membership in the UN's Committee of Development Planning. This in turn led to her appointment as rapporteur to the first UN experts meeting that addressed the issue of women in international economic development.

This experts meeting marked the first attempt by the of the Social Development Division of the UN Department of Economic and Social Affairs to focus on the roles of women in development or for the co-sponsor, UN Commission on the Status of Women (CSW), to address economic development issues as framed by the documents proclaiming the First Development Decade 1960-70. The original topic of the 1972 consultation was to be on welfare and status of women, according to Gloria Scott, then head of planning of the Social Development Division. She argued that "welfare and status were empty concepts without development" and persuaded her former professor, Sir Arthur Lewis, to chair a group of noted economists to address this issue. "Constant vigilance," she wrote, "was needed to retain the development focus which this meeting anchored in discussions about women." ("Breaking new ground," in Arvonne Fraser & Irene Tinker eds., *Developing Power.* 2004)

Development as a women's issue Ester Boserup's report of this Experts Meeting provided the UN with documentation that development was indeed a women's issue. Women's issues had been assigned to the Commission on the Status of Women (CWS) in 1946, a year after the UN Charter was ratified. Leaders of international women's organizations lobbied for their own space at the UN where women's issues could be raised. From its formation, CSW had focused primarily on women's civil and political rights, including labor rights, and on educating women. During the Cold War era, the communist countries argued in the Commission on Human Rights that economic rights such as housing, food, and employment were of equal importance with political rights, but this view was not reflected in the CSW. Developing country membership

increased in the UN as most colonies became independent; these countries lobbied for more attention to development issues causing the decade 1960-1970 to be declared the First Development Decade. Only during the Second Development Decade 1970-80, however, was the link made between women and development as a result of the recommendations of the Experts Meeting.

Also in 1972, the General Assembly finally passed a resolution declaring 1975 International Women's Year (IWY) after many years of requests from the CSW. During the debate, the themes of the year were articulated as equality, peace, and development: equality for the west, peace for the east, and development for the global south. At first, IWY was designated simply as a year, but the reinvigorated women's movement, especially in the United States, influenced their governments to support a World Conference for IWY which subsequently took place in Mexico City in June 1975.

Connecting with the women's movement Women globally were observing governmental policies that discriminated against women. Despite the fact that most newly independent countries gave women equal citizenship rights in their constitutions, prevailing customs allowed male dominance. In the US, the women's movement grew in strength and demanded equal wages, equal educational opportunities particularly to professional schools, access to credit and mortgages, and so on. Women in newly independent countries

wondered what happened to the nationalist rhetoric that promised equality for women and men. Deterioration rather than improvement of the status of women was observed in many countries. All of these trends were noted in Boserup's trenchant observations that utilized many studies by anthropologists and policy makers to substantiate her conclusions.

During this tumultuous decade, women organized in many countries to change development programming and social policies of their governments. The evident scholarship of *Woman's Role* and author's impressive credentials as a mainstream economist provided the burgeoning community of women in international development proponents with a convincingly academic reference. Once the awareness of Boserup's writings became widespread, her theories became the scholarly foundation of the women in international development.

As the second wave of the women's movement expanded around the world, the issue of women's roles in economic development programming gained momentum. Inga Thorsson had persuaded the Swedish Parliament to mandate government support for women in its foreign assistance programs as early as 1964. In the US Congress, a group of us feminists lobbied successfully for the inclusion of a paragraph in the U.S. Foreign Assistance Act of 1973 that directed administrators to integrate women into the new poverty-focused programs. This paragraph was subsequently included in resolutions for many UN agencies as

well as in the General Assembly, as these bodies began to anticipate the upcoming IWY. The activists and administrators who promoted greater visibility for the issues of women and international development found in Ester Boserup's book the statistics and trends that gave credence to their demands for a policy shift. Funds were short for the preparation of the 1975 UN World Conference of International Women's year. The 1974 population conference had held a series of preparatory meetings including one that focused on women and population. Reports and papers prepared for that conference added to the sparse literature that documented women role in economic development. Recognizing the importance of her contributions to the field, the UNDP asked Boserup to summarize her major viewpoints in a short pamphlet for the IWY conference; with assistance from Christina Liljencrantz, she wrote *Integration of women in development: why when, how*. Distributed in Mexico City, this pamphlet provided delegates to the IWY Conference with information to strength the conference document, the Plan of Action, regarding women and development.

A second activity that helped publicize both the topic and Ester's major contributions was the Seminar on Women in Development held in Mexico City just prior to the IWY Conference. Sponsored by the American Association for the Advancement of Science (AAAS), and under my leadership, over a hundred women and men from around the world gathered to analyze development issues and propose recommendations to the UN. These materials were also distributed at the governmental conference.

Ester Boserup participated in the symposium; it was the first time we met. Subsequently we represented our respective governments on the newly created Board of the UN International Instituted for the Research and Training for Women (INSTRAW) and met as several conferences and UN Experts Meetings. Never reluctant to express her own point of view, Ester always amazed her audience with her breadth of scholarship and historical knowledge.

ESTER BOSERUP'S IMPORTANCE FOR ACTIVISTS, SCHOLARS, AND PRACTITIONERS

Rereading *Woman's Role in Economic Development* for this essay, I am once again struck by the range of topics discussed and the identification of many research areas not yet fully explored. At first, many of us utilized the Boserup model to argue for policy changes in international agricultural development programs. In the 1970s, most development assistance was focused on increasing food production in rural areas and reducing rural poverty.

For years, urban areas were perceived as less needy but planners. As rapid migration produced squatter settlements filled with families struggling to provide a livelihood for their children, more attention was given to

housing and to available employment in the informal sector. As noted above, the ILO studies focused on enterprises large enough to provide employment; for some time the microenterprises operated by a woman or her family were ignored or discounted. Today, Boserup's emphasis on the critical role that women's income from the bazaar and service sector plays in urban survival is now broadly recognized. Home based work in both rural and urban areas continues to provide millions of women with income; women at home are now being organized in both developed and developing countries for the purposes of more efficient enterprises, better wages, and health and retirement benefits.

Multidiscipilarity Scholarship has become so fragmented today; the flood of information on the internet tends if anything to continue this process despite hopes that easy access to data might help bridge the chasms among disciplines. Ester Boserup embodied the interdisciplinary approach; she also championed the use of scholarship to influence policy. Nonetheless, she warns that using monetary proxies for non-monetized transactions lead to false conclusions, although many publications, such as the *Human Development Report*, promote this approach in order to convince policy makers about the importance of social trends.

Often, she argues, government policy conflicts with economic change and uses the examples of powerful agricultural lobbies that demand subsidies when "the government should promote structural reform" (1999:29). Excess food production in high income countries was exported to support subsidized food in urban areas in developing countries; while perceived as humanitarian, this policy overlooked the impact on food production and employment in rural areas. Subsequent reduction of world food surplus through policies that limited production further exacerbated the food situation around the world. Arguing for more attention to increased production in rural areas, she argues that "As long as economic infrastructure is more, it is not possible to modernize agriculture" (1990:280).

Boserup criticizes formal economic models, widely used for development planning, as static. Analyses of land, labor, and capital may be sufficient for short term plans, but long-term development analysis must take account of structural change, i.e.*change of the capacities themselves,* by land improvements or deterioration, population change, by natural change or migrations, major changes in income distribution and political systems, etc. Moreover, long-term analysis must take into account the changes in those structures which economists usually leave to be studies by other scientific disciplines, for instance national cultures... Rapid technological change created conflicts with national culture through its radical influence on the way of life: Cultural attitudes and behavior, which may have been rational before, are no more so.... The importance of these problems for economic development is overlooked

by economists, when they make the assumption that rational behavior is the rule whatever the circumstances. (1999:58-9; 60).

Women and change The ebb and flow that result from economic changes on the relative status of women and men as analyzed through age-sex-class-race hierarchies is a central theme of the Boserup model. She examines the conflicts among generations of women her new introduction to the 1983 Spanish edition of *Woman's Role in Economic Development*. "Since the first edition of this book appeared in 1970," she recounts how such changes as greater "access to jobs in large scale industries and modern-type services, the rapid spread of female education, and the access to health services and family planning" have altered their life experiences. Some older women have supported patriarchal Islamic governments because they "have more to lose than to gain by improvements in the position of young women ."

And in her last letter to me, in July 1999, she reflected on contemporary trends with concern. "I think that today the greatest threat to women comes from the US neoliberal campaign, which if it succeeds in privatizing schools, universities, child institutions, and culture, will also 'reprivatize women in their homes.' I wonder how long the European governments can keep up their resistance against the American pressure."

I prefer to recall her words from a July 1996 letter written in response to complaints about the backlash against the women's movement globally. "I had never dreamt that there would be so (many) big changes in the position of both women and poor countries in my lifetime, and find it inevitable that such large changes will cause a lot of reaction and both short and long run counter movements. So don't become too gloomy a pessimist."

Conclusion For many women active in influencing policy both inside and outside governments and international agencies, the existence of a scholarly base from which to argue cannot be overestimated. For example, Vina Mazumdar, who coordinated the 1979 India Commission on the Status of Women report, recalled learning of the Boserup book only after the report was in press. Reading that book made her feel more confident of the conclusions and recommendations found in the report . Vina's rush of discovery and identification that came from reading *Woman's Roles in Economic Development* is an experience similar to my own. Clearly Ester Boserup's book legitimized and documented the many tentative ideas growing in the minds of many women as a result of observing the changes affecting women in the developing countries. Whatever your views of specific findings or analyses, the entire community of scholars, activists, and practitioners has benefitted from the Boserup model.

Books by Ester Boserup:
The Conditions of Agricultural Growth: The economics of agrarian change under

population pressure. 1965. London: George Allen and Unwin.

Woman's Role in Economic Development. 1970. London: George Allen and Unwin. Translated into Swedish (1971), Danish (1974), Italian (1982), German (1982), French (1983), Indonesian (1983), and Spanish (1993), the latter containing a new introduction by Boserup.

Population and Technological Change: A study of long-term trends. 1981. Chicago: U. of Chicago Press.

Economic and Demographic Relationships in Development. Essays selected and introduced by T. Paul Schultz. 1990. Baltimore MD: Johns Hopkins Press.

My Professional Life and Publications 1929-1998. 1999. Copenhagen: Museum Tuscularnum Press.

Integration of women in development: why when, how. With Christina Liljencrantz. 1975. NY UNDP. 42 pages

THE ADVERSE IMPACT OF DEVELOPMENT ON WOMEN

DURING MUCH OF THE LAST QUARTER century, "development" has been viewed as the panacea for the economic ills of all less developed countries: create a modern infrastructure and the economy will take off, providing a better life for everyone. Yet in virtually all countries and among all classes, women have lost ground relative to men; development, by widening the gap between incomes of men and women , has not helped improve women's lives, but rather has had an adverse effect upon them.

The major reason for this deplorable phenomenon is that planners, generally men —whether in donor-country agencies or in recipient countries – have been unable to deal with the fact that women must perform two roles in society, whereas men perform only one. In subsistence societies, it is understood that women bear children and at the same time carry out economic activities that are essential to the family unit. Western industrial societies have chosen to celebrate the child-bearing role, glorifying motherhood while downgrading the economic functions attached to child bearing and household care, and erecting barriers to paid work for women. Accepting this stereotype of women's roles, economic theorists in the West imbued their students, indigenous and foreign, with the cliche that "women's place is in the home," classifying them forever as economically dependent. In doing so, they followed the unequivocal depiction of women in the law as legally dependent minors. Small wonder that the spread of Western "civilization," with its view of woman as "child-mother," has had an adverse impact on the more sexually equal subsistence societies. Communist doctrineerrs in the op posite direction: women are economic units first, mothers second. Since children interfere with work, the government provides day care; but little has been done in the Soviet Union or Eastern Europe to encourage men to share the responsibilities of children and home. This leaves women two time-consuming jobs: full-time work plus daily shopping, cooking, cleaning, and care of the children in the evening. Not surprisingly, the result is a drastic fall in birthrates throughout Eastern Europe accompanied (at least in the Soviet Union) by an increased marital stability and a high incidence of alcoholism among men. Yet even in the societies, where doctrine asserts that women and men are supposed to be economic equals, employment data show that women hold the least prestigious

jobs. It may be that in these countries also, men "subtract" a woman's home and child-care responsibilities from her ability to hold down important positions. Whatever the explanation, it would seem women lose twice.

Development planners must begin to recognize women's dual roles and stop using mythical stereotypes as a base for their development plans. A first step is to recognize the actual economic contributions of women. Even this is difficult. Statistics, the "holy building blocks" of developers, are made of the same mythical assumptions: a) "work" is performed for *money*, and b) "work" is located only in the *modern* sector. Thus the U.S. Department of Labor can issue a statement saying that in Africa only 5 per cent of the women work! This clearly is an absurd assertion about a continent where women are reported to be doing 60-80 per cent of the work in the fields and working up to 16 hours a day during the planting season. The "explanation" for the 5 per cent figure is that agricultural work done by family members is not recorded as "work." Nor are exchange labor, household work, child care, or many activities in the tertiary or informal sector counted as work. And since statistics do not show women working, planners do not plan for women to work. Too often new projects actually intrude on activities in which women already are engaged; but instead of providing services or training to women, assumptions about proper sex roles dictate that *men* receive the

new training, new seeds, or new loans. The gap widens.

Unfortunately, this phenomenon of increased dependency of women on men is not new. The pattern has been repeated time and time again, whenever a given society developed beyond sheer subsistence and created a civilization which required functional specialization. Documenting the erosion of women's position in ancient Greece and Rome, for example, Evelyne Sullerot, has observed that "as a rule it is in the early periods of each civilization that the least difference exists between the position of men and that of women. As a civilization asserts and refines itself, the gap between the relative status of men and women widens." (*Women, Society and Change*, 1971:19) May Ebihara has noted similar "reductions" of women's status in Southeast Asia's past. She points out that a Chinese visitor to the Khmer empire in Angkor in the thirteenth century recorded that women held many positions in the court; yet within a century, due to the spread of Chinese influence after the fall of the Khmer empire, women were reduced to being legal minors of their husbands. ("Khmer Village Women in Cambodia," in Carolyn S. Matthiasson, ed., *Many Sisters: Women in Cross-Cultural Perspective*, 1974:305-48)

Historically, these bureaucratic states produced a stratified society with the higher classes living in towns. It seemed to follow inevitably that women, separated from their essential food production functions, became

more dependent upon men, especially as upper-class men commanded large incomes and generally adopted a more ostentatious style of living. Women lost their economic base and came to be valued mainly for their female attributes of child bearing and providing sexual gratification. Thus they increasingly came to be "protected" or "confined," perceived as "jewels" for men to play with or as vehicles for perpetuating the family line. However, they were then also perceived –accurately – as *economic liabilities*. In subsistence societies, where women are a valuable economic commodity, a man pays a bride price to the bride's father to buy her services; in societies where women have lost their economic function, the exchange of money is reversed, and the bride's family pays the groom to accept her.

Recent studies recording women's roles in subsistence economies show a panoply of traditional roles, both economic and familial, whose patterns more often add up to near serfdom than to any significant degree of independence and personal dignity for women. Yet these studies show that, however onerous women's lives, development plans have seldom helped them. Rather, development has tended to put obstacles in women's way that frequently prevent them even from maintaining what little economic independence they do have. Laws and customs designed to protect women also can cause hardship. Even education can widen the gap between men and women. This is not to say that development never helps women; the case being made is that, *compared to men,* women almost universally have lost as development has proceeded. If economic planners would only look at recent (and long-standing) anthropological evidence, they hopefully would recognize that women's productive contributions to the economy have been and can continue to be important, and perhaps would begin to plan projects which not only support women's work but also open up opportunities for women to become part of the modern economic system. With this objective in mind, this paper will now review the existing evidence which shows how development has negatively affected the productivity of women in different areas of life.

CHANGE IN SUBSISTENCE ECONOMIES

In subsistence economies every family member traditionally is assigned roles which are essential to the survival of the unit, whether that unit is a small "nuclear" family or an extended one. Men as well as women have dual functions: family roles are integrated with economic roles. While in any given society these roles generally are sex-specific, they vary from culture to culture. Almost everywhere change has meant a diminution of men's roles in caring for and training children or assisting in household tasks. Since development is primarily concerned with economic activity, and since it is women's traditional economic role that has been

ignored, we shall focus on this function and how it has changed for both men and women .

Ester Boserup in her landmark book, *Woman's Role in Economic Development,* has linked the variation of sex roles in farming to different types of agriculture. In subsistence farming where land is plentiful, a slash-and-burn technique is the typical agricultural style; generally men clear the land and women do the bulk of the farming. This agricultural technique is still predominant in Africa but is also found in many parts of Asia and Central and South America. When population increase limits land availability, draft animals are brought in to increase productivity through the use of the plough. And the advent of the plough usually entails a radical shift in sex roles in agriculture; men take over the ploughing even in regions where the hoeing had formerly been women's work. At the same time, the amount of weeding to be done by the women may decline on land ploughed before sowing and planting, and either men or women may get a new job of collecting feed for the animals and feeding them. As population pressure on land increases further, more labor-intensive crops are introduced and grown year-round in irrigated fields. Women are drawn back into the fields to plant, weed, and harvest alongside the men.

In addition to their important role in farming, women in subsistence economies traditionally have engaged in a variety of other economic activities: spinning fibers, weaving cloth, drawing water, tending market gardens, and processing and preserving foods gathered from communal property. Women in Southeast Asia boil palm sugar. West African women brew beer. Women in parts of Mexico and elsewhere make pottery. Women in most countries weave cloth and make clothes. Women in most cultures sell their surplus food in local markets. Profits from these activities generally belong to the women themselves. Thus women in many parts of the world have become known for their astuteness in the marketplace. Javanese women have a reputation for being thrifty, while Javanese men consider themselves incapable of handling money wisely. In Nicaragua, women continue to dominate the traditional marketplace, which caters to the lower classes, despite the availability of modern supermarkets nearby. Market women of West Africa have parlayed their economic strength into political power as well. In contrast, Hindu and Arab women seldom are seen in the markets as buyers and never as sellers. But these women come from societies that have long been bureaucratized and in which women have lost some of their earlier economic independence.

Erosion of the role that women played in subsistence economies began under colonial rule. Policies aimed at improving or modernizing the farming systems, particularly the introduction of the concept of private property and the encouragement of cash crops, favored men. Under tribal custom, women who were farmers had users'

rights to land. Colonial regimes, past and recent, seldom have felt comfortable with customary communal land-tenure rights and have tended to convert land to private ownership – in some cultures thereby dispossessing the women, in disregard of local tradition, by recognizing men as the new owners. This was as true of the Chinese in Southeast Asia and the Spanish in Latin America as it was of the Europeans in Asia and Africa. Thus women still farmed the land but no longer owned it and therefore became dependent on their fathers or their brothers. Wherever colonial governments introduced cash crops, these were considered to be men's work. Much of the agricultural development was focused on improving these crops. To encourage the men to take jobs on plantations or to grow cash crops on their own land, governments frequently introduced taxes-thereby forcing men (who were more mobile) into the modern money economy, while women (with child-rearing responsibilities) remained in rural areas and hence in the subsistence economy. Their lack of access to money and loss of control of land left women with little incentive to improve either crops or the land in areas where they continued to dominate the farming system. Furthermore, access to the modern sector, whether in agriculture or industry, has drawn men away from their households and often even from their land, and thus has given women additional tasks that former ly were men's work. Not

surprisingly, productivity has declined as "development" has proceeded.

Efforts to reverse this trend have been undertaken by development agencies, but their stereotypes concerning the sex of the farmer often have led to ridiculous results. In 1974 Liberia decided to try to encourage wet-rice cultivation and brought to the country a team of Taiwanese farmers. To assure attendance at the demonstration planting, the government offered wages to the observers. Many unemployed men participated in the experiment while the women continued their work in the fields. Throughout Africa, rural extension services, modeled on those in the United States, have been staffed and attended by men only; custom prevented rural women from attending courses taught by men, and the courses taught by women-mainly home economics courses on canning and sewing were irrelevant to their needs. Cooperatives, too, tended to assume that farmers were males. Thus the men had access to credit or to improved seeds which they used to produce cash crops; women in the subsistence sector were barred from membership as well as from growing cash crops.

Perhaps because the economic position of women in Africa was deteriorating so quickly, active opposition to this trend started there. Nigerian women formed all-female cooperatives and demanded credit to buy more efficient oil pressers to use in processing palm-oil nuts. Under pressure from women's groups, the government of Kenya

reinterpreted the cooperative regulations to allow membership to women, and then formed a special task force to show women how to utilize this new opportunity. Zambian women were taught how to grow onions as a cash crop, in between rows of the usual subsistence crops. They were so successful that men demanded similar assistance; this venture turned sour when the women refused to tend the men's onions, claiming it was not a traditional obligation! In Tanzania the government is encouraging the establishment of Ujamaa villages, where land is held communally and workers are paid according to their efforts; in these villages, women for the first time are being paid for growing subsistence crops. Marjorie Mbilinyi writes that "it is therefore not surprising that women are the most ardent supporters of socialist rural policies in many areas of Tanzania." ("Barriers te the Full Participation of Women in the Socialist Transformation of Tanzania," paper presented at the Conference on the Role of Rural Women in Development, sponsored by the Agricultural Development Council, Princeton, New Jersey, 1974.)

The ways in which development agencies have introduced new technologies likewise have tended to contribute to the undermining of women's traditional roles. Small implements such as presses, grinders, or cutters generally have been introduced to men, even when the work for which they are a substitute traditionally has been done by women. The availability of corn grinders in Kenya, for example, clearly saves women many hours of manual effory though they also spend hours going to the grinding center. But why are women themselves not taught to operate these grinders? Oil presses in Nigeria, tortilla-making machines in Mexico, and sago-processing machines in Sarawak also are purchased and operated by men because only men have access to credit or to money. Stereotypes that women cannot manage technology are reinforced by the fact that illiteracy is more widespread among women, who therefore cannot read instructions.

Agricultural technology has produced the "green revolution" and has altered traditional agricultural practices. The high capitalization involved in buying improved seed varieties and fertilizers has pressured farmers into more efficient harvesting arrangements which often utilize fewer laborers and increase unemployment. Planners know this and often have tried to create alternative employment for the displaced *men*. But, in most economies that rely on wet-rice cultivation, it is the women who do the harvesting. A detailed study on Central Java, for example, noted that the women formerly accepted low wages for planting in order to receive payment in rice itself for harvesting work. Today the harvesting is done by mobile teams of men using the more efficient scythe; women, who harvested with a hand knife, have lost their rights to harvest and have not yet been able to obtain higher wages for planting.

Improved transportation systems have affected traditional markets in both positive and negative ways. In Mexico, for example, improved transport has increased demand for locally made ceramic animal figures, thereby increasing rural earnings. It has made manufactured fabrics available in even the smallest towns, enabling women to make clothing without having to weave the cloth. Moreover, travel to markets in town has eased the drudgery of women's lives in rural areas. On the other hand, improved transport has made many traditional occupations redundant. It has opened new markets for manufactured goods that compete with local, hand-made artifacts. Traders from more distant towns are taking over local markets, undercutting the traditional suppliers: women traders from outlying villages. In Java, the importation of Coca-Cola and Australian ice cream ruined local soft drink manufacture and ice cream production; both enterprises had been dominated by women. Sago processing by women in Sarawak was replaced by machine processing run by Chinese men. Men's enterprises also have suffered from competition with national or international firms. A study of governmental policies in Zaria, Nigeria, showed that small businesses run by men suffered from the lack of basic services, particularly water, light, and credit, and that this prevented their expansion; in contrast, two large local factories , producing tobacco and textiles, were fostered by governmental policy. Planners usually are aware of and try to ease the demise of small businesses in the wake of modern industrialization. What they have forgotten, however, is the sex of the entrepreneurs and hence have attempted to provide alternative employment for *men only*.

CHANGE IN THE MODERN SECTOR AND WOMEN'S EDUCATION

The elite character of all education as well as its bias in favor of men everywhere in the world means that rural women seldom are literate, a fact that inhibits their ability to move into new sectors when their traditional economic roles are superseded. Furthermore, according to the most recent UNESCO figures, the disparity between male and female illiteracy is growing. In Africa (where illiteracy is extremely high among both sexes), nine out of ten women still are illiterate. In Asia, female illiteracy rates range from 87 per cent in India to 52 per cent in Hong Kong; and even in Hong Kong, women are five times more likely to be illiterate than men. Generally, the higher the level of education, the lower the female enrollment. In Africa, some 20-30 per cent of female children attend primary school, but only 10-20 per cent of the secondary-school children are girls.13 In South Asia, of the 2.5 per cent of the adult population that continues in school beyond the age of fourteen, about one fifth are women. In Latin America, in contrast, where the percentage of adults who receive higher

education varies from 2 per cent to 10 per cent, nearly half the students enrolled in higher-education institutions are women. However, these few highly educated women remain limited in their options by the widely held belief that men and women have separate "proper spheres" in professional and public life.

In traditional rural pursuits, the lack of education was a relatively less serious problem. But that is changing as the modern sector invades the traditional sphere. Women in the markets, for example, are at a disadvantage because of their illiteracy and lack of knowledge of modern packaging techniques. The lack of education limits women's options even more severely when they migrate to the city. When they move with their husbands, they may be able to continue household crafts or petty trading. But trading on a small scale takes place within an established circle of customers; frequent moving can destroy a business. In some businesses, such as tailoring, women compete with men who have easier access to credit and therefore can provide a wider variety of fabrics. Lack of education is a handicap to these women. Dorothy Remy, who has studied the economic activity of women in Nigeria, has commented that "without exception, the women in my sample who had been able to earn a substantial independent income had attended primary school. All of these women had learned to read, write, and speak some English." ("Underdevelopment and the Experience of Women: A Zaria Case Study," in Rayna Reiter, ed., *Towards an Anthropology of Women*, 1975).

While married women find their economic independence severely limited in the towns of the less developed world, they at least have husbands to support them; life for unmarried women is more difficult. Surveys conducted in Dahomey indicated that from 25-30 per cent of women living in towns were on their own. In Latin America young women migrate into cities in larger numbers than men, and some seek employment in domestic service or as shop assistants; more often, however, prostitution is mentioned as the primary means of subsistence. Other women fit into the uncounted interstices of the economy. They buy a pack of cigarettes and sell them one at a time. They cook food and hawk it on the street. Although male migrants, too, engage in this informal sector, they usually progress into the "modern sector," where they are included in employment statistics. For the most part, however, women continue to work at marginal jobs and remain uncounted, since these economic activities do not enter into that mythical standard, the "gross national product."

All this is not to say that education has not opened up some new occupations for women, particularly for middle- and upper-class women. Since most of the early education systems in colonial countries were run by missionaries who placed a high value on education regardless of sex, girls have had some access to schools. In many

countries, nursing and teaching are considered respectable female occupations. In fact, there are more opportunities for women as teachers, nurses, and doctors in societies where sex segregation continues and men are limited in their contact with women than there are in less traditional societies. As sex segregation is relaxed, however, making this "market" for female professional employment less exclusive, the number of women employed in these fields declines and providing yet another example of the negative impact of development on women.

In those areas of Southeast Asia and West Africa where trading traditionally has been the women's preserve, many educated women have retained their entrepreneurial role, adjusting successfully to modern market conditions. In Ghana, the major marmalade manufacturer is a woman. The strength of organized market women in Guinea and Nigeria has given them influence in affecting government decisions. In Jakarta, the wives of the higher-grade civil servants run shops and make jewelry. In Thailand, several large hotels are owned and run by women . In the Philippines, women are adept as real estate agents, stockbrokers , and business managers; the fact that more Philippine women than men have attended private schools is a clear indicator of the value placed in that country on the ability of women to learn and to earn.

Only in crisis situations, however, are women generally permitted by society to engage in economic activities that otherwise remain closed to them. In Vietnam, for example, women were forced to support their families through years of war. Marilyn Hoskins has pointed out that women in Vietnam traditionally have been pivotal in the family; thus any activity that ensures the family's continuity or aids in its comfort is socially acceptable. Undoubtedly aiding in this acceptance are the many folk tales which portray Vietnamese women as heroines in the days before Chinese and French colonialism. ("Vietnamese Women in a Changing Society: Their Roles and Their Options," unpublished manuscript, 1973.) A similar ability of women to respond to modern demands (more quickly than their husbands) is found today among the Yemenite migrants into Israel. Yemenite men, more circumscribed than women by carefully delimited roles, have difficulty adapting to their new surroundings, while the women, expected to see to the needs of their families, have moved into the modern economic sector and in many cases have become the major income producers in their families. (Yael Katzir, "Israeli Women in Development: The Case of Yemenite Jews in a Moshav," paper prepared for the AAAS Seminar on Women in Development, Mexico City, Mexico, 1975.)

Thus education has only partly countered the historic phenomenon typical of the earlier bureaucratic as well as the later industrial societies: assigning of women to the home. Those women who succeeded in obtaining a

higher education during the colonial period usually could find jobs as easily as men, both because of the dearth of trained nationals and because the society itself was in a state of political and economic transition. An important factor enabling these women to participate was the existence of a supportive family structure in which kin and servants took over some of the women's household tasks and family responsibilities. Thus women played a prominent part in many nationalist struggles in Asia and Africa and were rewarded with high governmental positions in newly independent countries. The three current women prime ministers – of India, Sri Lanka, and the Central African Republic— have personal histories of political activity. In Latin America, women have entered such demanding occupations as law, medicine, and dentistry in larger numbers than in the United States.

Today, unfortunately, the situation is changing. *Fewer* women are in parliaments or political parties than during the early days of independence; professional women in many countries are beginning to have difficulty finding good jobs. These setbacks mirror those experienced by women in the United States, where a higher percentage of women received doctoral degrees between 1910 and 1920 than at any time since, and where more women held professional and technical jobs in the 1930s than do now. Several explanations have been offered for such trends. First, as educationa opportunities increase, more

middle-class children attend college and daughters of the middle class usually are more restricted by their families' sense of propriety than are the daughters of upper-class families. Second, the entry of large numbers of men into the ranks of job seekers, particularly middle-class men who feel women should stay home, increases employment competition and decreases women's chances. Third, the governments in many newly independent countries have become more and more dominated by the military; while professional women sometimes do obtain high-level jobs in the bureaucracy, virtually nowhere do they do so in the military.

Non-working women, whether educated or not, become more dependent on their husbands than those who have an income. While a dependent woman may have more status in the eyes of her friends because of her husband's job, many women resent the increased authoritarianism which tends to flow from dependency. Joseph Gugler writes about how such resentment has led to the radicalizat ion of women in West Africa. ("The Second Sex in Town," *Canadian Journal of African Studies*, VI, 2: 289-302, 1972.) At the same time, however, *release* from the drudgery of farm labor makes dependency and even seclusion acceptable to women in many parts of Asia and Africa. While Western women look upon seclusion, or purdah, as an extreme form of backwardness, many lower-class women in the old bureaucratic societies perceive it as an improvement of status – an

imitation of the upper classes. This process of changing life styles to emulate the class above has long been observed between castes in the Hindu hierarchy, where it is termed "Sanskritization." A study of purdah in Bangladesh indicates it has increased since independence from Great Britain. (Hanna Papanek,"Purdah: Separate Worlds and Symbolic Shelter," *Comparative Studies in Society and History*, XIV-3: 289-325, 1973.) In northern Nigeria, the attitude of Hausa women toward seclusion is influenced by religion and culture. Farming is carried on by Hausa women of the animist sect who cherish their freedom of movement and ridicule the secluded Hausa Moslem women who on the other hand appear to prefer to be kept in seclusion on the ground that it reduces their work load and raises their prestige. Nonetheless, it has been noted that seclusion has the effect of separating the sexes and increasing the hostility of women toward men; this hostility creates a kind of female solidarity that is not channeled into activism but is expressed, for example, in ribald singing. Among the animist Hausa, "women play an obvious economic role, one that is recognized by the men." The result is social solidarity rather than sex division. (Jerome H. Barkow, "Hausa Women and Islam," *Canadian Journal of African Studies*, VI 2: 317-28, 1972.)

Such increasing hostility between men and women may be responsible for the amazing rise in households headed by women. Around the world today , one out of three households is headed, de facto, by a woman. In the United States the figure is just under 20 per cent,but in parts of Latin America it is as high as 50 per cent; in Africa the end of legal polygamy has resulted in second wives being considered unmarried. The number of women-headed households is also growing in Asia, because the customary protectionfforded divorced women and widows by family practices imbedded in traditional religions is breaking down. Migration patterns-a function of economic opportunity- also have led to an increase in women-headed households. In Africa the men migrate to mines, plantations, or cities. The 1969 Kenya census indicates that one third of rural households are headed by women; Lesotho estimates are even higher. In Latin America, in contrast, it is the women who migrate first, often living in urban squatter settlements and raising the children by themselves. Whatever the reason, planners persist in the stereotype of the family as headed by a man; this concept reinforces the idea that only men engage in economic activity and leads to unfair planning. Modern laws and customs help create these women-headed households. Most countries in Africa have adopted laws making monogamy the only legal form of marriage. Second wives, who of course continue to exist, become "mistresses" and lose the protection that was accorded them under customary law. While Westernized African women argue in favor of the necessity for monogamy,

many market women indicate a preference for polygamy. A survey conducted in the Ivory Coast in the 1960s showed that 85 per cent of the women came out in favor of polygamy! According to Margarita Dobert, the women believe that "in a monogamous marriage power accrues to the man as head of the household whereas formerly both men and women had to defer to the head of the lineage." Furthermore, co-wives shared the burden of household work and cooking; one woman could go off to trade while another stayed at home to carry out household tasks. ("The Changing Status of Women in French Speaking Africa; Two Examples: Dahomey and Guinea. Unpublished manuscript, 1974, p7.)

Western law underscores women's major role as child rearing, treating women as dependents as far as property is concerned and generally awarding them custody of children in divorce. Thus modernization takes away women's economic roles while at the same time giving them the burden of paying for raising their children. Older religions such as Christianity and Hinduism avoided this problem by forbidding divorce; Islam and African animism allowed divorce but required men to assume the obligations of raising the children. By absolving men of the responsibility of caring for their children in case of divorce, recent legislation in Kenya has placed an oppressive burden on divorced Kenyan women.

Women-headed households are also increasing in the Soviet Union.

There the women are integrated into the economy, albeit at lower-level jobs, but their husbands are not sharing in household and family tasks. Women are rejecting not only marriage but also child bearing. It was interesting to hear Romanian officials at the U.N. Population Conference in Bucharest in August 1974 observe that concern over the falling birthrates in their country actually might have the effect of urging men to help more with the housework!

There is no clear relationship between family type and women 's ability to work. Women-headed households generally are relatively poorer. In most countries, the women lack education and are forced to earn money in marginal jobs within or outside the modern sector . In the United States, divorced women generally must adapt to a standard of living cut by nearly a half; the majority tend to find jobs on the low end of the employment scale and receive inadequate child-support payments. At one time it was thought that the nuclear family would be the prototype of the modern world. Women in the United States now complain of the restrictions of the nuclear family, at least where the partners are not equal. Yet several observers of Asian women have argued that the nuclear family is the primary liberating force from the patriarchal dominance of the extended family. Latin American observers, on the other hand, have suggested that the kin network that typifies traditional extended families actually allows for more equality of women because of the

shared obligations and duties within the family.

In China, the traditional extended-family pattern has been the target of much criticism by the government, undoubtedly because that form has been so intertwined with the elitist bureaucratic form of government. All levels of society now are required to share the drudgery of hard labor; college students and party functionaries in particular are required to work periodically on farms or on massive public works projects. Government publications suggest that the ideal of equality has been achieved, but typically the military and bureaucratic leaders are almost entirely men. Even the most influential Chinese woman today —Chiang Ching, wife of Mao Tse-tung— operates on the periphery. Recent visitors to China have been impressed by efforts to achieve female equality. Nonetheless, even the Chinese delegates to the U.N. Commission on the Status of Women admit that the men in the outlying areas of the country have not yet understood that women are to be treated as equals.

CONCLUSION

In subsistence economies, the process of development has tended to restrict the economic independence of women as their traditional jobs have been challenged by new methods and technologies. Because Western stereotypes of appropriate roles and occupations for women tend to be exported with aid, modernization continually increases the gap between women's and men's ability to cope with the modern world. Elites in these countries are imbued with middle-class Western values relegating women to a subordinate place, values often transmitted by the industrial world's bureaucratic systems, which frequently reinforce such stereotypes in their own societies.

In the developed "modern" world, women continue to experience restricted economic opportunities while at the same time finding increased family obligations thrust upon them. The strange contrast of this reality with the Western ideal of "equality for all" increasingly has made women aware of this injustice. Instead of docilely accepting their fate, women are becoming increasingly hostile, leaving marriage behind, and taking on the dual functions of work and family without the added burden of husband. A redress is overdue. Planners must not only consider and support women's economic activities but must also find ways of mitigating the drudgery of housework and the responsibility of child rearing. The roles assigned each sex must again be made more equal with men as well as women accepting their dual functions of work and family.

For a time after World War II, there was great optimism about the ability of the world to proceed apace with economic development. Today there is a growing realization that development is a more elusive concept than had been previously thought. Even where countries are able to boast of a rising

gross national product in the face of population growth, it is recognized that Western-style development approaches of the past have tended to make the rich richer and the poor poorer, both within countries and among countries. Not only women but the poor generally have been left out.

Not surprisingly, many economists are looking for alternative paths to development, and are showing an increasing interest in the experiences of such non-Western countries as the Soviet Union and China. In their impact on women, however, these non-Western models also are inadequate; in a sense they err twice, for while women's nurturing roles are deemphasized in favor of their economic roles, women continue to have access only to the less important economic and political roles. Clearly these models – whatever the impact of their policies on the women in their own countries – also cannot and should not be exported without major adaptation, or they too will undermine women's traditional roles. What is needed, therefore, is not an imported model, but rather an adaptation of development goals to each society, an adaptation that will ensure benefits for women as well as men.

THE MAKING OF A FIELD: ADVOCATES, PRACTITIONERS, AND SCHOLARS

WOMEN IN DEVELOPMENT, LIKE ANY applied field, not only crosses disciplinary boundaries but establishes goals and priorities consonant with the constraints of those systems within which its practitioners work. Scholars commenting on the field too often confuse this art of the possible with their own more abstract view of the world and so criticize development programs from an idealistic, if not ideological, perspective rather than from the realism of the practitioner. This confusion is exacerbated in the case of women in development by the existence of a strong international women's movement, which first raised the issue and then continued to monitor its incorporation into development programs. These advocates have their own agenda: equity between women and men. How this ultimate goal translates into action in particular circumstances is the subject of global debate among the advocates themselves and between the advocates and both practitioners and scholars who share the goals but not the perspectives.

One might think of the women's movement as a ray of light passing through a prism. It is essential to understand the constituent colors in order to understand the whole; it is equally essential not to confuse any one-colored refraction with the light ray itself. This chapter outlines the differences among three groups of women and men that have exerted major influence on the gradual evolution of the field of women in development: advocates, practitioners, and scholars. Failure to distinguish among the different goals and activities of these three groups and to appreciate their different audiences has distorted efforts to classify women in development proponents and programs.

ADVOCATES

The impetus for integrating women into development programs had two very different sources: the U.N. Commission on the Status of Women, and the U.S. women's movement. In the early 1970s, neither the staff and members of the women's commission nor the activists involved in the growing number of new women's organizations in the United States were particularly interested in economic development; rather, they drew on their suffragist heritage in their concern for equality before the law and greater access of women to education. In addition, the U.S. women were increasingly demanding the right

to equal employment, which they saw as basic to equal status in a society that measures achievement by income or profession. The primary objective of both groups was to influence governmental policies concerning women.

Women in development advocates emerged from these two arenas quite separately and, conditioned by the different environments in which they operated, held different interests and priorities. However, it was the meeting, cooperation, and debates between these two groups of advocates during the U.N. Decade for Women that produced the remarkable expansion of the field.

Meanings of Women in Development

Clearly , many strands of women's rights are bound up in the term "women in development." The relatively recent concept of ensuring women a fair stake in economic development joins earlier ideas of legal equality, education, employment, and empowerment. During the U.N. Decade for Women, different goals predominated at different times, and the objectives of various policies and programs were not always clear. It is therefore extremely important to understand each of the multiple objectives of "women in development," as well as the meaning of the term itself, as shorthand for the broader goal of achieving equity for women.

Equality before the law, as the focus of much of the effort of the U.N. Commission on the Status of Women,

resulted in the passage in 1951 by the General Assembly of the Convention on the Political Rights of Women. In subsequent years the scope of such conventions greatly increased until, in 1979, the General Assembly adopted the Convention on the Elimination of All Forms of Discrimination Against Women. This international bill of rights for women has since been ratified by 92 countries; a special U.N. committee oversees its enforcement. To monitor the implementation of this convention and to maintain pressure on governments to abide by its provisions, an international consortium of scholars and activists has set up the International Women's Rights Action Watch.

For a time during the Decade legal rights were downplayed. Most governments today have constitutions that grant women equality, but too often these rights are not enforced, except perhaps among the Westernized middle class. WID advocates have argued that for poor women, economic power would help them achieve their rights more than unenforceable laws. Recent studies, however, show that the relationship between women's earnings and empowerment is not straightforward. On the other hand, local women's organizations have been able to use legal rights to help protect poor as well as middle-class women who have been abused or divorced. Thus there is renewed interest in improving women's legal rights, particularly in areas traditionally regulated by customary or religious law, such as divorce or inheritance.

Education was understood by women both in the U.N. Women's Commission and in the U.S. women's movement to be the prerequisite for improvement in women's status. At the United Nations the Commission repeatedly has urged governments to increase girls' and women's access to formal education; in the United States, which has equal education through college, the focus has been on access to technical education and to professional schools. Yet international development programs for educational assistance were severely cut back during the Decade, in part due to the failure of many early literacy campaigns. These campaigns often did not work for the simple reason that classes held at midday conflicted with rural women's work schedules. Once such time constraints were acknowledged, development programs began to stress nonformal rather than formal education, aimed at providing the practical skills needed for earning income. Although such efforts are critical for helping poor adult women, they do not address the next generation. Advocates today are again emphasizing women's access to formal schooling, but they are also concerned with reducing the gender biases and improving the quality of educational materials.

Employment of women professionals in the United Nations and in development agencies is advocated both as a right in itself and as a more effective way of ensuring that development programs both reach and involve women. Indeed, so pervasive were women's demands for "affirmative action" in government hiring that many observers equated "women in development" with creating opportunities for women professionals in development agencies. This confusion became evident at the first congressional hearing on women in development called by Congressman Fraser to consider the question of international women's rights. In addition to hearing testimony about U.S. bilateral programs the Congressman, emphasizing the importance of professional opportunities in enabling women to realize their full potential, requested information on the number of professional women in the U.S. Agency for International Development (Committee on Foreign Affairs 1974). Worldwide, there has been a significant increase in the utilization of women in all phases of development work, from research to management to evaluation.

Empowerment is a relatively new term, but the relationship between organizing and influence has long been understood. Many international women's organizations formed during the suffragist period; after World War II they rapidly expanded their membership to the newly independent countries. As NGOs in consultative status to the Economic and Social Council of the United Nations, they worked closely with the Women's Commission and lobbied their own governments to support the International Women's Year. As development became a more pressing issue, some of these organizations began to work with grassroots

women's groups, funneling information and funds to them. By contrast, most of the women's organizations actively lobbying the U.S. government were recently formed groups representing the new wave of the women's movement. They put a strong emphasis on consciousness-raising both in feminist organizing at home and, in some cases, abroad. They drew on this model for training women to recognize and change cultural stereotypes that limited their leadership roles. But most international development agencies were reluctant to push actively for attitudinal change, on the grounds that foreigners had no business tampering with culture. Thus arose the distinction between global feminism and women in development.

Economic development was the original focus of WID. In both the United Nations and the U.S. Congress, WID advocates pointed out that neglect of women's activities had for years undermined development programming. This neglect disadvantaged women-headed households especially, contributing to the "feminization of poverty." National planners may have seen women as an unused labor force, but WID proponents argued that women were already overworked but underproductive, and before they would be able to contribute to economic growth, they would need relief from the drudgery necessary to their families' daily survival.

The documentation and valuation of women's work remained the dominant concern throughout the Decade for Women not only for the advocates but for practitioners and scholars as well. Increasingly, however, the other issues became incorporated into programming as practitioners sought to integrate women's programs into mainstream development efforts. Scholars also expanded the feminist research agenda beyond the initial focus on work.

PRACTITIONERS

Practitioners are women and men employed by or on contract to development agencies. By definition, their positions are constrained by the policies and bureaucratic behavior of these organizations. Failure to recognize these constraints has led to unrealistic expectations of WID programming and consequent disappointment. For practitioners, the central question was *how* to fulfill the mandate to "integrate women into the national economies of foreign countries." Their two major approaches since the mid-1970s were to focus on either *welfare* or *efficiency*. Each approach emphasized only one part of woman's life: as mother or as worker. Current debates revolve around ways to support women in all their roles.

Programming for Women's Welfare

Early development programming ignored women's income-earning activities, addressing instead only their reproductive role as mothers. Health programs, although called Maternal

Child Health (MCH), in reality focused on children; they did not take into account the fact that a mother's good health is the most important precondition for a healthy child. Population programs discussed women as "targets" of family planning and were surprised that many women did not choose to become "acceptors" of contraceptives. But eventually, as these programs came to recognize the value of child labor to poor families, especially in rural areas, they began to support programs reducing women's drudgery and increasing their income. They drew the obvious conclusion that otherwise, an overworked mother will want many children to help her today and support her tomorrow. This relationship between poverty and poor health and nutrition was long neglected by the health establishment. Only recently has the "Safe Motherhood" initiative of the World Bank stressed the health benefits of family planning, underscoring the importance of birth spacing for healthy mothers and children.

Welfare was, and continues to be, an integral part of both MCH and family planning programs because these programs are used to distribute foodstuffs through the Food for Peace program. Free food programs have been widely criticized for creating disincentives for poor farmers. Practitioners argued that they merely increase women's dependency. Further, in rural areas food was usually distributed at midday from a center on the main road. Thus rural women had to forgo a day's work to walk to the center. Such programs do often provide important social services in addition to food, such as free medical care for infants and/or free contraceptives. The problem is that they operate on the assumption that women are nonworking dependents who have ample time to walk long distances on a regular basis to attend clinics or receive food.

Food for Peace programs began as a famine response and remain a critical relief activity. The confusion arises when such giveaway programs become institutionalized as development efforts, treating the symptoms rather than the causes of poverty. Welfare is easy for development agencies; it garners support at home, where donors respond to images of famine; it takes less effort to give away food than to implement programs enabling communities to produce or buy it; and it does not threaten the status quo.

To the WID advocate, such programs simply reinforce the stereotypes of weak, dependent women. They support instead programs to help poor women earn money, since they consider economic activity the key way to improve women's status. They are not alone; many NGOs that solicit contributions on a welfare basis—because that is what moves the public—have also instituted multifaceted community development programs which often include income activities for women.

The major problem with the welfare approach lies not with overtly charitable programs but with the tendency of the welfare attitude to "misbehave" by

permeating and eventually dominating programs theoretically designed to generate income for poor women (Marya Buvinic, "Projects for Women in the Third World: Explaining their Misbehavior," *World Development* 14-5: 653-64, 1986). Three characteristics of poverty-alleviation programs make this a predictable outcome. First, most women-only programs are set up through intermediary organizations which focus on running welfare projects for women. Second, these organizations make assumptions about group membership and cooperation which tend to exclude the poorest women, the beneficiaries of these programs. Finally, these organizations running women's poverty alleviation programs have historically been themselves outside the mainstream of development programming.

Women-only projects were the easiest and earliest response of most donor agencies to WID objectives. Agencies usally selected women's organizations or church groups to implement such programs, although they lacked not only experience in creating viable income activities for the poor but also in running their own organizations on a business basis. Because these organizations had run social programs before, they tended to retain stereotypes about women's domestic roles, and they set up income projects based on incorrect assumptions about women's needs, daily activities, and skills. These projects assumed that women were predominantly housewives with ample free time, needing only "pin money"

for supplementary food or clothing. Further, these new income activities assumed that the participants already knew how to knit and sew, both middle-class activities quite foreign to most poor rural women. As a result, such projects—sewing and knitting clothes for tourists, weaving jute bags, crocheting—typically needed constant subsidies to stay afloat.

Gradually projects moved into activities utilizing skills that women already possessed, which meant activities still firmly within the female sphere: drying fruits, making purees, baking crackersk waxing batiks. Many of these small-income projects have failed due to insufficient preliminary market analysis. Many Peace Corps women's income-generation programs (i.e, those making baskets in Kenya and Nepal or tablecloths in El Salvador) have had to rely on the volunteers themselves to market the products; their access to customers in the capital city can seldom be duplicated after they leave.

Local women's groups were set up by intermediary organizations to deliver information and services. Typically such a group is open to all adult women in a village and income activities are frequently communal. Both these features make it difficult for the poor to participate. Social stratification exists in all villages, and group leadership positions generally fall to the better off and better educated, who naturally tend to make decisions that favor their own interests. They might decide, for example, that the group use its earnings to build a

new school, as happens often in Kenya. But the poorest women cannot afford to take time for activities that do not immediately help them support their families. Nor can poor women subsidize others who might work less hard.

The importance of the individual receiving a fair return for her own efforts helps explain the rapid expansion of affinity or solidarity groups as a source of credit for starting microenterprises, a technique pioneered by Bangladesh's Grameen Bank. According to this model, individuals in the group, though landless and without other assets, are able to borrow based on group surety.

Marginal projects, however successful, seldom have any impact on the large bureaucracies of national and international development agencies. Since women-only programs have generally been small , underfunded and widely perceived as inherently welfare-oriented, they have remained outside the mainstream of national economic planning. It is now clear that only when women's issues are integrated into regular development programming do they receive the attention and resources adequate to the task. Yet the need to offer help to poor women, mothers especially, is so overwhelming, that welfare remains the primary form of women's aid programming, even in an egalitarian country such as Sweden.

Efficiency as the Basis for WID Programming

The original formulation of WID marked the recognition that treating women only as mothers had left them out of development and thus undermined the effectiveness of economic development programs. as a whole. The solution was to design development programs integrating women. Thus practictioners used *efficiency* as the primary argument to convince the development community that women should participate in both the design and implementation of future projects.

Compared to earlier eras of development planning, making this case was relatively easy in the 1970s, when development emphasized basic human needs met through self-sufficiency rather than welfare. This focus meant encouraging the poor to take part in development programs rather than simply to await passively their benefits. Experience had amply illustrated that top-down programs functioned only as long as donors supported them; self-sufficiency programs required changes in behavior and attitudes likely only if people understood their advantages. Moreover, "people" had to include women. For all the rhetoric about participation, most programs reached only village male elites, if they reached to the village level the village at all. The logic of including women in the process of developing self-aufficiency was obvious and not terribly controversial; the problem became how to do it.

Integration into sectoral programs (such as agriculture or energy) designed to alleviate poverty seemed a logical approach. Time budget studies

had clearly demonstrated that women play a central role in securing food, fuel, water, and housing, and that rural women in particular spend many hours a day fetching water, collecting fuelwood, and above all producing processing, and preparing food for family consumption. They rely on labor-intensive traditional technologies for all these activities. More efficient methods of securing basic necessities would free time for income-earning activities and thus help them move towards self-sufficiency.

Appropriate technology groups took up the challenge of developing tools useful to rural poor women and men, such as grain mills, solar ovens, biogas disgesters, and energy-saving cooking stoves. The U.N. Decade for Water (1981-90) made a priority of installing improved wells and pumps, and clean water projects have also become a focus of UNICEF funding. Project evaluations have shown that show that new wells provide greater benefits if women are consulted about their placement during the planning process and if they are taught how to use and repair spigots and pumps themselves. Yet myths persist about women's abilities to understand and utilize new machineries or methods, and too often it is only men who given access to them.

Assisting women's work in agriculture and forestry has taken longer. This was again due to male agricultural experts incorrectly assuming that farming was largely men's work, and to female home economists whose training was suited to middle-class housewives, not to women subsistence farmers. Early efforts to reach women farmers with separate extension programs also "misbehaved." Reforming the bureaucracies of agricultural ministries, universities, and extension programs has proven exceedingly difficult, particularly in Africa where extension programs themselves were not very strong. A recent program in Cameroon provides one of the first models integratated extension effort. Foresters trained in managing commercial timber long ignored women's role tree planting and use; today women's knowledge of local species makes them a vital part of social forestry programs.

Basic needs programs aimed to increase employment opportunities, particularly in small enterprises and microenterprises in both rural and urban areas. Research has shown that these program do not generally discriminatae by sex. But the fact that women's enterprises tend to be smaller and less growth oriented – at least in part because women end up using their profits to buy food and/or pay school fees – has at times brought criticism that the women supported by microenterprise programs are not, in fact, entrepreneurial. Yet it is these small-scale who are borrowing and repaying loans from the Grameen Bank and similar institutions at rates far above male borrowers at any level of enterprise.

Rural development has preoccupied development agencies from the outset. They viewed cities as middle-class oases, where even the poor lived better than their rural cousins. The rapid growth

of urban squatter settlements, however, forced agencies to look at issues of housing and community development. Caroline Moser traces the critical role women play in these urban settlements and notes that their immensely time-consuming role as managers remains unrecognized ("Women, Human Settlements, and Housing" in C. Moser & L. Peake, eds. *Women, Human Settlements, and Housing,* 1987.) In addition, housing credit programs have tended to discriminate against women borrowers because, as household heads, they face greater time constraints and usually possess less collateral than men.

Increasing understanding of WID within the donor agency bureaucracies became a major priority for the development community. Interagency task forces linking organizations such as the FAO, ILO, and WHO were established to exchange information and share bureaucratic strategies. A women's committee of European and North American donor members of the Development Assistance Committee formed to put pressure on the parent body, the Organization of Economic Cooperation and Development. Both INSTRAW and the U.N. Commission on the Status of Women held experts' meetings and circulated the resulting recommendations throughout the United Nations. Meetings and conferences were held, guidelines published, and training programs instituted.

Universities also became the focus of educational efforts in the United States, where land grant universities in particular received USAID funding to supply technical overseas assistance. Arvonne Fraser, as director of the Office of Women in Development at AID from 1977 to 1981, supported a network of women professors and researchers at universities and lobbied within AID to ensure that women's issues were included in development studies and projects; she also supported efforts to increase the understanding of development issues by women's organizations around the world.

Reassessing Women in Development Programs

In the last few years a reassessment of WID programming has rejected the easy dichotomy between welfare and efficiency approaches. It had become clear from project evaluations that most WID programs had begun to resemble one another, regardless of whether they were originally defined as "sectoral" or "women-only." In general, they share the following characteristics:

- They organize women from similar socioeconomic backgrounds into small groups;
- They provide credit to individuals, but with group guarantees;
- They use training and technology to enhance current work;
- They introduce income-generating activities related to the domestic sphere.

Women's projects today are more likely to recognize women's double

responsibility for work and family care. Women-only projects focus more and more on activities that generate worthwhile returns, while sectoral programs take account of women's family responsibilities in their design. This convergence of women's projects, aiming to assure both welfare and efficiency, underscores the fact that women's lives are not compartmentalized between household and work or public and private; their concerns are not either/or; they are both.

The challenge for practitioners, then, is to design projects responsive to women's multifaceted needs while avoiding the most serious drawbacks of earlier programs, particularly their fragmentary nature. In particular, if these projects are to address the problem of women's poverty and powerlessness, they must make women more self-auffi-cient and self-reliant.

New Program Guidelines

To avoid the isolation and marginalization of women-only programs, current guidelines recommend that new projects for women should be incorporated in regular sectoral programs as part the original design, not added on as a "women's component." At the grassroots level, separate women's groups will still be necessary to insure that women can participate in and express their opinions about a project. Local groups should always be consulted first, even if it becomes necessary to set up new groups for specific activities.

Evaluations suggest that organizing is itself an empowering experience as women begin to share problems and to recognize they are not alone in their struggles. But empowerment ought not stop at the group level. Women's groups representatives should also attend and have a voice at meetings regarding a project. At the lower levels the representatives should be chosen from among the grassroots members; at higher levels female staff should be charged with representing any special concerns of women.

Project designers must remember that poor women, whether rural or urban, are already be so heavily burdened that they will prefer direct assistance with survival needs over opportunities to undertake even more time-consuming income activities. Simply providing more work or income without considering who controls both labor and income in the family may only increase stress and conflict, rather than giving women a measure of economic independence. In fact, independence may appear neither possible nor desirable to many women who see homemaking and childraising as their primary goals. So projects must both *respond* to women's expressed needs, in order to assure their participation, and at the same time *transform* women's life circumstances, in order to achieve the goal of self-auffiency. Therefore, planners must analyze how proposed new activities will affect not only specific aspects of women's work, but also how they will address persistent inequalities.

A cautionary note is necessary. Many women's projects will undoubtedly continue to resemble welfare programs, though they may encourage participation and self-sufficiency to reduce long-term costs. Governments prefer non-controversial programs. Therefore, even programs that empower women by enabling them to own land or houses will likely be presented simply as initiatives to increase agricultural production or improve urban housing. Still, even small steps may have important long-term effects: simply attending a meeting of women outside her own compound may profoundly enlarge a woman's world view.

Practitioners must operate within bureaucratic constraints and accept limited visions of change by male-dominated governments. Yet through their program work they can provide opportunities for women to alter their lives and increase their economic independence. The most successful efforts on this front have been led by charismatic indigenous leaders who have the prestige and contacts to intervene on behalf of their poor constituents, and do not hesitate to use them. Since any disruption of the status quo will undermine someone's privileges, providing political and economic protection for the poor as they organize, cut ties with moneylenders or challenge entrenched traders, is crucial. In the long run, it is preferable to avoid creating "win-lose" situations wherever possible.

SCHOLARS

Scholars of women in development are a much more diverse group than either the advocates or the practitioners. Constrained neither by the existing governmental systems nor by agency bureaucracies, they are free to utilize ideologies or images of the future to test and judge contemporary issues. All are grounded in feminism. Many, writing within the two major economic persuasions of liberal and Marxist economics, have provided valuable critiques of these theories. An increasing number of feminists dismiss both theories as out of date with both women's and global reality; nevertheless, they are uncomfortable with the distinctly feminist approach which argues for a female sphere. All these commentators on modernization and development draw on the rich scholarship concerning women's lives around the world.

Feminist scholars clearly support the contemporary women's movement's fight against the inequities of a world run by men for men. Elise Boulding (*The Underside of History: A View of Women Through Time*, 1976) sees the ideology and methods of this fight as the main difference between women's movements in the nineteenth and the twentieth centuries. The earlier movement focused on social change utilizing what she terms the "civic housekeeping rhetoric," that is, women translating to the community level "their sense of traditional responsibility for the wellbeing of their family." The early movement,

like today's, was concerned with peace, because women saw war as the cause of much social misery. But whereas the suffragists allied with men to reach their objectives, members of the contemporary women's movement see women as victims of patriarchy.

This feminism informs the work of most WID scholars, drawing them closer together as the flood of research swamps current male paradigms. Two sets of basic issues have dominated the field, one revolving around the counting and valuing of women's work, the other around the efforts of adapting or changing development theories to accomodate feminist thought.

Documenting Women's Work

WID advocates, echoing U.S. feminists' emphasis on women's need for economic independence, had argued that development was undermining women's "traditional" economic activities. WID scholars subsequently searched for ethnographic and historical documentation of women's work that supported this position. In the late sixties, however, empirical research rarely examined women as independent entities rather than as simply members of kin groups. A few anthropologists, following Margaret Mead's example, had begun to study women's roles in remote societies of the Third World, but since these were usually subsistence societies, little attention went to women's economic activities. An important exception was the study of West African women traders.

As WID practitioners began to design projects for women, their agencies became not only important users of data on women, but funders of research as well. Most studies conducted under contract have been descriptive or analytical, and guided by the same principles of liberal economic theory as the funding agency. These are pragmatic studies of the actual conditions of women farmers, or traders, or women's organizations; they deal with what is happening and what might be done within the current structures of authority and power. In contrast, the United Nations has funded research of a more historical and theoretical nature. Such studies are more likely to perceive women's problems as emanating from colonialism and the current capialtist structure of society.

Among the empirical studies, many focused on documenting how women meet the demands of home, family and subsistence production while also earning an income. Time budget studies proved a particularly useful method of enumerating and measuring women's economic activities, and for subsequently demonstrating that women's time constraints pose a major obstacle to rural development. Analyses of sexual divisions of labor show how women's work burdens have increased as men moved into more remunerative, technologically-advanced activities, leaving to women the most labor-intensive subsistence tasks.

Most subsistence economic activity was not included in national accounts. The 12-14 hours per day that women spent farming, food processing, fetching water and fuel, building houses, trading, weaving, brewing – none of this was considered work. Therefore a major effort of WID scholars has been to challenge both definitions of work and methods of data collection. Especially when counting women's agricultural work, different statistical methods can produce different results.

Concern with growing poverty among women, many scholars began studies of women's work in urban areas including prostitutes, domestics, and vendors; street food producers and sellers; and white collar employees. Reports of self-help housing, waste management, and community kitchens documents the variety of women's work in cities. But far the greatest focus has been on women microentrepreneurs.

Women microentrepreneurs were largely invisible in the early informal sector studies sponsored by ILO in the 1970s. However, the realization that this robust sector was a major source of employment for the rapidly growing urban populations in developing countries made clear the need to revise employment data. Women work throughout the informal sector, but most often in activities perceived as extensions of their domestic tasks: in cities, for example, they sell fruits and vegetables, snacks, or cooked meals; in rural areas they process food, dye cloth or brew beer. Increasingly, however,

women in the informal sector, whether or not they work out of their homes, are not self-employed but rather are vertically integrated into larger firms. Such women knit garments with hand machines, roll cigarettes, and assemble toys for local or multinational companies. The distinction between self-employed entrepreneurs and home-based subcontracted employees is murky. But it is an important distinction to make when designing programs to support either kind of woman worker.

The independence of women microentrepreneurs and the extent to which they utilize family labor or work for their husbands varies by region and culture. They tend to invest in their families rather than in economic expansion, raising the question whether they are in fact "entrepreneurs." If they do expand, it is most likely in an "amoeba" fashion, the enterprise replicating itself as a family member sets up her own shop. Resistance to growth would appear to be a sensible policy, however. When family enterprises grow, men frequently take them over. Growing family enterprises which take on employees must also reorganize and reset priorities, often resulting in failure. Besides, many women entrepreneurs are in fact more interested in investing in their children rather than in expanding their business. To the dismay of many economists, their priorities may reflect their adherence to a more "human economy." Women should not be penalized for questioning the primacy of the profit motive; rather programs should be

redesigned to accommodate this differing world view.

Women in home-based industries in South Asia also "tend to attach values other than purely economic ones to their home-based work." They are particularly concerned, for example, to find paid work that can be combined with their domestic chores. (Andrea Menefee Singh & Anita Kelles-Viitanen, eds. *Invisible Hands: Women in Home-Based Production.* 1987.) Home-based industrial subcontracting can be, though at the same time it can be highly exploitative. Beneria and Roldan (*Crossroads of Class and Gender,* 1987), for example, describe homework in Mexico City as a "disguised form of subproletarianization," yet recognize it is also an important part of women's survival strategies. Therefore they differ with earlier Marxist scholars by neither opposing home work nor calling for collectivization or other measures that might reduce the amount of work available.

Organizing these microentrepreneurs or home-based workers into some sort of group is a common first step to assisting them. A critical second step, securing political power to protect these poor women, has too frequently been overlooked. Most successful advocacy groups for these organizations were headed by powerful, if not charismatic, leaders who were not only from the elite, but well-connected politically. To protect their clientele, these leaders alternatively challenged and cooperated with entrenched institutions in their countries such as trade unions,

banks, and government ministries. It has become increasingly clear that middle-class women's organizations, by helping found and then protect poor women's organizations, can strengthen both, and contribute to the solidarity of women across class lines. Such actions help to diminish overt opposition, but programs that include some benefits for those whose power is being displaced, such as husbands or moneylenders, may be the most sendible and enduring approach.

Women in industry became the subject of much debate within the scholarly community as multinational corporations began to set up factories in developing countries. The question of whether industrial employment offers opportunity to women or exploits them continues to be an emotional one. Objections to supporting women's informal sector work frequently assumed that capitalist exploitation was potentially *worse* in the hidden, unregulated realms of home and sweatshop than it could be on the factory floor. Yet in reality the dividing line between exploitation and opportunity is an ambiguous one. Clearly, more research on all kinds of women's industrial employment is needed.

Adapting Development Theory

Scholarly critiques of the development community in general, and of WID in particular, have come primarily from three sources: Marxist feminists, women in the developing countries, and "female sphere" feminist scholars.

As noted earlier, WID advocates and practitioners are less interested in raising basic theoretical issues than in reforming development practices to include and benefit women. This nonideological stance, which includes scholars documenting the WID process, has both annoyed and confused those scholars who are consumed with theoretical arguments, however far they may be removed from reality. As the field matures, the pragmatism of the WID practitioners and advocates, and the information about women's lives gathered by WID scholars, have both begun to influence theorists. At the same time, theorists' concerns with global structures, power relationships, and values have become more relevant to practice, especially as the easy optimism of the 1970s begins to fade. Three theoretical questions require comment here: Do women constitute a category? How do women's issues relate to macroeconomic policies? How should women's work be valued?

Women as a category has been challenged by Marxist feminists, who argue that gender relations vary by class, because the cultural, social, economic, and political forces that make gender out of biological sex categories are themselves class-specific. Following the logic of class conflict, they say, women of different classes share no common interests. Mainstream and radical non-Marxist feminists, on the other hand, argue that all women, both in capitalist and socialist societies, are subordinated by patriarchy. While all these kinds of feminists agree on the need for women's *equality* with men, female sphere theorists celebrate *difference*. After years of debate, these days both class and patriarchy are generally accepted as causes of women's subordination...

Devaki Jain, coming from a Gandhian tradition, has tried to avoid the class-patriarchy debate altogether by arguing that women need first to sort out their common interests for a just relationship with men and then join with men in a united effort for revolutionary changes in all of society. In this manner she subsumes the idea of class, since all men will unite with all women; she also avoids the accusation, voiced by many Third World women at the Mexico City conference, that feminism was basically a fight against men, and thus "unbecoming and western" (*Women's Quest for Power.* 1980.)

Over the decade, several other sources of women's subordination have been identified, especially race in the United States. Third World scholars examine not only class and gender stratification in research on their own countries, but also the consequences of dependency, underdevelopment, and colonialism. Discussing gender oppression in India, many scholars add the additional complications of caste, ethnicity, and religion. Further, these writers suggest that lower-class women are more exploited economically, women in higher classes are more exploited by patriarchy. This difference, typical of societies that value the seclusion of women, reinforces violence against

poor women, who lose status because they must break seclusion in order to make a living.

This controversy over the structural causes of women's subordination provides an analytical tool for practitioners. Development assistance programs which respond to women's *practical* or material interests may help them survive and fulfill their gendered roles, but they do nothing to change patriarchal subordination and may in fact perpetuate it. In contrast, programs that take into account women's *strategic* interests, according to Maxine Molyneux, will include among their goals women's emancipation or gender equality ("Mobilization Without Emancipation? Women's Interests, State, and Revolution in Nicaragua," *Feminist Studies* 11/2, 1985). It does not matter whether programs are classified within the development community as welfare or sectoral; the critical question is whether the process of supplying basic needs includes "consciousness-raising . . . a change of attitudes, organization and mobilization for social and political participation, structural change and institutional and legal changes." Caroline Moser shows how housing programs for poor women could either simply supply shelter or, by enabling women to own their own homes, could bring about real structural change ("Women, Human Settlements, and Housing: A Conceptual Framework for the Analysis and Policy-Making," in C. Moser & L. Peake, eds. *Women, Human Settlements, and Housing,* 1987). In short, if programs

do not address the causes of women's persistent inequalities, they should not be considered feminist.

Feminism, then, provides a political basis for organizing women across societal divisions even as it recognizes differences in women's lives. As Ann Whitehead summarizes observes, "One of contemporary feminist theory's main contributions to the study of women was to rediscover shared gender as a basis for solidarity and common interest, and different gender as a basis for division of interest and ideological dissonance" ("A Conceptual Framework for the Analysis of the Effects of Technologial Change on Rural Women," ILO working paper. 1981:6).

Relating value and status to women's work has been a goal of feminist scholars throughout the decade, but it has often been obscured in the development literature where the emphasis is typically more on the economics of work. Despite evidence that women in many subsistence societies women worked long hours but were treated as slaves, the prevailing opinion holds that work is a necessary but not sufficient condition of high female status. Recent studies of newly industrializing countries show that women participating in the wage economy are far from liberated. Practitioners are taking greater care not to introduce development projects that simply increase women's work but do not empower them. Designing projects that best meet women's strategic as well as practical needs requires understanding who controls women's labor,

which necessarily requires looking back into the household and the issue of patriarchy.

Two different perspectives, both emanating for the female sphere approach, have questioned the pursuit of equality as the basis for an egalitarian society. The first is based on the tradition of women's autonomy in the private world, leaving the public world to men. In such societies, taking women out of the public labor force enhances family prestige, and therefore women's status, even though it also makes them more economically dependent. In many parts of Africa today, as the urban middle class grows, there is increasing pressure to stop their income activites, especially in the informal sector. But many women, accustomed to controlling their own income, are not convinced that the prestige of not working is worth the dependency it brings. Instead, they prefer to distance themselves from their husbands to retain control over their own income. On the other hand, the current Iranian government is mandating that men work to support the family while women stay home, and this decree has been welcomed by many poor and formerly hardworking women.

The second perspective questioning male values comes from scholars such as Elise Boulding who argue that after centuries of relative autonomy, women have developed a female culture geared to nurturing and survival. This autonomy was bolstered by a series of rights and perquisites based both on informal work and on services related to life-cycle events, illness, housebuilding, and the like. The mechanisms through which this autonomy functions include both kin and patron-client relationships. These relationships provide female support networks not only in the neighborhood but, more recently, at the national and global levels. Boulding argues that feminine values are essential to global survival; ecofeminists decry male efforts to dominate nature; peace advocates draw parallels between men's warmaking and violence against women ("Women's Movements and Social Transformations in the Twentieth Century," in *The Changing Structure of World Politics*, Yoshikazu Sksmoto, ed. 1988.)

Influenced by these arguments, many feminists in the development field are beginning to question the overriding WID concern with work and equality with men. They are concerned that these emphases are as narrow and ultimately unproductive as the earlier emphasis on woman as mother, and they fear that attacking patriarchy might undermine permanent female-male relationships. Many are beginning to wonder whether, by asking for equal rights with men *as if they were men*, women are not denying their own values and priorities associated with caring, and whether, *by using men as their measure*, women will not always be second class. In concrete terms, would granting land ownership to farming women in Africa only increase their work while enabling fathers to avoid any childraising costs, or would such redistribution of resources move African women toward greater equality?

Forming visions of the future remains a major challenge to global feminism. In reconstructing a new balance among women, family, and community, it is clear that individual responsibilities as well as rights must be stressed. Outlining her view of ethics in feminism, Gita Sen cautions women against seeking individualized autonomy and running the "risk of splitting off from ourselves the nurturant aspects of human existence... If we view a hierarchized, oppressive interdependence versus a nonhierarchical, alienated individuation as the only two possible alternatives, then we lost indeed" ("Ethics in Third World Development," Rama Mehta Lecture, Radcliffe College, April 28, 1988.)

Macroeconomic policies and women has become a critical topic of research. The debt crisis revealed the connection between global trends and women's poverty even when exact causality is difficult to establish. DAWN (Development Alternatives with Women for a New Era) chronicles the systemic crises that threaten both local environment and local economic activity—and hence women—but which are caused by macro policies that encourage exploitation of land and natural resources, open global capital markets, and militarism.

Structural adjustment policies of the World Bank have been increasing criticized as having differential effects on the distinctive structures of the male and female work force. These policies both reflect and perpetuate existing gender bias already existing in normal market-regulating policies. In agriculture, for example, gender divisions of labor mediate how men and women are effected by and respond to pricing and subsidies. Many believe that the African food crisis has been caused, in part, by misdirected macro level development policies that are blind to the importance of women's economic power at the micro level. Such research establishes the importance of relating macropolicies to microeffects when addressing the impoverishment of women; the fragmentary nature of data indicates a need for further studies.

The three Decade for Women conferences introduced large numbers of women to the formal U.N. process. Even more, these conferences fostered the internationalization of the women's movement. Out of Nairobi emerged a variety of global networks, founded by Third World women, to complement and balance the earlier American and European organizing efforts. There is widespread agreement among them that women will gain access to meaningful resources only if their views of human priorities are incorporated into broader debates on national and global issues. In particular, women's groups must show that the effects of macropolicies on women can no longer be neglected at the level of national politics.

CONCLUSION

This overview of the critical issues facing the field of women in development is meant to illustrate two trends.

First, women from diverse backgrounds and perspectives are finding increasing grounds for agreement. Women have multiple roles, and multifaceted identities. There is strength in their diversity; there is also strength in women's shared culture and values. New research is needed to explore whether these alternative values are merely an expression of subordination or whether they represent a fundamentally different life force or life view. In this research, scholars must remember to differentiate between women's objective and subjective conditions, for though economic indicators suggest that they are worse off than before the Decade began, women's organizations at all levels have given many women a sense of participation and power over their own lives that they have never had before.

The second trend is toward greater awareness of political power and of the need to assess political institutions through a gender-sensitive lens. If two decades ago the emphasis was on economics as a path for women to attain greater equity, today the emphasis is on politics: local, national, and global. If patriarchal institutions at all levels are responsible for the maintenance of persistent inequalities, then the next feminist agenda must be the analysis of these institutions in order to abolish or change them. If the emphasis of the Decade aimed to convince the development bureaucracies to include women, this new agenda must revitalize the advocates to pursue policy change even more vigorously, in order to give women a stake in the political process.

WOMEN IN DEVELOPING SOCIETIES: ECONOMIC INDEPENDENCE IS NOT ENOUGH

WOMEN IN MANY DEVELOPING COUN-tries are celebrated for their role in economic activities; customary law recognized and protected these roles. Tradition also specified appropriate occupations for each sex, but since many jobs were done by men and women working together, there has been considerable leeway in many cultures for the individual woman. The gradual penetration of modern concepts concerning law, occupations, economic development, or education is necessarily affecting traditional patterns both in towns and rural areas. During and since colonial rule, these laws and ideas have come largely from Western Europe and the United States. Most developmental aid similarly comes from the "West." Such aid carries with it Western occupational stereotypes which reinforce the modernization ethic of Western-educated indigenous planners. This vision of future society places women in the home, and so encourages planners to ignore women's present economic contributions. For this reason, development adversely affects women around the world, by eroding their economic independence.

To talk of economic roles is not to argue that women are equal to men. Contrary to the premise suggested in the title of this book, *Economic Independence for Women: The Foundation for Equal Rights*, women have long performed economic activities in addition to, and circumscribed by, their family responsibilities. Thus, a woman might make money in the markets, but still be subject to her husband's sexual demands or her father's plans for her marriage; children of a divorced woman or those born outside marriage frequently belong to the husband's tribe or family. The variation in traditional roles and their patterns, which range from amazing independence to near-serfdom, are discussed in some detail below. What is above all important to recognize are the linkages between economic activity, family roles, and both personal and political power which make up that elusive concept of status. It is also important to understand that development will continue, and should, for women lead exhausting lives in most of the world. But it should enhance their lives, not further degrade their status.

INTRODUCTION

It is imperative, in a book directed at an English-speaking audience, to reiterate the dangers of making culture-bound assumptions when comparing women's status across cultures.

We must especially beware of seeing women as mirrors of ourselves. For example, Americans tend to view the nuclear family as confining and search out new forms of marriage. Yet several observers of Asian women argue that the nuclear family is the primary liberating force from the patriarchal dominance of the extended family. Latin American observers, on the other hand, suggest that the kin network typical of their traditional extended families actually allow for greater female equality because of the shared obligations and duties within the family

Similarly, the practice of seclusion, or purdah, is regarded in much of the West as an extreme form of backwardness. Yet such seclusion is spreading today in parts of Africa and Asia, where it is perceived as an improvement of status, an emulation of the upper classes. Among the Hausa of northern Nigeria, animist rural women farm, but the urban Muslim Hausa women are reported to have refused this work, preferring seclusion. The Hausa's slave women also worked in the fields; with the abolition of slavery, these women also sought to improve their status by refusing to farm. This may account for the continued willingness of Hausa women maintain purdah. A recent study found that most women interviewed claimed they preferred to be kept in seclusion on the grounds that it reduced their workload and raised their prestige. The process of Sanskritization among Hindus—emulating the caste above your own—has led families who can afford it to stop their women from working in the fields so they may stay at home.

Family pattern and seclusion may be linked to religion, culture, and to economics. In very sparsely populated regions where women farm and land belongs to the tribe, women are entitled to sell the surplus crops after feeding the family, and keep any profit. In more densely populated areas, more intensive farming is necessary and the use of the plough is predominant. Men do most of this work while women must help with harvesting and weeding, and more recently, with fertilizing. Finally, in regions of intensive cultivation of irrigated land, both men and women must put hard work into agriculture in order to earn enough to support a family on a small piece of land.

What does her farming role have to do with a woman's status? In subsistence agricultural economies, a woman's work is recognized: a man buys her labor in the form of a bride price. Indeed, women who could afford to buy the work of other women could have wives! Wives became an investment, and polygyny was common. Not surprisely more men have multiple wives in areas where women work than in those where women are kept in seclusion. In 1996, about half of all married women live in polygamous marriages in Senegal, Togo, and Guinea; over 40% in Liberia, Nigeria, and Cameroon; one-third in Ghana, Niger, and Uganda. (Philippe Antoine & Jeanne Nanitelamio. "Can polygyny be avoided?" in Kathleen Sheldon, ed.,

Courtyards, Markets, and City Streets: Urban Women in Africa.) The cost of polygyny has tended to limit its continued practice in cities to the middle and upper classes. Lower-class men, both in Africa and in Indonesia, tend to have only one wife at a time, but ease of divorce allows for frequent changes of partner. Women's economic independence and the phenomenon of multiple liaisons seem to go hand in hand.

However, when customs changed, as among the Hausa women who refused to farm, men could not as easily afford second wives once they became economic liabilities, not assets. Thus, with seclusion, a father often had to provide his daughter's economic contribution to her prospective husband by giving her a dowry. Under some circumstances, the dowry then became of the man; but under Islam, with its easy divorce procedure, the dowry belonged to the woman and was returned to her should she be sent home. There are changes as a result of modernization. With the more intensive cultivation brought about by the "green revolution," women in the Punjab are returning to the fields and the marriage age has increased. Elsewhere in India, it has been reported that bride price has replaced the dowry as women begin to earn their keep. Lower castes have always paid a bride price, in any case.

In Southeast Asia, where women have long cultivated rice, neither extreme of buying or selling the woman is typical. In nominal Muslim areas such as Java, a bride's family may give a token payment to the groom's family; lower-class parents may sell their virgin daughter to a wealthy man who subsequently divorces her. But in Thailand, Vietnam, and the Philippines, women play fairly equal roles in marriage, as in the economy.

To talk about patterns of economic development is not to assume that all societies will pass through equivalent stages, nor is it to assume that a subsequent stage is an improvement on the previous. To do so is to ignore the realities of history. Women's status has clearly fluctuated over the centuries, as civilizations have risen and fallen. Evelyn Sullerot (*Women. Society and Change*. 1971) asserts that "as a rule it is in the early periods of each civilization that the least difference exists between the position of men and that of women. As a civilization asserts and refines itself, the gap between the relative status of men and women widens. This gap arises from the emergence of private property and the patriarchal family system in simpler societies where women had more options. Ebihara ("Khmer village women in Cambodia: a happy balance," in C. J. Matthiasson, ed, *Our Many Sisters: Women in Cross-Cultural Perspective*. 1974) also notes historical declines in women's status in Southeast Asia: a Chinese visitor to the Khmer empire in Angkor Wat in the thirteenth century recorded that women held many court positions; yet within a century, due to Chinese influence after the fall of the empire, women

were reduced to the status of legal minors, belonging to their husbands.

These older civilizations spawned many cities with highly stratified societies, although the majority of the population continued to live in rural areas. City women in these countries may be more traditional than their rural sisters; urban social norms will often be a mix of old and new, traditional and Western. Further, social stratification means that middle and upper class women live very differently than lower-class women. Therefore, after discussing women's status in elatively egalitarian subsistence economies and stratified societies separately.

A major question is whether Western civilization's impetus toward urbanization and modernization will cause or exacerbate social stratification in the name of an ideology which speaks of equality. In societies throughout the world, educated elites imbibe Western values and support Western laws. Like converts, they are often stronger in their faith than those born in the West. Indeed, it is precisely the indigenous national leadership's attachment to Western values which reinforces stereotypes of what is "proper" for women to do. They observe women's traditional occupations in their own cultures and measure them against Western values. Traditional women, on the other hand, adapt to Western influences, but remain primarily within an indigenous environment. Thus, the gap widens with each succeeding generation...

If women's economic independence is not enough, and if this independence is likely to fall before modern development of any type, then women's political role becomes crucial. Here again the impact of Western middle-class values seems to limit, rather than expand, opportunities for political participation. In most countries it would seem that women's place is going to get worse before it gets better, unless women in the developing world can force recognition of their traditional status upon the developers, both indigenous and foreign...

"OLD-URBAN" SOCIETIES

The development of the great civilizations of Egypt, Iran, Pakistan, and China began in 4,000 B.C. Yet today these countries are included on the list of "developing" nations. While the rural areas of these countries do greatly resemble those in subsistence economies, elements of more complex civilization (in particular stratification and religion) has long restricted the status of women in all but the lowest and the highest levels of society. To some extent, parts of Latin America could similarly be classed, due to the transplanting of traditional religion and the development of a rigid class structure.

Two major institutions have tended to restrict and protect the woman in these old-urban societies: the family and religion. As they have become more stratified, ruling class families feel an increasing need to protect their women. While upper-class men could

exploit lower-class women, they greatly fear the reverse. Thus, increasingly "civilized" countries have tended to segregate their women and restrict their contacts with men. The romantic myths and chivalric codes of the Middle Ages idealized the "protection" of women in Europe, while the isolation of women in harems and purdah characterized the high civilizations of the Hindu and Moslem empires. In China, bound feet both symbolically and practically restricted women's mobility. Families arranged their daughters' marriages, preferably before or just after puberty, to "protect" the bride's chastity for the recipient family.

As occupational differentiation increased class stratification, it also separated men's and women's domains. In most of these countries a woman played a powerful role in the domestic sphere, but was expected to have no role whatsoever in the public sphere of men (Rosaldo, 1974). Where women did develop outside interests, they were restricted entirely to meeting with other women. In areas of South and Southeast Asia, women often met to worship, as this was considered primarily their role.

Patterns of social segregation and seclusion were apparent even in the countryside. Typically, the lower class sought to imitate middle-class restrictions to demonstrate their upward mobility. Among Hindus this process has been termed "Sanskritization:" lower castes adopted food restrictions and methods of worship, and secluded their women. Meanwhile upper-class women, living in homes with many servants, had sufficient free time to train in arts, music, painting, and sometimes to get an education. Throughout history there are cases of unusual women, nurtured in such secluded environments, who excelled. Because it is essentially the family who enforces the mores, upper-class women have often been relatively free of restrictions simply because their families have been so confident of their own worth. Thus, today we have female prime ministers of India and Sri Lanka, just as we have had occasional empresses and queens. Such exceptions aside, most women in stratified societies lost privileges as they moved upward. Inheritance tended to be passed through the family rather than through the woman herself. Even in Islam, which does guarantee women some inheritance rights, the property is often turned over to her male protectors.

Women of the middle class in these old-urban societies tended to live in densely-built towns with many-storied houses, often in purdah quarters open only to tiny gardens or to the roof. These were frequently centered around the court, where there was a high demand for artisans and traders. Because these cities are so crowded, women generally do not raise vegetables or animals in the town center. In contrast, in parts of Africa and Southeast Asia today, many modern cities are a hodge-podge of Western urban development and village-type compounds,

where people live as much they would in the rural areas.

Nadia Youssef ("Women's status and fertility in Muslim countries of the Middle East and Africa." Presented at the annual meeting of the American Psychological Association, New Orleans, August 1974) has analyzed the work opportunities and economic independence of women in the Middle East and in Latin America. She argues that the coincidence of religious authority and family authority under Islam so restricts the options available to any woman that she can only with great difficulty choose to leave the protection of the family. Even the fact that Middle East women are typically divorced several times does not alter their dependence on the family: the divorcee returns to her own family with the expectation of remarriage. Thus, children are assigned to the grandparents, first on her side and then on his, so that she will not be encumbered in a new marriage with children from a former one. Marriage perhaps provides more freedom than living at home, but in neither case is it thought proper for a woman to work outside the house in the Middle East.

It is interesting to compare the restrictions on Middle Eastern Islamic women with the somewhat freer norms typical in northern Africa. In northern Nigeria urban women continue to observe purdah, but they work within the confines of their homes and sell their products through their children or male relatives. On Java, where Islam is blended with more indigenous beliefs, only the divorce laws seem to have served to undercut women's traditional independence.

Unlike Islam, Catholicism has provided women in Latin America with an alternative source of authority to the family. But for all its influence, the Hispanic tradition has never conquered the appeal indigenous beliefs. Thus, instead of only one pattern of proper behavior, there are several—a factor which allows women some choice for their personal behavior. This flexibility has led to a greater differentiation among classes in Latin America than in the Middle East. Lower-class women work; their relative economic independence role may give them the choice not to marry. Upper-class women with servants often have the freedom to become active in voluntary associations or choose a profession. Still, professions related to motherhood predominate. It is the middle-class woman who typically leads the most circumscribed life. As lower-class women struggle to climb the social ladder, they lose many prerogatives, a process clearly evident in the novels of Latin America.

In Hindu society, as in Islam, women were secluded; but while Islam usually only restricted contact with outsiders, Hindu women were secluded from any males. The contrast between this extreme seclusion and European marital relations could not have been more evident to the westernized Indians who entered the British civil service. They began to send their daughters to

missionary schools to learn English. Education had a profound impact on this generation of young women, who married before independence. Traditional Hinduism preaches duty, especially towards the joint family; women are expected to accept family members into the household on request. The second generation of women increasingly resented what they saw as intrusions by their families into their own nuclear households, especially when they began to work outside the house. That the woman works for her family and that she is a professional only during the day allow a complete separation of work and home. Thus, sexual harrassment is never an issue in offices in India, which most observers feel relieves Indian women of this strain common in Western society.

Until the communist revolution, China was highly stratified, with the same exploitation of women and men of the poorer classes, great restriction on the mobility of middle-class women, and relative freedom and education for elite women. Communist ideology defines all adults as equals, and all as producers. There have been massive attempts to undermine the family system and Confucian thought and to attack educational elitism by requiring college students to participate in farmwork or public work projects. Government publications suggest that the ideal of equality has been achieved, but typically the military and bureaucratic leaders are almost entirely men. Even the most influential Chinese woman today, Chiang Ching, wife of Mao Tse-tung, operates on the periphery. Recent visitors to China have been impressed by the efforts to achieve female equality. Nonetheless, even the Chinese delegates to the UN Commission on the Status of women admitted the men in the outlying areas of the country do not yet understand that women are their equal.

In the old-urban societies, then, lower-class women had the most economic opportunities within their own class level. With upward mobility came less economic independence and freedom outside the home. Elite women in traditional societies enjoyed somewhat greater mobility, if not freedom, and among them emerged some very unusual women leaders. In addition, some middle-class women are beginning to work outside the home, as part of their traditional responsibility to support the family. Generally, however, their jobs involve nurturing, and are most common in environments where clients are still segregated, as in schools and clinics.

POLITICAL POWER

In traditional societies extraordinary women have long played important political roles, either by themselves or in concert with men. For example, among some groups in West Africa, women frequently became chiefs. British colonial administrators refused to recognize such chiefdoms, seeing them as aberrations. Igbo women had their own political institutions and participated in

village meetings along with men. They were active in a variety of protests against colonial rule, including the 1929 tax protest known as the "Women's War." Women remained politically active in Nigeria after independence; they served in leadership roles and in several elections even fielded a separate party. Indeed, it was women's obviouly prominent role in West African politics which prompted General de Gaulle in 1944 to offer equal suffrage to many women in the French African colonies. Only belatedly did he recognize that it would then be necessary to extend the right to vote to French women as well. In Ghana women strongly supported Nkrumah, while women in Guinea mobilized to influence Sekou Toure Again, it would seem that their economic independence is necessarily related to their political role.

In Asia elite women played a central role in the struggle for independence. Such women frequently began their political careers when their husbands were detained or imprisoned. Daughters of the first generation of nationalists, they were generally as well educated as their brothers. Unfortunately, in most cases women's high level of political activity during periods of anti-colonial nationalism waned once independence was secured, for a number of reasons. First, increasing economic pressures, made it impossible for many families to educate both sons and daughters; most chose to send sons farthest. Second, as the population of educated individuals increased, educated women were less

likely to find jobs than their male peers. While the availability of leisure time encouraged some women to become politically active, economic dependence and cultural pressures dictated for many a more subservient role.

An alternate explanation for the decreasing number of women active in the party politics of developing countries was the declining influence of the independent professional class. As noted, most women active in the revolutionary period belonged to the educated elite and, like their male peers, joined the revolutionary movement primarily because colonial rule denied them the recognition they felt they deserved. After independence, their position changed. Their sons and daughters went abroad for their schooling, and many lost touch with home. Furthermore, as professionals they became more highly specialized, thus losing the "class" solidarity of the small literate minority. As a result, professionals themselves began to lose power to the organized bureaucracies of the military and administrative services. Neither of these services has been at all receptive to women. Not surprisingly, in those countries since taken over by military regimes or by military personnel in collusion with the civil service, fewer women serve in government leadership roles.

Obviously, women's exclusion from government affects their general economic position. Furthermore, both military and civil bureaucracies in developing countries tend to be "westernized" to the extent that its members have absorbed middle-class Western values.

Many of them believe that woman's place is in the home. The erosion of women's political and economic roles in many developing countries, then, reflects changing opportunities for the professional elite. On the other hand, women in Latin America have never played a very strong political role. Educated elite women there work in "nurturing" occupations, if they work at all. Further, Latin American politics have not fostered the development of a true party system.

CONCLUSION

Development has tended to restrict the economic independence of women in formerly subsistence societies, as new technologies and ideologies challenge their traditional livelihood practices. Because Western gender norms tend to accompany Western development aid, modernization continually increases the gap between women's and men's capacity to cope with the modern world. Elite beneficiaries of Western-style schooling in these countries tend to accept the notion of women's economic subordination. Thus, women in many developing societies are compelled to to trade economic independence for economic dependency, while not yet benefitting from Western laws and norms regarding equal rights.

In stratified old-urban societies, modernization and development have tended only increase the inequalities between men women of the lower and middle classes. On the other hand, elite women in these societies have benefitted from Western education and ideals of greater freedom. Only in some Islamic countries do elite women remain under the strict control of their male relatives.

In the USSR and Eastern Europe one finds an alternative model, where women and men are in theory equal economic units, but in practice women are relegated to economically less important roles. Because women's maternal role has been largely ignored in these societies, there has been a great drop in fertility rates. Men are still not taking on their share of household duties, and the women are in fact even more oppressed by two jobs—wage work and housework—than they are in many other developed countries.

The dislocation which development causes in the traditional economic roles of women in subsistence societies encourages the search for alternate models for development. What is needed is not an imported model, but rather an adaptation of development goals to each society. Only then can women now active in the economy be assured that their position will improve, and that they too will benefit from development.

NONGOVERNMENTAL ORGANIZATIONS: AN ALTERNATIVE POWER BASE FOR WOMEN?

WOMEN SINCE TIME IMMEMORIAL have organized themselves into groups to support their own activities and to assist others. In modern states, women's formal or informal organizations at national and local levels have offered chanty, raised societal issues, engaged in networking, and generally provided the glue that holds society together; men have occupied most positions of power in state institutions. Today, women have expanded their organizing to the global stage and broadened the scope of their concerns to include population, environment, technology, energy, and human rights, to name a few. This process was encouraged and enhanced not only by the four United Nations World Conferences for Women (Mexico City 1975; Copenhagen 1980; Nairobi 1985; Beijing 1995) but also by other UN world conferences since the early 1970s.

The impact of embracing this global agenda has been two-fold. First, the agenda of women's organizations now not only includes "soft" issues of family and charity widely regarded as appropriate for women's concern, but it also encompasses advocacy positions that confront what has been a predominantly male discourse on each of these topics. Second, women have joined the myriad single-issue nongovernmental organizations (NGOs) and have taken with them their conviction that these issues are also women's issues. Today NGOs and women's organizations increasingly challenge the power and scope of traditional political institutions within the state and lobby international agencies to reinterpret development policies. As the civil society expands in most countries in response to this era of limited government, these new organizations are touted as the real arena for citizen participation and the foundation of present or future democracy. Are NGOs really the new panacea for contemporary government? Should women's organizations be considered NGOs, or do they form a distinct type of organization? Does women's involvement translate into greater political power, or does participation in NGOs once again marginalize women? Are women more likely to influence major decisions facing society through separate or integrated organizations?

WHAT IS AN NGO ANYHOW?

The use of the term "nongovernmental organization" was adopted by the United Nations when it agreed to

provide a mechanism for citizen-based organizations to participate in the Economic and Social Council (ECOSOC). Such organizations are private and nonprofit; they represent people acting of their own volition and describe themselves in their formal documents as self-governing. As a residual category, the term covers a wide range of groups that are not commonly thought of today as nongovernmental organizations: trade union federations, business councils, international unions of scholars, lay religious councils, and professional associations. Women's organizations are also often distinguished from NGOs as the term is now used; this point will be further explored later in the chapter.

NGOs and the United Nations System

Nongovernmental organizations may file for consultative status with the UN, a designation that allows them access to meetings of the committees and commissions of ECOSOC. Members of NGOs may participate informally in these groups, roaming the chambers and halls to talk to delegates; they may . also, by request, be given the floor in formal debate. Further, NGOs automatically receive all documents from these discussions and may request that their own documents be distributed. This interaction between UN staff and governmental delegates on the one hand and the NGOs on the other was so valuable that other agencies in the UN system

identified their own lists of NGOs and granted them similar privileges.

As development issues began to dominate the UN agenda, new types of NGOs, concerned with issues such as agriculture, community development, population, environment, energy, technological transfer, and housing, sought consultative status.' Most international NGOs (INGOs) have affiliates or chapters at the national level in several countries. The objective of the INGOs is to monitor activities within the United Nations system of concern to their membership and to persuade the General Assembly to pass resolutions stating goals for national as well as international action. While such resolutions lack the force of law, they provide the national NGOs with a powerful tool that can be used to alter policies in their respective countries.

This policy role of INGOs was greatly enhanced as a result of the series of consciousness-raising world conferences that the UN convened, starting in 1972, on major development issues that had not been sufficiently addressed in the original UN Charter. These world conferences are official meetings of the UN system; the delegates from governments, UN agencies, and official NGOs are charged with approving an official action document that has been discussed and debated in preparatory meetings in the preceding years.

Parallel to these official formal conferences, there have been open, unrestricted, often chaotic and contentious, NGO gatherings, called NGO forums.

Loosely organized by the CONGO (Council of NGOs), these meetings typically feature seminars, panels, dances, films, and field trips, all meant to reflect the debates and disagreements among the wide diversity of interested people from around the world who are stakeholders in the issues under discussion. Some radicals considered even the NGO forums to be too close to the UN and its viewpoints and organized alternative NGO gatherings. During the UN Science and Technology for Development Conference in Vienna in 1979, the street theater groups set up an alternative to the "green" alternative to the NGO forum. Anyone, with or without affiliation to any group, could attend these NGO meetings, often without a registration fee.

In contrast, only "official" NGOs could attend UN conferences, although frequently NGOs working on the topic at hand could register for just the particular conference: fourteen hundred groups received recognition at the 1992 Earth Summit. Such accreditation allows NGOs to participate in the series of preparatory committees, or prepcoms, where the official document of an upcoming conference, often called a world plan of action, is discussed and refined, and where many of the most significant changes are made. NGOs not familiar with UN procedures often ignored these prepcoms and then became frustrated at the world conference when they realized the limitations placed on substantive changes at that time. At many conferences, about the middle of the first week when NGOs realized their impotence, some would organize a march on the official conference. At the 1980 women's conference in Copenhagen, activists actually invaded the chamber and halted debate. Usually, NGOs as well as many official delegates preferred the spirited discussions at the NGO forum to the measured minuet of official conference procedures.

Access to delegates is another matter. National and international officials are more available during the conference than in their protected home bureaucracies. NGOs lobby them about themes of the conference as well as on national policies. Often the delegates, official NGOs, and issue-oriented NGOs find common ground despite their earlier antagonisms. Government delegates, who at home ignored NGOs, found that could discuss issues in the more open UN conferences and realized that they needed the substantive help of NGOs for their political support back home

Out of these world conferences have come global networks of activists from international INGOs and national NGOs. The Union of International Associations lists over fifteen thousand NGOs that operate in three or more countries and draw their finances from sources in more than one country. A measure of their effectiveness is the frequent efforts of some authoritarian governments to reduce or abolish the role of INGOs in the United Nations system in order to reduce the global

reach of many powerful NGOs that are able to challenge national sovereignty on some issues. Another measure of their effectiveness is the growing attention given to these NGO networks by UN development agencies. From its inception in 1973, the United Nations Environment Programme sponsored the Environmental Liaison Committee to maintain a link with NGOs organizing at both the national and international levels. Following its creation in 1976, the United Nations Centre for Human Settlements, or Habitat, established the Habitat International Coalition, an umbrella group for NGOs and community-based organizations interested in shelter issues. The United Nations Fund for Population Activities was until recently the major funder of the International Planned Parenthood Federation and many of its national affiliates. The United Nations Development Programme sponsored a new global organization in 1992 called SANE (Sustainable Agriculture Network). NGO relationships with the World Bank are discussed below.

The proliferation of NGOs active in the UN has led to demands by the organizations themselves for a greater say in the overall deliberations; some are even calling for an assembly of NGOs to parallel the General Assembly with its governmental representatives. Such a demand is based on the claim that NGOs reflect people better than do governments, a widespread but unproven assumption. Yet a question persists: To whom are NGOs accountable? As

elements of social movements, NGOs are rooted in a particular set of beliefs. At what juncture are they perceived as interest groups that may as often undermine the political process as support it?

The report by the ECOSOC established Open-Ended Working Group on the Review of Arrangements for Consultations with Non-Governmental Organizations supports the desire of international NGOs to participate in global governance. Such consultations could use the expertise and practical experience of these groups in the formulation of international legal instruments, polices, and programmes. NGOs are in a position to advocate for their implementation nationally and globally. The working group stresses, however, that the vast growth in NGOs has occurred primarily at the national and local levels, an observation that led United Nations Secretary-General Boutros Boutros-Ghali urged a partnership to include multilateral agencys/NGOs/governments. Support for NGOs is perhaps stronger than ever under the administration of the present UN Secretary-General, Kofi Annan. When 637 NGOs from sixty-one countries assembled in New York in September 1997 for the opening session of the first General Assembly under his leadership, he told them that UN/NGO partnership is not an option, but a necessity.

NGOs and the World Bank

Collaboration between NGOs and governments is increasingly fostered by the

World Bank as a condition for loans. Since early in the 1980s, the Bank has had an NGO committee that specialized at first on environment but has more recently enlarged its concerns. Finding consultation with NGOs extremely useful, by the end of 1980s the World Bank had begun to include NGO participation in 50 percent of its projects. The committee has funded support staff and maintains a list of over eight thousand NGOs in its data base. Sunshine rules allow NGOs access to most internal documents of the World Bank, facilitating critique of proposed projects.

Debate continues within the NGO community about such close cooperation. Are the organizations working with the Bank being co-opted? The June 1991 issue of *Lok Niti,* the magazine published by the Asian NGO Coalition, ANGOC, is entitled "GO-NGO partnership: a marriage of convenience?" Its cover shows the groom, GO, and the bride, NGO, being married by the World Bank! Chandra De Fonseka asks: What is the World Bank's interest in forming partnerships with NGOs? At the outset, altruism and similar philanthropic motivations can probably be rejected immediately. After all, the World Bank itself would wholeheartedly agree that as a bank, it does not operate in such rarified lines of business...however poverty is bad for business.

NGO activists in Washington, D.C. are concerned that the Bank promotes NGO connections to minimize criticism of its commitment to market solutions. Widespread complaints about disastrous social impacts of most structural adjustment policies convinced the Bank to attach policy conditions to loans to prevent all reductions of government spending from being taken from budgets for social programs. Few see significant impact of World Bank policies because organizational rigidities minimize NGO influence. Worse, some critics fells that NGOs' goals are inevitably reshaped by their relationship with the World Bank.

The Bank's program cycle has also been criticized within the institution. Noting that most NGOs are brought in to assist in implementation after the project has been designed, some staff argued for consultation of NGOs "upstream," before the project is set. They believe that the current process does not allow NGOs to apply their distinctive attributes: their closeness to the community and knowledge of local circumstances and people. Involving NGOs early on would change the quality of NGO involvement.

NGOs' castigation of the World Bank and the International Monetary Fund reached a crescendo during the celebrations marking the fiftieth anniversary of the founding of the United Nations in San Francisco in 1945. A coalition of NGOs called Fifty Years Is Enough put forward demands for restructuring both institutions and rethinking their single-minded devotion to a single economic model. The role of these institutions in stabilizing the economies of East Asia in the financial crisis of 1997-1998 has propelled

criticism from the NGO community into the U.S. Congress during debates about replenishing funds for the IMF. The value premises of the critics contrast with the narrow economic principles that continue to dominate the thinking within the World Bank. Will the humanitarian predilections exhibited by most NGOs alter the market-oriented paradigm so dominant today? Does this soft approach reflect traditional women's values, or are these values themselves becoming more central within the civil society? Does this mean enhanced power for women in NGOs?

Challenging the State

Not only are NGOs confronting multilateral agencies and the UN itself; the Open-Ended Working Group of ECOSOC is urging these intergovernmental organizations (IGOs) to work with INGOs *above* and *within* the state. The implication is that national NGOs, through international networks, have a mechanism to make an end run around the state and in the process contribute to undermining state sovereignty. As IGOs and bilateral agencies increasingly promote NGOs as the panacea for all the inequities and problems encountered when governments in the lower-income countries of Asia, Latin America, and Africa pursue rapid economic growth, they are offering an alternative decision-making structure within these states. Economic transition in many of these countries has been characterized by a withdrawal

of the government from significant sectors of the society, thus fostering a civil society between government and market and providing space for NGO activities. Promoters argue that citizens, often constrained by oligarchical or authoritarian governments from participation in the formal institutions of power, can influence policies that directly affect their daily life and so help create a political culture and the social capital necessary to sustain.

Concerns about citizen activism and international interference have led many authoritarian governments, such as China and Vietnam, to prohibit the creation of indigenous NGOs and exclude international NGOs or limit their operation in their countries. Yet many tightly controlled governments find that they must trade greater openness to NGOs for international funding. Countries such as Indonesia try to contain NGOs by allowing them to function as service providers or advocate relatively safe issues, such as women's rights or environmental protection but not human rights, as long as their positions do not challenge the government. When several environmental NGOs documented that a major source of the disastrous fires in Kalimantan in the fall of 1997 was linked to corporations controlled by people close to President Suharto, these critics were protected through their international networks, which ensured reporting in the global media.

In sum, the change in nongovernmental organizations from a focus on relief to a concern with sustainable

development is a significant trend. More critical to global governance is the tendency of these increasingly articulate organizations to segue into advocacy and criticism of current international and national policies. While governments in many developing countries feel a loss of control, NGO networks and coalitions are propelled by great expectations for increased power and prestige.

WOMEN IN NONGOVERNMENTAL ORGANIZATIONS

Historically, women have been more active than men in voluntary organizations, whether at the village level or with the International Red Cross. As the power of NGOs surges into the growing space of the civil society, do women themselves and women's issues in general benefit? After all, NGOs proclaim greater participation and broader democracy than other top-down institutional forms. If women and their concerns are in fact being integrated into NGO debates and programs, what is the role of women-only organizations? These questions are central when examining the functioning and efficacy of NGOs at all levels. Because this chapter focuses on global governance and power, I discuss first the origin and current roles of women-only organizations as they interact with the United Nations and other IGOs. Next I review methods women have chosen to influence debates on such societal issues as population and the environment. Finally I

consider women's roles in mainstream NGOs.

Women's Organizations on the Global Stage

International women's organizations were founded over a hundred years ago to enhance women's attempts to influence governmental policies on social justice and temperance before they were granted suffrage; the first was set up by a Swiss woman in 1868. Leaders in many of these organizations served as delegates to the League of Nations, which did not have specific arrangements for NGO representation. Women from auxiliary wings of trade unions joined those from the women's organizations to set up in Geneva a Liaison Committee of Women's International Organizations, which monitored sessions of both the League and the International Labor Organization (ILO). These women, along with women from the Inter-American Commission of Women of the Pan American Union, were instrumental in adding language about women to the UN Charter in 1945 and securing the UN Commission on the Status of Women in 1947. Many of these same women's organizations registered for consultative status at ECOSOC and continue to provide leadership in CONGO.

Organizationally, these first-wave women's organizations are formally structured with hierarchical officers and procedures that often reflect *Robert's Rules of Order*. Although these

groups now have members from around the world, their leaders are drawn from the elite; their headquarters, and some would say orientation, are in the North. Most would consider women to have similar concerns everywhere for civil rights, education, and fair working conditions and so assume that there is one international women's movement.

Second-wave women's organizations have discarded tight structures in favor of more egalitarian forms and have preferred networks or coalitions to formal international organizations. These groups tend to be more active in outreach to the poor or disadvantaged. Focused on issues in their own countries and skeptical of any generalized category of woman, these new-wave groups have worked together at UN World Conferences for Women and associated meetings, such as prepcoms, and have participated in invitational seminars and professional meetings. Given their preference for networks, they have not sought consultative status at ECOSOC; but many registered as NGOs for the women's conferences; the final list of organizations attending the Beijing NGO forum at Huairou numbered 1,761.

Yet these newer women's organizations have had a profound influence on global governance. Two types of organizations predominated among those set up early in the 1970s: action-research centers, and groups working as agents to change the way women think or act. Both sought to alter the way donors conceived and implemented development programs and projects so

that women's concerns and needs were included. Their activities were readily apparent, and both approaches were given recognition when the General Assembly agreed at its 1976 meeting to set up two new institutions for women as a result of resolutions at the International Women's Year Conference in Mexico' in 1975. The UN Fund for Women, now renamed UNIFEM, was created to support grassroots women's groups. The International Research and Training Institute for the Advancement of Women, INSTRAW, was designed to conduct, collect, and disseminate research on women in development and to use this information to train government officials and NGOs to improve their projects.

Research Centers. The research groups were set up to assist in collecting data for the national reports on the status of women requested by the UN following the 1975 world conference. Founded by committed feminist, these groups sought new ways of creating knowledge that worked with poor women, not only to collect information, but also to collaborate with them in finding solutions to their problems instead of treating them as research objects. The report from DAWN (Development Alternatives with Women for a New Era), presented to the Nairobi conference by women scholars from the South, maintains that research organizations were the most effective of the new women's organizations in influencing policy.

Documenting women's invisible

work in subsistence households, agriculture, and the informal sector was crucial if women's economic activities were to be acknowledged and supported by the development planners. The need for such data was immense, and funds were readily available from donor agencies, population organizations, and foundations. Free-standing research centers were not the only ones involved; university faculty formed women's studies centers whose research went beyond scholarly endeavors to action projects. Agencies of the UN system such as UNESCO, ILO, and FAO commissioned studies; INSTRAW and UNIFEM supported research on basic needs such as water and technology. The secretariat for the 1980 UN Women's Conference funded research by women from the South to ensure a balanced interpretation of data.

Within the decade 1970-1980, the amount of research on women conducted throughout the world by women of all countries was indeed substantial. Internationally, the research findings influenced policies and programs of donor agencies and INGOs. Locally, these efforts spawned new organizations designed to work with poor women to ameliorate their problems; these groups were both integrated and women-only and focused on many issues new to more traditional women's concerns, such as community health, appropriate technology, household energy, and agriculture including crops and small ruminants. Women in these groups took their insights to the UN

conferences on these topics, inserting language into official documents that ensured that women as well as men would benefit from new initiatives.

The excitement and legitimacy of the new research on women encouraged most international professional associations to hold panels on women and often to set up a women's caucus or committee to encourage women scholars to attend conventions. Frequent invitational conferences were held; the first conference on women in development was held in Mexico City in 1975, just before the UN's world conference. Participants were visible as delegates and presenters at both the official and the NGO meetings. The idea of creating Women's World Banking, an NGO that promotes credit for women, was formed during these discussions. The action-research aspect led to the formation of the Association of Women in Development, which holds biennial conferences of scholars, activists, and practitioners from around the world.

The Copenhagen conference in 1980 was the site of the first meeting of the women's studies movement. The International Interdisciplinary Congress of Women was established to hold periodic meetings around the world on women's research and education. Typically decentralized, the Feminist Press publishes Women's Studies International, and the National Council for Research on Women maintains a roster of women's research centers around the world. The DAWN group of Third World scholars had begun meeting

prior to the Nairobi conference and presented its report to the NGO forum; its leading scholars continue to influence development policy individually and through the organization.

Change Agents. The second type of women's organization that has had a global impact has concentrated on changing women's lives. Leaders of these groups often come from research organizations and academia. Emerging during the 1970s, they initially focused on the growing poverty among women, especially those heading households. Working as separate organizations or within NGOs, they organized poor women in rural and urban settings and assisted them in earning money, improving their housing and services, gaining access to health and family planning clinics, receiving agricultural extension information, and attending literacy classes; that is, they worked to include women in all aspects of development programs. Debate over the "success" of such programs continues among scholars and practitioners; activists know that the mere fact of organizing is empowering.

Most women's organizations aim at more egalitarian decision making, though evidence suggests that this is difficult to accomplish; educated leaders often believe that they have the answers and manipulate, if they do not decree, certain decisions. Nevertheless, participation in groups outside the patriarchal family is mind-blowing for many women. Just hearing about new ideas, knowing that their problems are not theirs alone, and discussing alternative approaches to addressing their problems are provocative and stimulating. If at first most issues these groups took on related to poverty, relationships within the family and women's legal rights became more critical when households disintegrated. Domestic violence and rape became global topics openly discussed and addressed. Such issues span class and ethnicity and provide a foundation for a global women's movement encompassing many diverse institutions with their own issues.

In many ways, the network of research scholars provided the base for the contemporary international women's movement that embraces diverse feminisms. Grassroots groups at first tended to be fragmented over goals and ideology, but they have all emphasized participation and information, and their goal has been empowerment. As a result of all these activities, change is clearly happening at the local and state levels. What are the international implications of women's activism underscored by our greater understanding of women's roles and their economic and social contributions to society?

Women Influencing International Issues

International networks of women's organizations and coalitions have focused on identifying and inserting women's viewpoints into broader societal interests. Leaders of these groups often have their roots in women's organizations

or research centers. Other groups were founded by women who previously worked within mainstream NGOs on issues such as population, environment, technology, energy, housing, and water and sanitation and who felt that their perspectives were ignored by the dominant male leadership. These groups have been influential in many recent international conferences.

For example, in January 1985, the Environmental Liaison Committee of NGOs, which advises the United Nations Environment Programme, held a meeting in Nairobi to consider how to include in its proceedings more voices of women and people of the South. Invitations had gone out to leaders of development and population organizations that had a better record of including women. During the first day, men from Europe and the United States dominated the debate, insisting that priority be given to global environmental issues such as acid rain and pesticides. Discouraged by the silence of contesting views, especially from women of the South, someone brought a procedural motion: speakers from North and South would have to alternate, as would male and female speakers. Before they could speak, the men of the North had to encourage, even beg, women of the South to talk. The tone and direction of the debate changed abruptly. Not only were issues of health and sanitation in squatter areas added to the agenda of UNEP, but also a women's caucus was established.

The Nairobi Women's Conference,

which followed in June, featured a panel on women's stake in the environment. Presenters were members of Women in Development and Environment (WIDE), an organization that had been set up a few years before by the UNEP representative in Washington, D.C. Preceding the UN Conference on Environment and Development—the Earth Summit—in Rio de Janeiro in 1994, UNEP assembled over two hundred examples of successful environmental projects and brought the women who initiated them to a conference in Miami. A more political role for women at the Earth Summit was orchestrated by the recently established Women for Environment and Development (WEDO). This increasingly visible international coalition of women convened the World Women's Congress for a Healthy Planet in November 1991 to plan strategies for the Earth Summit and write a women's version of the official conference document, Agenda 21. Over fifteen hundred women from eighty-three countries attended. At the summit, WEDO held daily caucuses, just as the NGOs do for their members, to alert women about decisions taken and issues on the upcoming agenda. The visibility and sophistication of these efforts ensured that women's interests were included in the final document.

In Rio, a division occurred among women's organizations over wording on family planning. In the following two years, leading up to the 1994 World Population Conference, women active

in these overlapping issues met frequently to address the conflicting views. The International Women's Health Coalition coordinated the organization of meetings around the globe to draft and debate the Woman's Declaration on Population Policies. A final strategy meeting was held in January 1994 to rehearse individual and group responsibilities during the Cairo conference. The U.S. Network for Cairo '94 coordinated the activities of a broad spectrum of population, environment, and development organizations in support of the women's agenda. In Cairo, WEDO set up its daily caucus, briefing NGOs, official delegates, and the media. The result was possibly the most feminist document to emerge from any UN conference. Principle 4 builds on previous UN conferences when it declares: "Advancing gender equality and equity, the empowerment of women, the elimination of all kinds of violence against women, and ensuring women's ability to control their own fertility, are cornerstones of population and development-related programmes." Other principles declare women's rights to health and education to be prerequisites for all population programs.

Long-term preparation for the UN World Conference on Human Rights held in Vienna in 1993 also was instrumental in introducing the revolutionary concept that women's rights are human rights. In 1991 the Center for Women's Global Leadership at Rutgers University in the United States began planning for Vienna by convening women

from twenty countries first to decide on goals for the conference and then to orchestrate a campaign to secure support for this new initiative that brought domestic violence into public view. In Vienna, WEDO held daily briefings for NGOs, while UNIFEM arranged daily meetings for delegates. A mock tribunal that heard women's own stories of human rights abuses provided dramatic documentation of the need to include women's rights in the final document.

The pace of UN meetings increased in 1995, when the World Summit for Social Development was scheduled for March in Copenhagen. WEDO joined with DAWN to coordinate daily caucus meetings and also arranged panels and dialogue sessions during PrepCom II. After the successes for women's issues at Rio, Vienna, and Cairo, women continued to stress unity in the face of attempts by religious and culturally traditional groups to roll back these advances. Although similar defensive strategies characterized much of the activity at the governmental conference in Beijing, the NGO forum in Huairou provided active NGOs with the opportunity to disseminate information about crucial issues to the twenty-five thousand to thirty thousand women attending.

The women's groups that took the lead in coordinating lobbying at the four UN conferences were U.S.-based organizations with savvy leadership able to secure funding to enable women from around the world to participate in planning meetings as well as in the final conferences. All continue their

activities; but while the International Women's Health Coalition and the Center for Global Leadership maintain a focus on health/population and on human rights, respectively, WEDO has expanded its membership abroad and broadened the scope of its policy papers to include issues of globalization and global governance. WEDO's primers on transnational corporations, the World Trade Organization, and the structure of the world and regional development banks were widely circulated in Beijing.

In 1996, perhaps the last of these major world conferences took place when Habitat II convened in Istanbul. Women's concerns came late to issues of shelter. The Habitat International Coalition was founded in 1976, but not until one of its few women members organized panels that promoted shelter issues for the 1985 Women's Conference in Nairobi did the topic gain recognition as a basic women's issue. A Women and Shelter group was formed and began publishing a newsletter that reported on both community programs and scholarly publications. This caucus held meetings and participated in prepcoms for the 1996 Habitat Conference in Istanbul; at the conference, it worked with NGOs to ensure that delegates considered women's rights to housing.

Since the beginning of the UN Decade for Women, leadership for women's Issues has shifted from the older formal women's organizations to networks and coalitions of more diverse activist groups. Unlike earlier UN conferences, starting with the 1974 Population Conference, when changes in wording in the conference documents were the result of individual or ad hoc group efforts by NGO and government delegates, these new groups are diligent in their preparations for each topic and each conference. Not only are organized women more effective in changing policy statements, but also their national or local affiliates are able to lobby their own governments to follow the UN recommendations. The specialized groups, whether caucuses within mainstream NGOs or women-only NGOs, eloquently presented their perspectives at the most recent series of UN world conferences.

How much influence does all this lobbying activity have? If women's issues must first be inserted into single-interest or development policies, which in turn become the subject of negotiations at the agency or state level, do women's concerns simply fade away? At the 1995 NGO forum in Huairou, China, women working within the bureaucracies of bilateral agencies spoke at a plenary panel about problems in mainstreaming the women's development agenda. The speakers expressed great dismay and discouragement at their lack of progress toward including women and their issues at every stage of program design and implementation.

One of these institutions was the World Bank, whose new president, James Wolfensohn, attended sessions at Beijing.. The Bank has been widely accused of fostering economic reform in countries undergoing structural

adjustment in such a manner that social services are reduced and the social safety net for the poor is torn. Indeed, the reduction of government provision of these services is a major factor propelling the growth of existing service NGOs in those countries and the expansion of new NGOs into the provision of services. A group of women formed Women's Eyes on the Bank to monitor the implementation of the pledges made by Wolfensohn in Beijing. In addition, the World Bank set up the External Gender Consultative Group to work closely with policymakers. Leaders of women-only and mainstream NGOs have agreed to work within the Bank for reform in a symbiotic relationship with others involved in the Fifty Years Is Enough campaign.

Can external women's groups influence World Bank policies more than the long-existing but informal women's group within the Bank has been able to do? Women consultants have complained that policies concerning women are simply "tacked on" to program designs, if they are mentioned at all. The members of the External Gender Consultative Group want to start with a focus more on gender justice than on specifics of the project cycle. In some ways this is a more radical position than just proposing to restructure the Bank.

Women's Impact on Global Governance

Women today are charting several apparently contradictory paths to power and influence on the global stage. They are joining political parties and running with increasing success for elected office, and once in office they are contesting everything from the rigidities of rules to the lack of women's restrooms to the juvenile verbal assaults in the British House of Commons. Women also hold many leadership positions within national and international NGOs that champion values that resonate with women's traditional concerns and provide a countervailing force to traditional state power. Although male dominance may still be present in organizational structures and decision-making processes in state institutions and NGOs, women's voices and leadership are increasingly evident.

An alternate route to wielding power is to appeal as women and mothers for a change in the values that underlie government policies and programs. Repelled by corrupt parties and patriarchal leadership, some women turn their backs on existing formal institutions and concentrate on forming organizations and networks of women outside the normal channels of power. In every country, women are taking, charge of their lives; protesting domestic violence, sexual harassment, and male drunkenness; and demanding access to land and housing, microcredit and markets, employment and child care. The sum of these activities has produced the women's social movement that is fundamentally altering established institutions of society. The power of this social movement has enhanced the role

of women's organizations as they operate at the global level. At the United Nations and its agencies, in discourse with the World Bank, in negotiations at meetings of all types of NGOs, women have new presence and authority.

Women-only communities or self-help groups benefit from the global noise raised by the elite leadership within and outside mainstream institutions. But women leaders working within national legislatures benefit from the rising public voices of women demanding a gentler and more equitable world for women, their children, their families, and their communities. NGOs, with their growing influence in an expanding civil society, are yet another route for influence.

Is outside influence more likely to bring change in outmoded state institutions? Is the backlash against current trends toward gender equality a desperate attempt to stop an inevitable shift in patriarchal relationships between women and men? Is the lack of enthusiasm for women's issues among the younger generations in the United States, for example, a reflection of women's improved position? Around the world, male as well as female scholars and activists believe that the women's movement has already irrevocably changed society.

After a quarter of a century, the cumulation of women's activities globally has challenged male control in the family by reducing women's economic dependence on men. While women worry that such changes leave mothers with the double roles of nurturer and provider while letting fathers off the hook, many male scholars emphasize how these changes alter the basic fabric of society. Amartya Sen reconsiders approaches to the household with his discussion about women's improved bargaining position within the household ("Gender and Cooperative Conflicts," and Ken Kusterer proclaims "The Imminent Demise of Patriarchy" in my edited volume entitled *Persistent Inequalities,* 1990. Manuel Castells, my colleague at the Univeristy of California/ Berkeley, writes that "the transformation of women's consciousness, and of societal values in most societies, in less than three decades, is staggering, and it yields fundamental consequences for the entire human experience, from political power to the structure of personality" (*The Power of Identity.* 1997:136).

Translating the value shifts caused by the women's movement into new political, social, and economic institutions is a monumental task. Women need to pursue all available paths to power and influence, in women-only and mainstream NGOs, in nonconventional community organizations, and in political parties. The expanding civil society gives greater space to people's organizations and so allows greater opportunities for women to mold their own future.

THE STATE AND THE FAMILY: PLANNING FOR EQUITABLE FUTURES IN DEVELOPING NATIONS

T HE RAPIDITY WITH WHICH OUR GLOBE is shrinking is apparent to all of us all as we jet around the world in hours instead of sail in months, or self-dial on the phone instead of booking a call days ahead. Yet the implications of these incredible changes on the practice of our profession are too often overlooked. The impact of global change has been particularly striking on two fundamental institutions in our society: the state and the family. These institutions are basic building blocks for most development plans, whether in Portland or Paraguay. Any change in the function and characteristics of these institutions clearly must affect the way plans are made and implemented.

Challenges to the contemporary structures of the state and the family result from the enormous advances in economic and technological development over the last several decades. The predominant challenge comes from the evolution of the financial-industrial complex into a global network which frequently ignores national boundaries in its search for profits. Worldwide emphasis on the values underlying classical economics in turn undercuts family cooperation and support systems. A second challenge to the state and family come from growing numbers of advocacy groups, particularly the environmentalist and feminist organizations, that question the primacy of economic values and priorities. In doing so they challenge the institutions of the state and the family in ways diametrically opposite those of the financial-industrial complex.

These contradictory challenges to the power and functioning of the state and the family have profound implications for planning. The very speed of these changes means that their impact is only now being assessed, but the fact of these changes needs to be incorporated in all planning courses. After detailing these challenges briefly, I shall suggest ways in which curricula might address these structural and systemic shifts.

THE CHANGING STATE

The state has traditionally been considered the fundamental unit of international relations. Today, the control of the state is being challenged on two distinct fronts: economic and environmental. On the economic front, the communications revolution has truly globalized both the financial and industrial complexes. Transfers of funds, whether by banks or drug czars, can no longer be traced or taxed. Safe havens,

such as Swiss banks have long provided, are under attack by other nations that object to the maintenance of secrecy when illegal funds are at issue. One needs only to consider the contretemps surrounding the Iranian arms deals to realize the powerlessness of the U.S. to investigate large-scale financial transfers. But while Switzerland is negotiating for limited access to information, other havens such as the tiny city-state of Liechtenstein are becoming popular. Drug czars in Colombia seem to prefer to have their funds come home, but the circuitous route of their money laundering schemes makes prosecution of illegal transfer difficult if not impossible.

The new financial modes of operation also affect the way legitimate corporations do business. With global investments, it is difficult to assign profits to a particular country: the higher the local taxes, the greater the incentives to report profits elsewhere. Financial record-keeping may also be easily moved from one country to another. For example, U.S. financial institutions are major employers today in Barbados, where they send credit card charge slips for tabulation and inscription on computer tapes.

It is not only record keeping that is being increasingly decentralized. Industries can more easily monitor their far-flung operations utilizing improved communications. Inventories in South Korea appear on the computer screen in New York or Hong Kong, where decisions are made to dispatch shipments to appropriate markets in Europe or Africa by air or ship as the demand and

price decrees. New orders and specifications for children's jeans, for example, can be faxed almost instantaneously: the mix of colors and sizes can be adjusted while the order is being filled. A strike or civil disorder in Sri Lanka may not result in slow deliveries any longer, because manufacturers in Mauritius can be contacted to adjust production and take up the slack.

The ease of coordinating their global factories and the consequent expansion of the knowledge base regarding industrial conditions in various countries around the world allows multinational corporations to analyze cost/benefit ratios in different countries and has given rise to many "footloose" factories in low-tech industries. Thus, the decision of a new government in Mexico to increase taxes on *maquilidores* may result in reduced production in Tijuana or a new factory in Puerto Rico. The organizing of a factory in the Philippines by militant labor unions may result in a plant closing, with operations shifting to Indonesia. High-tech industry is less mobile spatially, but is still linked globally to extranational financial systems.

How can national governments control such movements of money and factories, which seem to slosh around the world seeking the most advantageous site for their momentary needs? Today there are no conventions, no regulations. In the longer run, international agreements may begin to regulate some of these new global systems. Meanwhile, what incentives or subsidies do planners recommend to their

clients, here or abroad, to stabilize local employment? Should cities or nations restrict unionization or reduce taxes in order to placate the multinationals' search for profits, or are other considerations of equal or greater importance?

This brings us to the second major challenge to national control today: the environment. If global flows of financial and industrial institutions are difficult to control, the environment is nearly impossible to control. Certainly it respects no national boundaries. The burning of the Amazon jungle is expected to affect global warming to a considerable extent. U.S. conservation groups have been sponsoring debt-swaps for the creation of national parks or the introduction of environmentally sound agricultural expansion. Brazil responded angrily, accusing these groups of infringing on Brazil's national sovereignty. Imagine the indignation we would have expressed a century ago if England had challenged the right of settlers to farm the Midwest plains—even though we now know how fragile the dustbowl soils are and how deleterious dust can be for the Earth's atmosphere.

National governments typically resist considerations of long-term environmental trends, looking the other way when chemical companies dump toxic wastes in rural cesspools or automobile tires fill old stone quarries. But when syringes from hospitals and clinics turn up on bathing beaches or rivers become unsafe for sailing or swimming, waste disposal can no longer be ignored. In this case, however, it is usually citizen

advocacy groups that force the pace of environmental protection and warn of future catastrophe. Operating as non-governmental organizations (NGO's) or as Green parties, environmentalist groups have moved beyond these protest groups and are beginning to question the predominant value structure that underlies our economic system: that profits are the overriding goal.

The state, then, is challenged by the financial-industrial complex on one side and the environmentalists on the other. Both challenges reflect global phenomena that the state itself cannot control and that are championed by global networks of likeminded people. But the messages from these two groups to the state are in conflict over the predominant values that should govern our society. The economically-focused groups complain about hindrances erected by individual states that impede the market and so reduce their growth and their profits. In contrast, the environmental groups question the narrowness of economic indicators that are based on the individual's pursuit of monetary rewards. They stress the collective responsibility of maintaining balance in our global ecosystem in order to avoid overexploitation and misuse of natural resources, such as the cutting down of tropical forests that contribute to the greenhouse effect, which may doom our future on this planet.

THE CHANGING FAMILY

The family as an institution preceded

the state, yet classical economic theory originally ignored the family as a unit of analysis and focused on the individual as the sole utility maximizer. New household economics brought the household back as a unit of economic analysis but assumes the existence of a single household utility function decided by the patriarch as benevolent despot or altruistic dictator.

Such an economic interpretation of the household reflects the fact that families in subsistence economies, whether pioneers along the United States frontier or Himalayan farmers in Nepal today, function as production units as well as reproduction units. The rights and responsibilities of family members in such units are based on an age-sex hierarchy and are culturally maintained. The senior male functions as a patriarch whose charge is the survival of the family unit before any concern with equity.

Although patriarchy is a worldwide phenomena, the relative position of women varies across cultures and does seem to be related to their economic importance within the family unit. This variance is clearly seen by reference to survival rates of females vis-a-vis males in different parts of the world. Africa has a ratio of 1.02 females for every male compared to only .93 in India and Pakistan, and .94 in China and Bangladesh. Traditions such as bride-price, a fixture in Africa south of the Sahara, where women grow over 80% of all food, indicate a higher value placed on women than does a dowry, which is given to the husband to balance the cost of bringing an extra unproductive person into the household. The increased incidence of female infanticide in China under the one-child-per-family policy and of the even more reprehensible spate of wife burnings in New Delhi over the last decade underscores the persistence of patriarchy.

In order to account for the variation of women's roles and status within the family, a group of economic writers have applied game theory to household decision making. Amartya Sen has pushed intrahousehold analysis a step further by arguing that the win-lose basis of game theory is not consistent with the desire of the household to maintain itself, because the win-lose approach may lead to a breakdown. Instead he has devised a new concept of cooperative conflict to describe male-female relationships in the family. He argues that "the importance of perception and agency emerges as being central to achieving a better basis for female well-being" ("Gender and Cooperative Conflicts," I. Tinker, ed. *Persistent Inequalities.* 1990:148). In particular, Sen notes that the perception of women's contributions to the household is enhanced by earning outside income but that both qualitative and quantitative contributions help establish a woman's claims to intrahousehold distribution.

In their efforts to revise economic theory so that it more accurately reflects reality, these male household economists are utilizing the insights developed by feminist authors over the last two decades. Internationally,

the adverse impact of development on women has been generally accepted. Ester Boserup's paradigm of women's roles in economic development at various stages of technological change has provided a basis for the field of women in development. By identifying male and female farming systems and male and female towns, she shows historically how the sexual division of labor was affected by different economic systems.

Responding to the monetization of the economy and the expansion of consumer goods from industrialized countries, the sexual division of labor began to change in most developing countries after independence. Too often, technological innovations in near-subsistence economies have only meant more work for women who already work at least two hours more per day than men. For example, cash crops were introduced in Africa to men. Women were expected to weed their husbands' crops, now often grown on the best land, while continuing to produce subsistence food crops on distant and less fertile fields. Tractors allow more land to be brought under cultivation in South Korea. There the women are expected to weed and harvest larger areas, usually without the benefit of more efficient tools. Income-earning activities such as knitting or baking only added to the daily drudgery of household tasks for the women while freeing men from household contributions.

In Africa and Asia, men have migrated to the cities to seek income and women have increasingly taken over male activities. Yet male earnings in the cities are seldom shared equitably with the women remaining behind. When women also migrate to the cities, they must provide for themselves and their families through alternative sources of income from work as domestics, or as micro-entrepreneurs, or in the expanding home-based industries. Recent studies undertaken by the International Food Policy Research Institute show that intrahousehold food distribution can be made- more equitable by improving women's economic opportunities outside the household.

Evidence shows that while women have taken over many of the male roles, men have not taken over female roles. It should come as no surprise, then, that many women opt out of the traditional family. As a result, the percentage of women-headed households has continued to rise, to perhaps forty percent in many urban centers. As in this country, these households are typically the poorest. There has truly been a global feminization of poverty. Attempts by nongovernmental organizations to assist poor women are colliding with the value preferences of the bureaucrats who fund such programs. Overwhelmingly, such agencies prefer to support intact families. Apparently they perceive that funding to women-headed households might encourage such family formation, which they see as a threat to society. Rather, by ignoring the inequities of the contemporary family, these bureaucrats perpetuate the conditions that have led to the rise of women-headed households.

Economic values also affect how programs for the poor are administered. For example, many credit programs for women microentrepreneurs have been discontinued because women did not use their profits to reinvest in their enterprises. Rather, women often used profits for school fees or to enhance the nutritional status of their children or to give gifts of food or money to elderly family members or female support groups. The interest of development agencies in small-scale enterprises centers on increasing employment and growth. Such a perspective neglects the importance of human resource development and ignores the importance of redistributive support networks among poor women. Paying into social security in this country is not perceived as a noneconomic activity; yet investing in the insurance of a support group is rejected.

IMPLICATIONS FOR PLANNING

We have seen that two basic institutions of modern society are under siege: the state and the family. Traditional forms of power and control are being eroded by global economic forces that are changing the financial and industrial modes of doing business and are altering the sexual division of labor, which in turn is reducing the effectiveness of traditional kin support and encouraging the formation of women-headed households.

Advocacy groups are also challenging these institutions at both the macro state level and at the micro household level. Environmentalists question the priority of profits over the ecosystem; feminists question the priority of profits over investment in children and in social support. Essentially, both environmentalists and feminists are suggesting that many of our current problems stem from the narrow value system of classical economic theory.

The globalization of the economy and the citizen challenge to predominant economic values are critical issues that need to be taught in every curriculum. The implications of these issues to planning are many. Clearly any planning related to economic development requires some understanding of global capital flows and transnational corporations. The changing power of any individual state suggests increased study of international and regional banks and agencies.

The challenges posed by environmentalists to contemporary economic development and its underlying values must be addressed and understood. Here again, the global networks of these advocacy groups are important in assessing the impact of their arguments in various countries. Industries that moved to developing countries to avoid the wrath of environmentalists are finding few havens today as the communications revolution is extended to these citizen groups as well as to the financial-industrial complex.

Planning that deals with the family must recognize the importance of women's work to the welfare of the unit. Hence, women's distinct roles need to be an integral part of any economic

development plan. Women's credit needs for housing or for income activities may require different delivery systems. For example, affinity or solidarity groups that rely on social pressure rather than assets to ensure loan repayment respond to women's typical lack of tangible property. Microenterprises dominated in many countries by women, such as the selling of street foods or the vending of produce, should be legitimized and credit extended. The expansion of home-based industry needs to be monitored to protect women's need for work as well as their need for protection from exploitation.

The fact of women's work also has implications for physical planning, since women generally must also take care of children and feed the family. Thus, women's work implies either childcare or home-based work. Spatially, homes could be built with space for work; or nearby community spaces might combine child care with work space. Community childcare facilities might be combined with community kitchens where women could cooperatively prepare food for themselves and sell it to other women and men who work all day. Transportation lines need to be planned with women's work as well as men's work in mind. If there

is a conflict, women's transport needs should predominate, since their presence at home is more critical than that of men's.

Feminist planners, like environmentalists, object to the predominance of the profit motive in development programming. They also object to the tendency of development agencies to emphasize welfare-oriented programs because they tend to create or perpetuate dependence rather than independence. What women need are programs that help them cope with the evolving institution of the family and its changing power relationships.

So fundamental are contemporary challenges to state and family that, if planning students are to be prepared for the twenty-first century, global interdependence must be recognized and taught. Equally important, the interdependent roles of women and men within the family must be recognized and taught. Inherent in any analysis of present challenges to the integrity of state and family is an understanding of the value system that is implicit in our market economy. Therefore, there must also be time in the curricula to address *value priorities* if we are to plan for a more equitable future worldwide.

INFLUENCING GLOBAL POLICY THROUGH UN CONFERENCES

T HE RESULT OF MY CHAMPIONING THE ISSUE OF WOMEN AND DEVELOPMENT LED TO MY March 1974 appointment as an advisor to the US delegation to the UN Commission on the Status of Women. Observing how meetings at the United Nations functioned, learning to understand the often convoluted materials on the agenda, and watching how experienced delegates presented their arguments was a valuable immersion into UN politics. My assignment was to ensure that an emphasis on international development would be added to the goals of the International Conference for Women to International Women's Year.

I had just started my job at AAAS, but Margaret Mead had encouraged me to accept the advisor position since I would be accompanying her to the World Population Conference later that summer – as discussed in Part 1. The Population Conference had been preceded by many meetings; both their background studies and recommendations had published. With Mead's enthusiastic support, I began to plan an international seminar that would take place in the weeks prior to the 1975 Mexico City women's conference. The fact that the Seminar was sponsored by the AAAS and its Mexican equivalent gave a greater legitimacy to the meeting that if a feminist organization had been responsible. Unfortunately, this is still the reality.

Just planning the seminar was an education in itself. In NYC, I solicited funds from foundations and found the women staff ready with money and advice. Women at the various UN agencies were excited at the prospect and warned me about how to avoid the pitfalls of bringing together people with diverse views. Their advice: meet in several small workshops, provide translation services, and combine the recommendations of each group into the final report with no plenary discussion. I was also cautioned to limit participation by Americans in order to maintain the international atmosphere.

Whom to invite? Again women in the foundations and the UN made suggestions. Other sources were authors of the articles we were collecting for an annotated bibliography of literature – in French, Spanish, and English – on women in developing countries. To assist in this collection and annotation, I hired women fluent in both languages. We sent letters of invitation around the world, for this was long before the internet. Eventually, 95 women and men from 55 countries attended: they were scholars, activists, medical personnel, and practitioners in development agencies. All were given copies of the bibliography and articles written

for the seminar including my "Adverse Impact of Development on Women." This material, plus the five workshop reports, was published the following year in *Women and World Development*.[1]

The Seminar was an extraordinary success: many workshop recommendations were taken to the official conference for implementation. Significant were two new UN programs, both recommended by the Seminar. UNIFEM, originally called the UN Fund for Women, focused on giving small grants to rural women's groups; it was placed within UNDP. INSTRAW, the International Research and Training Association for Women, was elevated to an independent agency with its headquarters in Santo Domingo. I represented the US on the first board, 1979-1983, and was a consultant to both programs.[2] Many seminar participants served on their country's delegations; others were active in the NGO forum, call the Tribune in Mexico. I organized several panels at the Tribune which accelerated the growing WID network.

NONGOVERNMENTAL ORGANIZATION AND THE UN

The term, nongovernmental organization, originated at the April 1945 meeting in San Francisco where the UN was set up. Government delegates were charged with setting up an international body designed to solve the pressing post-war issues of human rights, independence for colonies, and peacekeeping. All other delegates to the conference were referred to as non-governmental representatives. Their associations had been active in the precursor to the United Nations: The League of Nations and its agencies such as Food and Agricultural Organization and the International Labour Organization. NGOs in the Americas had attended meetings of the Pan American Union.

The UN charter formalized the relationship with NGOs by creating a mechanism to allow them consultative status at the Economic and Social Council (ECOSOC). The early joiners included trade unions, religious organizations, business associations, and two women's groups: the International Alliance of Women and the International Federation of Business and Professional Women. Today, delegates from these NGOs may attend official meetings but not speak; However but they are very active in meetings and committees, prepare research papers, and lobby delegates on the side-lines of major gatherings.

Defining NGOs as a residual term – meaning all organizations that are not

1 Women and World Development, I. Tinker and M. Bo Bramsen, eds., prepared under the auspices of the AAAS, Overseas Development Council, 1976, reissued 1980; Praeger. Spanish translation, Las Mujeres en el Mundo de Hoy: Prejuicios y Perjuicios. Editorial Fraterna, Buenos Aires, 1981.

2 I also founded the US Council for INSTRAW to inform academics about their publications and to assist in funding the agency.

governmental – has led to a continued confusion as to what exactly is a non-governmental organization or NGO. But these older NGOs had global interests that mirrored the ECOSOC. As new issues arose of international significance that had not been covered in the UN Charter, new agencies were created and new NGOs emerged. For example, economic development was of central concern to the former colonial countries; in response, the UN declared the First Development Decade, 1960-70, and founded the UN Development Programme in 1966. The Society for International Development, started in 1959, had pressed for the new agency. SID also provided me with a crucial platform in 1973 to argue for the inclusion of women in development programs.

The importance of NGOs is illustrated by the fact that the original charter spoke only about mankind but was amended on the insistence of women's groups to include the phrase "to ensure respect for human rights and fundamental freedoms without discrimination against race, sex, condition, or creed."[1] Including women in the charter led to the creation of the Committee on the Status of Women (CSW) as a separate entity of ECOSOC. I was instrumental in having AAAS recognized as an NGO in consultative status; as a result I was able to attend the official conferences at both the 1975 women's conference in Mexico City and the 1976 UN Conference on Human Settlements in Vancouver, Canada. The UN Human Settlement Programme (UN-Habitat), was then set up in Nairobi where the UN Environmental Programme had been located. Their Women and Shelter Programme provided me with much data for my articles on this issue.

Official UN conference documents are discussed over several years in regional meetings and preparatory committees and involve UN staff, government representatives assigned to the UN, and NGOs in consultative status with ECOSOC. The substantive issues to be addressed by the conference are well researched, but the document is also freighted with global debates of the day. The resultant document is then circulated to member governments; final revisions are made during the two-week official conference. Because governments send important political leaders to these meetings the issues are well covered by the media and receive global attention.

Over time, women activists have learned how to insert phrases and paragraphs throughout the process so that the final document adopted at the conferences reflects issues of concern raised by women's organizations and research centers. Often just adding "and women" to a phrase was sufficient; more often, a phrase was needed as a reason: since women collect most of the firewood. Although official UN documents lack the force of law, their political and moral power is considerable, providing activists in individual countries and internationally as well as the UN system with powerful tools for change.

1 See *Women, Politics, and the United Nations,* Anne Winslow ed., Greenwood Press, Westport, Connecticut, 1995, for detailed background on this history.

CONSCIOUSNESS-RAISING CONFERENCES

From its founding, the UN had convened many world conferences where NGOs with consultative status could participate. The expansion of activist NGOs with a single focus changed the dynamics of these world meetings. When the 1972 UN Conference on the Human Environment was convened in Stockholm, the "green" movement was already an important political force in Europe. Once these activists learned of the meeting, they flocked to Stockholm and demanded admittance, camping at the airport until the solution was proffered of a separate unofficial meeting. One result of the conference was that a new agency was established, the UN Environmental Programme, in Nairobi. In 1985 I was invited to Nairobi to help set up a women's caucus.

From 1972 until 1986, the UN world conferences organized parallel events to accommodate the thousands of NGOs who did not want to have consultative status because they only wished to attend a particular NGO Forum. Most naively assumed that they could impact on the governmental conference by attending. While the NGOs with official consultative status at the UN are steeped in UN procedure and understand how to influence the system, few of the NGO activists were conversant with the minuet that is the UN: meetings are carefully orchestrated.

The NGO Forums were open both to organizations and individuals, and combined professional panels with the gaiety of a fair. The panels provided a way to disseminate new ideas and research to UN delegates as well as among the growing NGO community. Most of all, they provided an opportunity for activists from around the world to meet and set up formal or informal organizations and networks. Participants at the parallel NGO conferences often exceeded the number of official delegates and drew most of the media.

For example, at the Beijing women's conference in 1995, some 5000 government delegates attended along with 4000 delegates from NGOs in consultative status: 31,000 women and a few men participated in the NGO Forum despite the Chinese government's restricting visas and holding Forum events at Huairou located 60 miles out of town.

Once these activists arrived at the conference site they begin to realize that any input they might have had should have taken place much earlier in the process. The almost inevitable result of this frustration is a march organized by many NGOs to the auditorium where the official meeting is taking place. Indeed, I used to say, "if it is Tuesday, there will be a march." Authoritarian regimes such as Romania prevented such a march while Kenya limited the marchers at the women's conference in 1985 by slowing access through the exit gate of the NGO Forum.

The impact of these marches on the deliberations is hard to assess, but they certainly alerted the government delegates to the depth of concern among the

general public. So although the UN documents passed at these meetings are purely advisory, they do serve as rallying points for the NGOs when they return home.

GLOBAL TENSIONS AND WORLD CONFERENCES

The decades encompassed by these major world conferences with their immense NGO Forums were a period of growing tensions between Global North and Global South. Whatever the official conference topic, discussions referenced the continual contentious debates over the appropriate priorities for and direction of economic development as envisioned and funded by the North. The North-South differences affected both agenda items and the final documents of the conferences, never more than at the women's conferences. Women lacked the power to influence negotiations over political posturing that old-boy networks had at other conferences, a power that facilitated compromise.

During the Decade for Women 1975-85, the most contentious issues concerned apartheid, calling Israel racist, and the global economic system.[1] However, each of the four conferences also promoted new areas of women's concerns. In Mexico City in 1975, development was the new issue. The 1980 conference in Copenhagen called for panels on women's health that went beyond the traditional maternal focus which was really on children, not women. EPOC convened and International Symposium on the issue before the conference and presented the report in Copenhagen. Housing and environment issues were introduced at Nairobi in 1995 while microenterprise was featured in Beijing. Still, most press wrote about fundamental conflicts between North and South.

These opposing perspectives were starkly clear at the Population Conference in Bucharest in 1974, the first of these conferences I attended. The North argued that for economic development to succeed countries had to adopt methods of population control; in contrast, the South believed that economic development would in turn lower fertility rates and so demanded development first. Both official sides tended to see women as objects, not people; in contrast, at the NGO Forum, women and cultural factors that influenced fertility choice were analyzed. The opposite views of women as agents versus women as objects were dramatically reversed in the third Population Conference in Cairo in 1994. Women's access to health and education were promoted as the preferable method of reducing population. A woman's right to control her own body – a fundamental goal of the women's movement – was also championed.

I have written about this conflict between the expectations of NGOs and the

1 For an analysis of these debates at the first three women's conferences, see "UN Decade for Women: Its Impact and Legacy", with Jane Jaquette, <u>World Development</u>, Mar. 1987.

reality of UN meetings for all four of the Women's Conferences.[1] I also attended and wrote papers for the UN Conference on and the UN Conference on New and Renewable Sources of Energy noted in Section 4. The power of the scientific community prevented political issues from overwhelming the substantive ones. My papers received wide distribution at these meetings and influenced the final documents as well as the research community.

As the size of these consciousness-raising conferences grew, due both to more nations joining the UN and to the explosion of NGOs, costs to the host government rose and citizens began asking why they should support a grand festival for middle-class activists. Today, such meetings are generally much smaller and are usually held at the UN headquarters in NYC. The last women's conference I went to was the Beijing + 5 meeting in 1980 in NYC.

Today the sites of North-South contention have shifted from UN conferences to other international meetings such as the World Trade Organization, the World Bank, or to meetings of the leaders of the industrialized world (G-7 in UN parlance). Conveners of these meeting have not yet created mechanisms for consultation with the NGO community, which itself has grown more diverse and disruptive. Without some open and official way for moderate NGOs to attend important world meetings and participate in the debate, the fissures between the North and South, between governments and civil society, become ever more fractious.

But times are changing, and the role of the United Nations itself is up for debate. The economic growth in many countries of the developing world such, as Brazil, India, and Indonesia, and the political emergence of China, are rearranging the fissures. Meanwhile, the power of social media and the internet are altering the methods of influence and protest by civil society.

1 "A Feminist View of Copenhagen," Signs 6/3: 531-537. 1980.

"A Personal Review and Appraisal of Nairobi", EPOC July 1985; reprinted in Signs 11/2: 586-589, Spring 1986; Journal of Women and Religion 5/1, Summer, 1986.

"UN Decade for Women: Its Impact and Legacy", with Jane Jaquette, World Development, Mar. 1987.

"Priority shifts over two decades at the UN World Conferences for Women," in Renuka Sharma & Purushotttama Bilimoria, eds., The Other Revolution: NGO and Feminist Perspectives from South Asia. New Delhi: Sri Satguru Publications. 1999.

"Symposium: NGO Forum, United Nations' Fourth Conference on Women, 1995," edited with Gale Summerfield in Review of Social Economy Volume LV:2, summer 1997, pp. 196-260; article on "Family survival in an urbanizing world." [republished in 50 years of City and Regional Planning at UC Berkeley: A celebratory anthology of faculty essays.]

"Historical perspectives on the Fourth World Conference for Women & the NGO Forum in Huairou and Beijing, 1995," reprinted in newsletters and distributed on the Internet by several lists.

A FEMINIST VIEW OF COPENHAGEN

THE WORLD CONFERENCE OF THE United Nations Decade for Women, which was held last July in Copenhagen, allowed the international debates on trade, development, and politics to dominate sessions so completely that such feminist delegations as those of the United States, Canada, and Australia were compelled to vote against the World Programme of Action. This program is meant to serve as a blueprint for improving women's economic and social position around the world, but three references in the document legitimizing the Palestine Liberation Organization forced the United States' negative vote. The confrontation over the Palestine issue spilled over into the forum sponsored by nongovernmental organizations (the NGO Forum), sending out waves of anti-Semitism that raised tempers, divided delegations, and again di verted energy from the real point of the conference: women's status and welfare.

To be fair, there were positive aspects of both meetings. A series of strong resolutions were added to the World Programme of Action by the official conference. The NGO Forum abounded with dynamic women of every creed and country whose interaction created stimulating new ideas and a proliferation of new networks. But at what cost, not only in money but in world opinion! I think women must look for new methods of influencing the United Nations and world opinion, and I seriously ask "What purpose would a repetition of a women's conference such as this one or that in Mexico City serve?"

The major problem with holding another world conference is that women take such matters very seriously, but men do not. Most women in Copenhagen – delegates and individuals – wanted to discuss issues relating to women: the growing shortage of fuelwood in many develop ing countries; the double issues of too many children and too much infertility; the problem of credit for women's groups and women's in dustries; the burden of the "double day" in every country; the impact on women of the spread of multinationals to less developed countries; the support systems, and lack of them, for aging women; the limited amount of research on women in history or women in the future; the role for women in primary health care as new delivery systems evolve. In fact, women wanted to discuss life and hope and tomorrow. The challenge, success, and inefficiency of the NGO Forum was the plethora of

women's groups; there were so many tunes and tempos that the too-frequent result was simply noise. The problem that presents itself is simple: How do you take one tune and encourage variation while at the same time eliciting orchestral support?

At the Mexico Conference of 1975, the International Women's Tribune (which was that conference's equivalent of the NGO Forum in Copenhagen) focused primarily on development issues. The situation of the conference in a developing country gave emphasis to this concern. Then, too, the women's movement was newer, less diverse, so that those going to Mexico were willing to concentrate on issues raised in the initial Plan of Action. The Tribune was cohesive physically as well. It was held in three large auditoria, replete with translation equipment and encircled by a loggia where participants easily met, yelled, or rested. In Copenhagen, the setting for the NGO Forum was a sprawling university building with many small classrooms, no central meeting place, and only one room equipped to offer simultaneous interpretation in several lan guages. A larger auditorium was a bus ride away; attending a function there thus meant the commitment of a morning or an afternoon. Major speakers appeared there and gave lectures, while the audience responded with counterstatements. The size of the room and the format of the meetings discouraged real exchange of information, and there was minimal opportunity to catch and talk to the speakers

before they disappeared back to the official conference or melted back into the forum. Every day for ten days there were three sessions of panels at the forum. Some panels had been in the planning stage for months, others were conceived the day before, or the hour before, but all these groupings – perhaps as many as 100 a day – tended to separate and disperse the participants. Titles often flagged "developing"' issues as opposed to "developed" issues; attendance at many was North American and European only. The self-selection and division of audiences, resulting in part from the dearth of translators, meant that also at these smaller meetings discussions tended to remain on the surface, and it is no surprise that simplistic ideological "solutions" were the predominant outcome. The forum was an exciting intensive course in *realpolitik* rather than the substantive interchange it was to have been.

The official UN conference was naturally even more dominated by world politics. The inclusion of agenda items on Palestinian women and women under apartheid guaranteed that. Nonetheless, the commitment of the women delegates to discuss substantive issues resulted in many exemplary resolutions being added to the Programme of Action. Of special note are those reminding the national and international planning committees on the Water Decade to include women and women's issues, or the resolution for added organizational support of rural women around the world.

For anyone who has attended other world conferences in this consciousness-raising series, neither the politicization of the official conference nor the diffuseness of the NGO activities comes as any surprise. These meetings are at best the imperfect breed, you say. And I agree. But with women's conferences, the negative aspects seem to me to out weigh the positive ones for two major reasons.

First, the male establishment does not take women seriously. Neither the U.S. State Department, nor the UN Secretariat, nor the Group 77 (shorthand term applied to some 120 less developed countries in the UN that caucus on issues of common interest) gives any standing in their priorities to women's issues. Hence, at the official conference there are no negotiating positions. No government or group really wants anything for women enough to com promise on other issues. Women's conferences, therefore, reflect the United Nations at its worst. Few countries send first-string players who have extensive experience in UN negotiations. The women delegates are caught between programmatic interests that they understand and diplomatic positioning derived from hundreds of previous conferences in which they played no part.

These UN women's conferences are in effect stacked against women. Once the debate moves to the New International Economic Order (NIEO), the issue is no longer "women's special needs" but rather nationalistic demands and the desires of women as citizens. That twist automatically changes the conference from a unity trip to an international debating society. The conference may dress up the issues in women's terminology, but the votes are controlled by the underlying NIEO debate.

Since women lack power in most nations and certainly in their diplomatic services, they seldom are given the opportunity to take part in the other fora where the NIEO is debated. Women ought to be allowed to participate in a continuous way in the important and aggravating debate on the New International Economic Order, not confined to a five-year cycle of appearances. They must insist that the issues of women's special needs are inserted in every relevant debate: women and food production at the Food and Agriculture Organization meetings, women and multinationals at the International Labor Organization and UN Industrial Development Organization conferences, household energy needs of women at the next big conference on New and Renewable Sources of Energy.

Second, the world press does not take women seriously. Because women's participation in UN meetings is rare, and because women readers are interested and concerned, the press comes, and makes fun. Few in the press understand, much less follow, UN debates. When they see women seeking instructions from home, they laugh at the women, though men do it all the time. When they see black American women siding with the African and Arab delegations to support

the Palestine Liberation Organization against the official U.S. position favoring Israel, they interpret the increasing isolation of the U.S. position in terms of trivial domestic politics. When they hear of the CubaIndia alliance the press dismisses this power shift as sandlot politics, just as the world press ignored the implications of the Mexico Declaration in 1975 when Zionism was for the first time added to the list of negative characteristics along with racism, imperialism, and colonialism.

I am tired of seeing women set up by the UN and ridiculed by the world press. I am tired of newspaper accounts that trivialize women's conferences. But we women need to face reality too. Storming the UN conference may make good press, but it is ineffective. Holding women's conferences by men's rules on men's issues is a no-win situation. We can take women's specific issues to men's specific conferences. And we should. For women are part of all the crucial issues of the Third Development Decade (1980-90.) In some areas – peace, for instance, or inter national trade, – women's interests are identical with men's. In other areas, women's responsibilities or occupations give them differential issues. Whatever the topic, we should be there.

But women have benefited from international networking. We ought to be able to create new types of assemblies where women's special concerns can be discussed. Perhaps women's caucuses on food or on health might be formed at the UN meetings; then after a few years such groupings might come together to assess the response of each individual nation and of the United Nations to the demands and requirements of women. Or a tiered series of national, regional, and international meetings might be arranged where topics of development or social change are debated and expanded level by level.

We women claim to have qualities unique to our sex that make us more compassionate leaders. It is perhaps the contrast between those claims and the resulting "cacophony" when we play by the rules of male games that makes us ridiculous in the eyes of the press. Let us improve our network, sharpen our tactics, plan new strategies, and, above all, demand that women's issues receive equity in the New Development Strategy which outlines the program of the Third Development Decade.

A PERSONAL VIEW AND APPRAISAL OF NAIROBI

HAVING CONVENED PRECONFERENCE seminars in both 1975 and 1980 and having attended both the governmental and nongovernmental meetings in Mexico City and Copenhagen, the World Conference to Review and Appraise the UN Decade for Women rounded off my involvement. I went with great trepidation, expecting the worst in unbridled UN rhetoric. The difference this time, I projected, would be a retrogression to an east-west debate instead of the critical north-south debate. How would the developed north and the developing south construct a more equitable world before the tensions between rich and poor, within countries as well as between countries, tear the globe apart?

All of the elements of both debates were there: peace, trade, Zionism, apartheid, the New International Economic Order; but so was a greater sophistication on the part of women from every corner of the globe. At the governmental conference, women delegates used their limited but growing power to forge a consensus on the major document before the official conference: Forward Looking Strategies. In 1975, the Plan of Action was passed by consensus only because controversial issues were separated into a

Declaration of Mexico that the United States, among others, voted against. In 1980, similar issues remained in the Programme of Action and the United States once more voted no.

It seems that the delegates at the meetings in Nairobi decided that there was a sufficiently distinct women's agenda worthy of defending against the men in their foreign-affairs establishments. Even though the United States voted against three paragraphs and abstained on one, we joined the consensus for the total Forward Looking Strategies. The four paragraphs that were put to the vote concerned: (a) coercive measures including trade restrictions and economic sanctions adopted by "certain developed States" (109 for; 29 abstentions, including the United States); (b) obstacles put in the way of the New International Economic Order by certain developed countries (103 for; United States against; 29 abstentions); (c) assistance to women in national liberation movements against South Africa and sanctions against that country (121 for; United States against; 13 abstentions); (d) Palestinian refugee women, calling for implementation of a UN program of action for the achievement of Palestinian rights (97

for; United States, Israel, and Australia against; 29 abstentions).

All of these paragraphs contain important code words that define decade-long debates in the United Nations system. Further, ever since the number of nations from the south in the United Nations increased to become the majority, the United States has increasingly found itself holding minority views. Dominating the north-south controversy has been the New International Economic Order demands, which include issues ranging from stabilized commodity prices to restructuring of the UN system; the reference in the Forward Looking Strategies to coercive trade measures reflects the current trade crisis but is part of the ongoing debate. United States positions on Israel, Palestinians, and South Africa have become symbols of north-south confrontation in the United Nations.

Perhaps one reason that the United States endorsed the Forward Looking Strategies is that the delegation, like other participants, felt that this conference may well mark the end of the series of major UN conferences of which the women's series was a part. The women's conferences have had enormous symbolic significance, especially in the developing countries. Thus there was great interest in declaring a follow-up meeting during the deliberations. Currently, the Forward Looking Strategies contains a recommendation for a meeting midway between now and an anticipated UN conference in the year 2000. Some delegates suggested

regional meetings, or meetings sponsored by individual UN agencies such as the International Labor Organization or Food and Agriculture Organization. Non-governmental organizations discussed holding their own meeting unconnected to a UN conference.

Forum '85 was a potpourri of substantive panel presentations, discussion sessions, songs, dance, selling of artifacts, movies, and talk, talk, talk. So much was going on, there was little inclination to waste time on organizing the demonstrations characteristic of the earlier meetings. The marches could have little impact on the UN conference and only divisive repercussions for the forum. Rather, most women thronged to the vast array of panels and smaller discussion groups. The level of sophistication at these gatherings was impressive, a giant step beyond most of the sessions at Copenhagen, both with regard to political understanding and substantive information.

Indeed, there was marked progress from 1975 to 1980 to 1985. In 1975, the broad issue of women in development was first explored. Relatively few people had thought about the problem; most of the experts at both the Mexico meeting's Tribune and the official conference were women and men who had been invited to a preconference American Association for the Advancement of Science seminar. Then the emphasis was on the adverse impact development was having on women because the economic con tributions of women had been overlooked or dismissed. By

1980, there was sufficient research to document the economic activities of women in near subsistence and modernizing societies. Meanwhile women in the north were demanding wages for housewives. In our rush to establish women as economic beings, we rather forgot the many other facets of being female. At Nairobi, women's many facets were again visible.

Panels were grouped around themes, and overlapping topics were often combined so that groups from various countries combined their presentations. The Equity Policy Center, for example, sponsored panels on women, environment and development in forest and water manage ment, energy, and sustainable agriculture, along with the Environment Liaison Center (the semiofficial NGO umbrella group of the UN Environment Programme), IFAD (International Fund for Agricultural Development), and the Green Belt Movement led by an outspoken Kenyan woman, Wangari Maathai. This series essentially combined the concerns of women in near-subsistence societies with worldwide environmental issues: again, a more sophisticated conceptual framework than simply documenting women's economic contributions to survival under such conditions.

The emphasis at these panels, and at most panels of the forum, was on development. Frequently, the concerns that women from the north brought up at such panels seemed irrelevant to, or even in conflict with, the interests of women from the south. Environmentalists from Europe and the United States organize over acid rain or pesticide usage; those from the south worry about erosion and available land for trees and crops and houses. Scientists from the north see technology as a giant out of control and wish to constrain companies from producing harmful chemicals or using nuclear power; women from the south want technologies to reduce the drudgery of their lives, and they do not wish to debate whether it is "appropriate" or not, if it works. Nor do women of the south wish to distance themselves from family support or obligations; they are pondering a new type of feminism, one that rejects atomistic individualism and accepts the responsibilities and limitations of family and society.

On the other hand, women from both south and north united against the few American moral majority types to sign a petition against the present U.S. government's position restricting funds to countries or organizations that provide information on all types of birth control methods, including abortion.

Other topics discussed included legal rights, women's studies, political participation, peace, religion, violence against women, female sexual practices, health and population, and refugees. There were panels on cross cutting issues such as access to the media; and there were country and region-specific panels: Caribbean women discussing migration and its impact on the family; women's centers from Sri Lanka, Peru, and Zambia presenting research findings; Black American women discussing

education; or African women discussing polygamy.

It was a rich buffet; no one person could sample all the offerings. It *has* been an amazing decade; the women of the world can look forward to greater understanding of each other and control of sufficient power to secure a peaceful future. Whatever the final outcome for future meetings, the three women's conferences have forged worldwide links among women that never existed before. Somehow or other, the women will continue to meet.

UN DECADE FOR WOMEN: ITS IMPACT AND LEGACY

INTRODUCTION

By its very existence the UN Decade for Women, along with the three international conferences which anchored it, promoted and legitimized the international women's movement. Its various activities provided stages at national, regional, and international levels where women's issues and priorities could be debated. Required attendance by governments at the three world conferences not only elevated women's issues to the level of international diplomacy, but also provided many women with a brief entrée into the male club where major international policy is made.

For years the UN had responded negatively to requests from the UN Commission on the Status of Women to hold a world conference. Finally, in honor of the 25th anniversary of the commission in 1972, International Women's Year (IWY) was proclaimed for 1975. That same year, in response to growing pressure from women inside and outside the UN, Secretary-General Kurt Waldheim appointed the first woman to a high-ranking position in the UN system: Helvi Sipila as Assistant Secretary-General for Social and Humanitarian Affairs. Sipila led the commission in lobbying for a world conference to crown International Women's Year. The General Assembly acquiesced to this campaign, provided that additional funds for the exercise would come from voluntary contributions, not the regular UN budget. Since the commission on women had spent most of its meetings after its creation in 1946 promoting women's *equality* before the law, that topic was to be the focus of the meeting and the year.

During the General Assembly debate over the resolution proclaiming IWY, however, two additional topics were added: development and peace. *Development* was emerging as the primary concern of the UN as Third World countries exerted their numerical dominance in efforts to restructure both concepts and agencies of development which, in their view, seemed to reinforce rather than alleviate underdevelopment. *Peace* was then still the perennial issue of the Eastern bloc countries, one they frequently associated with women. Although there was early evidence that women's organizations would participate to an unprecedented degree, the UN itself and its member nations anticipated just another world conference along the lines of the issue-oriented conferences on

environment in Stockholm (1972) and population in Budapest (1974).

What emerged, however, was a unique political and policy process unanticipated by its organizers or the UN. International Women's Year 1975 spawned the UN Decade for Women 1976-85 along with two additional meetings, in Copenhagen in 1980 and in Nairobi in 1985, to assess progress and revise goals. Thousands of women were participants in the parallel forums organized by the non-governmental organizations (NGOs) affiliated to the UN, and tens of thousands were mobilized by the process in countries around the world. It was a symbiotic process with women's groups of all types drawing confidence and purpose from the UN activities. The Decade organizers expanded their horizons with the support and funds generated by women's groups and their allies in national bureaucracies.

Nairobi was the high point of the Decade. The meeting began on Wednesday July 10th when some 14,000 women and men flocked to the NGO Forum for 10 days of seminars and debates. The following Monday, 2,020 official delegates representing 157 countries, joined by some 600 official delegates from UN agencies and from the 162 non-governmental organizations in consultative status with ECOSOC, delivered official speeches and began debate on the major conference document, *Forward Looking Strategies to the Year 2000*. The colorful opening ceremonies of the official conference, the singing and debating on the university's green at Forum '85, the planned visits to the Kenya countryside, even the hassle over hotel rooms—all these events took place under the scrutiny of the largest corps of the world's media ever to observe a UN conference.

As the excitement of that meeting fades, it is imperative to assess the short- and long-term influences which the Decade has had on three levels: women and women's groups, national governments, and the international system itself. Not only was there little agreement, among these three groups at the beginning of the Decade on an appropriate agenda for women, but within each of these arenas there were differing sets of goals and priorities. As the Decade moved ahead these differences became less important. The impact of the Decade for Women can be measured by the distance we have gone toward creating an international consensus on what women's issues are and how to develop policies to deal with them, and the growth of organizations, international and national, public and private, to press for change and implement new ideas. The full impact of the Decade cannot yet be measured; what can be traced is the process by which women arrived at a new consensus and the implications of that consensus for changes in policies and in resource allocation.

WOMEN'S ISSUES VERSUS GLOBAL ISSUES

In theory and rhetoric, the UN Decade was about *women*. Yet the politics of the

Decade revolved around the issue of whether the focus on women could be sustained in the face of the dominant UN agenda concerning such issues as the New International Economic Order, apartheid, or the PLO. This tension between, and controversy over, the mix of political touchstones and substantive positions has been characterstic of all the global UN world conferences since the 1972 Stockholm Conference on the Environment. Designed to raise world consciousness about major development issues, such conferences have information sharing and consensus building as their goals; they lack the authority to solve longstanding disagreements between member nations. Nonetheless, they have provided an arena outside the General Assembly where the fundamental debate between North and South could be further defined and compromises sought.

The two conferences which preceded the first women's meeting, the 1972 Stockholm Conference on the Environment and the 1974 Bucharest Conference on Population, illustrate this conflict between the non-governmental organizations (NGOs) whose primary concern was the substance, and governmental delegates whose concern was politics. The environment and population NGOs, largely composed of activists and academics from the North, had thoroughly researched and outlined the issues prior to their respective conferences. But in both instances, the representatives of the South interpreted the focus on global management

issues as a rationale for diverting scarce resources from Third World Development. In simple terms, the North was for environment, or population control; the South, for development. The dynamics of confrontation was so divisive that it took the NGOs representing these substantive areas more than a decade to establish networks of environment, population, and development groups which could work constructively together on their interrelated issues.

(a) Global issues in official documents

In setting up the Mexico City conference, Helvi Sipila as Secretary General of the conference set an agenda based largely on the commission's work on equality. But the General Assembly, by adding development and peace to the conference themes, vastly broadened the issues which they expected women to debate. Such issues could be looked at through a woman's lens: "women are poor, so we must create jobs or generate income for them." Or they could be viewed in terms of international dependency: "women are poor because their countries are unfairly treated by the international monetary and trade systems." Or they could be seen as a result of global power struggles: "women are poor because too much money is spent on armaments and not enough on development." As the women's movement gathered strength, the focus of the debate grew to encompass all three perspectives. Lucille Mair, Secretary

General of the Copenhagen conference and the first woman to hold the position of undersecretary in the UN system, summarizes this process by declaring that it was

> . . . no part of any preconceived design that a particular goal of the Decade should determine the thrust of each of the three conferences. And yet this is how it turned out. The core issue of Mexico City was Equality; of Copenhagen, Development; of Nairobi. Peace. This is not surprising; for the Decade, the formal framework of the contemporary feminist revolution, existed, not in Wonderland, but in the very real world. It was inevitably conditioned by the climate of that world ("Women: A decade is time enough," *Third World Quarterly,* VII-8:583.)

Broadening the Decade agenda meant the inclusion of several critical and highly charged issues. Restructuring of the international economic system, determining the fate of the Palestinians, dismantling apartheid, resolving the day-to-day, year-to-year conflicts of the UN General Assembly, were seen as essential preconditions for solving economic and political problems of women by many participants from the underdeveloped South; they were seen as extraneous "politicization" by feminists from the industrialized North.

The controversy began in Mexico City when, for the first time in any UN document, *zionism* was added to the list of *colonialism, imperialism,* and *racism* as a cause of underdevelopment. Debate on this issue so diverted the conference that there was no time to discuss several sections of the *Plan of Action,* the major conference document. Nonetheless, under pressure from the women delegates, the Plan was passed unanimously. The more controversial Third World positions were issued separately as the *Declaration of Mexico,* with 89 countries for, three against (US, Israel, Canada), and 18 abstaining.

In Copenhagen, with Third World confidence high, a condemnation of zionism was included in the conference document, the *Programme of Action.* Although Australia joined the US, Britain and Canada in a negative vote, the United States was left in the diplomatically awkward position of voting against a document it strongly supported because it could not accept language opposing zionism, favoring the PLO, and blaming the West for Third World underdevelopment.

As plans for the 1985 World Conference to Review and Appraise the UN Decade for Women moved forward, there was apprehension among US feminists that the US delegation might boycott meetings, and an expectation that, if they attended, confrontation would occur. At other world conferences both before and after Copenhagen, this kind of direct confrontation had been averted in the interests of agreement on narrower issues. For example, the

G-77 had met before the 1979 World Conference on Science and Technology for Development, held in Vienna, and decided to trade political rhetoric for the creation of a Fund to assist science and technology in the South. At the World Conference on New and Renewable Sources of Energy in Nairobi in 1981, contentious paragraphs were forwarded to the General Assembly so that the conference document would be adopted unanimously. Such compromises were always possible if governments agreed to reduce the political noise in favor of substantive issues; many feminists were convinced that their governments did not consider women's issues of sufficient merit to seek such accommodation.

At Nairobi, the US delegation threatened not to participate unless the consensus rule was adopted for debate, a demand which seems at odds with the US tradition of majority rule. Actually, this tactic of inserting consensus in the rules of procedure, a requirement which in fact allows the US – or any one country – veto power, was adopted by the US in the 1960s in response to the fact that it was increasingly outvoted in UN bodies as Third World membership rose. The consensus arrangement in Nairobi also explains the fact that, even though the US objected to four paragraphs during the debate and footnoted its exception to 10 others, it ultimately voted for the *Forward Looking Strategies*. What was not negotiable, from the US point of view, was the condemnation of *zionism*. Throughout the two-week session, the possibility of achieving a unanimous vote on the *Forward Looking Strategies* hinged on the willingness of the G-77 to omit that word and on US flexibility in voting for the total document while excepting paragraphs on NIEO, trade, apartheid, and the PLO.

Pressures on the US to accept such unpalatable sections and on the Middle East countries to drop *zionism* came from women in the delegations and at the Forum, from the European countries and, most of all, from the host government. From the time the Kenya government agreed to hold the women's conference, it was clear that they desired a mannerly affair with no unseemly demonstrations. As the NGO representatives tend to be less disciplined than the official delegates, Kenya proposed that the Forum precede the official meeting. A compromise solution was to begin the Forum on the Wednesday, July 10, five days before the opening of the official meeting which ran from July 15 to 31. As the NGO meetings typically run only 10 days, the overlap of the two events was only one week. Any momentum built up in the first days of the Forum was expected to be dissipated by all-day excursions to the Kenya countryside for all interested participants on the intervening Saturday.

In the welcoming speeches at both the Forum and the official conference, Kenya government representatives stressed the importance of presenting to the world a unified voice on women's issues. Throughout the proceedings, the

Kenya government kept up its pressure for a consensual outcome. Contrary to past practice, the African countries caucused apart from the G-77, in an effort to assist Kenya achieve its goal. The African delegations, for example, showed their independence when the Israeli delegate began her address to the plenary; delegates from many Arab countries left the hall and the African delegations remained, and applauded loudly. During the same speech, the security police prohibited the noisy demonstration occurring in the foyer from reaching the floor of the plenary.

During the tumultuous last session which began Friday afternoon at four and ran until nearly five on Saturday morning, the final drama was played out. Despite all the pressures for compromise, the stand-off continued late into the night. Finally, Kenya brought in an amendment which substituted "other forms of racism" for the word *zionism*. The paragraph, as rewritten, and the *Forward Looking Strategies* were adopted unanimously.

(b) The increased scope of women's issues

The compromise on zionism was an agreement between governments; it was political and symbolic; it was an agreement to disagree. At the Forum, however, there was a spirit of compromise, as more and more women recognized the importance of linking women's issues with global issues. While objecting to the political use of the UN agenda, a growing number of women from the North had come to acknowledge that apartheid, or living in PLO refugee camps, has a distinctly different effect on women than on men, just like modernization or health. Well attended Forum presentations by two different groups of Third World women scholars drew the connection between the feminization of poverty and the international debt crisis. The Peace Tent, an innovative and last minute addition to Forum '85, was the scene of debates over zionism, the Iranian revolution, and apartheid. Even the most conservative women saw the interrelationship between funding the arms race or funding development in the South and welfare in the North. The common thread was the realization that women are more likely to be poor and locked into that poverty than are men; and that the contemporary disorganization of the family harms women much more than it affects men.

The tendency remains for many women of the North to separate "women's issues" from "global issues," and to question the usefulness of spending time at women's meetings attempting to influence policies which are debated in more powerful bodies. Those who favor limiting the debate to issues of gender equality make the fundamental assumption that being a woman conditions one's status and role in a given context more than does class or ethnicity or the structure of the international economy. They believe that women can agree on actions to ameliorate the lives of women

worldwide and fear the divisiveness of a broader agenda.

In contrast, the perspective held by many Third World women is that the poverty and powerlessness of women cannot be addressed by looking at women alone but must be seen as a consequence of the Third World's economic dependency on the industrialized North. They believe that women of the North benefit from the existing international distribution of power and are therefore unlikely to be highly critical of it. Further, such women of the South argue that racism cannot be dismissed as a domestic issue of discord among groups; it is rather an international issue, a legacy of colonialism, that affects the economic and power relations among states. As a result of its persistence certain groups—blacks in South Africa and Palestinians—lack self determination.

In this context, it is clear that most women will be torn between their national interest and their interest as women. The charge that it was the male domination of the official meetings or the state subsidy of Forum participants that "politicized" the debates hides the fact that ignoring redistributive issues allows women representing the Northern countries to pursue their women's agenda and their national interest without conflict. For Third World women that conflict is very real. Failure to support national goals in favor of a "feminist" agenda can also cost Third World women political legitimacy at home.[3]

The UN, by broadening the topics to be included in the IWY resolution, had in fact encouraged women to enlarge the scope of "women's issues" beyond equality. In the end a compromise was achieved that promoted a consensus on women's issues without neglecting Third World claims.

(c) The substance of women's issues

Taken together, the three conference documents—the *Plan of Action*, the *Programme of Action*, and *Forward Looking Strategies*—chart an expansion in the expectations of women from Mexico through Copenhagen to Nairobi and an increased awareness of the policies that would be required to improve the status of women worldwide.

From the first, the goal of legal equality of women—including the rights of divorce, custody of children, property, credit, voting and other citizenship rights—has been accepted as a minimum basis of consensus from which to begin discussion of other, more controversial issues. The issue here has not been one of language but of implementation, especially where the gap between law and practice is very wide. Property rights, arranged marriage, dowry, and child custody are among the issues which still arouse controversy in countries where women's legal rights are severely curtailed by law and custom. In some countries the traditional rights of women have been undermined by legislation modeled on the "liberal" legal systems of the West;

for example, women's customary rights to the use of land under traditional kinship rules are lost under Western laws based on private property.

Debates over equality of treatment versus equality of result also exist, as is clear when issues such as maternity leave or child care are raised. On the whole, UN documents support a view that is different from the prevailing practice in the United States where "special treatment" of pregnant women and mothers is rejected in favor of the notion that women must be equal, that is, like men, whatever their biological roles or family obligations. The US view is based on a negative assessment of "protective" labor legislation and on widespread fear that women will not be hired if their employment obligates employers to pay higher costs for women's "fringe" benefits.[4] Outside the US there is less of a tendency to see treatment which takes account of women's differences as inherently "unequal." Governments bear most of the differential costs, an approach fostered in all three of the UN documents.

A second category of issues, central to all three documents, relates to economic concerns. Third World delegates, supported by a number of European governments, have framed the issue of the economic status of women within a global context of Third World underdevelopment and the call for a new international economic order. Once the issue is so defined, however, the documents turn rapidly to analyze ways in which development—all

development—marginalizes women, and how that marginalization might be reversed or avoided. Solutions at this level suggest very specific mechanisms for enhancing women's economic activities that do not easily fit into competing ideological rubrics. Thus, for example, the economic contributions of rural women in subsistence economies to family survival are emphasized while ways are sought to reduce their drudgery through appropriate technology including water points, food grinders and cookstoves, and to provide greater access to more productive employment and education.

A third category of issues which have sparked the most controversy among women themselves include those which lie at the heart of male/female power relations in all societies: women's rights to control their own bodies, and the many dimensions of violence against women including prostitution, genital mutilation, domestic assault, and incest. These were not significant in the *Plan of Action*, but are central concerns in *Forward Looking Strategies*. The UN consensus has moved ahead of that in the United States on two key issues which reflect different societal/ economical roles assigned to women: comparable worth, and wages and social security for homemakers.

Family planning moved from an issue of the North in Mexico City to a right of the South in Nairobi, with Third World women initiating a petition to the US government to maintain its funding of population groups

in spite of the opposition of the moral majority. The resolution read in part:

> The so-called "Pro-Life" lobby at this conference has been trying to ride on the backs of Third World women by using the fact that we have criticized unsafe family planning methods. They are using our words to lobby for the cutoff of family planning services in Third World countries, and in particular to promote an anti-abortion campaign which parades under the guise of a "Pro-Life" movement . . We demand quality reproductive health care, safe and accessible methods of family planning to protect our health, control our fertility . . We reject the domination of one country in the family planning area and its use of economic manipulation to coerce other governments . . .

A fourth element on the international agenda of women that has achieved growing consensus is the peace issue, which has built on an enhanced international network of peace activist groups spanning the ideological divisions between East and West, North and South. Since the early feminist movement, and particularly in the work of Jane Addams and groups like the Women's International League for Peace and Freedom, important sectors of the women's movement in the United States and Europe have argued that increased women's influence in politics would bring about a more peaceful world and the settlement of disputes by negotiation rather than war. Since the development of nuclear technology, the issue has become more urgent and the cause of disarmament has mobilized men and women all over the world. During the Decade the peace activists drew upon and discussed this concern from a female perspective.

Peace has been an issue in every meeting of the Decade. In 1985, a Peace Tent, organized by the International Network for Food and Peace and funded by an American philanthropist and peace activist, was a very visible part of events at the Forum on the campus of the University of Nairobi. In addition to seminars on nuclear disarmament, participants were involved in arranging women-to-women encounters among women from nations at war which represented an activist approach to "peace-making," the search for common ground that could form the beginning of a basis for negotiation.

Among the interesting initiatives emanating from the Peace Tent in Nairobi were two petitions being circulated among women around the globe. The first is a petition to the UN calling for women to be declared a "government in exile" which, if accepted, would qualify women for a seat in the General Assembly under existing procedures. The second is a request that the UN send in "peace-making" groups whenever they are invited to send in peace-keeping troops. Neither of these petitions

has much likelihood of success, perhaps, but they illustrate the innovative ways in which international cooperation among women can help push the international agenda in new directions and give women a new basis for arguing against military solutions.

In sum, legal equality, economic access to resources, sexual exploitation and violence against women, and peace have all emerged from the Decade as clearly defined issues. As a result of Decade activities there are more data on the status of women and how it is changing, more awareness that women are marginalized not only by economic dependency, but also by discrimination. The gap between male and female literacy actually grew in some countries, and the Decade documented the fact that modernization may reduce women's welfare and women's access to resources. The feminization of poverty is occurring worldwide.

Yet the Decade added to women's awareness of their situation *as women;* they have become more capable of demanding that their needs be recognized by governments, and better equipped to organize around a variety of issues and in a variety of organizations. Consensus on the issues is important, for such unanimity gives women the strength to move into the mainstream to try to achieve their goals. This consensus recognizes that there are bonds between women which cross national and class boundaries, and that women working together are much more likely to influence men than they would have been without this global agreement.

IMPLEMENTATION: THE TRIANGLE OF SUPPORT

We have summarized the debates and the progress that has been made on creating a woman's international agenda, and noted the symbiosis between outsiders and insiders, beween women's groups and other NGOs as contrasted with the UN and its member governments. The current agenda is a response to pressures from both sides: from women's organizations on the UN and its member nations to hold more meetings, conduct more studies, and include more issues in the conference documents; and from the UN process which has forced women to confront international issues. A similar relationship will determine the effectiveness of the official instruments created to carry out the agenda: without continued pressure from outside clientele, even sympathizers in the various agencies and bureaucracies are unlikely to work hard for the agenda.

Three links are identified in this implementation chain: specific agencies or offices within agencies, sympathizers in mainstream bureaucracies, and women's groups and networks. We shall briefly review Decade changes with regard to each.

(a) Official instruments

Efforts by the UN Commission on the

Status of Women to cajole national governments to set up "machinery" for women within their bureaucracies started long before the Decade, but received great impetus after the Mexico City conference.[5] It was a low cost response to pressure from women: an office was established within a ministry such as social affairs or labor, or perhaps placed in the office of the prime minister or president. In some countries a Women's Ministry was established. However limited, these offices have proven to be a training ground for administrators and politicians. Even such a symbolic office represents a leap forward in many countries; the challenge is to move past tokenism so that the issues of women, and the office itself, are perceived as important to national development. To make an impact on government planning, both funds and power are required. Because such decision-making power tends to come from within the system, these small focal points for women were generally dependent upon support from highly placed politicians or staff and from women's organizations. Funds were often easier to find if they could be provided from donor governments and outside foundations and were, often, used to collect data to be used in planning priority interventions.

Before the IWY conference, a woman's center attached to the Economic Commissions of Africa in Ababa was set up with Dutch funding by an American scholar of Africa, Margaret Snyder. This office became the prototype for the other UN regional commissions in Latin America, Asia and and Pacific, Europe and the Middle East. Such symmetry created confusion if not rivalry in two of the regions which had pre-existing commissions: the Inter-American Commission for Women of the Organization of American States, founded in 1928, and the Women's Commission of the League of Arab States begun in 1971. In all cases, it has been easier to get outside funds for studies than it has been to influence mainstream development planning. For most of the Decade, these machineries added more to our knowledge of women worldwide than they changed the way their own governments responded to women's demands.

A second type of state intervention has been to set up women's offices within development agencies. The first such office of Women in Development (WID) was set up in 1974 by USAID in response to legislation in the 1973 Foreign Assistance Act. Other donor assistance agencies followed suit as did the Commonwealth Secretariat. During 1974, resolutions created special offices in most major UN agencies so that by the time of the IWY conference there were women in the World Bank, UNESCO, ILO, and FAO responsible for integrating women into their agency's programs. These women attended the official Mexico City conference and participated in the debate. Evaluations of these offices show that they have all played critical symbolic and advocacy functions. Funds at the disposal of such offices are usually minimal, but have

been important in assisting women from both North and South to attend meetings, organize women's groups or carry out research. Subsequent policy papers have frequently influenced the way a mainstream program, say on social forestry, is carried out.

Two special organizations were set up within the UN as a result of the resolutions passed at the Mexico City conference itself: the Voluntary Fund for the Decade of Women (now UNIFEM) and the International Research and Training Institute for the Advancement of Women (INSTRAW). Like many recently established agencies of the UN, both UNIFEM and INSTRAW must solicit voluntary contributions from member states for all their funding. Recognizing its funding limitations, UNIFEM, under the tested leadership of Margaret Snyder, attached itself to UNDP both to carry out its own small projects as well as to press that agency to include women in its major programs. Similarly, INSTRAW tries to influence ongoing UN research and training activities while at the same time holding experts meetings and training sessions at its headquarters in Santo Domingo. One of the first accomplishments of its Yugoslav director, Dunja Pastizzi Ferencic, was to convince the UN statistical office to disaggregate all of its data by sex. In a sense, both organizations function as lobbying offices within the UN; and both remain precariously underfunded. Recognizing that outside support is essential, independent support groups for both organizations have been set up in several countries to increase their visibility and encourage greater funding.

The UN Commission on the Status of Women is the only women's group in the UN with central budget funding. Much of its effort has gone first into passing, and then into enlarging, the number of signatory countries to the 1979 Convention on the Elimination of Discrimination Against Women.

(b) Mainstream sympathizers

From the above description of special instruments for women, it is clear that for these offices to function they need political and bureaucratic support from within their own agencies and government. Pressure has been exerted in all national and international agencies to increase the number of women at high levels on the assumption that more women in decision-making positions would provide a larger pool of sympathizers. Although this has often been the case, outside support is also crucial. Professional women who have worked hard for recognition in a male bureaucracy may feel threatened by or may reject a feminist advocacy role but are usually willing to support positions put forward by the women's office or by outside activists. Plans to increase the number of female staff may be opposed by males in the bureaucracy, but they are likely to support programs designed to aid poor women. For these reasons, it is important to distinguish between two goals: (1) employment for

professional women; and (2) integration of women into economic development plans and other programs. Both types of efforts are critical; but they benefit different groups of women, and the methods used to achieve them are quite different as well.

A key step in implementing the women's agenda is to integrate major recommendations into the appropriate UN agency programs. The call for "multi-sectoral programs to promote the productive capacity of rural poor women in food and animal production" (para 176 FLS) will have greater chance of implementation if it becomes part of the FAO's biennial plan. Similarly, UNIDO and the ILO must recognize the particular needs of women in commerce and industry. While individual staff members in these agencies are engaged in responding to *such* issues, several women's organizations are urging that a series of conferences be held by the UN specialized agencies for women activists and scholars to demonstrate exactly how the agencies expect to implement the *Forward Looking Strategies* between now and the Year 2000.

(c) Women's groups and networks

The most conspicuous change over the Decade is the exponential increase in the number and types of women's groups in every country of the world, and the complex of networks and organizations which unite them. These groups pushed their governments to hold the first women's conference, to declare the Decade, to install WID offices and national machineries, to hire and promote women professionals, and to include women's needs in development programming. They spawned research and policy centers, training institutes, craft and credit organizations; they brought enthusiasm and leadership to population, environment, and peace organizations.

These groups are secular, religious, radical, lesbian, conservative, grassroots, and elite. As a result of all the national and international meetings which were part of the Decade, and the thousands of smaller meetings, seminars, studies, projects, events, women of the world not only know each other, but they know a great deal about each other. Women are empowered knowing what other groups have done successfully, and by having facts with which to present their case to their governments and planning institutions.

To maintain these international networks, a variety of organizations have been formed. The first was the International Tribune Center (NYC); growing out of the NGO meetings in Mexico City, it maintains contact among the burgeoning grassroots women's organizations. ISIS (Geneva and Rome) began as a network among radical women's groups formed around health and rape crisis centers; it continues as a vital information link among feminists. DAWN, Development Alternatives with Women for a New Era, has created ties among scholars and

organizers of the Third World in an effort to link such major issues as development, the international economic crisis, the subordination of women, and feminism into a coherent platform for policy and practical action. The International Interdisciplinary Congress of Women grew out of the Copenhagen NGO meetings discussing women's studies; it will meet for its third convention in Ireland in July 1987. Most international professional associations have women's committees which sponsor sessions about women and also ensure that women are broadly represented on the program. The Association for Women in Development brings together women and men scholars and development experts at their periodic meetings to discuss the integration of women into development programming.

These newer groups supplement the more established women's organizations such as the International Alliance of Women, International Council of Women, Zonta International, International Association of University Women, the various religious women's groups, which were among the 162 NGOs attending the Nairobi conference. A global NGO conference on women has been proposed by these groups for 1990 as preparation for the next UN women's conference between now and 2000.

Meanwhile, efforts to move the women's agenda forward are focused at the national level. Everywhere, women's groups are learning how to lobby their own governments to provide more resources for women and to change laws and customs to achieve greater equity. Everywhere more women are moving up political and bureaucratic ladders to positions where they can suggest more equitable programs and policies. These women are strengthened by their members, their knowledge, and their own government's public commitment to the *Forward Looking Strategies*.

The psychological dimensions of this mobilization process should not be underestimated: the Decade provided the opportunity for women to recognize that a women's agenda is legitimate and feasible, and that such an agenda commands agreement and support across national boundaries and international conflicts. The Decade enabled women to meet and share successes and failures in their effort to achieve a better life for women worldwide. The Decade with its official and its informal meetings, its new networks and newly invigorated older organizations, empowered individually and collectively in a manner unparalleled in history. It will be difficult to track all the effects of the Decade on public policy or private lives. But there is no doubt that the Decade solidified and enhanced the international women's movement; women will continue to work together to effect change.

THE FOURTH WORLD CONFERENCE FOR WOMEN IN BEIJING; THE NGO FORUM IN HUAIROU

THE FOURTH UN WORLD CONFERENCE for Women, held in Beijing and the accompanying NGO Forum, moved to Huairou are over. After twenty years of women in development (WID) and seven UN world conferences including the four for women in Mexico-1975, Copenhagen-1980, Nairobi-1985, and Beijing-1955, the events seem a fitting closure to this phase of my life; reaffirming, chaotic: a kaleidoscope of patterns/reactions. The events have been reported very differently by different people and, as in the film Rashomon, even I can view the NGO Forum from many perspectives.

Forum as celebration and inspiration: An overwhelming sense of delight pervaded the Forum: deep pleasure that all these women from all these countries could gather and celebrate their common advances toward equality, analyze their differences, and debate the economic, social, political, and cultural impediments toward greater self-realization. Women, and some men, crowded the information tent, roamed the streets where groups from everywhere around the world sold local handicrafts, books, jewellery: their assigned spaces in the marketplace were too distant and soon abandoned. Groups of tents added meeting rooms

to those in the middle school. Government training centres provided their large seminar rooms. One convention centre had space for 1500 and offered translation; a second large space was half built as was the exhibition hall. Large gatherings for plenary programs or cultural events were planned for the sports field that had been paved with tiles: the rain cancelled entertainment and sent speakers, including Hillary Clinton, indoors. Beach umbrellas over tables and chairs brightened the space which became a favourite place to meet on sunny days, drinking spring water or eating Chinese fast foods. Huairou felt as distant and as joyous as an adult summer camp.

Estimates of participants rim from 20,000 to 25,000 at the NGO Forum and 4,750 (with some overlap) at the official meeting itself growing as the UN membership has reached 185 countries. Comparable figures show 14,000 NGO participants at Nairobi, 8000 at Copenhagen, and 6000 at Mexico with the official meetings gradually increasing from 2000 to 3000. The geographic location encouraged more Asians; affluence brought large numbers of Japanese and Koreans; South Asians have always been well represented; new were the NGO women from Vietnam, Laos, and

Cambodia, many financed by the Ford Foundation.

The plethora of panels running for 1.5 hours each all day encompassed academic presentations, religious prayer meetings, reports from grassroots groups, motivational sessions; their format ran from show-and-tell to formal papers to fancy agency handouts. Identified by little and sponsoring group only, selection was difficult; names of speakers were publicized only for the single daily plenary sessions. To let people know who was speaking in the other meetings, everyone handed out leaflets and posters covered telephone poles and bulletin boards. Some more aggressive groups, such as the large number of Japanese and Koreans, accosted women wandering past and invited them in, often offering candy or souvenirs. Outside the middle school, women from Yemen handed out fliers about a video on women's lives in their country. But many tents or rooms, often as many as one-third, stood empty: no one came to lead the panels on aqua-culture or Zairian media or Indonesian culture. A Turkish woman lectured the audience as if we were her students. The Nigerian journalists postponed, some consultant groups cancelled. Full panels were rewarded with standing room only, although many women just sampled and moved on.

New features at this Forum were special large tents for the geographic regions, for youth, and for the disabled; book stores and UN agency exhibits; and a communication centre where Apple set up Macintosh machines and APC provided temporary e-mail addresses, allowing thousands of women to send e-mail. The US delegation to the governmental meeting came out to the Europe and N. American tent, once that conference had begun, to give briefings on debates on the Platform for Action. Also new was the advertising, not only by Apple. Esprit gave out a handy shoulder bag to each participant with the logo: 'Seeing the world through women's eyes.' Some women argued we should give the bags back because Esprit presents a progressive image but treats subcontractors very badly; but no one did. Some of the 40 women in the American delegation—six men were also on the delegation—were giving out flag tie tacks pinned to a card reading 'Courtesy and Maidenform Worldwide, Inc.'

China as the site: Emerging from its self-imposed isolation from the international community, China sought to host the Olympics in order to increase its global prestige. Failing in this attempt, the country hosted the Asian Gaines in its Olympic Stadium and offered to host the Fourth UN World Conference for Women. Hosting these large conferences of official delegates from governments and UN agencies is expensive in itself with the high cost of simultaneous interpretation in six or seven languages; the continual expansion of the parallel Non-Governmental Organization (NGO) Forums adds greatly to the price tag; no other Asian country offered and it was that continent's turn.

From the beginning some countries objected to the choice, citing human rights transgressions. Many feminists supported the selection, believing the issues raised would assist the Chinese women who were striving for greater equality in their own country. Both concerns stem from the Chinese government's predilection for controlling its citizens; its attempt to control international participants at the NGO Forum, as it did control those from China, resulted in extremely negative press. Whether this media attention deflected the coverage of women's issues or gave greater visibility to the meeting is still debated.

China's ability to control its people also allows it to organize and manage huge events such as the spectacular opening of the NGO Forum held in the Olympic Stadium. Over 20,000 women and a few men were bused or ferried from hotels in Beijing and Huairou on the late afternoon of August 30. Roads were cleared and police with mobile phones controlled both the vehicles and the crowd; a women's orchestra and chorus entertained us as we waited. Precisely at five, interspersed with the usual compulsory ceremonial speeches and the passing of a torch in a brief but politically loaded introduction, wave after wave of precision troupes engaged the audience in this visual extravaganza. School girls in red and white helped attach a large NGO banner to a long helium balloon that floated up to compete with a dirigible proclaiming not only the UN slogans of equality, peace, and development, but also friendship. Elementary school boys in Turkish costumes beat red drums while forming patterns like miniature marching bands as girls of the same age drummed and danced on a large round movable stage. Red-skirted 'minority' women undulated their hips singing expressive songs which contrasted sharply with measured presentations of classical songs. The movable stage turned into an island by exuding inflated 'rocks' as dancers undulated wider long green banners to imitate the sea. My favourite was the hundreds of pom-pom girls interspersed with men turning six-feet tall fans from yellow to blue, open and shut, to vary patterns and colours. Chinese dragons stormed into each bleacher section, charging up and down the stairs: we were told that for the first time, women were the prancers. Finally, as the sun set, men in blue, green, and purple reflected the fading light with square shields about a meter square, mirror-like on one side, blue on the other, while women in similar shades fluttered long banners or held doves aloft, weaving patterns and filling the field: as three sails of range lettered equality, peace development rose in their midst a thousand doves were released by tiny tots and a dove cut-out emerged at the orchestra stage!

NGOs and China: China has almost no NGOs and clearly neither understands nor tolerates the concept. When I visited Guangzhou in 1992 leaders of the Women's Federation whom I met insisted that this mass organization of the

community party was an NGO (technically so is the party). A few professional organizations had been formed, and a 'hot-line' in Beijing was just beginning. Apparently, contemplating the Womens Conference, the Chinese first thought that foreign visitors would sit quietly in large auditoriums while the government extolled the accomplishments and equality of their women. As the raucous nature of NGO meetings penetrated the minds of the Chinese government, they first tried to sever the NGO Forum from the FWCW but were told they must have both or neither. Next they approached the US and other governments asking them to prohibit their own citizens from travelling to China seeking to limit numbers; when these tactics failed, the Chinese instituted advanced registration (forms had to be submitted, along with two passport photos and US$50. before April 30; I was #3740 of USA) and required confirmed hotel reservations and proof of registration in order to get a visa.

As the politics of transition from Deng Xiaoping heated up, the government decided to move the NGO meeting site from downtown Beijing to the resort town on Huairou some 35 miles away. To encourage delegates to stay in Huairou or a nearby lake resort, everyone had to reapply for hotel space thus delaying confirmations: mine came two weeks before I planned to leave; and visas take a week to get. The result was a jam at all consulates. Of the 36,000 women registering, only some 25,000 probably went to Beijing. Whether

others simply got discouraged and decided not to go, or whether the Chinese purposely delayed some hotel letters is unclear. But certainly some women never received their hotel assignments and had to cancel. A professor teaching in NY state but holding a Chilean passport was unable to get a visa though she applied at several consulates.

All participants with NGO visas were required to stay in specific NGO hotels, all of which had doubled or tripled their rates. I stayed in the three star Landmark Towers hotel in a double room costing $180 per night; fancier hotels jacked up prices as high as $320 per night. The Sheraton offered newer, larger doubled rooms at $145 to government delegates. I assume, that some of that overcharge paid for the 'free buses' amid unwanted surveillance.

Fleets of buses ran from Beijing hotels to Huairou from 7:30 am to 7:30 pm; to ensure that the trip on this two lane road would take only an hour amid a quarter instead of much much more, the government closed the road to normal traffic. The government also organized airport like security checks at the Forum, the subject of some of the earliest protests. Soon everyone was simply walking around the units; the Chinese continued to sit amid watch, and once in awhile asked you to please walk through. Attractive young English speaking Chinese were trained for two days (many were students studying the US and recalled to help at the Forum) to circulate among the sessions, join groups at tables to listen to the discussions, converse with

participants, and then report on everything they heard.

Responses by the host government to the uncontrollable NGOs were excessively paranoid. The local media described us all as lesbians and prostitutes ready to disrobe at the airport or in taxis. I wondered how many locals were disappointed when the march of naked women on Tienanmen Square did not materialize on Saturday evening! Streets were cleaned, and many street vendors prevented from selling throughout the conferences; locals complained that fresh produce was hard to find and expensive.

In Beijing, hotels had extra security guards on every floor to record any contact between Chinese and foreigners and to report meetings of five or more that were technically prohibited in Beijing. The workshop portion of a symposium I was helping to organize on Poor Urban Women was held in town to avoid the bus rides. A seminar room was engaged, but first the Sheraton, then the Landmark, found something wrong with the rooms after, presumably, being informed our meeting of 20 women was illegal. After late night haranguing, the meeting was allowed to proceed with the provision that a Chinese woman professor, who had spent a year at Yale, would be allowed to observe our meeting. Every taxi ride was recorded by our assigned registration numbers which we had received after registering. Women who registered with US or Australian groups but who were of Tibetan origin or who were identified

in Beijing as being from Taiwan were followed and apparently hassled. Many women found their luggage 'lost', and may have been searched before the bags turned up at their hotels.

Issues: 'Human rights are women's rights and women's rights are human rights' was the slogan that dominated the conference. It is the NEW issue for women, a direct assault on patriarchal privilege that allows men to beat-up and even kill wives within the family and under customary law protection. Bolstered by recognition at the Human Rights World Conference in Vienna in 1993, this concept was inserted in the Platform of Action as well. Hillary Clinton raised it in her speech to the official meeting, which was studiously ignored by the Chinese press, because she said women's rights included their right to decide on how many children they wanted: no forced abortions (China) and no preventing family planning (Vatican). The slogan is a nice way undercut male privilege without devising a new framework. Of course the Chinese record on human rights also came under attack as did the government attempts to control participants in the NGO Forum.

Centers concerned with domestic violence had mushroomed in every country around the world in the last decade. A topic nearly taboo in the US two decades ago, domestic violence is now addressed in media and meetings everywhere. Because all women of all classes, ethnicities, religions, countries are subject to domestic violence, human

rights has become a powerful uniting theme. Issues of work tend to divide women' along class or 'ideological lines. Education is broadly supported but debates continue about content and appropriate training. Demand for human rights for women creates only unity.

Inheritance rights to land and house have traditionally been governed by customary law as well. The concept of equality implied in the phrase 'women's rights are human rights' implies this should change. The Islamic countries opposed the idea of equality since the Koran designates that women get half of a man's share of assets because men have the responsibility of caring for women—a principal of equity, or fairness. Indeed, when this inheritance was promulgated, almost no other customary law gave anything to women. Ambiguous language as to implementing the law eventually allowed this provision to be included in the Platform. Increasingly critical is a woman's right to own her house and the land surrounding it. With over half of the households headed by women in many urban shuns around the world, and as support by . fathers of their children and by other kin erodes, women need such entitlement to protect themselves and their children from homelessness and destitution.

Although some right-to-life supporters appeared at Huairou, their voices were muted; one Swiss industrialist found his way to most panels on family planning and forcefully stated his pro-life position. At the official

meeting, most delegates preferred to stand by the consensus reached at the 1994 World Population Conference in Cairo: improving women's access to education and adequate health services is the best way to address the problem of increasing world population. The Draft Platform of Action listed health and education among the 12 critical areas of concern, but not reproductive rights directly. Rather, this issue was subsumed under health which noted that half a million women die each year from complications due to pregnancy and another 100,000 due to unsafe abortions. Also included in the health platform were grim statistics on the rapid spread of HIV among women: by the year 2000 some 15 million women will be affected and as many as four million may die.

Protests: In most major UN 'consciousness-raising' world conferences, including the three on women's issues, protests by the NGOs who attend the Forum have usually been focussed on the UN procedures which limit access and influence of NGOs in the final stages of approving the conference document. Numerous prep-corns (preparatory committee meetings) and regional meetings precede a world conference where issues for the conference and wording of the document can be hammered out. NGOs with long term consultative status know the procedures, but these topical conferences on environment or population or women encourage attendance at the NGO Forum by national and international

organizations less familiar with the measured steps of the UN. After a few days of discussions and exhibitions, the uninitiated activists realize just how marginal they are to the process... and they protest, usually with a march across town to the governmental meeting. China foreclosed that option by locating this NGO Forum in Huairou. Instead, their heavy handed security measures provoked unprecedented protests against the Chinese hosts both for their handling of the conferences and their abysmal civil rights record.

Others protests, primarily aimed for home consumption rather than at UN or Forum debates, were orchestrated with an eye toward the media which dutifully videoed these daily demonstrations and highlighted them. In fact, these marches were peripheral to concerns of most Forum participants: South Asians wearing blue and dancing for their rights; Muslims objecting to lesbians and lesbians demanding their rights; organizers berating the Chinese. Women everywhere seemed to have learned the power of CNN.

Rashomon: the Forum was a celebratory gathering that facilitated networking and glowed with good will; the Forum was chaotic, the program so inclusive as to lose focus, the panels except for the plenary, uneven and often non-existent. The Chinese laboured extensively to provide a charming experience for the NGOs within their narrow disciplined perspective; the Chinese security was intrusive and offensive in its attempts to control the assertive women at the Forum. The NGOs provided the visibility and arguments that kept government delegates from retreating on contested issues in the Platform of Action; the radical NGOs detracted from the serious mainstream concerns by staging media events.

Such are the diverse perceptions of participants. Few would have missed the event, though one friend who found the meetings arduous said she had been 'looking forward to looking back on the experience.' Yet profound questions remain about the role and representation of NGOs both at the UN and around the world. The spectacular increase in numbers of NGOs registered to attend the meeting and the official conference was encouraged by lack of any screening of applicants. Given the crush of official delegates, only 100 seats were reserved for the 3500 (1500 experienced and 2000 new) NGO's accredited to the UN conference, each allowed several delegates. Such restricted access reflects the limited roles assigned NGOs: advocates who supply background information from their constituencies to delegates and media, and report back to their organizations on the problems and progress within the UN.

Many NGOs are demanding greater representation, especially those from countries whose official stance disagrees with their own, such as the pro-choice scholar who kicked off Argentina's delegation, with its pro-Vatican position. But if governments aren't representative of people's views,

are NGOs? In the Philippines, Corey Aquino opened up local government meetings by requiring NGO representation on many bodies. The number of development NGOs alone exploded to over 20,000 and fervent NGO leaders are spending much of their time trying to decide which groups are real NGOs. Even policemen have NGOs now, they say. At Huairou even groups of NYC psychiatrists registered as an NGO as did two women from Egypt. With other colleagues, I am in the midst of a study about development NGOs in Indonesia, Mexico, and India: the more we research the less I know. More information about NGOs and the UN are also clearly needed.

Future: Success of these UN meetings can only be measured by shifts in world attitudes and by changes in national and local laws and practices. Already 'Beyond Beijing' meetings are being held by NGOs in cities throughout the world to identify priorities for their own countries, and to plan campaigns and organize actions most likely to convince their own governments to improve the lives of women and girl children. Local action changes the world; as women everywhere have learned. It should be an interesting twenty first century.

WOMEN'S ROLES IN THE RURAL ECONOMY

ONCE THE POLICY WAS ESTABLISHED THAT WOMEN'S CONCERNS SHOULD BE CONSIDERED in the design of economic development programs, research documenting women's activities became essential. When economic development theory was promulgated in the 1950s, the mindset of the male economists was shaped by the societal stereotype that women's place was in the home. About the only women this described were middle class American and European women. When arguing for a policy shift, I had used all available data I could find. Now the need was for detailed accounts of women's actual economic contributions as well as studies of the impact of new programs.

The highest priority was to provide detailed accounts or time budgets in order to identify women's actual roles in subsistence economies. Many dedicated anthropologists lived for months in villages recording the daily lives of women, and in some cases also those of men and children. A seven village study in Nepal was particularly useful. Cumulated data from these and other studies showed that women worked many more hours than men. Women's survival tasks focused on providing food for their family: planting, farming, harvesting, processing, storing, and cooking basic grains and vegetables. For cooking, they needed to fetch water and to gather fuelwood, often from long distances. Caring for children was folded into these duties and did not register any additional time. Men in these studies often relaxed by smoking or drinking; women had **no** leisure.

These date were immensely influential. Planners altered programs that had conflicted with women's work. Belated recognition of women's daily drudgery provoked the emerging Appropriate Technology (AT) community to design new implements that could alleviate many of women's food related tasks. At AAAS annual meetings I organized panels about AT and food security.

WOMEN FARMERS

Early economic development programs focused on agriculture both for food and for cash crops necessary to fund a country's growth. Because planners ignored women as farmers, they introduced programs concerning population, health, and literacy aimed at women. When women did not show up for the classes in mid-day, planners were scathing about women's desire for change, calling them lazy.

If they saw women working in the fields in developing countries, they assumed these were merely vegetable gardens. In their minds women did not work, and certainly did not farm. Even today, the UN estimates that 45% of farmers are women; in Africa, women continue to grow some 80% of food.

In a widely distributed *Care Brief*, I listed six "lingering myths that impede development:" 1- women are men's dependents; 2- women don't "work;" 3- women aren't farmers; 4- work with animals is men's domain; 5- women's income is only "pin money;" 6- women don't understand business. I reiterated that when planners believe these myths, their program design is faulty which in turn undermines their implementation. Other obstacles facing rural women were the lack of income-earning opportunities and of legal protection, especially for access to land.[1] I also wrote an op-ed for the *Christian Science Monitor* "African Conundrum: food today and in the future." [2]

As a result of my activism and publications, I was honored by the Rural Sociological Society and presented with the Distinguished Service to Rural Life Award. In my acceptance speech I commented: "Although the focus of my talk today is international, I cannot stress enough the importance of drawing parallels between developed and developing countries whenever possible."[3]

I was able to draw comparisons to developed countries based on three exploratory workshops that EPOC had convened. At the first workshop for US women farmers, the women's major complaint was that most men considered women's work on farms as trivial.[4] At the European workshop held at the Rockefeller Bellagio enter in Italy, presentations were given both by scholars and civil servants to illustrate the wide range of farming systems across Western Europe. To my surprise, in parts of the Poland women's roles resembled those in Asia. I was also fascinated by the Finnish program which trained young women in milk production so they could provide vacation time for men on remote farms: the program also became a sort of marriage bureau! A workshop at Atibaia, Brazil, underscored the problems encounter by women on all of the many Latin America farming systems.[5]

1 "Feminizing Development: For Growth with Equity," CARE Brief #6. Issued in cooperation with the Overseas Development Council, Washington D.C., 1986.

2 "African Conundrum: food today and in the future", op-ed Christian Science Monitor, 23 Apr., 1986.

3 "Women in African Development", The Rural Sociologist 5/5, Sept., 1985.p. 358

4 "Women's Roles on North American Farms," EPOC project notes, Fall 1982.

5 "Mujeres, agricultura y modernizacion en America Latina rural," in C. Spindel, J. Jaquette, y M. Cordini, eds., A Muljer Rural e Mudancas no Processo de Producao Agricola, Instituto Interamericano de Cooperacao para a Agricultura, Serie: Proposicoes, Resultados e Recomendacoes de Eventos Technicos. No 337, ISSN 0253-4746, 1984.

REDUCING DRUDGERY THROUGH APPROPRIATE TECHNOLOGY

Early efforts to improve agricultural production in developing countries included sending US farm equipment for use on farms in India. Replacement parts for tractors and other machinery had to be imported causing long delays for repair. Further, villagers, who for centuries had used farm animals to plow, did not know how to care for tractors and often adorned inoperable machines with wreathes of marigolds. In 1973, E. F. Schumacher published *Small is Beautiful: economics as if people mattered.* This publication spearheaded the search for more appropriate technology to lessen women's work. Unfortunately, these efforts, conceived in a laboratory setting, generally continued to ignore the human aspect of their use and often resulted in more work for women.

As the AT community began to consider how technology was actually used, their efforts became more successful. It took some time for agencies to realize that teaching men to use the new technologies was often useless when it was women who were primarily involved. When wells were dug in southern India, men were initially trained to repair them; but since men did not carry water and so did not visit the well, it was women who noticed problems. Once women were trained in basic repair, the wells stayed usable for a longer time. In south India, women were also given pre-addressed, prepaid postcards to mail to the nearly town requesting a mechanic to ride his bike out to make more complicated repairs.

Providing potable water to villagers became a major thrust of the AT community. Conventional development programs emphasized irrigation that would increase crop production. Villagers got sick drinking water from irrigation ditches. Access to water was improved in Nepal by the use of gravity-fed plastic piping, but the system worked better when women were trained to monitor the flow since they were the ones going to the wells daily. As the climate warms and the ground water reserves diminish, potable water becomes even more of an issue: one can live days without food, but not without water.

Women in subsistence economies did most of the harvesting, processing, and preparing of food. AT was utilized in an effort to reduce the estimated losses of between 20 and fifty percent between harvesting and consumption by improving storage and preservation. Today, food losses in production remain acute, but waste at the supermarket and in homes is a growing problem.

The outcomes of using AT were both positive and negative. The green revolution increased the productivity of farms and allowed wives to withdraw their labor. Yet in India, women's status was reduced when their work was no longer needed: bride price was replaced with dowry. Similarly, where rice mills were introduced in Nepal, utilizing the mills did reduce the hours women spent pounding the

grain, but this also caused a drop in the income of village women who used to do this task. Utilizing all this research, I summarized how AT impacted on women in several papers.[1] I attended the 1979 Conference on Science and Technology for Development, in Vienna, where I chaired several workshops on technology & women at the NGO Forum.

ENERGY FOR COOKING AND LIGHTING

The oil crisis in 1973 prompted scholars to study the impact of costly fuel in developing countries. Their data revealed that a majority of the world still used biofuels to cook or heat their homes. In response, the AT community began to design more efficient cook stoves. One of the first was the Lorena stove, an easily built clay stove designed in the highlands of Guatemala: wood was plentiful to feed the firebox and the ambient heat warmed the chilly homes. When the Lorena stove was imported to Saharan Africa where wood was scarce and ambient heat a negative, the new stoves were simply not used. Another failure was an attempt in Mexico to use solar heat for cooking by focusing the sun on the cooking pot: women were expected to stand in the sun during cooking. However, solar boxes, designed for slow cooking, could be left unattended throughout the day and have been widely adopted.

Micro-hydro generators enabled the expansion of rice mills, and also provided electricity in remote areas. These small generators could be taken out of streams when heavy rains fell. Still they produced enough power for local use and did not require the building of a dam. Lighting in these rural areas not only promoted education by allowing students to read and write at night, but also data show a drop in births. Refrigeration helped with the preservation of food and also of vaccines and other medicine.

Biogas digesters promised both electricity and cleaner villages. In India, women had traditionally used cow dung in cooking. Dung was added to human waste and processed in biogas digesters to produce methane for cooking. China's version of this technique utilized pig waste that had previously been spread on crops as fertilizer. The chemical process killed most of the germs improving the health of the villagers. Both countries subsidized biogas throughout their rural

1 "New Technologies for Food-Related Activities: An Equity Strategy," paper read at the AAAS meeting, Houston, January 1979; in Women and Technological Change in Developing Countries, eds. Roslyn Dauber and Melinda Cain. Denver: Westview Press for the AAAS, 1980. Summarized in Development Digest, Vol. XX, No. 1, Jan., 1982.

"Issues of Women, Energy, and Appropriate Technologies in Developing Countries," paper read at the International Association for the Advancement of Appropriate Technologies for Developing Countries, Denver, Dec. 1980; in Agriculture, Rural Energy, and Development, ed. R. S. Ganapathy, Ann Arbor: University of Michigan, 1981.

areas. Unfortunately, for a successful conversion to methane, input to the digesters should remain constant, hard to do with the seasonal intake of food by animals or humans. Today mostly large towns in developing countries and cities in the US use the system, primarily to treat sewage.

Because literature about women's use of energy was minimal, I was invited to a variety of preparatory meetings to the UN Conference and New and Renewable Sources of Energy in Nairobi in 1981. These workshops were sponsored by the UN, the National Academy of Science, and by Bellagio.[1] At the UN Conference, I met many of the authos of the articles I had used in my papers. The following year, I was invited to present my views at a post conference Global Experts Meeting in Vienna in 1982.[2]

Papers that I presented at these meetings utilized time-budget studies to insert human energy into the debate. Over a decade, I had documented both the failed and successful technologies, and emphasized the intended and unintended impacts these innovations had had on women. A set of six action-research studies from South and Southeast Asia deserves particular mention. *Rural Energy to Meet Development Needs* provided me with excellent details for my argument that many innovations actually added to women's drudgery.[3] My final article on this topic, *The Real Rural Energy Crisis: Women's Time*, was published widely in short and long versions.[4]

In Bangkok in 1983, EPOC convened a workshop on Uniformity of Information Reporting on Biomethanation Standards, which was co-sponsored by UN Economic and Social Council for Asia and the Pacific and Commonwealth Science Council.[5] As rapporteur, I summarized the findings in the workshop report which

1 Department of Public Information, Non-Governmental Organizations Conference on Energy: Development and Survival, New York City, 1981. Member of panel on Energy and the Poor.
International Workshop on Non-Technical Obstacles to the Use of New Energies in Developing Countries, Bellagio, Italy, 1981.
 "Changing Energy Usage for Household and Subsistence Activities: Some Implications for Information Collection," presented at the National Academy of Sciences CIR/BOSTID Workshop on Energy Survey Methodologies, Jekyll Island, GA, Jan 1980. Reprinted in: Important for the Future, UNITAR, June, 1980.

2 Global Experts Meeting on Women and the International Development Strategy, Vienna, 1982. Expert/presenter on Women, Energy, and Development.

3 Rural Energy to Meet Development Needs: Asian Village Approaches. M. Nural Islam, Richard Morse, & N. Hadi Soesastro, editors. 1984, Boulder CO: Westview Press. My book review appeared in *The Journal of Asian Studies.*

4 "The Real Rural Energy Crisis: Women's Time", The Energy Journal 8/87:125-146. 1987. Longer version originally prepared in 1984 for IDRC through the Equity Policy Center; circulated by ILO, and published in Ashok V. Desai, ed., Human Energy, Wiley Eastern, New Delhi, 1990.

5 Workshop on Uniformity of Information Reporting on Biomethanation Standards, convened by EPOC,co-sponsored by UN Economic and Social Council for Asia and the Pacific and Commonwealth Science Council, Bangkok, 1983. Rapporteur. EPOC expert for the conference was Norman L. Brown

illustrated the influence that different countries had on the development of biogas. I utilized this material in my paper for "The Political Context of Rural Energy Programs" presented in Stockholm as part of a UN Group of Experts discussing the Role of New and Renewable Sources of Energy in Integrated Rural Systems.[1]

My involvement with women and rural energy began in 1980 and seemed to influence development policies. Thus I found it discouraging that the field seemed to stagnate when I attended a conference in Dakar in 1995 – fifteen years later. Few new approaches for providing rural energy were presented by any of the international participants.[2]

REFORESTATION

Another strategy to improve women's processing and cooking of food was to plant fast growing bushes and trees to provide the needed fuelwood closer to home. Belated recognition that "the useless bush" in the Sahelian region of Africa provided fuelwood in places where trees were scarce and that women used leaves and seeds for medicinal purposes finally changed the attitude that all land must be turned into farms. In Vietnam, the forests in remote areas provide income for women collecting leaves and herbs for Chinese medicine.

In countries with existing forests such as Nepal, programs were designed to increase biofuels through forestry management, often planting fast growing species interspaced between newly planted trees. Because women mostly utilized the mountain forests in Nepal, some agencies promoted women's committees as managers or the forest, overlooking the heavy workload the women already had. I wrote about my concerns that this approach was setting women up for failure.[3] Published in a professional journal whose articles are peer reviewed by experts in forestry, I utilized data from a wide variety of disciplines to show the relevance to women. The article was subsequently republished in a collection on *Gender and Natural Resources.*

1 "The Political Context of Rural Energy Programs," in M.R. Bhagavan & S. Karekezi, eds., Energy for Rural Development. Zed Press for SAREC (Swedish Agency for Research Cooperation with Developing Countries), 1992

2 "New look at energy" in Women and Global Energy Policy: New Directions for Policy Research, IFIAS [International Federation of Institutes for Advanced Studies], Fall, 1995I

3 "Women, Donors, and Community Forestry in Nepal: Expectations and Realities," Society and Natural Resources, 7/4. 1994. Reprinted in **Gender and Natural Resources**, edited by Carolyn Sachs, 1997. NY: Taylor and Francis.

WOMEN'S ROLES ON NORTH AMERICAN FARMS

Women's roles on North American farms was the topic of a seminar convened by EPOC July 7-9, 1982, at the Wingspread Conference Center in Racine, Wisconsin. The seminar was the first in a series of such meetings to be held around the world, to discuss Women, Farming and Modernization. While women's productive roles on farms in developing countries are by now widely recognized, this activity is still often seen as an indication of under-development, one that will disappear with modernization. The purpose of EPOC's seminar series is to make visible the continued, often growing, number of jobs which women do on and around the farm and so contradict the myth that women play no part in modern agriculture.

The seminar was unique in bringing working farm women together with scholars, extension workers, and staff from the U.S. Department of Agriculture. The twenty-five participants discussed the importance of the roles played by the 3.1 million women living on North American farms (calculated at 2.9 million for U.S. and 200,000 for Canada). Participants brought with them a wide range of concerns, experiences and perspectives. The farm women came from both commercial and small farm backgrounds - some working alongside their husbands in all facets of the farm operation, others specialize in specific farm tasks such as bookkeeping and management, while still others carry out the majority of the farm operation on their own. As an alternative or an additional job, many of these farm women hold outside employment to keep their families eating and farms solvent. And of course, these women also have the primary responsibility for the care of their families.

The personal experiences of these farm women were intermixed with the extensive knowledge of the scholars, the Department of Agriculture employees and the extension workers. These women and men draw expertise from national level census and survey data collection and analysis, from regional interviews with farm women, and from years of experience with agricultural economics in international development work.

Each participant gave an individual presentation as part of a panel and was actively involved in the ensuing discussions. The panels focused on:

- the relationship between agricultural development theory and North American agriculture:

- the position of women in North American agriculture and changes in that position over time: **variations in the position of farm women as related to geography, commodity and farm size:
- rural change and strategies for household survival, particularly the growing importance of off-farm income;
- the availability of appropriate support services for farm women.

Once the substantive information has been presented and discussed, four working groups were formed to identify specific issues and make recommendations for action around the following themes:

- The economic and social implications of current changes in the structure and organization of agriculture.
- The impact of farm women's growing participation in community and women's organizations.
- Improving the education and extension services offered by U.S. land grant universities.
- Identifying critical research gaps and increasing the availability of information on North American farm women.

The contrast between agricultural development theory, which assumes that with modernization comes a decline in the importance of agricultural roles played by women, and the recent indicators of the critical roles women play in North American agriculture laid the foundation for the seminar discussions. Women have not left the fields and taken on a life of leisure, as is too often implied in the literature and accepted by policy makers, but continue to work both on the farm and in off-farm employment. A major policy implication of women's continued importance on modern family farms is clear: countries with a strong female workforce should invest in the education of these farmers and in the upgrading of their farm resources.

In recognition of the fact that the lack of available data perpetuates the invisibility of farm women, discussion focused on the difficulties of enumerating farm women and of classifying their agricultural labor. For the first time in 1978, the U/S. Agricultural Census recorded the sex of farm operator and found that 5% of the farms were operated by women. While useful, this figure does not consider the majority of women who are involved in farming but who would not be recorded as the single farm operator. Seminar participants recommended that the U.S. Agricultural census be altered to allow for the designation of multiple operators, or farm partners.

This question of classification is not simply a statistical problem which makes for difficult analysis of the position of farm women, but it is also an issue of self concept. It was not easy even for the farm women in the group to define their roles. Are the farmers? Farm partners? Co-managers? Or, farm helpers? A seminar work group

suggested that exploration of these questions by farm women in women's organizations could help farm women feel confident in their agricultural roles, however defined.

Despite the limitations of available data, panel discussions reviewed what is known about the position of farm women on both small, but growing, number of highly specialized commercial farms and on the declining number of diversified family farms. Active farm women are found on all types of farms, but the role which they play vary considerably by commodity, region and size of farm operation. While farm women involved in large commercial farms often specialize on managerial tasks and community activities, women's roles on small family farms reflect the diversity of the enterprises themselves, and often include such tasks as caring for livestock, raising vegetables, and marketing product as well as supplementing farm income with off-farm jobs. Because of the limited access these small enterprises have to either labor or capital, farm women's contributions are seen as particularly important. Women also appear to be playing an important role in the growing areas of vertically integrated agricultural production where management responsibility lies largely outside the farm operation. For example, it is often women who receive the shipments of young chicks from the poultry companies and are responsible for the care of the birds for the few weeks before they are once

again picked up by the poultry companies for slaughter and sale.

While it is shown that women play critical roles in the overall survival strategies of most farm households, the specific strategies adopted are closely tied to available resources, including crop land, unpaid family labor, and capital. Some of the differences in the roles and the interests of farm women based on farm size and value of agricultural enterprises were represented amongst the seminar participants. Yet, regardless of women's specific tasks, these and other farm women remain the focus of the interaction between the farm business and the farm household. Not surprisingly, a major determinant of farm women's involvement in the farm operation is their age and the presence or absence of children.

One manifestation of women's invisibility in modern agriculture is the continued separation of home economics services which are oriented towards women and agricultural services which are predominantly directed towards men. Seminar participants recommended that the provision of extension services further integrate the areas of home economics and agricultural production in recognition of the fact that women are involved in both. A similar isolation of women from agricultural information has traditionally existed in university education. Despite the growing number of women enrolled in agricultural programs, participants felt that the land grant universities have been slow to adopt programs to suit

women's needs and should be encouraged to do so.

The findings of the seminar leave us with no doubt about the critical roles which women play in North American agriculture, particularly on small family farms. These women's future is problematic, as is the very existence of small family farms. And will be greatly influenced by agricultural trends and governmental pricing policies. Farm women have begun organizing to both draw greater attention to their own roles and needs, and to lobby on behalf of their family farms. Their issues, their farm work and their organizational activities all deserve wider recognition. Materials from the seminar will be published in a variety of forms to reach various communities which should know about the current position for farm women, including: universities, planners, government bureaucrats, and women's organizations.

WOMEN IN AFRICAN DEVELOPMENT (INCLUDING CITATION FROM RURAL SOCIOLOGY)

AWARD FOR DISTINGUISHED SERVICE TO RURAL LIFE; JAMES J. ZUICHES, CORNELL UNIVERSITY

Reading the materials submitted for the nomination of Irene Tinker for the Distinguished Service to Rural Life Award was both a pleasure and an education. Our honoree has spent her entire career focusing on the key issues of rural development in developing countries. She is being recognized for the excellence and breadth of her research, policy, and program-development efforts targeted to rural women in developing countries. The issues she has addressed—the role of women in development, women and agricultural production, population, family planning and health, fuelwood and energy, appropriate technology, food processing and marketing, and equity issues associated with each topic—all are of intrinsic interest to rural sociologists in this country and around the world.

Tinker's career has included academic appointments as a faculty member and university administrator, independent consultant, staff officer in the American Association for the Advancement of Science (AAAS),

administrator in a federal agency, and founder and director of the Equity Policy Center, her own research- and action-oriented nonprofit organization. The primary goal of the Equity Policy Center is to identify the need for and to promote policies and programs aimed at ameliorating the position of the world's most vulnerable populations, focusing particularly on the women among them. Thisgoal is accomplished by emphasizing a sectoral approach to household and rural energy, food production and consumption, and analysis of the differential impact of policies on women and men.

She has had a career as a catalyst, bringing people together to attack a new or continuing problem and galvanizing them to action. She has been an organizer and institution builder when the need has been apparent. Her legacy is impressive—first president of the Federation of Organizations of Professional Women and co-founder of the Wellesley Center for Research on Women, of the Washington Women's Network, and of the International Center for Research on Women. As an active professional, she has served on the panel on agriculture for the National Academy of Science, as judge for the Mitchell Prize, and a participant

in United Nations conferences, work-shops, and commissions on energy, women and development, and science and technology for development .

After she received her Ph.D. from the London School of Economics, most of her work over the past 30 years has had a clear and direct effect on the lives of rural people. In the early 1970s, Tinker orchestrated the AAAS study and volume on *Culture and Population Change*. In 1975, she organized a seminar on Women in Development in Mexico City. In 1982, she organized the first in a series of international conferences on the changing roles of women and men in agriculture. In 1980, her center organized a symposium on "Health Needs of the World's Poor Women." These programs and efforts would be defined as purely academic if it were not so apparent that a program of public-policy recommendations and political action was derived from the conferences, research, and publications.

Tinker was personally instrumental in bringing about recognition by the U.S. government of the importance of the role of women in the development process in its foreign-assistance programs. Her primary work in this field led to her close cooperation with congressional leaders concerned with the direction of our foreign-assistance activities, and she is uniquely responsible for the "Percy Amendment" to the Foreign Assistance Act of 1973. This provision of the law directed the Agency for International Development (AID) to consider both the impact of development-assistance programs on women and the participation of women in the development process. Further, it directed the creation of a separate office charged with responsibility in these areas; that office took for its name "Women in Development," the term Tinker used to characterize her concerns. That phrase has become a part of AID's planning and programming process—as well as in the development community as a whole—and Women in Development or "WID" concerns are now common mandatory subjects to be addressed in all of Jars development-assistance projects.

There have been three significant developments in the evolution of our foreign-assistance programs. First was the "New Directions" mandate that focused AID's attention on benefits to the rural poor. Second was the recognition that development assistance must be designed with a concern for environmental protection and improvement if it is going to have a lasting beneficial impact. The third was the recognition of the importance of "Women in Development" concerns. It this last development, largely the result of Tinker's sensitivity, persistence, and hard work, that made the first two developments meaningful by providing the context in which AID entered a period when it could hope to design successful projects that are environmentally sound and bring the maximum direct benefit to the rural poor—the majority of the people—of the third world.

The members of the Rural Sociological Society, your friends and colleagues,

are pleased and honored to be able to make this award to you, Irene Tinker, for your Distinguished Service to Rural Life both here and in developing countries.

WOMEN IN AFRICAN DEVELOPMENT: REMARKS ON ACCEPTING THE DISTINGUISHED SERVICE TO RURAL LIFE AWARD

First, let me express my appreciation at being honored here today. It seems most fitting that you should select a woman this year as the UN Decade for Women draws to a close. It is even more fitting that we should consider the role of rural women in the world today, for rural women still are the majority around the world.

The Importance of Cross-national Comparisons

Although the focus of my talk today is international, I cannot stress enough the importance of drawing parallels between developed and developing countries whenever possible. Remember that the United States is still the primary model—the vision of the future—for much of the rest of the world. Unfortunately, that model as used in less developed countries is often decades out of date, frequently based on an interpretation of this country taught to present leaders of those countries when they were students here in the fifties. Consider how many new interpretations of U.S. society you are discussing

at your annual meeting. Most of the topics have direct international applications—the invisibility of female farmers, the importance of off-farm income earned by all members to the survival of the family farm, the role of cooperative extension and community organizations in conveying information, adoption of innovations, issues of energy use and new technology, the impact of migration on rural areas. It is essential that your findings and hesitations be communicated to designers and implementors of international assistance. Many of you are already doing this. One notable effort has been the establishment of the Center for Rural Women at Pennsylvania State University that combines the study of women in rural portions of that state with the study of women worldwide. The farming-systems project at Kansas State and the University of Florida is concerned with identifying the constraints of different farming systems here and abroad.

The Equity Policy Center (EPOC) tries to draw such comparisons in all its projects. Our International Symposium on Women and Their Health brought together women and men concerned with the delivery of primary health care among the poor in Appalachia as well as Ghana and among women in the U.S. migrant stream as well as Afgan women refugees. One result was a set of meetings at the World Health Organization to give greater attention to the health needs of poor women and to the role of poor women in providing health care for their families and communities.

Similarly, the EPOC seminar on the Changing Roles of Women and Men in North American Agriculture prompted the International Association of Agricultural Economists to add a working group on women at all subsequent triennial meetings.

By identifying the importance of foods eaten outside the home to the diets of people in developing countries, our Street Foods project has resulted in the Food and Agriculture Organization (FAO) changing the way it conducts nutrition surveys; by documenting the adequate income of street-food vendors and the employment absorption of this activity, municipal authorities have been forced to reconsider their current policies of harassment and eradication; and by illustrating the linkages with small-scale food production and processing, our findings have altered farm projects in several countries. Indeed, EPOCs primary concern is to show how activities of women are central to family survival worldwide and thus encourage development planners to include their interests in all programs.

The International Women's Movement

The growing acceptance of these efforts reflects an altered worldview symbolized by the UN Conference to Review and Appraise the Achievements of the United Nations Decade for Women that was held last month in Nairobi. I was pleased to be one of some 10,000 women who joined with 2,000 women

of Kenya to celebrate the growing strength of the international women's movement. Two factors stand out that indicate this strength. First is the political victory of women. Unlike the two previous women's conferences in Mexico in 1975 and Denmark in 1980, women delegates prevailed over their male colleagues and foreign-affairs ministers to pass by consensus a feminist vision of the role of women in the year 2000. The United States accepted such widely diverse statements as those that link violence in the home with violence in the world, deplore the arms race, or urge comparable pay for work of comparable worth.

Second, there has been the amazing coverage of the conferences in the media. Over 1,400 press passes were issued. Compare that with the daily coverage of the General Assembly when it is meeting in New York. Some women complained about the types of stories. Of course, U.S. media reported ad naseum about a few American women adept at handling the press and so overlooked the hundreds of women leaders from all corners of the globe. And it was unfortunate that the major story for days dealt with the hotel crisis. Nonetheless, the conference and the forum were covered! Editors clearly understood that there was an audience of women and men who wanted to hear about the debates in Nairobi— and there were many newswomen who themselves wanted to attend.

Much has changed since the UN Conference for Women in Mexico in

1975. At that time, if you'd mention women to a development planner, his eyes would glaze over. "Exporting women's lib!" they would laugh. "No," we would reply, "we are trying not to export male chauvinism." Such was the level of our discourse. Now, 10 years later, we have facts and figures to support our basic argument that development tends to have an adverse impact on the lives of poor women—both rural and urban. The major cause of this negative impact was the tendency of development planners to ignore the economic roles that women play in near-subsistence economies; as a result, women's food producing and processing activities have been undermined or bypassed, though her family support responsibilities remain the same. Development programs have tended to focus on men and to be based on the assumption that the household is a cohesive unit in which all members work for the best interests of all. More income to the man would thus help all members of the household; thus, it does not matter if the woman's economic activities are undercut. Indeed, some planners have argued that a measure of development is when women no longer have to work in the fields—a fine statement if alternative income opportunities are provided, but hardly realistic under most circumstances in rural areas of the developing world.

Today, as a result of many careful time-budget studies, we know that women everywhere work longer hours than men —10-12 hours per day of economic work for women compared with 6-8 hours per day for men. Further, studies show that as soon as cash crops are introduced, men's workdays decrease while their personal income goes up. In contrast, women work even longer hours and support their children with even less help from the men than before. Data support the observation that women spend almost all of their income on their families while men buy drinks and second wives with theirs.

Agriculturalists know that women provide 45% of the world's agricultural labor and grow a majority of the world's food crops. Environmentalists appreciate the fact that women tend and harvest trees, utilize fuel carefully as they cook meals, and adopt new cookstoves only if they save both time and fuel. UNICEF has discovered that training women to repair water pumps is the best way to ensure their continued functioning, for it is the women who supply water to their households. It is impossible today to listen to a major speech concerning development whether in the UN or the World Bank or in academic circles without some recognition of the need to consider women in the design and implementation of development programs. It is a bit like the media at Nairobi. I am awfully glad that they were there, but when will they take the subject seriously?

Intergrating Women in Planning

Consider the current African crisis. Earlier this year, the FAO listed 24 countries in Africa—the entire Sahelian area

and most countries to the south—that were suffering famine conditions and facing catastrophic food shortages. The hearts and vocal chords of the north have been touched, and more aid than can be handled has been flowing in. Development efforts have been washed away in the floods. Good intentions of governmental officials to alter the price inequities that keep local food costs down to please the urban citizens of all classes are being swept away by the current abundance of imported food.

Any observer of the African scene knows these dismal facts. By attempting to go beyond the symptoms and treat the disease, the World Bank and other assistance agencies are putting great pressure on governments for new price structures that give incentives to farmers. Many agencies are funding training for women agricultural extension workers, recognizing that women are the farmers who grow food. And the agricultural research centers that spawned the Green Revolution are preparing new "packages" of improved seeds and fertilizers for distribution in Africa. The optimist argues that in two or three decades Africa will be producing surpluses of food just as Europe and North America are doing today. After all, in the midst of famines in Asia in the 1950s, who would have expected India to be nearly self-sufficient in grain today? But it won't happen. The solutions are to the wrong problem.

Future Scenarios

These solutions are based on a series of assumptions that generally fit Asia but do not fit Africa. For example, one assumption is that the land belongs to the tiller. Conventional wisdom supports the belief that tenants are unwilling to invest in land they do not control. Yet women are essentially tenants on their husband's lands and can be dispossessed by divorce or by the death of their husband. Traditionally, women could return to land controlled by their lineage. But with increasing land pressure and the privatization of landholdings, such is no longer the case.

Another assumption is that increasing the price of agricultural produce will increase the production. Two problems here concern who gets paid and who has the time to work harder. Encouraged by development agencies, African governments have invested in cooperatives as a method of increasing agricultural production. Some countries use these coops as buying mechanisms to maintain low prices—and thus discourage production. But whether the price is low or high, the payment almost everywhere goes to the owner of the land, not to the tiller. When coffee coops were first introduced in Kenya, production fell instead of increasing as projected. It took a female anthropologist to instruct the government in the reality of the situation. Women had received the payment for coffee directly from the marketing boards, the coop sent the money to their husbands, who were often working in Nairobi and

who easily found uses for the funds other than supporting the country wife and children. Today, coops take out school fees before sending the remaining money to the men. Even when the woman receives money for crops she sells, increased production implies more time spent growing the food. Where is a woman who already works 12 hours a day to find more hours? Data show that women in many countries stop cooking meals during planting and harvesting because they have no time to prepare the food and collect the fuel-wood, much less to cook. And if food crops become cash crops, will women be forced to work on the cash-crop fields belonging to the husband to the detriment of her own food-crop fields?

Given the realities of the African scene, what are the possible solutions to the African food crisis? Would it be "land to the tiller?" For years, this was the rallying cry of Americans concerned with development overseas. To our present government, it surely sounds socialist, for to them private ownership is supreme. Feminists argue that women should have rights in the land they till. Emotionally and ideologically, I agree. But this is probably unrealistic, considering the vast amounts of land involved. First, would the male governments in Africa want or dare to pass such legislation? And if they did, is this really the best solution for African women? Already they do a majority of the work. If they owned the land, would the men work at all? Would the solution be to "get the men back on the farm—after they've seen Nairobi?" The World Bank says that the urban to rural wage differential is 8 to 1. Could the government reverse that? And if they did, would these macho males return to female work on the farm? And if they really did return, what happens to the women? Who will pay the school fees?

So what is the solution? Perhaps it involves some middle path that combines medium-scale commercial farms—where all agricultural laborers, male and female, received equal pay—with the small-scale farm plots owned and utilized by women. Would this mid-solution work? How would you get there from here? Are there other realistic possibilities? I'm sure that there are, but no one is thinking about them. They are treating the symptoms of the disease and not concerning themselves with the real underlying causes of the problem. Until development planners and academics grapple with this fundamental fact of African agriculture—*who are the farmers?*—will they be unable to answer such basic questions about programming as who benefits from current programs, who will get the income from increased prices for agricultural produce, or what will be the impact of these programs on agriculture in the year 2000 on families, on women, and on men.

Without answers to these questions and without understanding the probably unintended impact of new programs, the problem of African agriculture will not be solved. I propose that one of the leading agricultural universities

in this country convene a small task force charged with imaging the form of African agriculture in the year 2000. Utilizing computerized projections, they could compare current policies and alternative solutions as to their probable impact on future production patterns and on the farmers. Only by stimulating thinking that encompasses the multifold complexities of the problem is it like to be solved. It is obvious that women as African farmers hold the key to the future of African agriculture. When will the planners, the scholars, and the media discover this lightly veiled secret and begin planning for a more equitable future for African women and men?

NEW TECHNOLOGIES FOR FOOD RELATED ACTIVITIES: AN EQUITY STRATEGY

THE WORLD'S FOOD SUPPLY HAS BECOME a topic of international diplomacy. The 1974 World Food Conference in Rome focussed attention on the increased demand of the growing world population for food resources. Generally optimism prevails about the ability of the scientific establishment to respond to the food crisis with new technologies capable of keeping food production ahead of consumption. The National Reseach Council's 1977 *World Food and Nutrition Study* states that "The most important requirement for the alleviation of malnutrition is for the developing countries to double their own food production by the end of the century. We are convinced that this can be done given the political will in the developing and higher-income countries."

The basic strategy for rapid agricultural development, as outlined in the Rockefeller Foundation study, *To Feed This World*, is to increase both productivity and farmer's income. "Each agricultural development effort should have income generation through increased productivity as a primary objective." The importance of income in formerly subsistence economies increases as more and more crops and services become part of the monetary economy. It is widely recognized that increasing

production is only part of the solution to world hunger; it is also necessary to reduce extreme poverty so that the hungry are able to buy food.

Since the greatest concentration of poverty is in developing countries among the rural people with little or no access to land, this has meant fostering rural enterprise and job creation, both on and off the farm. More recently, a third strategy has been added to the effort to alleviate world hunger and malnutrition: the reduction of postharvest food loss. Conservative estimates indicate that 10 percent of durable crops such as cereal grains and legumes are lost between harvest and consumption; a comparable figure for nongrain staples such as yams or cassava, and for other perishables including fish, would be 20 percent or more. Technology to improve the storage, processing, and preservation of various foodstuffs should be able to reduce losses by 50 percent, automatically increasing available food on the world market by 10 percent.

These three strategies – increasing production, improving income-generation, and reducing postharvest food losses – are widely accepted among development planners as ways to address the world food crisis. All three strategies start from the premise of meeting

the basic human needs of the world's poor. *Yet nowhere do they acknowledge the fact that women provide over half the agricultural labor in developing countries, or that they do most of the postharvest food processing and preservation.*

BIASES IN ECONOMIC DEVELOPMENT THEORY

Two unexamined biases in contemporary economic development theory impede the inclusion of women as equal partners in development. The first is the continued perception of dichotomies between the modern and the traditional sectors, between the economic activities done for money and those done as volunteer or citizen, between productive work and welfare activities. Statistics still tend to reflect only activities in the modern monetary economy; other activities are not considered productive, and hence not work. Clearly the role of an economic development planner is to modernize the country, to improve the agricultural sector through crop specialization, improved marketing facilities, and mechanization. An increase in the Gross National Product, it was argued for years, would trickle down to bring a higher standard of living for everyone. Now the argument includes income-generation at the bottom as well, but the basic tenets of the theory go unquestioned.

The second bias, related to the first, holds that women don't "work", or if they do, they shouldn't; keeping women dependent on men is a boon to the male ego. Thus a 1977 draft of an AID agricultural policy paper suggested that one measure of development would be the reduction of the number of women working in the fields. Almost anyone, male or female would prefer less arduous work than weeding or harvesting in the hot sun, but only if alternative family income were available, either through new jobs for women or the doubling of men's income—neither of which the policy's plan in fact offered. Its statement clearly reflected a bias, in seeing women's only suitable occupation as the caring—"non-economically"—husband and children.

Economic Activity in the Informal Sector

These two biases have skewed development for both poor men and women. First, statistical collection limited to the modern sector has obscured all activity in the informal sector. Thus planners for Africa receive data indicating that only 5 percent of women work. It is too easy to forget that this figure applies only to the modern sector and then neglect, for planning purposes, the fact that women do 60 to 80 percent of the agricultural labor in Africa, and also dominate the marketing and processing of agricultural produce.

Men, too, find employment in the informal sector. This kind of economic activity long appeared, for men at least, as a transitional phase. Post-industrial societies are not supposed to have an informal sector. It took the National

Institute of Mental Health to recognize the existence of an "irregular economy" in the United States, and to fund studies of the so-called "economic terra incognito." The institute's 1977 study concluded that the "irregular economy arises from a lack of institutional response to a misallocation of goods and services, i.e., to a failure of the distribution and pricing systems to adjust and serve areas of unmet needs."

These comments clearly beg the question "what is work?" Kathleen Newland's *The Sisterhood of Man* (1977) shows how different countries define which activities are included in national income accounts. She describes the long work days of Iranian nomad women who, in addition to the care and feeling of the family, "haul water into the camp on their backs. They milk and shear the animals, mostly sheep and goats. They collect such edible plants, berries, roots and fungi as the surroundings afford. They churn butter, make cheese and yogurt, and refine the leftover whey into the daily beverage. They spin the wool and goat hair into thread or press it into felt and make clothes, tent cloths, and carpets for their families' use. From each tent-household of an extended family a woman goes daily to collect firewood from the brush; on the average, she spends half a day at the task, plus another hour at the camp breaking the torn-off branches of thorn-bush into pieces small enough for the cooking fire."

In the national economic account of Iran...the only portion of the nomad woman's *work that will show up even as subsistence production is her output of woolen textiles and dairy products. If she lived in the Congo Republic instead of Iran, the accountants would also include her food-processing activities in calculating the Gross Domestic Product, but they would omit her protuctionof handicrafted articles. Taiwan's bookkeepers also would leave out handicrafts; they would, however, assign economic value to the woman's water carrying and wood gathering. But in Nigeria, it would be argued that, in rural areas, wood and water are free goods, like air, and so are the human efforts that make them usefu. (pp.129-130.)*

The inconsistencies of the present method of income accounting is increasingly apparent in the United States. With the rise of two-income families, nearly half of the food consumed in America is eaten outside the home. Suddenly the task of feeding the family has been moved from an invisible category to economic activity. Many of the services to the sick and infirm which were formerly undertaken by compassionate volunteers, predominantly women, must now be paid for. While many women as well as men are dismayed by the decline in volunteerism, no one should be surprised. Money is the measure of success and status in the United States; nonproductive activities are viewed as peripheral and marginal—at least until they begin to disappear.

Women's Contributions to Family Survival

Assumptions about women's roles have

neglected the importance of their economic activity to family survival. Poor families especially depend on women's contributions. In Java, women from landless and near-landless families earn one-third of their households' total income, a much larger share than contributed by wives from larger landholding classes. In Mexico, women's contribution to family budgets varies by culture as well as class. Everywhere, women's responsibilities to their families often makes them more adaptable in crisis situations.

Particularly in Africa, gender norms in many societies expect a woman to use her own earnings to provide food, clothing and education for her children, as well as food for her husband. During the Sahelian trought, many observers noted that if a family's millet gruel contained only a single piece of meat, it went to the husband, who of course ate first. Peace Corps volunteers urged women to grind the meat so that some protein might be left for the children; they did not presume to suggest that men contribute money to buy food. As men's earnings have increased through cash crops or urban employment, they do not necessarily feel obligated to increase their share of child support. Recently a Kenyan woman sued her urban-based husband in District Court for their son's school fees. In defense, he claimed that he had given her a piece of land, but she was responsible for the care and schooling of the children. Surprisingly, the woman won the case, on the grounds that the land

plot was too small to generate enough income to cover the fees; besides, the husband was well-employed.

Because African women provide the bulk of family support, industries and plantations since the colonial period have been able to pay male workers sub-living wages. A recent UN report found this "functional relationship between the subsistence and the modern sector" in Lesotho brings in 95 percent of the country's cash earnings. At any given time, close to 40 percent of the working-age male population resides in South Africa, earning wages too low to support their families. Women's subsistence farming in their home village, then, is crucial to family survival.

Migrant labor patterns have clearly contributed to the increased numbers of women-headed households around the world. Economic development policies leaving women behind in the subsistence economy while pushing men into the modern sector encourage the disintegration of the family. Today women head between 25 and 33 percent of the world's households, due to divorce, death, desertion, long term migration, or because they never married. These female-headed households constitute the poorest group in every country.

WOMEN AND THE FOOD CRISIS

The three major strategies for addressing the world's food crisis: increased production, increased income-producing activities, and a reduction in

postharvest food losses, can also aid rural poor women. Women in Asia and Africa provide between 60 and 80 percent of agricultural labor; they produce 95 percent of the village food supply in Kenya. Indeed, poor rural women everywhere work in the fields, though they may deny doing so if it implies low status. Their role in processing, preserving, and preparing food is even greater. But modernization, by undermining many of their traditional occupations, has made it more difficult for them to grow or buy food for their families. For this reason, programs providing income-generating activities for women may improve health and food security more effectively similar activities aimed only at men.

In order for the food crisis strategies to succeed, women must not only be included in planning, they must be central to it. In particular, they must be consulted in the selection of new technologies, trained in their use, and given means to control those most related to their spheres of economic activity.

Below I will review the impact of current development policies and new technologies on women's work in the production, processing, preservation, and preparation of food, emphasizing positive change while noting cases where women's traditional activities have been undermined. I will argue that the low priority given to the promotion of these technologies is directly related to the two unexamined biases under discussion.

New Technologies and Women

Almost universally, new technologies for food-chain activities have been introduced to men, regardless of women's contributions. This tendency assumes that only men can understand and properly use "modern" technology, while poor and illiterate rural women would be unable to change their customary practices. Further, rural credit is scarce, and seldom extended to women because they lack collateral. Land is the primary rural asset, and colonial governments registered communal land in the man's name.

In other words, women's poor access to land, credit, and education prevents them from acquiring the new technologies which might help them out of the mire of poverty so that they could, in turn, improve their access to land, credit, and education. This vicious circle had intensified women's dependency on men in many rural areas and undoubtedly encourages urban migration. With fragile marriages the rule rather than the exception, women have little incentive to improve their use of land either for farming or fuel-gathering. Given their incredibly long workdays, poor rural women have almost no spare time to learn new processing or preservation techniques. Living at the margin, fearful that any change might make them unable to feed their families, women are rightly suspicious of new technology. Thus interventions must not only reduce their workloads, but must also

provide sufficient income to pay for the technology, and to compensate for any traditional women's occupations which it might make obsolete.

To date, most new farming technologies have hurt, not helped, poor rural women. Small food processing machines and new preservation techniques have had mixed effects. Technologies to reduce cooking fuel demands are only now being seriously considered as the environmental impact of current usage patterns becomes apparent. The provision of water for cooking and other household uses has taken second place to water for irrigation, despite the Water for Peace campaign in the 1960s, and the 1977 UN Water Conference agreements to provide universal access to clean water by 1990.

I will briefly discuss how technological changes at each stage of the the food chain—production, processing, preservation,and preparation—have affected women's work and well-being. As linked processes, successful intervention at one stage can trigger change in another. Often the vital spark comes from new access to credit, land, or training, frequently provided by women's networks or organizations. The final section will present strategies for increasing women's access to and control of new technologies, along with a discussion of delivery systems. Where possible I will note how the effects of technology on women vary along class lines in modernizing, increasingly stratified societies. I will focus, however, on rural poor women, recognizing that they too are not a homogeneous group. Thus while women generally have been bypassed by modernization and technological innovations, I wish to stress the importance of refining the target groups in all women's development projects.

Production

Women play a major role in most developing countries in all kinds of agriculture, from subsistence farming to local and export cash cropping to small animal and fish culture. Technological innovations have most transformed the production of cash crops such as bananas, cotton, pineapples, rubber, tea, coffee, sugar cane, peanuts, and sisal. While many of these crops are edible, they are seldom part of the local diet. Rather, they tend to compete for land and labor with food crops, which until recently have not received nearly the same levels of research attention. Only when wheat and rice became major commodities on the international market were there concerted efforts to improve production. The resulting "Green Revolution" has increased rice and wheat yields dramatically, but other major subsistence crops, such as yams and millet, have yet to respond to research efforts. The agricultural research community has largely ignored local commercial vegetable crops and small animal breeding, underscoring again the perceived dichotomy between the modern commercial sector and the traditional subsistence sector.

The impact of the new technologies

both on subsistence and cash crops varies both by and by farming system. Ester Boserup, in her landmark book on *Women's Role in Economic Development,* links women's status to the need female labor in subsistence farming or livestock care. Thus the spread of plow technology, which men adopted, helped undermine women's status historically. Similarly, the introduction of the sickle in Indonesia or new crops in the Sudan, by lowering women's utility, also lowered their status.

AFRICA

Modernization has had the greatest effects on women's status in Africa. In the past, women held fairly independent and equitable positions in both nomadic and agricultural communities. Such societies were not highly stratified. During the colonial period, women in agricultural societies felt the impact of technological development in industry and commercial farming primarily as a threat to their own access to land and labor for food production. This threat took different forms in different societies; in some men migrated to cities or mines to work; in some women had to take responsibility for both cash and food crops; in some land for food crops was converted to commercial use. The end result was to increase rural women's work while often undermining their status vis-a-vis men.

Women have continued to grow food, but must also seek money from other activities. Meanwhile, male urban migration has left more and more women responsible for running family farms on their own. Statistics show that one-third of farm managers in Africa south of the Sahara are women, with even higher percentages recorded in aame countries: 54 percent in Tanzania and 41 percent in Ghana. Algeria reported female participation in agriculture had more than doubled between 1966 and 1973. Yet agricultural extension services continue to ignore women.

In many parts of Africa, women must grow both food and cash crops with inadequate land and labor, in arrangements not just inequitable but inefficient. In Tanzanian agriculture, for example, the inefficiency arises from the fact that women. have limited access to information and land which would allow them to become more productive. This differential access is based on accepted social norms and customs. Similarly, the heavy work load already imposed on women often prevents them from adopting improved technology that requires additional labour inputs. Thus the present village and household organization of labour limits the potential for increasing production.

Where women work on the husbands' cash crops, they are often receive little if any compensation. It is no surprise, then, that whenever food and cash crops both need attention, women opt to work on the food crops. It is a different story when they have the opportunity to earn a decent income from cash crops. In the Gambia, where women in one scheme received the

proceeds from the sale of onions they grew, over 4,000 willingly participated. The scheme was so successful that men asked for assistance in planting this crop, and the government complied. The women, however, refused to work on their husbands' onion plots, though they continued to grow traditional crops on their husbands' land. Apparently the mens's onions withered.

Plantations

Plantations are less common in Africa than in Asia, but women on both continents have long provided cheap labor. On the coffee and tea plantations in Uganda and Kenya, however, pesticides have reduced the need for weeding—and thus women's labor—by as much as 85 percent. At the same time, government efforts to expand plantation production has consumed land previously used for women's subsistence farming. In Upper Volta, a foreign development scheme for swamp rice essentially turned the crop over to men through male extension agents working directly with men in the villages. In the Cameroons, women were forced off the cleared land near the village, which was subsequently replanted with coffee and cocoa plantations. Women then had to walk much farther to farm.

New settlements

New settlement schemes have had a particularly deleterious effect on women. In one Nigerian scheme, the

government provided five hectare plots for commercial soybean production. Corn could be grown for personal use, but amounts were limited by the availability of seeds. No garden land was provided, which left women without land to grow food (besides corn) as they had done before joining the resettlement program. Men received the cash crop income; women received no wages for their labor. Further, men's clearing and ploughing activities were mechanized, but not the women's planting, weeding and harvesting tasks.

In Kenya, the Mwea irrigated rice scheme did allocate garden plots to the women, but these were very small because it was assumed that rice from the irrigated plots would be added to the diet. Women in fact did receive some rice in return for their labor on husbands' land, but since the men refused to eat rice, women had to sell it and buy traditional food at increasingly high prices. The women did not have time, nor land, to raise enough food for their own consumption. Thus they worked longer hours than before but could not provide as much food for their families as before. In addition, they often had to buy cooking fuel since fuel was scarce in the resettlement area and they had too little time to collect it anyway. So while the total family income of the families on the scheme has risen, allowing some households to buy transistor radios and bicycles, nutritional levels have fallen.

In the Sudan, the Halfa Agricultural Scheme involved the settlement of the nomadic Shukriya, whose women

traditionally owned livestock and enjoyed rights to the milk of all the animals they tended. But on the scheme they have neither, nor rights to own land. Thus they can only earn money by picking cotton at very low wages.

Falling nutritional levels

The combination of rising family income and deteriorating nutrition found on the Mwea rice scheme is not uncommon. The primary reason for this seemingly contradictory phenomenon is the fact that men usually control this income, and often spend it on home improvements, consumer goods (i.e. radios), "prestige" feasts, or liquor and gambling. Meanwhile, while their wives lack money to buy food they can no longer raise.

A second reason for increasing nutritional problems lies in the marketing system. The fragmented nature of the present marketing system in Africa means that traditional subsistence crops are not always widely available. Perishable crops cannot be shipped any great distance due to inefficient transport. Staples in many rural areas are sold only by one merchant. Urban markets typically offer a greater variety of food, but rural women may not be able to afford either the foodstuffs themselves or the cost (in time and money) of getting to and from town.

Income-producing projects

While improvements in agricultural technology have on the whole not worked in favor of African women, there are signs of change. The Integrated Farming Pilot Project in Botswana, started in 1976 to help male farmers improve their dryland farming and livestock management techniques, has recently expanded its program to include 100 women. Week-long courses will stress vegetable gardening and poultry-keeping. Further, agricultural extension agents will organize special field days to demonstrate new techniques to women. Peace Corps volunteers have made scattered attempts to encourage the raising of bees, poultry, and rabbits, but most have not generated much local interest.

Peace Corps fishery initiatives have had a more lasting impact, particularly in Northwest Cameroons. Because fish-raising is a new activity in much of interior Africa, customary gender norms do not define it as only appropriate for men. However, only since 1978 have any of the "fish"volunteers been women. In one Zaire project, men dig the fish ponds and women carry the agricultural and animal wastes used as fish food. In six months there can be as high as a two hundred return! For now, the fish are sold and eaten so quickly that preservation is not a problem, but marketing needs immediate attention if production is to expand. Fishery projects will likely have the greatest nutritional benefits if women are assured income from marketing as well as production.

The most successful African program for income-producing gartering

and pigs is in Kenya. Its growth seemed almost spontaneous. While the government is now assisting in marketing, they played very little role earlier. It is instructive that the women expanded their gardens and small animals once they had time to do so. Every study of African women speaks about their overwork. How can women so close to survival dare to stop doing any one of the daily chores that keeps her family alive?

The *mabati* movement in Kenya gave women time. Tin roofs mean that rainwater can be saved and stored, releasing women from the daily chore of fetching water, a chore that takes two to ten hours per household. The women used the traditional rotating credit societies to accumulate cash to buy the tin roofs. Each woman puts so much money in a communal pot; each woman wins the pot in turn when her name is drawn by lot. With the time saved by available rainwater, and often with cash earned by selling some of the water, the women increased their production of vegetables, chickens, and pigs for sale in the urban markets.

This project would seem to corroborate the assumption that the major stumbling block for increased production of food among African women is their present time overload. Yet population pressures have meant that both water and fuel are harder to find, so that the time women spend in the traditional support for the family is increasing. Children can help the mother in these tasks. Thus concern for improved water and energy supplies not only would release women for more productive activity, but would also alter the present incentives for large families.

ASIA

The Green Revolution, while increasing the food supply, has also tended to increase unemployment and contribute to stratification in rural areas. More recent studies have disaggregated the impact on women and on men. In India, the overall impact has been a reduction of employment opportunities for women, a trend reported in the Census of 1951. A study in Punjab, India, noted that while displaced men were given an opportunity to take the training necessary to operate new machinery, women were left to work on the increasingly scarce unskilled jobs. The report continues that this "pauperisation caused by the disappearance of their traditional avenues of employment" has pushed many poor women into the cities. Nutritional levels are so low among landless women that they lose twice as many children as women from landed households. Children that survive are malnourished, with the worst cases observed among female children.

Such poverty has made plantation work attractive to many poor Indian families, both in India and in neighboring countries. On tea plantations in India and Sri Lanka, women make up over half the labor force; on Indian and Malaysian coffee estates, they make up 44 percent of the labor force, while their participation in rubber estates is

only somewhat less. A major reason for this growing female labor force is the wage differentials between males and females: women are paid about 80 percent of male wages for the same work. As production costs rise there is greater incentive to utilize new labor-saving technologies and to increase the percentage of women being paid reduced wages in the labor force.

The differential impact of the green revolution on women of different classes has also been noted in Indonesia, where the intensive farming system has traditionally supported a more equitable society than the plough farming system of South Asia. The new high-yielding varieties of rice have triggered a change in the traditional harvesting patterns. Because of the high investment in the new varieties, particularly in fertilizer, landlords wanted an increased return from the crop. Further, population increase has multiplied the number of harvesters, who are traditionally women. Women use a small knife, the *ani-ani*, for cutting individual stalks of rice. Leaning from the waist, the women might leave as much as 10 percent of the rice in the fields—a practice which provides a sort of social security for the poorest in the village. The harvesters divide the rice stalks, not evenly, but rather by levels of obligation which may reflect class. Between 12 and 15 percent of the crop goes to the harvesters under this system. Thus traditional harvesting patterns mean that the available rice is only about three-fourths of the rice in the fields.

The new harvesting pattern involves a new technology: a hand sickle. Gangs of men are hired by a middle-man to complete the harvest; with the sickle, little rice is left in the field. Further, the men are paid by weight rather than by rice stalks. Total "cost" of the harvest is therefore only between 6 and 8 percent of the rice in the field. This change in harvest practices automatically showed an increase in rice production, has drastically reduced female labor, especially among the landless, and has effectively abolished the gleaned rice for the poorest.

Population pressures and technological change have also reduced work opportunities for the poor males, thus increasing the importance to family survival of female income from trade and handicrafts. It is men, in fact, who have a smaller set of viable alternatives to agricultural labor. Women are, in a sense, better equipped to deal with the situation of increasing landlessness and can manipulate a more familiar set of limited options.

The multiple strategies which poor rural families use for survival can be illustrated with two cases from the wet zone of Sri Lanka. One household with 13 members had seven sources of income: (1) operation of 0.4 acres of paddy land by the adults, (2) casual labor and road construction by the head and eldest son, (3) labor in a rubber sheet factory by the second son, (4) toddy tapping ant jaggery making by the head and his wife, (5) seasonal migration to the dry zone as agricultural labor by the wife, eldest

son and daughter, (6) mat weaving by the wife and daughter, and (7) carpentry and masonry work by the head and eldest son.

Another household with 11 members had six sources of income, mostly agricultural: (1) a home-garden by the family, (2) a one acre highland plot operated by the wife, (3) labor on road construction on weekdays and on the plot on weekends by the head, (4) seasonal migration to the dry zone as agricultural labor by the daughter and son, (5) casual labor in a rice mill in the dry zone by the eldest son, and (6) casual agricultural labor in the village by the head and his wife.

The economic contribution of women to family survival is evident in the study of two Philippine villages, one Muslim and one Christian, near Davos on Mintanao. The Muslim women grow, harvest, and sew *nipa* palm for house shingles, while the major occupation of the Christian women relates to fishing. All the women had worked for money at some point in their lives; all control the family budget; and all but one continues to contribute to the family income. Throughout the Philippines, and indeed all of Southeast Asia, women play an important entrepreneurial role. Traditionally, such activity was not considered particularly high status; perhaps for that reason it was left to women. It is clear that these women, even though they live in a village economy that is often referred to as subsistence could not live without money to buy foot. Even their basic

diet of vegetables ant salted or dried fish must be purchaset in the market.

A major factor which encourages women to increase their economic activity in the monetized economy is the ability to keep control of their earnings. The success of the Korean Mother's Clubs is a case in point. Based on historic cooperation of women in supporting each other in providing expensive ritual festivals for marriage or death, the Mother's Clubs were set up to facilitate the distribution of birth control pills. Three-quarters of the Mother's Clubs organized Mother's Banks. Encouraged by financial resources of their own, women in many villages started projects to earn money with which to build schools, run stores, and improve village services. While the groups have now branched out into a variety of income-producing activities, market protuction including gathering of nut's for sale was frequently the first income-producing activity. Women are also employed in public works projects, but at lower wages than men, a fact that reiterates Korean women's low, if improving, status.

Studies of women's roles in agriculture in the Muslim countries of North Africa and West Asia have been inhibited more than elsewhere by cultural norms that encourage undernumeration. In Thailand the labor force participation rates in the Southern province, where one-quarter of the population is Muslim, for females over 11 years old is 63.9 percent, as compared to a national average of 86 percent. This suggests

few Muslim women are reported as actively employed.

Studies in Turkey confirm the invisibility of Muslim women in statistics even when they take complete charge of the farms in areas of intensive out-migration of males. Mechanization has contributed to greater social stratification, with resulting leisure available to wives of the larger landowners. Wageworking families continue to pick cotton, hazelnuts, tobacco, and strawberries.

Recent efforts to reach rural poor women in Bangladesh have been impeded by purdah restrictions. Nonetheless, women's cooperatives are successfully marketing fish, bananas, limes, ducks and chickens, and vegetables. Operating solely with capital saved by the women themselves, these cooperatives are seen as models for the rest of the country. Yet of the 13 cooperatives in the country, only two are totally Muslim. Muslim husbands still resist the idea of their wives leaving the compound for weekly meetings.

As men are drawn off to work in Saudi Arabia, Yemeni women are taking over much of the farming. As notes above, the poorest women in the New Halfa resettlement scheme benefitted from greater opportunity to pick cotton. Yet the recognition of women's economic activity is resisted the most in the conservative Muslim areas. Status is attached to seclusion except for the Westernized elite; with the recent revolution in Iran, even that is subject to change. Nonetheless, it is clear that poor women in all countries, including Islamic ones, must and do contribute to the survival of their families.

LATIN AMERICA

Women in the agricultural labor force in Latin America, while lower than that in Africa and Asia, is still an impressive 40 percent, according to the Economic Commission of Latin America. This figure is low, according to Carmen Diana Deere. In her review of women doing agricultural work in Peru, Deere found that 86 percent of the women in peasant households participated in the agricultural work as compared to the 1976 Peasant Family Survey of 38 percent. Self perceptions are partly responsible; if a man resides at home, he is the farmer. The majority of the women that considered themselves to be agriculturalists were female heads of households with no adult male present. ("The Agricultural Division of Labor by Sex: Myths, Facts, and Contradictions in the Northern Peruvian Sierra," paper read at the Latina American Studies Assoiation , Houston, Texas, November 1977.)

In Honduras, 13 percent of the rural households are permanently headed by women; the figure rises to 25-27 percent if seasonal migration is included. These women tend to be landless, and must seek wage employment on the cotton and coffee plantations. In the Peruvian highlants, the transition from the hacienda system to minifundio has relieved women of many servile tasks formerly required by the landlord. But

it is difficult for a family to live off the small plots of land. As men are forced to seek wage income off the farm, the responsibilities of the women increase, increasing her self-esteem and status. As landlessness or near-landlessness increases, the poor farmers must increase their wage labor. In Peru and Honduras men migrate seasonally from the mountains to work on large farms. In Northeastern Brazil, the farmers assist with the sugar harvest on the large plantations.

On the small farms, then, modernization has meant an increase in women's labor as the men frequently seek work elsewhere. In addition, manufactured goods in the market have undercut many local handicrafts previously made by women, making them more dependent on income from agricultural production. Women in Mexico who work on commercial crops are paid less than men. The rationale given is that women do not work, they merely help with the farming.

PROCESSING

Processing and preserving of home-grown and home-consumed food is not an economic activity which is counted in the GNP. Women's contributions in this area are even more invisible than their work on farm production. Yet it is here that small technologies can have their greatest impact; they can: reduce post-harvest food loss, thus providing more food for con sumption or sale; reduce drudgery and so give women

the gift of time; form the basis of income-producing activities. The test of any technology introduced at this level must be its social utility. That is to say, the introtuction of the technology should improve the quality of life of the people meant to benefit from its introduction. How the technology is introduced, who owns it, and who controls its use are fundamental questions that must be the basis for planning.

Many of the "new" technologies presently being tried around the world have in fact been tried many times before. That is why the major focus today is on process and adaptation. No longer can it be assumed that a piece of equipment or a method of production can be packaged and dropped in a village where, like a genii, it will transform the quality of life. Disaggregating the intended beneficiaries by sex, and also by socio-economic levels, is clearly a necessary step, but not alone sufficient.

Technologies which can assist women in carrying out their food-related post-harvest activities fall within two general categories: mechanical technologies which reduce the expentiture of human or animal energy, primarily in the processing of food; and improved methods of preserving and storing food. I shall discuss the policy issues relates to the choices of technologies and review present technologies under each category, giving particular attention to the impact of the choices on income-producing activities of women.

Grinding mills for corn, wheat, and millet, as well as rice hullers, are now

widespread throughout the developing world. Small presses for palm oil, coconut milk, or sugar cane are witely distributed. Grinders and beaters for making peanuts into oil are also becoming common. Simple, low-cost hand-operated machines can relieve much of the drudgery from these activities while not displacing too many laborers. Preferably, these machines are sold on long-term credit to women's organizations.

As early as the 1950s corn grinders were introduced into what is now West Cameroons through the patronage of a respected elderly village woman. Once the technique of drying the corn before grinding was understood, the grinders were quickly adopted through corn mill societies which were formed to pay back the cost of the grinder within a year. These societies became the trigger for other development efforts. With the increased leisure that the women now had they turned to other community based projects. They dug roads to their villages so that lorries could come in to take out their produce, they piped water into storage tanks so that the abundant small streams of the rainy season could still provide them with water in the dry season, and they built meeting houses in central villages in which they could hold classes throughout the year regardless of the weather. They learned how to look after their children and how to cook and make soap. The women fenced in their farms, set up cooperative shops. Above all they learned how to read and write and

to do simple arithmetic. When independence came in 1961 the movement had spread as far as the coast; the membership exceeded 30,000 women. Thus the organization was able to make its voice heard in the community on most matters affecting women.

Yet when the same organizer, Elizabeth O 'Kelly, tried to introduce rice hullers in Sarawak, the technology proved inadequate; the hullers were not strong enough to withstand the constant usage by all the women in a longhouse. Yet the intervention from outside was enough to encourage the formation of Women's Institutes which focussed their activity on piping water and improving farming. Fourteen years later these Institutes run seminars, organize flood relief, and even run their own radio station. This type of responsive intervention is being tried in many parts of Africa today; the process may be more important than any specific technology as long as the technology is simple and inexpensive enough for the women's organizations to buy and run it. (*Aid and Self-Help,* 1973)

Marilyn Carr, in her excellent book on *Appropriate Technology for African Women,* argues that most hand-operated crop processing machines used in Africa have proved more economically efficient than more sophisticated imported machines. A study in Kenya compared four types of corn-grinding; a Nigerian study compared four types of palm-oil presses. Another study in Nigeria compared two techniques for processing *gari* from cassava. This found

that a locally-generated 'intermediate' technique was far superior to a fully mechanized foreign machine. Among other things, unit costs of production are about 20 percent lower with the 'intermediate' technique. (Book written for the African Training and Research Center for Women of the Economic Commission of Africa, 1978.)

In Upper Volta a government program is assisting women's groups to acquire hand grinders. Yet even remote areas have commercial mills powered by diesel oil. During the last round of oil price increases one mill owner near the village of Tangaye raised his grinding fee by 25 percent to compensate for a price rise in oil of 33 percent. As a result he lost so many customers that he was forced to open the mill only twice a week, on market days, rather than every day as he had done in the past. Expenditures for fuel comprise 50-60 percent of the monthly cost of running the mill. Currently the government of Upper Volta, utilizing funds from US Agency for International Development, is installing a solar unit in that village to power a grinding mill and to pump water. This photovoltaic system is highly experimental since the present costs of battery storage make the unit very expensive. For the time being, then, hand grinders may still be the most economically efficient method of grinding local grains. But for how long?

In Indonesia the intermediate alternative for rice hulling is a small, relatively low-cost, Japanese-made, machine-powered rubber hull roller. In the four years, from 1970 to 1974, the number of these small rice mills exploded until they dominate the market, and can process up to three-quarters of local production. This rapid switch to rubber rollers cost over one million jobs on Java alone and 7.7 million throughout Indonesia. Yet hand-pounding continues in Indonesia for most domestic consumption, about 40 percent of the crop. The fact that nearly all home-consumed rice continues to be pounded underscores the lack of money which village women have to buy food. Not only are the costs for commercial milling extremely low due to the over-capacity of the many new mills on Java, but milling gives more usable rice per weight. While it is true that pounded rice is more nutritious in that more bran remains with the final product, this dietary advantage is more important to the poorest who no longer have a share in the harvest. For them the economists' argument that in fact the new rice mills have lowered consumer costs of rice per kilogram is important— if they have money with which to buy the rice.

Development agencies continue to explore the impact of this technology. Economists point out that small rice mills using rubber-rollers add to national income nine times the value of the lost jobs. But who benefits? Clearly the distributional impact of this change has been in favor of the larger farmers and the owners of the rice mills. The losers are the poor, but it is the women who lost the jobs. The Indonesian

government does have public works programs to provide income to their poorest citizens. But where 125 million women-days of wage labor were lost on Java in 1972, the county public works program provided only 43.5 million man-days of employment. Recent reports note that for the first time in Java women in large numbers are now vying for this strenuous job. The impact of rice hullers has clearly been an increase in rural poverty.

Governments should be able to anticipate such impacts, altering tax, subsidy, or pricing policies in such a way that the poor consumers benefit from lower prices and greater volume of grain. But only a job can replace a job; without income, lower prices are irrelevant. Because statistics fail to reflect the actual employment of the poor, especially poor women, economic costs of new technologies in the area of food milling are ignored. The first step is a more accurate accounting of real work in rural areas. The nutritional dimensions of new grinders must also be considered. Incomplete milling through hand-pounding leaves sufficient bran in the rice to provide needed vitamin B. Husks are fed to chickens, later consumed. What will prevent deficiency if hand-pounding is further reduced? Can new techniques for handling husks prevent their turning rancid and so provide an alternative food, a new breakfast cereal for the poor?

In Bangladesh, government policy could presumably slow the introduction of small rice mills, allowing time to develop alternative economic activities for displaced labor. A hand rubber roller is being considered a halfway measure which may reduce the economic advantage of the power mills. This intervention should be carefully monitored. No one can really argue that the hand pounding is of itself good. But the heavy work must be balanced against no work when evaluating the impact of any new technology.

Postharvest food losses are enormous. Most observers agree that a 10 percent increase in the available world food supply could be more easily achieved through a reduction of losses than through increased production. Some of these increases may be illusory, as with the increased yield of rice by the use of sickles: the "lost" rice had provided free food as a sort of social security for the poorest in the village.

Improved storage for grains has been a goal of many development agencies including the Peace Corps. Weevils and rodents destroy half the corn stored in rural Cameroon homes; small changes can reduce that loss by half. Rodent baffles, inverted funnels on support poles of the cribs, can be fashioned from old kerosene tins or molded in clay. Metal storage tanks work well in dry areas but cause mildew problems in more humid areas. VITA (Volunteers in Technical Assistance), under contract to Peace Corps, has issued a training manual on storage techniques.

Waxing cassava has reduced losses in Latin America and is being tried on plantains in West Africa. Solar dryers

are being touted as a substitute for the habit, widespread in South Asia, of spreading grain on the black tarmac: one car can wreak havoc. Yet buying a piece of heavy black plastic to line a box is out of reach for many poor. Selling such dryers at subsidized prices would seem an important project. In Tanzania an improved solar dryer was demonstrated at a recent workshop; women were taught to make the mud container and the form for the plastic core.

Many traditional methods of smoking or drying fruit, vegetables, fish, and even meat are being stutied for improvement and wider dissemination. In Thailand fish pickles by one method frequently produces illness; another traditional method is safe. In Ghana one group traditionally smoked fish until cheap electricity from the Volta Dam gave an advantage to freezing fish; the knowledge is rapidly vanishing.

Canning has not been widely taught, perhaps because of the concern over botulism poisoning. Ester Ocloo, owner and manager of a commerical cannery, said she once came to the United States on her own to learn home-canning techniques at a university in order to teach women in Ghana to do their own canning. In 1977, the UNICEF in Dacca brought out an instructors manual on Food Preservation in Bangladesh as part of a project to encourage income-generating activities among women. The emphasis is on canning: chutney is featured in addition to fruits and vegetables. Canning lends itself much more to community

enterprise than to individual effort. Finding markets must be a part of the planning, for the glass container itself prices the product out of the reach of the poor.

In Honduras, Save the Children Foundation assisted a remote mountain village to set up a cooperative mango cannery. It has survived many setbacks. The institutional consumers actually bought less than anticipated; the remoteness of the village added greatly to transportation costs; and the resource poor area has made diversification difficult. Attempts to encourage local consumption through a deposit system on the glass jars has worked only in the immediate neighborhood due to the rugged terrain. But local women take advantage of bottle return; they buy the puree and dilute it with water for sale at soccer matches. Attempts are now being made to market the mango puree as dried "fruit leather," a familiar product in Asia —the Bangladesh book calls it "mango dried sheet"— but not well-known in Latin America. Experiments using plastic sheets to wrap the leather produced a product more chemical than natural. In addition, the cooperative hopes to utilize a system of vacuum-packed plastic bags as soon as it is perfected by a similar cooperative in Costa Rica. Meanwhile, the coop members are planting mango trees; they have also contracted with a neighboring village to pickle their excess onion crop. Despite the difficulties of setting up this women's cooperative in such a poor and remote village, the

coop is functioning. The husbands migrate out at least half the year, but they did help with the building of the cannery, and maintain the equipment. Perhaps if the foreign technician had been female, the women might have been taught this skill. The women, working a six-day week during the mango season, earn $1.50 per day or $42. per month. Men in the region earn between $150. and $300. a year, so that the cannery earnings are an important addition to family income.

For shorter-term preservation, solar coolers and refrigerators are being developed. Improved handling of both fresh and dried perishables are expected to reduce losses. Chemical fumigants and insecticides are particularly useful in reducing losses among cereals and tubers. Experiments in biological control of pests through the introduction of predators continue. Resistant species are being teveloped. Details of the state of the art for reduction of food losses may be found in the 1978 report by the National Academy of Sciences, *Postharvest Food Losses in Developing Countries*.

The careful scientific language of the report masks the dominant role which women play in postharvest activities. One paragraph in the staff report alone recognized the human element behind technological change: the discussion group "took note of the fact that the subsistent fisherman and fish merchant are generally second class citizens, often living in crushing poverty, with no hope for the future. This fact and the role of women in the society

conditions what, how and by whom technology should be offered, how it should be delivered, and what incentives are necessary to convince the people to adopt the remedies." Such oblique langauge is not sufficient to counteract the biases among developers and planners that technology is for men. Community-based technologies which reduce food losses and so provide surpluses for sale can and should provide alternative incomes for women displaced in the agricultural production activities.

PREPARATION OF FOOD

Selling of cooked foods is an income-producing activity of great importance to the poor woman, though it is seldom recorded in national accounts. Outstanding among the sparse literature on this subject is Emmy Simmons' study of "The Small-Scale Rural Food-Processing Industry in Northern Nigeria." Even among the secluded Muslim women living near the city of Zaria, "It is rare...to find a rural woman who has never set up production in some food-processing enterprise." These women produce a variety of traditional lunch and snack foods from grain, cowpeas, peanuts, and cassava. Most of the women work alone at home in seclusion, sending their daughters or other young relatives out to sell to neighbors or in the market. Their work is sporadic, more an extension of home activities than a commitment to enterprise. Nonetheless Simmons found that

333

all the products, with one exception, produced a return on cash investment of between 6 and 40 percent. (*Food Research Institute Studies*, XIV 2, 1975)

Two major problems threaten the future of this important income-producing activity: (1) the single owner-operator pattern of the industry, and government policy. Working out of their homes, the women mingle family feeding with commercial cooking, confusing the profits. Also such small scale production leads to uneconomic buying of supplies and inefficient distribution of the products. Much of the profit or loss relates to the size of portions versus the price: frequent price fluctuations of ingredients means that the seller must understand the market. Many women have a canny sense of pricing, but others quickly go out of business. A cooperative organization would seem a logical alternative which would improve investment return, make credit easier, and allow intermediate modernization of the industry. Yet Simmons remarks on the apparent unwillingness of the women to work together. Whether this reluctance to organize stems from cultural or religious practices such as seclusion or easy divorce, or whether no appropriate model or collective action has been tried, is unknown.

Currently, the single owner-operator pattern remains competitive with products made by larger industrial establishments, both those in the area offering similar traditional products and those which provide competitive European style breads and candy. Government

policies favor larger industry through subsidies and taxes. It seems clear that if the women do not join together to become more competitive, their share of the market will inevitably shrink. Simmons summarizes the impact of this decreasing production on the women themselves and on the rural village economy: *[W]omen's ability to meet social and economic obligations on their own with earnings from their profitable commercial enterprises will be decreased; the village economy will become less self-sufficient as far as producing and consuming local products; and the value added and income generated by the agricultural sector will migrate more directly to the urban sector. Nutrition may be adversely affected... The deprivation of a substantial means for earning income will have the effect of downgrading women's independent and family roles.*

Selling of lunch food and snacks is a traditional part of the economic activity of the West African coastal market women. As the Ivory Coast becomes more urban and workers commute further to their jobs, both breakfast and lunch are often purchased from vendors. While western style lunch shops and fast food chains are appearing, their prices are too high for the average worker. Government has begun subsidizing commercial caterers to provide modern pre-packaged meals at offices or on work sites. Consistent with its pell-mell rush to copy the west, the government of the Ivory Coast celebrates only the modern. Barbara Lewis, in her insightful study of the overcrowded world of petty traders in that

country, notes the lack of government support for the organizational efforts of the market women to set up wholesale purchasing and group savings schemes. Indeed, governmental policy, as demonstrated by courses for women offered through Social Centers run by the Ministry of Work and Social Affairs, appears "designed to refocus women's attention away from moneymaking toward homemaking, rather than providing social or technical skills to upgrade gainful productive activities." ("Petty Trade and Other Employment Options for the Uneducated Urban West African Woman," paper for the AAAS Workshop on Women and Development, 1979. p9)

The reluctance of modernizing govenments to accept the continued existence of a more traditional sector has been addressed in several Latin American countries. "Local" markets have been funded by AID but they only occasionally include local industry. A recent review of Mexico's rural industry program notes the complete lack of attetion to women's employment. Of the 60 industries studied, only nine relate to food-processing; but no mention was made of women's traditional roles in these industries. This report reiterates the danger of assistance agencies setting up non-competitive industries through grant programs: once the subsidy runs out, the industry fails. (Kimberly Conroy, "Mexico Rural Developmen Project PIDER: Analysis of Rural Industry Program," The World Bank, April 1979.) The literature on women's

projects is full of such failures. It is imperative that women's projects be fully competitive and economically viable. Small crafts projects to help women earn "pin money" are not only passe, they are almost destined to fail. Such failures reenforce the biases against women's real economic activity. Even well-conceived schemes may fail if they are not totally integrated into the country's national plan. Will the increased production of millet beer by women's organizations in Upper Volta be undercut by the new Heineken beer factory? Both projects have heavy government subsities.

There are several lessons to be learned from these several studies: the importance of an organizational base for women's economic endeavors, and governmental recognition of and support for the economic parameters of the projects. There is a tendency to overload women's projects with welfare concerns: health, education, family planning. These often take precedence, and sink the enterprise. As selfsufficiency is preferable to dependency, so economic activities should be given priority over welfare programs. Recognizing the economic role of women is the starting point.

THE BASICS OF WATER AND ENERGY

Rural survival, much less rural industry, depends upon the availability of water and fuel. The time spent scavenging for fuel or fetching water consumes large amounts of the day for rural women,

children, and men. Reducing this expenditure of time must be a priority for rural development. Solutions must be appropriate to the need. Too many wells have caused desertification in the Sahel; too much water has caused severe sanitation problems in India. Elaborate schemes for modern water supplies lie on the planners' shelves in many developing countries.

Clean water for all by 1990 is a slogan often repeated. But where are the development plans to accomplish this? Is part of the problem the lack of monetary value assigned to domestic water supply? If water is seen only as welfare, then hardheaded planners, anxious to show an increase in GNP, do not encourage such projects. If clean water were tied to rural industry, as irrigation water has been linked to agriculture, perhaps more funds would be allotted to this need.

Similarly, energy for use in the household and for rural agriculture and homecrafts has gone largely uncounted in national energy statistics. This is due to the custom of measuring only "modern" or "commercial" energy: oil, coal, natural gas, hydroelectricity, and nuclear fuels. Yet such an energy-accounting procedure ignores what in many cases amounts to more than one-half the total energy used in many developing countries, exclusive of animal and human power.

Rural areas, where a majority of population in the developing countries still live, are seldom served by electrical power grids. Diesel motors power pumps for irrigation, provide energy for small industries and run small lighting systems for wealthy enclaves. But most rural people, like the urban poor, are unable to afford commercial energy in any form even where kerosene is subsidized. Some two billion people continue to rely on non-commercial energy resources to cook, smoke food, heat water and space, or provide light and safety. These resources are primarily firewood, twigs and brush, agriculture residues, and animal dung. In rural areas of South Asia, due to heavy deforestation, animal dung provides as much as 50 percent of the total rural energy consumed. As the amount of dung burned increases, food production will fall unless artificial —and energy intensive— fertilizers are substituted. (Joy Dunkerly, et. al., "A Report to the World Bank" October 1978)

It would seem that many countries are following India's path toward deforestation. Experts estimate that Senegal will be bare of trees in 30 years, Ethiopia in 20, Burundi in seven. Ninety percent of wood consumed annually in developing countries is used as fuel. Reasons for this alarming increase in the use of forest reserves are largely related to the population increase both directly in increased cutting and indirectly as more land is cleared for agricultural crops to feed the growing populations. Improved health measures have opened up river valleys in Africa and the terai in Nepal to settlers, also reducing forests and exacerbating erosion. As available resources drop, the time consumed in

gathering fuel increases. In India it has been stated that one person in a family of five must spend fulltime gathering dung, firewood, and refuse. Even higher estimates apply to Tanzania. Such time requirements encourage larger family size, for children help the family more than they cost.

When one examines the uses of this energy, it appears that some 40 to 50 percent of the total energy consumed in rural areas is used in cooking alone. In the case of India, for example, this leads to the conclusion that approximately one-fourth of the country's total energy budget is used in rural areas just for cooking, while rural Bangladesh uses about 40 percent of that country's total national energy budget just to cook food. As much as one-third of the family's budget may go for fuel in the Sahelian countries.

As the worldwide energy crisis has engendered a new look at renewable energy resources, some interest is being directed toward improving both the supply of fuel and the efficiency of its use. Mud and sand "Lorena" stoves have cut firewood use in half in Guatemala. But experiments in Mali suggest that the traditional three stones and open fire is still the most efficient cooking method for local food. Pressed rice husks are being marketed; improved methods of making charcoal are being developed; biogas is being produced in many village converters.

Reforestation projects are being upgraded and new plant and tree varieties tried. Biomass plantations will

be tried in the Philippines; this fuel will go for large electrical installations as well as for local needs. Small hydro plants may reduce the erosion in Nepal caused by overcutting of trees for firewood. Solar water heating can reduce other fuel usage by a third in Gambia. Solar dryers, solar water pumps and purifiers, and solar sprayers are all in various stages of production. Uses for windpower are being expanded as styles and capabilities are the subject of experiments.

As technology turns to the energy crisis, will development once again have an adverse impact on poor women? Improved access to fuel supplies will certainly lessen the drudgery of daily living *if the women can afford the new fuel or the new stove.* Economics is not the only determining factor in the adoption of new technology. Taste, ease of preparation, even the sociability of the kitchen, must be taken into account. Yet shortage of fuel has already changed diets in Guatemala, where many families can no longer afford fuel for the long cooking of beans. Such variables can only be learned at the project site. This was recognized by the participants at the AAAS Workshop on Women and Development sponsored by the U.S. Department of State to develop recommendations for the U.N. Conference on Science and Technology for Development meeting in Vienna in August 1979. The Workshop recommended that the United Nations sponsor worldwide pilot projects, one in each major region of the developing world,

focussing on household energy. And because household is clearly a women's issue, women's views and women's groups must be involved at every phase of study and implementation.

A similar recommendation was put forward by the working group on Energy for Rural Requirements, part of a UNIDO International Forum on Appropriate Industrial Technology which met in New Delhi in November 1978. *"[I]t is the women of the developing world who are most concerned with the problems of energy supply and use, because it is they who do the cooking and, in most countries, gather the fuel. Furthermore, it is usually the women who draw and carry the water for domestic use. Thus, although action programmes undertaken to meet the energy problems of rural areas must involve people at the village level during planning and implementation, their impact on women must be taken into account, and indeed should not be planned or implemented without the significant involvement of women at both the planning level and the village level."*

CONCLUSION

Women's tratitional economic contribution to the survival of their families is being eroded by technology as the control and profit of technologies flow largely to men. In agricultural production, technologies have been concentratet on cash crops and on selectet basic grains. Generally the impact of these technologies has been to increase production, concentrate landholdings, and encourage social stratification. In Asia

and Latin America the wives of larger landholders have greatly reduced their involvement in the fields. While this release from hard work is to be commended, there is often an accompanying loss of status. In India, a switch from bride price to dowry has occurred in some areas where brides are no longer valued for their economic contributions. (Scarlett T. Epstein, *South India Yesterday, Today, Tomorrow.* 1973) In Africa, however, well-off farm women tend to remain in the rural areas managing the farms and often hiring other women to help with the harvests, particularly of cash crops.

Poor women in all the developing countries have had to work harder as a result of these new productive technologies. Women heads of households or wives of men who migrate to wage jobs elsewhere undertake both the traditional male and female agricultural activities. Families with only a garden plot or splintered field must send *all* adult family members to work as day laborers. As mew technologies reduce the need for inskilled laborers, a few men are trained for the semi-skillws jobs. (Indeed, men left in the unskilled labor pool are perhaps worse off than the women; women's wages are less, so they are displacing men in plantation work.) Women have traditionally worked at a greater variety of unskilled jobs and so in many countries they are able to survive through market selling or handicrafts. Elsewhere, women have joined the urban migration, working for

low wages in industried or as domestics (or even as prostitutes.)

The garden plot where the poor women can grow food to enhance her family's nutrition and then sell the surplus emerges as an important factor in survival. Clearly, greater attention to garden crops and to marketing of fresh vegetables and fruits should be a priority in any planning for rural development. Similarly, attention to small animals and fish culture could add immeasurably to the welfare of the poor, if not to recorded GNP.

New technologies can be useful to women. Technology could greatly reduce postharvest food loss, providing additionood for poor families or supporting small food processing industries which can provide much needed income

to poor women. Improved methods for processing and preserving food as well as improved access to water and fuel can also free women from back-breaking and time-consuming labor. But without income, a woman cannot try her hand at new economic activities, much less improve the health of herself and her family or attend literacy classes. Moreover, if new technologies continue to be introduced to men only, women will be worse off than before. This vicious circle must be broken, ant technology is both part of the problem and part of the solution.

THE REAL RURAL ENERGY CRISIS: WOMEN'S TIME

RURAL ENERGY NEEDS IN THE DEVELOP-
ing countries consist of, first, fuel
for heating and, second, mechanical or
muscular energy for agricultural produc-
tion, food processing, and other basic
survival tasks. Over the past decade, in
response to the worldwide energy crisis,
the focus of concern for micro-level
energy needs has been on the fuel needs
of the rural poor, primarily for cooking.
Earlier interest in the application of ap-
propriate technologies to accomplish
mechanical food tasks was displaced by
this new enthusiasm. This definition of
the problem (rural energy needs = fuel
needs) called for two types of solutions:
planting more trees to supply fuel, and
introducing new designs for cookstoves.
Such stoves were to use either (a) tra-
ditional fuels more efficiently or (b)
new, renewable, energy sources. On the
whole, these interventions have not
been widely successful for two reasons:
(1) the problem itself was not perceived
accurately, and (2) the solutions offered
actually required more time and effort
from rural women who already work in-
credibly long hours every day.

There is no question that firewood
is becoming increasingly scarce in much
of the developing world. This scar-
city has led to increased use of other
burnable materials such as agricultural

refuse and dung, as well as twigs and
leaves from scrub trees and bushes.
However, it is an unwarranted leap to
judgment to conclude, as most donors
have, that rural families are causing the
deforestation by their fuel-gathering
practices, and that, among other mea-
sures, more efficient cookstoves would,
consequently, slow the denuding of
the countryside. This is not the only
(and in many areas not even the cen-
tral) problem. Other major causes of
deforestation are: clear-cutting for new
homesteads and commercial logging in
mountainous areas; over-grazing in Sa-
helian areas; and commercialization of
firewood and charcoal to provision rap-
idly growing urban areas.

Like much of the pressure on wa-
terholes and savannah in the Sahel, the
pressure to open up new farmland on
unsuitable hillsides (which should be
preserved as watershed areas) is due to
rapidly increasing population. As their
ancestors did, the new farmers and herd-
ers gather fuel in traditional ways. But,
in many places, such as Burkina Faso
and Nepal, the time spent on this ac-
tivity is still significantly less than the
time spent fetching water. The basic
problem is that the depletion of wood
stocks is often not noticed until most of
the timber within reasonable gathering

distance has disappeared. If rural women and men do not perceive fuel scarcity to be a problem, they are unlikely have any interest in proffered solutions.

Only recently have development officials begun to talk with rural women who are, in many rural areas, the primary fuel-collectors. Initially, rural energy projects introduced technological "fixes" which required great investments of women's time. It is no wonder that, so far, these solutions have been largely unsuccessful. This outcome only underlines the fundamental fact that a major barrier to rural development is the scarcity of women's time.

THE REALITY OF WOMEN'S TIME

Fifteen years of scholarship in the area of women in development has produced a wealth of data on women's work in rural areas of the developing world. Perhaps most revealing are the growing number of time allocation studies which document the actual daily activities of women and men throughout a year. Studies from Indonesia, Burkina Faso, Nepal and India, for example, have disaggregated fuel collection from other work. They show that time spent in fuelwood collection in the first two countries is relatively trivial, while in the latter two it is greater, but still much less than the hours spent fetching water. In all four countries, food processing is by far the most time-consuming survival activity for women. Finally, in all four countries women work

two to three hours more than men work every day. One a particular good South India multi-village study also found that approximately 83 percent of all fuel gathered is twigs and branches; another 7 percent is roots while 10 percent is made up of leaves and agricultural refuse. This survey also found that not only logs, but branches, twigs, and roots are all traded in the market. This means that poor villagers spend some of the fuel-gathering time collecting materials to sell. In addition, it indicates that some of the poorest families must buy fuel because of time constraints. Similiar studies in North India support these conclusions, and also show that poorer families use more twigs and leaves than do the better-off families. Because they need to gather fuel for sale as well as home use, they also rely more heavily on help from children.

The Nepal study demonstrates the importance of food processing to the total family income. Conventional income statistics totally ignore this form of work. The study shows that, on average, women's food processing activities account for 13 percent of total household income; that percentage is higher for wealthier households. In two villages where women brew beer, their contribution is 15 and 23 percent, respectively. The labor demands of food-processing work as well as daily survival activities place a premium on help from daughters. The need for female children to work on the farm and in the household is the major reason given by villagers for not sending

their daughters to school (Meena Acharya & Lynn Bennett. *The Rural Women of Nepal: An Aggregate Analysis and Summary of Eight Village Studies.* 1981).

Two recent surveys in East Africa seem to indicate a greater pressure on firewood than is revealed by the previously discussed time allocation studies. In Tanzania, women are recorded as spending up to 12 hours per week collecting distant firewood; this is supplemented by twigs picked up by women and children traveling to and from the farm fields. Men in this part of Africa do not help at all with firewood collection. A Kenya study found women spending between 30 and 60 minutes a day collecting firewood. Three-fifths of these families also had charcoal burners, and used the two types of fuels for different purposes. The wealthier farmers purchased the charcoal, but in one-quarter of the households the men made charcoal for use and sale. Such variations between villages indicate the rapidly changing nature of the problem. As available stocks become scarcer, better-off villagers begin to buy fuel, a switch which may in fact reduce the pressure on woman's time if her husband pays for it.

Rural water supplies, on the other hand, are not commercialized anywhere. Thus even women who no longer have to collect wood may still have to walk great distances to find water. Population pressures and ecological degradation are putting great stress on underground water just as they are on forests. In Kenya, fetching water is a more onerous chore than gathering firewood, in many households taking five to six hours daily of women's and girls' time.

Rural Projects

The time allocation studies clearly portray the critical inelasticity of poor women's time, particularly in rural areas. Activities required or requested as a result of development programming must be carefully weighed by each woman against existing duties, to ensure that a change will not leave her and her family worse off than before. A woman will not use a lorena-type cookstove if she has neither the time to gather the wood it requires nor an implement to cut it. Nor will a woman add half an hour to her daily schedule to water newly planted trees if she sees no clear benefit to her or her family.

A better understanding of women's time will help identify both the primary constraints to rural development and the appropriate approaches to fuel availability crises. An example of where this did *not* occur is Burkina Faso, where descriptions of the land degradation around Ouagadougou led to generalizations about fuel shortages in the rural areas. It was observed that women carried branches and twigs on their heads while men used carts, so an experiment was set up in one village where women would rent carts for pennies a day. But few availed themselves of this opportunity. No wonder, when a time budget study showed that women

spent an average of only six minutes a day on this activity!

In general it seems that the poorer the family, the longer the hours worked by the women, and the more important the women's economic activity is to family survival. Only where overpopulation has put severe stress on the carrying capacity of the land, such as in Bangladesh, may the very poor landless women have some unused time. Thus, women's time constraints are directly related to poverty and underproductivity. To survive, the very poor need more paid work to do. More specifically, poor rural women need to be able to spend less time on survival activities so that they have more time available to earn money; they also need better access to income-generating work. To reduce drudgery without providing income opportunities only further impoverishes the poorest, who would otherwise earn a livelihood fetching twigs or pounding grain for their better-off neighbors.

In urban areas, the commercialization of fuel, water and grain milling has reduced the amount of time many women spend on unpaid household survival tasks. On the other hand, to be able to pay for basic goods and services they must spend long hours working for income, often in the so-called "informal sector." Time constraints on rural women are reflected in urban economic activities: fuel and water are commercialized and staple grains are all brought in from surrounding rural areas. Such urban demand is a major cause of growing fuelwood shortages,

increased prices, and desertification along the access routes to urban areas. Further, urban usages of fuel differ from those in rural areas; it is in urban areas that the charcoal stoves are of greatest importance.

Such commercialization of goods formerly considered "free" puts additional pressure on poor families to generate income. Much of this income is secured by providing services to other urban poor as well as the urban elite. Preparing and selling street food is a major entrepreneurial activity, one that reduces the time women must spend further processing and preparing food in the home. This activity has important implications for fuelwood consumption. Household producers may use more wood, but street food may be cheaper for consumers than the cost of buying the ingredients and preparing the food themselves. In sum, current research on the lives of poor women in developing countries provides extensive data of critical importance to engineers, foresters, planners, or anyone concerned with micro-level projects such as social forestry or improved cookstoves. The economic roles of poor women, both rural and urban, have been extensively documented. Together with time allocation studies, they show wide variations in women's work by region, culture, class, and ethnic group, yet underscore several critical facts which are consistent throughout:

- poor women everywhere work longer hours than men;

- their economic contributions, both monetary and non-monetary, are absolutely essential to family survival;
- women's income generally goes entirely to household needs while that of men does not;
- water carrying and food processing are more sex-typed than fuel collection.

INTERNATIONAL SOLUTIONS TO THE HOUSEHOLD FUEL CRISIS

The international development community's response to the perceived household energy crisis in developing countries took two distinct paths: technology and forestry. Foresters once concerned only with commercial logging initiated programs in social forestry. Appropriate technology groups joined with engineers to experiment on all manner of new and renewable energy sources for household cooking and heating needs, as well as to develop more fuel-efficient cookstoves. Initiatives which did not Each of these initiatives encountered problems whenever they ran afoul of the existing time constraints and responsibilities of rural women.

Social Forestry

Early social forestry programs focused on community woodlots, most of which failed to meet expectations. Other programs have involved planting along public roads, and supplying seedlings for individual planting. For any such approaches to succeed, villagers must first perceive a fuel shortage. An Agricultural Projects Services Center survey in Nepal found villagers placed higher priority on obtaining a reliable source of clean water, irrigation, fruit trees, and a health post than tree seedlings. That water ranked the top priority reflects how much time women collecting it.

Successful tree planting programs need, for starters, ready access to seedlings. A Tanzania woodlot program found extension workers' advice was also very important. In some countries, non-governmental organizations raise and distribute seedlings; Mothers' Clubs in Korea earned income for their members with such a project. The National Council of Women of Kenya's "Greenbelt" project not only supplies seedlings but pays a handicapped villager to care for them. Unfortunately, some foresters continue to resist this solutions.

Successful community woodlots need the support of a cohesive community, but such is seldom found in class or caste stratified villages in Asia. Conflicts over land ownership or rights to communal lands have undermined woodlot efforts worldwide. Communal programs have run into difficulties even in the People's Republic of China, where tree planting has been included under the "responsibility system," shifting decision-making and from the team or brigade to an individual family. But it is not sufficient to consider only the socio-economic and caste barriers to

communal action. Given the sex-typed divisions of labor, women are often automatically expected to care for communal woodlot trees, despite already long work days, and the likelihood that they will never benefit from them.

Another major reason that community woodlots have not succeeded is that they were a rural solution to an urban problem. As roads push further into the countryside, the temptation of the rural poor to cut firewood for sale increases. A study in Hyderabad, India, records firewood brought in from as far away as 200 kilometers. Roadbuilding into the backlands of Kenya has also led to widespread forest cutting. Even in predominantly rural Malawi, the cities now consume 16 percent of all firewood. Thus projects which provide seedlings and "improved" cookstoves for the rural poor run into two problems. First, the community woodlot seldom replaces the free forest as a source of fuel for the community. Rather, those who gain control of the lot begin to sell firewood. Second, the local poor continue using twigs and leaves as fuel, and so are uninterested in cookstoves designed for wood. Only if social forestry projects recognize this tendency to commercialize firewood, and ensure that those who tend the woodlot also benefit from the sale of the trees, will such projects have any chance of success.

Planting of trees by individuals, rather than communities, seems a more promising solution. Governments need not pay for planting, and

care and control of the trees becomes a household matter. Further, villagers can choose tree species which meet their needs for food, fodder, and medicine, as well as for fuel. In the past, foresters' lack of knowledge about non-commercial species has made it difficult for them to choose the most appropriate ones for tree-planting projects. It would behoove them to be in constant contact with the potential users, which are the local women, to learn about the specific characteristics of traditionally used plants and trees. Indonesian researchers recommend that social forestry projects integrate trees and perennial vegetables in home gardens, as is customary in Java, rather than focusing exclusively on trees for fuel. Even when fuel is the predominant concern, the varying qualities of woods for different cooking or smoking tasks must be considered.

For household use, families should plant a mix of fast growing varieties and multi-use trees on their homesteads. The landless should be granted ownership of trees on rights of way, in return for their guarding and watering the seedlings. Landless villagers, especially women, can be taught to grow seedlings for sale. Household plantings should also be encouraged in urban areas. Most towns in developing countries have unbuilt areas, even downtown, where trees as well as gardens can grow. Tree planting on home plots, along roads, irrigation canals, and railroad tracks, and around the city itself can help supply firewood for the urban

poor. Planting on public spaces should also provide wood for landless villagers.

Indian government efforts to maintain fairly extensive plantings on such spaces became involved in jurisdictional disputes between Public Works, the Forestry Department and other government bodies. However, these lands are often considered part of the grazing commons, and restricting their use hurts the poor most. One study in a Haryana village found that harijans (formerly called untouchables) grazed goats along canals, while upper castes primarily stall-fed cattle. In all castes, women are responsibile for all livestock except camels; thus for them, access to grazing land or fodder, and time to seek it, is a major priority. When goats graze on public spaces, it is unlikely that newly planted trees would survive. In Bangladesh, the Lutheran Relief Service now pays local villagers (often destitute women) to guard and water newly-planted roadside trees. Like payment schemes elsewhere, payment is per living tree, not according to the number originally planted. Fruit and branches from these trees also presumably benefit the caretaker. These schemes provides essential income to the poorest villagers, and might be more widely emulated.

In all these cases, it is important to remember that the very poor may, as mentioned above, decide to sell the better firewood and continue to use twigs and leaves for their own cooking. Designing cookstoves which burn such fuels efficiently are now being tested, and should be incorporated into social forestry programs. Further, it is essential to remember that marginal households may not be able to care for new trees without additional assistance. A study of a Sudanese refugee camp showed that trees survived only in the better-off households. Poor households could not afford the time to fetch water for the trees, nor could they buy water from a vendor as the wealthier refugees did. Also, the poor did not have money to buy wicker fences to protect the seedlings from animals. Programs offering free seedlings to the poor must plan in advance for such problems.

Forestry Service

Traditional forestry services are beginning to adopt ideas from social forestry. For example, the service in Maharashtra is hiring the poor to guard trees in forest areas: tribal couples receive farm land in return for protecting seedlings from grazing animals and trees from illegal cutting. In Indonesia, the Forestry Department has responded to villagers' needs for grazing land by intercropping elephant grass (for stall-fed cattle) between teak and pine stands. On the other hand, forestry officials have still not given sufficient attention to women's extensive knowledge of the forests. One study of slash-and-burn cultivators in the Kalimantan rain forests, for example, showed that women learned about the care and uses of the many root, tree and vegetable crops in their complex agricultural cycle as part of their education. Hoskins documents how forestry officials in West Africa ignore women's

knowledge about both tree and "useless bush" species ("Women in Forestry for Local Development: A Programming Guide," in *Invisible Farmers: Women and the Crisis in Agriculture*, B. C. Lewis, ed. 1981).

During the past decade, the concept of social forestry has expanded steadily. No longer does it refer simply to planting trees for fuel in village woodlots. Today, there is greater appreciation of the complexities of the roles of forests and trees in the lives of the people, both women and men. Recent donor meetings underscore this shift. The 1983 FAO-sponsored "Proceedings of the Workshop on Rural Energy Planning in the Developing Countries of Asia" calls for more micro-level studies on all aspects of rural energy. It also emphasizes the need to take into account "the villagers' perspectives regarding how and where energy fits into the overall picture of the rural economy." It takes care to avoid sex-specific terms, recognizing the wide variations in sex-specific work roles among the participating countries. A recent USAID workshop on "Human factors affecting forestry/fuelwood projects" lists gender as one of the five research issues important to all levels of forestry projects, from commercial to subsistence.

Recognizing this same imperative, FAO's Forestry Division has added Marilyn Hoskins to its staff. An anthropologist who pioneered recognition of the connection between women and forestry, she will be responsible for insuring that field data on users' needs is appropriately disaggregated, and the that villagers consulted include women as well as men.

Women in development more generally have stressed the need for women as data collectors and extension agents, in order to ensure that women's voices are heard. The growing number of women forestry professionals should eventually ease the current shortage of women trained in these fields. USAID/Asia, for example, has had two women foresters on its staff. Other agencies should emulate USAID and FAO.

Improving Cookstoves

Early technological responses to the rural energy crisis assumed that traditional cooking methods were hopelessly inefficient. This assumption turned out to be incorrect, but supported a second misconception: that excessive firewood consumption by rural households was the major cause of spreading deforestation. The "solution" then became to develop and disseminate a new, more efficient cookstove, in particular the lorena stove.

In fact, research has shown that traditional cooking methods reflect the lifestyle and responsibilities of the women who cook. As part of their education, women learn to manage all phases of cooking, adjusting for the fast or slow cooking requirements of different foods. They use the fire for drying grains on the stove or in the rafters and use the smoke as insect control (an attribute of cookstoves seldom considered by technologists.) They can coax heat from twigs and leaves, not just firewood—which is generally required by the new cookstoves. In Indonesia,

daughters help with the cooking routine so that the fragile twig fire can be manipulated to greatest efficiency. They clearly understand the trade-off between fuel consumption and time saved and may stoke two fires to speed a meal when harvesting awaits —if they do not forego the meal altogether. They understand the properties of various fuels: some smoke more, but the poor are often forced to burn green or wet fuel. Some wood, such as eucalyptus, gives an unpleasant odor; some, such as jute, is used for kindling, not cooking.

Many traditional stoves are easily portable, like ceramic Thai models, or easily replicated, such as the ubiquitous three stones arrangement, or the Bangladesh "hole-in-the-ground." Most traditional stoves accept anything burnable, but "improved" stoves generally require wood cut to a specific size even though women often do not have axes or saws. Further, women themselves both make and repair traditional stoves. Improved cookstove programs have too often assumed that stove construction was too complicated for women to learn, and so instead taught men to make them. Such an approach not only reduced women's utility and status within the family; it also meant that new stoves fell into disrepair, because women could not afford to have them fixed.

The experience of a Peace Corps Volunteer in Burkina Faso clearly illustrates these points. The volunteer taught rural women how to build a clay shell for the traditional three-stone stoves. This simple improvement increases stove efficiency by stove 40-50 percent, and has been adopted much more readily adopted than a previously introduced heavy concrete stove, for a few reasons. First, it is cheaper. The concrete model cost 250 Cfa (about 58 cents) for materials. In families where men control the cash, they are seldom willing to spend it on technology for women's traditional activities. The clay shell, by contrast, costs only women's time. In addition, it is a "woman's stove." The construction techniques are similar to those used to build granaries. Concrete stove construction, however, involved masonry skills locally considered to be within the male domain. Furthermore, as a "woman's stove," women can repair the clay stove themselves. To have the use of concrete stoves, on the other hand, women depended on men to build and repair them.

Growing appreciation of the many advantages of traditional stoves has made proponents of new cookstoves more cautious in their claims of greater utility, even if the new models do burn more efficiently. They have also become more sensitive to the culture and living conditions of the likely stove users, whether they be the rural poor, urban poor, wealthy peasants, or the urban middle class. They have refined in particular their methods of reaching the rural poor, who tend to use low-grade biomass and lack money to buy stoves. More emphasis has gone to making simple improvements on existing models which are easy to construct

and repair, and which take minimal adjustment in cooking techniques.

Also, even relatively poor families use more than one cookstove in their homes. Increasingly, they keep kerosene stoves for fast heating of water for tea, or they use bottled gas on weekday mornings when the children must be rushed off to school. Families use different cookstoves depending on fuel prices. Different preparation methods also require different stoves. In Afghan refugee camps, women use subsidized kerosene for tea-making and other purposes, but bake their traditional bread, *nan*, in a sunken wood-burning oven. The diversification of cookstoves, as new stoves are offered, should also be considered in future design.

Health concerns have also become more important. Studies in Gujarat, India of indoor pollution generated by the traditional Indian chula has showed that during the rainy season (when smoke does not exit through the roof), many women inhale smoke equivalent in some respects to 20 packs of cigarettes every day—a dose one hundred times worse than the "acceptable" level as defined by WHO. Epidemiological studies on air pollution from cooking fires confirms it is the source of much illness and early death of women in rural subsistence societies.

Other Technologies for Cooking

The health hazards of nightsoil motiviated the development of biogas digesters in China. The introduction of community biogas plants to treat urban sewage continues to be as persuasive an argument for this technology as energy efficiency. Biogas digesters in rural areas are not without problems; they tend to be biased toward richer farmers, and conflict with women's time schedules. They also have technical problems related to temperature and input variations. Yet it remains a technology with great potential at both the village and the city level. In one South Indian village where a biogas digester provides free methane to villagers, the human energy saved has enhanced the nutritional status of the village women, not by increasing the food available, but by reducing their human energy expenditure!

Solar reflectors were also introduced to relieve the pressure on firewood. They were quickly discarded as inappropriate because they required women to (a) stand in the hot sun, or (b) cook meals at midday when they would otherwise be working in the fields. The slow-cooker solar oven, on the other hand, is having modest success for example in Gujerat, where the government initially subsidized its diffusion, then left its spread to market forces. Hot boxes, which keep pots hot once removed from the fire, provide an inexpensive slow-cooking method, and also merit wider diffusion. Such specialized technologies clearly have a place in the array of new cookstoves.

THE FUEL/FOOD EQUATION

Efforts to reduce the amount of fuel consumed by rural cooking have focused on improved cookstoves and different cooking pots. Yet the object of cooking is food, not fuel efficiency. Remarkably little attention has been given to altering the composition of the food to reduce or dispense with cooking time. For example, fermenting soybeans into soybean cake reduces heating time from twelve hours to one. Agricultural extension workers introduced soybeans into West Africa. Local women did not use them for food because of the long cooking time, so they were fed to animals, until someone discovered how to ferment the beans. Many traditional techniques such as fermenting, pickling, and smoking can cut cooking times. Evidence that lack of fuel can force poor people to change their cooking habits or even reduce their food intake makes it clear that the issue of cooking time is of vital importance. The switch to rice and wheat from grains which require longer cooking has important implications for national food policies, especially where such quick-cooking grains must be imported. Pretreatment or partial cooking of more traditional grains might be considered as a way to reduce household energy use.

Women spend more time processing food than they do either fetching water or gathering fuels. It is essential to consider both sides of the fuel/food equation. My concern here is not with the use of agricultural lands for firewood or fuel crops, but rather with the fuel/energy inputs to feed subsistence families. It has already been noted that women respond to the conflicting pressures on their time in a variety of ways. They may use two fires —and twice as much firewood— to reduce cooking time; or they may skip meals entirely. They may switch to faster cooking foods such as rice instead of millet, or join their neighbors in communal kitchen in order to save both time and fuel. The nutritional impact of various fuel-saving measures must also be considered. In Guatemala, for example, many peasants have cut back on bean consumption because of the long cooking time. In the Sahel, uncooked millet mixed with water serves as a midday meal. These adaptations to fuel scarcity may have serious long-term effects.

In this food/fuel equation, most donors have prioritized fuel. But if women could reduce somewhat the two to three hours a day they spend processing food (or if they did not have to walk as far to fetch water) then they would have time to cook more carefully, thus conserving fuel. Or they would have more time to earn money, and be able to buy improved cookstoves, or biogas systems, or stoves using gas or kerosene . . . assuming that there were income opportunities available. Also, reducing women's human energy expenditure would in turn would reduce the amount of food they would require to maintain a survival-minimum caloric intake. This relationship was demonstrated in South Asia, where village

women are chronically underfed. The introduction of piped water, a biogas digester producing free methane, and tree lots for animal fodder, reduced women's daily energy expenditure by 700 calories, men by 500 calories, and children by 300 (Srilatha Batliwala, "Rural Energy Scarcity and Nutrition: A New Perspective." Prepared for the Foundation for Research in Community Health, Bombay. 1981). Such a strategy for reducing food needs of the rural poor may be as effective as trying to increase food supplies.

Less ambitious than the village-wide experiment cited above are improvements in food processing techniques. As with improved cookstoves, however, even the simplest technology may be too expensive for the poorest families. Small commercial grain mills are widespread in developing countries, but often the poor cannot afford them. In Burkina Faso many women had their grain ground only during the harvest time, when they were busy in the fields. In one particularly counterproductive technology improvement programan in Indonesia, the introduction of small rice mills is estimated to have put seven million women out of their work of hand-pounding the rice. These same women, jobless, could not themselves afford to get their own rice ground.

New technologies, whether cookstoves or grain mills, cisterns or plastic water piping, or new species of crops or trees, all require a new balance in the daily time demands of poor women. While shortages of fuel, water, food vary around the world, all three are necessary for survival. What my paper has stressed is that without considering the time pressures on women who use these resources to feed their families, many interventions with otherwise reasonable technologies will fail.

CONCLUSIONS

The real rural energy crisis is women's time. Technologies which reduce the drudgery of food processing or the collection of water are central to solving this crisis, as are improved cookstoves. Planting and tending trees often adds to the pressures on women's time, so they are unlikely to cooperate in community efforts unless they benefit from them. Thus the current focus on fuel issues at the rural level is laudable, but insufficient. Much more emphasis needs to be placed on reducing human energy demands through mechanical substitutes. This must be done in a manner that does not further impoverish the already over-burdened poor women, especially women household heads. Rural energy projects undertaken without consideration of the cultural context and living conditions of the poor may encounter unanticipated results that undermine the projects and actually make the life of the poor —especially women— more difficult. However, projects which directly address the poverty of women' time have the potential to release women and their families from age-old constraints, vastly improving the quality of their lives.

WOMEN, DONORS, AND COMMUNITY FORESTRY IN NEPAL: EXPECTATIONS AND REALITIES

INCREASING DEFORESTATION AND FOREST degradation in the Himalayan kingdom of Nepal is jeopardizing the development and prosperity of both the country and the region. The extent of the problem was gradually documented in the years after the overthrow of the hereditary Rana prime minister rule in 1950, as the country expanded communications with the outside world. Initially, the subsistence activities of family farmers appeared to be the major cause of this environmental stress. Over the past two decades, the Nepalese government and foreign aid donors have instituted forestry programs designed to reach remote communities of farm families, and to involve them in the protection and upgrading of public forests. In recent years, they have begun putting particular emphasis on including women. By recognizing and encouraging women's role in forest management, these participatory programs have won local and international praise. Unfortunately, they have also raised unrealistic expectations. Many factors contribute to ecological degradation in Nepal, and to look for a panacea is unwise. Disappointing outcomes of community forestry programs could be too easily blamed on women's inclusion, thus promoting a backlash that would undermine women's struggles for empowerment in this fragile, rapidly changing society.

TWO PROLEMATIC ASSUMPTIONS

The high expectations for the women and forestry programs rest on two problematic assumptions: the first, mentioned above, puts primary responsibility for forest degradation on subsistence farmers; the second holds that women are somehow "closer to nature" than men. These assumptions contain elements of truth, but they have encouraged forestry programs to adopt simplistic approaches to what are in fact very complex social and ecological problems. By designating women as the guardians of community forests and designating community forestry as primary approach to forest policy, planners and women alike are investing their hopes and expectations in programs that ignore the reality of family and class power relationships.

Causes of deforestation

Prior to the oil crisis of 1973, the energy research community paid little attention to traditional household fuel

consumption. When studies conducted in the wake of the crisis showed that most households in developing countries relied on biomass products, many concluded that subsistence farmers' firewood consumption was the cause rapid deforestation and desertification observed in both semi-arid and mountainous regions. Overnight, crash programs were funded to replant trees and reduce household fuel demand. Governments and NGOs developed and distributed "improved" cookstoves worldwide; "social forestry" was established as a sub-field, promoting forest use by local people rather than commercial interests.

A decade later, it is clear that neither improved cookstoves nor social forestry programs have lived up to expectations. In both cases, failure has often resulted from top-down, technological "solutions" that neglected local needs and constraints; in particular, *women*'s time constraints have made it impractical for them to tend new plantings or alter cooking practices. In addition, tree species selected for social forestry programs did not meet local forest users' needs for trees providing not just fuel, but food, fiber and fodder.

Critics now not only question this technological response to deforestation; they challenge the fundamental policy assumption that environmental degradation is primarily caused by subsistence farming families. Brower even argues that "hasty application in the Himalaya of experience and practice derived from Western relations with environment and resources" has become part of the problem ("Crisis and concervation in the Sagarmatha National Park," *Society and Natural Resources* 4(2): 151, 1991.) Gilmour's paper for an IDRC workshop in 1991 suggests that the crisis scenario for Nepal was based on short term observations that lacked historical perspective. He notes that deforestation is not a recent phenomena: a century ago, forests were cleared in order to mine iron and copper while the wood was used for smelting. Nor has deforestation increased markedly in the last three decades, although a decline in the density of national forests is apparent.

Three other factors contributing to Nepal's environmental problems are often overlooked: the geological characteristics of the region, illegal timber harvesting, and rapid modernization that is being stimulation by the development process itself. The Himalayan mountains are continuously being pushed upward as the tectonic plate under the Indian subcontinent moves northward. This geological destabilization is exacerbated by monsoon rains that concentrate 80% of all rainfall in four months of the year. Surface erosion caused by these forces accounts for less than one-sixth of the total with most sediment resulting from processes that are largely outside man's control.

The negative environmental implications of rapid modernization, particularly urbanization and infrastructure projects, tend to be ignored by governments intent on economic development.

Brick kilns in Kathmandu Valley not only consume vast amounts of wood, but also contribute of the air pollution that obscures the glorious mountain views throughout much of the year. Population densities exploded in the Terai, the lowlands bordering India, once malaria was controlled, but government forest policies continue to focus on the hills, and so neglect profound regional variations. The sole exception to government inaction has been the environmental impact of increased trekkers in the mountains: fuel for campfires must be brought in and trash removed.

Despite the expectation that urbanization would promote an energy transition to more efficient fuels, urban demand for firewood remains strong in Nepal. In Kathmandu in 1988 kerosene cost less than firewood, but supplies were so unreliable and stoves so expensive that few families switched. In Champi, a degraded forest area near Kathmandu, 35 percent of all households sell firewood to urban markets as their main source of income. Road expansion in the hill areas also contributes to environmental degradation. Road cuts appear as wounds on the fragile hills of Nepal, oozing soil down steep slopes. During construction, road crews use surrounding trees for heating asphalt as well as for cooking. The Swiss Agency for Technical Assistance (SATA) has switched to using cold bitumen emulsion on new roads, arguing that the bitumen process is cheaper when the cost of replacing trees is added to asphalting costs.

Efforts to arrest forest depletion have been severely hampered by favoritism and corruption in the granting of timber-cutting rights. Officials at all levels of the Ministry of Forestry have been linked to the illegal sale of privileges in every recent regime; during the 1980 referendum and the 1991 election campaign, politicians virtually sanctioned deforestation by promising handouts of forest lands in return for votes. Political will to end corruption and to address the environmental impacts of urban fuel demand and road building does not yet seem to exist within the power structure, and so cannot be addressed by the donor community. By contrast, forestry projects aimed at poor subsistence farmers are politically uncontroversial and relatively cheap.

Women and nature

Women's extensive use of and knowledge about forest products has only recently been documented. In Nepal both westernized government foresters and foreign experts have typically devalued indigenous knowledge, making it difficult for either the development community or the local patriarchal society to appreciate women's inherited learning.

By contrast, "ecofeminists" in the West celebrate women's perceived affinity with nature, and see parallels between the drive of industrialization to conquer nature and the desire of men to dominate women. Women better appreciate "the interconnectedness and diversity of nature," according to

Vandana Shiva, a leader of the ecofeminist movement (*Staying Alive: Women, Ecology, and Development* 1989.) Among ecofeminists' best-known heroes are the Indian Himalayan women of the Chipko Andolan movement, who hugged trees in order to prevent commercial cutting. The international romanticization of this movement has focused on the symbolism while ignoring the real needs of women living in the hills of Uttar Pradesh, according to a young Indian scholar who insists that "we must disentangle the realities from the myths" and focus on the basic problesm. Nonetheless, this championing of poor women over development has made Shiva something of a cult figure among environmentalists worldwide. Increasingly, environmentalists in the South have joined with ecofeminists to question the mainstream environmentalist constituency of the North, with their technocratic views, and to support those grassroots movements in the South concerned with social justice.

In Nepal, dependent as it is on the largess of foreign aid, the argument for including women in forestry programs is based on efficiency, not social justice. Development practitioners support the inclusion of women in forestry projects because women are major users of forest products and are likely to continue utilizing the forest illegally unless provided with fuelwood and fodder alternatives. In order to succeed, in other words, practictioners argue that forestry programs must enable women to meet their familial and community responsibilities (if not necessarily their personal needs and wishes). Yet the influence of ecofeminism penetrates the program objectives and reflects claims of superior knowledge by women.

Community forestry in Nepal

Community forestry programming was developed to respond to the perceived worsening of deforestation and forest degradation in Nepal. For many years, many observers blamed the problem on the 1957 Private Forests (Nationalization) Act, which placed all forests under government control. The act was meant to reduce large forest holdings granted by the former feudal overlords, known as Ranas, to their supporters, but the lack of cadastral surveys defining clear boundaries to national forests made it possible for individuals to clearcut forest land for agriculture use and then register the land as private property. Forest degradation was attributed to villagers who, it was assumed, no longer had vested interest in the protection and upkeep of local forests, and so over-exploited them. Despite widespread rejection of this explanation, this assumption was incorporated into the 1989 Master Plan for the Forestry Sector, 1989-2010, funded by the Asian Development Bank and the Finnish government, and thus remains the basis for current policy.

Subsequent legislation under the 1957 act set up a forest-use permit system, but the regulations proved difficult for the small forest service to

enforce within the extensive nationalized forests. This legislation turned forest officers and rangers into policemen, an unpalatable role, according to former Nepali forester Tej Mahat. In 1973, Mahat began experimenting with ways of involving local forest users in forest protection; his pilot project greatly influenced community forestry policy in Nepal. Like Mahat, most development experts considered centralized national forest control not only wrong but unenforceable, given the country's topography understaffed forest service; they argue that in the hills of Nepal *there is generally no alternative* to community forestry - and that its essence is a *real transfer of responsibility* for forest protection and management, from the central government to the users.

The 1976 National Forestry Plan transferred to village communities (then known as *panchayats*) the rights to manage local forests for their own benefit. Religious institutions such as monasteries and temples could also acquire forests, while a category of leasehold forests allowed other institutions or individuals similar rights. The forest available was immense: it was estimated that local villages could have formal responsibility for managing more than 2.5 million hectares—over two-fifths— of existing forests. The implications for the forest service were staggering. Instead of a centralized cadre of foresters trained in commercial forestry and charged with enforcing forest laws, the service had to reinvent

itself as a rural development agency, capable of working with poor villagers not only to maintain existing forests, but also to plant non-commercial trees for fuelwood and fodder. The forestry institutes would have to drastically alter their instruction: currently students continue to be trained as rangers who do not require empathy towards villagers and their problems. The task of reversing this situation and creating a cadre of people with a new 'world view' implies a generational change.

The general outlines of community forestry in Nepal was not affected by the return to multiparty elective government in May 1990 with no substantative changes beyond substituting the word "community" for "panchayat" where it appeared. The 1989 Master Plan for the Forestry Sector, 1989-2010, was endorsed by both the interim and elected goverments and formed that basis of the Forest Act of 1992 that was passed in September and signed by the king in January 1993. Although this legislation repeals earlier laws that emphasized central state control of the forests, its brevity leaves many of the specifics of forest denationalization to future legislation.

International influence

Much of the impetus for emphasizing community forestry came from the donor community. Their influence derived not only from their funding but also from their representation large numbers of professionals brought into

Nepal as advisors and managers. As early as 1954, a forestry expert from the Food and Agricultural Organization (FAO) observed that "deforestation frequently assumes disastrous proportions." The Nepalese government asked in Australia to plant eucalyptus near Kathmandu in 1962; in 1978 the Nepal-Australia Forestry Project (NAFP) took the lead in implementing the community forest concept. USAID funded the first aerial survey in 1964.

By 1987, some 37 international agencies (eight multilateral organizations or international banks, fifteen bilateral agencies, and fifteen international non-governmental organizations) as well as three Nepali groups were involved in forestry projects and data collection, usually as part of broader development programs. These forty organizations along with five semi-governmental corporations, two international research groups and the International Centre for Integrated Mountain Development (ICIMOD), plus some twenty-two different governmental departments or boards, ran 68 discrete forestry programs. More than half of these projects included community participation in tree planting, forest protection, or promoting improved cookstoves; the others ranged from commercial timber programs to studies the use of forest products as medicine, food, or craft materials, to environmental and topographical surveys, and conservation and resource policy and planning. Among the 35 participatory programs were six major afforestation

projects, 15 watershed projects, and 14 small forestry projects run by NGOs.

The donors' role in such projects was, for better or worse, extremely influential. Their financial clout alone was immense; for example, the Tinau Watershed Project in Palpa District, jointly financed by Swiss and German aid, supported 70% of activities carried out by the District Forest Office. The CARE project at Begnas Lake near Pokhara hired villagers to build stone fences around plantations to encourage their cooperation. Not everyone approved of this practice of coopting villagers with income. A Nepali forest officer and a Swiss aid official noted that the Integrated Hill Development Project in Dolakha District pays "the villagers to grow trees in the nursery... then pays the villagers to plant and ... protect the trees from themselves." Not only is the cost extremely high, but the process has made the people dependent on the project and reduced their previous involvement in forest protection.

Implementing community forestry

The 1978 Panchayat Forest Rules and Panchayat Protected Rules created two categories of community land, both based on the lowest level political and administrative unit, known then as *panchayat*. Nepal at the time listed 2913 village and 23 town panchayats; population of village panchayats varied from between 2000 and 5000. Degraded forests, enclosed to permit regrowth, were termed Panchayat Protected

Forests and are now called natural forests. Over-grazed and barren lands were turned into village plantations, using seedlings supplied by the forest service. Income from the sale of forest products grown on the plantations, but not those taken from the forest, went to the village panchayat.

To receive title to local forest lands, a panchayat had to produce a management plan in consultation with the District Forestry Officer (DFO) that then wound its way through several higher levels of the bureaucracy, a procedure that considerably slowed down the process. Difficulties in developing an acceptable panchayat management plan encouraged some local forestry officials to proceed informally, a choice that may have made the agreements more durable after the end of the panchayat system in 1990.

Because the community forest program assumed that years of instability in rural areas had undermined any traditional organizations that once controlled forest access and use, management plans were to establish village-level "users' committees," charged with overseeing plan implementation. Early on, debate arose over the composition of the committees: should they consist of locally elected village officers, or of actual forest users; would village elite allow members from all groups? Increasingly, as the persistence of caste and gender hierarchies became more apparent, the question became: is there a *community* at all? A report to the Overseas Development Institute argues that the word implies "that local communities are an homogeneous entity, united for common action by their need for firewood and fodder...(and ignores) the differential access to both natural and political resources within the village dependent upon... caste, class and gender." Hamlets within a village, known as wards, often reflect ethnically distinct settlements. Further, panchayat boundaries were often arbitrary: contingent areas may be in different panchayats, while wards in one village may be separated by several hours' walking time across a deep ravine. Several panchayats, even in different districts, may have customary rights to the same forest lands, thus raising the need for multi-village committees. During my field research, panchayat officials frequently mentioned the difficulty of reconciling the interests of local user groups with those of the larger panchayat.

The original assumption that fuelwood was the primary forest need was quickly revised, as the role of livestock in hill agriculture became better understood. Animal manure is essential as fertilizer, and 35% of animal feed come from trees. This farming system requires one large animal per person for a family of 5 or 6; thus for each hectare of agricultural land, 1.3 hectares of forest land are needed to supply fodder. Foresters, however, had not been trained to grow fodder trees. Those with the Australian project said they started from an almost unbounded ignorance, but through trial and error, the project

learned techniques for propagating fodder trees which are now, in fact, widely copied.

Forestry programs have been much slower to rethink approaches to the introduction of theoretically "improved" cookstoves. Some 35,000 improved and highly subsidized cookstoves were distributed by 11 different projects funded by six independent agencies through forestry programs between 1981 and 1987. An assessment in 1987 found that the stove model being disseminated was inappropriate for a large segment of the population and recommended redirecting research toward less expensive versions, possibly modeled after widely used indigenous stove types. In addition, the insistence on including cookstove promotion in community forestry projects requires forestry workers in many projects to take on responsibility for both kinds of programs.

Including women

In Nepal, women fetch animal fodder daily, while men collect fuelwood much less frequently, harvesting timber for storage a few times a year. But as men have increasingly sought work away from the hills, women have taken over even more of the farming chores. Development agencies realized some years ago that neither community forestry programs nor cookstoves would win local acceptance if they did not fit women's work schedules. During the 1980s, most forestry projects began using professional women as project and field staff, but they stayed in Kathmandu. NAFP appointed a Nepali woman as Women's Coordinator, charged with interviewing NAFP staff and villagers about women in the project, distributing improved cookstoves, and running a scholarship program girls. The coordinator found women in the project area aware of the need to protect the forest, but gravely concerned that bans on cutting forest fodder would hurt those women who had no trees their own land.

This worry was well founded. In Banskharka, an authoritarian village chief had formed his own forest committees and closed the forests, forcing many near-landless lower castes to break the law or migrate to India. Women headed households were particularly vulnerable. In one ward, male outmigration had left five of eight households headed by women. The village chief allowed only male household heads to register common pastures as their own personal property, thus usurping the women's forestry rights even though **all** the households had contributed equally to the forest's purchase 40 years before. Accusations of witchcraft against some of the women helped justify the actions.

At project sites, local women were hired as nursery managers and forest watchers. Although gender hierarchies remain strong in the Hills, greater equality exists among the lower castes, who are most likely to take these jobs anyway, than among village Brahmins and Chettris. The Tinau Watershed Project hired six female "motivators" to

visit women's user groups and encourage cultivation of improved grasses in silva-pastoral plots, according to the DFO Diwakar Pathak. With alternative fodder from these grasses, the women could accept the closing of the degraded forest areas to allow natural regeneration. Because many poor women survived by selling firewood in the towns, the project also supported alternative income-generating activities. One widow began to make orange and lemon squash in her rural home, bottle it, and then sell it to roadside snackshops. Collecting and selling seeds from the forest produced income for other women. Some forestry projects used women a nursery attendants.

Women's membership in forest user committees proved more problematic. Traditionally, two classes of villagers use the forest: women, children, and some men who collect fodder, bedding, and fuelwood from the forests; and men for the traditional elite who decide rules for forest access and exploitation of timber. Since user committees duties' included overseeing the planting and weeding of panchayat plantations, as well as the control access to panchayat forests for fuelwood collect, all women's activities, men could accept women members, especially when the suggestion came from the district forest controller (DFC) or the local development offices (LDO).

Whether to accomplish women's participation by establishing separate women's committees or by ensuring female membership in male forest committees was the subject of some debate.

The Nepal-Australia Forestry Project opted for integrated committees. Although Australian aid has been active in Nepal since 1966, the project's planning documents did not mention women's role in forestry until 1985. It then announced its goal to raise "the social and economic status of women in the project area by involving them directly in the community project;" it rejected the idea of a separate women's component "because the role of women is integral to almost every one of (the Project's) aspects."

Evaluations of women's participation in Thapagaon, in the NAFP area, indicate the difficulties in changing local attitudes. Apparently women were put on the forestry committee to please project personnel and one elected as vice-chairman, but they "were actively discouraged from attending the meetings." As one woman said, "we are only invited to meetings when foreigners will be present, otherwise we are completely excluded." In addition, their husbands and fathers did not inform them of decisions made at the meetings. The NAFP coordinator commented that most village women are illiterate and have a very localized view of life, while the "male members of society... may not be very keen to give power and authority to the women as it will threaten the *status quo.*"

Such examples of exclusion indicate the need for separate rather than integrated programs, according to many Nepali feminists. Indira Shrestha harshly criticized the NAFP women's

programs a an evaluation report: *It is disquieting to find that...there is no awareness of the need to make any special provisions to incorporate women into community forestry, either in terms of forest officials, field staff, or the rural population....Unless there is a distinct component for women... and training programmes for women to build up a cadre of female field staff, the Nepal Australia Forestry Project cannot achieve its envisaged goal* (Women in development in Nepal: An analytical perspective. 1989:56). Yet NAFP showed no signs of changing, and funded a training manual that reiterates that women in forestry must be part of all programs and male extension workers must learn to work with women.

A USAID-funded Integrated Rural Development Program in western Nepal also tried integrated forest committees. This program required that women comprise 25 percent of committee membership. In addition, panchayat officers could not serve on the committees, but only local forest users. This arrangement allowed women to have a say in daily forest use, while still allowing the traditional male village elite to prepare the management plan.

Darchula District, in western Nepal, claims the oldest and greatest number of women's forestry committees, in part due to the efforts of a situation an enthusiastic District Forest Controller and a British woman volunteer. While the majority of members belong to upper castes, lower caste Tamang and Gurung women are bold and independent members, drawing on their experience working as traders in India. Women members say they "enjoy belonging to a group and "improving" themselves by taking on new tasks and responsibilities."

Two panchayats eventually decided that women-only committees were not reasonable and elected men to join. Men also frequently attended meetings of the all-women committees; in some cases they dominated the discussions, in others not. In one village the women asked men to form an advisory group to assist them. However, when women in Pipalchaurie, Darchula District, tried to discipline men caught illegally cutting wood in the government forest, the women ran into opposition from other men, who thought that they were "getting above themselves." Clearly, women's efficacy as forestry committee members depends in part on the support of local men.

A 1987 workshop on "Women's Participation in Forest Management," sponsored by Winrock International, allowed Nepalese and expatriate field workers to exchange information and make policy recommendations. Two conclusions threw into question the entire concept of women in community forestry. First, the group rejected separate components for women, arguing that "the issue is not 'how to involve women' but 'how to involve motivated community members who will ensure that community interests are met in the management of the resource.'" Secondly, the workshop rejected the idea that only female staff could reach

village women, and stressed that forestry programs could not afford to wait 20 years for the recruitment and training of sufficient numbers of women foresters. "The emphasis should be on making current personnel effective."

These ideas stand in stark contrast with recommendations made at the "International Workshop on Women, Development, and Mountain Resources" held at ICIMOD in November 1988. Well known feminists researchers and writers, rather than field workers, presided at this conference; their views were endorsed by the men attending. Their report emphasizes the importance of "gender as an analytical category" in research, policy, and program implementation. Analyses of gender variables, it stated, will illuminate women's decision-making roles in resource management, a necessity if women are to be treated as more than laborers. The report also identified women's limited land-ownership rights – a topic usually avoided because of its deep cultural roots – as a major obstacle to women's ability to participate in resource-related decision-making. In addition, it called for hiring more women as development professionals. Subsequently, the Institute of Forestry began offering 15 percent of all seats to women.

These contrasting views reflect, first, the difficulties of implementing policies designed in Kathmandu in rural areas, especially given the cultural distance between educated urban women and women villagers. Further, only a limited number of trained women (or men) are willing to work outside the capital. Secondly, the contrasting policy recommendations reflect the ongoing debate in women-in-development circles: should programs for women be separate or integrated? Experience has shown that neither approach works alone. Program design that incorporates both women's and men's concerns along tends to attract more funding and bureaucratic support; program implementation usually functions better when women work together in their own organizations.

While the two workshops disagreed on project design and staffing, both emphasized the diversity of women's activities, and called for closer coordination among village-level development projects. Even here perspectives differed. The Winrock group advocated training women in community participation skills; ICIMOD participants spoke of involvingwomen in the market economy in order to improve their status and economic security. The two views respond to women situated at opposite ends of the transition that defines their identity: first approach emphasizes women's community and falands while formingmily roles, while the latter stresses women's individual autonomy.

CURRENT ISSUES

Nepal's return to multiparty elective government in May 1990 created an atmosphere more conducive to citizen participation. In rural areas, the new climate allows "more space and leeway for... creative and innovative grassroot

development experiments," according to Deepak Tamang who conducts action-research porjects for a Nepali NGO. Indeed, evidence suggests that even under the previous regime many remote communities continued to monitor and manage their own forests, substantiating the argument that common property regulation is likely to be the most effective response to scarcity and that overuse occurs only when resources are open to unregulated access by individuals." Indeed, an analysis of current management systems suggests that they are not simply replications of ancient practices, but rather dynamic responses to new situations that sometimes adopt some of the formal features of earlier systems.

ICIMOD researcher observed more community involvement in forestry in central Nepal in 1990 than ten years earlier; he also found the forests in *better* condition, primarily because there were fewer livestock to be fed and cared for. A USAID projecthad developed a plantation on degraded land and hired forest guards to protect the trees; grazing and cutting of trees for fuel or fodder were prohibited, although collection of dry fuelwood was allowed. Villagers were forced to reduce their livestock holdings, an action facilitated by the increased availability of chemical fertilizers to replace manure for agricultural use due to a recently completed motorable road to Gorkha, and hour's walk away. To feed the remaining livestonk, farmers planted trees on their own land. Ancillary effects of theses changes have benefitted both women and children. Fewer livestock to tend meant more children in school. Less fodder to collect meant that women had more time to respond to the activies sponsored by the two NGOs active in the area.

The new atmosphere has encouraged greater activity among women who participated in unprecedented numbers during anti-panchayat demonstrations. The 1990 Constitution proclaims equal rights for women and repeals all previous discriminatory laws, but such legislative changes do not in themselves necessarily guarantee women's status will improve. The 1950 Constitution also gave women greater inheritance and marital rights, but societal attitudes towards women prevented them from exercising those rights. And during the writing of the new Constitution, the parties initially supportive of women's rights went back to tradition when these values came in conflict with traditionally entrenched practices.

More women have become active in forest user groups. In one Save the Children USA forestry, for example, they take part in training programs to learn how to plant and raise seedlings, and women's groups run local nurseries. In one case, a group has used its nursery profit to start a revolving credit fund for its membership.

Aware of decreasing forest resources, more and more villages are taking advantage of community forestry legislation to register their own forests and restrict access of neighboring villages who then rush to register their own

forests, creating a domino effect. In Gorkha District, 84 community forestry areas had applied for rights by the end of 1992 and 32 had received them. Four of the five user groups sponsored by Save the Children, USA, in *ilaka* (sub-district) 1 of Gorkha District were women's groups. In one instance, three separate women's groups combined their small plantations in order to apply for recognition and increase the pool of households able to patrol the forests. In another, the women registered as the official group but set up a separate male advisory committee. Nearby, women and men together established a ward plantation, but only men were listed as official users. The evaluator emphasized that *""The practice of listing only the women in the user group...does not mean that women and men are opposed to each other. It would have been impossible to make the forestry program a success without the cooperation of the men".* While both women and men take leadership roles in community forestry, a division of labor exists: women tend to manage plantations while men manage natural forests. These trends in Gorkha are significant but do not are necessarily predict how other districts might proceed.

Administrative changes are slowly making an impact. Although the panchayat system has been abolished, the same administrative divisions (except for Zones) remain so that the issues of community, and of locally entrenched hierarchical authority patterns, persist. Village Development Committees have replaced the panchayats at the community level, but District Forestry Officers are allowed to by-pass the community and register users groups at the ward level. Because these units are small, ward user groups from the same Village Development Committee or even from neighboring village committees may join into a more logical geographic unit to manage natural forests and/or forest plantations.

The conflicting roles of forest rangers are being addressed, forestry planning staff informed me, by creating three distinct cadres and training them accordingly: rangers assigned to the hills will be trained as community foresters to work with women and men to sustain the forest; rangers in the Terai will fulfil the more a more technical role, advising industries that are growing their own materials. Special conservation units will manage national forests surrounding the highest mountains. Private interests in forestry are to be granted recognition through greater use of leasehold rights which will transfer management to various classes of community.

SUMMATION

In this article I have argued that community forestry programs, based on the erroneous assumption that the subsistence farm family is largely responsible for forest degradation in Nepal, create unrealistic expectations. On the positive side, recognition that villagers must have control over the forestry resources they utilize if they are to maintain them has altered rural dynamics and

allowed more participation throughout the country.

It is an equally unrealistic expectation that women, with their spcial affinity to nature, can solve deforestation through forestry or cookstove programs. This assumption makes them particularly vulnerable to being identified as the cause of failure when project goals are not achieved. On the other hand, the inclusion of women in forestry committees sends a signal of legitimacy and approval from government that challenges the status quo. Simply raising the issue has forced both planners and administrators to confront the sexual division both of labor and of decision-making at the village level. Evaluations of pilot programs reflect the complexity of social change and caution against importing assumptions to Nepal either about women and nature or about gender relationships.

The history of community forestry in Nepal and of the efforts to include women in forestry programs illustrates the complexity of economic development and its inevitable corollary, social change. Easy solutions offered by conventional wisdom need to be set aside and the entire development program in Nepal reconsidered in light of the realities portrayed in recent reports. Identification of the broad array of programs and lifestyle changes that are at the root of deforestation in the Himalayan hills is the first step toward addressing environmental degradation in Nepal.

WOMEN MAKING MONEY

E CONOMIC DEVELOPMENT LED TO INCREASINGLY MONETIZED ECONOMIES. WOMEN WHO were primarily farmers often made small baskets or pottery to exchange or sell, or took surplus produce to the local market. These women or men, whether selling fulltime or in down time on the farms, were too small to be counted as enterprises. Marxist theory considered them part of the peasant system which would soon be incorporated into the labor economy. In the 1970s, recognizing the persistence of the informal sector, the International Labour Organization (ILO) began a series of studies about this sector trying to estimate the numbers of people so employed. Even then, they ignored women or family enterprises by defining the sector as those enterprises with 5 or more employees. I became engrossed in the effort to convince governments and the World Bank to begin including informal enterprises in their overall economic data and so further confirm women's critical economic roles.

INCOME PRODUCING PROJECTS

The money economy undermined the local demand for small crafts as imported cloth or plastic buckets seeped into the local markets. To provide alternate income, many NGOs tried to teach rural women to knit and sew even when the local culture considered tailoring or weaving as male occupations.[1] The results were too often failures. In Egypt, local organizers ended up buying the clothes the villagers sewed, and using them for rags. In Nepal, the poorly knit sweaters were seldom sold. In Bangladesh, chairs were acceptable on the local market but were not of good enough quality for exporting. However, where women were given sewing machines, they made clothes for their families and could also earn money by sewing for neighbors.

In many countries local crafts were so attractive that organizations and even Peace Corps Volunteers strove to find a market for them. Quality control was always a problem, but the primary reason these efforts were not sustainable was because they ignored the costs of marketing. As long as the NGO carried the goods to the cities and found shops to sell them, women did receive a modest

1 "Women, gender, and the informal sector: Sub-Saharan Africa" in *Encyclopedia of Women and Islamic Cultures: Volume IV Economic, Education, Mobility, and Space*, 2007, p. 191. Leiden: Brill. Suad Joseph, general editor.

income. Once the costs of taking the goods to market and selling them were factored in, most such efforts collapsed. However, the rise of the internet has revived some of these projects because marketing costs are low.

When I was first in India in 1951, I often bought silk scarves from Benares and wood carved in Kashmir. Quality was uneven, and buying them entailed bargaining which I was not good at. The Cottage Industries Organization realized that tourists would prefer a store where the quality goods could be sold at fixed prices. Several times I accompanied, the buyer for the new store, Prem Bery, as she visited craft establishments to explain the new standards to the women dyeing cloth or weaving silk. I bought the silk for my wedding dress from this shop. Visiting the now quite glamorous Cottage Industries store is a required stop for tourists.

International agencies also introduced income-generating projects for women. One of more successful was the ILO. Their projects utilized traditional craft skills in the design of new products. In Bangladesh, I bought wall hangings made from coir, a technique previously used in making burlap bags. In Laos, ILO introduced new colors and more sturdy cloth for making Shan bags – the ubiquitous shoulder bag used throughout Southeast Asia. I still use my rainbow colored bag.

I collected details of all these programs meant to help women earn money. Those sponsored by development organizations were subsidized. Those that included marketing as an integral part of the project have been the most successful.

CREDIT SCHEMES FOR ENTREPRENEURS

A second approach to helping women vendors was to organize women already involved in some sort of income-earning activities. In Ahmedabad, India, poor women made money collecting paper off the streets, selling fuelwood, stitching comforters using scraps from the cotton mills, or bringing produce from distant wholesale markets into the city. If they needed money to buy thread or vegetables, they once paid as much as 50% interest a day. Ela Bhatt organized these women into SEWA – Self Employed Women's Association – and started a bank where the women could deposit their jewelry for credit, then retrieve it later. Income instantly rose when the exorbitant fees were not long needed. All members of SEWA had to learn to sign their names; some became fully literate and became staff of the organization itself. It continues today as an organization run by women for women. I first met Ela Bhatt in 1974 and invited her to the Mexico City Seminar. Her participation at ILO debates on informal sector activities has influenced that agency to broaden its definition of workers. I learned much from her when researching street foods.

The Grameen Bank was started by Mohammed Yunus in a small remote town in Bangladesh. Having just arrived in Chittagong as a professor of economics at

the university, he was furnishing his house with cane chairs. The woman making them produced only one at a time because she could not afford to buy the raw materials in bulk. Yunus offered her credit and began a study of how the poor got loans. Yunus learned that women repaid at a higher rate than men and began to focus on credit to women. But there were few vendors in town, almost none of them women. In the surrounding villages, women were poor farmers with no entrepreneurial experience and often deeply in debt.

To address the need for these farming women to earn money, he instituted two basic concepts that today characterize the Grameen Bank. First he organized women into small groups; these groups served as collateral since he understood that social pressure from others in the group would compel a high level of repayment. Secondly, he realized that the poor borrowed money at exorbitant rates for dowry or other customary celebrations. So he required all members to limit such spending and to practice birth control. These directives and the reasonable loans from the Bank reduced family expenditures. Thus, even if the small enterprises the women began were not very profitable, the family standard of living improved.

This success led many agencies to introduce similar schemes in other countries. I studied them in many places and concluded that the Grameen Bank was so rooted in the Bangladesh culture that it did not travel well. But the momentum of offering credit to women spread widely; the most effective schemes, in Bangladesh and elsewhere, were those giving loans to women already engaged in enterprises.[1]

Just after I moved to Portland, the American Planning Association asked me to write an article about what international credit schemes might offer planners in the US. Literature about credit programs in the states had concluded that credit was not the primary problem in the US; rather asset accumulation and training were key factors in alleviating poverty. Individual Development Accounts had recently been introduced in Portland. Participants may open an IDA at a local bank only after completing a training course on financial management. They then deposit 10 or more dollars a month for 2 or 3 years; matching funds at a ratio of as high as 5 times are added to the IDA account. Thus a participant will have much as $1800. To use as down payment on a house, buy a franchise, or enroll in college.[2]

1 I detail the various credit schemes in "Credit for Poor Women: Necessary But Not Always Sufficient For Change", Journal of the Marga Institute, Columbo, Sri Lanka, special issues on women, Spring, 1989. For a comparison of SEWA and the Grameen Bank see: "Many paths to power: women in contemporary Asia," 2004, in Promises of Empowerment: Women in Asia and Latin America, Peter H. Smith, Jennifer L. Troutner, and Christine Hunefeldt, editors. Pp. 35-59. NY: Rowman & Littlefield

2 "Alleviating poverty: investing in women's work," Journal of the American Planning Association. 66/3: 229-242, summer 2000.

STREET FOODS

Most programs to help women produce income emphasized credit for the very poor with little or no experience in the market. I decided to study women who were already making money as vendors. Selling processed food on the streets was wide-spread in urban areas, especially in Southeast Asia. Curious about the scale of their income, I sought funds for a multi-country study about who makes, sells, and eats food on the streets.

At the time, no one considered these "snack foods" an important part of the economy. But I knew that full meals were also sold and decided I needed a more distinctive name for the study and settled for Street Foods. Preliminary research found no studies of this sector; to understand women's involvement required a field study of the trade. And since foods sold reflect local availability, the research had to cover an entire year of sales. Interviewing vendors required local staff so I looked for women's research groups as partners both to provide training to them but also because men could not interview women in many countries.

My original goal for this action-research project was to understand the Street Food trade in order to increase the income of the vendors. A second goal immediately emerged: how to improve the safe and quality of the food sold. Details of the methodology our team developed and how this action-research expanded to seven countries under EPOC overview– Philippines, Indonesia, Thailand, Bangladesh, Egypt, Nigeria, and Senegal, plus two using our methodology: India and Jamaica – are summarized in a chapter for an academic publication[1] ecounted in the Introduction of my book on *Street Foods*.[2] EPOC freely shared the methodology and some other groups sent us their results which I utilized as illustrations in the book.

In each country EPOC placed a team to study the sector for a full year. To engage local administrators and academics, and to check the translation of the questionnaires, EPOC set up an advisory committee. Our findings were presented to the committee and to the funders at the end of the project. I then visited each project after five years to see how effective our recommendations had been. Finally, I struggled to organize all this material into a readable book; a fellowship at the Rockefeller Bellagio Center in Italy helped me assemble the final manuscript.

Findings from the EPOC study led to many significant policy changes:

1 "The Urban Street Food Trade: Regional Variations of Women's Involvement," in Esther Ngan-ling Chow & Catherine White Berheide, eds., <u>Women, the Family, and Policy: A Global Perspective</u>, Albany, NY: State University of New York Press, 1994.

2 Street Foods: Urban Food and Employment in Developing Countries. NY: Oxford University Press, 1997.

- the street food trade produces significant income and feeds a large segment of the urban population;[1]
- legal issues such as where vendors could sell their wares or what health permits they needed inhibited, but did not stop, the practice;[2]
- attitudes toward street foods rapidly changed once the importance of the trade to the income of the municipality was documented, although large metropolitan areas increasingly limited the areas where street foods could be sold;[3]
- FAO, which had been advising governments to demand impossibly high standards, began to organize the vendors to help them improve their food and status.[4]

Our findings challenged a series of informal sector assumptions rooted in Marxist theory and embellished by the ILO studies.[5] According to these beliefs, all informal sector activity was exploitative and would eventually be absorbed in the formal economy. The expansion to subcontracting seemed to confirm this, but careful studies of women's work for subcontractors often found they were independent contractors, ie microentrepreneurs. I wrote an article on this confusion with a brilliant graduate student, Lisa Prugl, titled "Microentrepreneurs and Homeworkers: Convergent Categories," which is reprinted in this volume.[6]

Street food vendors were not embedded in industrial production. Rather, their

1 "Street Foods: Income and Food for Urban Women," in Marianne Schmink, Judith Bruce & Marilyn Kohn, eds, Learning About Women and Urban Services in Latin American and the Caribbean, Population Council, NY. 1986. pp 205-227.

 "Street Foods as Income and Food for the Poor," Dossier 49: Sept.-Oct., 1985.

 "Street Foods: The Fast Foods of Developing Nations", VITA News, Jan. 1987.

2 "Legalizing Street Foods in the Third World: The Right to eat on the street", Howard Law Journal, Fall, 1987.

 "The Case for Legalizing Street Foods", CERES, Rome: Food and Agriculture Organization, Sept/Oct., 1987.

 "Legalizing Street Foods in the Third World", Whole Earth Review, pp 72-74. Spring, 1989.

3 "The Street Food Project: Using Research for Planning," Berkeley Planning Journal, 8:1-20. Dec., 1993. Bangkok became much more supportive of food vendors after the financial crisis in the 1990s; when an out-of-work banker began selling sandwiches and made a good living. The government now views vending as buffer for bad times.

4 "The Organization for Development and Support of Street Food Vendors in the City of Minia: Model for Empowering the Working Poor," Cairo: SPAAC for the Ford Foundation, Aug., 1993.

5 Street Foods: Testing Assumptions about Informal Sector Activity by Women and Men. Special TREND issue Current Sociology, 35/3 (Nov. 1987). International Sociological Association. London: Sage.

6 "Microentrepreneurs and Homeworkers: Convergent Categories", with Elizabeth Prugl, World Development, 25/9:1471-1482, Sep 1997.

goal was family survival. Economists expect enterprises to maximize profits, but the street food data demonstrate that the family worked long hours together to improve their long term prospects by send children to school. Eating left-over food also enhanced the family's nutritional intake. Thus the husband accepted lower earnings and valued the marriage, confounding game theory where one party wins at the expense of the other. Amartya Sen explains this variation by noting that the family is a unique unit which does not follow gaming theory since winning could lead to the dissolution of the marriage.[1]

Our data showed that street food vendors were not the poorest of the poor and were not transitory. They certainly understood the market and could distinguish profit earned by the enterprise by accounting for the costs of eating the left-over food. All pushed their children to study so that they would not have to continue to be vendors. Many had long term goals to use their profits to buy shops that sold goods with longer shelf life. Vendors were acutely aware of the risks of their trade and avoided taking loans for their business. When a husband in Nigeria gave his wife money to start selling, it was not a loan but an investment in family survival.

The original concept of the street food project was to study women vendors to see if they were making money.[2] Our findings underscored how much women's involvement in the trade was impacted by cultural traditions across the nine countries for which we have comparable data. In Nigeria, 94% of all vendors were women: they sold food while men sold snacks at gas stations. Three quarters of the vendors in Thailand, the Philippines, and Senegal were also women. In Indonesia and Jamaica, many enterprises were owned by the couple. In Muslim Bangladesh and Egypt as well as in Pune, India, men owned most of the businesses. Nonetheless, all had unpaid women helpers who made the food at home and sometimes helped in the selling at the market. The income from street foods earned by women was distinct only where families maintained separate budgets. Overall, vending was a profitable activity.

Findings from the EPOC study led to many significant policy changes:

- the street food trade produces significant income and feeds a large segment of the urban population;[3]

1 Amartya Sen's chapter in my edited volume <u>Persistent Inequalities</u> enlightened my understanding of this issue: "Gender and Cooperative Conflicts."

2 "Street Foods as a Source of Income for Women," with Monique Cohen, <u>Ekistics</u> 310; Jan.-Feb., 1985.

3 "Street Foods: Income and Food for Urban Women," in Marianne Schmink, Judith Bruce & Marilyn Kohn, eds, <u>Learning About Women and Urban Services in Latin American and the Caribbean</u>, Population Council, NY. 1986. pp 205-227.
 "Street Foods as Income and Food for the Poor," <u>Dossier</u> 49: Sept.-Oct., 1985.

- legal issues such as where vendors could sell their wares or what health permits they needed inhibited, but did not stop, the practice;[1]
- attitudes toward street foods rapidly changed once the importance of the trade to the income of the municipality was documented, although large metropolitan areas increasingly limited the areas where street foods could be sold;[2]
- FAO, which had been advising governments to demand impossibly high standards, began to organize the vendors to help them improve their food and status.[3]

Our findings challenged a series of informal sector assumptions rooted in Marxist theory and embellished by the ILO studies.[4] According to these beliefs, all informal sector activity was exploitative and would eventually be absorbed in the formal economy. The expansion to subcontracting seemed to confirm this, but careful studies of women's work for subcontractors often found they were independent contractors, ie microentrepreneurs. I wrote an article on this confusion with a brilliant graduate student, Elizabeth Prugl, titled "Microentrepreneurs and Homeworkers: Convergent Categories."[5]

My fascination with street foods continues. On several visits to Manila after my book was published I investigated the changes and challenges to their street food trade. The paper I presented at the University of Illinois Champaign/Urbana indicated that selling to schools had become a major outlet for vendors and compensated for the restrictions adopted by city governments.[6]

"Street Foods: The Fast Foods of Developing Nations", VITA News, Jan. 1987.

1 "Legalizing Street Foods in the Third World: The Right to eat on the street", Howard Law Journal, Fall, 1987.
 "The Case for Legalizing Street Foods", CERES, Rome: Food and Agriculture Organization, Sept/Oct., 1987.
 "Legalizing Street Foods in the Third World", Whole Earth Review, pp 72-74. Spring, 1989.

2 "The Street Food Project: Using Research for Planning," Berkeley Planning Journal, 8:1-20. Dec., 1993. Bangkok became much more supportive of food vendors after the financial crisis in the 1990s; when an out-of-work banker began selling sandwiches and made a good living. The government now views vending as buffer for bad times.

3 "The Organization for Development and Support of Street Food Vendors in the City of Minia: Model for Empowering the Working Poor," Cairo: SPAAC for the Ford Foundation, Aug., 1993.

4 Street Foods: Testing Assumptions about Informal Sector Activity by Women and Men. Special TREND issue Current Sociology, 35/3 (Nov. 1987). International Sociological Association. London: Sage.

5 "Microentrepreneurs and Homeworkers: Convergent Categories", with Elizabeth Prugl, World Development, 25/9:1471-1482, Sep 1997.

6 "Street food vendors in a modernizing world: action research documents their importance" 2003.

In the United States, street foods have proliferated in many metropolitan centers as migrants introduced their traditional foods to the local cuisine. In Portland, Oregon, where I now live, food carts began this way. As the economic difficulties in 2009 intensified, many young educated people began preparing gourmet foods, adding to the array of street food now available. Newspapers and *Gourmet* magazine interviewed me because my book was the top entry for street foods on Google search. The economic crisis had a similar effect in Bangkok where an investment broker has become a sandwich entrepreneur.

New York City vendors have been organized by a lawyer, Sean Basinski, as part of the Urban Justice Project. He contacted me in 2009 when he was preparing to go to Nigeria on a Fulbright fellowship to study street foods. His work has grown: he has organized annual contests to select the best cart food in NYC and recently introduced a Stepladder Award for vendors who have moved their business to a permanent shop. At the Joint Annual Meeting of the Association for the Study of Food and Society and The Agriculture, Food and Human Values Society in San Francisco in June 1998, I gave the keynote address comparing the challenges of vendors in the US and abroad.[1]

A SOUTHEAST ASIAN VARIATION

While I was in Bangkok in 1983 setting up the workshop on biogas, I used the opportunity to meet with Soon-Young Yoon. She had just published a study of the city's massage parlors and found that the majority were a front for prostitution. Rather than responding with outrage, Yoon noted that many of the women were recruited from the poor areas of northwest Thailand where women were expected to support their parents. Their income for one year in Bangkok was equal to a lifetime income from farming. So the women used their money to buy land and build a house for the family. They were honored on their return to the village, and often recruited others to go to Bangkok.[2]

I persuaded two male participants in the workshop to accompany me to a massage parlor. Women in bathing suits with numbers on their chests wandered

Symposium -- *Women in the Age of Economic Transformation: Successes and Models,* Nahid Aslanbeigui, Steven Pressman, Gale Summerfield, eds. March issue of the *International Journal of Politics, Culture, and Society.*

1 "Street Foods into the 21st Century," *Food and Human Values,* 16/3:327-333, Sep 1999. Revision of remarks at the 1998 Joint Annual Meeting of the Association for the Study of Food and Society and The Agriculture, Food and Human Values Society in San Francisco in June 1998.

2 This relaxed attitude toward prostitution continues today in East Asia according to papers presented at a Conference on Globalization, Gender, and Development in Eugene, Oregon, that I attended in October 2014.

behind a one-way glass. Customers selected a partner for an hour's massage. Both men decided to wait for me while I followed an older woman to the rooms: clearly I was not going to engage my masseuse for the rest of the day, so management would not waste the services of the young woman I had chosen on me. Far from being a relaxing Swedish style massage, I was given very physical treatment clearly meant to arouse sexual desire. The overhead mirrors and a large Jacuzzi accentuated this approach and confirmed Yoon's conclusions.

Comment – This is a recurrent theme throughout the world: women use their earning to support their families to a much greater extent than men do. Development agencies and NGOs now understand this and focus food distribution, microcredit, and many other programs on women. The Thai example simply illustrates how poor women fulfil their traditional duties and are so honored for doing so.

CREDIT FOR POOR WOMEN: NECESSARY BUT NOT ALWAYS SUFFICIENT FOR CHANGE

DEVELOPMENT PROGRAMMES MUST always be analysed in terms of longterm impact as well as immediate utility. Since development assistance agencies, like most bureaucracies, are consumed with the daily or at best, yearly, flow of funding and responsibilities, long- term-impact studies generally fall to scholars. In this article I should like, therefore, to address a form of successful development program—credit for poor women—in terms of both credit programs' immediate contributions to poor women's survival and their long-term implications.

Small-scale credit programs have become increasingly common over the past decade, providing hundreds of poor urban and rural women and men with capital to invest in income-producing activities. These programmes have been widely lauded, both for reaching the poorest sectors of society, and for their impressive loan repayment rates. They typically rely on utilise form of affinity-or solidarity group, an approach which has overcome many of the criticisms of cooperatives or women's organisations.

Nonetheless, there is a growing resistance by some donor agencies to loan funds at this level, on the grounds that they are economically defensible.

Further, there is a growing concern that the income-generating activities resulting from such loans increase women's work more than they improve their livelihoods The fundamental theoretical issues these criticisms raise will be addressed, following a brief review of existing credit programs.

CREDIT PROGRAMS FOR THE POOR

Credit. at reasonable rates and without collateral requirement, is now available to the poor in many countries. Such loans have benefited poor women especially, allowing them to start micro-enterprises and so earn income critical to theirs' and their families' survival. Most such programs are based on the Grameen Bank model, developed by economics professor Muhammad Yunus, which utilises the aforementioned affinity groups to guarantee loan repayment. Earlier efforts to make credit available to the poor through co-operatives failed in stratified societies precisely they did not account for existing intra-village power relationships.

While the Grameen Bank has achieved phenomenal repayment rates of nearly one hundred per cent, rates vary among programs patterned on the

Bangladesh model. A major reason for the difference is the assumption that giving credit is the only objective of a credit project. In fact, successful credit programs are the entering wedge in social change. Critical to this change for both women and men is a shift in household spending priorities. But for women, the ability to earn money can also have profound effects on intra-household divisions of labour and resource allocation.

Since the Grameen Bank is so much more than a bank credit scheme, the following section will analyse its distinctive programmatic and philosophical approach to helping the poor. The next section will then address the criticisms levelled at credit programs by both economists and feminists.

The Grameen Model

The sucess of the Grameen Bank program does not rest on the provision of credit alone, but credit is the motivating factor. Organisers offer landless villagers low-interest loans, available in 1983 at a total cost of 13% per year—as compared with a local moneylender rate of 10 percent per week ! Before villagers are eligible for such loans, however, they must form an affinity group, the most visible of the bank's innovative techniques. Also important in the Grameen model are emergency provisions for loans or loan repayment. Equally critical, attitudinal change efforts address some of the underlying causes of persistent poverty.

These three elements: group solidarity withindividual responsibility, safety net features, and attitudinal change have the potential to lead a restructuring of village social and economic relationships. To the extent that these credit projects succeed, they bring about a concomitant shift in resource allocation within households as well as villages. It is important to determine whether local people will welcome or feel threatened by this shift.

Group solidarity with individual responsibility

The affinity or solidarity group is modeled after the rotating savings group, a traditional system of saving found throughout the world. Members generally know one another either through family, neighborhood, or workplace ties, and tend to be of the same sex and similiar socioeconomic status. Each member puts a set amount into a kitty on a regular basis, each week or each market day; the total kitty is then distributed in turn to each member. No additional money is added, but the rotating credit group, by requiring regular savings, allows an individual to accumulate a significant sum for use when it is her turn to receive the total amount.

Contemporary affinity groups are composed of the same kind of members, but introduce additional lending funds. As loan guarantors, each group member is responsible for loans made to any other. Clearly, then, group members must trust one another, for the

group itself does not benefit as a group. This important condition is a critical characteristic of affinity groups. These groups do not work together on community projects; they do not share their profits; theoretically they would share losses but in fact seldom are required to do so. They simply stand surety for individual loans. Hence, group cohesion with individual responsibility is the first prerequisite for the success this type of lending program.

The Grameen Bank suggests that each group consist of between five and ten persons of roughly equal status; neither relations nor members of the same household may join the same group in order to avoid introducing traditional hierarchies. The by-laws require members to attend weekly meetings and save one daka each week. The Bank grants loans only *after* the group has demonstrated its own savings discipline. Even then, only one member is allowed a loan at a time; the second member must wait for the first to repay. Since other group members stand surety, they must approve the loan as well as the prospective borrower's plans for using it in a money-making enterprise. To insure individual control of their funds, all members must learn to sign their names.

Safety net provisions

In most developing countries the only loans available for the poor are through moneylenders. Despite the negative connotations, money- lenders often provide services which banks do not. They give loans for non-productive activities, and stretch loans out during a bad harvest. They know their borrowers, and distinguish the hard-working from the drunkards. On the other hand, moneylenders' flexibility and familiarity with their clients also often gives them the power to inflate interest rates, require free labour, or even demand sexual favors.

Two kinds of Grameen Bank funds allow it to respond to its members' emergency needs, so that they can avoid dependence on moneylenders. These funds, plus the weekly savings required of each member, also help insure that borrowers can repay loans even during periods of personal or family hardship. One fund available for "non-productive" loans, is created by taking 5 percent of all loans granted by the Grameen Bank and adding this to the individual members' savings. This fund is necessary because many moneylenders will refuse to loan to a villager who has taken advantage of lower interest loans from development groups, unless the borrower agrees to again become a regular client of the moneylender. This fund is controlled by the group, which by unanimous agreement may loan out up to half its assets to any member, typically for expenses resulting from unexpected illnesses or death. In addition, each group must establish an emergency fund, created by depositing half the total interest accrued on any loan, to repay loans if a member cannot, due to

an accident such as the death of cow or the damage of a rickshaw.

Attitudinal change

Group members spend the first meetings discussing the causes of their poverty, such as too much money spent on dowries, weddings, or other social events, and too many children. Reducing social expenditures and avoiding the high interest payments on loans for such expenditures can immediately improve a family's standard of living. Group discussions also emphasize the importance of smaller, healthier families, and the need for family planning; some programs even offer contraception. Calisthenics and nutritional education also encourage group members to take care of their health. As the Bank's influence has spread, it has begun instituting group discussions about intrahousehold power relationships. In particular, role-playing activities provide opportunities for new women members to share strategies for resisting their husbands' attempts to use the loan funds for personal use.

Summary

Affinity groups provide peer support and advice for members as they undertake personal enterprises. The groups also employ peer pressure to insure loan repayments and to change profligate spending habits, while providing for emergency cash needs that might otherwise ruin fragile new enterprises.

Equally important, they encourage women to see their loans as distinct fromn household accounts, and so protect them from misuse by males in the household. The Grameen Bank, in other words, is far more than a credit program, a fact central to its success.

Other Credit Programs

The Grameen Bank model was clearly handcrafted for the socio-economic conditions of the Bangladesh countryside. Other credit programs have necessarily adapted the model to different circumstances, though not always successfully. Some, for example, provide only economic and/or technical assistance, and ignore social conditions. A growing literature describes individual cases; here we wish to discuss briefly several types of programs in terms of their utility to poor women over both the short and long term.

Variations on the theme

The Agricultural Development Bank of Nepal began a program in 1974 to increase the income and employment of small farmers and landless labourers. Although two women's groups were set up in 1978, it was not until the establishment of a separate Women's Development Program in 1981 that women's participation in this program became significant. To qualify for membership, local men and women must have an annual family income of less than Rs. 1,200, and own at least a small plot of

land. As members, they are expected to reduce spending on weddings, funerals, and other social occasions.

Agricultural productivity for rural development is the primary focus of the loan programs, and most male members borrow for this purpose; most women use their loans either to buy cattle or goats, or start knitting and sewing enterprises. Unlike the Grameen Bank, the Nepal program gears loans to the activities they fund: loans for farming are not due until after the harvest, while loans for handicraft production may be due sooner. might have a shorter loan period. Thus a group member might take out two or three loans with different maturation dates at the same time, and several members have loans simultaneously.

For this reason, although group serves to stand surety for its members, collateral is generally required as well. Landless men pledge their homesteads, and women must pledge their husbands' lands. As a result, there is sometimes a mixing of money from loans to women and men in the same family, though not in the same group. Easy loan availability allows farmers to cover repayment with new loans, so they can continue borrowing even if their farms are not making any money. On the whole, farmers seem to have increased both production and income by intensifying cropping rather than by purchasing inputs. Women have had a rather high default rate on loans for animals, because the animals become ill or die. The loan program is now attempting

to upgrade the animals purchased, and has begun providing veterinary services and an insurance scheme. Overall, there is both a perceived and real improvement in family well-being. Even without showing increased income from agriculture or cottage activities, reduced social expenditures plus the availability of low-interest is estimated to increase families' money supply by about ten per cent!

Group-based credit

Early efforts to integrate women in development programs supported women's income-generating groups. Unlike affinity groups, the former either use profits from group activities for community improvement, or distribute the money equally among members. This type of organisation for credit and income has two major problems. First, typical activities promoted for such groups—knitting, crocheting, sewing, or batiking—were based on Western stereotypes of women's roles, and presumed both time and skills which poor women seldom have. The finished tablecloths, mats, or dresses were meant for middle-class, not local consumption. Too often these activities were not economically viable, given the limited market, poor product quality, and the added costs of management and distribution. Frequently, when the patron withdrew, the enterprise collapsed.

Secondly, the poorest women cannot afford to participate in time-consuming activities when they are

not remunerated in cash or kind. In Kenya, women run buses or grow vegetables and use their profits to pay for schools or the requisite entertaining of visiting government officials. Women themselves say that if they distributed their profits, men would appropriate the money.

Some programs do benefit the poorest, however. Indeed, studies show that landless women have more time at their disposal than do wives of small farmers. The Grama Vikas program in south India provides credit to groups of landless women for sericulture projects; they use their profits to rent land for growing food which improves theirs' and their families' nutritional status.[5]

Microentrepreneurs

Credit for small-scale urban economic activities became popular among donor agencies as part of the effort to focus on basic human needs during the 1970s. Evaluations of such credit programs distinguished between "pre-entrepreneurial" and "entrepreneurial" beneficiaries: The former were usually illiterate recent migrants who lacked the "street smarts" urban natives used to operate their micro-businesses. These conclusions appear drawn too exclusively from research in Kenya, where recent migration has been particularly high and where there is no strong tradition of women market traders. Rural origins do not necessarily correlate with lack of trading skills, as found in studies from Indian cities.

These categories are important, because perceptions of beneficiaries' needs strongly influence project design. The assumption that "pre-entrepreneurial" individuals lacked marketing skills meant that they were targeted for a broad array of services besides credit. Most in this category were women. The National Council of Churches of Kenya reported that 76 percent of participants in its urban programs were women, supporting on the average 6.5 dependents. In the Philippines, three-quarters of the beneficiaries of four different credit and support programs were women. Working Women's Forum in Madras, India, helps provide credit to women microentrepreneurs who typically support households of eight to ten people. In the slums of Bangalore, women ran most of the supported enterprises; the project leader there saw men as "irresponsible drunkards."

Banks in some countries are now encouraged or required to lend to microentrepreneurs. The Philippines Commercial and Industrial Bank Money Shops are set up in any market with at least 400 potential individual clients. The Banco Popular y de Desarrollo Communal in Costa Rica loaned an average of 247 dollars to 83 solidarity groups with 447 members (67 % male and 37 % female) in one year. In several Indian cities the Bank of Baroda maintains special branches solely for loans of less than 2000 dollars. The Badan Kredit Kecamatan in Central Java has 486 village mini-banks which made close to 300,000 loans

totalling 15 million dollars in one year. Most loans support petty trading; sixty per cent of the beneficiaries are women. Originally the scheme was both urban and rural. But the rural character reference system, in which prospective borrowers must be sponsored by their village head, did not transfer well to cities. As a result defaults were high, and the urban programs were dropped.

Yet bank programs offering loans to microentrepreneurs remain the exception; on the whole, bank borrowers are larger entrepreneurs or farmers, usually men, who seek only credit, not counsel, do so primarily to increase the size and profitability of their enterprises, and seldom are provided with or required to undertake training programs.

Two basic difficulties plague many of these microenterprise programs. First, because the multifaceted approach is expensive, it never reaches but a fraction of the urban poor. So most economists prefer simple loan programs through existing banks, but such loans tend to go to men who already head small or medium-sized firms. Credit programs for poor women are generally only run by the intermediary donor organizations which have charitable origins and so bring with them attitudes and methods that stress family survival and well-being rather than enterprise or self-sufficiency. Their loan programs tend to have low pay-back rates, since many clients seem to treat them as gifts. These organisations continue to operate on the belief that the poorest people need training in the use of their existing resources and income more than they need capital. The Grameen Bank's experiences would suggest that they need both.

Secondly, the belief that women are unable to undertake entre-preneurial activity without additional training and welfare has been used to justify cutting back on such multi-service programs on the grounds that they are neither cost-effective nor growth-generating. This raises questions about the definition and purpose of the microenterprise, which will be addressed below.

The growth obsession

Donor agencies supporting private enterprise increasingly question funding for "non-productive" activities. They perceive multi-service programs for microentrepreneurs as welfare, and the income generated by them as insignificant, because few microentrepreneurs reinvest their profits in growth. But this narrow understanding of economic activity is myopic and outmoded. Indeed, observers remark that the "moral economy" of subsistence societies, emphasizing basic security for the whole community over the wealth of the individual, has helped such societies survive. A similiar "subsistence ethic" prevails as well in some poor urban communities. While modernization has undermined this sense communal responsibility in much of the world, many Africans still look with suspicion on the accumulation of wealth. Historically, wealthier village men gained status, and

sometimes titles, by holding elaborate parties which effectively re- distributed their riches; some male savings associations spend their funds on drinking sprees. Spending practices which seem at odds with western economic values may in fact be wise survival strategies. Today, when the limits of economistic models have never been more obvious, is a good time to begin to rethink the universality, if not the underlying value base, of these concepts.

Gender Patterning

We all have many roles. Our social status and identity come from a mix of activities, many circumscribed by culturally dictated expectations of women's and men's behavior. Feminist scholars have challenged the male biases inherent in most academic disciplines, and demonstrated the need to analyze gender patterns. While debate continues over whether maternal nurturing tendencies are biologically or culturally induced, such scholars also recognise how much these gender patterns shape womens' other societal roles. In effect, gender patterns explain why women are not measured by the same yardstick as men, and are relegated to second-class status. Women are now searching for their own measures of status, their own scale of worth.

Women's scales will take account of family nurturing, and make it a higher priority than individual pursuit of profits and growth. But hardline economists consider such attitudes evidence that women are "pre-entrepreneurial;"

for them reinvestment in growth is the more proper economic behaviour. Feminists, on the other hand, increasingly ask why economists must continue to be honoured as the high priests of the modern age. Gender patterning has generally undermined women's ability to advance their careers and command wages in the open market.

Alternative values

If women are to be discriminated against in the job market because of their concern for family survival, it is no wonder they frequently appear less economically ambitious than men. Rather, they often seek employment which fits better with their other roles than does formal wage work. The Indian Government's Commission on Self-Employed Women took found abundant evidence of this tendency in testimony collected from home-based workers and street vendors across the country.

Microenterprises are easier to manage if they stay small. Family-run enterprises need not distinguish between household and business accounts, and though economists decry such mixing of funds it is in fact book-keeping practice for microentrepreneurs. Avoiding paid employees also simplifies cash flow problems: family workers are rewarded with clothes, school fees, extra food, not money. The parallels with subsistence farming are obvious. Perhaps by reconsidering microenterprise in this light, its logic and utility will become more apparent, and

it will be easier to encourage this type of employment.

Sustainability

Once we accept that microentrepreneurs are economic actors, however they use profits, the next issue is how to insure their viability so that they can repay loans. As noted above, in the past donor groups tended to specify the income-generating activities borrowers would undertake, which often proved inappropriate. The Grameen Bank, by contrast, encourages borrowers to identify activities themselves. In a rapidly changing world, however, traditional livelihoods may become obsolete in the near future, and it will be necessary to help microenterpreneurs adapt their skills to alternative occupations. Credit for sustainable enterprises, in other words, should replace the concept of credit for growth.

Credit does not necessarily empower

Women's income generating-activities do not necessarily or automatically improve their status. While women without access to their own income are clearly dependent upon others, income alone may not end dependency if a woman's husband or father simply withdraws his support in equal measure to that which the woman supplies. Intrahousehold distribution of resources and control of labour are obviously critical to any understanding of the long-term impact of credit, and the income it earns, on women's lives.

Examples abound of women refusing to participate in income-generating development projects because they perceive additional work. These incidents point to the need to assess the real impact such work has on women's lives. If the objective of these projects is to help women survive, then perhaps subsidised food or distribution of free goods would be preferable. If the objective is to transform women's lives, to give them greater autonomy, then closer attention to intrahousehold and community power relations is essential. If husbands feel threatened by a shift in power, then they may attempt to undermine women's economic advancement. Even women household heads are frequently beholden to male family members, and so cannot escape patriarchal control. Hence if women's projects are to survive, they must be presented so that men feel that they will also benefit from the project activities, or at least not be harmed by them.

Recognition that those in power do not easily abandon their claims, either within the household or the national political and economic structure, has begun to inform the planning and evaluation of poverty programs. For example, credit programs for small-scale farmers have performed better when parallel programs for larger farmers are offered simultaneously, but by different administrative cadres. Small-scale entrepreneurial credit programs have failed, on the other hand, when they appeared

to compete directly with large-scale industry. Additionally, advocacy organisations for the poor are more likely to succeed if they are headed by charismatic and politically well-connected elites. To protect their clientelem these lenders alternatively challenge and cooperate with their countries' entrenched institutions, such as trade unions, banks, or government ministries.

Middle class women's organisations can play a similar role in protecting poor women's organisations and helping them obtain credit for activities they have identified themselves. Understanding and accepting this limited role, instead of presuming to know what is best for the poorer women, will empower both groups, and help build women's solidarity across class lines.

Conclusion

Credit programs for poor women and men have provided much-needed funds to the poorest stratum of society. The most successful programs are those that not only offer credit, but also help change intrahousehold and societal power relationships. Programs that provide income for daily survival are certainly useful, but if they add to women's workload without improving their bargaining power, then one must question their utility. Perhaps, in these cases, openly acknowledged welfare programs are preferable.

Those credit programs with low repayment rates may be seen as welfare since they act as a short-run redistributive mechanism. Many bureaucrats, for this reason, do not even expect repayment in some programs. Indeed, when price supports and protectionism for large industries are taken into account, it becomes clear that in many countries that the poor have been subsidizing the rich. No wonder that advocates for the poor complain of unfair treatment by governmental planners. Why, for example, should poor borrowers bear the entire cost of their lending institutions when government revenues support credit lines for large entrepreneurs?

In the long run, however, loan programs must be economically self-sufficient, with a revolving fund account. Thus high repayment rates are important even where the government pays for administrative costs. Such credit programs enable women to pursue income-generating activities. If the conditions of women's lives are to improve, however, credit programs must also encourage women's empowerment, and provide support also for those likely to object to this shift in power.

In sum, this paper has illustrated how credit can be used either to reinforce existing inequities or to encourage social change. It is this measure, not repayment alone, that should be the goal of programmers truly concerned with poverty alleviation and gender equity.

ALLEVIATING POVERTY: INVESTING IN WOMEN'S WORK

POCKETS OF POVERTY CONTINUE TO plague the United States despite the overall booming economy. Twice in 1999, President Clinton visited such areas of the country to dramatize his "New Markets" initiative. In the summer, business leaders, bankers, and members of Congress accompanied the President to seven sites including Appalachia, tribal lands in South Dakota, the Mississippi Delta, and Los Angeles. Clinton's strategy to improve income and living standards in these poor communities emphasizes the need for private sector investment in the "untapped markets" with federal assistance in the form of tax credits and loan guarantees. He plans to create a guarantee fund, the America Investment Credit, to encourage investments in the poor at home just as the Overseas Production Investment Credit does abroad.

The November tour celebrated efforts by private communities and individuals to provide funds and programs for these poor communities, reflecting a global trend of nongovernmental organizations supplementing or replacing government efforts to alleviate poverty. Already in place in the U.S. are many federal programs, including the relatively new Individual Development Accounts that supply funds to a variety of nongovernmental groups for alleviating poverty. Recent policy shifts are now encouraging Community Development Corporations, familiar players in most U.S. cities, to expand from their emphasis on affordable housing to offer entrepreneurial training and microcredit programs. So compelling is the need to raise the income and living standards of the U.S. poor that the Speaker of the House of Representatives, Dennis Hastert, joined the President in South Chicago to announce a merger of the "New Markets" initiative with the Republicans' "Renewable Communities" proposal. Reiterating the invisibility of the poor in our booming economy, members of the Congressional Progressive Caucus visited Georgia in November on an "Economic Human Rights Bus Tour" to emphasize the continued need for social services.

Given the nation's prosperity in the 1990s, many Americans are surprised to learn that poverty continues to be a critical issue throughout the country. One in every five of our children lives in poverty; over 36 million Americans do not have adequate access to food; and 44.3 million lack health insurance. At the same time the top 1% of the U.S. population owns 40% of the nation's wealth, or more than the poorest 92%

combined, reflecting the largest gap between the rich and poor in 50 years.

This trend of increased wealth disparity, despite overall improvement in a country's gross domestic product, is a global phenomenon. Between 1988 and 1993, 55-60% of the world's population experienced declining income: the poorest lost one-quarter of their real income in last 5 years; the richest 5% saw their incomes increase 25%. Recent figures collected for the World Bank 2000 Development Report on Poverty indicate that in 1998 1.2 billion people world-wide had consumption levels below $1 a day – 24 percent of the population of the developing world.

The negative impact of rapid economic change was first noted in 1960 when a World Bank study indicated that, despite growth in GDP experienced by many developing countries as a result of programs initiated under the United Nations First Development Decade (1960-1970), income gap had widened. Although 40% of the population enjoyed increased income, the bottom 40% in most countries were worse off than they had been before development programs began. In response, internationally, bilateral, and multilateral development assistance policies refocused in the 1970s on Basic Human Needs. During the United Nations Second Development Decade (1970-1980), the World Bank and the US Agency for International Development (USAID), among others, gave priority to alleviating poverty rather than emphasizing industrial and infrastructure projects.

Some leaders of developing countries were unsettled by this trend to invest in the poor rather than in industrial growth, arguing that in the long run economic prosperity leads to the growth of a middle class which moderates income disparities and helps create a more stable and democratic society. The parameters of this debate between advocates of the market economy and those favoring more equitable development are well documented. The World Bank, which led the shift toward poverty alleviation programs, also supports growth and continues to argue for a dual strategy. These issues of development priorities resonate today and exploded into the popular press during the World Trade Organization meetings in Seattle in December 1999.

What lessons might U.S. planners learn from experience with poverty alleviation programs in developing countries? Two elements are shared by the most effective antipoverty programs:

- community participation needs to be disaggregated by social groups, especially women, rather than being based on territory, and
- microenterprise programs can effectively support existing and new businesses with credit and technical assistance.

The evolution of these insights is examined in this article which begins by tracing the shifts in development

assistance policy after World War II from an emphasis on infrastructure and industrial growth to a focus on the basic needs of people through rural and community development. This shift encouraged the expansion of national and international nongovernmental organizations (NGOs) as many moved beyond disaster relief into development programming. Attention to alleviating poverty led to an increasing focus on women and ways to increase their income. Microcredit stands out as an extremely successful approach: the Grameen Bank model is presented and the complaints of its critics are analyzed. Several broader programs that support microenterprise by offering broader financial services and policy support are discussed. The final section discusses microenterprise programs that have been introduced in the U.S. over the last decade and compares their characteristics with the programs existing in developing countries.

SHIFTING EMPHASES IN INTERNATIONAL DEVELOPMENT PROGRAMMING

International economic development programs, introduced into the developing countries in the later 1950s, were largely based on the Marshall Plan, which provided massive funding to post-World War II Europe to ensure its rapid recovery from the war's devastation. Claiming universal paradigms, economists assumed that programs

that worked in industrial Europe could be applied to the largely subsistence economies in Asia and Africa, despite obvious cultural, political, and historical differences.

Economic development rapidly monetized these areas as infrastructures paid wage labor and trade in consumer goods increased. Desires by government leaders of the newly independent countries to modernize their capitals or even maintain embassies abroad required an increase in foreign exchange; one response by the development community was to increase agricultural extension services that focused on cash crops. Schools were built in tiny villages, often by foreign volunteers, but students had to pay school fees, and their parents often had to house and feed the teacher.

Villagers also needed money to purchase industrial goods that began reaching the most remote settlements. Plastic buckets lasted longer than handmade woven grass baskets and could not be easily broken as clay pots. Lengths of printed cloth or ready to wear pants saved time weaving, dying, and sewing, besides being more fashionable. New products such as radios and wrist watches were the mark of a modern man, broadening the world view of villagers and injecting the concept of time into traditional societies.

New agricultural techniques or village improvement programs were imposed with little community input. Inappropriate programs tended also to increase the distrust of villagers for the

central state, and as soon as the projects ceased and money stopped flowing, villagers tended to revert to age-old patterns. The myriad of caste, class, and religious distinctions, especially in South Asia, were ignored; and everywhere the impact of these top-down programs on the traditional division of labor between men and women, young and old, landed and landless, were disregarded.

In this transition, men were incorrectly assumed to be the family provider and the farmer. Agricultural innovation for cash crops and staples was directed at them, even in Africa south of the Sahara where women still produce about 80% of all food crops. The tradition of bride price, especially in Africa, gives men access to women's labor and fertility; so women were also expected to weed and tend the husband's fields while still growing food for the family. The system of separate budgets for women and men means that women have to care for her own children – clothing, feeding, and nurturing them, then supplying their school fees and uniforms.

In much of Asia, women under the dowry system have less autonomy or individual responsibility: they work within the extended family tending small farm animals and contributing 45% of all farm work. Everywhere, women were responsible for fetching water, collecting fuel for cooking, and processing and cooking food. Time pressures on women increased. New buckets and cloth could ease their burden if they had the money to purchase them, but new jobs or crops were directed at men. Sometimes women would pawn their only assets – their bracelets and earrings.

Throughout the developing countries, rural cooperatives were established to supply services and information to farmers and to buy and market their crops. But cooperative membership was granted only to the male land holders who then received the profit from sales even where women did most of the farming. In response to this inequity, Kenya women coffee farmers turned to growing food crops instead of producing coffee; coffee production declined dramatically until their husbands agreed to pay their children's school fees before any profits were distributed.

In South Asia, where villages are comprised of many income strata, the territorial base of cooperatives resulted in the higher status land-owning farmers receiving most of the benefits. In Bangladesh, separately organized women's cooperatives were somewhat more egalitarian because wives of the wealthier farmers were prevented by the custom of veiling from participation in the cooperatives. The only credit available to the vast majority of poor was from moneylenders whose usurious interest rates tended to enmesh the borrowers in perpetual debt. Few women were able to borrow because they lacked collateral other than their jewelry.

NGOs focus on women

Most of the early development programs focused on men and were implemented by government officials.

As development policy began to shift toward alleviating poverty, more and more nongovernmental organizations moved from charity concerns to development programming. Their multifaceted community development programs included setting up health and family planning clinics, drilling new wells, and introducing new household technologies such as improved cookstoves to reduce fuel consumption (and the time needed to collect fuelwood) or grain grinders to that cut food preparation time.

NGO staff in villages observed that in societies where the patriarch controls the assets and labor of the household, community participation based on a territorial village with its traditional male leadership reinforced women's inferior status. For women to participate in discussions about their needs, women needed separate organizations not only because the local culture inhibited women's participation when men were present, but also because women's economic and social roles, and therefore their needs, had begun to change. Paramount was women's need for money. Women spend their income on the family while men are more likely to spend it on themselves. Subsequent studies show that food distributed to women generally reaches their children, and that women's right to a house provides her family both with income and shelter.

Nongovernmental organizations initially responded to women's need for money by replicating the approach of prewar missionaries who taught women to crochet and knit. These activities presumed time to do the work, a scarce resource among rural women. They further assumed some skill which was not likely to be found among women farmers. Later efforts to commodify woven baskets, decorative pottery, or traditional weaving based on locally existing skills still had to address the issues of market demand and distribution. Few of these efforts provided the women with any significant income, and then only if the organizers marketed the goods without costs. Recent efforts by alternative trading organizations to sell handmade goods through catalogs and specialty stores have resulted in a higher return on well-constructed craft items, but most poor women lack the skills to produce high quality goods. Nonetheless, craft work does supply income for many poor women and men.

MICROCREDIT PROGRAMS IN DEVELOPING COUNTRIES

Unlike most industrialized societies, developing countries generally lack the resources to provide such essential social services as free elementary schools, much less offer welfare payments to the poor. Instead of poverty maintenance – the welfare prototype in the U.S. and Europe – economic development programs in developing countries have had to seek ways to increase the income, productivity, and assets of the poor. Increasingly, the focus has been on assisting small and micro

businesses, an approach overlooked in the U.S. until recently.

Grameen Bank: Observing the tiny credit needs of a woman making cane chairs, then professor Mohammed Yunus was inspired to start the Grameen Bank for Bangladeshi families owning no more than .25 hectares of land. Loaning small amounts of money to women or men using only peer groups as collateral, the Grameen Bank has become the prototype for microcredit schemes. These peer groups of five persons are single sex, and multiple members of one family may not be in the same group. Although at first more men than women joined the Bank, today over 90% of the borrowers are women due to their stronger repayment records. Because rural women in Bangladesh have limited mobility for cultural reasons, they can easily meet weekly in the village center as is required by the rules; men may be working outside the village or trading in a provincial market. At these meetings, aspects of the Sixteen Decisions required of all members are discussed, and information about health and family planning is provided. These Decisions are designed not only to encourage banking discipline, but also to practice social goals such as not paying dowry when their daughters marry, not overspending on weddings and funerals, and limiting family size. In other words, the Grameen Bank trains the poor to reduce spending as well as to save and utilize credit.

When an individual joins the bank and forms a peer group, each one is expect to begin to save; this amount may be less than a dime a week. Once she knows she can save from daily expenditures, she is allowed to borrow money for a productive activity agreed upon by her group. Interest on the loan is set above the prime rate in Dhaka, about 16% a year, in comparison to moneylender rates that often top *40% per month*. Most of the interest goes to support the administration of the bank, but a portion is set aside into two different funds: an emergency fund available to members with the agreement of the peer group, and a fund to repay the debt of a member who dies or becomes very ill.

Originally most loans were for buying farm animals to raise, new pots for making food to sell, or a new foot-pedaled rice grinder so that the borrower could earn money by processing larger amounts of rice for wealthier neighbors. Small trading or craft work also received support, although a man would have to do the public selling since in many cultures women are not supposed to be seen in public markets.

So immediate was the positive impact of these small loans on the rural poor that most nongovernmental organizations in Bangladesh began similar programs, many of which were predominantly or exclusively for women. Overall, the many studies of these programs show that the families of the members eat better and have improved nutrition because of increased income. Husbands show increased respect for their wives, and family violence against the women

entrepreneurs is reduced. Women often secure loans so that male members might work pedaling a bicycle rickshaw, selling street foods, or trading. Many women have even purchased land so their husbands or sons can farm.

Some critics claim that the male family members control the loans, and that women are merely a conduit. Such critics ignore the cultural context of rural Bangladesh where studies show that women's access to funds itself seems to raise their status within the family. Further, research indicates most women use credit both for their own projects and also for family enterprises such as farming and selling the harves which are typically male activities. Indeed, rural women often function as family managers so their ability to improve the family income increases their status and self-confidence.

Recent variations of the Grameen Bank model in Bangladesh include lending to existing small and micro enterprises. Evaluations suggest that their growth rate is more impressive than the tiny economic efforts of the poor landless women. Some critics disparaged the tiny amounts of credit offered the poor women saying that such drudgery perpetuates poverty and noting the number of failed ventures. What is overlooked is the fact that much of the money is actually used for social investment in health, schools, or clothes. Consider the economics of a poor family who previously had to borrow for such expenditures at 40% interest per month, or over 400% a year. The ability to acquire money at 16% interest per year automatically extends the meager family budget and improves the family living standard. In other words, the availability of inexpensive credit has perhaps been more important than the productive activities. That this credit flows through women has enhanced their status.

Global microfinance programs: Adaptations of microcredit have appeared in most developing countries. Today, most NGOs operating in Vietnam offer microcredit programs. One of the earliest, Tototo Home Services in Mombasa, Kenya, taught poor rural women to dye and sew clothing. The Self Employed Women's Association (SEWA) in Ahmedabad, India, organized women already engaged in petty commerce such as those who sell vegetables in city streets or carry firewood from the rural areas for sale in the city; the Working Women's Forum in Madras, India, which began as a political organization, provide banking services to their members. Women's World Banking has affiliates worldwide for whom it provides loan guarantees. For many other organizations, financial services are only part of a broad pallet of activities. In Latin America, *Accion International* initiated the founding of village banking where women themselves grant loans and keep accounts. Such an approach would not work in rural Bangladesh, with its high illiteracy rate and cultural restrictions on women. Efforts to hire women who had completed secondary school as outreach staff for Grameen Bank met with

local resistance even though secure new housing was built for them in country towns. Thus the Grameen staff remains predominantly male and a source of criticism by many feminists.

Houses as a source of shelter and income: After a major flood, the Grameen Bank added loans for housing. Because these loans are given only to long-time members, almost have gone to women, who must show they own the land before receiving the loan. Since women move into their husband's village when they marry, the husband's family must give the wife the land in order to allow the house to be built. Specifications call for a tiny 10x20 foot shelter with a tin roof supported by six reinforced concrete poles. Woven mats serve as walls and may wash away in a flood, but the posts and roof are more durable. Because Islamic law allows women to own and inherit land, unlike customary laws in many other traditions, these poor rural women and their children, living in their husbands' villages, are protected from homelessness should their husband desert them or die young.

Unfortunately, the Grameen Bank loan program for housing has not yet been widely copied. Yet the home as a site for producing food and income, as well as for shelter, is of growing importance. Many income-producing programs introduced by NGOs for women were home- or farm-based. Besides preparing food for selling on the street or producing crafts, women are taught food production and given free seeds. Even in the squatter areas, families can grow

significant amounts of vegetables or raise chickens or rabbits. The importance of home-based work is overlooked by economists and seldom included in national accounts. Yet women, stressed between earning a livelihood and caring for children, often prefer home-based work.

SEWA has led an effort to organize home-based workers since many of its groups work out of their homes. SEWA originally organized women by occupation within a national union even though the women had no employer and therefore took their complaints directly to the municipal government. For example, SEWA's lobbying against police harassment of street food vendors not only changed the municipal policies but has led to the formation of an international vendors association. When the union disassociated itself with SEWA over its insistence on including the lowest castes within its membership, SEWA began to resemble an NGO. Utilizing organizing techniques both from NGOs and unions, SEWA founder Ela Bhatt was instrumental in founding Homenet, an organization for home-based workers, which now has over 10,000 members in several Asian countries. The group lobbies for childcare, health coverage, and access to a pension program. Such an idea might well be tried in the U.S. where almost half of the 17 million small businesses are home-based, according to the Commerce Department's Census Bureau.

Home-based work is a critical source of income for women, especially in urban areas where rapid economic

transition and relaxed cultural restrictions have led to increased family disintegration. Globally more than one third of all households are now headed by women. Women left behind in rural areas when their husbands migrate are seldom included in this count because they cling to the hope their husbands might return. In Bangladesh, the Grameen Bank has a program to help women secure rights to their village homes; in Costa Rica, NGOs led the campaign to ensure that women could obtain ownership of subsidized government housing for the poor to women. Because women are almost universally the caretakers of their children and because homes are increasingly the site of their economic activities, women need security of tenure, if not ownership. As in the U.S., NGOs are facilitating rights to houses for women around the globe. The United Nation Centre for Human Settlements is promoting women's tenure as a follow-up to the 1996 UN World Conference on Habitat; current details are available on its web site <http://www.unhabitat.org/>

In sum, community participation abroad has come to mean participation by distinct groups within a community that often lacks territorial boundaries. Policies for alleviating poverty have emphasized the need to invest in women, providing access to education, health, a house, and financial services. Programs funded by the World Bank as well as those run by NGOs generally organize women separately. Even programs not originally designed for women, such as microcredit institutions, often shift toward them because alternative resources are seldom available to women while men have alternatives. This explains why most participants in microcredit programs are women and why investing in women's work has become a major intervention designed to help women out of poverty. In the last decade, these programs have been tried throughout the U.S.

MICROENTERPRISE PROGRAMS IN THE UNITED STATES

In the U.S., small businesses (employing less than 20 people) made up almost 90% of all firms in 1994, and employed almost 20% of those working in the private sector. Micro businesses, defined as employing fewer than 5 people, made up more than 60% of all businesses and employed over 5% of the private work force in the U.S. A majority of those businesses had gross sales of less than $25,000, most small business owners worked less than 40 hours a week, and their businesses were not their primary source of income. As U.S. welfare policies focus on moving people off welfare and into the market, many organizations are looking at international microenterprise institutions for inspiration.

The idea of credit offered to women using the peer group as collateral has been tried in the U.S. in the mid-1980s by nonprofit agencies working with women receiving welfare benefits.

Other programs reach men as well as women and may require some type of collateral as well as financial management training.

Finding income activities for women is difficult because of their time constraints due to household responsibilities both in the U.S. and abroad; the "caring" economy is largely the domain of women, though its costs are not factored into family or national income accounts. The stress produced by this "double day" expectation, that women work and care for the household, is not well documented. It is not surprising that a study of community based organizations in nine sites in the U.S. found that those community organizations controlled by women generally espouse a broader social agenda than those run by men. These groups expanded the narrow neighborhood focus on housing and enterprise development to encompass community participation, child and elder care, leadership training, and outreach beyond the immediate community to networks serving battered women. By building participation into their programs, these organizations also created a democratic space where community residents could both form ties with each other and develop as individuals while collectively working for the betterment of the whole community. This move away from territorially based groups to national and statewide networks is occurring abroad as well as in the U.S. and has enhanced the ability of organizations to stimulate social change by providing much greater access to information and resources.

An alternative for providing daycare is training women to develop enterprises at home. Women enrolled in a craft training program in Portland, Oregon, all had toddlers or teenagers at home who needed their care. To meet women's needs to earn income and care for their families, a local community development association, Neighborhood Pride Team, created a separate project, Trillium Artisans, to train women to design and produce quality crafts that could be sold at fairs and in selected downtown stores. Their products include quilts, decorated picture frames, art work made from recycled materials, and catnip-filled pet toys. One participant earned sufficient income so that she could quit her night job – but not yet her day job – and stay home with her teenagers.

Today, over 300 microenterprise programs in the United States provide training, technical assistance, and/or lending to well over 50,000 businesses. A 1996 study of the practice of microenterprise programs in the U.S. by The Aspen Institute reviewed the program strategies, costs, and effectiveness undertaken by seven programs in different states. Significant are the data on clients: 73% women, 60% from minority ethnic or racial groups, and 43% had household incomes below the poverty level. A 1999 study tracked 405 borrowers from these programs over the course of 5 years. When the programs began, 138 of the 405 were living in

poverty; at the end of five years, over half had moved out of poverty, a difficult achievement since it meant doubling their income. Typically, the new enterprise was a second or third income for the family and constituted 37% of total family income. Although most of the borrowers earned an income higher than the minimum wage, just under half were able to continue their enterprise for five years due primarily to illness in the family, unexpected pregnancy, or accidents. Lack of health insurance proved a major problem and was often the reason for returning to wage employment.

These two Aspen Institute studies document significant adaptations of the overseas models in the U.S. context:

- Most programs offer loans primarily to businesses that have been in existence for at least a year.
- The peer group approach does not work well in the U.S.: when a member of the peer group defaulted, the group would simply dissolve. So instead of the peer group providing collateral, more diverse methods have been used, including credit checks, TV sets, books, or business inventory. Further, the ability to appraise business plans put forward by other members of the peer group is difficult in the more highly competitive economy in the U.S. Microentrepreneurs do seek peer support, but from others working in similar sectors. Many are forming micro chambers of commerce where they can learn of business trends and regulations. A few such groups exchange meetings with the local chambers of commerce.
- Credit is not the major problem for microentrepreneurs. Most nonprofit organizations running microenterprise programs find the biggest need is for training. In fact, finding clients to take loans is often a problem. Existing entrepreneurs benefit most from technical assistance and discussion with those running similar businesses. Credit card loans are faster and easier, though the interest is higher. Owners of start-up firms are more likely to request loans after the training period, but many use their own resources instead. Family supporters often loan money for little or no interest, just as they do abroad, as I found in my nine-country study of street food vendors who rightly feared to become enmeshed in debt. Immigrant communities and refugees in the U.S. repeat this pattern.
- Clients in the Aspen studies were poor by U.S. standards but still had significant assets compared to borrowers abroad. These assets included cars, real estate, and especially houses: 39% of the low income study participants and 53% of the non-poor participants

owned their own homes which ranged in value between $54,000 and $81,000.

- The idea of saving before borrowing is a fundamental concept of microcredit programs abroad. Its translation into the U.S. was extremely difficult due to strict bank regulations that make small loans very expensive to administer. Community groups offering training and organizations increasingly send potential borrowers to an NGO specializing in loans, often in concert with a local bank. This trend is fostered by the Community Reinvestment Act which encourages banks to provide services in their own communities. Thus a major adaptation in design has occurred: community organizations arrange for banks to make loans. This partnership arrangement is helping draw the business community closer to the community activists, a trend that helps overcome the persistent idea that public sector groups lack business acumen.

Individual Development Accounts

The idea of encouraging savings by the poor is central to a new type of program in the U.S. that also encourages public-private partnerships, the recently introduced Individual Development Accounts [IDAs]. These accounts are predicated on the concept, argued persuasively by Michael Sherraden in *Assets and the Poor: A New American Welfare Policy* (1991), that asset accumulation is essential for the poor to move out of poverty. Sherraden contends that U.S. welfare policy, because it limits assets the poor may own to receive assistance, actually tends to keep the poor in poverty. Proponents note that many governmental programs encourage asset accumulation by the middle-class "from the 19th century Homestead Act and the G.I. Bill of 1944 to individual retirement accounts and mortgage-interest deductions."

The Center for Enterprise Development (CFED) sought funding from private foundations to test this concept by creating IDAs which they describe as "leveraged savings and investment accounts for poor and working-poor families restricted to high-return investments in education, homeownership and business development. They are, in essence, 'Super IRAs for the Poor.'" The Downpayments on the American Dream Policy Demonstration (ADD) chose 13 community-based organizations to launch the demonstration in September 1997.

Participants may open accounts only after completing a training course on financial management. They may then open an IDA at a participating bank and deposit 10 or more dollars each month for 2 or 3 years; matching funds from the community organization are placed in escrow at a ratio from 1:1 up to 7:1 depending on the program.

Total funds vary by program, but at the end of the savings cycle, a participant can receive as much as $4500. from the combined savings and the matching grant. The bank sends this money directly to the institutions supplying the house, education, or materials to start a business. Early indications are that about 70% of the participants in the Portland, OR, program run by Human Solutions, expect to use their IDA accounts to purchase a home; participants wishing to start a business and or pursue additional education each numbered 15%.

Impressed by the idea of assets for the poor, Congress passed the *Assets for Independence Act* in the fall of 1998 and appropriated $10 million to the Department of Health and Human Services for the first year. By February 1999, the number of IDA programs had increased beyond the 13 ADD sites with 973 accounts; 59 additional sites had enrolled 1384 account holders and another 174 programs were in the planning stages. Nine AmeriCorps-VISTA (Volunteers in Service to America) had already been trained and assigned to work with participating nonprofit organizations, and more were being recruited.

Conclusions and Policy Implications

Poverty alleviation programs that have been implemented abroad document that income and asset creation are more effective for helping the poor rise out of poverty than are welfare programs that provide maintenance alone. Focusing enterprise opportunities on women have also proved more effective for ensuring improved nutrition and nurturing for children than efforts focused on men. Similarly, rights to housing for women improve family livelihood and stability. Investing in women clearly makes sense for programs that address poverty, in the U.S. as well as abroad.

While complete replication of programs from one culture or country to another is neither possible nor desirable, lessons learned about success implementation of successful programs are useful to keep in mind. While microcredit programs have proved critical for the poor in many developing countries, training in financial management and the avoidance of high interest loans is equally important. As economies become more complex, training in business practices has also become increasingly important. Such emphasis is already widely embraced in U.S. microfinance programs.

Community development programs need to disaggregate groups in order to serve the specific needs of different classes, ethnicities, or genders. Abroad, programs for poor women have focused on providing housing and income directly to them. Home-based work appeals to many women because it allows them to work while carrying out their family responsibilities, as it does in the U.S. New methods of organizing such workers so that they may obtain health coverage and other benefits are being tried in Asia and might prove applicable in the U.S. as well. Tax credits to

encourage large banks to participate in Individual Asset Accounts and microcredit programs, currently under discussion in Congress, would seem as important a strategy to alleviate poverty in depressed areas in the U.S. as attracting industry.

Programs for the poor are costly, but not investing in the poor results in many other social costs. Further, subsidies for lower-income citizens should be compared to the many ways the middle and upper classes are supported through legislation and tax regulations. A country with extreme disparities in income such as we are now experiencing in the United States is in jeopardy. Poverty alleviation programs that create trust among the participants and allow people to move beyond the vulnerabilities of poverty into greater stability should be a priority for planners and policymakers.

Wider policy implications

Over the last decade, the international microenterprise programs have revolutionized the way many non-profit organizations in the U.S. offer credit and entrepreneurial support to the working poor and not so poor. The Grameen Bank model has been adapted in many US settings. *Accion International* has itself introduced programs adapted from its Latin American experience to rural and urban communities throughout the U.S. Yet it is not the offering of credit alone, but the social aspects of these microcredit programs that

have made a difference abroad and may affect the way these adaptations work at home.

Seen in a broader context, these community based programs designed to encourage entrepreneurship through the provision of training and credit have roots not only in government and in civil society but also in the market. Efforts to create rigid divisions between these three aspects of social activity, as is the fashion today in free market circles, or to absorb them into a whole, as was the intent of communist societies, have failed. Perhaps it is the *partnership* aspects of international development that need to be understood if global affluence is ever to reach the poor. Indeed, the divisions in the U.S. between community organizations with their charitable roots and private enterprise with its business edge makes this partnership more difficult here but one that must be tried

Partnership does not stop with public institutions. Critical is partnership within the family. New initiatives for programming, whether by the international, national, or non-governmental organizations, are scrutinized for their differential impact on women and men, and adjusted accordingly. Such programmatic requirements have not assured an even-handed distribution of resources within the family any more than new community credit programs have eliminated poverty. But both efforts provide insights into methods of planning and implementation that are as relevant to the U.S. as abroad.

The debate about the appropriate roles of markets and governments and civil society is as pertinent within the international development community as in the U.S. To counter the tendency for rapid economic transformation to increase income disparity, all sections of society need to work together on solutions. Participation of those affected is essential for any successful outcome since a major lesson from abroad is that the most important resource in a poor community is the people themselves. Investing in the poor, especially poor women, should become a policy priority for all poverty alleviation programs

THE URBAN STREET FOOD TRADE: REGIONAL VARIATIONS OF WOMEN'S INVOLVEMENT

S ELLING READY-TO-EAT FOOD ALONG THE streets is a ubiquitous activity in cities around the world. Women visibly dominate this street food trade in such diverse countries as Nigeria, Senegal, Thailand, and the Philip pines where they sell local varieties of breakfast porridge, or tea with sweets, or meals of noodles, rice, or cornmeal topped with vegetable and meat sauces. In contrast, men sell the fried soybean cakes to school children in Indonesia, hawk lentil-rice snacks at Bangladesh bus stops, or provide falafel to hungry Egyptians.

It is hard to visualize an urban center in the developing world without these colorful vendors; what is more, they are an established presence even in "developed" cities such as Los Angeles, New York City, or Washington, DC. The pervasiveness of street food vendors clearly suggests their crucial role in feeding the urban populace. What may be less obvious, however, is that the street food trade is also a critical element in the survival strategies of the urban poor, and especially of women.

The study of the urban street food trade described in this chapter has provided important comparative data on how women and their families secure their livelihood, and the extent to which government policies or development programs assist or impede this enterprise. More specifically, this study illustrates the varied influences of culture and patriarchy on women's economic responsibility for, and power within, their families. This study has also shown how the confusing tangle of urban policies which formally and informally regulate street food vendors replicates the contradictions within both development theory and practice with regard to these micro-entrepreneurs. Thus, this study makes clear how both the structures of the family and the policies of government affect the functioning of the trade and the implementation and outcomes of programs designed to increase incomes among the urban poor.

The first section of this chapter sets the context for examining women's roles in the street food trade by examining the family setting for these women entrepreneurs and then by reviewing the development theories and policies that have treated micro-entrepreneurial activities such as the street food trade as marginal and dispensable. The second section presents data drawn from the Street Foods Project of the Equity Policy Center (EPOC) which initiated studies in provincial cities in seven developing countries

in Asia and Africa between 1982 and 1985: Iloilo, Philippines; Bogor, Indonesia; Chonburi, Thailand; Manikganj, Bangladesh; Minia, Egypt; Ile-He, Nigeria; and Ziguinchor, Senegal. A brief overview of the street food findings is followed by an analysis of women's involvement in preparing and selling street foods, and the impact of government policy on street vendors. Utilizing these findings, I will argue that the the theories both about family and economic develop ment have obscured reality.As a result, the importance of women'seco nomic activities for family survival and the impact they have on intra household dynamics have been denigrated and undervalued.

FAMILY: WOMEN AND PARIARCHY

Both culture and history influence the gender relationships observed by the street vendor families and help explain the wide variations in women's involvement in the seven countries EPOC studied. The explanatory power of class differences within any given country are more problematical, especially where social stratification is weak. Together culture, history, and class combine to produce distinct patterns in the distribution of power and responsibility within the family. These patterns predict how the street food enterprise in each country is established and run.

The seven countries under discussion represent three widely different types of gender relationships:

Bangladesh and Egypt are part of the patriarchal belt that extends across North Africa and encompasses West, South, and East Asia; Senegal and Nigeria reflect the separate budget culture of Africa south of the Sa'hara; the remaining three countries, Thailand, Indonesia, and the Philippines, depict a Southeast Asian pattern that is distinct from the other two categories.

Some feminist theoreticians might consider all these systems "patriarchal" because, in the ideal, the husband acts as head of the intact family while divorced, widowed, or single women are controlled and protected by male relatives. Such an over-generalization, however, would mask clear differences among these types of gender systems as to women's autonomy, economic responsibilities, and physical freedom. Using the term "patriarchy" to apply to any form of male dominance "obfuscates rather than reveals" intrahousehold dynamics, according to Deniz Kandiyoti. She suggests that "women strategize within a set of concrete constraints that reveal and define the blueprint of what I will term the 'patriarchal bargain' of any society" that women strike "to maximize security and optimize life options . . . " ("Bargaining with Patriarchy." *Gender and* Soceity 2:274, 1988.) Essentially, Kandiyoti argues that women under patriarchy negotiate a balance between economic and physical security and greater autonomy.

This trade-off between protection and freedom is challenged by Egyptian scholar Sarah Loza. She maintains that

women have *more* autonomy within a benevolent patriarchal family than they would living and working independently in the unfriendly urban streets. This opinion is reflected by many young middleclass Egyptian women who are choosing to wear that symbol of patriarchy, the veil, which they insist gives them both greater protection and freedom of movement. Such diverse views simply illustrate the complexity and variety of patriarchal bargains.

What does seem to be common across cultures, however, is the relationship between the material basis of the family and the amount of protection it can offer to women. The more that women contribute to the economic support of the family, the stronger their bargaining power. The phenomenal rise of women-headed households worldwide indicates both women's economic prowess and the collapse of family support systems. At what point does family disintegration take place? Is there a difference among types of patriarchal systems that predict the point in time when the "bargain" breaks down? Are women vendors independent heads of households or do they function within some type of exploitative patriarchal family system? Would development program support to women vendors result in their working longer hours for no obvious benefit, an outcome that in fact happened when improved fertilizer increased men's crops and required more time weeding by their wives, or when women's new income simply has meant that their husbands contributed

less to the household budget? Or would women be able to utilize their added income to improve the nutrition or living standards of their family members? Thus, family composition as well as the control of labor and income within the family become critical aspects of the study.

DEVELOPMENT THEORY

For years the street food trade, like other micro-enterprises, was generally dismissed as insignificant economic activity by development economists. Both Marxist and liberal economists believed that such petty trading was a holdover from earlier economic systems and would disappear as development proceeded. Instead, vendors are in fact increasing in variety and numbers as rural migrants flood the cities of the developing world. As a result, scholars began to rethink and redefine the myriad of economic activities that take place outside the formal sector, particularly in urban areas. The impetus to undertake studies of the informal sector came from the International Labor Organization (ILO) which realized from its projections for global industrialization that the goal of the World Employment Program of 1969 for full employment could not be attained solely through work in the formal sector.

These early studies provoked a heated scholarly debate between proponents of Marxism and of liberal economics who saw the informal sector respectively as exploitative or as

opportunity. Further, since according to both perspectives the informal sector was expected to disappear in the wake of modernization, scholars were forced to reinterpret both theories to account for the persistence of these economic activities. Today there is widespread recognition that informal sector enterprises are not only a permanent feature of contemporary economies but that the increasing informalization of existing formal sector firms has added to their numbers. While the scholarly debate continues about the desirability of such trends, industry continues to adapt to changes in the global economy by inventing new forms of relationships between formal and informal enterprises.

The new respectability of the informal sector did not, however, extend to micro-entrepreneurs. These tiny enterprises were largely excluded from the ILO research because, as one-person or family activities, they were judged as too small to grow and employ others. ILO economists often characterized such entrepreneurs as the "community of the poor." Thus women entrepreneurs, who tend to be clustered at the smallest end of the informal sector, remained invisible.

Parallels to the invisibility for planners of women's work in rural areas are obvious. Women's work in subsistence agriculture was reflected neither in definitions nor in statistics. As a result of women's statistical invisibility, stereotypes of women's lack of economic contribution were perpetuated and development programs were designed that focused on men, undercutting and undervaluing women's work. During the 1970s, stimulated by the second wave of the women's movement and given legitimacy by the U.N. Decade for Women – 1976-1985, scholars documented women's economic roles in developing countries, advocates translated these data into policy, and practitioners began to redesign women's programs to recognize women's roles in agriculture and crafts. Together they created the field of women in development.

The legacy of these beliefs about the informal sector continues to influence policies toward micro-entrepreneurs in many ways. The wide variety of economic pursuits classed under the vague terminology were ignored for many years; yet even after scholars began to study these enterprises, women 's work continued to be overlooked. Today, literature on women's work as micro-entrepreneurs both in home-based industry and in street vending is growing. It is written primarily by women and not yet well integrated into mainstream thinking. This lack of attention to microenterprises reinforced stereotypes of these activities as low-paying, dead-end jobs of trivial economic importance and so masked the contribution they made to income and food distribution for urban populations in developing countries.

DEVELOPMENT POLICY

Without data to justify programming, planners for many years left micro-enterprise development out of their

projections. Attitudes began to change as the development community became increasingly concerned with the growing disparity of incomes in developing countries and shifted the priorities of assistance programs during the Second Development Decade from infrastructure projects to the provision of basic needs. Many international non-governmental organizations (NGOs) began to move beyond the provision of food aid by setting up programs to help the poor earn an income. These programs often focus on "income-generating" activities for women's groups. Lacking an understanding of economic forces, however, many of these income generating programs suffered from middle-class stereotypes concerning women's "appropriate" activities, that is, knitting, weaving, or sewing. Such an approach narrowed the available occupations and often resulted in a glut on the market of Bangladesh jute bags, Kenya baskets, or Peruvian alpaca sweaters. Because economic considerations such as demand for the goods produced or the method and cost of marketing were seldom researched, this type of project became identified with welfare, not income.

Gradually, information began to circulate about innovative poverty programs devised by indigenous NGOs: SEWA (Self Employed Women's Association) in Ahmedabad, India, instituted a bank for women employed as street vendors or in home-based enterprises; the Grameen Bank in Bangladesh originated a system to offer loans to landless women and men with no

business experience. Donors began to replicate these credit programs for the poor, even in the United States. Critics continue to argue that such programs create dependence through welfare attitudes and are much too costly to replicate. Rather, they advocate lower cost programs that provide training, technological advice, and loans to small enterprises in order for such enterprises to grow and compete in the free market.

This debate does not merely reflect the question of welfare versus investment; it revolves around basic values and goals of both the entrepreneur and the donor. For example, is the objective of the support program solely to increase profits? Or are such considerations as exploitation of employees, pollution of the environment, or cornering the grain market to be deplored or forbidden? If the programs emphasize growth, they are likely to be focused on small (usually male) entrepreneurs rather than on the micro-entrepreneurs (predominantly female). Many advocates of free market economics emphasize efficiency. They claim that loans to existing enterprises have a higher cost-benefit ratio because their growth increases labor demand; further, the larger the size of the loan the cheaper the overall cost per dollar of the loan program.

Essentially, the argument is between the supporters and challengers of classic hard-edged economic values. The challengers question the basic tenet of classic economics: that all individuals only seek to maximize their own happiness. Rather, they applaud the actions

405

of many women micro-entrepreneurs who invest in their families instead of their enterprises and propose that such family and community values become the basis of a more human and humane economics.

The effect of this debate on women in the street food trade has been two-fold. First, women's work in the informal sector remained invisible even as data were collected on both owners of and workers in the small and medium enterprises because women's "pre-entrepreneurial" enterprises tend to cluster at the smallest end of the scale among the com munity of the poor. Secondly, since many economists have tended to dismiss micro-entrepreneurial activity *a priori* as non-economic because these enterprises are not likely to create a surplus in order to grow. They argue that any assistance given to micro-entrepreneurs would have a negligible effect on economic development. Growth is the only measure of success; family survival and investment in the nutrition and schooling of children are not considered adequate outcomes for extending support to microentrepreneurs in a free market climate when resources are scarce.

EPOC'S STREET FOODS PROJECT

The EPOC Street Foods Project was conceived in the midst of these debates. Instead of evaluating artificially introduced income-generating activities, the project would first undertake an in-depth study of an existing micro-enterprise. Instead of subscribing to the idea that poor women do not know how to run a business, the project would analyze existing practice and constraints and suggest interventions that could facilitate the enterprise. Customers would be interviewed to assess the demand. Because the focus was both on micro-enterprise and on women' s ability to earn a living as entrepreneurs, the study would collect data on both women and men in order to compare the extent and type of involvement in the enterprise.

The selection of street food vending was a logical choice for the in-depth study. Women are charged with the provision of food in all societies; their move to the marketplace appeared to be a relatively easy one in most countries. Anecdotal evidence of women selling prepared food is frequently included in both travel notes and scholarly articles. Yet, while market women have been widely studied in many parts of the world, the selling of prepared foods throughout the city by either women or men had not been a focus of research in these studies. As noted above, scholars studying the informal sector did not include micro-enterprise activities.

Research Design

EPOC began the Street Foods Project in 1982, studying provincial towns in Senegal, Nigeria, Egypt, Bangladesh, Philippines, Indonesia, and Thailand. Each country study took between one

and a half and two years to complete. While EPOC coordinated the research, we had a resident director in only four of the countries; in Nigeria, Egypt, and Thailand local research groups directed the study with EPOC providing a consultant.

During the process of selecting a city site in each country, local administrators and scholars were interviewed about their views of the importance and utility of the study and their knowledge of relevant scholarly literature and government documents. These interviews pro vided country-specific information on family structure, existing development programs, and governmental regulations regarding street food vendors. Those individuals expressing interest in the project were invited to join an advisory committee along with leaders of women's organizations, community-based NGOs, and vendor organizations (where they existed).

The committee members provided important local support for and legitimacy to the study. They were asked to assist in finding staff to do the surveying and interviewing, to suggest issues to be studied, to review the results of the surveys and questionnaires, and to help inter pret the overall findings. Committee members presided over each final briefing held for a broad array of NGOs, municipal bureaucrats, and scholars, and led the discussion to identify possible interventions or programs that would help vendors improve their surroundings, increase their income, or enhance the quality and safety of the food sold.

The lack of basic data on street foods necessitated a research design that avoided assumptions about who made, sold, and ate prepared food on the street. The first step in each town was to map the streets and locate all vendors selling at various times during the day. This census was repeated two or three times during a year to reflect seasonality. A 10 percent sample of vendors was selected, based on location and type of food sold, for the administering of both a social and an economic questionnaire. These vendors were frequently observed in order to verify who was actually selling, making decisions, preparing the food, cleaning up. In addition, calculations were made about the costs of the food the vendors sold in order to check their responses to the questionnaires about profits and operating costs. A customer survey identified who eats the food, where and when; a household survey of food consumption indicated the importance of food bought on the street in the total diet of the customers. Samples of foods were tested for contamination; also, cleanliness habits in preparation, serving, and cleaning up were observed both in the homes and at the point of sale.

To refine our knowledge about the division of labor both at the point of sale and at home where preparation of many foods took place, fifteen vendors were observed for at least a week each, at home and while selling. This intense involvement with the lives of vendors

provided an opportunity to compare questionnaire results with observed behavior. These case studies provide an insight into the motivations and goals of the people who prepare and sell food on the streets.

The ultimate objectives of the project were practical: First, to design interventions that enhanced income and improved the quality or safety of the food. Second, to utilize this information from one existing economic activity to improve programs that assist women micro entrepreneurs in general and so challenge assumptions and theories about them that had previously impeded assistance.

Street Food Trade

The diversity of towns included in the Street Food Study are striking. Population size of cities studied varied from Manikganj, a district office center whose commercial importance as a river town was declining, to a rapidly modernizing Bogor, satellite city to Jakarta. Minia excepted, these data support the intuitive assumption that the number of street food enterprises increases with, and faster than, the increase in city size. A possible explanation for the exception of Minia lies in the types of food eaten at home and that eaten on the street. In most countries traditional foods eaten at home take a long time to prepare, so busy housewives or employed women will avoid this effort by feeding their families street foods. In Egypt, however, the basic diet of cheese

and bread is served cold so that meals require a minimum of preparation, especially if bread is purchased. Supporting this explanation is the fact that the favorite street foods in Minia are bean-based *foul* and *tamia,* foods that take considerable time to prepare.

Our data on the numbers of vendors reflect the season when the largest number of vendors were on the streets. The seasonal variations were primarily due to women-headed firms and reflected women's roles in agriculture. In Ziguinchor the total of vendors in the rainy season, 748, were less than half of the 1,534 vendors recorded in the dry season; the town itself is semi-rural with agricultural lands interspersed with commercial strips and modern buildings. The decline was less precipitous in Chonburi where the 1,370 dry season vendors were reduced to 948 in the rainy season. In contrast, the total number of vendors dropped only by 5 percent in Bogor during the prime agricultural season. These seasonal variations suggest that for some women vendors selling street foods is only one of several survival strategies.

In Iloilo and Manikganj the seasonality was based on religious holidays rather than on agriculture. Christmas brought extra vendors out in Iloilo but this increase was balanced by other vendors who stopped selling for a time, perhaps returning to their natal villages. In Manikganj, the Islamic month of fasting alters eating habits. Special types of street foods for breaking the fast after sundown and for eating during the

night replace the foods sold through-out the rest of the year. The street food vendor census revealed that relatively few sellers actually move constantly. Rather, the vast majority of vendors, even those selling from wheeled carts, sell from a single definite place every day, though some had two daily spots while others moved on week ends (to the botanical gardens, etc.) or changed on market days. Even women selling from baskets carried on their heads tended to squat in the same place every day: in front of a school in the morning, outside the court, or near a cinema in the afternoon. By custom, good places are reserved and jealously guarded; their rights may even be sold. The really mobile vendors follow regular routes. Bicycle carts are used to pedal breads or *sate* (meat or chicken on a skewer) or ices. Vendors using shoulder poles pro-vide table and food: on one end of the pole they hang a stool and tiny table to balance a brassier on the other end which is used for heating water for tea or for grilling sate. These mobile ven-dors account for perhaps a quarter of all sellers in lfe, 18percent in Chonburi, and 10 percent in Ziguinchor.

An important finding of the study is the large percentage of street vending establishments located outside of major commercial areas. Because more com-plaints are registered about vendors blocking sidewalks and streets in down-town areas, city planners overlooked the street vendors near bus stops, cine-mas, schools, and hospitals, as well as in both poor and middle-class residential areas. In fact, it is logical that food is sold where people congregate; fast food establishments in the United States are more often outside than inside urban centers. Further, selling food in their own neighborhoods is an obvious ad-vantage to women, who must usually balance their home responsibilities with their vending.

Patriarchal Context of the Trade

The cultural and religious traditions of each country influence the patriarchal bargain women make as they reduce their autonomy in return for protection. These traditions also dictate women's roles in the street food trade. In Minia, Egypt, and in Manikganj, Bangladesh, patriarchal control is re-enforced by re-ligion, which is predominantly Islamic in both countries; women's expected behavior differs little among the Coptic Christians in Egypt or the Hindus in Bangladesh. While purdah (complete seclusion) is no longer widely practiced and veiling in public is a political state-ment now, women are expected to be modest and retiring. Therefore, vend-ing in public places is an economic al-ternative of the last resort. These two cities also had the smallest percentage of women among the total number of vendors enumerated: 1 percent for Manikganj, 11 percent for Minia. Women vendors in Manikganj were ab-solved of their non-conformity to the social norms applied to most women on the grounds of necessity: they had

to work to survive because they were widows without family able to support them; or in one case, the woman's husband was a drunkard. In Minia the social restrictions seemed less severe; only slightly more than half (57 percent) of the women vendors were either widowed or married to men who did not work. Other women in the Minia sample became vendors to support large families.

With her husband's permission and approval from the building owner, Sanaa sells *foul* (stewed beans) in front of the apartment building where her husband works as a porter; the family lives in a room under the stairs. His monthly salary of 15 LE (Egyptian pounds) could not feed a family of ten, four children each from previous marriages. Sanaa now earns around 2.5 LE per day, nearly four times as much as her husband's salary if she works twenty-four days a month.

The women vendors in Ziguinchor, Senegal, and Ile-Ife, Nigeria, come from a very different cultural tradition than the women described above; as in most areas of sub-Saharan Africa, the family does not function as a unit. Instead, women and men operate in separate spheres, have differing responsibilities, and keep separate budgets. Islam seems to have moderated this system marginally in Ziguinchor, but there is no observable difference in that city between the Muslim vendors (93 percent) and the Catholic vendors. More significant was tribal origin: nomadic men and women dominated the meat

and yoghurt trade respectively. Men are expected to supply the staple food for the family; however, a majority of the women vendors (59 percent) were the primary support for their families (an average of 9.5 persons) because they were divorced or widowed or had husbands who did not contribute (the husbands were absent or unemployed.) Even in families where the man supplied a monthly bag of rice, his expenditure was about equal to the woman's spending on millet and ingredients for the vegetables and meats eaten as sauce.

In Ile-Ife, about 70 percent of the vendors followed some form of Christianity: Protestants were the largest, 47 percent; Catholics, 14 per cent, and Aladura (African Christians), 10 percent. One-quarter of the vendors followed Islam while the remaining 3 percent said they adhered to an indigenous religion. As in the other areas, the overall cultural pattern seems unrelated to religious belief. Almost none of the women were widowed or divorced, yet all were the major provider for their children. Three-quarters of the women also supported one or more other children who lived with them.

In Southeast Asia the family system is distinct from those described above; women exhibit much of the autonomy characteristic of African women but maintain a more interrelated relationship with their spouses. Before marriage, young women often assisted their mothers, stopped vending when their children were small, then returned to work to earn money for school fees. In

Indonesia and the Philippines, many enterprises were jointly run.

Islam has had some effect in Indonesia; although the country is technically 90 percent Muslim, various islands have experienced Islam's penetration differently. In east and central Java the former animistic and Hindu beliefs have been intermingled with Islamic ones, while in the western part of the island a purer form of Islam predominates. Bogor, the city studied, lies on the borderline between the resulting cultural patterns. This variation helps explain the lower percentage of female street food vendors in Bogor than found in Jogjakarta in central Java only some 200 miles away. Instead of selling on the streets, many women in Bogor earned income in "invisible street foods," that is, by informal contracts to supply meals to offices or dormitories, or by marketing sweets through shops.

In Catholic Philippines, divorce is not allowed. Women and men both contribute to the family; indeed, jointly run street food enterprises were by far the most profitable. In Buddhist Thailand, where divorce is not common, five percent of the vendors were separated. Women vendors in Chonburi were of both Thai and Chinese origin, but no Thai men were found in the trade. In both Philippines and Thailand, many of the male spouses worked at lower paying but higher status government jobs. The importance of income was illustrated in Iloilo where one-fifth of all vendors had some college education.

In these seven countries, then, three distinct family patterns influence women and their enterprises: classic patriarchy of Egypt and Bangladesh, separate spheres and budgets of Africa, and the intermediary Southeast Asian pattern. Women are independent vendors in Africa and Southeast Asia; men and women work together in Southeast Asia as well as in Bangladesh and Egypt. In all countries, culture and history are more important than religion in influencing women's behavior.

Where the patriarchal bargain values seclusion for women, poverty may both force women to work and excuse them for doing so. But in other areas, women of all classes are expected to work and do so. Because street vending is relatively lucrative, this activity is often selected by middle-class women as well as by poorer ones. In all the countries the idea of men protecting the women of the family seems to hold; in none of the countries was harassment of women sellers by men mentioned as a problem in contrast to women vendors in Washington, DC, for whom this is a major problem.

Women in the Street Food Trade

The percentage of women selling street foods varies across the towns studied from a mere one percent in traditional Muslim Manikganj to 94 percent in Ile-Ife with its history of market women and traders. In Ziguinchor and Chonburi about three-quarters of all vendors are women; in both countries, as in

Ile-Ife, women and men sell separate types of food and do not work together. This commonality may trace its origins to the more strict sexual division of labor typical of slash and burn farming systems that continue to be practiced in parts of Africa and in the hills of Thailand. Separate budgets and the mother's responsibility for feeding her children are part of the female farming system. It may also reflect the fairly low status of commerce versus warriors or rulers that is embedded in their cultural traditions.

Women's involvement in the trade, however, is not synonymous with being women vendors. In Manikganj and Minia a significant number of women played some role in street food vending. In Manikganj, 26 percent of the male vendors have unpaid help from their wives; another 10 percent buy from women neighbors on a regular basis. Thus, 36 percent of the male vendors in Manikganj had female help in their businesses, a figure which raises women's involvement in street food vending from one to thirty-seven. In Minia, the town with the second lowest percentage of women vendors, women were either the sole or major vendor in 17 percent of the enterprises. In addition, 14 percent of the male vendors were assisted by females, either in food preparation or in washing up; this assistance brings women's involvement to 31 percent, the lowest figure overall of the cities studied.

In Southeast Asia, the traditionally strong role of women is mitigated by religious custom to produce three distinct patterns. In both Iloilo and Bogor, about one-quarter of all vending establishments are operated by couples, a finding that reflects strong family values. As noted above, Bogor's women vendors are fewer in number than have been found in other Javanese towns where Islamic influence is less intense. It appears that the women reported as part of a couple were often assistants to their husbands, although in some instances each made and sold foods complementary to each other. For example, one man would sell noodle soup and his wife would sell herbal drinks; in another couple the woman sold fritters and her husband sold ice drinks.

Iloilo exhibits the reverse pattern. The traditional dominance of Southeast Asian women in commerce continues; Christianity requires monogamy and permanent marriage so that couples indeed see themselves as permanent entities. Women operate about two-thirds of the firms alone, but when a woman becomes successful she is often joined by her husband, who may assist *her* in selling. Husbands also may help by obtaining or buying a truck and going out into rural areas to buy ingredients at a lower cost. Thus, women in Iloilo run some 90 percent of all vending establishments.

This strong female commercial role is evident in Chonburi as well, but (as in the African cities) women vendors operate independently from men. This contrasts with the cooperative patterns of Bogor and Iloilo, where women and men assist each other in both the selling

and preparation phases of operating the enterprises. In Minia and Manikganj, spouses help each other in preparing street food but not in selling it. In Manikganj, family members helped widows construct their selling kiosks but did not appear to play a regular supportive role. In Minia, however, 17 percent of the female vendors received help from their spouses. Thus, the results of the street foods study identify only two types of vending systems: separate sex and family enterprises. In Ile-Ife, Chonburi, and Ziguinchor, women dominate the trade; most of the foods they sell are different from those sold by men. In the other four countries, the enterprise is a family business. In Bogor and Iloilo couples work together in the selling as well as the making of the foods. In Minia and Manikganj, wives prepare foods in the home; but women alone or those without an 'earning' husband will sell on the street and may receive help from their spouse or other male family members. The impact of patriarchal bargains on women's autonomy to choose to trade is evident; the configuration of the enterprise is influenced by additional factors that need further research.

Income and Its Use

Street food vendors do not usually keep written records, but most have clear memories for expenses and income. However, few are willing to confide such details to interviewers. Therefore, we crosschecked answers given on the questionnaires by estimating daily costs and observing daily sales. These findings were once again checked during the in-depth study of selected vendors and their families. In all of the towns, return on the street food trade was generally higher than income derived from entry-level jobs in government, industry, or domestic service, but the variation is wide between countries and within the occupation.

In Iloilo average vendor profits were above the minimum daily wage; in Bogor they were higher than the wage for construction workers. In Manikganj vendor income was more than twice the wage of an unskilled agricultural worker, more than that of a mason, and about the equivalent of a carpenter. In Minia the vendors' average monthly income was 35 percent higher than minimum wage. Women vendors in Ziguinchor made more than housemaids. The Chonburi study indicates that even the lowest reported income is sufficient to support a family of four or five. The Ile-Ife study was conducted in the midst of a recession; data reveal that only a quarter were making a good income; half were only making a meager income. It is likely that these vendors represent casual sellers who gave up after the "street cleaning" exercise of the government.

Overall, male vendors made a higher income than female vendors. One reason seems to be that women sell foods that take longer to prepare (two to three hours), as compared to men's preparation time of one hour. Shorter preparation time and no

household tasks to do means that men generally spend more hours actually selling street foods. Thus, women make less money than men except in Bogor, where women often sell medicinal beverages which are very profitable. Where couples work together, as in Iloilo and Bogor, their income is higher than either sex working alone.

Women's income from street foods is essential to household survival. Our data indicate that in Ziguinchor, 59 percent of the women vendors are the sole support of their families. In Minia, 55 percent of the women vendors are primary household providers, as are 70 percent of the men vendors. Data from Chonburi show the importance of women's income to their extended families: While 20 percent of the women vendors provide the main source of income to their nuclear family, another 21 percent, all unmarried , are the primary support for parents or siblings. In Manikganj the women, all widows but one, were vendors because they had no other source of income; the woman who sold fruit from her garden had to beg as well. The data from Iloilo indi cate that 75 percent of all vendors derive their primary income from street vending; since women run 90 percent of the firms, this means that they are the primary earner in 68 percent of the households. In Ile-Ife, two-thirds of the vendors have no other source of income; further, 92 percent report that they also fed their families from their street foods.

These data suggest that whether the enterprises are run by women alone or by family cooperation, the street food trade is an important source of livelihood. Further, the poorer the family, the more critical are women's roles, a finding that echoes studies done in rural areas. Bangladesh and Egypt, the most conservative countries studied, relaxed restrictions on women's freedom of movement in the face of economic need. The Street Foods Project did not attempt to find out whether the income earned by women actually altered the intrahousehold dynamics. However, women's ability to earn income from street foods does improve the nutritional status of the family. In Nigeria the family fed on the street foods. In Senegal, where local Islamic custom dictates that men supply the basic staple to the family, the study found that 84 percent of the men provided their households with a large bag of rice each month. Women's daily expenditure on vegetables and meat to use as sauce equalled the cost of a bag of rice over a month. Yet neither the women nor the men realized their costs were equal and continued to say that men fed their families. Without street food income, the women would have been unable to buy the sauce ingredients.

Policy and the Street Food Trade

Governmental policies toward street vending are generally hostile around the world: Conventional wisdom is that street vendors clog the streets and

produce congestion, pollute the air with their fires, produce waste, and sell contaminated food. These indictments underscore the widely held belief that vending and other micro-enterprises are oldfashioned remnants of tradition or symbols of underdevelopment that are embarrassing to modern municipalities and should be regulated or even expunged. These indictments also reflect the assumption that street foods are a marginal economic activity.

Regulations

All the cities studied had some form of required registration, and certificates were required by the health departments. Procedures for registration are generally onerous and costly, so that most vendors did not, or could not, comply with the law. Enforcement of these regula tions was uneven. Although there was some indication of corruption, fees were sometimes not charged because the police knew the profits for the day were low. In Los Angeles, street food vendors are illegal but usually ignored in face of more pressing and destructive crimes. The majority of street food vendors were illegal, or at best extra-legal. Indeed, the primary difficulty they faced, according to the street food vendors themselves, was this lack of legitimacy, a condition that allowed them to be harassed by police and protectionist groups. Most feared was the periodic clearing of the streets by police or army, a fact of trade that discouraged vendors from improving their carts or stalls or otherwise investing in their enterprise.

One such government sweep occurred in the final days of the study in Ile-Ife. The new military government decided to enforce laws against vending. Six weeks after the streets were cleaned, the project staff scoured the city in search of as many vendors as they could find. This special survey suggests that the military action pushed out the more casual of the vendors but the women with the largest sales and longest experience had reappeared.

Such harassment is inconsistent with the economic importance of street vending to the municipality and the importance of street foods in the urban diet. In Bogor, the average household spent 25 percent of the daily food budget on street foods; the figure is 30 percent in Iloilo. In Chonburi an amazing 47 percent of the average household expenditure is on street foods with a slightly higher percentage of the budget being spent by the poorest income group. In fact, in Thailand where multiple dishes are the traditional diet, 70 percent of households in Chonburi do not cook food for every meal and 13 percent of the families surveyed *never* cook at home. In Ile-Ife 83 percent of all households surveyed buy breakfast from vendors between four and seven times a week. These data prove that street foods are indeed the fast foods of developing countries. Translated into labor force participation, we find that even in Manikganj some 6 percent of workers are directly or indirectly

involved in the street foods trade; the figure rises to 25 percent of all workers in Bogor! Aggregate yearly sales, expressed in 1985 U.S. dol lars, contributed two million dollars to the economy of the small dis trict town of Manikganj and an amazing sixty-seven million in the booming city of Bogor.

When presented with these data during the EPOC briefings, municipal authorities realized that their policy of harassment was illogical, that they should not disrupt as important a trade as street foods. As a result, representatives of vending groups and governmental agencies have met in several towns to seek new solutions to the problems inherent in vending, and to try to improve the trade, not obliterate it. In at least three towns, the EPOC study encouraged NGOs to offer credit and support programs to vendors and in Bogor, the Dutch government is funding a training program for food vendors.

Food Policies

Other national policies also affected the street food vendors; while pricing policies for foodstuffs affect enterprises all along the food distribution system, the tendency of governments to ignore traditional foods is of greater concern to vendors whose food reflects indigenous diets. In Senegal, imported rice was subsidized but local millet was not. Women selling a millet-based breakfast food often diluted it with the rice, – which should have been more expensive – when millet prices rose!

Also in Senegal, large quantities of milk powder imported under food aid programs affected traditional yoghurt production. Nomadic women used to have a monopoly on yoghurt; male market traders, unlike these women, had sufficient capital to buy the large bags of powdered milk and began to produce yoghurt in competition. In Indonesia, nutritionists on the street food project staff created an improved *kropok* (puffed rice chips) by adding subsidized imported soy flour. The new product went off the market when the subsidy was withdrawn. Imported wheat promoted bread as a substitute for traditional staples in several countries.

Findings of the EPOC study precipitated a change in the manner in which nutritional surveys are conducted. Previously, the usual method was to gather data on food prepared and consumed at home; clearly such data are invalid in light of data showing that perhaps onefifth of all food is eaten outside the house. Agricultural policy was altered in the region around Iloilo because the study showed a demand for different foods than originally planned. Pricing policies for rice versus millet were also challenged by street food findings of millet use by food vendors. Such policy implications of this microstudy underscore the interrelationships among women and their families to such major social institutions as the economy and the state.

In all these instances, the move from traditional to modern food has had several significant implications. Agricultural

products less suited to the environment are favored; modern food is often less nutritionally balanced; and production of the newer commodity shifted from female to male. In the future, government policy needs to consider these effects when subsidizing food.

CONCLUSION

Three pertinent assumptions widely held both by theorists and practitioners are challenged by the findings of the street foods study: (1) that the income from such enterprises are trivial; (2) that street foods are snacks with marginal nutritional value; and (3) that women's involvement in the trade represents economically unimportant "pin money."

Theories that denigrate the importance of income derived from vending, referring to the operators as the "community of the poor," are clearly dismissing these entrepreneurs without investigating their income. While municipal administrators are adapting some policies to the needs of vendors, the planners in development agencies continue to hold onto unrealistic assumptions about economic trends and values that would offer support only to enterprises that grow to employ more workers. They overlook the critical contribution that income from vending plays for the poor. For casual vendors, who indeed make a meager income, selling is only one of many activities utilized to survive. For all vendors, their income from street vending is essential to the household. The fact that three-quarters of the enterprises are owner-operated should not mean that they are not worthy of credit programs and other types of support from NGOs and the donor community so that they are able to improve their productivity and income.

Use of income for family needs instead of enterprise growth leads some economists to reject these entrepreneurs as lacking in business acumen. In contrast, credit is widely dispensed to small farmers so that they can increase their productivity; and no donor expects every farm to grow from one hectare to five or ten. This double standard for enterprises versus agriculture is compounded by a double standard for micro-enterprises run by women and those by men.

The nutritional content of street foods were dismissed because the extent and variety were unknown. The study has also identified other types of prepared food services thus far largely unstudied. These "invisible street foods" include informal restaurants, catering, contract meal arrangements, and community kitchens. To solve the problem of feeding the magna cities of the future, research on these activities and women's involvement in them are essential.

The strong role of women street food vendors in those countries where they sell alone was expected. What the current study has added is the importance of women in joint family ventures even in such patriarchal societies as Bangladesh. Analysis of the case studies not pre sented in this chapter illustrates women's decision-making roles which

flow from her economic activity. These findings are consistent with recent research which emphasizes the relationship between women's work and the nutritional status of her children.

Women's involvement in the street food trade relates to the family system that is embedded in the culture and history of the society. Within the constraints of society, women make different patriarchal bargains in order to support the family, or their children, economically. Even in the more classic patriarchal systems, poverty overrides propriety; women must work, and men not only accept but often assist their wives in their trade.

The fact that in all the kinship systems represented in the study women stayed within the family came as a surprise. We had expected that more of the independent women sellers would be heads of households *without males present*. Infact, even wives of drunkards continued to support them. It would seem that the patriarchal bargain is more flexible and less onerous than predicted. Thus, the importance of women's economic roles in the family questions the applicability and perhaps the definition of patriarchy itself.

The street food study provides primary data that can be used to improve development programs for the urban poor; it speaks to intrahousehold bargains not well understood by scholars or practitioners; it forces a new look at the economic importance of micro-enterprise in providing income and services to urban populations. More studies of survival strategies of the poor are needed if global equity is to become a reality.

STREET FOODS: URBAN FOOD AND EMPLOYMENT IN DEVELOPING COUNTRIES — CHAPTER 9

T HE ULTIMATE GOALS OF THE STREET Food Project were from the beginning focussed on both the micro and macro level. At the city level our objective was to utilize the findings of the studies to identify interventions that would improve the economics of the trade and the safety of the food the vendors sold. These interventions were to recognize and support the critical role women, as well as men, play in each city's trade. At the international level our objective was to influence the organizations and debates which shape food policies. Chapter 9 illustrates how these twin goals played out in the food arena. At the local level, training programs in food handling replaced sporadic enforcement of unrealistic health standards in many cities. At the macro policy level, the EPOC studies helped reorient public health experts, particularly at the Food and Agricultural Organization, away from the support of stringent laws restricting the sale of food on the streets, toward a recognition of the value of the trade.

This chapter focuses on the institutions and policies which shape the business climate of street food vending. At the conclusion of each study, participants in final briefing seminars proposed a range of interventions to help

vendors as microentrepreneurs. These included measures specific to the street food trade, such as ideas for improved vending carts, or for providing better serviced locations, or for setting up mini food centers. Most other suggestions for local initiatives reflected the development community's contemporary approach to helping microenterprise more generally: creating organizations of vendors in order to better provide services, particularly credit, as well as to facilitate communication between vendors, their middle class advocates, and government.

At the time of the street food studies, two broad debates were shaping both research and aid policies for microenterprise. Both originated from the fact that neither neoclassical nor Marxist economic theory could satisfactorily explain why apparently pre-modern artisanal and trade activities were not disappearing with urbanization and industrialization, but in fact appeared to be proliferating. Within the development community, debate revolved around the definition of economic activity. Many economists argued that enterprises which did not accumulate capital and grow were "pre-entrepreneurial." Street food enterprises seldom expand and so were assigned to this category. As part

of the "community of the poor," it was assumed they were simply surviving,— certainly not contributing to economic development.

The second debate, which began as a policy concern but later developed into a heated and at times obscure academic argument, centered on the definition of the "informal sector." This term became popular in the 1970s, when a series of International Labor Organization studies on alternatives to formal sector employment in developing countries highlighted a vast and diverse range of small-scale enterprises. But because most street food vendors work alone or with family assistance, most often unpaid, they were typically overlooked. Subsequent scholarly analyses drew on fairly orthodox Marxist models which focused on the perceived exploitation of informal sector enterprises, and their dependence on the formal sector for resources and markets. Since neither was really interested in microenterprise, we did not see how either debate would contribute much to EPOC's efforts to understand and assist street food vendors. Our findings, however, would challenge their assumptions about some of the smallest scale entrepreneurs of the informal sector.

Although gender issues were relevant to both debates, of the two, the development community initially took more notice of women's economic activities. But since women in the informal sector are more often engaged in microenterprise than small enterprise, and so comprised the majority of the

"community of the poor" or the "pre-entrepreneurial" category that allowed economists to dismiss their work and leave any assistance efforts to NGOs. EPOC's Street Food Project, by contrast, specifically intended to document women's entrepreneurial activities.

Gender became more central to informal sector theory as industries around the world began to increasingly "informalize" their workforce in the 1980s. In order to cut labor costs, they contracted abroad with larger factories, which in turn subcontracted assembly and sewing to home-based workers. Women were predominantly hired at both levels. The increasing use of industrial home workers in everything from electronics to toys rekindled trade union concerns over regulating this form of employment.

In this manner, the debate over whether the informal sector exploits workers or provides opportunity centered on the household: Is home-based work, whether industrial homework or microenterprise, a form of oppression or opportunity? Are women microentrepreneurs such as street food vendors really independent, or are they tied into an exploitative capitalist system? And because they are women, are they further exploited within a patriarchal household that controls women's labor, or are they partners with their husbands in managing family survival? In this respect, is there any real distinction between women as microentrepreneurs and as home-based workers?

The Street Food Project speaks

to all three discourses by providing, through its case studies, detailed data on informal sector microentrepreneurs. The reality presented challenges the theories at many points. As background for the policy discussion, this chapter begins with a review of the recommended interventions of the advisory committees in each city that were meant to improve the health and/or income of the street food vendors. The interventions reflect the perspectives of the development community with their own internal inconsistencies that revolve around participation versus government planning. The difficulties encountered when trying to implement the interventions often had their roots in common assumptions made by the theorists in the distinct policy debates about microenterprise and about the informal sector. The current controversy over home-based work is more pertinent than the earlier discourses to street food microentrepreneurs; these feminist debates speak to the economists, some of whom are reexamining household economic theory.

IMPROVING THE MICROENTERPRISE

For much of the postwar era, both international development agencies and centrally planned governments attempted to impose social change and economic development through top-down programs and policies. As passive resistance and non-compliance undermined these efforts, an alternative school arose advocating participation of the affected populace. EPOC's efforts to work with street food vendors marked an intermediate position between conventional development planners and proponents of "bottom up" development, who too often saw each other's methods and priorities as completely incompatible: one side lobbied for sidewalks for pedestrians, the other for selling space for vendors; one side was more concerned about safe food, the other about cheap food. But the ideas and impetus for interventions and change came from outside the vendor community. To affect changes in the behavior and practice of the vendors, they had to be involved. The current wisdom recommends both organizing vendors (to make them more effective participants in planning, assistance and advocacy processes) and giving them incentives to comply with regulations and safety standards. Training programs which supply vendors with health certificates as well as access to well-serviced vending sites are one example of the latter method.

Carts, kiosks, and vending centers

The aesthetics of vending intrigued many vendor advocates. If the carts looked cleaner and more attractive, they would enhance the tourist trade, as in Minia, or mitigate objections in crowded Makati in Manila. Indeed, in Makati, the vendors had to wear aprons and hair coverings as food safety measures. To encourage the vendors to use

the new carts they were sold on long leases at subsidized cost. Using a new cart also signified completion of the training courses. Confusion arises over what types of foods are sold from carts. In fact, no city seemed concerned over truly mobile vendors, with or without a cart. Most ambulant vendors sell pre-prepared food: ice cream, bread, peanuts; exceptions are noodle soup and *sate* vendors in Indonesia. Focus was on the "permanent" semi-mobile carts, most of whom do some food preparation at site, usually behind or at the side of the cart which in fact serves more as a counter than a kitchen. Often their food is served on plates. Water for washing is obviously necessary, but the sites are temporary. In Minia, the carts were first designed with two water tanks, one for clean and one for dirty water. These tanks made even the aluminum cart too heavy to move; the current design requires only a clean water tank. In Makati, the municipality delivers water to the carts. Most of these theoretically mobile carts never move. The fiction is maintained for legal reasons: permanent establishments fall under different regulatory statutes; more critical, permanency implies the right to be where they are, yet they are intruding on public spaces.

Erecting permanent stalls services with water, electricity, and sewerage and renting them to vendors would seem a more logical solution for those selling food outside congested market areas. Location is a major problem; vendors resist being moved away from customers, as the Jakarta attempts underscored. Efforts to acquire land for kiosks in Minia have to date been unsuccessful. The *bukaterias* in Ife and Ibadan add covered seating space to street food sites and assemble many establishments together providing a cafeteria selection. The stalls face inward to a common green and entry to the area is restricted for security purposes. Place this concept within a modern shopping center and you have the upscale street foods now sold in Manila or Bangkok or Jakarta. As vending structures improve, the rents often increase, pricing many out of the market. A low-cost alternative is to provide scattered vending sites near customers throughout the city. In Iloilo, vendors relocated from commercial streets to a nearby cul-de-sac found that the added seating space encouraged customers to walk the extra block. The Pune municipality allocated vending sites, but since it did not extend infrastructure facilities they are not well utilized. Several cities have set up successful but inexpensive selling sites and water points around bus stops.

Organizing vendors

By setting up an advisory committee in each city studied, the EPOC project hoped to create a group of local scholars, activists, and government officials aware of the vendors' problems and willing to address them. During the study the EPOC staff became the conduit for information flows between vendors and the committee; representative

vendors were often invited to participate in the final seminars. But an ongoing mechanism was needed. Organizing the vendors seemed a logical next step, but this is a time-consuming activity, and vendors may not have either the time or interest to become active.

Typically, social change organizations in developing countries, such as NGOs, trade unions, or some political parties, have been run by educated middle class members for the benefit of the less well-off. The extent to which the beneficiaries, or so-called grassroots activists, can influence the actions of the organization is extremely variable and hotly debated. At the heart of the debate is the issue of contrasting motivations and incentives between the leaders and members. In developing countries today, most organizations working with street food vendors, like those concerned with poverty alleviation in general, operate as non-governmental organizations (NGOs) playing an intermediary role between government and the poor. These intermediary NGOs grew out of a tradition of groups devoted to charity. Because they are presumed to have no stake in the activities for the poor, their members are able to play a judicious role among the beneficiaries, preventing powerful economic, kin, or ethnic groups from excluding others. The Manikganj Social Service organization offered to administer a credit program started with funds EPOC secured. The Pune report entreats the Rotary and Lion Clubs to work with the vendors.

In contrast to these charitable groups, market organizations exist in many cities to promote the interests of all vendors in a particular location; a primary concern was keeping the market clean and orderly. Health officials in Nigeria used these groups to convey information about training programs for street food vendors. In Bogor, the IPB project planned to organize all vendors by location on the street, much as market vendors are organized by their position in the market. The street vendor-only association that existed in Iloilo in 1983 appeared to be a self-organized group; taken over by more political leadership, the association became a vehicle for corruption and was later disbanded.

Associations of vendors appear fairly powerless against the government, but middle-class advocacy groups lack the perspective of the vendors. In Ibadan, Isaac Akinyele was instrumental in setting up two organizations, one for vendors, one for advocacy. In 1985 he encouraged graduates of his training classes to organize as the Ibadan Women Food Vendors Association in 1985; a few years later set up his own intermediary NGO, Food Basket Foundation International, to further his advocacy efforts.

A unique solution to this problem of bridging the advocates and the beneficiaries is being pursued in Minia. The Street Food Vendors' Organization (SFVO) of Minia, described in detail in chapter five, presents a unique solution to the problem of coordinating the

efforts of advocates and beneficiaries. It challenges the prevailing models, straddling the gap between altruistic organizations and self-interested groups. Although the Board of the SFVO is comprised of vendors and local elite, the organization is dominated by its strong willed chair. As a government employee, she works a 36-hour week and attends to the affairs of the SFVO most afternoons. In contrast, many vendors work eight to ten hours a day, seven days a week, producing and selling their foods, which limits their participation in the organization. Because the SFVO is not yet self-sufficient, the chair's ability to obtain grants is central to its success. Donors push for self-sufficiency as if the organization were a trade union, yet the numbers of street food vendors in Minia are insufficient to support the level of services currently available, even with a greatly increased dues structure. These services are exemplary but the question of whether they are too ambitious and expensive for a small organization persists.

The Self Employed Women's Association (SEWA), in Ahmedabad, India, offers a modified trade union model for organizing vendors. Founded in 1971 by Ela Bhatt, SEWA includes both street sellers and home-based workers among its members, organizing each into separate units. SEWA trains and employs natural leaders from each unit to work as organizers and liaison with the unit membership; informal discussions women's rights are an important activity of these outreach workers. Educated women serve as paid employees of the organization, avoiding the potential "charity trap" between the worker and the educated middle-class. Its large membership base has allowed it to initiate and sustain membership services, including bank and health clinics, both of which charge small user fees. Bhatt has used the prestige and experience of her organization to give worldwide visibility to self-employed women, both those who work at home and those who sell on the street. SEWA has been prominent in the ILO meetings on the Convention for Home-Based Women, and in 1995 it convened a global meeting that produced the Bellagio International Declaration of Street Vendors.

Services to vendors

Once an organization is set up, the organizer must persuade vendors to become active participants' the types of incentives and services offered are critical to the continued existence of the organization. Vendors work long hours preparing and selling their products, although in many countries women reduced their time spent on street food ending because of their household duties. In Ziguinchor and Ife, female vendors often utilized female kin to carry out these household chores. In Minia, the vendors who are active in the SFVO are all male, but the percentage of members who are women has steadily risen as the benefits of membership become clear. In Manikganj, once the credit program

was disbanded, vendors ceased their participation in MASS.

Vendors in both the EPOC and FAO studies identified their insecure legal status as their most pressing concern, not credit as had been assumed by the wider development community. Most vendors did not borrow money either to start or to run their enterprise. When vendors got into debt, it was often because of a family crisis, usually related to the health of family members or the vendors themselves. In Iloilo, a successful barbecue vendor nearly went bankrupt when her son contracted hepatitis; to pay the hospital bill of 2000 pesos, an amount that was more than her monthly earnings, she had to borrow from moneylenders at the usurious rate of 40% per month. Aware of the pitfalls of borrowing at high interest rates, most vendors were scrupulous about the obligations, personal or financial, that they incurred.

As an outcome of the EPOC studies, programs in Manikganj and Minia began offering credit to vendors. The Manikganj scheme emulated credit programs run by BRAC or the Grameen Bank throughout Bangladesh, which utilize affinity groups in lieu of material collateral to guarantee repayment of production loans. In Minia, the SFVO made credit available to members in a program similar to the loan service offered through SEWA. The pay back rates in both instances were much higher than those at local banks. Both programs charged a commercial interest rate. When vendors had difficulty

repaying loans, it was usually for reasons unrelated to their enterprises. In Manikganj the only vendor who defaulted did so after a divorce. In Minia, one vendor was late with his repayments because he was in the hospital for a week after his cart fell over and broke his leg. More troubling was the vendor who borrowed money to build a house, then could not repay from business proceeds.

These problems demonstrate the importance of providing distinct types of credit for different purposes. Vendors and other microentrepreneurs typically have no access to loans for social, that is, non-productive, purposes. The vendor who misused the limited loan capacity of the SFVO for a housing loan might well have been willing to pay a higher interest rate and accept more stringent collateral requirements had such loans been available. Crises that cause borrowers to stop repayments need to be met by separate arrangements. People living on the margin lack savings that they might use for unexpected bills; indeed, the hospitalized vendor was assisted by the crisis fund started by a group of SFVO members, though not by the organization itself. The Grameen Bank provides a useful model for these needs: it links two subsidiary funds to all regular loans, one to provide for loan repayment in an emergency, the other to accumulate funds available to members for non-productive or social loans. A separate housing loan program is also available to long term members. Such alternative loans avoids both the misuse of productive

loan funds and the necessity for members to borrow from moneylenders.

Health problems of members and their families cause many vendors to go out of business; working capital is used up and the business cannot be restarted. Even though both the Philippines and Egypt have national health programs, vendors in those countries, as elsewhere, have to pay for prompt and decent care. In Ife, Kujore obtained funds from the local branch of Soroptomists International to support a health clinic in the market. Research on vendors' health awareness showed the need for general health education. SEWA provides just such a service through its Community Health Program, which also runs clinics in the squatter settlements where members live; local women were trained as health workers. The clinics are open to all comers for a small users' fee; in the long run SEWA hopes the clinics will become self-sufficient. At the same time SEWA is lobbying the central government to create a national fund, open to self-employed workers, that would include health insurance. The SFVO is also lobbying for the existing social pension schemes available to self-employed businessmen be opened to vendors. In Bangladesh, the Grameen Bank is investigating what type of health coverage its membership prefers.

Alternative mechanisms

Experiences gained from these various attempts to reach and/or organize vendors show the difficulties of privileging only one model. Street food vendors are a subset of vendors, a subset of home producers, and a subset of food handlers. Joining with larger groups would minimize effort and maximize the vendors' influence. The problems of market vendors focus on keeping physical space attractive, clean, and safe; street vendors are necessarily more worried about harassment and legitimacy. Home producers often stop their own street selling activities and become contractors or traders. Opportunities for organizing self-interest associations with similar microentrepreneurs depends on local circumstance. The legal and political climate affect how both self-interested and charitable organizations champion the cause of the vendors. Governmental structure can encourage or discourage local officials to counter national policies less advantageous to street food vendors.

Despite plans in five of the seven EPOC cities, only one street vendors' organization, the SFVO of Minia, is functioning today. The combination of charitable and self-interested perspectives in this one organization is unique; it is a work in progress and deserves long-term observation. Continued viability of the organization will likely require an expansion of the membership base so that the organization can more toward greater, but hardly total, self-sufficiency. The many services offered its vendor members show how difficult it is for a single-purpose organization not to enlarge its scope, and thus often its expenses, under pressure from membership.

Macro-discourses and policy

During the nineteen seventies, two bodies of literature emerged from the escalating criticism of the prevalent development policy. Investment in infrastructure and large industry in developing countries, promoted by the UN First Development Decade, had exacerbated the disparities of income between rich and poor; plans for the Second Development Decade shifted the focus to basic human needs of the poor. On the other hand, industrial growth in these countries of the South was not keeping pace with population growth raising the specter of wide scale unemployment. To mobilize resources to address this issue, the International Labour Organizations (ILO) held a conference to plan for full employment by the year 2000, then mounted a major research effort to look beyond industry for job opportunities. Both the UN and ILO initiatives spurred studies at the micro level to find out how the poor really lived and survived. But because of the preoccupation with growth and employment, such studies rarely reached down to the micro level of street food vending. Data from the Street Food Project thus both supplements and challenges assumptions and policies flowing from these distinct discourses.

Reaching the poor

Large development agencies had few channels to people outside government and industry, so with increasing frequency, bilateral assistance channeled funds for basic needs programming through NGOs. Most international NGOs at the time had experience primarily providing services, such as maternal and child health, or charity, such as food distribution or cash transfers. Programmatically they tended to work with or through local NGOs. Their approach to helping the poor was multi-faceted, lengthy, and labor intensive; success was hard to demonstrate. Critics complained that these all-encompassing programs actually created dependency, not self-sufficiency, while proponents lauded the staying power of NGOs needed to address the causes of poverty. The alternative, many economists argued, was to provide the poor with jobs or self-employment and they would help themselves, particularly if the registration procedures in the host countries were simplified and the regulatory requirements relaxed. In the late 1970s, USAID funded a multi-country study of 20 existing urban poverty programs to determine which approaches were most effective and replicable.

Among the many groups helping the poor earn income, the USAID study revealed a clear distinction between the charitable NGOs, working with poor "pre-entrepreneurial" women whose needs reached well beyond business skills, and the business NGOs, whose clients were existing entrepreneurs, predominantly men, who needed access to technology and credit to expand their enterprises.[103] As the concern with poverty faded in the 'eighties and private enterprise became the focus of US

development assistance, the funds for programs that worked with "pre-entrepreneurs" were cut, on the grounds that these microentrepreneurs were not acting in a properly economic manner and so money spent on them was essentially welfare, not development funding.

It was against this backdrop that the Street Food Project was framed. The project findings undermine many assumptions about the street food trade. Vendors are clearly entrepreneurial; the income of most male and female vendors places them well above the poverty line. Vendors would benefit from improved registration requirements and procedures; an array of credit programs could help them both survive and improve their enterprises. New technologies could help producer vendors both improve their foods and increase their volume. But with all these prescriptions for small entrepreneurs fulfilled, most street food vendors' operations would probably still not satisfy the economists' standards of growth.

The EPOC findings show that few vendors invest in their enterprises to the extent economists anticipate. Their enterprises do not grow into large restaurants, although some replicate their stands in amoeba-like fashion. Where and from what kinds of facilities (permanent or mobile) they sell relates to what foods they sell, and most vendors do not change their products over the life of their enterprise. Vendor families manage the activity as they might a farm; the many tasks involved provide livelihoods for extended family members; profits are invested in the next generation. Improved production is desirable, but the family does not seek to expand. Yet planners and economists have persisted in calling such behavior, whether by microentrepreneurs or peasants, "traditional," "pre-capitalist," and "pre-entrepreneurial." It could also be based on fundamentally different values: family over individual, cooperation over competition, altruism over selfishness. Men as well as women vendors exhibit these perspectives, which surely cannot be dismissed simply by calling them traditional.

But these values also make economic sense in survival terms. First, in countries without social security or pensions, the family is a fallback position. Yet family disfunction and disintegration is a familiar phenomena as modernization proceeds. Many vendors commented on the importance of helping out their children and younger kin so that they would in turn be taken care of in old age. In Chonburi and Ziguinchor, vendors spent income on family rituals and obligations; in Ife women supported children of kin. In Bogor, some vendors felt familial obligations kept them from accumulating savings which they could invest in housing, and avoided kin pressure; but most studies of Indonesia report the continued rural-urban connection as part of long range survival strategy.

Second, the quantitative leap from self or kin employment to an enterprise with paid, non-kin employees cannot be exaggerated. Such a move is

as likely to cause bankruptcy as growth; over half of new enterprises in the US fail in the first year. Third, the issue of unpaid or underpaid labor looks different from this family perspective. Spouses and children received support in return for work; when demand for their labor diminished, they had more time for education, starting new employment, or retiring. Most family assistants to street food enterprises were apprentices; many were also students who received room and board as well as minimal pay. For all these assistants, low or unpaid jobs in street food enterprises are probably cost-effective, given time constraints and alternative job opportunities. Such reasoning is similar to the situation of welfare recipients in the US, who find that entry level jobs cost them too much in lost governmental support.

In the last decade, the success of micro-credit schemes in a variety of countries around the world has muted the economists' criticism, although the debate continues with regard to assistance funding. Both the affinity model of the Grameen Bank and the individual banking model of SEWA have been replicated, adapted, even combined, and extended to the US. In the US, pressure from international NGOs on Congress maintained line item funding despite administration policy; a study of 11 successful microenterprise finance programs in nine countries found that the programs reached the very poor while the financial institutions themselves grew and are approaching self-sufficiency.

The fact that the more successful lending programs include many additional services besides micro-credit tends to downplayed in the current political climate. As was shown in the Street Foods Project, vendors making different levels of income and producing or selling different products in different countries require different types of programs. For many vendors, credit might be a useful service; for others, legitimation, training, new technology, or vending sites may be a higher priority.

Providing employment

The impetus and much of the funding for studying the informal sector came from ILO's search for employment opportunities. As the agency responsible for developing employment statistics in the 1930s, ILO began to expand its definitions in the 1970s. In looking beyond the formal sector, ILO legitimized research into a variety of economic activities not previously thought worthy of study. But debate over the precise definition of the informal sector clouded much of the empirical findings and made comparisons across sectors or countries difficult. As field studies proliferated in the 1970s, academics debated theoretical models of relations between the formal and informal. One particular question centered on whether the sector was subordinate to and exploited by capitalism, or whether the sector was comprised of independent entrepreneurs. Subordination implied that low wages in the informal

sector subsidized higher earnings in the formal sector. Unpaid family labor compounded the exploitative nature of informality, keeping costs low and preventing accumulation that might allow the enterprise to grow. Disaggregating owners from workers in informal sector enterprises also showed that employees received very low compensation. Such conclusions were not the good news about the employment potential of the sector that ILO had anticipated.

Despite these bleak conclusions, members of the development community saw the potential to alleviate poverty by promoting microenterprise. They portrayed the informal sector in a more positive light. Proponents estimated the informal sector's share of total employment at anywhere from 40% to 75%, depending upon what activities are included. Although they called for more attention toward ways the government could support the sector, ILO's director of these studies, S. V. Sethuraman, continued to believe "that informal units are not run by entrepreneurs in the true sense of the term" and applauded the ability of NGOs to provide tailor-made technical advice to these units.

The next round of studies, led by Alejandro Portes, examined how small enterprises within the informal sector could reduce costs for large formal industries in both advanced and less developed countries. This research focused on various industrial strategies to increase flexibility and avoid high labor costs, such as sub-contracting,

downsizing enterprises, or off-shore sourcing. The authors emphasized the high level of integration among firms, with smaller enterprises dependent on the larger formal firms for inputs, technology, and markets. Lourdes Beneria's and Martha Roldan's study subcontracting in Mexico City shows how the more marginal workers, especially women, are clustered in the lower paying illegal enterprises at the bottom of the pyramid. Despite the exploitative nature of this work, they said "we do not conclude that, from the perspective of women themselves, their engagement in homework is totally negative." Their income may improve their position within their households. Also, homework allows women to move in and out of employment at different points in their life cycle.

This evolving discussion about the position of informal sector enterprises in the local and global economy helps place the street food trade in the macro policy debate. EPOC data contested many of the early ILO characterizations of the informal sector: most vendors were not recent migrants; they possessed skills that included both an understanding of the local economy and of food preparation; and for the more successful, street food vending was a lifetime occupation. Key findings document the profitability of full time vending enterprises, and the contribution of the street food trade to the urban economy. Such findings have helped change perceptions that the informal sector was a refuge for the poor. On the other hand,

the income data also showed wide variation among street food vendors, indicating that many poor women and men use vending as part of a survival strategy, usually combined with seasonal agricultural work, as in Manikganj and Ziguinchor, or with other forms of petty trade, as in Ife.

Informal sector enterprises were also presumed to be illegal. Regarding street food vendors, this issue of legality is complicated. In Bogor (58%) and Minia (72%) vendors had paid the fee required for selling; but many in Minia sold foods other than those on the permit. In Pune, where two licenses were needed, 61% had the license from the Encroachment Department but only 14% one from Health. Virtually all vendors paid a daily selling fee in Ziguinchor and a majority did so in Manikganj; in the latter town, however, only 20% had the required business document. Market vendors in the Iloilo and Chonburi also paid daily or monthly fees; sidewalk vendors in those cities and in Manikganj made some arrangement with the store owners for the privilege. Yet in most countries the trade remains officially illegal, so paying a fee reduces but does not eliminate the risk of harassment. Over-regulation and erratic enforcement clearly inhibit investment and accumulation, for the street food vendors as well as many other informal sector microenterprises.

Street vendors, like many other workers in the informal sector, often produce, retail, wholesale, and even consume their own merchandise. This multiplicity of functions questions and confuses prevailing categories of economic activity. Many cities required all vendors, whatever functions they carry out, to have permits for all of them. In contrast, census enumerators, finding that vendors do fit not their classifications, miscount or ignore these enterprises, rendering them invisible in national statistics. Until vendors are correctly enumerated, policies to improve their conditions will be difficult to implement.

Gender aspects

The above discussion shows some divergence of women's roles from men's in the debates surrounding microenterprise and informal sector. Overall, women vendors made less money because of the time they devoted to household responsibilities. In large or polygamous families found in Ife and Ziguinchor, vendors were sometimes able to turn over these domestic responsibilities to other female family members and work longer hours. But most female vendors maintained the double day, juggling work and home. Vending is an attractive occupation to women because of its flexibility. Women, even more than men, spend earnings on their families, and therefore do not accumulate capital for investment in their enterprises; lack of investment capital in turn keeps them at the low-technology, low-earning end of the spectrum. On the other hand, women's return on

investment, at least in Ziguinchor, was as high as for men.

Above I argued that the case studies show that many vendors, male and female, view their enterprises as part of family survival strategies. But the authors of the Jamaica Street Food Study, illustrating the diversity of motivations of the vendors, write that:

Women and men appear to have different approaches to vending. Women, though they might have been vending all of their lives and might be part of a family of vendors, seem to see this activity as a temporary thing to make two ends meet rather than as a career. Men see it as a business: they have dreams of moving from a food-stand to a restaurant...

The production functions undertaken by many vendors place them within the debate over home based work even though few engage in subcontracting. Most vendors and their families produce or prepare the foods they sell, and much of this activity is done in the home. In some countries, families even grow the foods they process and sell. Other food producers sell directly to middlemen or to customers without selling on the streets. It is clear that home-based family-operated enterprises enjoy a comparative advantage typical of the informal sector: flexible labor supply and free working space. Such cost savings allow the informal sector entrepreneurs to find niches in which they are more efficient than formal sector industry. In other words, these enterprises can only survive with free family labor.

Many feminists see this system as inimical to women because the male household head controls both women's labor and the use of the house. In fact, many microenterprise projects were subverted by men precisely because the men felt they were losing control of their wives. Because the bulk of unpaid family labor in the street food trade is female, these women would seem to be particularly exploited by patriarchal control. According to Deniz Kandiyoti, however, even unpaid economic activity can improve the household bargaining position of women. This observation was echoed in the case studies of women producers in Manikganj.

In many of the countries studied, whether spouses' incomes were pooled, as in Thailand and the Philippines, or kept separate, as in Nigeria, Jamaica, and Senegal, women are expected to help meet regular household expenses. Elsewhere, women participate in family survival strategies as necessary. Overall the studies corroborate the growing evidence that a woman's income, no matter how small, improves not only her bargaining position within her family, but also the nutritional level of her children. It even "alters established patterns of social/spatial interaction," that is, the way different spaces in and around the house are used and by whom, according to research in Guadalajara by Faranak Miraftab.

At the micro level, then, working at home for income is perceived by both researchers of the informal economy and by proponents of microenterprise as a useful strategy for women. Besides allowing a woman to better meet her and her family's expenses within marriage, she also needs her own money in case her husband divorces or abandons her. Income also allows women to leave abusive unions. Lourdes Beneria and Martha Roldan identified "the two fundamental mechanisms of husbands' control over their wives. Husbands' predominance... was found to be based, not on ideological mechanisms alone, but significantly on privileged access to income and coercive means of control". Many European and American feminists wonder why women remain in marital unions, and indeed the rise in households headed by women has been widely documented. However, women in other cultures, particularly in Asia, argue that too much emphasis on individual rights undermines the greater values of family and community. There is a cautious move on the part of some feminists in the United States, concerned with the conservative appropriation of the term, to reimage the family and demonstrate its relevance to development.

At the macro level, trade unions in Europe and the United States fought for years against the existence of home based work. The global expansion of subcontracting has begun to undermine regulations regarding homework that currently exist in industrialized countries as corporations in those countries attempt to cut production costs in order to compete with industry in developing countries. In response, the ILO conducted research into the issue and reiterated that "homeworkers constitute a particularly vulnerable category of workers due to their inadequate legal protection, their isolation and their weak bargaining position." Many in the labor movement consider home-based work exploitative and would prefer to ban it; failing that they would organize homeworkers to demand living wages and benefits although in the past, organizing homeworkers has been unsuccessful. They have proposed that the ILO adopt a Convention on Home Work recognizing them as dependent workers and "promote equality of treatment between homeworkers and other wage earners."

In contrast, NGOs working in developing countries celebrate the major successes of their microenterprise projects, most of which are home-based. They consider income from these enterprises as essential both for survival and empowerment. This dichotomy of exploitation versus opportunity mirrors the overall positions taken during the informal sector between those who thought small-scale entrepreneurs were independent versus those who saw them as dependent workers within the capitalist economy. The difference is that the former debate did not usually reach into the family or the home. Only with the growing research on women were the gendered aspects of the informal sector clarified. In contrast, the

microenterprise programs from the beginning were focused on women and their familial roles.

In the home, as illustrated in the Street Food Project, it is difficult to distinguish between industrial homeworkers and microentrepreneurs. Even when women work within a subcontracting pyramid, the distinction is one of degree. A woman seamstress may bring in family workers in times of high demand, or may hire a neighbor and thus become a jobber herself. In this way, home-based workers often are both employer and employee, but they continue to be constrained by their socially constructed roles as mothers and housewives. At the 82nd International Labour Conference in June 1995, when the proposed convention on homework was discussed, homework advocates from industrialized countries and development groups such as SEWA cooperated in support of the convention, against opposition from those concerned with employer rights. They see the categories as fungible and perceive the need to extend protection to the increasing number of workers outside the formal workplace, whatever they are called.

CONCLUSION

The Street Food Project provides a wealth of information that expands, deepens, and challenges the two major debates of the seventies and eighties over the role of poor small-scale entrepreneurs in developing countries. Neither free-market liberals of the

development community nor Marxist-influenced informal sector scholars initially paid much attention to family and individual enterprise. Over the past decade, both these discourses have themselves evolved. The success of micro-credit schemes proved to the development community that microenterprise merited investment and assistance. The expansion of subcontracting accompanying the restructuring of the global economy increased labor movement concern over work outside the factory, bringing the debate over oppression versus opportunity into the home and family.

Street food vendors are generally independent microentrepreneurs but some are dependent workers or subcontractors; the dichotomy is hard to maintain because it rarely fits reality. Microentrepreneurs move between the categories or may be both at once. Considering that most homeworkers are women, one cannot discuss their labor, whether as independent microentrepreneurs or as subcontracted employees, without reference to their other socially constructed roles as wives and mothers.

Early literature in both the women-in-development field and in women's studies tended to focus on the woman *apart* from these social roles. This limited vision resulted in development projects, meant to make women's lives easier, instead added to their workload. The feminists' narrow conceptualization of family has alienated many who believe that individual rights should not always take precedence over the

needs of family and community. Most women street food vendors appeared to subscribe to family welfare. Research on men's responses to rapid social and economic change is in its infancy. The opinions recorded in the street food vendor case studies often show similar concern with the family, but perceptions of what their own roles should be certainly differed from women's perceptions. Clearly more research is needed to understand better how household and family dynamics shape the economic strategies of the urban poor.

AFTERWORD: PUTTING IT ALL TOGETHER

Weaving together the individual reports of these seven diverse cities, each using the basic design of the Street Foods Project to produce distinct patterns, has been a daunting task. Each study expanded into new areas propelled by the demands of the local situation and the curiosity of its staff. The focus and success of interventions to improve the trade in both its economic and food service aspects varied even more, dependent on the local political as well as cultural climate. Returning to the field five to ten years after each study was completed was both a humbling and exhilarating experience. In Iloilo, the present and former mayors welcomed me at the airport with a banner and flower garlands, and the former Regional Director of the national planning authority produced data about economic change over the last decade.

In comparison, all the members of the research team in Ife had scattered abroad: to Zimbabwe, Saudi Arabia, and the United States; but the local public health coordinator continues to train vendors. In nearby Ibadan, as in Bogor and Minia, local leadership has expanded far beyond the EPOC project and is engaged in impressive programs that combine research, training, and organizing. In Manikganj, the local non-governmental organization shifted its focus from credit for vendors to technical assistance for producers and producer/sellers of street foods. Rapid economic development in Thailand has altered the patterns of the trade as more foods are produced industrially, mostly by indigenous firms; meanwhile, the popularity of taking quick meals on the street has, if anything, increased as congestion magnifies transit time between home and work. In contrast, the economy of Ziguinchor, constrained by civil unrest, has sent many vendors to Dakar to survive.

The first four EPOC studies – in Iloilo, Bogor, Manikganj, and Ziguinchor – were perhaps the most influential. For the first time, estimates were available on the aggregate annual sales of street food vendors in each city. When the mayors of each city heard these figures that documented the importance of street foods to municipal revenues, we caught their attention. In Iloilo, Alex Umadhay, regional executive director of the National Economic and Development Authority and a member of the local advisory committee for the

Iloilo project, compared his previous attitude toward street food vendors to flies: they are so pervasive that you tend to ignore them and just brush them off. Like most people involved in the project, he became a champion of street food vendors.

The sheer size of the total labor force involved in street food vending is staggering. The average number of persons working in each enterprise was 1.5 to two in Indonesia and Bangladesh, 2.9 in the Philippines. Assuming a labor force that is of 40% of the population, then 6% in Ziguinchor and Manikganj, 15% in Iloilo, and 26% in Bogor of the labor force works in the street food trade.

Demand for street foods is equally impressive. The percentage of total household food budget that was spent on prepared food was nearly half in Chonburi and Ife, a quarter in Iloilo and Bogor. The smaller and poorer the family, the higher percentage of their food budgets they spent on street food. In Minia, one vendor served 60 customers a day or about 50,000 a year; if each person ate only one time, that number would that about a third of the citizens ate street foods in a year, considerable less than the 82% of all Americans who eat at least once a year at a fast food establishment. Nonetheless, the income and food that represents in a low income country is significant.

The year-long studies were carefully designed and meticulously carried out. Reported income figures were tested against observation and estimates of

the costs of inputs and the amounts of sales. However, to obtain aggregate figures a series of assumptions are made that can alter the totals considerably. Whatever the actual income, labor force and numbers of customers, the importance of street foods in the economy and in feeding the city is undeniable.

The EPOC definition of street food enterprises encompassed ready-to-eat food sold in the informal sector. Like that term, our definition was residual: all non-formal restaurants. In these cities, a restaurant was a place frequented by the middle or upper classes and by foreigners. As a result, our data reveal a hierarchy of enterprises that ranged from the local equivalent of restaurants and bars to the seasonal ambulant seller of agricultural surplus. By focusing on working vendors, we selected the successful entrepreneurs; what happened to the vendors who dropped out of our enumeration we do not know. These observations suggest that many poor try a variety of jobs in order to survive. Those that are not skilled entrepreneurs probably take up another activity.

By focusing on the sellers, we observed but did not study the multitude of food producers and processors who made food sold to the public by someone not kin. By focusing on the street sellers, we did not include the food sellers who deliver at workplaces and homes. Nor are the backward linkages to small agricultural producers or to market women included. If all of these producers and sellers were added to the

street food numbers, the percentage of urban dwellers involved in feeding the cities would expand notably. If unpaid labor for these various activities, and the largely unstudied number of people involved in urban food production were added, then we might begin to understand how cities really feed themselves. If we do not have this information, how can we avoid crisis and starvation in the mega-cities of the twenty-first century?

The Future of the Street Food Trade

Singapore's solution to street food vending is widely admired by government planners in Asia. In the course of its rapid modernization from Malay houses on stilts in the 1950s to a world-class metropolis of today, Singapore pressured its street food vendors to get off the streets by building stalls over parking garages or in market malls and prohibiting street selling; a few night markets on parking spaces were also permitted. As result, the number of registered vendors dropped by one-half. EPOC was not successful in its efforts to secure funding for a small survey of mall vendors to find out how many formerly sold on the street, but our Iloilo study showed that no street vendor moved up to run a formal food establishment. Most observers believe that these new outlets require substantially more capital and a different style of doing business than is typical of street rood vendors, and so they draw on a more wealthy sector of the business community.

Emulating Singapore and the United States, new shopping malls are opening in Thailand, Indonesia, and the Philippines that include an indoor "street food" bazaar along with fast food franchises such a Kentucky Fried Chicken and Pizza Hut. Clients at these malls seem to come from the middle and upper classes. But in the large cities in all these Asian cities, vendors still sell their more affordable food to a broad range of customers. Even in Singapore, street food vendors may be found near construction sites where they sell to immigrant labor that arrives daily from Malaysia. The challenge for planners is to arrange serviced mini malls or bus stops with rental spaces that street food vendors can afford. Expensive relocation on the Singapore model does not serve the majority of people in developing countries.

Regulations for street vending need to be appropriate and easily understood. The benign administrator is preferable to the unpredictable and malevolent enforcer, but reasonable rules that are applied fairly will help stabilize the trade and encourage vendors to invest in improved technologies that increase income and food safety. Once the importance of street food vendors is accepted, then finding accommodation for their enterprises that does not infringe on rights of pedestrians or store owners should be possible. Some sort of organization that mediates between the vendors and the government is

clearly desirable; further research into the functioning of such organizations is needed.

If local sweets and munchies are to survive the onslaught of industrial snacks, NGOs and/or government need to work with the producers of these foods to help them package and market their goods. In Chonburi, local *bon-bons* were already produced centrally and sold by mobile vendor throughout the town much as bread was sold in Bogor and ice cream sold in almost every city. Larger *bon-bon* manufacturers in Bangkok are expanding. Because food is preferred fresh and storage is a problem, support for local food industries of all sizes make economic and employment sense for local governments.

As the street food trade becomes more institutionalized at the top end of the hierarchy, more educated vendors and more men will be attracted by its profitability. Also, attitudes of the educated toward business and commerce are beginning to shift in many countries where a college degree used to mean government employment. Where the economy is depressed and alternatives are scarce, this transition will be faster, as is already apparent from Nigeria to Jamaica to the Philippines. Whether women, with their double day, will be able to compete, is questionable. Interventions at all levels of the trade are needed to maintain gender equity and to provide credit and services.

Street vendors, at least the successful ones, are not the very poor. Programs to help them improve and expand are

very different from those required by smaller and ambulant vendors. Further, alternative employment for the casual seasonal, and often very poor, vendors will still be needed. Recognizing the diversity of vendors within the street food trade is the first step toward meeting their needs. Finding incentives for vendors to improve their food handling, and providing facilities that make such upgrading, is another major project. The realization that vendors reflect community health standards means that long term change requires customer as well as vendor education.

BON APPETIT

The case studies provided a gastronomic travelogue and an insight into the lives of the street food vendors. Comparative data documented the similarities and differences across the countries and showed demographic and gender variations among the vendors. Cultural attitudes affected what foods were eaten, by whom, and when. Details about the income to individuals, families, and the city underscored the importance of the trade economically; figures about household expenditures on street foods showed the central place prepared food has in the diets of people in most, but not all, of the cities studied.

The goals of the EPOC project were to assist the vendors at the micro level and to influence macro policies affecting the vendors and the trade. These impacts in both theory and application focused on the dual nature of the trade

as a microenterprise and as a provider of food. What remains is to stimulate further research into the many unexplored areas of urban feeding and food production, to encourage new organizations and support mechanisms for the urban poor, and to explore the different roles and expectations of the women and men who engage in the street food trade.

MICROENTREPRENEURS AND HOMEWORKERS: CONVERGENT CATEGORIES

Dᴏñᴀ Gᴏɴᴢᴀʟᴇᴢ ɪꜱ ᴀ ꜱᴇᴀᴍꜱᴛʀᴇꜱꜱ ɪɴ Nezahualcóyotl, a suburb of Mexico City. She learned how to sew as an apprentice in various workshops in her neighborhood. After a few years, she struck out on her own and established a firm relationship with a trader in the Central District. Once a week she goes to the District to pick up pre-cut material, takes it home to assemble and, upon returning the finished clothing, is paid by the piece. Dona Gonzalez makes most of her income from working for the trader. But, when there is little work, she turns to making or altering clothes for individual clients in the neighborhood. From her pay, Doña Gonzalez has to absorb a variety of costs. When the trader is not satisfied with the quality of her sewing, she has to redo pieces at her own expense. She has to provide thread, elastic, and other materials needed to complete the pieces of clothing. She also bears expenses for lighting, electricity, spare parts, needles, oil, and transportation.

Traders in Mexico City prefer to give out work to women who can complete large quantities of work. Doña Gonzalez owns two sewing machines, one standard and one industrial. She uses one machine herself; sometimes her sister-in-law helps her out on the second machine. Yet, since Doña Gonzalez has two children and must take care of household chores, she often cannot achieve the level of productivity the trader desires. Therefore she draws on the help of neighbors during times of high demand. She assumes the role of an intermediary giving out materials to them and paying them for the finished product. During such times, she thinks of herself as an entrepreneur and dreams of establishing her own workshop.

Is Doña Gonzalez a homeworker or a microentrepreneur? Is she a dependent employee or self-employed? Has she hired out her labor or does she run a business? Development practitioners, policy makers, and organizers usually assume that home-workers and microentrepreneurs are distinct categories which require dissimilar types of intervention. Subcontracted home-workers need to organize, obtain legal protection, and bargain collectively; the self-employed need access to credit and develop entrepreneurial skills. But, as the case of Doña Gonzalez shows, the distinction between home-workers and microentrepreneurs can be fuzzy; as a result, the approach of governments and international organizations toward

these home-based workers has some-times been contradictory.

As flexibilization and downsizing encourage greater use of subcontract-ing, protection for home-based workers has perforce become an issue for gov-ernments. Responding to the challenge of workplace decentralization, the In-ternational Labor Conference, the pol-icy-making organ of the International Labor Organization (ILO), in June 1996 passed a Convention on Home Work. The Convention requires ratify-ing states to develop a national policy on homework which ensures equality of treatment between homeworkers and employees. Yet governments and intergovernmental organizations, in-cluding the ILO, also promote micro-enterprises, which are usually home based. For example, the ILO supports programs and sends out consultants to assist governments in developing mi-croenterprises for impoverished women, such as jute tapestries or silk weaving in Bangladesh. The World Bank has in-creased its micro-credit financing and is proposing a new facility which would help donors enhance the effectiveness of this form of assistance. For years the US Congress has supported USAID funding for microenterprise programs in spite of opposition from the Reagan and Bush administrations; the budget in 1995 was $140 million. At the In-ternational Labor Conference, however, this approach received little attention. Even homeworker advocates who lob-bied behind the scenes and who use the microenterprise approach in their work found it wise to keep the issue off the agenda out of fear that it would engen-der union opposition and derail the Convention.

Nongovernmental organizations (NGOs) that support home-based workers have found it useful to com-bine microenterprise development with union organizing techniques. Their practice illustrates that the opposition between homeworkers and microentre-preneurs is arbitrary. A feminist analy-sis reveals the dichotomy of exploita-tion versus opportunity as a simplistic interpretation of women's work that neglects their specific relation to the family. Women in home-based work are inserted differently into the labor force than men because of socially con-structed roles which tie them to the home. An approach which reflects this understanding combines the insights gained from both microenterprise de-velopment and union organizing.

WHAT IS HOME-BASED WORK?

Home-based work is a descriptive rather than an analytical category, and so is used loosely not only in a variety of sectoral activities but also to include individual employment and family/kin/community workshops. While we focus on the individual worker in our argu-ment, actual descriptions of the home-based workers' environment and em-ployment underscore the fact that their work arrangements often involve other family members, whether occasionally

or frequently, paid or unpaid, and sometimes expand to a kin-based workshop. From empirical descriptions four categories of home-based work emerge: industrial homework, craft production, making and selling foods, and new forms of home-based work encompassing consultants as well as clerks.

incense sticks, polish plastic and solder printed circuit boards. Few countries have legislation on homework, but most that do define homeworkers as employees or quasi-employees. They may not meet some of the standard criteria of employees but per statute are to be treated as if they were employees.

(a) Industrial homework

Industrial homework is particularly common in the leather and garment industries. The typical industrial homeworker is a seamstress who gets pre-cut materials from a manufacturer or an intermediary, sews the garments together at home, and is paid by the piece upon returning the finished products. Some seek assistance from relatives or friends when demand is high, and these women often work together at home. Nearly as common as homework are sweatshops or home workshops which may be family-based or employ relatives and trusted friends. They share many of the characteristics of homework and may be seen as an extension of the homework system.

Industrial homeworkers can be found in a large variety of industries. In addition to sewing garments and shoes, embroidering, and knitting, industrial homeworkers assemble electronic parts, artificial flowers, jewelry, toys, auto parts, and umbrellas. They package cloth, sweets, sunflower seeds, metal sponges, bath plugs, and medical supplies. They peel shrimp, brussels sprouts and onions, roll cigarettes and

(b) Crafts production

Crafts producers range from skilled basket weavers and potters to artisans who create batik cloth or jewelry to highly trained artists and wood carvers. Some make household goods, personal ornaments, or religious objects for home use, barter, or sale in the community; others also sell their goods as tourist or export items. In Mexico, crafts producers weave hammocks, embroider traditional clothing, weave shawls, and make pottery. In Turkey, Iran, and Afghanistan, homeworking artisans weave carpets. West African wood carvers replicate ancient masks for museums around the world. In Sri Lanka, crafts include brass ware, goods made from shell, and rope made from coir (coconut fiber). Indonesia is famous for batiks so artistic they are sold as paintings. Indian silks and Kashmiri wood carvings are internationally renown.

Although many crafts producers continue to use traditional knowledge and techniques to produce time-honored arts, as entrepreneurs they most constantly adapt their products to demands from both neighbors, tourists, and marketing groups. In many

developing countries, craft workers are being organized by governments as well as by national and international nongovernmental organizations into marketing cooperatives or micro-credit associations that provide assistance for improved products. Similarly, merchants also recruit active crafts producers or train new ones to adapt traditional designs and colors for western tastes and organize this production as a subcontracting system.

(c) Food producers and vendors

Street vendors and small stores are an ubiquitous sight in cities and towns around the world. They sell everything from local produce to prepared food to overruns from the local clothing factories to illegally imported watches. While many peddle their goods on the streets, they often use their homes as a base and many work out of their garage, porch, or front room in residential areas. This is particularly the case with regard to the sale of agricultural products and prepared foods. Largely the domain of women, home is often the work place for those preparing foods or agricultural products for sale.

Selling of agricultural products is highly "gendered" throughout the world. Men tend to trade staple and cash crops, usually through cooperatives or marketing boards, while women predominate in selling produce independently in rural or urban markets or to middlemen. In India, women peel cashews for factories, raise cocoons for silk production, and collect forest products such as bamboo, *tendu* leaves, seeds, and fruits. They sell these to government marketing boards or to private traders. In Jamaica, women grow and dry fruits that they sell to stores or hawk themselves. Dairy products, unprocessed or in the form of yoghurt, cheese, or butter, are considered women's domain around the world. In Egypt, women have developed a sophisticated network of distribution channels themselves, in contrast to modern marketing schemes in India that, while providing an alternative to middlemen, have drawn independent dairy producers into male-dominated cooperatives.

Selling cooked food is equally gendered but varies by culture and custom. In Bangladesh, the favorite munchies, *canacur* (a crunchy mix of tiny colored and fried pasta, puffed rice, peanuts, and spices) is produced by village women on mud cookstoves and packaged in plastic, often with the producers' own labels. Male family members may market the *canacur* directly or sell wholesale to distributors in larger towns. In squatter areas of the Philippines, women sell homemade meals and pastries from their front porches; in Nairobi, women sell illegally brewed local beer from shacks in slum areas. Women in Indonesia, India, and the United States cook meals on contract for office workers or harried housewives and deliver the food directly to offices or homes. In Berkeley, California, gourmet food shops sell special breads,

443

cakes, and candies produced at home by local residents. Caterers, both men and women, arrange feasts for weddings and celebrations in every country. Even more pervasive are the vendors of street foods, prepared at home or on the spot, and sold from a basket or cart or stall in neighborhoods or downtown. In this occupation, which provides income for a great number of urban poor in low income countries, some vendors sell on commission or are employees of a larger franchise, but most are tiny enterprises providing income for an extended family but often hiring relatives or neighbors.

(d) "New homework"

Computers and improved communications technology have encouraged not only decentralization, subcontracting, and global dispersement of industry, but have allowed more white collar workers to work at home. Popular media celebrate the new flexibility and freedom which executives find in home-based work together with cautionary tales about difficulties in keeping home and work apart and missing career advancements. But new homeworkers are considerably more varied. In addition to managers, they include computer programmers, technical authors, translators, insurance claims processors, data entry clerks, typists, and telemarketers.

So far, the use of computer and communications technology in home-based work appears most prevalent in industrialized countries. But banks, airlines, and credit card companies in the United States subcontract data processing to companies in the Caribbean and Philippines and open up the possibility of exporting "new homework" to these countries.

MICROENTERPRISE DEVELOPMENT AND UNION ORGANIZING

According to ILO researchers "homeworkers constitute a particularly vulnerable category of workers due to their inadequate legal protection, their isolation and their weak bargaining position."" They report that a majority are women who often earn very low wages, work long hours, and have little job security. While these researchers had in mind subcontracted homeworkers, there is no doubt that their findings are relevant to all categories of home-based workers described above. What types of policy interventions can help improve the situation of home-based workers? Those sympathetic to unions answer this question very differently than most development practitioners.

Many in the labor movement consider home-based work exploitative and would prefer to see it abolished. Unions have a long history of hostility toward home-based work. In industrialized countries at the beginning of this century, homeworkers competed with factory workers and allowed employers to evade negotiated wages and statutory protections and benefits. Today home-based workers appear as the optimal labor force for companies seeking

flexibility by subcontracting and by hiring contingent workers. These developments again have forced homework on the agenda of unions. But feminist influence inside unions as well as intense lobbying from homeworker advocacy organizations have changed attitudes, and some international union federations have reversed their calls for a ban on homework. The International Textile, Garment and Leather Worker's Federation (ITGLWF), the International Federation of Food, Beverages, Tobacco and Allied Workers (IUF), and the International Confederation of Free Trade Unions (ICFTU) all have expressed their solidarity with home-based workers, called for the regulation of homework, and supported homeworker advocacy organizations in their struggle for an ILO convention. Unions in Australia, the Netherlands and Canada have begun innovative pilot programs to organize homeworkers, bargain on their behalf, lobby for improved legislation, disseminate information about their legal rights, and provide legal advice.

The new ILO Convention on Homework implies the union logic. It is limited to dependent employees, excluding the homeworker who has "a degree of autonomy and economic independence necessary to be considered an independent worker under national laws, regulations or court decisions." The convention requires that states treat homeworkers like other workers, guaranteeing their right to organize, providing protection against employment discrimination, facilitating

access to training, requiring a minimum age of employment, and ensuring occupational safety and health, equal remuneration, social security and maternity protection.

In contrast to unions, development practitioners have approached home-based workers as self-employed entrepreneurs. Practitioners involved in development programs in low-income countries often argue that any income to women is essential both for survival and empowerment; they celebrate small scale lending programs for microentrepreneurs as a major success story. Their understanding is that income from microenterprises is insecure and can be made more predictable.

The central component of microenterprise programs is to provide credit to small businesses, many run by poor women. Acknowledging the barriers that these women face to obtaining formal credit, microenterprise programs make access to credit "convenient." They offer loans at affordable (though not necessarily below market) rates. Application and disbursement procedures are quick and simple, program offices often operate in the community, and loan officers help borrowers to complete their paperwork. Because many microentrepreneurs lack collateral, these programs employ social group pressure and the promise of future loans to guarantee repayment.

The degree to which credit programs actually empower women or provide a "seedbed for industrialization" has recently become controversial.

These programs remain extremely popular however, because of the high repayment rates for loans, and because they succeed in stabilizing the incomes of beneficiaries. They seem to work best in the poorest countries. Those with the greatest success have incorporated social and behavioral changes as an intrinsic part of the program; the most basic of these is regular saving. The programs are gaining popularity. A recent international conference co-chaired by Hillary Rodham Clinton, Queen Sofia of Spain, and Tsutomu Hata, a former Prime Minister of Japan, called for $21.6 billion to provide micro-credit to 100 million poor people over the next eight years. (Currently microenterprise programs have about $10 million.) The programs are become popular in the United States as well.

HOME-BASED WORKERS: SELF- EMPLOYED OR EMPLOYEES?

Unions and development organizations differ in their approach to home-based workers because the former assume these workers are dependent employees, the latter that they are self-employed. Criteria employed in different legal traditions yield insight about the employment status of home-based workers but fail to capture the multiple power relationships in which home-based workers are embedded. Most important, they ignore the gender dimensions of power which frame the work relationships of these workers.

Legal traditions in countries around the world generally rely on two criteria to gauge the employment status of workers: subordination and economic dependence. Under the first a worker is said to be an employee if she or he is subordinate to a provider of work. One widely used indicator of subordination is the degree of control a provider of work has over the worker; i.e. does the provider control working hours and where the work is performed; and does the provider have disciplinary power over the worker? A second indicator of subordination is whether the worker is under the direction of the work giver, i.e. does the work giver specify designs and the particular way in which the work is to be performed? Tests for the economic reality of dependence, the second broad criterion for employment status, gauge whether a worker takes risk (by investing capital, providing raw materials, hiring employees, refraining from fixing prices in advance, having only short-term relationships with the provider of work) and whether the worker has opportunity for profit or loss (by having access to a broad market and possessing skills with a market value.) For home-based workers these legal tests yield ambiguous results.

Home-based workers are not under the direct supervision of providers of work and therefore not considered subordinate under the first legal criterion. For some industrial homeworkers this is the only legal aspect which makes them different from factory workers. Like factory workers they are

under the direction of the work giver, i.e. they have to follow closely instructions about how to assemble the provided materials. They also appear economically dependent on most criteria, having limited skills and limited access to a market to sell their products and thus little opportunity for profit or loss. Most are in a long-term and relatively permanent relationship with their work givers and prices are usually fixed in advance. But for some industrial homeworkers economic dependence is ambiguous: many seamstresses own their means of production, e.g., sewing machines and scissors, and many are required to contribute raw materials such as thread, oil, or glue. Furthermore, industrial home-workers, such as Doña Gonzalez, sometimes turn into intermediaries, profit from the work of others, and even come to head workshops in which they employ neighbors and relatives.

For crafts producers and sellers of food and agricultural products the situation is even more ambiguous. For example, carpet weavers in Turkey produce in the putting-out system and as independent producers. But the two systems differ in degree only. Under the putting-out system, an intermediary provides thread and sometimes a loom. Home-workers have to weave according to his or her designs and are paid by the piece. Under the independent production system weavers procure their own yarn. While some raise their own sheep, spin and dye their own yarn, many buy commercial yarn, often from the same merchant who buys the finished product.

On the surface those working in the putting-out system would appear as employees while the independent producers would appear to be self-employed. But merchants usually convey to independent producers what kinds of designs sell particularly well and have at times introduced new designs. Many weaving families are indebted to merchants; they are independent on the surface only. Home-based workers under neither system are supervised; under neither system are they clearly self-employed or dependent employees. Most provide their own means of production (in many places it is the men who own the looms in the family) and use a traditional skill, but they have no access to a profitable market or to alternative buyers. Crafts producers around the world are open to great exploitation under these systems.

This situation has been widely challenged by governmental agencies, non-profit and for profit institutions who organize producer groups. provide fair prices, access to international markets, and a wide range of services including advice on color and design and lecturing on quality control. Government agencies buy the goods outright or sell on commission in upscale stores in the major cities. India began its Cottage Industries Emporium in the early 1950s and has served as a model throughout the world, providing quality goods in current styles for the sophisticated consumer. Alternative

Trading Organizations (ATOs) such as Pueblo to People or Marketplace link producers in developing countries with consumers in Europe and the United States; commercial endeavors such as the Body Shop or Pier One purchase crafts products. e.g., handmade paper from Nepal and baskets from Guatemala for gift packaging.

Thus, crafts producers today rarely sell directly to the end consumer but to merchants, "middlemen," governmental organizations, or ATOs who export their wares or sell them locally in national markets or to tourists. They are independent because they are not supervised and use traditional skills and techniques – albeit often adapted to new demands. But they also depend on a limited number of buyers and have a weak position in the market.

GENDER SUBORDINATION AND WORK OPPORTUNITIES

The ambiguity of home-based workers' employment status is clear from these examples. But what is usually not considered in discussions of employment status is the dimension of gender subordination. The large majority of home-based workers are women. Working at home, their domestic roles visibly affect and interact with their paid work. Thus home-based work, more than any other type of female employment, challenges the gender bias in constructions of workers as legal and economic subordinates. On the one hand, these

constructions do not take into consideration the way in which women's ties to the home limit their opportunities. On the other hand, they reveal that a dualistic understanding of workers as either employed or self-employed fails to capture the complexity of women's insertion in the labor market.

Legal constructs, such as employee and self-employed, are built on Western liberal assumptions about autonomous and self-contained individuals. Feminists have argued that women, for better or worse, lack this autonomy. They are tied to the household, to subsistence production, to the family; they do not fully own their labor power. The result has been, on the one hand, that women have not been able to freely sell their labor power, i.e. they have not been able to fully proletarianize themselves. On the other hand, women have not been able to pursue entrepreneurship to its fullest. In Western societies it is marriage which curtails women's autonomy; the marriage contract makes a woman into a housewife "who lacks jurisdiction over the property in her person." Ideological constructions of proper womanhood in other parts of the world similarly shackle opportunities.

In Europe, North America, and among upper caste or upper class families in urban areas globally, the ideal married woman is widely perceived to be a housewife who stays home to take care of the household and children. Not surprisingly, national statistics in Europe, North America, and Australia show industrial homeworkers

to be much more likely to be married and have dependent children than their office or factory counterparts or than women in the labor force in general. But the housewife image disregards the often substantial contribution of women to household budgets and legitimizes their lower pay. Even formal sector jobs pay lower wages to women than men, avoiding illegality through differences in classification or through occupational segregation. No wonder that subcontractors consider it often legitimate to pay homeworkers below subsistence wages.

In some regions of Asia, the Middle East, and North Africa, ideological constructions demand women's seclusion and so tie them to the home. Since it is expensive to support family members who do not earn an income, many secluded women participate in putting-out systems in cities such as Lahore and Karachi in Pakistan, Istanbul in Turkey, and in Allahabad in India or become microentrepreneurs cooking street foods sold by male family members in northern Nigeria, Pakistan and in Bangladesh. They gain access to the market only through the mediation of men. In rural areas home-based work is often integrated into the activities of farming households and replaces farm income among landless families. Here women's work is often perceived as an extension of the traditional division of labor. Historically, women have often combined economic activities with household maintenance; with the penetration of the monetary income, the

income possibilities of such work have become even more important. But women's economic contribution is often subsumed under the entrepreneurship of men: their work is seldom appreciated and submerged in a pool of family labor, and their bargaining position within the household rarely improved.

While some feminists interpret women's tie to the household as resulting from ideological constructions that are designed to subordinate them, others find in women's strong valuing of the family a potential alternative to selfish individualism. Recently women from the South have criticized the emphasis on individualism (and, we would extrapolate, the striving for autonomous employment or self-employment) as Western ethnocentrism and suggested that it is necessary to celebrate motherhood as one stage of life. In Asia, they argue, families and communities are more important than the pursuit of selfish individualism. Some writers proclaim that women in patriarchal Islamic households have more time for their own interests than those in western arrangements. In Africa, the non-pooling household has encouraged women to work for themselves; yet when family survival is threatened, men and women contribute what they can to household maintenance with husbands setting up their wives as microentrepreneurs. Women's strong family and community orientations are particularly compatible with various forms of home-based work.

Regardless of interpretation, feminists agree that the legal image of a

self-contained individual free to sell her labor power is simply not appropriate for women. Social constructions of women as unfree labor, as housewives, secluded women, or contributors to the farming household, limit their opportunities in the market. Such constructions constrain women's ability to sell their labor power to the highest bidder because they require women to make their income earning compatible with the demands of the household, the farm, and/or the family enterprise. They also make it more difficult for women to succeed as entrepreneurs, because they constrain them from venturing away from home in search of opportunities for profit. In practice home-based workers occupy positions in the labor market whose dimensions of subordination and dependence are not captured in the legal definitions of employee and self-employed. An individual not free to sell her labor cannot approximate these dualistic, mutually exclusive categories. Accordingly, the distinction between dependent homeworkers and microentrepreneurs loses its usefulness.

SUPPORT FOR HOME-BASED WORKERS

Organizations which support home-based workers have long had to negotiate the ambiguities of their employment status and tailor their interventions accordingly. Local contexts strongly influence their approach. But invariably they have come to accept union organizing and microenterprise development as two strategies which should be combined. Furthermore, homeworker advocacy organizations take care to consider the specific needs of women workers embedded in a multiple relationships of subordination. Two of the most vocal groups are the Self-Employed Women's Association (SEWA) of Ahmedabad, India, and the West Yorkshire Home-working Group of Great Britain. They differ substantially in their origins and provide good case studies of the way in which union strategies and enterprise development can be combined.

(a) SEWA

SEWA has its origins in the Indian union movement. SEWA's goal, to organize self-employed workers, initially caused considerable consternation and the organization had difficulty obtaining government recognition as a union. But SEWA staff argued that "the bulk of workers in India are self-employed and if unions are to be truly responsive to labour in the Indian context, then they must organize them."

SEWA itself is a hybrid organization: part union, part cooperative, part bank; it is often considered by the development community as an NGO. As such, SEWA effectively combines homeworker organizing and micro-enterprise development, "struggle" and "development," political work and economic empowerment. Renana Jhabvala, SEWA's secretary, asserts that the

organization found inspiration in three separate movements: trade unions, co-operatives, and the women's movement, "and sees itself as part of a new movement of the self-employed which has arisen from the merging of all three."

SEWA's efforts in support of the self-employed are well known. The Association runs a bank which provides an opportunity for savings and gives credit following many of the principles of microenterprise programs. Micro-credit helps reduce SEWA members' indebtedness to traders as well as providing capital for their enterprises. Furthermore, SEWA has set up a number of cooperatives which strengthen the market position of their members and help sever their ties of dependence on traders and contractors. SEWA also has negotiated for its members better access to raw materials, such as waste from textile mills, and fought police harassment of street vendors.

SEWA also pursues activities much more similar to traditional union strategies. The organization conducts legal camps and workers' education classes for home-based *bidi* rollers which teach them about their legal position, minimum wage laws, and welfare benefits to which they are entitled. These classes have become the standard organizing tool for *bidi* workers. SEWA negotiates wages with employers on behalf of individual homeworkers and groups of homeworkers and has successfully appealed to labor inspectorates to enforce existing standards. The association has brought homeworkers to the attention

of labor inspectors and the labor commissioner. induced them to raid illegal bidi workshops of traders who did not pay minimum wages, and lobbied to provide home-based bidi workers access to welfare benefits.

SEWA also has lobbied for better legislation to protect home-based workers. In 1987, Prime Minister Rajiv Gandhi appointed the association's general secretary, Ela Bhatt, as a "private member" to the upper house of parliament; in this position she introduced a bill on home-based work. Although it never reached the floor, Bhatt gave visibility to home-based workers as head of the National Commission on Self-Employed Women and Women in the Informal Sector, conducting a series of public hearings around the country which produced an immense amount of testimony and data that were subsequently published by the government. SEWA was crucial in lobbying for the ILO Convention on Home Work. The Association is responsible for gaining the support of international union federations and played a leading role in establishing an international network of homeworker advocacy groups, Homenet International, which is coordinating international advocacy work and functions as a clearinghouse.

SEWA is sensitive to the gender needs of its members. SEWA bank not only provides access to credit but also a place for members to deposit their savings. According to association leaders, savings accounts are even more important than access to credit because

they allow women to create a cushion for unforseen events and keep men from appropriating women's earnings. The bank recognizes that investment in housing is a productive investment for women working at home: it therefore approves loans to upgrade housing. SEWA also seeks to change laws and practices detrimental to women's status; it has agitated to improve the rights of divorced Muslim women and condemned the practice of *sati* (i.e. immolation on a husband's funeral pyre.) SEWA's organizing strategies necessarily differ from those of unions because home-based women workers are dispersed. Action-research and community organizing tools are important ingredients in its strategies. In some cases SEWA has used child care and health issues as focal points for organizing.

(b) The West Yorkshire Homeworking Group

The West Yorkshire Homeworking Group is one of many local "homework campaigns" which have been active in Britain since the 1970s. These campaigns often originated from the efforts of social workers and community organizers gaining support from local authorities. Homeworking campaigns are only beginning to organize homeworkers and have primarily relied on advocacy and lobbying activities. They produce so-called "Fact Packs" which they distribute to homeworkers free of charge. These contain information about employment rights, welfare benefits, and

addresses of unions, homeworker advocacy groups and other grassroots organizations which provide support and assistance with grievances. Homeworking groups also distribute newsletters and operate hotlines which homeworkers can call for information. An important element of these efforts is to instill in homeworkers an identity as workers and to overcome their identification solely as housewives.

Homeworker advocacy groups at times negotiate with employers and provide support with grievances against employers. Low payment or non-payment are the most common complaints. Because they have their work delivered, homeworkers often do not know who their actual employers are and so do not know where to complain when they are not paid. Advocacy groups help homeworkers identify their employers and provide legal support. To a small extent, they have begun collective bargaining, negotiating wages for whole groups of homeworkers. In at least one case West Yorkshire groups have been able to trace a subcontracting chain and put pressure on the main work giver, a large, well-known company, to ensure that their subcontractors pay minimum wages.

Homeworker advocacy groups have gained the support of the British Trades Union Congress and of parts of the Labor Party for better legislation on homework. A bill introduced in the late 1970s failed to receive a majority in parliament but created publicity and led the government to conduct a

special survey on homework. Some British unions, who have faced severe loss of membership and are fighting for survival, are now actively collaborating with homeworker advocacy groups and seek to organize homeworkers. The West Yorkshire campaign also played a critical role in the lobbying for an ILO convention; it provides the central office for Homenet International and is publishing its newsletter.

For the most part British groups have thought of homeworkers as disguised wage workers who needed to gain their rights as workers. But international contacts have led to a change in attitude in the West Yorkshire organization in particular. The group has become sympathetic to some of its members' aspirations to start their own businesses. It has begun to support microentrepreneurial projects and cooperatives. A sewing cooperative and a cleaning cooperative are among the early ventures. The group's newsletter has showcased women who work as childminders at home and who have started a restaurant. There also are plans for a crafts store featuring the products of homeworkers in India and other parts of the world.

Like SEWA, the British groups use gender-sensitive techniques and address the specific concerns of women. They work with community groups in ethnic neighborhoods to contact homeworkers, provide child care to enable homeworkers to attend meetings, provide transportation and, when doing

research, try to give homeworkers an allowance for lost earnings.

CONCLUSION

In the efforts of organizations supporting home-based workers the categories microentrepreneur and dependent homeworker converge. Despite this convergence in practice, the understandings of professionals working in development and those coming out of the labor movement conflict. Within the development community, this conflict opposes the World Bank and ILO. Whereas World Bank economists feel more comfortable thinking of home-based workers as microentrepreneurs, lawyers in the ILO prefer to see them as dependent employees who need to be given their rights.

Instead of emphasizing their theoretical distinctions, lawyers and economists, union organizers and development practitioners would do well to learn from each other. Unions need to consider individual and group-based alternative methods of earning income, possibly taking over marketing activities themselves. Creating income opportunities can facilitate organizing activities. SEWA's cooperatives have served as a backup for women who lost work because of their organizing activities. They also have pushed up wages and benefits in a whole sector of the economy by setting higher levels. SEWA's bank has given the organization the financial flexibility to pursue its own agenda.

Microenterprise groups would do well to learn from unions the effectiveness of organizing and demanding rights for a vulnerable segment of the workforce. Unions show the importance of political action. While international NGOs have been skilled in influencing policy, many local NGOs still operate from a charitable, and often patronizing, standpoint, seemingly innocent of power relationships that surround their projects. Further, although the micro-activities frequently seem far removed from national or international economic trends, the union approach teaches the importance of recognizing global economic linkages.

Both development practitioners and union organizers need to acknowledge the flexibility with which women move from being self-employed to participating in putting-out systems and family workshops that sit on the cusp between dependent employment and independent entrepreneurship. They should recognize that NGOs and governments can be as exploitative as merchants or employers, and that all these groups can also genuinely be concerned with the welfare of women home-based workers.

Organizing is the essential first step to ensure that women workers are treated fairly and that they can participate in decision making about their livelihood. The organizing group, whether NGO or union or government cooperative, is critical in order to provide political representation, national recognition, and economic protection. Women workers need services that range from upgrading of skills to child care to health insurance. Educating them about their rights not only as workers but as women is essential to enhancing their bargaining power within the family and community. These activities are basic. whatever the ideological stance of the advocate. Artificial distinctions between the ideal independent self-employed entrepreneur and the exploited and dependent subcontracting worker only obfuscate the debate, and by perpetuating a false dichotomy, delay measures to improve the lives and income of home-based workers.

SECTION 6

FOOD AND SHELTER IN URBAN AREAS

U RBANIZATION WAS NOT TAUGHT IN ANY OF MY UNDERGRADUATE COURSES. MY FIRST encounter with problems in cities came as result of my activism protesting exclusion of minorities in parts of cities. In Berkeley in 1955, Asians were prohibited by real estate contracts from living in the hills. When a group of us sat with the buyers to see whether the rule would be enforced, I confess we were all a bit disappointed when it was not.

When we moved to Maryland in 1960, I immediately canvassed our new neighborhood seeking signatures for an open housing law – which did not pass. Later I started a short-lived Club of All Nations to provide a meeting place for younger Embassy staff from Asia and Africa who were not always welcome in Washington establishments.

Urban development was just beginning in Washington, DC. Like governments in both north and south, their idea of improving the city was to bulldoze slum areas. A swampy area along the Potomac waterfront known as Foggy Bottom was an early target. Workers' flats lacked sanitation and were soon demolished. As the bulldozers crept closer to fashionable Georgetown, alarmed residents halted the destruction. In 2002, we bought a small flat in the area, delighted that the Kennedy Center – on the cleared land along the river – was within walking distance. The remaining worker houses had been modernized inside but had been required to retain the original exterior.

Urbanization policies at that time did not consider the fate of the evicted people. Rather they focused on transportation corridors, zoning, and suburban alternatives. The issue stayed with me. I taught a course on the issue at Federal City College; then in 1972, I initiated an intra-university seminar to evaluate urban growth globally. Little research was being done on the social aspects of urbanization so the seminar was meant to search out what was known. In 1976, I organized a two-day symposium on habitat during the AAAS Annual Meeting, then edited the articles prepared for this symposium for publication and distribution at the UN Conference on Human Settlements.[1]

1 <missing>

INDONESIAN RESEARCH STUDY IN 1972

Deciding to return to international issues after my tumultuous years at Federal City College, I successfully applied for a fellowship to study urbanization in Indonesia in 1972. This was the fourth time I would be spending considerable time doing field research. In India in 1951-53, I had focused on national elections and the Parliament; in 1965, my research was on regional and local government. My work in Indonesia from 1957-1959 covered all levels of government.

In most cases, colonial governments had set up a top-down administration that the independent countries had tended to continue in order to exert control over the largely rural areas. Laws governing the indigenous population were usually based on traditional or customary law. But citizens of the home country were not judged by these laws. In India, the British created municipalities which functioned as extraterritorial units; anyone living in the area could utilize British civil law. This was how market women in East Africa could buy land in the city but not in rural areas.

India also has a long history of expanding limited elections allowing political parties to grow in influence. Also during the 1930s, the prestigious Indian Civil Service was opened to Indians. The existence of a large cadre of Indians in the administration facilitated the transition to independence. In the following decades, the power of the civil service eroded while political parties grew in strength. Parties needed to reach their constituents throughout the country. In 1957 the government appointed a commission to consider ways to improve services to the rural areas; by 1965 several states had begun to introduce different methods for allowing the villages/*panchayats* to vote. In 1972, a Constitutional Amendment was passed extending *panchayti raj* to all states. The following year, another amendment required that women hold 30% of these seats; the quota was increased to 50% in 2011.

Such decentralization did not take place in Indonesia until 1999. In 1972, efforts were being made to rationalize the system inherited from the Dutch. Municipal areas were not territorially based: Dutch law was extended only to their citizens. As cities grew, they often surrounded traditional settlements as well as squatters living along river beds or behind colonial homes. These areas continued to be governed by the *bupati* who headed the county administration. This odd bifurcation of administration vastly complicated the provision of electricity and sewerage to either area.

I proposed to study how municipal areas were dealing with increased migration and its subsequent demand for housing and services. After meeting with central government officials in Jakarta and hearing from them how they expected cities to respond, I spent a month in Surabaya which I knew well from my 1957-59

research trip. I then visited three provinces in Sumatra, spending time in their capital cities – Palembang, Padang, and Medan – to view how the provincial government was coordinating urban-rural migration.

This research trip provided a base for many of my courses when I became a professor of City and Regional Planning at Berkeley in 1989. The visit also altered my career path as a result of being asked by the US Information Service to give a talk on the US women's movement. My discussions with professional women in Jakarta shook my belief that economic development would help women and well as men. This was not happening in Indonesia: I formulated a new mantra: the detrimental impact of development on women. For the next fifteen years, I concentrated on expanding the women and international development movement.

EVOLUTION OF HOUSING POLICIES

Housing policies for urban areas were slow to evolve since most of the developing countries remained predominantly rural until the twenty-first century. Projects focused on improving both food and cash crops; houses were of no concern as they were self-constructed from available materials. Most villages were homogeneous. Inequality was somewhat mitigated by annual festivals which shared food and drink.

When I began my field work in Indonesia, the attitude toward migrants who squatted along canals or roadways was simply to clear them out, often with no notice. Such an approach was ineffectual as the squatters soon returned. In order to follow the evolution of housing projects, I viewed a wide variety efforts whenever I traveled to developing countries for conferences or other research.

In Bombay, squatters blocked sidewalks and overflowed into side streets. Eventually the city built apartments on the outskirts of town and moved the squatters to these modern flats. Yet the poor returned, often selling their apartments to people with enough money to pay the cost of utilities and for transportation into town. To survive, the poor had to be near their customers. Early efforts by the World Bank to provide homeless with land and a utilities core around which they could build their own shelter also turned out to be too expensive for the poor but attractive to those with more funds.

Issues of distance and transportation were overcome in Peru by "land invasions" outside Lima. Well organized groups would move overnight to the scrub lands outside town where their leaders had already laid out regular plots which were assigned to families before the move. Lots were also reserved for schools and churches. Politicians needed the squatters' votes and soon acquiesced to pressure to provide land deeds and basic services to the new settlements. In 1976, I found

these invaded areas had been assimilated into the city; the houses were well-constructed and the lots large enough to grow vegetables.

Without access to close-in land, most cities began to focus on schemes to upgrade the squatter areas: building paved paths and digging ditches to replace the muddy trails; providing water sources, latrines, and electricity. Years later I walked through a large *kampong* in the heart of Jakarta. Some sections seemed like the rest of the city with water and sanitation and paved pathways, but many areas still had muddy paths and lacked services. However, none were as chaotic or dirty as the jumbled shacks I saw in the notorious Mathure valley in Nairobi.

Favelas in Brazil reflected how longer term residents improved their communities. NGOs provided health clinics in the favelas I visited in Salvador and Rio de Janeiro, and trained residents in nursing and contraceptive services. These volunteer groups also leverage municipal funds and personnel such as teachers and hospital supplies.

During our trip around the world as faculty on the Semester At Sea in the spring of 1997, I was able to visit the shanties on the steep hills ringing Caracas, Venezuela, where Cuban doctors ran clinics – sent in exchange for oil. The slum areas in lowlands near Cape Town were segregated between Africans and Coloureds: what limited services the government provided went primarily to the African areas. Segregation was also enforced in Osaka where Koreans – many who had lived in Japan for years – were provided inferior housing. I incorporated all these experiences in my teaching and writing.

Obviously, housing policies encompassed the equivalent of urban community development. The UN Habitat Commission attempted to emphasize this broad approach by using the term *shelter*. They defined housing as any structure that could shield a person from the elements: canvas or cardboard or corrugated metal as well as brick or concrete houses. Further, they insisted that these projects must include infrastructure and social services. Shelter thus meant much more than the physical house. I adopted the term in several chapters I wrote about women and housing to emphasize how women used their homes to grow food, raise animals, and produce food or goods for sale.[1]

The importance of growing food around the house was emphasized by a nutrition officer in the Manila government. I had approached him to talk about food values in street foods. He took me to a slum area where he had been introducing women to prolific vines, which scrambled all over the shanties' roofs, and new vegetables for the tiny plots in the sun: he stated that a house on five square meters could grow enough food to feed a family of five, except for rice!

1 The Many Facets of Human Settlements: Science and Society, Irene Tinker & Mayra Buvinic, eds., Pergamon Press, 1977.

Communist housing policy – Communist countries considered housing a basic right and allocated housing through work groups. At first what was provided was often a room in an existing structure such as those I visited in Moscow or Hanoi. In 1983, on my first trip to China, Mil showed me the two-story house in which he had grown up on the St. John's University campus in Shanghai. A family was living in each of its eight rooms. The dean of one of the technical schools using the old campus was living in Mil's parents' bedroom; because of his rank, the dean also had use of the adjacent sleeping porch. On our next visit to Shanghai in 1999, the house was rubble, about to be replaced by a mid-rise apartment building.

USSR began this practice of constructing massive housing units when all older apartments were filled. They were ugly concrete structures, often hastily and poorly built. In Moscow and St. Petersburg, I was able to see how older apartments had been divided so several families could live in them. On our river cruise between the two cities, the university lecturer from St. Petersburg was also an expert on housing policy. She gave talks on history of communal housing: early units were fairly spacious, but the size kept shrinking as demand grew.

In Vietnam, I toured a five story walk up which had a ramp along the steps to make rolling a bike up easier. Each family was allocated a single room of about 5 square meters. Cooking was done on the balcony; toilets and running water were located in a central core on each floor. Housing was allotted by work group and so varied in size and amenities. Because women also were employed, they had the same rights to a housing unit. Usually the husband had a better job so the family would select his allotment, as I was told in China. However, one Vietnamese woman confided in me that she had been able to keep her space for a relative! I was able to observe these policies, and hear about changes as the governments opened up the economic sphere, while editing papers for the book on Laos, Vietnam, and China described below.

Housing as a basic right was championed in Singapore as well. Lee Kwan-Yew declared that Asian values were superior to human rights as promoted in the West after he observes homeless men begging on the streets of San Francisco. He argued that providing a house and a job was more important than allowing free speech. While this debate has faded, the idea of rights to shelter is gaining political traction in the US.

WOMEN AND HOUSING

Housing policies, designed by male economists, were generally considered to be gender neutral; only UNICEF and UNCHS (Habitat) articulated the need for considering women's subordination when designing shelter policies. The belief in

the intact family headed by a compassionate husband clouded most early efforts at providing shelter for poor women. Too often, these projects created as many problems as they solved because they neglected to adjust to the diversity of cultures and the variety of household structures.

In 1992, Hemalata Dandekar, Professor of Urban Planning at the University of Michigan, convened perhaps the first conference addressing housing policies and programs for women. Case studies from first and third world countries, discussions of housing for non-traditional living arrangements, shelter options for the elderly, as well as papers about infrastructure, services, and income opportunities produced the "multiple visions" that was the goal of the organizers.

My paper focused on the UN Center for Human Settlements.[1] At the Center, now referred to as HABITAT, Diane Lee-Smith had started a newsletter "Women and Shelter," which formed the basis for several workshops at the women's conference in Nairobi in 1985. In 1991, UNIFEM asked me to evaluate UNCHS programs for women, a project which allowed me to view these efforts first hand.[2]

NGOs led the efforts to enable women to build their own houses. In Costa Rica, COPAN built three new communities with women doing much of the construction. To accommodate older women, building credits could be earned by watching children or serving meals. Once the houses were completed, COPAN found that a common law husband would move in expecting that the house would be registered in his name. Instead, COPAN persuaded the government to register the houses in the name of the woman, unless the couple was legally married: in this case the house was registered in both names. COPAN began in 1975 when feminist members of a communist organization started organizing women in the barriers to fight for reproductive rights. When I visited one of these communities years later, women leaders showed me around. I promoted this approach to women's ownership in many publications.

Another interesting case study I frequently quoted was based on the dissertation of my graduate student, Farank Miraftab. She found that women living with their children in worker's housing in Guadalajara made the same total family income as men and their wives did who lived in new communities in the hills. In the city, single women could kick out any abusive males since the women paid the

1 "Women and Shelter: Combining Women's Roles," in Gay Young, Vidyamali Samarasinghe, Ken Kusterer, eds. Women at the Center: Development issues and practices for the 1990s. West Hartford: Kumarian Press, 1993.

 Engendering Wealth and Well-Being, ed. with Rae Blumberg, Cathy Rakowski, & Michael Monteon. Chapter: "Beyond Economics: Sheltering the Whole Woman." Westview, Mar., 1995. pp. 261-283.

2 "Global Policies Regarding Shelter for Women: Experiences of the UN Centre for Human Settlements", in Hemalata Dandekar, ed., Shelter, Women and Development: First and Third World Perspectives. Ann Arbor, Michigan: George Wahr, 1993.

rent; the result was less domestic violence. These women relied on their children to support the family, so most dropped out of school early. Wives in the hills did not work but spent their day porting water from central water points and carrying household necessities from distant stores. Women in both the city and the hills worked hard, but since the children in the hills did not have to work they attended schools and so improved their future job prospects.

WOMEN'S RIGHTS TO LAND

A woman's right to a place to live challenges customary law which privileges male control over property. Indeed, wives are considered their husband's property in many societies governed by common law, as in England or in the United States until the 1970s. In many farming societies where women's labor is critical, men pay a bride price for rights to her body and her labor. If a man dies, the woman was passed to another member of the family. In subsistence societies this practice assured the woman of land to till and a house to live in. In Zimbabwe, when the family wished to evict a widow from her farm plot in order to sell the land, the court insisted on her right to stay. This prompted President Robert Mugabe to call for a Constitutional Amendment to ensure that patriarch control over such land continued. Students in my Women and International Development class at Berkeley did case studies on how male control was affecting women in modernizing countries.

Today, in some urban areas, when the husband dies, the family might discard the woman but seize all the couple's material goods rendering her penniless and possibly homeless. Land rights in former British colonial areas were different in cities and in rural areas: British law was introduced in municipal areas while customary law prevailed in the countryside. One of my undergraduate students found that in Tanzania several trading women bought a tiny house together in Dar es Salaam. When a husband died, his family could not take a radio or a frig from the house because such action might anger other families who could not know to whom such things belonged.

A successful entrepreneur in Nairobi protected her business by buying a plot in the city, a story recorded in Diana Lee-Smith's book *My House is my Husband*.[1] Middle class families were not exempt from this custom: when a Luo tribesman and lawyer married took a Kikuyu lawyer as his wife, and then died suddenly with no will, the clan members descended on their house and removed everything

1 "Women's access to housing and work: and evaluation of UNCHS programs in Indonesia, Bangladesh, and Nepal," an evaluation for UNIFEM, the United Nations Fund for Women, and HABITAT, the United Nations Centre for Human Settlements, March 1991. Research for this report undertaken in the three countries in December 1990 and January 1991.

including his body. The wife sued, and the case dragged on for years. The compromise: the clan took the body and the wife inherited the house and its contents. In a small world series, a Kenya lawyer who argued this case for the wife was a lecturer on the Semester at Sea!

Over half of people in Nairobi live in slums or informal settlements. Lack of security in the alleyways has resulted in violence against women and the spread of HIV/AIDS. This disease so decimated Uganda that grandmothers were raising children on land to which they had no claim. A distant male clan member could evict them. Recent laws to protect the grandmothers are weakly enforced. The connection between rights to a house and HIV/AIDS has been recently studied by ICRW: women could hardly refuse the advances of her male partner if she would become homeless. I wrote several position papers to indorse this ground-breaking multi-country study in South Asia and Southern Africa; women's rights to property were listed in the Gender Millennium Goals at the UN.

In 1994, I co-sponsored a seminar in Bangkok with Chulalongkorn University to explore how women were fairing in the communist countries of Vietnam, Laos, and China. Through professors in California, we had invited women researchers from Vietnam and China but were told only apparatchiks would be allowed to come from Laos. Amazingly, twelve women came by train, using the money we had sent for a three plane tickets. Still, before the opening ceremony, only the Senior Director asked to speak. So, in my welcome address to the participants, I told all participants that we were going to conduct the seminar as we do in the States, calling on each person by name, not title. We then went around the room asking each woman how they wished to be addressed, and asking everyone to speak. And it worked! All participants from Laos were ecstatic that their views would be heard.

During the discussion, lists were made of significant issues for research which the group would pursue. Subsequently, six participants prepared discussion papers on the changing family structures for the Beijing Women's Conference in 1995. Our Chinese researchers were prevented from attending; instead, an official read a party line document.[1] The working group which had studied women's housing problems later met in Berkeley where open discussion was possible. All their chapters, including those authored by the Chinese women, appeared in *Women's Rights to House and Land: China, Vietnam, and Laos*.[2]

1 Lee-Smith, Diana, 1997. "My House is my Husband:" A Kenyan Study of Women's Access to Land and Housing. Architectural and Development Studies, Lund University, Sweden.

2 "Symposium: NGO Forum, United Nations' Fourth Conference on Women, 1995," edited with Gale Summerfield in *Review of Social Economy* Volume LV: 2, summer 1997, pp. 196-260; article on "Family survival in an urbanizing world." [republished in 50 years of City and Regional Planning at UC Berkeley: A celebratory anthology of faculty essays.]

URBAN AGRICULTURE

Growing food in urban areas is a long established custom, but like street foods, its impact was not taken seriously until studies were done of its contribution to urban food supply. Partly this is because most of us think of a city as densely populated. In fact even in developed countries, open areas are common. During World War II, victory gardens sprouted in the middle of London and roof gardens fed people in St. Petersburg.

In developing countries, farmers often plant crops along riverbeds as the water recedes, harvesting before the heavy rains. Empty lots, road edges, all sprout crops where the poor live. Backyards often have space for vegetable gardens around the world. When the Berkeley administration asked faculty to come up with ideas for simple research projects that could be done by local school children, I proposed a survey of a low-income area of Oakland where backyard gardens were common and the Salvadorans also raised Guinea pigs to eat.

Such food was for home consumption, and largely ignored by planners who assumed that modern food supply systems rendered urban food production obsolete. Globally, the supermarket became the symbol of a modern city and was seen as the most efficient system of supplying megacities with food. As a housewife, I disliked the packaging of everything in reams of plastic, or the selling of hard tomatoes because they traveled better. Well before the move toward farmers markets and eating locally, I questioned this idea of efficiency and wrote a proposal to measure the energy concumption and costs of long distance transport, wrapping and selling food, then disposing of all the waste. At the time, this countered received wisdom; no one would fund it.

One of my graduate students, Laura Lawson, wrote a thesis about urban gardens in the Bay Area. An example stands out: on an old parking lot in downtown Berkeley, an entrepreneur was growing herbs and baby lettuce in raised beds for sale to Chez Panise. My research assistant, Susanne Freidberg, compiled a bibliography of publications from around the world, and together we compiled an issue of *Hunger Notes* in 1992 called "Urban Food Production – Neglected Resource for Food and Jobs."[1]

This publication was widely circulated among those NGOs and donors groups concerned with world hunger and so brought academic studies to those involved in impacting on policy. I was invited to write an article for the newsletter of the Rodale Institute, leaders of the organic agriculture movement in the US. This led to an invitation to a conference of Canada's International Development Research

1 Women's Rights to House and Land: China, Laos, Vietnam, edited with Gale Summerfield. Boulder, CO: Lynne Rienner, 1999. I wrote "Women's empowerment through rights to house and land." pp 9-26.

Centre on "Cities Feeding People." IDRC had funded four graduate students to study urban agriculture in Africa; these reports, along with my Foreword, were circulated within the development community.[1]

One study also presented at this conference reported on how Shanghai was being reported as self-sufficient in food by the Chinese government. This startling declaration had been made possible by adjusting the urban boundaries of the city to include its surrounding county! So what is urban? The definition continues to confound.

Jac Smit, an author in *Hunger Notes*, initiated an exploration into the occurrence and characteristics of urban agriculture in Asia, Africa, and Latin America as a consultant for the United National Development Programme. Among his findings: 67% of Nairobi's urban families and 65% of Greater Moscow are farmers; 56% of urban farmers are women; 60% of metropolitan Bangkok is used for agriculture; 30% of the agricultural product in the US is produced within metropolitan areas. Worrisome is the fact that 10% of the world's population eats food that uses polluted waste water. Jac established the Urban Agricultural Network to support all these urban farmers by producing an exhaustive volume detailing their problems. I was pleased to serve on its Advisory Committee.

The importance of urban agriculture was thus spread throughout the agricultural and development communities. In 1995, I wrote an article for the World Bank's magazine *Urban Age* that combined my interests in street foods, urban agriculture, and urban food systems: "Feeding Megacities: A Worldwide Viewpoint." [2]

MY YEARS AT BERKELEY

During my tenure at Berkeley, in the Department of City and Regional Planning, I was able to combine academic research with advocacy both in the area of housing and of urbanization. As a professional department, policy studies were welcome, not discounted as in Liberal Arts. And since city planning covers so many disciplines, I was able to pursue my interests in women and in international development without hindrance.

True to my joint appointment in Women's Studies, I always drew attention to the differential impacts of policies on women and men. Women's Studies also encompasses both social science and the humanities. I learned much from my colleagues in the humanities, but was not constrained by them, especially those wedded to post-structuralism. For two years I served as chair of the newly-created

1 <u>Hunger Notes</u>, "Urban Food Production – Neglected Resource for Food and Jobs." Fall, 1992. World Hunger Education Services, Washington, DC

2 "Urban agriculture is already here," in <u>Cities Feeding People</u>, Ottawa: IDRC, 1994. Article based on this report appeared in <u>Ag-Sieve</u> 4/1:6 (1993), the newsletter of Rodale Institute.

Department. To celebrate this elevation from Program, I invited all the women who had started and maintained the program to write up their contributions. We distributed this history at a reception at the Women's Faculty Club. Again to preserve women's history, I asked my undergraduate research assistant to write up the history of women at Berkeley. These reports are archived in Berkeley.

The graduate students provided a depth of knowledge in their own fields of study which broadened my ideas and provided important data for my publications.[1] Many women in my undergraduate course on WID wrote insightful papers; several went on to study related issues in graduate school. Also, the challenge of teaching undergraduate courses to students filling their distribution requirements forced me to clarify and simplify thoughts.[2]

Research grants from the university allowed much of the field work. Having a base at the university meant I no longer had to solicit funds for my salary; outside grants thus covered more travel and research assistants. Further, the status of a Professor at the University of California/Berkeley gave my articles and speeches greater legitimacy than if I still headed a feminist organization. Some things change very slowly.

1 "Feeding megacities: a worldwide viewpoint," The Urban Age, World Bank, winter 1998:4-7.

2 My graduate students at both American University and Berkeley, mostly women but a few men, wrote papers, dissertations, and articles that I have used in many of my own publications where you can see them quoted. I could not possibly list them all.

WOMEN AND SHELTER: COMBINING WOMENS ROLES

PROVIDING SHELTER TO BATTERED women and their children has been a major activity of women's organizations in the United States for several decades and, more recently, around the world. Additional demands for women's shelters have come from homeless women who, with their children, constitute a growing segment of the homeless. Yet the issue of women and shelter is a relatively new one among scholars in the fields of women in development and women's studies. The objective of the panel and workshop at the Association for Women in Development (AWID) meetings was to challenge scholars, activists, and practitioners from both South and North to consider the centrality of shelter issues to women's survival and well-being.

Shelter policy represents a culmination of women-in-development policy because it encompasses a broad range of basic women's issues of grave concern to urban and rural women worldwide. Women's access to land and housing challenges male control of resources and lays the base for greater gender equality. Yet because shelter is based on households, policy in this sector recognizes family and kin networks and promotes cooperation. Finally, because shelter policy combines women's income and nurturing roles, it allows greater choice for women than programs that emphasize either work or motherhood alone.

This chapter first asks why such a basic issue as shelter has been left off the research agenda of global women's issues for so long and discusses three explanations for its marginal status. The second section identifies the types of issues now being addressed by women and shelter researchers, as reflected in the AWID panel session. This leads to an exploration of the confusing terminology used – "shelter," "settlements," "habitat," "housing" – and the attempts to construct a new language.

Finally, the activities of networks and organizations involved with women and shelter are outlined, particularly those groups whose leaders were present at the AWID workshop.

SHELTER AS A NON-ISSUE

Shelter is such a basic need that in the earliest debates about women in development it was simply assumed to exist, along with children. Women's role as mother and homemaker assumed some sort of a shelter: an adobe enclosure that she helped construct; a bamboo frame hung with mats woven by women; caves

decorated by women and men; collapsible tepees or yurts sewn by women and used by nomadic tribes; more permanent stone or wooden houses. In order to reproduce the species, women used their homes and the space around them for subsistence tasks to feed and clothe their families.

Three reasons help explain why shelter has taken so long to emerge as a women's issue. First, the preeminence of economists in development planning compelled early women-in-development proponents to redefine women's work in economic terms. Second, the preoccupation of the development community with rural issues excluded both urban areas and housing from major funding. Finally, the concept of the household as an undifferentiated unit meant that even housing advocates overlooked women's particular needs for a long time.

As development altered the division of labor, often increasing a woman's subsistence tasks while excluding her from work for monetary remuneration, two issues were given priority by women-in-development programmers: reducing the drudgery of and the time spent on subsis tence activities and introducing women to income-producing activities. *Where* women would do these activities was seldom discussed. For efficiency, new grain mills might need to be in the market. Access to running water, however, might be provided in compounds to relieve women of treks to the well. Handicrafts were usually produced

at home, but small canning factories or bakeries required separate structures.

All these activities were defined as work, and statistics on economic activity were reformulated to include women's contribution to the economy of household and nation. Politically, women-in-development proponents had decided that women had to be perceived as economic actors if they were to be included in economic development. Women's roles in reproduction were interpreted in the biological sense rather than in the broader Marxist sense of reproducing the labor force. Domestic activities of housework, child care, and nurturing —women's second day – were purposely excluded from the definition of work. Women's economic activities were to be inserted into the definitions and concepts of the dominant economic paradigm: Equity would become possible on the leveled playing field. Women's household responsibilities were minimized , and with them, shelter.

A second reason that shelter has not been a development issue until recently is the preoccupation of the development community with rural areas. Despite that fact that soon over half the world's population will live in urban areas, the predominant focus of donor agencies and nongovernmental organizations (NGOs) alike has continued to be on rural problems ranging from poverty to agriculture to infrastructure. Cities were considered synonymous with wealthy elites who did not require development assistance.

As squatter settlements grew, some

concern about urban housing began to surface. Delegates to the World Conference for International Women's Year, held in Mexico City in 1975, included a reference in their World Plan of Action stating that because women spend more time than men around their homes, their needs should be featured at the 1976 World Conference on Habitat held in Vancouver. This view was not reflected in the 1976 conference documents, although the plan of action for human settlements "called for active participation of women in planning, design and execution of all aspects of human settlements." The Habitat conference did prompt the establishment of the United Nations Centre for Human Settlements (UNCHS), cause Barbara Ward to write *The Home of Man*, and encourage appropriate technology groups to discuss solar heating, water and sanitation. A prize was given for the best design for squatter houses in the notorious Tondo section of Manila. (The design pleased architects but was too expensive to be widely copied.)

The World Bank was the only development agency that engaged in urban housing at the time, although the U.S. Agency for International Development (USAID) had established a housing loan guarantee program. The World Bank developed the "sites and services" approach to low-cost housing and began programs to upgrade existing slums and squatter areas. Canada's International Development and Research Centre (IDRC) funded a series of urban studies on such new issues

as street vending and low-cost housing, but neither programs nor research mentioned women. The International Labor Organization (ILO) had begun a series of urban studies on small-scale enterprise in the informal sector in 1972. But because the research design emphasized enterprises of five or more persons, women's informal-sector work was largely excluded.

The lack of interest in urban issues within the development community was reflected among women's scholars. Esther Boserup included a chapter entitled "Women in Cities" in her influential *Woman's Role in Economic Development*, but few people referred to her ideas of male and female cities. Market women, especially in West Africa, continued to attract attention; novelists such as Cyrille Ekwensi chronicled "walkabout women" in Lagos, and studies appeared about the new urban women in African towns. When Hanna Papanek wrote one of the first articles detailing women's different experiences in cities, "Women in Cities: Problems and Prospectives," for my AAAS Mexico Seminar, housing was ignored.

The final reason that shelter remained a non-issue for so long revolves around the conception of the household: Shelter is for a household, not an individual. The implicit message of the women's movement is that women are actors in their own right; intrahousehold issues were sidestepped by emphasizing the feminization of poverty worldwide, which resulted from the disintegration of the family and the disappearance

of subsistence and barter economies. Development programs tried to assist poor women, whether they were part of more traditional households or heads of their own. Empowerment in this scenario was self-esteem and the ability to make their own decisions. When such programs and the concomitant change in women's status altered the prevailing patriarchal control, programs were often taken over by men or dismantled. Alternatively, men simply reduced their contributions to household support, leaving the women to work harder for no economic benefit. Such outcomes required practitioners to adjust programming with intrahousehold dynamics in mind.

Scholars also turned their attention to intrahousehold dynamics in response to a new household economic theory that treated the household as a cohesive unit whose welfare was decided by a benevolent patriarch. Critics challenged the idea of the household as an undifferentiated unit and documented intrahousehold bargaining. Control over labor and income within the household becomes the site of power and is the subject of a growing literature that analyzes women's ability to control their own or the family income and traces the impact of women's income on children's nutritional status.

What makes the household different from other economic groups such as firms is that bargaining to win is constrained by the desire to keep the unit functioning. Amartya Sen, writing for my *Persistent Inequalities* in 1990, developed the concept of "cooperative conflict" to move economists beyond game theory in analyzing the household. Individual interests of both women and men are thus subsumed under the greater good of the larger unit. Carole Rakodi argued that you cannot delink the household from familial or kinship domains and underscored women's willingness to compromise to maintain this base: "Women see the household as the entity with which they identify their interests even if they come off second best, because there are few other sources of resources and support outside the household and kinship network Despite its lack of unity and greater or lesser impermanence, the household is still the basic living unit and access to housing needs to be assured primarily, if not exclusively, on a household basis" ("Women work or household strategies" *Environment and Urbanization* 3.2:41-42, 1991.) In sum, the fictive unity of the household is supported not only by planners and religious leaders but by household members themselves.

If household is a constant, its composition and survival strategies are not. Rakodi suggested that the household life cycle is particularly important with regard to housing policy. A newly married couple may live with a parent; a young couple may rent; better-off families may have rooms for elderly kin. Family members may stay in school, take or change jobs, or migrate as a result of household strategies. Household size changes not only from births

and deaths but by conscious decisions as distant kin or unrelated friends join to share costs and chores. Single mothers often decide to live together for child care or to protect themselves from gossip. Young rural cousins are incorporated into urban households, often as semiservants, in order to attend secondary schools; children of mothers on drugs or in prison move in with aunts or grandmothers. Kinship networks provide short- and long-term housing as family or clan members alternate urban, periurban, or rural residence. In sum, the definitions of nuclear or extended households taught in college or written in censuses are obsolete, if they ever existed. Households headed by women are only one of many patterns of household composition. In the United States, we understand that the family is no longer solely a father-mother-two children grouping; we must understand that this is a global truth.

Shelter remained a non-issue for feminists as long as they focused on the individual woman, her work, and her exploitation within the rural household. Development programs emphasized recognizing and ameliorating women's domestic production and then adding income-generating activities. The context of household was assumed in rural areas, but place and space were largely ignored, although time budgets were a major explanatory tool. Indeed, much criticism has been leveled against such programs for their myopia in excluding men's decision-making roles concerning women's labor and income. Many

failed programs may be attributed to the focus on women as individuals without family or kin obligations. In the final analysis, the household is an enduring unit for nurturance and survival, and its members require shelter.

SURVIVAL AND SHELTER ISSUES

Shelter as a topic began to be mentioned in urban studies of women's work as street sellers in Latin America and India: Where did these women live, and how did they care for their children? Production of street foods or electronics and other piecework by women often takes place at home. Issues raised here range from the political – how to protect invisible workers from exploitation, to the practical – how can foods prepared in crowded domestic space be kept safe to eat? This interrelationship of work and home has become a major new policy issue.

More explicit references to women and shelter came as a result of the growing research on squatter settlements, slums, and company housing in urban areas of Latin America. At first, anthropologists who were observing life in these areas and were sensitive to gender differentiation simply noted the large number of female-headed households or discussed how wives could not remain in company housing if husbands left. As housing schemes for the urban poor became more common, studies showed that women were less likely to receive credit to buy land or materials

because of either their irregular income in the informal sector or their inability to supply the requisite sweat equity.

NGOs have taken the lead in providing housing loans for women, often requiring or enabling women to register land and houses in their own names. In Bangladesh, international agencies made funds available for loan programs to replace rural housing destroyed by floods. The major NGO lender, the Grameen Bank, required land titles to the house plot to be registered in the *woman's own name* if she took out the loan; even if the man secured the loan, the house had to be registered jointly. Since housing loans were available only to Grameen Bank members of two years' standing, 95 percent of its housing loans went to women. In this manner, poor rural women had the security of their own homes to counter the ease of divorce under Muslim law.

Women's right to register government-supported housing in their own names or jointly with their legal husbands was granted in Costa Rica when President Oscar Arias signed the Real Equality Bill in 1990. Pressure for this bill had come from Comite Patriotico Nacional (COPAN), an activist organization with a high proportion of women members. All COPAN members had to contribute 900 hours of communal labor to be allocated a house, but this labor could consist of child care or cooking instead of housing construction.

In Latin America, where squatting takes place on government land, land rights may be easier to confer than in countries in Asia and Africa, where land is controlled by customary land tenure systems. In Nepal, for example, customary land inheritance laws prohibit even individual men from exercising any rights over inherited lands. In response, middle-class families in Kathmandu purchase land that is not governed by customary law and then register their new homes in the wife's name to avoid any claim by male kin. The situation in Indonesia, where cadastral surveys remain incomplete, is also typical of much of Africa: Land titles often obscure whether land is subject to customary or international commercial laws. Such confusion makes urban planning difficult and retards investment. Governments are under pressure to codify land rights; it is imperative that women do not lose rights to own land as this process takes place.

A second major shelter issue is access to infrastructure and transportation. Caroline Moser, who chaired the AWID panel on "Women and Shelter," organized a special short course on women and housing at the Development Planning Unit of University College, London; a selection of working papers prepared by students in that course were subsequently published in perhaps the first book on the topic. In her introduction, Moser writes:

The importance of focusing specifically on women relates both to the central role that housing and infrastructural services, such as water, electricity, and sewerage, play in their lives, and to the fact that this tends to be ignored by those involved in the planning of

human settlements. (Caroline Moser & Linda Peake, eds. *Women, Human Settlements, and Housing* 1987)

The emphasis on infrastructure reflects problems encountered when squatters take over vacant land and then make efforts to obtain services. Moser notes that this concern with the environment in which housing is situated defines the meaning of "human settlements." So central to women's responsibilitie s for the household are these basic infrastructural services that women play a leading role in mobilizing the community to demand them. Indeed, Moser argues that women are so central in this activity that it constitutes a third element in women's multiple day: as producers, reproducers, and community managers. Others have noted the periodicity of women's involvement, whether in organizing to demand services or setting up community kitchens, depending on need and political circumstances. At present, this role in community organizing appears to be primarily a Latin American phenomenon, perhaps because there is a longer history of urbanization there.

The infrastructure concern has been mirrored in research conducted by Ayse Kudat at the AWID Forum, based on her staff work for both UNCHS and the World Bank. She focused primarily on drinking water availability to women in Nepal, Pakistan, and Bangladesh. Studies in crowded slums in these countries (living areas for a family were typically two square meters of rental space) indicated that women have no place to store water, so they take their tasks to the water points, where they wash clothes, dishes, and children. In rural areas, water becomes a transportation problem . But most women were more concerned about improving their housing than their water supply and evinced little interest in credit programs just for water systems.

Transportation represents a related concern. Inadequate transportation links between squatter settlements and jobs in town particularly inconvenienced women in Brazil because scheduling did not take into account their other domestic duties. In Asia, women's need for safe, inexpensive, modest transportation, which is now met by bicycle rickshaws, is being discounted; crowded urban buses are a favorite alternative championed by planners, even though women are molested daily in such vehicles. Nor can large buses navigate the lanes in most urban slum areas.

The interrelationship between affording shelter and earning an income has produced a series of studies. Aliye Celik, from the UNCHS New York office, emphasized the employment potential of construction itself in her paper for the AWID panel. She reviewed programs that have taught women how to improve their traditional skills, such as brick making, and trained women in nontraditional jobs as electrici.ans and plumbers. Women construction workers have to overcome some discrimination at first, but income is usually significant for those who stay with the

work. Celik also stressed the importance of including female architects in the planning process so that kitchens suit women's sizes and tasks, a problem with many male-designed houses.

UNCHS itself now mandates that shelter programs for poor urban dwellers include income activities for women. The reasoning behind this mandate was the observation that many upgrading projects so improved the housing that the original inhabitants moved out: Either the costs of new services were so high that the poorer families could no longer afford to live in the upgraded area, or the value of their homes so increased that they were tempted to sell out to middle-class buyers who appreciated the central city location. The assumption was that the husbands were already employed, so the additional family income earned by the wives would enable the families to remain in their improved housing.

It is difficult for housing professionals to include income activities for women in their planning, but they are looking to local NGOs for help. Relevant findings emerged in my 1991 evaluation for the United Nations Fund for Women (UNIFEM) of UNCHS programs in Indonesia, Bangladesh, and Nepal. Credit programs for poor women and men in both Bangladesh and Indonesia have increased the incomes of the very poor in remarkable ways. In contrast, income projects designed for women by many NGOs in both Bangladesh and Nepal were still of the "knitting and sewing" variety that

need to be subsidized for women to earn anything. In Indonesia, women's income projects are informed by the government philosophy that women are primarily housewives whose employment should supplement their role as homemakers, so they seldom provide significant income.

But lack of income was not the major reason that families moved out of the five-story walk-ups that replaced ground-level shacks in Jakarta. Their main complaint was the difficulty of conducting their existing enterprises from small apartments above the street. Planners generally overlook the importance of the home as a productive unit; this is a normal concept in rural areas but contrary to prevailing attitudes about urban housing. Historically, only since the industrial revolution has "home" been defined in the US, not as a place of work but as a refuge from the public world. In fact, around the globe, a sizable portion of urban women utilize their homes as self employed microentrepreneurs, home-based outworkers, or unpaid workers in small family-owned shops or enterprises. In the United States, at least 25 million people worked full or part time at home in 1988; the American Home Business Association claims a higher figure of 31.6 million home-based workers and adds that one out of seven U.S. businesses is entirely home based.

To summarize, shelter research begins with a concern over access to and control over housing. Provision of adequate infrastructure for transportation,

water, waste disposal, and electricity constitutes a second cluster of issues. Inextricably bound up with shelter is the concept of home as a productive unit, a concept at odds with visions of modernization held by many planners. Taken as a whole, shelter concerns are at the center of discussions on the environment and urbanization. All these issues have strong gender differentiation; studies of current programs help shape future policy.

TERMINOLOGY

This chapter has adopted the use of the term "women and shelter" to describe the broad program of activities encompassing housing, infrastructure, homework and domestic production, and community management. This usage has developed over time and was adopted by the Habitat International Coalition's Working Group on Women and Shelter in 1988. A review of this evolution is instructive.

The United Nations Centre for Human Settlements, also known as Habitat, was set up as a result of the 1976 World Conference on Habitat; the new agency included within it the Centre for Housing and Building. (Because the name Habitat has been borrowed by several NGOs, UNCHS now uses its initials instead to avoid confusion.) "Housing" was considered too narrow a term, referring only to the built structure and the land underneath; "human settlements" includes the surrounding environment – a vague expanse that is awkward to limit. A new term was added when UNCHS designated 1987 as the International Year of Shelter for the Homeless. "Shelter" seems to imply an even more flimsy protection than a home, so why has it become the preferred term? Further, given the household basis for shelter, why has the phrase "women and shelter" been given precedence over "gender and shelter?"

UNCHS has been advised by the Habitat International Coalition (previously called Council), or HIC, since the agency was established in 1976. HIC is an international group composed of NGOs and community-based organizations (CBOs) drawn from all regions of the world. Only in 1987 did the HIC general assembly pass a resolution calling for equal representation of women and men on the board of directors. That meeting in Nairobi was the largest since Vancouver and was attended by over 250 participants representing some hundred organizations. When voting procedures did not equalize women members on the board, a working group was formed to monitor the inclusion of women and shelter in HIC activities. During the debate on this action, the board recommended an alternative approach: The group would be called Gender and Housing; membership would include men, and its charge would be to work toward the inclusion of women in all HIC programs. This concept was rejected at the first meeting of the working group, which argued:

[Since the group's] mandate was to make women's shelter issues visible, the name Women and Shelter better served this purpose. . . . To use the name Gender and Shelter would easily lead to a methodology of comparing women's situation in relation to men's situation in shelter requirements. This approach reenforces women's invisibility and denies the methodologies which identify the unique social and economic characteristics of women in relation to their shelter. The methodology which defines what men have in relation to what women have leads one to believe that to give women what men have will resolve present disparities. But to identify women's social, political and economic characteristics in relation to shelter, which is different from men's social, political and economic relation to shelter, contributes to the beginning of a concept that more effectively addresses gender inequalities in shelter program design.

The group defined shelter as "the integration of the needs of entire communities in the areas of income, education, employment and training opportunities, and basic services as well as housing." Nonetheless, several members of the working group objected to its use because it might be confused with emergency shelters for battered or homeless women. So the working group decided "that a vocabulary to make women's relation to housing in development visible has to be constructed. . . . The process of concept and language development must first come from the articulated experience of the women in grassroots communities." To accomplish this language creation, the HIC Women and Shelter Group developed a global network supported by a newsletter. Included in the network are women involved in the construction industry and community organizing as well as development practitioners and scholars.

NETWORK ACTIVITY

The AWID workshop on women and shelter allowed the views of several HIC network members to be presented. Pamela Sayne from Toronto emphasized the political nature of women activists becoming involved in housing. Describing herself as both a teacher and a graduate student, Sayne opined that research has become part of the problem and reiterated her view that grassroots networks create knowledge to challenge conventional wisdom . Caroline Pezzulo (see UNCHS 1990), chair of the NGO committee on shelter and community in New York City, reported briefly on ways in which community housing groups in Zambia, Bolivia, Sri Lanka, and the United States include women in grassroots housing programs. Coordinator of the *Women and Shelter Network Newsletter,* Diana Lee-Smith is an American architect who has been living and working in Nairobi at the Mazingira Institute for the past twenty years. To reflect "voices from below"

and to ensure participation of and accountability to community-based organizations that are active in shelter issues, the newsletter is published in four languages: Spanish, French, Portuguese, and English. It reports on local organizations and their meetings, such as the one called by the pavement dwellers in India.

Two grassroots groups discussed their programming. Grassroots Organizations Operating Together in Sisterhood (GROOTS) is an international network set up in 1989 through the efforts of the National Congress of Neighborhood Women, which was organized in Brooklyn in 1974 by women of the area. Working with other low-income women, GROOTS provides an international forum for their views and problems while encouraging them to participate in the development of their own communities. The Women's Institute for Housing and Economic Development in Boston was represented by Jean Kluver. The institute was founded by architects seeking innovative solutions to the housing problems of low-income women; it provides technical assistance and information on housing and related services to social services and non profit organizations working with low-income women and femaleheaded families.

The HIC women and shelter group has a symbiotic relationship with women in UNCHS that is typical of women inside bureaucracies and activists outside. Pressure to include references to women and shelter in the documents produced at the UN World Conference for the End of the Decade for Women held in Nairobi in 1985 persuaded UNCHS to create a focal-point office within the agency. At the workshop, Colombian sociologist and social worker Catalina Trujillo reviewed the efforts of this office to support and stimulate grassroots involvement through a series of regional meetings.

The concept of women and shelter clearly puts women at the center of the development process. Significantly, it reunites women's fractionated interests by recognizing their productive and reproductive roles. The basis of shelter is the dynamic household, changing in composition with the life *cycles* of both individuals and families. This concept of household brings women and men together in their survival strategies.

The focus on women and shelter emphasizes women' s unique needs in several key ways:

- It addresses evolving forms of living arrangements resulting from increased individual mobility and insecure social and family safety nets: shelters for women who are battered, drug dependent, and homeless as well as housing for women heads of households and the elderly.
- It recognizes the critical need to provide hostels for young single women who migrate to cities for industrial or clerical employment. Especially in countries where unattached women are automatically

considered immoral, some sort of modern YWCA system is necessary if single women are to live a dignified and secure life.

- It unites women's roles in production and reproduction by expanding women's opportunities for income in and around the homestead, going beyond crafts to home-based contract and own-account work, and finding new markets for food production, including growing vegetables and fruits; raising animals, poultry, and fish; and preparing street foods.
- It reduces the time women spend on survival tasks through improved infrastructure, namely the provision of clean water and safe disposal of wastes, and through transportation arrangements that encompass safe and convenient access and appropriate transport.
- It reaches women of all income levels with its concern for the legal and human rights of married and single women.

Yet concern for shelter within the women-in-development field continues to reflect the limited approach that is predominant in the development community, one that focuses on housing and infrastructure, especially on replacing or upgrading squatter settlements. The hesitation of development agencies to confront social issues such as domestic violence and female headship continues to limit shelter programs. The stereotype of home as refuge blinds planners to the importance of home as workplace.

Conversely, shelter policy is a relatively nonconfrontational topic through which many issues on the feminist agenda can be inserted into development programming. The emphasis can be on the need to provide shelter and services to women and their children so that the young generation does not become a burden in the future. Legal rights for women and minorities can be introduced into the current debate on how to adjust and combine land tenure rights as they are differentially presented in customary and modern legal systems. Policy on shelter for women can address priority issues confronting women today and into the twenty-first century.

BEYOND ECONOMICS: SHELTERING THE WHOLE WOMAN

WOMEN ARE NOT SOLELY HOMEMAK-ers; nor do women live by work or bread alone. Indeed, even these two categories of housewife/reproducer and worker/producer do not exhaust the many roles women play in their daily lives: caretaker, community manager, teacher, nurse. A whole woman is all of these things. The ability of women to balance and perform their multi-faceted roles is affected profoundly by their household status and relation-ships. Whether her work takes place in or around the home, on the farm, or at some distance, her access to resources and control of surplus or income de-pends on household composition and intrahousehold bargaining.

Perhaps because shelter is so cen-tral for survival, its existence was simply assumed, and ignored, by early development planners. Gradually, as urban migration crowded sidewalks and vacant lots of cities throughout the developing world with squatters and produced peri-urban invasions of orga-nized settlers, planners confronted the critical need for low cost urban hous-ing. To call attention to this need, the United Nations initiated the HABITAT Conference in Vancouver in 1976 and established the UN Center for Human Settlements (UNCHS) to focus attention on shelter which includes more than a roof over one's head... but also involves a range of other sup-porting facilities that, together with a house, are necessary for a healthy living environment. This covers water and energy supplies, sanitation, drainage and access to transport networks. In sum, shelter includes the link between the home and the built environment of human settlements.

Recent catastrophes have under-scored the inadequacies of much rural housing. In October 1993, a devastat-ing earthquake in central India killed thousands of farmers asleep in their houses which were piles of stone with little or no mortar; more wealthy cit-izens survived in their reinforced con-crete homes. Yet to date, compared to its fundamental nature, housing con-cerns and the broader shelter issues in which housing is embedded have been widely neglected both by development agencies and by women in development (WID) proponents.

This chapter argues that because shelter issues encompass the many facets of women's lives, a focus on shel-ter provides an opportunity for the de-velopment community to recombine the fragmented perspectives of wom-en's lives into a realistic portrayal. A

focus on shelter also allows men back into the private sphere of the family from which they seemed excluded in the public/private debate. In this way, shelter could become the focus for a human-centered development approach that reunites the affective and the economic worldviews.

The first section reviews the implications of economic development policies to indicate why women's lives were fragmented for program purposes. In the next section, the evolution of housing policies, both urban and rural, is analyzed in terms of the differential impact of various housing approaches on women and men. The third section considers the gender ramifications of two major aspects of shelter policy: provision of services, and the use of space in and around the house for income activities or food production.

DEVELOPMENT POLICIES

Shelter was listed as one of the primary basic human needs by development planners as they shifted their emphasis from infrastructure projects emphasized in the 1950s and 1960s. Roads or electricity were justified by their contribution to economic development; water was always for irrigation, not for the household. Economic activities were presumed to be done predominantly by men, largely outside the home. Too easily, the public-private and male-female dichotomies became the basis of programming. Work at home, whether subsistence farming or small

home-based industries, whether done by women or men, went unrecorded in statistical data. The resulting inaccuracies strengthened stereotypes of distinct male and female roles and caused many a development program to fail.

As WID scholars began to document the differential impact of development on women, they utilized the same sectoral categories that framed the development debate because their policy objective was to ensure that women were integrated into development programs. Two decades ago the first challenge was to record women's economic activities in subsistence livelihoods so that economic projects would not ignore or undercut their contributions to the household. Women's unpaid work in gathering fuel, water, food, and forest products; in planting, weeding, and processing agricultural products; in weaving baskets or cloth; and in making pottery, batiks, or beer became the subject of hundreds of studies. Improved data on farming more accurately portrayed roles of all family members by age and gender and demonstrated that men as well as women accomplish many off-farm tasks that are essential to their families' livelihood.

Women's work became the focal point for women in development research in reaction to earlier programming for women that had considered women only in terms of their maternal or family planning activities. Gradually the health and family planning programs began to recognize women's economic activities: population

programs combined with income activities, health clinics schedule hours when women were not weeding in the fields. The caring role that women play, nurturing children and ministering to the sick and the elderly, has been widely noted, particularly as structural adjustment policies reduce available health and child care services. Such activity is assumed and undervalued.

Research on the urban informal sector was initiated by the International Labour Organization in 1972 primarily to identify employment opportunities for men. Focussing on small, as opposed to family or self-employed enterprises, their data generally ignored women. Once again it was left to women scholars to study women selling in both urban and rural markets or producing and vending street foods. More recent scholarship on home-based work, both microenterprise and sub-contracting, reiterates the home as the locus of much of women's work. This literature emphasizes the importance of women's income to the survival of poor families. The richness of data on women's economic and family roles contrasts with the poverty of parallel studies on poor men and frustrates efforts to produce realistic gender analysis of family survival and livelihood techniques.

The accumulation of micro studies on women and work has altered data collection and affected program planning. These studies also delinked subsistence tasks, such as farming, fuelwood and water collection, food processing, or craft production, that could be considered economic activity from childcare and household maintenance and thus narrowed the concept of reproduction. Although marxist economic theory honors the role of reproduction in the sense of reproducing the labor force and so allows some claim that marxism is more sympathetic to feminism, liberal economic theory dominates development planning and for many years ignored the household or considered it a site of consumption, not production. Only recently has attention turned to the household and provoked a debate on cooperation or contention within it. The definition of work as solely an economic activity has led to demands for wages for housewives because non-monetary activity is not esteemed in contemporary society.

The emphasis on income also disadvantaged working women; studies show that women make less money than men and spend less time in the market or on production because they have a second job: the double day, the responsibility for the household. The advantages of women's income are also easily undermined if women cannot control the money they earn or if their husbands reduce their contribution to the household. Clearly, women's work is only part of the whole woman.

Volunteer work with a household or community focus goes largely unrecorded and unappreciated. Whether undertaken for charity purposes or as part of organizing efforts to affect policies or for strengthening a kin network, women play a significant role. To

highlight the utility of social contacts to the welfare of the family, Hanna Papanek devised the term "family status production" ("Family status-production work: women's contributions to class differentiation and social mobility," paper presented at the Regional Conference on Women and the Household, New Delhi, January 1985.) Men are also active in family, kin, and community networks but their activities are interpreted in economic or political terms, thus reinforcing the public-private dichotomy.

By fragmenting activities of both women and men, and by emphasizing sectoral programs, development programs created unbalanced lives. Shelter as home and community, work and play, wealth and well-being, brings the family into focus and reverses the prism of women's spectrum of roles so that these many strands join into the whole woman.

HOUSING POLICIES

Housing concerns first surfaced as a development issue in response to pressures from developing countries whose cities were being inundated with migrants. By 2000, half the world's people will live in urban areas, up from one tenth a century ago; more importantly, two-thirds of the people in the developing countries and a majority of their absolute poor will be urban. Seventeen of the twenty-three urban agglomerations with over ten million inhabitants will be in the developing world. In Latin American and

the Caribbean where three-quarters of the people already live in the towns and cities; women outnumber men by 108 to 100. Urban-rural ratios are rapidly changing elsewhere; the rate of urbanization is particularly high in west Asia/North Africa and Oceania where about half the women are urban today. As governments struggle to absorb the new migrants, the experiences in Latin America are used as models and generalizations about both problems and policies are too often projected on the rest of the world without adequate adaptation.

Urbanization promotes visions of highrise office and apartment buildings casting shadows on narrow canyon-like streets. In fact, few cities are as densely built as the archetypical Manhattan. Quarries, swampy areas, or creek beds are by-passed as commercial and middle class residential areas sweep outward, following arterial roads; these "unbuildable" areas are rapidly filled with low income settlements. Existing villages are engulfed by city expansion, their open spaces filled with homes of rural kin. Estimates suggest that as much as three-quarters of newly built urban housing in developing countries is unauthorized. This does not automatically mean such houses are all shacks; lack of authorization may arise from zoning limitations, building standards, or disputed land rights. These legal and regulatory issues affect all types of buildings: commercial or residential, mansion or hut. But for the urban poor, housing choices for the migrants or expanding urban households

is extremely limited: self-built housing in irregular communities or rented accommodationswhere facilities and even living space is often shared. Policies and programs relating to these categories have differential gender impact.

Self-built housing has received the most attention from both scholars and planners. The sight of shantytowns surrounding westernized capitals, of straw shacks along rivers, or of hovels on steep sides of hills is familiar throughout developing countries. On seacoasts, wooden walkways thrust out over tidal flats to link houses on stilts, an age-old technique that relies on water action to wash away refuse and excrement dropped from above. Rural kin often descend on urban relatives and jam another shack into space meant for a garden. Parks and vacant land sprout settlements overnight; invasions by entire communities moving all at once into peri-urban areas created instant *suburbios* all over Latin America. Political parties in Peru and Mexico often promoted such invasions and protected the inhabitants; in Chile similar efforts turned the squatter settlements into a political battleground. When squatters lack political support, squatters are attacked as they were around Monterray, Mexico, in 1971; the Brazilian government attempted to eradicate major *favelas* in repeated bloody campaigns during the 1960s.

In Asia, government response at first was to evict these illegal squatters, trucking them out of town. Most were back the next day. A second response was to hide them; President Marcos had high fences erected along the highway from the airport to Metro Manila in order to shield squatter areas visitors. Today, when government planners wish to move squatters in order to beautify the beachfront for tourism, or to clear streets of pavement dwellers, or to build a shopping center at a central location, house builders on public land are usually compensated or offered alternative housing. Squatters on private land have no such protection, though governments may buy the land and sell to settlers in order to prevent rioting. Resettlement is often offered as part of sites and services programs, but where land is scarce, governments may build highrise apartments. As an alternative to the high cost of such programs, many squatter settlements have become legitimized and upgraded through government schemes.

Sites and services programs require the government to acquire and clear available land throughout the city and install basic infrastructure. This might simply mean surrounding the area with a road, dividing the area into house plots reached only by pathways, providing water points for every ten or so plots, and building common latrines, bathing and laundry facilities. More elaborate, and expensive, programs provide a core unit on each site with water and electrical outlets and a bathroom connected to the city sewerage system. Housing plots are then sold, usually through subsidized credit schemes; families build their own houses at their own

pace. Sometimes governments decree the standards and style, or even provide materials at cost. Reflecting housing demand, the higher cost core model in Karachi was often sold to lower level civil servants or to speculators.

In order to provide such housing to lower income families, many non-governmental organizations (NGOs) have adopted the sites and services concept but require citizen participation: potential buyers are expected to contribute work toward preparing the area and providing infrastructure. NGOs eventually recognized that such labor was more difficult for women heads of households who often constitute over half the squatters in many Latin American cities. Because women household heads both work and care for their families, working on the project site was often impossible and credit was hard to obtain because women are more likely than men to work at informal sector jobs with uneven incomes. In San Jose, Costa Rica, COPAN counted childcare or work in other COPAN projects such as their pharmacy or library toward the requisite work points, enabling both women and elderly to qualify for COPAN housing. Further, the organization staged demonstrations to make home loans easier to get and led efforts to introduce a law in 1990 that guaranteed women's ownership rights to any home subsidized by the government. To keep home building costs down, COPAN also trained work crews, mostly men, to lay foundations and erect much of the housing in order

to meet seismic standards. In contrast, Save the Children USA trained and then hired women of the community to lay foundations and build brick homes at their sites and services project in Colombo, Sri Lanka.

In typical compartmented fashion, development agencies assigned housing programs to urban areas and have only recently realized the vast need in rural areas. Because attention to rural housing is generally the result of a major catastrophe, new housing must be built to an enhanced standard. In Bangladesh, floods regularly wash away traditional rural huts with their bamboo poles and matting sides. UNCHS has encouraged NGOs to provide housing loans, and most have followed the lead of the Grameen Bank which insists that housing for which it provides loans must have four reinforced concrete posts and a tin roof. Loans were only made to members, over 90% of whom are now women. Further, each woman had to own the land on which her hut would be built; if her husband or male relatives would not give her land, she could first obtain a loan for buying land. Once the housing loan was granted, the householder would prepare the mud platform for the approximately 12 by 20 foot structure. A local male artisan, trained by Grameen Bank, would position the four posts in concrete, build wooden braces, and wire on the roof. The posts are made locally by teams trained and paid by the Bank. The women would weave rush matting to serve as walls for her home.

Floods might sweep the mats away, but the frame would withstand the waters and save the meager household goods tied to the cross poles.

Upgrading is the term utilized for programs that introduce minimal services for and infrastructure into existing spontaneous, but unplanned, communities. Upgrading emphasizes the creation of pathways and the provision of electricity, water standpipes, and common latrines. Early World Bank programs focussed on squatter areas in India and on the *kampungs* in Indonesia. It is critical to distinguish between these two types of settlements. Squatters cluster primarily on unused and unbuildable public lands; in Calcutta, for example, marshes constitute 21% of the municipal area and have been generally untouched by commercial development so that squatters have burgeoned in places subjected to frequent monsoon floods.

In contrast, Indonesian *kampungs* are not illegal settlements. Rather they are former villages with land rights governed by *adat* or customary law. Under Dutch administration, urban *kampungs* were grouped with rural areas under provincial civil servants; European sections of the city were under a Dutch mayor and land in those sections was regulated by European law. These two distinct systems of land rights have yet to be reconciled, and clearly urban development is impeded until such reconciliation is achieved. What is critical to remember is the difference in security between

squatters on public or private land and villagers with traditional land rights.

Kampung improvement projects were first introduced by the Dutch in the 1920s. Renewed emphasis began the 1960s and utilized funding provided both by the Asian Development Bank and the World Bank plus numerous bilateral and NGO donors. Despite the rhetoric of encouraging citizen participation, most *kampung* improvement projects (KIP) appear to involve top-down imposition of designs originating in Jakarta for KIP throughout the country. In interviews, *kampung* dwellers particularly appreciated the cemented footpaths and roads that allowed the use of motorcycles and bicycles inside the settlement; ease of transport encouraged the setting up of small shops within the kampung. However, realigning paths as part of upgrading was found to cause social as well as physical dislocation in a study done in Pune, India. The lack of consultation and the preconceptions of order by planners resulted in bisected neighborhoods and interfered with established patterns of social interaction.

A 1992 survey of squatters in the Juhu area of Bombay City, India, enumerated 93,000 people from fourteen states of India living on about 175 acres in 17 different, and not always continuous, pockets of land along the ocean beaches and up into nearby marsh land. Settlement began over forty years ago, and little space is left on government land so that some families have pushed into neighboring private land. In 1974 the area was officially declared a slum

by the municipality, a designation that provides a minimal degree of protection against eviction, but only for those on government land. About half the families live in houses constructed of brick and cement with a permanent fireproof roof; but almost no houses include a private latrine. Most houses have electricity illegally, but half of the families pay more for this illegal use than they would if they had legal connections. Party organizers, local NGOs, and an outreach project of the Women's University in Bombay have been able to pressure the city to improve toilet facilities, increase health and education services, and introduce training in income activities for the women.

Squatters in many countries have been able to pressure governments to upgrade their areas by providing basic services and allocating land rights. The *pueblo jovenes* or new towns outside Lima are well documented examples of settlements in the desert fringes of the city. These settlements began as carefully planned invasions: vacant land was mapped by the organizers as for any housing development with lots designated and space set aside for roads and sites for schools and clinics. Overnight, the entire community set up shacks on their assigned lots. Once people were in place, the community would agitate for electrical connections and water: first for daily trucks to bring in water, then later for pipes. Evicting an entire community is nearly impossible; community leaders would offer votes for land tenure if not ownership rights. As

squatters felt more secure, they would begin to construct well built houses, usually hiring skilled workers from the informal sector. Over time, many of these "young towns" have become fully legalized, and visually they are difficult to distinguish from nearby suburbs.

Governments are also pressured to provide services to land that has been purchased. In Mexico, most cities are surrounded by land owned communally by *ejidos* or Indian communities. Technically such land could not be sold, but it was, at relatively low cost; in 1992 a law was passed allowing communal land to be sold but because its implementation has not begun the impact on land prices or on existing settlements is not known. Similarly, around Bogota, land that was not zoned for housing has nonetheless been sold at low rates to poor people who erect sub-standard housing on steep slopes, and then agitated for services. In both instances, the land may be legally held but the housing is unauthorized. Yet it is unlikely that either government would try to evict the settlers. A distinct type of upgrading is being promoted in Bolivia to reduce Chagas disease caused by a parasite that thrives in cracks in adobe houses and in thatched roofs throughout Latin America as far north as Texas. This parasite can cause both heart and gastrointestinal problems after a ten year incubation period.

From the outset, most squatter settlements contain a wide range of housing types. While many houses emulate those traditional in rural areas, other

are erected using modern materials from the start. Two story stucco houses of local merchants stood out among shacks in Lima's new towns in the years before most residents could improve their dwellings. *Kampungs* are full of middle level bureaucrats who prefer a crowded inner city to distant government flats. Recent evidence shows that many families move out, renting their former homes. In Pune, India, 30% of houses in a slum upgrading area were rented; landlords benefitted from increased services and promptly raised rents, forcing poorer squatters out to the unimproved margins of the area.

Removing squatters in order to construct new roads or buildings, or to clean up public spaces such as sidewalks or parks, is a difficult and expensive process for governments today. Pavement dwellers in Bombay were threatened with demolition of their shacks in 1985 when SPARC (Society for Promotion of Area Resource Centres) began organizing the women pavement dwellers to resist being moved until a satisfactory resettlement site was allocated. SPARC was motivated by studies they had reviewed which indicated most low cost housing and resettlement schemes rapidly became slums. Throughout India, half the families offered housing in the periphery move back into town because they cannot afford costs of the shelter with its higher grade services and cannot afford either the money or the time required to commute back to their work. Further, the move destroys

their community networks through which they learn of jobs.

Resettled families can often sell their housing rights to somewhat better off people. Indonesia provided walk-up apartment houses for families moved in order to widen a central boulevard in Jakarta; they too sold to middle-class families because they were not allowed to continue home based work in the apartments and so could not afford the higher costs of improved housing. The UNCHS is encouraging housing projects to link income programs for women with all resettlement schemes so that the families can afford the upgraded standard of living. To prevent resettled families from selling their newly acquired homes and returning to squatter areas, some NGOs hold onto title for five or more years. Other groups accept the idea that many poor may prefer to trade their stake in a house for cash that would allow them to start a trade or buy rural land.

Many governments subscribe to the idea that they must supply housing to those who cannot afford it, but the cost of such programs have overwhelmed low income countries. Europe set this example, rebuilding their cities and towns after World War II from Norwegian fishing ports above the Arctic Circle to massive high rise structures in Prague and Moscow. Post-colonial countries expanded housing stock for their employees at all levels, following on the colonial tradition. Rapid modernization and increased national income allowed both Singapore and

Hong Kong to house their citizens in high rise buildings of varying quality; in India, however, low income housing with its modern services was quickly appropriated by the less poor.

Critics complain that the term "self-built housing" is misleading: as illustrated above, few poor men or women possess the skills to build structurally sound urban or rural housing from currently available materials. The term was widely adopted in the early 1970s to underscore the argument that the poor themselves designed shelter that was more appropriate to their income and life styles than most government built public housing of the day. Originally meant to describe self-initiated as opposed to government designed and built housing, the concept has come to mean, literally, self-built. In fact, squatters save money to buy materials and hire skilled labor in order to upgrade their homes as long as land rights are somewhat secure.

In less developed countries such as Nepal, where some 80% of the people live in poorly built "temporary" housing, as much as half of the unskilled construction work in urban areas is supplied by poor rural women. A recent study in Nepal found that 61% of households interviewed used female family members in constructing their own houses; as shelter became more formalized, fewer women were utilized. This contrasts with south India where women constituted nearly half of all laborers for house construction but seldom participated in the building of

the mud huts that comprised 25% of all dwellings in Vellore, but rather worked on more modern construction.

Housing design often reflects the family's life cycle as well as income. Second rooms, adjacent or upstairs, may have outside entrances for rental, knowing that once their children are married, they could occupy separate quarters. In Lima, Peru, a problem arose when squatters were granted legal rights to land upon which they had been living: renters claimed equal rights with some squatters. Municipal authorities complained that these claims discouraged multiple dwellings in the new towns and so pushed new migrants further into the desert; consolidation of existing squatter areas would allow for improved and cheaper municipal services.

Critics of self-built housing also complain that emphasizing houses built by people allows governments to abdicate their responsibility for providing housing for its citizens. Without government intervention, land markets soar in urban areas making land acquisition by the poor impossible and encouraging illegal squatting. Streambeds and marshes, clogged by houses and refuse, become environmental disasters endangering the health of both squatter and middle-class. Growing attachment to the free market ideology makes it more difficult for governments to address land use planning, but the urban crisis demands governmental action. As such plans are formulated, gender

aspects of self-built housing should be acknowledged.

Rental housing has received less attention than self-built housing or upgrading, perhaps because it is not a new phenomenon. While buildings erected for rent are recorded, the informal and often illegal nature of much rental accommodation in homes, found both in comfortable middle class suburbs and in squatters shacks, is difficult to monitor. Throughout the world, worker housing or walk-up apartments designed for the lower middle class are rapidly becoming slums through overcrowding and subsequent deterioration of services. As cities grow, downtown slum areas are ripe for redevelopment, adding to the housing crisis for the poor.

Choices among rental units vary by family life cycle, income, and kin networks. Around the world, young women and men from rural areas move in with urban kin to attend school, helping with childcare and cooking. Older relatives come looking for work and help in the household until they are able to pay rent; related couples often share accommodations for years. Young men or women without kin seek hostel rooms, often so crowded that they are forced to share beds. The YWCA concept, so important for single women in the United States, is replicated in many parts of the world. However, in Dhaka, Bangladesh, young female secondary school leavers doing clerical work often stay for years instead of weeks since they literally have no place to go. Village girls who come to work in the newly opened garment

factories rent space in squatter areas and are often preyed upon by pimps.

In Indonesia, circulatory male migrants find both shelter and assistance in earning money through the *pondok* system, boarding houses where the manager also runs an enterprise. *Pondok* residents tend to cluster with others from their own village or area. An entrepreneur selling products like ice cream or bread on commission will provide his on-premise workers with board and lodging, and his vendors with equipment and shelter. Other *pondok* bosses rent pedicabs or pushcarts to residents and may supply street food vendors with raw materials. In Surabaja, one study found the relationship of the manager to the residents more like uncle-nephew than the often exploitative arrangements typical in Jakarta.

In Guadalajara, Mexico, young single mothers prefer the downtown slums with shared facilities to distant squatter settlements: living in close proximity with other families provided company and reduced gossip while closeness to shops and work allowed more time at home. Male companions are tolerated as long as they contribute to household expenses, but are told to leave if they drink too much or fail to help. To help with expenses and childcare, and to provide companionship, three-fifths of the women research on female-headed households had shared their homes for periods of three months or longer, compared with 43% of male headed households. Self-built squatter homes in the periphery presented

greater hardships for single mothers, because distance, lack of shops, and poor services meant that domestic activities are more burdensome than they are downtown. As their children grow up, some older women overcome the gender bias in housing construction to acquire land and build, or have built, their own house.

A Canadian researcher focussed on accommodations available to women headed households in Gweru, a medium sized town in Zimbabwe. Nearly half (42%) of these women live alone, 50% lived only with their children, while the remaining 8% had other kin or non-relatives living with them. Overall, a quarter of women heads supported at least five persons in their household. 80% of these women heads crowd into municipal rental housing, sharing rooms with other families and using common pit latrines and wash areas. Middle income women household heads prefer to seek lodgings at double or triple the costs of municipal housing. High income women rent their own apartments. Family size among the poorer women and high income women was similar while lodgers had the fewest dependents living with them. The lack of available accommodations leads to family fragmentation with young children left behind in the villages and older children sent back to rural areas to work. Lack of living space prevents women from bringing in alternative child caretakers; lack of garden space raises food costs for the family.

A current study of the process by which individual families acquire housing and how they use it is being undertaken in informal and regularized settlements in eleven countries plus low income areas in Boston. Their aggregate findings emphasize the critical nature of security. Even when incomes rise, households will not spend more than 15% of their income on shelter without some assurance regarding security of occupancy as owners or renters. Even with such guarantees, renters seldom spend above 20% of their income to improve their homes, but property owners increase their expenditures to 30% of household income. Such findings sustain observations of investment in *kampungs* or squatments as residents feel more secure in their tenancy and underscore the policy imperatives that call for land use rights in urban settlements.

These scattered studies suggest that women accept crowded slum conditions in rental housing because the support of community that arises from shared space, both rooms and facilities, as well as proximity to work, facilitates the daily demands on women to feed and succor their families. Household size and composition is constantly changing as male partners come and go and as children are farmed out to kin. Gender biases affect women's ability to acquire rental housing, but constructing "self-built" homes in the periphery is rejected as much for their isolation and lack of services as for the difficulties in obtaining assistance and funds. Older women with grown children or married couples

where the wife does not work outside the house more frequently own homes and rent space to others.

SHELTER ISSUES

Shelter encompasses more than the structure of a house. Human habitat includes the built environment, the space surrounding buildings, and the access to services and transport. Because women continue to have primary responsibility for family maintenance, shelter issues have a differential impact on women and men that should be understood and incorporated in urban policies and planning. Three crucial issues that affect a woman's ability to provide a livelihood for herself and her dependents will be briefly presented to illustrate the centrality of living space which encompasses more than a roof over one's head: water and sanitation services, home based work, and home food production.

Access to water and sanitation services loom as critical ingredients to the quality of life and to every woman's ability to keep her family healthy; yet most cities are grossly underserved. Whatever the housing type, the first service demand is for water supply. Burgeoning urban populations from California to Egypt must compete with agricultural users and demandmay exceed supply. Beijing's projected demand by the year 2000 will outstrip supply by 70 percent. Elsewhere, groundwater reserves are rapidly being exhausted: Mexico City exceeds its recharge rate by 50-80

percent, causing the city to sink. Available rivers are often badly polluted, and ground water is becoming polluted by both domestic and industrial wastes. In Jakarta, less than half the urban residents are served by the municipal water system; yet more than half of the supply "disappears" through illegal connections or leakage, enough water to supply 800,000 annually.

Lack of water and sanitation are a major cause of dangerous environmental health conditions in squatments according to a review of over 100 urban studies by a World Bank team. Urban poor have a lower life expectancy and higher infant mortality rate than most rural poor or urban middle class. Particularly for children, private latrines and sewerage are critical for health. It is no surprise that women in many informal settlements lead the agitation for improvements in water supply and in the construction of baths, toilets, and wash areas.

Caroline Moser, in her influencial 1987 book *Women, Housing, and Human Settlements*, argues that in Latin America women spend more time in community management than men because of their household obligations. Further studies elaborate on this model, showing how women establish mutual-aid networks and organize collective action to secure urban services during the first phases of settlement. Longitudinal studies show, however, that working women cannot keep up the activism but the better off women continue their leadership by setting up community kitchens which introduce patron-client relationships

into the settlement that are cemented by parent-godparent reciprocal arrangements. Interestingly, women's community activity do not seem to have political implications because neither mode of organizing, whether through networks or the clientelism, goes beyond the limits of family.

Such activism among women is less marked in Asia where upgrading is government policy and settlers are seldom consulted. NGOs with elite leadership are more likely to organize squatters than are residents themselves. Indeed, government programs often impose technologies for upgrading that are inappropriate. Squatter settlements may be supplied with water taps for each block, but often the distance and weight of the water means that residents continue to buy from water carriers who cart water down the narrow paths on shoulder poles or tricycles. In *kampungs*, municipal taps are frequently installed on donated land meaning that the wealthier residents have the water nearby. In smaller Indonesian cities, families invested in upgraded water and bathing facilities rather than in larger or better built homes, a choice that could have a measurable impact on family health security.

Toilets are usually communal in squatter areas, and the problem of keeping them clean is often solved by paying a custodian, sometimes by charging for each usage. The Juhu Beach squatment of Bombay, India, discussed above, has one latrine for each 134 people and one water tap

for each 673 persons. A World Banks report states that "in 1987, less that 60 percent the world's urban population had access to adequate sanitation, and only one third was connected to sewer systems. Where sewage did exist, 90 percent of the wastewater was discharged without treatment." Conventional methods of treating water and sewerage are too expensive for services to keep up with population, so services are usually confined to wealthier areas. Brazil has taken the lead in experimenting with low-cost technology that range from simple pit latrines with hydraulic seals and pour flush toilets to simplified sewerage systems.

Solid waste management is actually fairly efficient in most Asian squatments: poverty encourages collection and recycling of almost everything by traditional scavengers. Efforts to modernize the waste pickers are often protested by the workers themselves who, despite their low social status, often earn incomes above other manual workers. Many cities are seeking methods of improving trash collection while providing employment for displaced workers. For example, donkey carts have long been used by the traditional waste collectors, or *zabbaleen*, to negotiate the narrow alleys of old Cairo and carry the trash to the outskirts of the city. Gradually, the municipality is assisting them to acquire small trucks. An NGO is promoting the use of protective masks and clothing for the *zabbaleen* women and children who sort waste in their settlement and has funded technology to

recycle much of the waste, thus adding to household income.

As caretakers and housekeepers, women more than men are burdened by insufficient water supply, unsanitary toilet and washing facilities, and inadequate waste collection. But though women are often leaders in demanding that the city improve these services, their community management seldom translates into political power. Further, upgraded services will reduce jobs as water carriers and garbage pickers which provide income for poor urban workers, an impact that replires planning for alternive work.

Home based work describes the norm of previous centuries: weaving of cloth or baskets, making furniture or pottery, building or repairing the house, all done by most families between subsistence farming tasks. Most craftsmen also worked at home, living over their workshops. The industrial revolution moved workers to factories where unions flourished; to protect the factory workers, the unions then began to fight the remnants of industrial home work, especially related to textiles.

Two interrelated contemporary trends have reversed the concentration of industrial work outside the home and have enormous implications for gender relationships: the informalization of industry and the communication revolution. Rapid and accurate tracking of components has allowed the disbursal of manufacturing sites throughout the world, a trend that has created assembly plants around the globe but has also encouraged multiple layers of sub-contracting for everything from garments to toys to television sets. The web of interrelationships among jobbers and subcontractors, from women to their sisters and friends, makes tracing homework, much less organizing the workers, nearly impossible. Studies show how the number of women increases at the edges of the web where payment rates are the lowest. Yet this income from homework is critical for poor urban families. In periods of high unemployment, women's income from home work may surpass that of their husband's. Instances are recorded of men joining their wives enterprises part or full time. In her study of spatial aspects of homework, Faranak Miraftab argues that home-based work bridges the duality between women and men in Guadalajara, "bringing the domestic and public spheres together and ... bringing the possibilities of income generation and increased wealth into the home which previously defined a site of economic confinement for women." ("Space, gender, and work: home-based work in Guadalajara, Mexicao" in Eileen Boris & Elizabeth Prugl, eds. *Invisible No More: Homeworkers in Global Perspective.* 1996)

The communication revolution has created the "electronic cottage" where women and men utilize computers and fax machines to interact with the office. Such use of home contradicts the predilection among middle class to treat the home as a retreat from work and assign domesticity to women. Penny Gurstein

provides historical context, noting that while contemporary homes offer more privacy for individuals than medieval homes did, they are "still planned with minimal privacy between family members." She concludes that "home-based work could potentially have an impact on the way homes and neighborhoods are structured, precipitating a change from the segregation of single use zoning to a natural integration of housing, workplaces and services" ("The electronic cottage: implications for the meaning of home" in *Traditional Dwellings and Settlements,* 1991:15).

While unions look with dismay on the increase of home based industrial work, the development community is promoting microenterprise around the world. Because microenterprise means entrepreneurial activity carried out by an individual alone or with family members, most microenterprise is also home-based. Street food vendors will prepare foods at home; although some sell in front of their houses or in the market, other may be ambulatory, moving further into the neighborhood. Service activities such as hairdressing, barbering, making herbal medicines, or sewing also fluctuate between home and community. Craft work such as dying or printing cloth, creating batik, weaving baskets or rattan chairs, remains largely at home. These activities, like sub-contracting, provide essential income for poor families.

Around the world, NGOs are offering credit, largely to women in groups, so that they may set up their own microenterprises. Following the Grameen Bank model that was pioneered in Bangladesh, credit is secured only by the group; social pressure has resulted in an astounding 98% repayment rate. Loans are used to start enterprises that range from producing special spices to goat raising to catering services. In the United States such groups are spreading, supported by their own magazine *Equal Means.* Ideologically, microentrepreneurs are perceived as tiny independent businessmen while industrial home workers are perceived as exploited workers. These oppositional standpoints set the trade union movement against non-governmental groups with trade unions resisting and NGOs supporting work for women at home. On the ground, it is often impossible to assign to a particular activity the "good" label of microenterprise or the "exploitative" label of industrial home work.

Urban food production is another extension of traditional home-based work that has not only survived the industrial transition but is becoming more important in the contemporary world. Guinea pigs, long a staple of Andean diets, are now raised in downtown Oakland, California; vines twine over squatter shacks in Cebu, Philippines, providing essential vitamins and minerals to a rice diet; corn grows using recycled water from domestic tasks in the new towns outside Lima, Peru. Upward mobility in African cities is marked by a move from food production to flower gardens, a process encouraged if not

forced by colonial regulations still on the books.

Urban food is also produced commercially: as much as seventy percent of all poultry eaten in Kampala, Uganda, is raised in the city. Fish ponds are a common economic activity along rivers in India or China. Trees are cultivated for fruits and nuts as well as firewood in Burkino Faso or Indonesia. Throughout Africa, the greening of cities reflects urban migration and failing rural infrastructure. UNICEF reported that food production in the Kampala, Uganda, contributed enough nutrients to prevent malnutrition among children despite disrupted farm production caused by the civil war.

The actual contributions to food security of household or urban areas are unknown; research has been paltry in the area. Women, however, are expected to feed their families and food production is an indispensable alternative to income earning for fulfilling this obligation. Commercial food production that has been recorded is largely done by women, but fish ponding in Asia is usually a man's work. As with home-based work, home-based food production requires new social arrangements and new planning guidelines to accommodate changing lifestyles and needs of urban residents.

The critical role that non-waged income plays in family survival was underscored by a recent eleven country study that found households relying on microenterprises for 30% of their income and on rental for another 10%;

only 60% of household income was from wages and salaries. Income constraints on households may cause worsening nutritional if costs of resettlement or upgrading are too high, unless opportunities for urban food production are available.

CONCLUSION

Shelter for the urban poor will become even more critical as natural population increase and continued rural-urban migration put more and more strain on urban areas. Most land within municipal boundaries or in adjacent areas available for informal settlement has already been occupied forcing new self-built homes further to the periphery. Distances to town and lagging transport systems complicate formal employment outside the home and so encourage the using the home as a base for work and food production. Downtown slums will be replaced by more valuable buildings unless there is government intervention in the land markets. Suburban families may add room or floors to accommodate kin or renters; green space around the homes will be filled with shacks or utilized for food production.

As housing shortages increase in central cities, governments should set up temporary housing centers and consider building shared housing units so that single women and men as well as women household-heads can find safe accomodations near their work. Such housing would particular benefit the most vulnerable group of migrants:

young single women. Too often today, the kin with whom many live may reduce them to servant status; non-kin may force them into prostitution. Single women household-heads with double days will have the greatest difficulty finding shelter near available work. Poor working men need receiving centers that provide entry into employment as well as decent food and sleeping space; little is known about such institutions as the Indonesian *pondok* in other countries.

Informal kin and village networks have aided migrants for years; client-patron relationships – whether based on political parties, religious groups, or clientelism – have provided some direction and support for longterm residents. More recently, NGOs have begun to work among the urban poor, focussing on *shelter* issues of housing, water, sanitation, and microenterprise and *community* issues of environment, education, and health. All these institutions – the traditional ones based on kin or village or the newer, sectorally focussed NGOs – deal with reality and try to moderate it. But the situation in most cities is deteriorating as services are strained: transport corridors are clogged raising the cost of food and complicating existing employment patterns; rivers and canals are polluted, water scarce and unsafe; schools and clinics cannot meet the demand.

Needed first is more information on how urban dwellers in fact survive today. Research has been concentrated in a few areas such as informal sector activity or self-built housing. Differential gender roles in the informal sector have been explored, but the impact of housing choices on gender has only begun to be studied. More attention to the intersection of jobs, services, housing, and food to shelter issues is needed in order to develop urban space for the next century. New approaches, new designs, and new interventions are critical if cities, as well as their inhabitants, are to survive.

WOMEN'S EMPOWERMENT THROUGH RIGHTS TO HOUSE AND LAND

WOMEN'S RIGHTS TO HOUSE AND land in rural and urban situations have not, until recently, been deemed a critical problem by scholars or practitioners concerned with development issues. For too long, women were denied agency, glorified for their selfless devotion to their children, and embedded in kinship systems that provided some sort of shelter. Development projects focused on rural areas and sought to relieve the drudgery of subsistence living, improve income, provide credit, and increase agricultural production – all as part of a family. Today, families everywhere are disintegrating; cultural traditions that protected women, as they also constrained them, are collapsing. To survive in this rapidly changing socioeconomic milieu, women need the security of land and house to provide income and shelter for their children, and they need the power to control who shares the house.

As long as customary law governed the use of agricultural land, women had access to farmland through fathers or husbands. Such practice was based on deeply entrenched sexual divisions of labor that differed from one culture to another but generally reflected women's rights where women were subsistence farmers. Even in communist countries, where women and men in theory equally shared farming tasks on land that belonged to the commune or state, the gendered nature of household tasks was resistant to change. Assumed, along with the family unit, was a family homestead. Rural housing was self-built in most cases, by women as well as men, and belonged to the family unit.

Urban land seldom has had the clarity of customary rural land use with its communal ownership. European colonial powers, steeped in concepts of individual landownership and leasehold rights, usually established specific areas for their commercial and residential centers that were registered as foreign or private land; preexisting cities were surveyed and land adapted to Western legal systems. Surrounding lands usually remained under local customary traditions for use as agriculture and living space and were largely unmapped. Colonial administrators lived apart from indigenous cities. Servants' quarters were provided in these European settlements, but migration to cities was generally discouraged, especially for women. Indigenous women of high status were frequently secluded within the home; working women moved freely, often at personal risk, but were less restricted by cultural practices than

were their rural kin. Cities continue to attract women and men seeking greater choices of life and work than exist in the countryside.

Today, as such customary land near cities is engulfed by rapid urbanization, rights to these lands are often challenged. Relatives move in to share *kampongs* in Indonesia, or government housing in Dar es Salaam, or bachelor quarters in South Africa. Older housing becomes crowded urban slums. But in many countries only men can sign rental contracts. Even in squatter settlements men are presumed to be the head of household when titles for self-built shelters are provided. In rural areas, commercial agriculture penetrates field and forest, putting pressure on farmers to sell land rights. Housing is separated from farmland, especially where land shortages and population increases result in rural landlessness. Family ties are loosened, women and men migrate together or separately, but children stay with the mother, increasing her need for shelter.

Trends toward globalization of the economy and predominance of market forces are propelling demands for clarity of land titles by indigenous as well as foreign investors. Most countries have instituted cadastral surveys; land is registered by household head, who is almost always presumed to be male. Such land rights preempt traditional claims to land use, whether by women farmers, nomadic herders, or poor gleaners. Accompanying this dislocation of traditional practices is the disintegration of family, as modernization reduces kinship ties and sanctions that bound families together. Too often, women are losing their customary rights to the use of land and house while being left by their partners to raise their children alone. This double-bind has pushed the demand for women's own rights to land and housing to the top of crucial issues for women during the twenty-first century.

Critical support for this effort has come from the 1993 Convention of Human Rights, which declared that "women's rights are human rights." Enthusiastically endorsed at the 1995 UN World Conference for Women in Beijing, this revolutionary concept sweeps away customary patriarchal control of women enshrined in customary law and allows women to demand civil rights on an equal basis with men. Where this concept is made into law, women can charge men for violence within the house as men might charge a robber on the street; bride price, which purchases the right to women's fertility and labor, would be outlawed. Going from convention to law to implementation is a long and difficult process. Nonetheless, international recognition of women's human rights is a marvelous and truly significant first step.

This chapter surveys the current state of women's rights to land and housing in developing countries, drawing on the sparse literature and on personal research. The first section reviews efforts to recognize women's economic rights through development

497

programming, discusses the issues of poverty and women-headed households, and presents the debate about what factors empower women in household bargaining. The second section provides a geographic examination of land and housing problems and presents some of the proffered solutions. The final section begins with an analysis of suggested laws and practices that could provide women with some claim to land and housing and to existing laws that could be enforced to protect women's rights. This discussion provides the context for the ensuing chapters on Singapore, Vietnam, Laos, and China that show how changes in access to housing and land have altered women's lives, both enhancing and undercutting their household bargaining power.

WOMEN'S CHANGING ROLES IN THE HOUSEHOLD

During the first two-thirds of this century, women as individual actors were little studied in developing countries. When a Yale librarian in the 1970s searched the collection of Blue Ribbon Anthropology studies conducted before World War II, she found almost no references to women as a category; rather they were wives and mothers, part of a family or kinship system. Most sources for Ester Boserup's 1970 pathbreaking *Woman's Role in Economic Development* came from post-1950 sources; the major exceptions were studies of West African trading women that celebrated their market strengths and led many

Western scholars to romanticize their independence and underestimate the persistence of a patriarchy rooted in land control.

Postwar economists, theorizing about development in the Global South, saw women as possible impediments to change because of their conservative religious predilections. As the second wave of the women's movement took hold, women began to contest this dismissal of women and to document women's economic roles in subsistence activities and in remunerated enterprises that exist outside the formal sector. Time-budget studies and ethnographies of women's economic activities attest not only to women's essential economic contributions to family survival but to the longer hours of work women typically do when compared to men. As scholars were making women's invisible work in subsistence activities visible, activists sought to affect economic development policies whose premise was that women did not work (Tinker, 1990).

WOMEN HEADING POOR HOUSEHOLDS

Rapid economic change affected these subsistence activities even as they were being described. Migration increased, alternative forms of income freed men and women from traditional constraints, and the weakened ability of elders and society to enforce conformity to customary rules on marriage and family all contributed to new patterns of household

structure, especially to the rise of women-headed households. Most such households lacked access to resources, whether rural land or urban housing, that typically were allocated through the male inheritance or male employment. The traditional solution for women rejected or abandoned by husbands was to return to their natal home. But poverty too often precludes that possibility. Many women migrated to towns, sometimes leaving their children with relatives; but the rise of women-headed households in rural areas should not be overlooked. In cities, women often moved in with kin, assisting the wife with her home and income tasks.

In Nigeria, young women worked in another woman's street—food vending stall, often in return for room and board; students flocking to a provincial capital for higher education sought out relatives for similar work, often sleeping in the vending stalls at night. In Senegal, younger women often became second or third wives in polygamous households, where they were charged with family support while older women earned income in street food-vending. Where housing was tied to employment on plantations or in industry, women had the choice of circulating as companions among men with such rights, seeking out rental rooms, or becoming squatters. Even minimal control of their own housing allows women to control their liaisons: In Guadalajara, women renting units with shared facilities were empowered to end abusive relationships or those in which the companion did not contribute to household expenses.

When women cannot find succor with kin but must earn their own income, they are greatly disadvantaged economically, especially when their children are small. Formal-sector wages are typically lower for women than they are for men; self-employed or vending women usually earn less than their male counterparts largely because they must split their working hours between income activities and family support. In rural areas, women agricultural laborers also are paid less than are men; food-for-work projects usually pay the same, but women tend to work shorter hours in order to care for their families. The presumption has been that most women-headed households are among the poorest.

Counting households headed by women and measuring their poverty present major methodological problems. Even today, with more determined counting techniques, accuracy in counting such households is elusive. Women whose husbands have migrated to urban areas or abroad are seldom willing to assume desertion. Adult men in present households are still considered the heads, even though they may be father, son, or son-in-law. Furthermore, visible males in the house through visiting unions or resident lovers temporarily alter household structure but not control. Daughters with children move into their parents' house and maintain their own identity, yet they lose their classification as household heads in the census.

499

The original educated estimates – that 30 percent of all households are women-headed – remain a useful guideline. This estimate was made prior to the 1975 World Conference for Women in Mexico City as a heuristic device to call attention to a trend that was widespread globally but largely unnoticed by development planners. By noting this high proportion of all households in many developing countries headed by women, Women In Development (WID) proponents hoped to ensure that women's concerns were included in programs designed to afford basic human needs to the poor in developing countries. The conflation of this approach with similar scholarship on poor women in the United States who are on welfare resulted in the widespread use of the term "feminization of poverty."

Because defining households, much less women-headed households, is problematic, assuming that women in such households are the "poorest of the poor" varies by culture, marriage patterns, and kin and government support, among other factors. Recent studies to question whether all women-headed households are poor and to stress the diversity of women-headed households. Different country studies find that many children in Kenya keeps the womrn poor where elsewhere women alone have fewer children. Studies on the nutritional status of children generally find it higher in households headed by women, although this reflects priorities as much as income. In Guadalajara, Mexico, women-headed households living in centrally located shared housing had total incomes equal to intact households in peripheral settlements headed by men; but most household members worked, precluding schooling for older children and thus replicating poverty in the next generation, while children in intact households did continue at school.

Household poverty levels are, if anything, more difficult to measure, involving as they do concepts of household as well as monetary values that are strongly affected by cultural practices, local entitlements to rationing and housing, and access to land for self-provisioning. Kin ties that provide exchange of food and goods between urban and rural residents also complicate the accuracy of a "poverty line." In Vietnam, World Bank poverty studies based on caloric intake that declared 51 percent of all Vietnamese as poor, as compared to government research that produced a 20 percent figure.

HOUSEHOLD BARGAINING

Development programs sought to alleviate poverty among poor women through income activities and then through microlending programs. Still, donor governments avoided targeting women heads for economic projects, fearing accusations of encouraging family dissolution or immorality. As a result, most such programs focused on women with partners. However, women's difficulties in controlling their income within patriarchal households

have raised many questions about the effectiveness of such programs. Men often reduce their household contributions once women's income rises, producing a zero-sum game. Recent criticisms of the Grameen Bank complain that women's loans were largely used by their husbands; an eight-village, two-year study notes that while only 9 percent of the women used all their funds for their own activities, 70 percent used at least some of the money themselves. The study concluded that although the economic contribution of these activities was small the empowerment of women was significant.

Economists have argued that outside income is a dominating factor in household bargaining. Even unremunerated agricultural labor appears to increase the patriarchal bargaining where women are the primary subsistence farmers, but not in countries where women's labor is assumed to be an extension of household responsibilities. Similarly, women working within family enterprises have power that is related both to culture and to their importance to the enterprise. Thus, women in Taiwan gained little from their work in small family enterprises, while women involved in street food preparation in Bangladesh—but who did not sell on the streets—were seen as integral to this income activity.

Most efforts to assist poor women in earning income involve membership in some sort of organization. The collective is everywhere stronger than the individual; it provides information and insight into issues beyond the household, but it also shows the isolated woman that she has similar problems to those of her neighbors. From Korean Mothers' Clubs to the Grameen Bank, organized women gain greater self-esteem that quickly translates into other forms of empowerment. Indeed, these many small units have swelled to the global women's movement that is causing a paradigm shift unparalleled in history. As women become empowered within and outside the household, they begin to question a basic element in the maintenance of patriarchal dominance: access to land and house.

Our concern with these data is to show the need women have for permanent shelter, whether they are poor or not, with dependents or not. Because women, even those with means, are disadvantaged when considering rights to land and housing. These rights vary by custom and history and affect any contemporary efforts to ensure use or ownership rights to women. Their ability to demand these rights is often related to available work alternatives and opportunities. Guaranteeing women's equal rights to housing, however, allows women a secure base from which to build a future for her family and enhances her bargaining power with her partner.

LAND AND HOUSING RIGHTS

In 1900, only one in eight persons lived in cities. The perception of the development community that rural poverty

and underemployment were the primary issues in Asia and Africa has persisted long after migration trends have altered the rural-urban balance. By 2000, half of the global population will live in urban areas. Of these, 20 percent will live in cities of 4 million or more. Seventeen of the twenty-three megacities with more than 10 million people will be located in the Global South. The rapidity of change is greatest in Africa; but in Bangladesh, Dhaka has grown from a provincial backwater to a megalopolis expected to reach 19 million by 2015. These population changes are accompanied by the globalization of industry and a new emphasis on individual self-sufficiency over community and kinship support. Laws and practices of the market economy are based on patriarchal Western law that reinforces traditional customs and dominant religions that similarly privilege men. Yet women everywhere are still expected, and expect themselves, to be the primary caretaker of children. And as life expectancy increases, they care for the elderly as well. Without a place to call home, how can women possibly carry out these social roles?

RURAL PATTERNS

Women's access to farmland is critical in Africa, where culture dictates that women grow food to feed their families. Historically, a woman's labor, along with her fertility, was a major investment by the husband that called for a significant bride price to be paid

to the bride's family, resulting in the persistent low status of women in the domestic domain. As a commodity, women became the property of the man's family, to be inherited by another family member should the husband die, along with the material goods accumulated by the couple. Although this arrangement used to guarantee a woman's continued access to land so that she could feed her children, the safety-net aspects of this practice are weakening; women too often lose both access to land and their material possessions, including shelter, upon the death of her husband.

The pervasive control of men over women in Africa has been documented in studies in Uganda, Kenya, Zambia, and Morocco, among others, which further indicate that women's position tends to worsen as the part of the household income which consists of money increases. An indication of this continued low status is revealed by figures on polygamy, which today has become predominantly an African phenomenon even in countries that are not necessarily primarily Muslim: Nearly half of all women in Togo, Senegal, and Guinea, and more than 40 percent in Liberia, Cameroon, and Nigeria, live in polygamous unions.

The introduction of modern farming methods and of commercial crops has, if anything, made the work of African women farmers more onerous. Expected to continue supplying food for the family, women's fields were too often relegated to marginal lands while

the prime land was taken for commercial use by husbands who were still able to require women to work those plots; fertilizer may increase weeds, and tractors enlarge farm sizes. In recent years, economic development programs have recognized these issues and sought ways to improve women's productivity by insisting that women have access to cooperatives, extension services, and appropriate technology. Yet even when men migrate and leave their wives to work on their fields, men's control of land continues to undermine women's ability to make independent decisions about the farm. Thus, programs meant to aid women may have only added to their burdens. So also did such heralded land-reform schemes as Julius Nyerere's *Ujamaa* village efforts, which increased women's workload but did not result in their receiving monetary compensation because men controlled the sale of crops. Women tried to save their access to land by appealing to customary rights, which were locally considered stronger than land titles. A local researcher found these rights malleable and responsive to power; if women accumulate money through trade or enterprise, women often try to buy land in another woman's name.

Changes in land tenure rights generally privilege men and allow them to abrogate women's land rights. Local officials in Cameroon were concerned that new laws on land registration were being abused by educated young men of the region who filed their names for titles, presumably expecting to claim these rights once the older tribal members, who knew who had what rights, had died. Land allocations data from the Transkei in the 1920s revealed that the custom required men to be married in order to qualify for land. Once land was surveyed to provide for white settlers, only a finite number of arable allotments remained; these were to be inherited by the oldest son of the first wife. As a result of these changes, the value of rural wives decreased, and women without access to land were forced to migrate; this influx led authorities to prevent women from living in towns.

In contrast, recent studies in Namibia show that those areas that remained under the control of local chiefs, through a sort of reservation system, preserved women's traditional rights to land. Their access continues and, due to matrilineal patterns, women heading households are able to acquire land use rights: These households held 6.38 hectares of land on average as compared to 7.19 hectares held by male households.

Customary landholding brings with it the dominance of bride price as well. In South Africa, the conflict between customary rights over women and civil rights giving women equality with men raged throughout the constitutional discussions. Until 1990, women's issues were subordinated to the national struggle, but drafts of the constitution reinstated power to tribal chiefs, a move women feared would legitimize women's subordination. In

1992, the Women's National Coalition was formed from eighty-one groups and thirteen regional alliances of women's groups, plus the women's caucuses or "gender desks" of all major parties; within two years, this group issued the Women's Charter for Effective Equality, which stipulated that customary law would be subordinate to the Bill of Rights. The amended constitution, passed on February 7, 1997, gives women equal legal rights with men to land and housing.

However, progress in allowing tenant families rights to remain on land where they have lived and work for decades is slow. Because of frequent postponement of the effective date of tenancy, landowners are kicking off residents before the laws on land tenure and redistribution are implemented. Teresa Yates documents her letter with the story of Mrs. Moko, who has lived on a farm for thirty-eight years and worked there for twenty-nine years. Because she stopped working to care for her grandchildren, she was told to leave. She has filed a claim for unfair dismissal, but the best outcome she can hope for is some compensation. She will still have to leave her home ("Waiting for a revolution," Institute of Current World Affairs newsletter, August 1997.)

Kenya proclaims equality of gender in its constitution but rescinds its own nondiscrimination clause specifically in regard to personal law, which has far-reaching effects on the lives of women and their access to property. Even houses that are traditionally constructed on their farmland by women and men together are now presumed to be the property only of the husband. Some women convert to Islam, which does allow women to inherit land under personal law, but civil law may not be supported in practice. What is fascinating in Kenya, however, is the distinction between rural and urban land, the result of British colonial law. According to prevailing cultural assumptions, women are assigned to rural life and work, but to the ownership of urban property. Men, on the other hand, are assigned to urban life and work but to the ownership of rural property, from which women are generally excluded. Women can purchase urban land, but few have sufficient funds to do so.

To address the growing problem of Kenyan women for access to land and housing, the 28,000 women's local organizations throughout the country are beginning to mobilize for this purpose. These community organizations have been alienated by the elite leadership of Nairobi-based women's organizations; they are rotating savings groups, burial societies, income-producing enterprises, and agricultural support groups. Many have been allocated land by local authorities for crops and schools. Why not for rural housing clusters near urban settlements? Because an organization would hold the use rights to the land, individual women would be protected from demands of their kin just as organizations have allowed women earning money from enterprises to save

in face of demands from husbands for access to their earnings. (Diana Lee-Smith. *My Home is My Husband: a Kenyan Study of Women's Access to Land and Housing. 1997.*)

Issues of women's access to land, both arable farmland and communal resources such as forests and commons, are equally critical in India. Bina Agarwal contends that land is the major source of power within rural households, and without access to or ownership of land, women cannot alter the fundamental gender relationships rembedded in current family structures: "Command over private land could strengthen rural women's bargaining power in ways that merely enhancing wage employment opportunities . . . could not" ("Bargaining and gender relations; within and beyond households," *Feminist Economics* 3-1: 13, 1997.)

In order to extend household bargaining models beyond reliance on economic factors along, Agarwal argues for broadening and prioritizing the factors that contribute to and inhibit women's ability to bargain by considering a wide range of social norms and perceptions that operate not only within the household but beyond it as well. Extrahousehold influences include, among others, laws on land-owning and inheritance, and access to bureaucrats adjudicating land claims. She also stresses organizational support, noting that women acting collectively have far greater power than individual women.

To illustrate, tribal women in the Panchmahals of Gujerat State, India,

have traditionally collected fuelwood and fodder in nearby state forests. Increased degradation of these forests meant greater restrictions on access; so a local nongovernmental organization (NGO) worked with local women to rehabilitate wastelands and plant their own plantations. Organizing women and so empowering them was central to the effort; women's new assertiveness allowed them to take on men who were illegally cutting grass on their plantation.

Such organizations are widely perceived as critical to women's empowerment and have been encouraged by NGOs, local action groups, and most development projects. These positive factors may be countered by women's lack of knowledge about their rights under new laws and regulations. More problematic are prevailing social norms that discourage women from invoking their rights because social acceptance for utilizing them is absent.

As a result of rapid socioeconomic change, the plight of women alone, whether widows or mothers who have been divorced or discarded by their partners, becomes more difficult. Men abdicate their responsibilities to help support their children, an action that would have been constrained in most traditional cultures. Even widows were offered greater protection than they now receive. In India, widows in most communities are legally entitled to inherit at least some land, though a study found that less than half exercise even use rights over what ought to be their

land. Once again, women were not always aware of their rights.

Women's reluctance to challenge the new laws when they conflict with traditional landholding patterns is evident in Laos. In Vietnam, land that had been consolidated into communes is currently being redistributed to families and may be registered in the names of both husband and wife. Note that while technically all land belongs to the state, land use rights may be bought and sold as though they were ownership rights. In one district in the Mekong Delta, the Vietnam office of Oxfam (United Kingdom and Ireland) has been encouraging district officers to put both names on the documents. Oxfam found that women knew little about the process and thought that registration of both spouses was routine. Without a sense of the potential impacts that having the land registered in their names could have on their lives, women also have no interest or ability to exercise their rights. The report recommends that the government hold meetings exclusively for women in the communes to educate them about their rights and privileges attached to a Land Use Certificate.

In Laos, the new Land Law (1996) and Forest Law (1997) show how easily women's land rights can be undermined. Lowland Lao women live in matrifocal family units; a daughter, usually the youngest, inherits the parents' land and housing along with the obligation to care for them. Even though the law is gender-neutral, forms require the land to be registered in the name of the head of household instead of in the name of the owner of the land. Furthermore, since husbands are responsible for official activities outside of the household, they commonly handle the registration of household land. Men sometimes register property under their own name even though it belongs to their wives. The Lao Women's Union has been holding seminars for district staff and for women throughout the country to inform them about women's rights and the registration procedures.

Islamic conventions allow women to inherit land, a right that was extremely progressive when it was proclaimed. Once women have some land, accumulating more is not seen as unusual. Bangladeshi women have been using their loans from Grameen Bank to accumulate agricultural land. Because women utilizing loans for various traditional women's income activities have a low return, some women lease land so that their husbands and sons can cultivate it. A few are able to actually buy land, often in her own name. One woman, under pressure to marry her fifteen-year-old daughter, gave her land as dowry to the prospective groom from another village but registered the land in her daughter's name so her husband could not claim it in the event of a divorce. Overall, using credit to invest in land, though against the rules of the Grameen Bank, effectively raises these women and their families out of poverty.

Protecting women's traditional land use rights is a problem in Mexico as well,

even among the Zapatistas. A review of the thirty-four points that constitute the Zapatistas' Commitments for Peace show that although land is the dominant demand of this resistance effort, women's right to possess land is not mentioned, even though a majority of those expelled from the land, largely because they are Protestants, are women. The Commitments for Peace include support for women's health and for artisan centers. But the women themselves do not raise the issue of land, even for widows or single women.

Rural housing tends to remain under family control. When catastrophes such as earthquakes devastate homes, new designs are introduced without regard to use rights. In October 1993, a devastating earthquake in central India killed thousands of farmers sleeping in their houses which were piles of stone with little or no mortar; more wealthy citizens survived in their reinforced concrete homes. Some years earlier, Nepal's rural housing was crumbled by strong quakes. In both cases, funding through the United Nations Centre on Human Settlements (UNCHS) assisted the countries to rebuild. Customary inheritance through the male kinship was not questioned.

Through the intervention of the Grameen Bank, the story was different in Bangladesh after rural houses were swept away by abnormally severe floods. Loans for rebuilding to build tiny rural homes that measure roughly ten feet by twenty feet were offered only to Grameen Bank members of several years' standing; an evaluation in 1989 showed that nearly 95 percent of all housing loans went to women. However, a home loan would not be granted if the woman did not own title to the land under the house; if her husband's family or other owner would not grant her title, the bank would give her a loan to buy the land first.

URBAN HOUSING

Some sort of shelter is essential for human survival; for poor urban families, shelter may be a temporary shack erected on sidewalks or on marginal land. In 2000, 2 billion of the 3 billion people living in urban areas will be in developing countries: A majority of the absolute poor in the Global South will be urban. In Latin America and the Caribbean, where three-quarters of the people already live in towns and cities, women outnumber men 108 to 100. Informal housing predominates in many urban areas: two-thirds of the people in Nouakchott, Mauritania, and in San Salvador, El Salvador; more than half in Guayaquil, Ecuador, and Delhi, India; between 40 and 50 percent in Mexico City, Lima, Peru, Nairobi, Kenya, and Manila, the Philippines; and as much as 25 percent in Bangkok, Thailand. And as the populations of these cities grow, marginal spaces within the urban areas fill, leading both to increased density in squatter areas and to urban sprawl.

Squatters resist resettlement outside town because of the high costs in money and commute time.

Furthermore, expenses for maintaining improved services are often beyond their household budgets. Throughout India, half the families offered housing in the periphery move back into town because they cannot afford costs of the shelter with its higher-grade services and cannot afford either the money or the time required to commute to work. Moreover, the move destroys their community networks, through which they learn of jobs.

So squatters contrive to remain where they are despite the lack of water and sewerage. A 1992 survey of squatters in the Juhu beach area of Bombay City, India, enumerated 93,000 people from fourteen Indian states living on about 175 acres in seventeen different, and not always contiguous, pockets of land along the ocean beaches and up into nearby marshland. Settlement began more than forty years ago, and little space is left on government land, so that some families have pushed into neighboring private land. In 1974, the area was officially declared a slum by the municipality, a designation that provides a minimal degree of protection against eviction, but only for those on government land. About half the families live in houses constructed of brick and cement with a permanent, fireproof roof; but almost no houses include a private latrine. Most houses have electricity illegally, but half of the families pay more for this illegal use than they would if they had legal connections. Party organizers, local NGOs, and an outreach project of the Women's

University in Bombay have been able to pressure the city to improve toilet facilities, increase health and education services, and introduce training in income activities for the women.

Pavement dwellers are the poorest and most vulnerable squatters: They erect temporary shelters on pathways and sidewalks. In Bombay the women of this community were organized by the Society for Promotion of Area Resource Centres (SPARC) to resist the threatened demolition of their shacks in 1985. The women's own organization, Mahila Milan, has, after a decade, begun construction for 560 families on municipal land near their pavement site. To keep costs down, the women are manufacturing their own wall blocks and precast beams and are providing all unskilled labor for the fifty-six unit, two-story building, which incorporates many of the design features tried and tested in other housing projects. A similar group in Pune was recently allocated land where the women have helped build two-story apartments with the assistance of the Bombay group. The project has been receiving much media attention and has generated so much excitement that Pune has now committed to finding land for two other Mahila Milan collectives under threat of eviction.

Because urbanization began earlier in Latin America, most squatter areas have been upgraded and provided with basic services. Women in these settlements often took the lead in demanding improved local services, leading Caroline

Moser to add to women's double day a third role as community manager. This leadership was possible because women in Latin America are less likely to work outside the house than are women in Africa and much of Asia; even under structural adjustment policies, the labor participation rates for women in a squatter area of Guayaquil, Ecuador, rose from 40 percent in 1978 to only 52 percent in 1988 (*Women, Housing, and Human Settlements:* Moser, 1993.)

Elsewhere in Latin America, worker-priests began organizing these popular sectors after World War II; many base and community organizations continue to receive funds from abroad through the Catholic Church and NGOs. The Pope opposes political activities by priests, so links with the church are being obscured. In Caracas, Padre Armando Janssens founded the Centro al Servicio de la Accion Popular (CESAP) in 1974; it is now the largest NGO in the country. Their borochures indicates that homelessness, especially of children, was not a problem until recently because of the high birthrate.

The numbers of street children are not as critical as in Brazil, for example. Less than half of children on the street claim to have no family. The majority live in two-parent households although not necessarily their own parents. Reasons for working on the street relate to family violence and stepfathers as well as inadequate educational and employment opportunities. Crowded living conditions clearly contribute: Half of

urban Indian families consist of 4.4 persons living in a single room.

Women in cities lose the kin support that is common in rural villages; they also must earn more money to feed their children. Kenya studies show that urban households have a lower sense of well-being than their rural counterparts, whose monetary income may be lower because opportunities for subsistence agriculture are limited. Nonetheless, urban poor, especially in Africa, engage in many types of urban agriculture, from animal, fish, and poultry-raising to vegetable production. As money plays a larger role in the family budget, men, by virtue of their ability to earn more, come to dominate women more. Lack of restraint from extended-family members allows men to indulge in domestic violence and to walk out on their children, resulting in the worldwide increase of women-headed households noted above.

Critical is the ability of these women heads of households to provide shelter for their families. In the 1970s, development projects were initiated by governments and NGOs to assist the poor in building their own houses. These efforts, which offered credit to household heads and required sweat equity to reduce the costs, assumed an intact family – that is, one with a male head. Even self-help housing that required sweat equity disadvantaged women who had less time to work and lacked money to pay for a replacement. As a result, most urban women remained dependent for shelter

on the men with whom they lived and who could throw them out should he fancy another woman. Married or not, women in most countries do not, and often cannot, have title to their homes in their own names or with their spouse.

Costa Rica offers perhaps the most exciting home ownership program. The housing organization Comite Patriotico Nacional (COPAN) found that more women than men participated in their housing programs, both in the political action to obtain housing resources and in the actual design and construction of their homes. Once the houses were completed, men from whom the women had been separated frequently decided to move in and tried to claim title. In reaction, COPAN pressured the government to pass the Real Equality Bill in 1990. This exemplary legislation granted women household heads the right to register government-supported housing in their own names; if the woman were married, the house was registered in the names of both wife and husband.

Women alone also need the right to rent places to live. In many countries, women are considered minors, unable to sign binding contracts. In Zimbabwe, female-headed households comprise between 43 percent and 48 percent of all households, and 42 percent of these women-headed households are women living alone. Although many of these women are widows or come from broken marriages, many middle-class professional women remain single by choice, as they do elsewhere in Africa.

Rental housing is in short supply. After independence, houses were sold to sitting tenants who were overwhelmingly male: Women were considered illegal lodgers in single-male quarters, and only males qualified for married quarters. As a result, children are usually sent back to rural areas, since women lack space to bring in relatives to help out and, as they are lodgers in overcrowded quarters, there is no space to grow food.

Customary law in many parts of Africa provided for widows by marrying them to a brother of her husband, thus providing the widow with continued access to land while keeping the family investment in the woman's labor intact. Under these circumstances, all property in the house and the house itself belonged to the male lineage. Many urban women heading households are widows who have been chased away by kin of her dead husband or are women who ran away rather than marry the brother. In many African urban areas today, the male lineage still tries to appropriate property but does not wish to be responsible for the woman. Besides the famous Otieno case in Nairobi, where the lineage eventually obtained only the body of their kinsman, many studies record the devastation such practices wreak on women. In Dar es Salaam, groups of women are purchasing urban homes together, thereby preventing any one lineage from trying to seize the property. Such practices continue, even though in many countries laws now secure women's rights to inherit their own and often their

husband's property. For example, in Zimbabwe, laws were passed in 1981 that give women property rights in the case of divorce and rights to the home on death of the husband; but the laws are seldom implemented.

In cities, rights to the house are paramount because they are more than places to sleep. Neither governments nor NGOs involved in urban housing projects have sufficiently acknowledged the extent to which houses are sites of production as well as residents. For example, squatters who had been relocated in desirable downtown walk-up apartments in Jakarta built with help from UNCHS sold out to middle-class tenants because they could not continue their productive enterprises in cramped space above the streets. More dramatic, in 1994, police burned corn crops in urban backyards in Harare, Zimbabwe, despite near-famine conditions in that country. Family enterprises are more competitive than small enterprises because they pay no rent and are often closer to markets.

Conflict between tribal or customary laws and modern legal systems adopted in most countries makes urban planning almost impossible. The lack of cadastral surveys and clear land rights inhibits foreign investment and the construction of modern buildings. If women seldom hold title to their urban dwellings, neither do men. Recent studies on urban land policies indicate that only 22 percent of barrio dwellers in Venezuela owned their land; in Cameroon only 20 percent of all urban land

had been surveyed and titled, a higher figure than the 6 percent of all lands in the country that are registered. Indonesia incorporated traditional land tenure systems into a new agrarian law, but adherence to traditional *adat* continues in about one-third of Jakarta. But as titles replace customary land control, men generally receive these new and stronger land rights.

Empowering Women through Property Rights

Rapid economic transformation of developing countries is causing an acceleration of Western laws governing property ownership, both in near-subsistence societies and in former command economies. Pressures from population growth on agricultural land, as well as land consolidation by wealthy landowners and agribusinesses, are causing land shortages and increasing landlessness. Women are particularly vulnerable because land they farm is seldom regarded as their own either under customary or civil law. Frequently, women are even losing rights to homes where they have lived for years and to house plots where they can grow some of their food. Subsequent migration to urban centers by both women and men adds to the creation of megacities and their formidable housing problems.

To some extent, the privatization of state-held property in communist countries has distinctive features: Former landowners are claiming property confiscated at the time of the countries'

communist revolutions. Even in these countries, however, traditional rights and customs have not been totally erased, particularly in Laos, Vietnam, and China; evidence of customary procedures and rights is seeping back into property transactions, with unpredictable results.

To counter these negative trends, a growing number of NGOs are working with poor women in both rural and urban areas to defend their access to land and housing, understand their legal rights, and organize for self-protection. These NGOs act as intermediaries between the community-based organizations and the funders, who are often from outside the country. The growing power of NGOs reflects both the broadening of civil society and the inability of the state to address critical societal problems. Both Vietnam and Laos now allow foreign NGOs to operate in their countries but require that implementation be through mass organizations such as the Women's Unions that were originally set up by the Communist Party. China has resisted foreign NGOs but has allowed a few women's organizations, such as a domestic violence hotline, to operate outside the All China Women's Federation.

The belief that women are more likely to influence decisions of importance to their lives through their own organizations is becoming more recognized. Early development programs concentrated on economic empowerment, but women's lack of power within the household has often limited the impact of women's economic advances on their lives. If household bargaining results in a breakdown, it is essential that the woman with her children does not lose her shelter. Hence, using the power of women's organizations to change laws on titling processes for land or housing is critical.

Throughout this chapter, we have cheered the imaginative examples of such actions that are drawn from widely diverse countries: Costa Rica and its Real Equality Law, Laos where national education programs are presented, and the Grameen housing loans in Bangladesh. Pavement dwellers in India have obtained tiny urban land allocations through the Mahila Milan organizations. In Kenya, women's community organizations tare starting to petition for communal housing plots. Questioning customary law and its control of women and their rights is widespread throughout the world; the United Nations Convention for the Elimination of all Forms of Discrimination against Women has been ratified by 167 countries and is becoming a powerful moral tool to enhance women's rights around the globe. Women's growing political power, as manifested in these many organizations on all tiers of government, needs to be extended to the household by initiating ways for women to obtain rights to their own land and housing.

THE INVISIBILITY OF URBAN FOOD PRODUCTION

Special Issue of *Hunger Notes*, Irene Tinker, Guest Editor. Article with Susanne Freidberg.

REALITY IS SO OFTEN IN THE CONCEPtion. If you walk down a street and do not see the vegetables growing in a front yard or gourds climbing along house supports, ignore the sound of chickens on a veranda, dismiss a community garden on a vacant lot as uneconomic, or do not consider fish from a backyard pond as an importantsource of protein, then for you, urban food production does not exist. These activities are invisible because they go unrecorded; planners have assumed that modern food supply systems render urban production obsolete.

The purpose of this issue is to persuade policymakers that urban food production not only exists but is of growing importance to increasingly congested cities. It is important both for home consumption by the poor and also as income for urban residents. The articles here summarize the current state of knowledge about urban food production, a term we prefer to use rather than urban agriculture in order to emphasize the inclusion of animals, poultry, birds, and fish in the discussion.

The symbiotic relationship between food and animals that exists on rural farms is equally discussion important in the city. Animal waste can fertilize gardens or provide food for fish.

Animal and vegetable wastes can fuel biogas digesters that produce methane gas for cooking or lighting. Where culture permits, human waste can become productive in a similar manner, thus helping to solve the burgeoning waste disposal problems of cities. Exhausted pit latrines make excellent sources of manure or sites for gardens.

Existing studies of urban food production as well as the few related urban nutrition projects underway have focussed on the poor who produce food to add variety to their meals and to enhance the nutritional value of their diets. David Drakakis-Smith, a longtime scholar of urban agriculture in developing countries, documents the importance of home production to urban diets and argues that food production should become part of the response by food policy experts as they address malnutrition among poor urban residents. Daniel Maxwell underscores the importance of gardens in Kampala, the capital of Uganda, where the urban farmers grow staple tuber crops as well as vegetables. Evidence of the importance of rooftop gardens in such diverse cities as St. Petersburg and San Francisco show how crisis and poverty encourage home gardening worldwide. Street trees along urban boulevards also add to local

diets; in Burkina Faso, for example, indigenous shea nut trees are left standing and become a source of cooking oil or income for urban residents as cities expand. Chickens, rabbits, and guinea pigs are easily and frequently grown in urban areas; as Steven Lukefahr records. This renewed emphasis on micro livestock includes small strains of larger animals as well and is the subject of a recent report from the National Research Council in the United States.

Food production in cities becomes increasingly critical as urban agglomerations expand. By the end of the century, as many as 24 of the world's metropolitan regions will have more than 10 million inhabitants each! Of these massive cities, 17 will be in developing countries. Already, urban food costs account for half of the household budget in many of these cities, according to a recent study by the Population Crisis Committee. Growing one's own food is clearly an important survival strategy.

An increasing number of urban farmers also grow food to exchange or sell. Urban and peri-urban agriculture as a commercial activity is being explored by several United Nations agencies and has resulted in the formation of the Urban Agriculture Network as Jac Smit and Annu Ratta explain. Laura Lawson's data on Kona Kai Farms in downtown Berkeley, California, shows impressive profits from a "farm" less than half an acre in size! Gardening also has social aspects. Teaching jail prisoners to become urban gardeners helps to rehabilitate them. Encouraging

the homeless to garden provides them with both income and self-esteem according to Lawson's study in the town of Santa Cruz on Northern California's Monterrey Bay.

The studies reported in this issue of *Hunger Notes,* along with the research literature review by Susanne Freidberg, provide convincing proof of the importance of urban food production both for nutritional needs and commercial value. They also prove the need for improved data on this phenomenon, particularly quantitative studies based on entire cities.

In order for such city-wide research projects to have significant impact on the policies of governments and the programs of community organizations, the studies must be directly comparable from one city to another, from one point in time to another, and from one researcher to another. For that to happen, similar definitions and methodologies must be used. How, for example, do we define "urban"? Does urban refer to a certain density of population, or does it refer to particular circumstances of infrastructure, or to municipal political boundaries even if those boundaries include rice paddies or rural villages? How do we quantify urban agriculture? Do we measure the space it utilizes or impute the sale price (actual or potential) of the various crops and livestock produced? Do we quantify urban agriculture variously according to the different types of products (e.g. tomatoes versus staple crops, or crops versus animals) or by different kinds

of production system (e.g. commercial operations versus home gardens)? If municipal waste is converted into fertilizer for urban fields or into feed for fish ponds, is the use of this input by food producers to be reckoned as a service or as a cost to the food producer? Similarly, if the waste from animals or birds is used on urban gardens, how are the environmental impact and nutritional utility to be measured? Who has access to urban street trees, and who maintains the trees on public land? How does urban food production fit into the overall food supplyand distribution system of contemporary cities?

These are only some of the questions about which researchers need more consensus. We are proposing a workshop of scholars currently interested in urban food production to debate these problems and establish guidelines for the design of future research.

Once comparable city-wide studies are underway, we need to start asking questions about municipal policy and political will. If policy makers see urban food production as a means of fighting urban hunger and poverty, how can they ensure that the most afflicted (women, landless immigrants, etc.) have and can keep access to food-producing resources? In the current context of worldwide recession, national austerity programs and shrinking municipal budgets, if we cannot expect lavish assistance for urban food producers, what are the most efficient yet equitable ways to support their efforts? We need to know from urban food producers themselves – especially the most disadvantaged – what forms of property, inputs, and assistance they consider critical.

Urban agriculture offers nutritional and environmental benefits, that much is obvious. We also know that it takes place next to factories and highways, on waste dumps and sewage-strewn riverbanks. Does food grown on such sites pose a serious health hazard to consumers? Is the hazard more serious than the malnutrition they might otherwise suffer?

We know that governments do not always look kindly on urban food production, especially as practised by the poor. We know also that these attitudes often change during periods of economic crisis. But why wait until desperation strikes? How can planners integrate urban food production into their municipal projects as simply a normal part of the urban environment? How can researchers and advocates convince them that they should do so?

Answering these questions will require copious data collection but also careful thought. We hope that this issue of *Hunger Notes* helps encourage both.

URBAN AGRICULTURE IS ALREADY FEEDING CITIES

URBAN AGRICULTURE IS WRONGLY CONsidered an oxymoron. Despite its critical role in producing food for city dwellers around the world, urban food production has largely been ignored by scholars and agricultural planners; government officials and policy makers at best dismiss the activity as peripheral, and at worst burn crops and evict farmers, claiming that urban farms are unsightly and unsanitary health hazards. Recent studies, however, document the commercial value of urban-produced food, as well as its contribution to the economic security and nutrition of the urban poor, especially women-headed households.

The International Development Research Centre (IRDC) was the first major international agency to recognize the importance of urban food production. In 1983, it funded six city studies in Kenya, to be carried out by the Mazingira Institute of Nairobi. Additional studies and reports funded since then have helped bring urban food security to the forefront of the IDRC agenda. In the spring of 1993 it organized two events designed to bring this policy concern to a wider audience: a policy and planning conference in the Ottawa headquarters and panels at the annual meeting of the Canadian

Association for African Studies (CAAC), held in Toronto.

The focus on African urban agriculture is logical. While many of the continents' cities have long grown much of their own food, farming has becoming an increasingly critical survival strategy for city-dwellers hit by the rising prices, currency devaluations and massive layoffs mandated under World Bank structural adjustment programs. In some countries, food markets undermined by political unrest and infrastructural decay, combined with declining rural production, have all made self-grown provisions especially crucial to urban food security.

The CAAC panels brought together scholars studying urban agriculture in Ethiopia, Kenya, Mali, Tanzania, Zimbabwe, and Uganda. Their research examines topics such as cooperative market-gardening, urban squatter farming, land tenure struggles, and energy issues. Taken together, their findings challenge the assumptions of both neoclassical and Marxist development theorists who once dismissed urban agriculture as a remnant of peasant culture, and confidently predicted its disappearance. Such assumptions characterized attitudes towards the urban "informal sector" as a whole, until numerous

studies demonstrated the importance of family and individual craft and vending enterprises to urban employment and household security. It is time that urban agriculture be recognized as a vital part of this sector, as it provides income as well food for significant proportion of the urban population.

The papers also challenge development planners who, on the basis of a perceived rural-urban dichotomy, assign food production solely to rural areas. In reality, of course, city-dwellers have long tended gardens, fruit trees, and livestock. Even in industrialized countries urban gardens flourish. In New York City, for example, vegetable plots cover former wastelands; South Bronx herb gardens supply Manhattan's gourmet restaurants. In an industrial neighborhood of Berkeley, California, Kona Kai Farms earns a quarter of a million dollars annually on less than an acre of land, selling its salad greens, herbs, and edible flowers as far away as Hong Kong. Apartment dwellers in St. Petersburg compensate for unpredictable and high-priced Russian food markets by growing vegetables in rooftop gardens. Clearly, the evidence no longer supports the model of the urban-rural dichotomy, nor the development policies it has informed. Planners need now to focus on the supporting the types of food production most suitable to the urban and peri-urban landscape.

What is urban agriculture? Urban agriculture refers not merely to the cultivation of garden, field and tree crops, but also to the raising of conventional

and "micro" livestock (i.e., rabbits, guinea pigs, snakes) as well as poultry, fish, honeybees, and other locally eaten foods. Defining "urban" or "peri-urban," however, is more difficult. Municipal boundaries seldom reflect land use. As cities expand, they often annex surrounding villages, where inhabitants may continue to farm despite restricted space. Transportation systems tie even more remote villages to the urban economy through both kin exchange patterns and market relations. City-dwellers often maintain their own farms in nearby villages, and shuttle out weekly or leave some family members to tend the crops during the growing season. China, long ago recognizing the role of the urban hinterland in feeding urban populations, created municipal boundaries the size of counties in order to allow city governments to control outlying food production.

City gardeners make the most of scarce space. Squatters grow corn in front yard window boxes, while middle class homeowners plant vegetables in their flower beds. Even dense metropolitan areas contain river valleys, flood plains, cliffs, and quarries unsuitable for building, but ideal (or at least feasible) for gardens. Land-poor urban farmers often cultivate public areas along roads and railway tracks or under high tension lines, despite their vulnerability to destruction by authorities.

Without a common working definition of "urban" and "peri-urban" based on density or built characteristics, or standard methods for measuring productivity,

it is difficult to compare the information already available on urban agriculture in specific cities. The next stage of urban food production research should begin with a standardization of definitions and design, to facilitate quantitative data collection and comparison. Analyses of such data can have a powerful impact on policy decisions.

Significance of urban food production All the studies demonstrate the importance of urban agriculture to household income as well as food supply. In Kenya, 67 percent of Nairobi households farm, though only 29 percent do so within the city limits. For many urban-dwellers, self-grown food is a critical part of the diet: 25 percent of the households in the six major Kenyan cities claim they could not survive without it. Although most food is grown for home consumption, 23 percent of Kenya's urban farmers sell some of their produce, often to buy cooking fuel. About a third of the women food vendors grow at least some of the goods they sell. Fifty-one percent of Kenya's urban households keep livestock, though only 17 percent in their place of residence. While poultry is the most common form of livestock kept in Nairobi, a few large dairy herds also graze within the city limits, contributing to the capital's milk supply..

In Kampala, half the land in the city is farmed by about one-third of the total population; 70 percent of poultry and eggs eaten in the city are produced there. Kampala citizens even grow staple tuber crops, about 20 percent

for home consumption, and the rest for sale. In Addis Ababa, members of garden cooperatives sell most of their vegetables, but those they feed their own families cut household food budgets by 10 to 20 percent. Urban gardening is so common in Mali that the capital Bamako is self-sufficient in vegetables; many of its citizens also grow their grain during the rainy season. Zimbabwe's government has in the past restricted urban agriculture in the capital Harare, but in Bulawayo, the second major city, riverbank crops and backyard poultry and pigs are generally tolerated. In Bolivia, by contrast, the government actively encourages urban gardening by community groups, schools, and individual households.

Surveys by Save the Children in Kampala indicate that urban agriculture contributes significantly to the nutritional status of children from poor households. Both Save the Children and UNICEF concluded, in fact, that these households' self-grown food made supplementary feeding programs unnecessary, despite civil dislocation at the time. The Addis Ababa study also showed that the vegetables consumed by the farming families enhanced their diet.

Who are urban farmers? Given that women grow most of the food in most societies of Africa south of the Sahara, it is no surprise to find that they comprise the majority of urban farmers. The Kenya study records 56 percent female farmers in all six towns, but notes that the proportion rises to 62 percent in the larger cities. Sixty-four percent of these

women farmers are heads of households. In Dar es Salaam, two-thirds of the women farmers are between the ages of 26 and 45, when their families' food demands are typically greatest; by contrast, over a third of the male farmers were over 56 years old, perhaps indicating that they lived alone, or were producing mostly for the market.

Urban farmers are usually not recent migrants, but rather longer term residents whose families have better access to scarce urban land. Nor are they necessarily jobless and destitute; in many cities white collar workers, even mid-level bureaucrats, grow food in spacious gardens around their homes.

Issues: As suggested above, land access is a major determinant of the ability to farm. In Addis Ababa, the co-operative was set up precisely to try to legitimize the members' rights to land they had farmed for the last seventeen years; its leaders feared that new land policies will privatize formerly nationalized property. In Kenya only 41 percent of the urban farmers owned the land they used, while 42 percent – primarily the poorest farmers – cultivated government land. In Kampala, extremely confusing land-holding patterns reflect ongoing conflicts between claimants of "customary" and "modern" tenure rights. Many customary-tenure landowners arrange with urban farmers to cultivate their land until the owners have received official title to their property, in order to prevent unauthorized squatting.

Government attitudes also affect how urban agriculture develops in particular cities. Colonial governments typically forbade urban agriculture on the grounds that it was "unsightly"; many of these laws remain on the books. Enforcement varies from country to country, but is often relaxed during periods of national food shortage. Ambiguous laws and the threat of harassment often discourage farmers from investing in soil or crop improvements. But even in cities where urban farmers are not prosecuted, their ability to continue or expand production in the future will depend in part on land values and zoning. Could gardens replace some parks as important green space in built-up areas? How should such land be taxed?

Some governments condemn urban agriculture as a health hazard. In East Africa, one persistent though widely disproven myth holds that malarial mosquitoes breed in urban maize plots. Another criticism focuses on the sanitation problems created by wandering livestock. But proponents of urban farming argue that the health benefits far outweigh the potential risks.

Conclusion: The IRDC studies clearly demonstrate the importance of urban food production as a source of both income and food. They show that while city-dwellers across the socio-economic spectrum grow their own food, this practice is especially crucial to the urban poor, and above all to female-headed households. The studies also emphasize the growing commercial value of certain urban-produced foods such as vegetables, poultry, and eggs.

Governments have typically neglected or harassed urban food producers. Clear laws regulating both public and private land use would be a more positive approach, and would encourage urban farmers to invest in improvements. Better access to information about crop, fertilizers, pesticides, and irrigation techniques could also greatly increase land yields, while immunization and feeding advice would help urban farmers raise healthier livestock. To encourage these kinds of policies and programs, however, further quantitative and comparative research must provide governments with the information needed to understand the needs and practices of contemporary urban farmers.

FEEDING MEGACITIES: A WORLDWIDE VIEWPOINT

AMAZING SHIFTS IN THE WORLD'S POPU-lation during this century require that we rethink many of our assumptions about how we plan to feed city residents. In 1900, only one person in eight lived in an urban area; today half the world's people live in cities. Yet the development community and universities have been slow to turn the focus of their research and programs on community development, agriculture, or environment in urban areas. This inattention is the result of the highly segmented nature of our experience and knowledge. Food production is perceived as rural, while urban areas are considered centers of commerce and industry. Thus neither food experts nor urban scholars have considered urban food an appropriate topic for study.

Innovation in agricultural extension has focused on large-scale farms and plantations. International agricultural research centers for many years emphasized commercial grain crops. Although current programs encompass root crops and home gardens as well as agroforestry, the venue is still rural. Until a few years ago, the Food and Agricultural Organization (FAO) interpreted its primary mission in terms of rural agriculture, although a decade ago its nutrition and food safety divisions began a series of studies on street food; more recent FAO projects include urban and peri-urban food production and forestry. Even the International Fund for Agricultural Development, with its focus on poverty and the landless, reports very few programs for poor in the cities.

Urban studies have been similarly narrow in their focus. As an interdisciplinary field, urban studies encompasses a variety of disciplines, none of which include food. Geography and demography study urbanization and migration. Studies of political economy analyze the full range of employment and political integration patterns. The structure of land markets and transportation networks forms the core of much urban planning, which also includes an abundance of studies about informal housing. The study of food is strangely absent.

This absence of accurate information about food systems and practices has particularly adverse consequences for municipalities in developing countries. These cities are all too often inclined to follow the complex, highly capitalized, and energy-consuming supermarket model of food distribution commonly found in more industrialized societies. Replication of institutions and systems from one country to another is fraught with unanticipated

consequences. Transplanting energy-intensive demand food systems to lower income countries must take into account existing infrastructure inadequacies, especially whether reliable electricity is available to maintain low temperatures for food storage, whether clean water can be obtained, and if waste disposal is sufficiently timely to ensure safe food-handling practices. As this method of food distribution grows, so will urban congestion and already dangerous levels of pollution. There is a corresponding requirement to improve methods for recycling the plastic and paper that is used in packaging. Analysis of supermarket system costs not only needs to include energy flow and the ability to sustain the system, it also must consider impacts on urban residents in terms of food availability, diets, and employment opportunities.

URBAN PLANNING FAVORS ELITE

Despite the predominance of poor people in cities of the developing world, most planning favors the elite. Income statistics reinforce the presumption that city dwellers are better off than those living in rural areas. But urban poverty is underscored when income is adjusted to reflect the high costs of food in cities. A survey of the world's 100 largest metropolitan areas found that in 60 of the cities, families spend between one-third and one-half of their income on food. By contrast, residents of Washington, D.C. spent less than 10

percent of their income on food. Planners quote this low cost of food in the United States as a reason to replicate the supermarket model elsewhere.

As land prices soar and congestion increases, produce markets in central locations are often moved out to the periphery. Such moves dislocate supply lines for small grocery shops and street vendors, while further increasing the costs of fresh foods as transportation costs are added to the prices that sellers ask. Remote locations also discourage many middle-class people from patronizing these markets, altering the types and quality of foods sold in much the same way that inferior produce is found in U.S. inner-city stores. These markets are replaced with gleaming supermarkets in upscale shopping centers. Affluent middle-class residents and the foreign community appear to be the major customers, particularly in the newer Asian malls, although older outlets maintain a broader customer base for limited commodities.

FOOD MALLS REPLACE OUTDOOR STALLS

Outdoor food stalls are razed in Singapore to be replaced with food malls atop parking garages. In neighboring Bangkok or Manila, where internationally based fast-food outlets abound, the middle class flock to McDonald's and Kentucky Fried Chicken franchises, but most local dwellers are content to eat street foods. Such approaches to supplying food to the cities might produce

different out-comes if the apparently cost-effective methods of packaging, freezing, transporting, and selling were viewed in full light of the realistic costs of pollution and energy for delivering food to the market and for recycling or disposing of packaging. Such studies need to be undertaken, but in the meantime, the elite and foreign communities will continue to patronize these high-cost solutions for the provision of both fresh and prepared food.

Most important is information on how these urbanites currently feed themselves. Indeed, as world production of staple crops continues to lag behind increases in population, knowledge about small-scale food production in urban and peri-urban areas and an understanding of the prepared food sector become essential parts of any project designed to feed the megacities. Recent research has been conducted at the micro level, where people grow and process food both for their own consumption and for the market. Such data challenge the limited palette of potential solutions to feeding the cities, and argue for broadening the available alternatives.

Urban dwellers in the megacities of the world's southern regions are continuously adapting food systems to meet their needs. Two areas have been thefocus of extensive study: street foods and urban agriculture. Given the colonial restrictions still in force in most developing countries, both activities operate on the edges of legality, opening up the producers to harassment and bribery by municipal officials. Issues of food safety arise in both sectors. And while farmers, vendors, and their customers represent many income levels, poor women are a significant majority of producers and vendors in most urban settings. The income and food resulting from their enterprise is critical to the maintenance of poor households, especially to the two-fifths of these households headed by women.

STREET FOODS

Traditional food markets in developing countries, where both fresh produce and prepared foods are sold, have been studied extensively by anthropologists, but their place in the urban food system is not usually described. Rapid urbanization has resulted in extreme overcrowding of these markets; vendors infiltrate into adjacent alleys and roadways, dump trash in gutters, and impede both foot and vehicular traffic. Too often the government's response is to harass the vendors and destroy their stalls or carts. For example, since 1983, the military governments in Nigeria have waged a "war on indiscipline" against all vendors that has resulted in protest marches in several cities. Such actions have devastating effects not only on the vendors, but on their customers.

Street foods are central to the diet of many urban areas. Data from a comparative study of nine provincial cities indicate that nearly half the typical household food budget is spent on street foods in urban areas of Nigeria and Thailand; in a rural town in

Bangladesh, this percentage was still 16 percent. While the lower income groups in this Bangladeshi town spent nearly one-quarter of their budget on the fast foods of the developing countries, street food expenditures increased with income in both Southeast Asia and Nigeria. In congested Bangkok, 23 percent of the housing stock consists of rooms only, without kitchens; but plugging in an electric rice cooker is easy in a single room. Although inventive cooks can apparently produce a meal in the cooker, 48 percent of the average household budget is spent on prepared food eaten out or brought home.

Street food sellers make a reasonable income, especially compared to other alternatives available, particularly for women. In the nine countries studied, the average income of street food vendors was well above the declared – if seldom paid – minimum wage. In Thailand, over half the vendors earned an income comparable to the wages paid to military or police captains, middle school teachers, and nurses. When a successful vendor in Jakarta reported her profits as Rps 10,000 per day in 1983, an Indonesian official commented that if this vendor worked 25 days a month, her salary would be equal to that of a director general.

FAMILY ENTERPRISES

In all the countries, street food vending is a family enterprise, as the work is too heavy for one person alone. In both Senegal and Nigeria, the trade was found to be segregated by gender, but female kin and daughters assisted the women. Elsewhere, family members engaged in preparing the food, purchasing ingredients, and washing utensils; in both Indonesia and the Philippines, couples often plied their trade together. Women vendors predominated in Nigeria and Thailand, and outnumbered men in Indonesia, the Philippines, Senegal, and Jamaica. In the more conservative cultures of Egypt, India, and Bangladesh, few women sold on the street. Actual profits were in most cities lower for women, although return on their investment might equal or surpass that of men. Women tend to sell traditional foods that require little investment in new equipment or processors: they also work shorter hours than men because of household obligations.

Besides street foods, many women prepare meals directly for customers. Working women in Bangkok take home food in boxes; textile workers eat daily meals at the homes of *kaniwallahs*; office workers in Jakarta place orders a day ahead for meals to be brought to their desks; lunch is catered in women's homes for workers in congested Latin American cities. Largely unnoticed and unstudied, these "invisible street foods" constitute another part of the informal prepared food systems already well established in major urban centers.

Street foods and catered meals are frequently cheaper than foods prepared at home, especially when time spent shopping and cooking is factored in. The preparation of traditional dishes, such

as millet porridge in Senegal, is often extremely time consuming, so many people prefer to buy these foods on the street. In Nigeria, as the economic recession worsened and the cost of imported food increased, the middle class reported eating more traditional foods bought on the street to save time. Both food and fuel costs are higher per capita when cooking for only a few people.

Traditional foods are often more nutritious than faster cooking, newer foods, such as white bread, although efforts are under way to improve nutritional content by adding soy flour or vitamins. The vendors' families also benefit from eating unsold foods at the end of the day, a practice that clouds profitability but enhances nutrition.

URBAN AGRICULTURE

If the importance of street foods to urban food and employment has been underestimated, urban agriculture has been ignored. Perceived as an unfortunate and unsightly hold-over of rural practices, many municipalities retain colonial laws that prohibit the growing of crops or the raising of animals. Fruit trees and fish ponds are less often regulated. Despite the prevailing view of many planners that green spaces along rights-of-way, in parks, or in front of residences should be reserved for trees and flowers, urban dwellers plant food crops and fruit trees; and raise goats, cows, poultry, fish, bees, rabbits, snakes, and guinea pigs in urban and peri-urban spaces.

Obviously, food grown and raised at home reduces expenditures. Equally important, food production can be a potent source of income. As much as 70 percent of all poultry eaten in Kampala, Uganda, is raised in the city. Asian farmers long ago perfected ways to raise fish commercially in urban ponds. Women in urban Egypt have for decades sold butter and cheese made from milk drawn from cattle stabled in their homes. River beds and vacant lots are filled with vegetables in most cities. In Africa, observers note that whenever there is economic failure or civil unrest, the greening of cities as marketing systems falters and food prices soar.

Recognizing the importance of urban food production to family survival, many nongovernmental organizations have initiated projects for the urban poor. Women figure significantly in these activities, especially in Africa where they are culturally responsible for feeding their children. UNICEF found in Kampala that urban farming was associated with better longterm food security and nutritional status of children, particularly in the lower income groups that make up some 80 percent of the city's population. Furthermore, urban farming constituted the largest single nonmarket source of food for the urban population.

But what is urban? In this discussion of urban food systems, a nagging issue remains unresolved how to define "urban" or "peri-urban." Municipal boundaries seldom reflect land use. Urban densities often extend well

beyond the incorporated city government boundaries. In some countries, city size has expanded for political reasons, often engulfing existing villages whose residents continue to farm in increasingly constricted surroundings. Improved transportation patterns tie even remote villages to the urban economy through both kinship relationships and market necessities. Urban dwellers frequently maintain their own peri-urban farms, shuttling out weekly or leaving some family members there to tend the crops during the season. China long ago recognized the different land uses in zones surrounding urban areas and created municipal boundaries the size of counties to allow urban areas to be self-sufficient in food, a policy being undercut today by rapid urban expansion.

Perhaps, instead of attempting to define what is urban and what is rural, it is more critical to recognize a continuum of land use patterns for production and residence. Still, it is difficult to discuss and compare types of urban farming or to link the proliferation of street foods to urban densities without some agreement on terms. Without solid comparative studies such as the street foods project, influencing policy is more difficult.

Even without more studies on urban food systems, there is enough evidence to question the efficacy and wisdom of pursuing the supermarket model as the primary solution to feeding the cities of the 21st century. Alternative patterns for the production, distribution, and retailing of produce and of street foods respond to the needs of the poorer residents in terms of both nutrition and income. A more judicious combination of approaches is clearly required.

SECTION 7
HERSTORY OF WOMEN AND DEVELOPMENT

THE OVERVIEW CHAPTERS INCLUDED IN THIS SECTION WERE WRITTEN AFTER I RETIRED from Berkeley. While they have as their basis my original publications, these chapters benefitted from the burgeoning research being done by women situated in many development organizations and bilateral agencies. The misguided promotion of *gender mainstreaming* weakened women's programs until they realized that for effective advocacy, a women-focused department was still essential. I discuss this issue in my last two overview chapters.

The various agricultural research centers were not affected by the promotion of gender mainstreaming because the focus was on research not implementation. Rather, as the number of centers increased, their coordinating board as well as individual centers recruited prominent women researchers. The fact that today such institutions must have experts on women is a tribute on the overall impact of the women and development movement. Their research was particularly pertinent to my later writing.

Food shortages were widespread at the end of World War II. In 1943, the Rockefeller Foundation set up a center in Mexico where scientists could experiment with methods to increase crop yields. It was there that Nobel laureate Norman Borlaug perfected his high-yield, disease-resistant wheat varieties. Other cereal grains were similarly developed. Their success led to the "Green Revolution" which increased production dramatically in the 50s and 60s. Governments adopted these high-yielding varieties of cereal grains and the changes in farming necessary to ensure the inputs needed including irrigation, synthetic fertilizers, pesticides, and mechanized tools. As the social and environmental impacts of this system became clear, the system became more adapted to local conditions. Women were affected both positively and negatively as I note in these overview chapters.

In 1960, a research center in the Philippines was added to improve rice varieties. Soon new centers were added to study cassava and tropical agriculture. By 1971, fifteen centers had been established with branches throughout the world. They were linked thorough CGIAR, The Consortium of International Agricultural Research and had broadened their scope to include farming systems, forestry, and fisheries. Today these centers operate as a separate entity within the World Bank. All centers have women on their boards as well as on staff. Their research studies have been an important source for my lectures and publications.

For me, the most important of these centers has been IFPRI, the International Food Policy Research Center, set up in 1975 in Washington, DC, to focus on social science as aspects of food production. At first the studies investigated governmental policies that encouraged the adoption of innovative techniques. Once grain production increased, IFPRI investigated which methods of subsidies and distribution were most likely to ensure that the poor, especially the women and their children, received the food. Their findings highlighted power relationships within the family which in turn led to systems where the food was distributed directly to women. Studies of nutritional deficiencies also indicated the importance of women's income because men often spent their income on themselves.

Per Pinstrup-Andersen, then director of IFPRI, was fascinated by my Street Food studies and helped me with contacts, funding, and the distribution of the book. Much of subsequent research at the center has included women's economic activities related to the selling of food. These global studies are not only conducted by women researchers, but IFPRI has instituted women-friendly staff policies. Research staff need not live in the DC area but must come to the office for a week a month when they are not in the field. Thus women do not need to choose between their work and a husband's job outside DC.

Throughout my academic career, the Institute for Current World Affairs has provided a unique source of information. I was first aware of ICWA in 1955 as I was applying for my fellowship to study in Indonesia and found copies in Cal's library: a fellow was writing his monthly letter about daily life in a Javanese village. Four forestry fellows – all women, perhaps because traditional forestry jobs were then dominated by men – investigated forestry policies and products in Africa, and Asia. All wrote extensively on women's use of the forests, and all subsequently held jobs in international development agencies. Much later, a summer intern at EPOC became a fellow in Indonesia and wrote about the degradation of mangrove swamps filled in to make way for Javanese settlers in Kalimantan. She used this material for her doctoral dissertation at Berkeley where I was on her committee.

My graduate students provided me with tutorials about academic enthusiasms when I returned to teaching after fifteen years of activism. At American University, a nun taught me Marxism: at Harvard, I had learned that since the state did not wither away, Marxism was not worth studying. The role of Marxist critiques in economic development has now receded in importance though may be revived by the current concern with inequality and the revival of more statist approaches to development. At Berkeley, I realized that the entire Post-Modern debate had passed me by; a very patient grad student elucidated the literature and sparred with me over my skepticism. When a new faculty member proudly discussed her empirical research during her talk on deconstruction, she replied that her work was an example of post-empiricism.

Many new strands of thought have emerged since I wrote about the WID movement. I find identity politics particularly revealing. I discuss these debates in the summary chapters as well. Women in the many countries I visited and wrote about have published books about their own countries: their work provides depth to my earlier and incomplete observations. Kristen Ghodsee, now a professor at Bowdoin University, has studied women's movements and development in Bulgaria; her writings challenge many assumptions about the UN Women's Conference held by western scholars. I have included her point of view in my summary publications.

Realizing at last that I was unlikely to do anymore field research, I turned to ensuring that the history of WID and its role in creating the global women's movement was not lost. Convinced that if women do not write about their own accomplishments, men certainly will overlook women's successes, I co-edited a book of memoirs written by 27 women from 12 countries which detailed what they did to promote the global women's movement. My Introduction recounted our collective journey.[1] Drawing on my fifty years of involvement with the field of women and international development, I wrote two reflective chapters; the first focused on Asia,[2] the second on how economic assistant helped women organize.[3] In 2014, two chapters on the concept and evolution of WID were published, one in a volume written primarily by male economists,[4] the second in a handbook on Transnational Feminist Networks.[5] These are included in this volume.

1 This requirement of having all undergraduates complete one international course was new, proposed by a committee on which I served.

2 Developing Power: How Women Transformed International Development, edited with Arvonne Fraser. Feminist Press, 2004. Introduction: "Women transforming international development" pp xiii-xxx.1 Chapter: "Contesting wisdom, changing policies: the women in development movement" pp 65-77.

3 "Many paths to power: women in contemporary Asia," 2004, in *Promises of Empowerment: Women in Asia and Latin America*, Peter H. Smith, Jennifer L. Troutner, and Christine Hunefeldt, editors. Pp. 35-59. NY: Rowman & Littlefield.

4 "Empowerment just happened: the unexpected expansion of women's organizations," 2006, in Jane Jaquette & Gale Summerfield, eds. *Women and Gender Equity in Development Theory and Practice: Institutions, Resources, and Mobilization*. pp. 268-301. Duke University Press: Durham NC.

5 "Women's economic roles and the development paradigm," with Elaine Zuckerman in Bruce Currie-Adler, Ravi Kanbur, David M. Malone, & Rohinton Medhora, eds. *International Development: Ideas, Experience, & Prospects*, 2014, pp 116-132. Oxford University Press for the International Development Research Centre of Canada.

DEVELOPING POWER INTRODUCTION: IDEAS INTO ACTION

This introduction positions the 27 authors in this volume of memoirs into the events of the last fifty years that witnessed the rise of the Global Women's Movement. Their names are in bold.

THE 1970S WERE HEADY DAYS FOR THE incipient global women's movement. The energy and turmoil fueling the reassertion of women's rights in the United States provided greater visibility to the continual demand for equality by women around the world. Persistent efforts within the United Nations, struggles by women in newly independent countries, research findings that described how colonialism had blunted women's rights and roles had documented the inequities of women. The increase of funding for countries in Asia, Africa, and South America for economic development projects designed to increase the gross national product of the country were reinforcing women's subordination rather than liberation; activists in donor countries lobbied for new policies. These distinct approaches to improving gender equality: working through the UN or within nationalist movements, conducting research, or changing donor policies coalesced into a global women's movement as a result of two different forces. First was the proclamation of a UN World Conference for the International Year for Women to be held in 1975. Second was the requirement that programs of the then major economic development agency, US Agency for International Development (USAID), integrate women's concerns in their projects; a concept that was rapidly adopted in both national and international agencies.

Recall the worldview at the time. The US had led the world to victory over Germany and Japan, then had initiated a major recovery package for Europe, the Marshall Plan. Economists projected this model of economic development to the newly independent countries of Asia and Africa, certain that their approach was universal. This male view of the world hardly mentioned women except to opine that often women's religious views made them resist change. If pressed, economists noted that women and children were subsumed under the household where their happiness and goals would be projected by the benevolent patriarch, an assumption since demolished by gender-sensitive economists.

During the 1960s, new UN members from formerly colonial countries had become a majority in the international body and brought with them a heightened concern for economic development. While the industrialized countries – the Global North – who were donors of development assistance modeled progress on their own experiences,

the developing countries – the Global South – agitated for changes in the international policies and treaties relating to, among other things, trade and industrialization: these debates continue. The donor countries introduced new types of agricultural methods and crops based on newly discovered technologies, urged a slowing of the birth rate, promoted literacy and health. That such programs affected women differently than men was not recognized, much less considered.

Women researchers, Ester Boserup preeminent among them, had observed how colonial and then development programs undermined many of the traditional rights of the women in those countries. Activists in Washington, DC, where the United States Agency for International Development was then the dominant donor of development aid, agitated against the detrimental impact of development on women. Indeed, because development projects were using Northern models, they were perpetuating the unequal gender relationships which the second wave of the women's movement was attacking.

These three sites of protest against prevailing roles assigned to women – women in newly independent countries, women in the United Nations, and women challenging donor countries to change policies toward women at home and abroad – have formed the global women's network. This network consists of women's organizations in every country in the world. Their consistent theme is active participation in

issues and events that concern them as countries industrialize. These women espouse many ideologies, diverse approaches, distinct feminisms. In some countries, feminist organizations, perceived as elitist, are distinguished from women's groups whose interests are closer to the poor. Scholars have argued that because an individual is socially constructed, women must be studied in the context and so espouse the use of gender in development (GAD) as a more accurate term than women in development (WID). Such terms all describe the process of integrating women's concerns into programs and policies related to world development Put together they comprise the most important social movement of the twentieth century: the global women's movement.

Looking back from the new century, the accomplishments of women over the last four decades are truly phenomenal. How they influenced, and profoundly changed, international development policy, how they altered the concept of human rights to encompass women, how they gave voice to women and for women's issues, is a story that must be preserved. That is the purpose of this book. The authors are women from around the world who have played a significant role in global change. In their chapters, they combine their personal backgrounds with a description of why and how they became involved in the global women's movements, what actions they took, and how their actions expanded their own horizons and capabilities. To accomplish their goals, most

have been at one time or another activist, practitioner, and scholar. Few had anticipated that they would act on the international stage. They reflect diverse backgrounds and different perspectives on the specifics of international development and women, but all describe the unusual confluence of circumstances that made possible their contributions to this extraordinary movement. They credit global networking for enabling such momentous changes in the way women are perceived and treated in the world today.

Clearly, these women did not act alone. Fundamental to the change in women's status are the multitude of women around the world who organized themselves into small and large organizations to challenge the cultural prescriptions that both protect and support them. They come together in women-only groups, as women's sections of larger associations, or as integral members of political parties and non-governmental organizations. Often they design and implement development projects and influence policy as do women within governmental agencies. Other women evaluate development projects or study policy trends. Universities now offer courses on women in international development and scholars write books about problems and successes. Efforts to refine the field had led to debates over the usage of "women" and of "gender" and over the way to institutionalize change through mainstreaming. Our authors reflect their own perspectives

about these disagreements; but not on the goal of enhancing women's status. Together these activists, practitioners, and scholars have profoundly influenced development policy at all levels from community to national governments and international agencies and helped change the lives of women around the world.

WOMEN INFLUENCING THE UNITED NATIONS

Global networking and organizing were greatly enhanced by the four United Nations World Conferences for Women – Mexico City 1975, Copenhagen 1980, Nairobi 1985, and Beijing 1995. Preparations for these conferences was the responsibility of the United Nations Committee on the Status of Women (CSW) which was set up in 1946 as the result of lobbying especially by women from Latin America who had been active in a similar body of the Organization of American States. The women's networks organized to promote suffrage around the world had continued to function through such organizations as the International Council of Women, the International Association of University Women, the International Alliance of Women, and Country Women of the World, all of whom immediately applied for non-governmental status at the United Nations.

During the nationalist struggles for independence from colonial powers, women activists from such groups also participated in demonstrations and

organizing; many were rewarded with significant governmental positions in their newly independent governments. During the 1950s, most former colonial countries in Asia became independent and joined the United Nations; African countries followed in the 1960s. Often women from these countries, such as Vijaya Lakshmi Pandit from India or Annie Jiaggi from Ghana, held more visible positions in the UN or in their country delegations than did women from the industrialized world. Such women provided exemplary leadership at the United Nations and the women's world conferences.

COMMISSION ON THE STATUS OF WOMEN

When the United Nations was formed in 1945, women and their rights were little discussed. Latin American women with experience in the women's commission of the Organization of American States, lobbied unsuccessfully for a similar body at the UN were able to add a provision calling for equal rights of men and women to the charter's preamble. Continued agitation led the Economic and Social Commission of the UN to create a subcommittee to the Human Rights Commission in 1946; in the following year, 1947, the Commission on the Status of Women became a separate entity.

Under the leadership of Margaret Bruce from the United Kingdom, the CSW focused during its early years on women's legal rights and education.

Despite a limited budget and staff, the Commission, supported by international women's organizations participating at the UN, was successful in steering a series of measures through the UN General Assembly on women's rights relating to citizenship, employment, and family law. In contrast, the delegates from the communist bloc maintained that such issues were irrelevant since women and men were equal in their countries. For many the significant issue for women was peace. When themes for International Women's Year were proposed, peace was included along with equality and development. The symbol of the Year was a dove of peace whose wings enclosed an equals sign and whose body held the sign for female.

Gradually, other topics were introduced into the CSW. In 1963, **Aziza Hussein**, delegate from Egypt and the first Arab member of CSW, "dared to raise the issue of family planning as a relevant agenda item, particularly as regards countries suffering from excessive population growth.... The effect of my words thundered like an explosion." Other contested debates that Aziza writes about in her chapter include a discussion of women's status in Islam and women's rights in occupied territories.

Less controversial within the Commission was drafting language for the Declaration on the Elimination of All Forms of Discrimination Against Women which was drafted by CSW beginning in 1965 and adopted by the UN General Assembly in 1967. After the Mexico City Conference the

CSW revisited the issue, and in spite of weak support from western countries, a Philippine draft formed the basis of a Convention on the Elimination of All Forms of Discrimination Against Women (CEDAW). **Letitia Shahani** recounts the fascinating tale of the unorthodox approach she took in ensuring the debate on this draft. CEDAW was subsequently adopted and presented for government signatures at Copenhagen conference in 1980; by the following year twenty member states had ratified the convention giving it the status of a treaty. Women, for the first time, have a UN body to which they can appeal. Clearly CEDAW is one of the most critical successes of the global women's movement.

Ratification is supposed to mean that the convention has the force of law in the particular country, but ratification does not always mean implementation. Thus women's groups often present "shadow" reports to the UN Committee that monitors implementation when they believe governments are not complying with the Convention. Nonetheless, the existence of CEDAW and other UN documents exert strong pressures on governments to expand women's rights. **Arvonne Fraser** helped set up the International Women's Rights Action Watch to give attention to the problems of implementation globally, and to encourage governments, such as the United States, to ratify CEDAW.

PUTTING WOMEN INTO ECONOMIC DEVELOPMENT

In the General Assembly of the UN, the developing country delegations were lobbying for more focus throughout the system on development issues. The First Development Decade 1960-1970 had emphasized infrastructure and industrial projects. This approach to development resulted in an increasing inequality between rich and poor. As a result the UN Economic and Social Commission (ECOSOC) urged greater attention to social issues in development. A 1969 report of an experts meeting in Stockholm reiterated that under the capitalist approach to development social indicators were ignored as were women's economic roles. The report stressed the importance of "integrating women in development," a phrase **Gloria Scott** authored. In her chapter, she recalls her efforts in 1972 to convene a second experts' meeting, this time exploring the relationships between women and development, and to draw CSW into co-sponsorship.

The rapporteur of the meeting, and member of the UN Development Planning Committee, was Ester Boserup whose landmark book *Woman's Role in Economic Development* had been published in 1970. Of her role in that meeting, Boserup writes that the CSW Secretariat "saw it as a means to get members of the Commission to change their focus from the generally unpopular subject of abstract women's

rights to the popular one of economic development."

Boserup had found that even in countries with a large participation of women in agriculture, women were nonetheless classified as housewives or "non-active" persons. To challenge these data categories, Boserup assembled case studies from Asian and African countries that provided hours worked by women and men in both paid and unpaid work, including agricultural work, household enterprises, and the fetching of fuel and water. Women's work varies by agricultural system: in Africa south of the Sahara, women are the primary farmers while men assist in clearing the fields and protecting their homes. The plow changed agricultural techniques and required men to work in the fields as well as women but gave men control over new technologies to women's disadvantage. Boserup believed that population increase drove the technological change which in turn altered women's roles. Male migration to cities is easier where women are farmers as in Africa; female migration predominated in Latin America where women had little agricultural role.

Boserup criticized European colonial policies that imposed western models not adapted to the local cultures and led to the loss of women's status. Two of her points stand out: first, the promotion of land ownership deprived women of use rights in areas of Africa and South East Asia, and second, the belief that men were superior farmers encouraged the introduction of technology and cash crops to men, especially in Africa, thus leaving women to continue using traditional low yield methods for growing subsistence crops. Such policies ignored women's essential and often predominant agricultural roles while undercutting their ability to grow food to feed their families.

Boserup's insights challenged many prevailing economic development theories not only regarding women but also agriculture, technology, and population. Her book on women provided the intellectual foundation for the women in development movement; but as its guru, she is more often quoted than read so that many of her pertinent insights on women in cities are overlooked. Her research sparked a tremendous interest among women's scholars in producing further case studies to corroborate or challenge her evolutionary presentation.

Other women, traveling abroad for research or to supervise donor assistance, also noted the cultural dissonance created by economic development policies and determined to change the approach. The first country to alter its programs to include women was Sweden, in 1964, persuaded by Inga Thorsson, and active politician and cabinet minister who later joined the UN. A grant from the Swedish government funded the women's position at the Economic Commission for Africa; **Margaret Snyder** discusses her impressive efforts to set up that pathbreaking office.

In Washington, DC, a group of

young scholars, influenced by the rising voices of US women, observed in their research abroad that development projects were exporting the very stereotypes about women's work against which they were demonstrating at home. In her chapter, **Irene Tinker** recounts how she organized a women's caucus within the Society for International Development to document these observations. Testimony at the Department of State and before Congressional hearings led to an amendment of the Foreign Assistance Act of 1973 that mandated women's inclusion in programs designed to alleviate poverty abroad. Known for the US Senator who introduced the amendment, the Percy Amendment became a model for resolutions within the UN system as well as among bilateral development agencies that mandated efforts to integrate women into development. The insights into the detrimental impact of development on women illustrated in Boserup's book and instilled into bilateral programs influenced the agenda at the first UN World Conference for Women in 1975.

UNITED NATION'S WORLD CONFERENCES AND WOMEN

The growing strength and visibility of the reinvigorated women's movement influenced UN staff in New York City. Women within various departments began to demand and end of discrimination against women at work and for promotion. Both **Gloria Scott** and

Kristen Timothy describe the chilly climates within which they operated. When the New York Times ran a story on how the UN with its claim to support equality discriminated against women in their hiring policies, the Secretary General hastened to appoint Helvi Sipila as the first woman Assistant Secretary General.

Sipila's first task was to organize events to mark International Women's Year in 1975; she became the Secretary General when International Women's Year was expanded to include a world conference as well. The General Assembly proclaimed the themes for the year and conference as "equality, development, and peace" reflecting the primary preoccupations of the three ideological blocs: communist East, industrialized West/North, and developing Third World or South. The first World Conference for Women was held in Mexico City in June 1975.

PATTERNS AND POLITICS AT WORLD CONFERENCES

Starting in 1972 with the Environment Conference in Stockholm, the UN began to convene world conferences on topics relating to development that either had not been included in the original UN charter or needed updating. As was true with previous UN conferences, member governments, UN agencies, and NGOs in consultative status with the UN were expected to attend. But in 1972 the "green" movement was already an important political force in Europe. Members

of these environmental organizations demanded to be heard and camped out at the airport to put pressure on the UN to accommodate them.

Ever since, at major UN world conferences, nongovernmental organizations, or NGOs, with a stake in the outcome of the particular conference and with official representation at the UN, have organized a parallel event, an NGO Forum, that is open to issue focused organizations and to the general public. These meetings combine professional panels with the gaiety of a fair; they provide a way to disseminate new ideas and research to UN delegates as well as among the growing NGO community. Most of all they provide an opportunity for activists from around the world to meet and set up formal or informal organizations and networks. Participants at the parallel NGO conferences often exceed the number of official delegates and draw most of the media coverage.

While the NGOs with official consultative status at the UN are steeped in UN procedure and understand how to influence the system, most activists attending the UN forums do not. Once they arrive at the conference site they begin to realized that any input they might have had should have taken place much earlier in the process. The almost inevitable result has been a march on the official meeting unless the country where the conference is taking place has an authoritarian government.

Official UN conference documents are typically the subject of many rounds of debates in regional meetings and in preparatory committees, and the language is freighted with global debates of the day. Final revisions are made during the two week official conferences, and over time women activists have learned how to insert phrases and paragraphs throughout the process so that the final documents adopted at the conference reflect issues of concern raised by women's organizations and research centers. Although official UN documents lack the force of law, their political and moral power is considerable, providing activists in individual countries and internationally as well as the UN system with powerful tools for change.

The decades encompassed by these major world conferences were a period of growing tensions between North and South. Whatever the official conference topic, discussions referenced the continual contentious debates over the appropriate priorities for and direction of economic development as envisioned and funded by the North. The North-South differences affected both agenda items and the final documents of the conferences, never more than at the women's conferences; generally women lacked the power to influence negotiations over political posturing that oldboy networks had at other conferences, a power that facilitated compromise.

Today the sites of this contention have shifted from UN conferences where the North does not dominate to meetings of the World Trade Organization or those of the leaders of the industrialized world (G-7 in UN parlance) which are dominated by the champions

of unfettered globalization. Thus the South finds itself with fewer methods of influencing the world debate in these fora. Nor have the conveners of these meeting yet created mechanisms for consultation with the NGO community, which itself has grown more diverse and disruptive. Without some open and official way for moderate NGOs to engage the world meetings in debate as the UN world conferences provided, the fissures between the North and South, between governments and civil society, become ever more fractious.

These opposite perspectives were starkly clear at the second major consciousness-raising conference, the Population Conference in Bucharest in 1974. The North argued that for economic development to succeed countries had to adopt methods of population control; in contrast, the South believed that economic development would in turn lower fertility rates and so demanded development first. Both official sides tended to see women as objects, not people; in contrast, at the NGO Forum, women and cultural factors that influenced fertility choice were analyzed.. The opposite views of women as agents versus women as objects were dramatically reversed in the third Population Conference in Cairo in 1994. Women's access to health and education were promoted as the preferable method of reducing population. A woman's right to control her own body, a fundamental goal of the women's movement, was also championed. Many authors in this collection have

been active in family planning groups as well women's organizations.

FOUR UN WORLD CONFERENCES FOR WOMEN

The patterns discussed above were clearly visible during the four women's conferences. But some differences were distinct. The range of women's interests are all-encompassing and include those discussed in the separate UN conferences on food or population, environment or technology.[1] Women demanded place on the official delegations and railed at the predilection of governments to send men as the delegation head while including wives of high officials as tokens. Some women were convinced that the governments used women's conferences as a proxy for global debate, recognizing that many women delegates had no alternative to following the political line.[2]

1 Ester Boserup condenses her ideas in her chapter in my edited book honoring her contributions: Persistent Inequalities. A full discussion of her work may be found in my "A Tribute to Ester Boserup."

2 Many authors attended other UN conferences. Aziza Hussein has attended all three population conferences: Bucharest 1974, Mexico City 1984, and Cairo 1994. Kathleen Staudt and Elsa Chaney provided influential background papers for the World Conference on Agrarian Reform and Rural Development in 1979 in Rome. Irene Tinker could be found adding phrases about women at the population meeting in Bucharest 1974, at Science and Technology for Development in 1979 in Vienna, and New and Renewable Sources of Energy in 1981. Marilyn Hoskins took part

Indeed, the specific concerns of both women delegates and women's organizations often diverged from the political interests of their own governments. As agenda items increasingly reflected this divergence between specific women's issues and global debates over economic and political issues, many women questioned the usefulness of spending time at women's meetings attempting to influence policies which would be ultimately decided by the General Assembly or other powerful bodies and urged women engrossed in such global issues to lobby these other bodies instead of interfering with more practical resolutions designed to help poor women. Such issues were widely viewed as essential preconditions for solving economic and political problems of women by many participants from the South; they were seen as extraneous "politicization" by feminists from the industrialized North. Perspectives of what is a woman's issue clearly shifted over the two decades as the interconnection between macro and micro economic policy and practice became obvious; research traced the impact of decisions about trade, debt, and industrialization on women. This disagreement about what constituted "women's issues" is addressed by many authors in their chapters.

The NGO conferences were particularly instrumental in enlarging the scope of debate and in shaping a global women's movement. The number of women and the few men attending NGO activities at women's world conferences has risen steadily from six thousand at Mexico City to over twenty thousand at Beijing. Official delegates from member nations and UN agencies have increased to about 3500 as new countries join the UN and more agencies send delegations. Similarly, the number of NGO representatives accredited to observe the official proceedings has grown to nearly 1000. Nearly 30,000 participants and countless media representatives gave exceptional visibility to women's issues during the Beijing meeting.

Mexico City, 1975: Planning for the UN conference for International Women's Year was abysmally short. Neither the UN bureaucracy nor most member countries were enthusiastic, but they were pressured by women's organizations and supportive NGOs. The official document, called the Plan of Action, was was not reviewed by regional preparatory committees as was usually done but many of the ideas from meetings of women before the population conference were incorporated. Much of the agenda was based on previous work of the CSW dealing with equality. But the General Assembly, by adding development and peace to the conference themes, opened the conference to the unresolved conflicts within the UN General Assembly. In 1975, the most contentious issues concerned restructuring the international economic system, determining the fate

in the latter conference in Nairobi. Arvonne Fraser was a U.S. delegate to the 1993 world conference on human rights.

of the Palestinians, and dismantling apartheid.

During the discussions at Mexico City, *zionism* was for the first time in any UN document identified as a cause of underdevelopment, along with colonialism, imperialism, and racism.[1] Debate on this issue so diverted the conference that there was no time to discuss several sections of the Plan of Action, the major conference document. Nonetheless, under pressure from the women delegates, the Plan was passed unanimously. The more controversial positions were issued separately as the Declaration of Mexico, with 89 countries for, three against (US, Israel, Canada), and 18 abstaining.[2]

Substantively, the Mexico City conference endorsed the demand for women for legal equality which encompassed the rights of divorce, custody of children, property, credit, eduction, voting and other citizenship rights. Governments agreed to set up special offices, or national machineries, for women to monitor and support changes in programs and policies that would benefit women. The difficulties of this effort are evident as **Dorienne Rowan-Campbell** notes her efforts to

coordinate these moves with the governments in the Commonwealth.

Development was a relatively new topic for women to discuss. Ideas for new projects emerged at a pre-conference Seminar on Women in Development which was attended by many delegates and advisors. Convened under the aegis of the American Association for the Advancement of Science and its Mexican counterpart, and organized by **Irene Tinker**, the discussions and recommendations carried academic respectability important for international acceptance. The idea for Women's World Banking was germinated at the seminar; **Michaela Walsh** traces the subsequent expansion of that unique organization.

Two new UN institutions were established a the world conference to deal with major issues of development. The International Research and Training Institute for the Advancement of Women (INSTRAW) was set up to encourage and coordinate research on women around the world; **Aziza Hussein** and **Irene Tinker** served on its first Board. The Fund for Women, later renamed UNIFEM, was provided with funds for grants to women's organizations at the local level. **Margaret Snyder** became UNIFEM's first director; she describes her efforts to create a viable agency.

The NGO Tribune, organized by Mildred Persinger with advice from Rosalind Harris, was relatively unstructured with many rooms for impromptu meetings. US feminists, certain that they had the keys to achieving women's equality, enraged many women from

1 For example, the US delegates were reprimanded in Copenhagen for attending a reception given by the Cambodian government-in-exile at a time the US supported Pol Pot.

2 It is ironic that terrorists are currently proclaiming US support of Israel and its undermining of a Palestine state as a major unifying issue for Muslims. The site of conflict is no longer a debate within the General Assembly but in global terrorism.

Latin America with their views about global dependency and class warfare; this ethnocentrism of many Northern feminists continues to be a source of contention in development programs as well as at global meetings. More positively, the Tribune spawned the International Women's Tribune Center (IWTC) to provide an interchange among the many women and women's groups that were present in Mexico. IWTC has maintained and expanded its communication reach around the world and held events at all subsequent women's conferences, a saga related by **Anne Walker**.

Copenhagen, 1980: The upsurge of support exhibited in Mexico for further exploration of women's changing status led the UN to declare a Decade for Women 1976-1985 and to hold both a Mid-Decade Conference in Copenhagen in 1980 and an End-of-the-Decade conference in Nairobi in 1985. Global political events dominated Copenhagen even more than they had the first women's conference. Even the selection of Denmark for the conference was due to the abrupt change of government in Iran since Teheran had been designated as the site for the second women's conference. The overthrow of the Shah exacerbated the tensions in the Middle East and sharpened the debate about Israel. The contentiousness displayed at the NGO Forum itself was emblematic of the global dissension. Delegates not only marched from the Forum to the UN official meeting, but invaded the floor and demanded to be heard. The fracas resulted in the US withdrawing its funding for UNIFEM and INSTRAW.

Condemnation of *zionism* was actually included in the conference document, the Programme of Action. The United States, Australia, Britain, and Canada voted against the document because they could not accept language opposing *zionism*, favoring the PLO, and blaming the West for Third World underdevelopment. This vote embarrassed the women in the US delegation and upset US feminists.

Despite the political static, the Copenhagen conference produced the best researched document of the Decade. Secretary General of the conference and later the first woman to be named a Deputy Secretary General, Lucille Mair, engaged women scholars primarily from the South to write well researched papers on topics relating to women's work and development that became the basis for paragraphs in the Programme of Action. Regional meetings were convened to ensure inputs from women around the world. Emphasis was given to the importance of rural women's income to family survival; solutions included adopting appropriate technology to reduce their daily drudgery: fetching water, carrying firewood, pounding and processing food to eat. Other paragraphs called for improving their access to education and productive employment. Education is a central theme in **Vivian Derryck's** chapter which she helped promote as the executive director of the

U.S. secretariat preparing for the Copenhagen conference.

At the NGO Forum, organized by Elizabeth Palmer, a gathering place was set up by the International Women's Tribune Center where women could congregate and network. Panels included new topics such as women's health – as distinct from maternal health that had long been the sole focus. The volatile issue of domestic violence was discussed as a result of pressures by ISIS, among others; **Ana Maria Portugal** discusses this in her chapter. Women's studies was for the first time part of the Forum, organized by Florence Howe and Mariam Chamberlain. Networking during those panels provided the Feminist Press with new authors and produced an ongoing International Interdisciplinary Conference for Women.

Nairobi 1985: As plans for the 1985 World Conference to Review and Appraise the UN Decade for Women moved forward, everyone feared a repeat of the confrontation in Copenhagen. At the official UN level, **Letitia Shahani** was named Secretary-General of the Nairobi conference. Like Helvi Sipila, she had long been active in the CSW and sought ways to ameliorate the situation. Her efforts to ensure that consensus was reached on the conference document called the Forward Looking Strategies is recounted in her chapter.

US feminists feared that the US delegation might decided not to attend, wishing to avoid another confrontation such as Copenhagen. Some observes

believe that only when Maureen Reagan arranged to head the US delegation, was the US attendance assured. Still the US was adamantly opposed to agreeing to the inclusion of *zionism*. The Kenya government, with support from other African countries, pushed for a compromise in language in the early hours of the final debate, and the document was adopted unanimously.

The Kenya government was also determined to avoid disruptions at the Forum; police checked passes at each gate to the university campus where the NGO Forum took place, effectively controlling egress. Women in Kenya were also apprehensive about the reach of their government in controlling the Kenya delegation that was planning the conference.

Determined to avoid the confrontations at previous women's conferences, the international NGO committee, under the leadership of Dame Nita Barrow, began planning two years ahead. Chairing the Kenya committee for Forum 85 was **Eddah Gachukia**, who writes about her several roles and distinct observations in this as previous women's conferences. Seeking ways to reduce tension among NGO participants, the committee agreed with the Kenya government suggestions to start the Forum mid-week before the official conference thus limiting the overlap of the two meetings to a week. Many excursions to game parks and villages were set up to distract the participants. Several significant activities also reduced friction. The IWTC sponsored

an appropriate technology fair that was particularly intriguing to the many Kenya women who attended the Forum. Another was the Peace Tent, an innovative space where informal debates over *zionism*, the Iranian revolution, and apartheid took place. The emotional diatribes often gave way to embraces and tears.

A newly formed group of women scholars from the South, called DAWN—Development Alternatives with Women in a New Era, launched a report which has helped reframe the discourse of women and development. The report, and the panels in which its members discussed perspectives from the developing countries, gave voice and visibility the distinctions and similarities of women's struggles around the world. Questioning the emphasis on individualism among Northern feminists, they reassert the importance of family and community. At the macro level, they illustrated the connection between the feminization of poverty and international economic policies. **Devaki Jain** traces the origins of DAWN; **Peggy Antrobus** presents some of its more recent activities.

A series of panels emphasized the role of women in the environment; another documented the importance of housing for women, especially in urban squatter settlements. Population panels reflected a reversal of attitudes with the South declaring family planning a right while the conservative US administration had reversed its policy at the 1984 Population Conference in Mexico City.

Beijing 1995: Women's organizations locally and globally continued to lobby their governments about the importance of have another world conference to evaluate the progress achieved on the strategies proposed in Nairobi. Once again the host government, China, became apprehensive at the thought of thousands of feminists converging on their capital and influencing their women. **Kristin Timothy** was one of the major UN officials responsible for the Beijing meeting and recounts the political maneuvering with China over details of the NGO Forum.

When Chinese efforts to send the Forum to another countries failed, the Chinese concocted other means of control. Participants were required to register months in advance and pay a fifty dollar fee to cover the cost of a dog-tag they were required to wear; visas were only issued if the participant was successfully registered. The location of the NGO Forum was shifted to a muddy site 60 miles outside Beijing in Huairou; many buildings were unfinished when the meetings took place. Attendance by Chinese women was severely restricted, and each panel was assigned an observer expected to report to the government. Despite the rain and mud and surveillance, Huairou was an extraordinary experience. Not only did more women attend from all parts of the globe, but they represented the spectrum of women If all classes and education, from Indian dalits to Hillary Clinton.

In the decade between Nairobi and Beijing, four major world conferences

had been held in which women's presence and issues were significant: environment in 1992, human rights in 1993, population 1994, and social summit 1995. Most critical for women were the resolutions declaring that women's rights are human rights – inside the family as well as without; and that education and health care for women are the preferred approach to slowing population growth. Conservative efforts to restrict the scope of these resolutions were not successful at Beijing; rather the mantra "women's rights are human rights" has been indelibly etched on the world's consciousness.

Beijing + 5: The NGO community has sought the continuation of the mega conferences, but the cost and unruliness that characterized many has made both the UN and member governments chary of these events. Instead, five year reporting meetings have been introduced instead. Coupled with the shift away from the UN toward the global financial meetings, the plus five meetings have tended to focus on topical issues rather than political. Beijing + 5 was held in June 2000 in New York City. NGO events were scattered around the city, reducing opportunities for networking and effectively limiting opportunities for demonstrations.

However, years of experience have taught the women's movement more effective methods of implementing their goals. UN conferences were critical in raising women's issues globally and promoting networking. The psychological dimensions of this mobilization

process should not be underestimated. The four world women's conferences and the many events that surrounded them legitimated women's agendas and united women across ideological and national boundaries; **Jaqueline Pitanguy** demonstrates how these women's conferences encouraged Brazilian women to organize. The networking that grew out of these lobbying efforts and out of research and programmatic collaboration fed the global women's movement which has grown exponentially since the 1970's.

INFLUENCING POLICIES OF DEVELOPMENT AGENCIES

The resolutions passed at the Mexico City conference provided women with legitimacy when they lobbied for new offices within donor agencies to respond to the need for considering women's concern in all programs. Resolutions also stressed the importance of a women office or bureau, called a national machinery in UN parlance, within each country's governmental structure. Women's organizations pressed for such changes, often staffed these offices for a time, then returned to continue their efforts to influence policy through action research.

Economic development assistance flowed from UN agencies, bilateral aid from industrialized countries, and from foundations. Many authors in this book discuss their efforts, both working within the institutions and lobbying from without, to change development policies.

All argued that development programs as they were originally conceived were having an adverse impact on women by ignoring their economic contributions to their families and countries. Like many powerful ideas, the insight that development was undermining rather than advancing women's status was simple to explain once the right questions were asked. The stereotype of woman as housewife taken care of by a caring husband is largely a middle class myth; once women were considered separately as individual citizens and workers and their work enumerated, women's economic contributions to family and country were obvious.

Documentation was essential; many authors in this book pursued research in their own and new areas. Programs for women had to be developed and funding provided; other authors discuss their efforts to convince development assistance agencies and nongovernmental organizations to recognize that while women's concerns are distinct, women are, worldwide, the caretakers of children.

Within the UN, the two new agencies set up in Mexico City, UNIFEM and INSTRAW, were dependent upon voluntary contributions for their establishment and survival. Only recently has UNIFEM achieved a visibility commensurate to its mandate. Meanwhile, the UN Development Programme continued its small women's office, the International Labour Organization commissioned studies on rural women, and the World Bank established an office with **Gloria Scott** as its first director. When **Marilyn Hoskins** went to work for the Food and Agricultural Organization, she found that supporting women's issues within a sectoral division was still challenging.

Donor agencies set up new offices to initiate projects for women and to monitor overall programs. This dual function of separate programs and mainstreaming women and gender is both difficult to manage and essential for successful implementation of activities designed to improve opportunities for poor women or those marginalized by religion, ethnicity, or customary practices. Debates on how to balance these functions are discussed by many authors as they recount their careers within two bilateral agencies; **Arvonne Fraser, Jane Jaquette, Elsa Chaney, Kathleen Staudt** write about the setting up or the USAID Office for Women in Development; **Geertje Lycklama** reflects on the different approach that led to her posting at the Dutch Ministry of Foreign Affairs. For many years the Ford Foundation distributed as much or more funds than many countries, focusing on innovative or demonstration projects; **Cornelia Flora** discusses her work in Latin America.

Governments installed a variety of offices for women; many of our authors observe this process and how country offices were supported by UN regional offices and also the cross-regional Commonwealth. The challenges of coordinating women's issues within the Commonwealth with its

mix of developing and industrialized countries is recounted by **Dorienne Rowan-Campbell.**

RESEARCHING WOMEN'S GLOBAL ISSUES

The challenge to produce studies and data to support changes in international development policy led to the setting up of research centers in many countries, some attached to government centers or state universities, others free-standing. Perhaps the first was the International Center for Research on Women which **Irene Tinker** founded in 1976. **Devaki Jain** focused on women's issues in her Institute for Social Sciences; the WAND offices in Jamaica produced textured work on the Caribbean under **Peggy Antrobus'** direction. All faced the problem of summarizing academic studies so that the findings were accessible to policy makers. To bridge the gap between practitioners and scholars, Tinker later established the Equity Policy Center which worked with those carrying out projects. **Daniela Colombo** built on her media experience to promote women's international development, then set up AIDoS, an action-research center in Rome. Other organizations were awarded funds to carry out USAID projects. **Elise Smith** recalls efforts of the Overseas Education Fund, and then of Winrock International, to implement such projects. **Martha Lewis** tells of her experiences leading up to her work with Partners for the Americas.

On US university campuses, especially those land-grant institutions that received large USAID funding for agricultural development, WID offices were set up to ensure that women's concerns were integrated into such projects. **Kate Cloud** lead such an effort at the University of Arizona, then spearheaded a national effort. **Jane Knowles** portrays the intensity of resistence to including women found on many campuses. Teaching about WID soon followed; in contrast to the central control of curriculum within the higher education system in many countries, universities in the US are free to introduce new courses. An early advocate of such courses was **Elsa Chaney**. Like many of our authors, she returned to academia after her action years, as did **Cornelia Flora, Jane Jaquette, Kathy Staudt, Jacqueline Pitanguy, Geertje Lycklama, and Irene Tinker**. Two others have become senators: **Letitia Shahani** in the Philippines and **Geertje Lycklama** in the Netherlands.

CONCLUSION

In this book you will find how interrelated have been the lives of many of these early WID leaders, and how many roles each of them played. We have asked each of our authors to emphasize a few of the most significant actions she undertook in order to trace the expansion of the women and international development initiatives. But few stopped with one or two efforts; rather they continue to write and research and lead in many

distinct ways and in a wide variety of venues. What each author has revealed, and what should intrigue the reader, is when and how she reached that "a-ha" moment when disparate facts and ideas crystalized into a new path for thought and action.

CHALLENGING WISDOM, CHANGING POLICIES: THE WOMEN IN DEVELOPMENT MOVEMENT

WOMEN'S "YELLOW PAGES" LISTED nearly three hundred women's groups in Washington, D.C. in the early 1970s, more than in any other city in the world. The ferment stirred up by the second wave of the women's movement brought together professional women into a myriad of new organizations and networks. In New York City, feminist writers and artists promoted separatism to counter patriarchy in magazines, radio, and television. In contrast, we women in Washington worked with the government to change laws and regulations to improve the lives of women. The first national Women's Commission, convened by President Robert Kennedy in 1960 and headed by Esther Peterson, identified causes of inequality in the country. We lobbied Congress for change, testified at hearings despite the lack of good data, and marched in support of the Equal Rights Amendment to the U.S. Constitution. Issues we addressed included equal pay, equal access to professional schools, parttime work, and training programs for "displaced housewives" who had bought into the myth of male support in marriage. Groups formed to demand funding for rape counseling centers and to advocate improved health services.

We felt empowered. During those halcyon days, equality of women under the law moved closer to reality. The women's movement spread throughout the U.S. as states, and some cities, set up their own commissions on the status of women. Press coverage of women's events, which began as derisive, became more sympathetic and soon even the international press was reporting about the accomplishments of the newly energized women's movement.

BACK TO ASIA

During much of this time, I was teaching comparative government at two predominantly black colleges, Howard University and Federal City College (now the University of the District of Columbia) and managing my household of three young children and their father with considerable help from my mother-in-law. Choosing to work in these institutions reflected my commitment to civil rights, but also the limited opportunities for women in university departments of political science. The ingrained prejudices my colleagues endured forced me to examine my own status of white educated female and to understand both the privileges and limitations of that background. While the black bourgeoisie welcomed me, the

black nationalists made it clear that I had no place in their revolution.

I needed to update my international skills if I were to teach elsewhere. Economic development assistance for the developing countries was at its height; projects were expected to raise the gross domestic product of the country, with improved livelihood trickling down to the poor. My earlier research in India and Indonesia had focused on elections and legislatures. It was time to study the impact of development on the lives of the people. So in 1972, I returned to Indonesia to investigate the rapid urbanization and the explosion of squatter settlements.

While in Jakarta, I was asked to talk about the U.S. women's movement. In order to set our change in context, I needed to relate it to women in Indonesia. Yet almost nothing was written about women outside anthropological ethnographies. I began quizzing the Indonesian professional women I met about their own experiences; I began to talk to wives at receptions, something I had usually avoided on the assumption that housewives were not interesting! What I learned was that independence had brought a period of expanding opportunities for women that was increasingly narrowed as the growing middle class demanded jobs for their sons. Soon the Indonesian government was promoting motherhood as the ideal female occupation despite the traditional roles of women as entrepreneurs and farmers. This conservative attitude toward women was being legitimized

by actions of the development community that was exporting the same belief system we women at home were trying to change!

Was modernization actually hurting women? Was the promise of progress being turned on its head? Growing up in a scientific family where progress and technology were unquestionably good, to me this revelation was incendiary. This realization, that development was having an adverse impact on women, has shaped my life ever since. Indeed, this movement called Women in Development (WID) brought together strands of my life into a single focus: my predilection to organize friends for a purpose, my conviction all that people are equal, my belief that ideas could influence actions, and my curiosity about the world.

UNITING THE STRANDS OF MY LIFE

By eight years old I was organizing kids in the neighborhood to form an acting group when the boys told me I could no longer play softball with them. At twelve, when the Girl Scout leader refused to start a Sea Scout troop so we cold sail on the Delaware River, I found a sympathetic woman to head the new troop. Before my junior year in high school, we moved to Wilmington, Delaware. The public school system was segregated and weak, offering little academic challenge; instead I reorganized student government elections and arranged school dances for the teen

aged service men home on leave during World War II. More controversial was the social I organized for students from the four Y's: YWCA, YMCA, YMHA, and the Colored Y; my picture made the front pages of the local newspaper. This commitment to civil rights stayed with me when teaching at two predominantly black colleges in Washington, DC, or participating in the 1963 Mississippi summer voter registration campaign.

My college years at Radcliffe were an intellectual treat; the choral society was an inspiration, and I met talented poets and writers when we started a co-ed literary magazine. To raise money for the magazine, I even organized a fashion show for Mademoiselle Magazine the fall after I was one of their college editors. Only Spanish class gave me trouble. Though I had done badly on my College Board exam, I had insisted on taking second year Spanish; only the good will of the teacher allowed me to pass. By then I learned you could pass the language requirements for graduation by taking a test. So after working for two months as a waitress at Stouffers in New York City where I had worked the summer before, I took bus and train to Mexico City. Several marriage proposals later I bussed home again, memorizing word cards on the way, and passed.

This Mexican foray underscored my ignorance about the rest of the world. Harvard offered few courses dealing with contemporary foreign countries outside Europe. In Rupert Emerson's course on nationalism we read Nehru's *Autobiography*; five years later he granted

me a Sunday morning interview in New Delhi. A new course we called "rice paddies" introduced me to China and Japan; only many years later did I visit Shanghai where by husband was born. When Harold Laski, a frequent visitor at the home of my mentor Perry Miller, urged me to come to London School of Economics (LSE) for graduate work, I went.

The international atmosphere in London was intoxicating; my lack of knowledge about the non-western world was palpable. Politics were also exciting. I planned to study elections and the British parliament; when the second postwar elections were called for the spring of 1950, LSE emptied as we all campaigned. Laski caught pneumonia and died; without his dominant presence, political science at LSE lost its edge. Besides, finding a new angle for my dissertation was difficult. Why not study how the British institutions functioned in India? For a year I immersed myself in Indian history and politics while arranging, with two colleagues, to drive a tiny Ford Anglia to New Delhi across the Middle East in order to experience life in those countries. The atmosphere in the countries uncannily reflects many contemporary crises: unrest in Macedonia, tension in Jerusalem, international fights over oil, a nationalist government in Iran, and fighters on the streets of Kabul where we found the only paved roads in that underdeveloped country.

In India, I followed election commissioners around India from north to south as they held elections by state,

observing and studying the great democratic experience of their first general elections. Running low on money, I began looking for a job, but instead found a husband, Millidge Walker, who was working at the U.S. embassy. In the summer of 1953 we returned to London via Africa, driving in a new Austin from Mombasa around East Africa, then north to Cairo and across the desert to Tunis before taking a ferry to Italy. Colonial Africa was stirring; I met many leaders through my reporting for the Calcutta *Statesman*. Roads were worse than in the Middle East, and violence was simmering everywhere. Driving that route would be impossible today.

After receiving my doctoral degree from LSE, we drove the Austin through France, Spain, and Morocco; then from New York to Berkeley, California. I worked with the Modern India Project while my husband studied for his doctorate. His research took us to Indonesia for two years; in 1960, his teaching position at the American University moved us to Washington, DC. In 1965, three kids in tow, we revisited South and Southeast Asia.

Despite all this exposure to developing countries, I hardly thought about women as women: we are all equal, no? I had interviewed women members of parliament and leaders of political organizations, including Indira Gandhi. These were strong elite women, active in their independence movements. Gradually such women have been eased out as the more conservative middle class culture reserves political power to men, even when they promote a widow or daughter as a party leader. Today, women are finding their own turf by founding women's organizations.

ORIGINS OF WOMEN IN DEVELOPMENT

When I returned to Washington in 1972, I brought together women who had been in the field to discuss this detrimental impact of development on women; we formed a women's caucus of the Society for International Development, called Women in Development. Pushpa Schwartz and Patricia Blair, editors of the *Development Digest*, decided to publish summaries of the growing literature on the topic including Ester Boserup's book, *Woman's Role in Economic Development*, which had just become available in the U.S. Her work, and those of other authors, substantiated our belief that western forms of development, whether colonial or aid programming, were undercutting women's traditional economic activities.

Boserup traced the impact of increased population on agricultural technology which in turn altered agricultural systems in which women and men played distinct roles and fashioned an historical theory of stages of economic development. Our activist group focused on changing the way economic development projects were undercutting women's livelihood. The concept, once you think about it, is simple. It recognizes that globally most women, especially poor women, work. But

this economic value of women's work was overlooked because subsistence and farming activities, such as fetching water or fuelwood, working in the fields, or processing food, are not paid and so are not included in national accounts. In cities, women selling street foods or working as domestic servants are not counted either, though they do earn money. So the economists looked at statistical data that made women's work invisible, and focused their economic assistance projects entirely on men. Too often these programs also undercut women's ability to work and provide for their families.

The WID group organized a series of panels at the 1973 Costa Rica meeting of SID. Because we had missed the official application process for presentations, our three panels were scheduled at night. This turned out to be a benefit as no other panels competed with ours. Men as well as women attended, and once they realized that development programs affected women and men differently, the audience was convinced of the need for new approaches and projects that reached women specifically.

THE PERCY AMENDMENT

The next major event, in the fall of 1973, was at the Department of State. Virginia Allan, then the highest ranking woman in the Department of State, convened a briefing on International Women's Year in her capacity as the Assistant Secretary of State for Public Affairs. This was routine, but not the

fact that she added leaders of women's organizations around the country to the usual list of academics and journalists concerned with international affairs. Typical of such meetings, State Department officials lectured us about the United Nations, U.S. foreign policy, and the UN International Women's Year and conference with its three themes: equality, development, peace. The audience grew restless. Women in these new egalitarian organizations were used to interacting and criticizing; leadership was suspect. Finally a women from out of town, rejecting the niceties of the setting, blurted out her complaint, punctuated with four letter words, that State was putting us on, that there would be no time for discussion. The shock of her words was palpable. Allan rose to the occasion saying that everyone who wished to talk would be able to: the meeting would continue several hours beyond the scheduled close and would meet again at eight a.m. if necessary. Next morning my turn came to expound on the "detrimental impact of development on women."

Meeting with Allan later that day were Mildred Marcy who was head of the U.S. Information Agency (USIA) women's programs and Clara Beyer, a venerable civil servant on loan to State from the Labor Department. Aware that Congress was at that moment debating a New Directions foreign assistance bill that would refocus development policy from infrastructure development toward basic human needs of people, Beyer asked Marcy if something about

women could not be added to the bill. This germ of an idea eventually became law in a manner I now recognize as typical but which did not fit anything I had been taught in political science textbooks. Marcy, encouraged by her husband who was the chief of staff for the Senate Foreign Relations Committee, drafted an appropriate paragraph and considered which Republican senator (in this Republican administration) might be willing to introduce an amendment. She enlisted the help of Scott Cohen, Senator Charles Percy's foreign relations assistant. It was Cohen who reminded Percy as he was rushing for a plane on Friday, October 2, 1973, that he promised to introduce the amendment. His colleagues, aware no appropriations were called for and perceiving the bill as a gesture to women, passed the amendment by voice vote.

The entire foreign assistance bill was passed later in the day and was sent to conference committee. Because the Percy amendment was not in the House of Representatives version, Arvonne Fraser, a committed feminist and activist, had also been at the State Department briefing, and convinced her husband, Representative Donald Fraser, head of the House Foreign Affairs Subcommittee on International Organizations and Movements, to add a session on the status of women to a series of hearings he has already scheduled on the international protection of human rights. The speaker who proceeded me, head of the Department of Labor's Women's Bureau Carmen Maymi, had just returned from a tour of Africa and was appalled that official statistics showed that only 5% of women were in the labor force. The contrast between such national data, counting only women working in the formal labor force, and the reality of African women subsistence farmers, who raise some 80% of food for the continent, clearly illustrated the need for the amendment.

The conference committee, thinking of the amendment as "apple pie and motherhood," threw it out. Two types of lobbying saved it: political pressure and information. Mildred Marcy alerted Virginia Allan, then in Hawaii at a convention of the Business and Professional Women; as a result, women from all over the country deluged Congress with telegrams. Marcy herself was active in League of Women Voters and stirred up more support. That these were mainstream women's organizations was critical as they were harder to ignore than the more strident newer women's groups who were already busy trying to defeat the Hyde amendment that prohibited the use of USAID funds for abortion use abroad. Lower key, but critical to increasing support for the amendment, were the calls I made to staff of every member of the conference committee to explain how current policies were unfair to women while the amendment would make foreign assistance programs more equitable. All this lobbying was successful; the amendment reinstated, and Senator Percy became a staunch supporter of WID. In 1974 he introduced a

similar resolution into the UN General Assembly and headed the delegation to the first UN conference for women in Mexico City in 1975. He assigned one of his staff, Julia Chang Bloch, to oversee the implementation of the amendment in USAID; subsequently, when Bloch held high level posts in USAID and served as US Ambassador to Nepal, she remained a strong WID advocate.

GOING INTERNATIONAL

In January 1974, I was appointed a US delegate to the UN Commission on the Status of Women meeting in New York City as an advisor specializing in development. Arvonne Fraser was also an advisor but on domestic issues. We were quickly immersed both in the planning for the 1975 International Women's Year (IWY) and conference, and also in UN politics and procedures. The clarity of the WID argument, buttressed by the 1971 Expert Committee Report on women and economic development which Gloria Scott had organized, not only influenced the Plan of Action for the IWY conference but also resulted in resolutions for integrating women into development programs being introduced into working plans of most of the UN agencies in addition to the General Assembly.

At both UN world conferences held in 1974, one on population and one on food, women formed ad hoc groups to draft and lobby for additional paragraphs about women in the respective Plans of Action. At every subsequent world conference, women with increasing sophistication, inserted language concerning women's work and responsibilities into the appropriate sections; I personally attended three of these conferences: on population in 1974, on science and technology in 1979, and on new and renewable energy in 1981. I was also an NGO representative at all the four world conferences for women. At all seven conferences I participated in panels at the NGO Forums and lobbied delegates at the official conferences.

In direct policy terms, I believe that women's concerns are most readily accepted by the global political establishment when arguments are made in specific terms. Energy and environmental specialists understood the critical activities of women in collecting and burning firewood and responded with new forestry plans and new types of cookstoves. Agriculturalists began to introduce new crop varieties to women. In contrast, debates on women's concerns at women's conferences were often manipulated by the male power structure pursuing a political agenda. However, women's conferences, especially the NGO Forums, provided a marvelous space to meet and exchange ideas with women from every country in the world. The networks formed at these meetings promoted the global women's movement that has influenced all levels of society more profoundly than any other social movement in the twentieth century.

AAAS SEMINAR IN MEXICO CITY

In 1972, I became the first director of

International Science at the American Association for the Advancement of Science. Working with a committee of eminent scholars headed by Margaret Mead, we produced a report on the cultural aspects of population change for the population conference that influenced population policy and research for many years. Mead took me with her to Bucharest to help present the findings: her efforts were vivid illustration of the power of ideas.

This experience convinced me that AAAS should produce a similar report for the International Women's Year conference. Compared with the extensive literature available on population, there was a dearth of data on the impact of development on women for the staff to review. To add to this literature, I proposed a pre-conference seminar on WID, asking participants to produce new research or reports; the idea was supported by Margaret Mead, then president of AAAS.

Seeking funding for the seminar, I turned for advice to the few women staff members of major foundations in New York City. Joan Dunlop at the John D. Rockefeller Fund organized a meeting of funders where I could meet them at one time. These women were marvelously supportive; many attended and contributed to the seminar. The United Nations Development Fund (UNDP) and the United Nations Institute for Training and Research (UNITAR) became co-sponsors of the seminar and provided both recent studies on women and invaluable advice. They rightly

insisted that the seminar must have simultaneous interpretation, despite the cost, and warning of inevitable political posturing, suggested tight scheduling, especially for the final plenary meeting. Their suggestions helped the Seminar on Women in Development avoid the acrimony that characterized many subsequent meetings on the topic. Sponsorship by AAAS, a well known international scientific organization, added to the prestige of the seminar; the AAAS counterpart in Mexico, Mexican National Council of Science and Technology, assisted in local arrangements.

In Washington, I hired a Danish scholar, Michele Bo Bramson, to head the project. She in turn gathered a team of recent graduates to collect and summarize all available literature. Lead researcher Mayra Buvinic prepared the annotations for publication. Once the project was over, this invaluable collection was moved to the International Center for Research on Women which I had founded in 1976 to monitor the implementation of the Percy Amendment. Buvinic also joined ICRW where she provided outstanding leadership as director for twenty years.

What is hard to comprehend in this day of instant communications, is the difficulty we had in identifying participants for the seminar whom we wished to be representative of all regions of the world. Michele and I contacted women's organizations, professional associations, foundations, and government agencies as well as our funders and co-sponsors for names and addresses.

We cross checked names as many references were only a name. The official invitation was sent by mail; the letter stated that each participant was expected to provide a five page case study that would then be translated for distribution in French, Spanish, and English; several eminent scholars wrote background papers to lead the discussions. Eventually, ninety-eight women and men from fifty-five countries arrived in Mexico City to attend the seminar held during the week preceding the First UN World Conference for Women.

AFFECTING POLICY

The impact of the seminar was immediate. Background papers and workshop reports were distributed at both the official UN conference and the NGO Tribune. Ten of the participants were on official delegations while over thirty gave presentations at the Tribune. Several recommendations of the workshops were incorporated in the World Plan of Action, the official document of the conference. Notable among these were provisions concerning women's access to credit, a concept now at the heart of most poverty alleviation programs worldwide. Esther Ocloo, a dynamic business woman from Ghana whom I called the "marmalade queen" because she began selling orange squash and marmalade, was a passionate advocate of the need for credit and became a board member of Women's World Banking. The provision that the number of women in national delegations to the UN and other international forums be increased was quickly implemented, but another critical provision stressing the importance of incorporating women's needs urban and housing plans, still requires much greater support. The seminar made delegates aware of the need for further research on women, and established the International Research and Training Instituted for the Advancement of Women (INSTRAW). A fund for women, later the UN Fund for Women (UNIFEM), was also set up to provide funding for women's organizations at the local level. UNIFEM has become a major center for international women's activity and documentation; its evolution is recounted in this book by Margaret Snyder.

Because raising funds for research is less compelling than assisting poor women, INSTRAW has struggled to find its place in the UN hierarchy despite that fact that is the only women's organization with a seat in the General Assembly. I was a member of the first board of directors and have continued to consult with them. Some years later I set up the US Council for INSTRAW to publicize its activities and increase its funding from the US government.

INFLUENCING DEVELOPMENT PROGRAMMING

To this point in my life I had acted as journalist and scholar: interviewing, studying, writing. I thought that if bureaucrats were provided with significant

information about how their projects were adversely affecting women, they would immediately alter their approach and change their projects. A brief stint in government as a presidential appointee under President Jimmy Carter, as Assistant Administrator for Research in ACTION, convinced me otherwise. As committed as I am to incorporating women's concerns into policies and projects, I had great difficulty in influencing policies in this small agency that then encompassed Peace Corps, Vista, and other volunteer activities. Convinced my comparative advantage was working outside government, I resigned and set up an action-research center, the Equity Policy Center (EPOC), designed to consider the needs of men as well as women and to be involved in evaluating and implementing projects.

At EPOC we followed the vicissitudes of development policy. Demands for short term results led many development agencies to pursue the "flavor of the month" trying to find new solutions for new issues. The various UN world conferences often supplied these new issues. Wherever possible we supplied a women's viewpoint, to technology or energy, to health or housing, presenting papers and reports at UN and scholarly meetings, inserting paragraphs about women at the topical UN world conferences, and consulting on actual projects dealing with these issues. Underlying most of women's needs for appropriate technology or improved cookstoves is their shortage of time: women everywhere work a double day,

working for money or subsistence, then coming home to their household responsibilities. Many add to the strain on their time by caring for the elderly or organizing for community improvement. Efforts by many nongovernmental organizations (NGOs) abroad to increase women's income were based on sewing or knitting skills perhaps appropriate in the west but unknown to African farmers or Asian rice growers. These craft activities seldom provided adequate income for the time worked.

Instead of looking for income activities that might be introduced to women in developing countries, I decided to study ways that women already earned a reasonable income and focused on women selling food on the street. Little data existed, for "snack foods" were dismissed as a trivial part of the informal sector. So I coined a new term, Street Foods, and proposed studying the entire process of who makes, sells, and eats foods on the street; the challenge was to identify possible interventions that could improve the income of the vendors or improve the safety of the food sold. EPOC directed studies in provincial cities of seven countries and provided our methodology for studies in two other countries. The social construction of gender in these different countries dictated whether women or men were the predominant vendors. In both Nigeria and Thailand, women number over 90% of vendors. In contrast, in Bangladesh few women were seen on the streets, but because women assisted their husbands in producing the street

foods, we concluded that women were in involved in 36% of the enterprises. The cooperation within the family was significant in Asia and Egypt, something we had not expected to find; this contrasted with the tradition of separate budgets in the African countries. These findings are significant both for development planning and for women's studies.

The policy implications of the study were immense. Our data underscored the importance of street foods in the economies of the cities as well as to the diet of the people; trying to get rid of vendors simply was not possible. The Food and Agricultural Organization (FAO), which had been advising governments to crack down on vendors unless they met impossibly high health standards, switched its approach to one of working with the vendors, educating and organizing them. Municipal officials were amazed at the economic value of the enterprises and rethought their adversarial position; some set up areas for vendors replete with clean water; the major source of contamination of foods came from poorly washed plates and utensils. The street food study also challenged much of the conventional wisdom concerning the informal sector.

As funding for WID research diminished during the Reagan administration, I returned to the university to teach and write, translating my new understanding of development and women into academic terms. *Persistent Inequalities: Women and World Development* presents the accumulated knowledge of two decades of research on WID from diverse theoretical perspectives and includes chapters by both Ester Boserup and Amartya Sen. As a professor of City and Regional Planning at the University of California-Berkeley, I wrote about the distinct needs and uses by women of housing and about the growing influence of nongovernmental organizations. Academia lags well behind the development community in its incorporation of women's perspectives into all aspects of research and planning. It is for this audience that I continue to write about the differential approaches of women and men toward values, goals, and livelihood. Much needs to be done by activists and practitioners as well as scholars if gender equity is to be achieved. Still our generation filled the glass at least half full.

MANY PATHS TO POWER: WOMEN IN CONTEMPORARY ASIA

THE WOMEN'S MOVEMENT, CLEARLY THE most influential social movement of the last century, has empowered women in most countries around the globe. By joining together, women at all levels of society are enhancing their capabilities, exerting their influence, and making their own decisions within their households and their communities. Utilizing this base of growing power and knowledge, many women are increasingly seeking seats in formal political institutions. However, the way women are wielding this growing power to build new societies varies widely and produces different patterns around the world. Such diversity arises from the cultural and religious characteristics of the societies in which they are embedded, as well as from the colonial and post-colonial economic and political systems of the countries in which they live.

Asia today illustrates the commonalities and diversity of women's paths to power. Given the broad and often contradictory trends among the countries and the ambivalent attitudes toward gender equality by women and men alike, any broad assessment of the region is impossible. Instead, to illustrate both the various approaches utilized by women's organizations and their achievements and problems, I have identified four distinct patterns that exist: in China, South Asia, Southeast Asia, and South Korea. In each area the underlying culture with its overlay of religion, colonialism, and governmental system limit the choices available to women. A template exists to assess empowerment by noting how women use their power: enhanced services –from water to health to education— for their communities and families; greater opportunities for providing livelihood for themselves and their children; increased gender equality in household, community, and national decision-making; freedom from violence.

How women seek to achieve such goals varies, but increasingly they utilize women's organizations directly or indirectly to reach accomplish their objectives. National organizations often focus on legislation that would expand women's rights: to work, to divorce, to own land, to receive inheritance, and to give recourse to violence against them. But laws only indicate the direction of change which must come about through efforts of women themselves, uniting together. Their goals may be welfarist, but their methods require agency. In early days of organizing, perhaps, agency was exhibited primarily by the elite leadership; but increasingly

women at community levels are startling observers with their actions. An analysis of these paths provides explanations of the different ways women use power and suggests directions of their future empowerment.

FOUR ASIAN PATTERNS

The context within which women's organizations function explains their diversity. Hinduism, Buddhism, and Confucianism originated in region; Islam and Christianity arrived before Columbus sailed to the New World. All have adapted to local cultures as they spread. The migration of peoples throughout Asia is complex and contested, but patterns persevere. Societies in Asia have traditionally been stratified and, despite their constitutions which grant equality to all women and men, class and caste distinctions persist along with patriarchal dominance. India and China historically embodied a patriarchy that did not value women. Separating these civilizations were mountains filled with migrant tribes whose subsistence activities promoted greater equality. From Ladakh through Nepal, Bhutan, and Burma these groups provide a different gender pattern which has spilled over into much of Southeast Asia. This pattern is characterized by greater gender equity in land ownership and in commercial activities.

Asia was also influenced, if not actually controlled, by a spectrum of colonial powers that imposed different values and governing systems. While the British were the dominant force in the region, France, the Netherlands, Japan, and the United States instituted their own colonial versions of society and commerce. Generally, the prevalent attitudes of the male expatriates reinforced existing patriarchal strictures. Colonial powers and missionaries also introduced western education for girls as well as boys, and so produced a cadre of elite women who became leaders in their countries' national movements. Most of these national movements were socially conservative; women involved in independence struggles did not make demands for change in women's social status. Even where education was made compulsory, by the US in both the Philippines and South Korea and by the communist Party in China and Vietnam, women's activism was conditioned by culture and religion.

Post World War II Asia was a devastated region. Fighting continued in Indochina and Indonesia as nationalist battled the returning colonial powers; Britain and the United States set dates for independence of their former colonies. Famines plagued India that had been pushed further into turmoil by the Partition which created Pakistan. In China the communists defeated the nationalists, then spread their influence to neighboring countries. First in Korea, then in Vietnam and Laos, foreign troops joined the fray. Poverty was pervasive; governments addressed the issues of food and of security in different ways. Most created Five Year Plans;

in none of them was women's economic contribution recognized.

Present government systems in the various countries reflect both the colonial past and the education of the leaders. Thus Fabian socialists in India have promoted greater gender equality through politics and planning. In contrast, the socialist leader in Indonesia Dr. Sjahrir, brought back from Holland the emphasis on women as mothers, a view that continues to constrict women in Indonesia. With the exception of communist countries, post-independence Asian countries preserved many elements of customary and family law which limited women's rights; yet even though new constitutions in the communist countries proclaimed women and men as equal, the gap between ideology and reality remained immense, especially in China. Efforts by contemporary women's organizations throughout the region are addressing these inequities in many imaginative ways that go beyond legal changes. In contrast, in China, Laos, and Vietnam, women are organizing to maintain their legal rights in the face of patriarchal resurgence as their economies open to market forces.

A majority of women leaders are drawn from the educated elite who, in stratified societies, rank above men of lower caste or class. In many Asian countries elite women have had a history of organizing and even protest, though such activity was often part of broader social or political movements. What is new about women's empowerment today is its penetration to the community level in both rural and urban areas. Such change is a direct result of governmental efforts to modernize their economies. Hesitantly most government planning offices, pressured and funded by international assistance agencies, began to include women into the development process. Local and international nongovernmental organizations –often led by women– were instrumental in reaching poor women. Whatever the program goals, women were formed into groups. In many Asian societies the mobility of rural women has traditionally been extremely limited; and Asia was predominantly rural fifty years ago. Allowing, even requiring, these women to leave their household compounds for reasons other than work in the fields, and to meet together had an extraordinary impact of these isolated women. Women's agency came slowly, impelled by consciousness raising; the male decision makers seldom noticed.

Once again outside influences affect national policies as international and bilateral development agencies with their packages of projects designed to achieve economic development. Too often such programs fail to differentiate among recipient countries or to adapt to local circumstances. Such is usually the case when the goals relate to women because their status within each society is embedded, as we have stressed, in the religious and cultural practices and in the history of women's activism and education. Further, the priorities given by different countries among the palette of development programs – health, education, family

planning, agriculture, industry, informal sector, credit, community development – produced distinct patterns of modernization. The method of implementation and the strength or weakness of civil society contributed to these very different patterns.

As women have been incorporated into development planning at the community level, elite women became involved both in these efforts and in the burgeoning global women's movement that was facilitated and sustained by the United Nations world conferences on women beginning in Mexico City in 1975. Rapid economic transformation dislocates societies; changing women's roles have often produced a backlash from male leadership as women's traditional subservience vanishes. Male leaders in many countries have conflated nationalism with a return to tradition that privileges male dominance. Vina Mazumdar finds that such anti-modern efforts are based on "a romanticized view of that traditional culture that is often quite divorced from historical reality. When played off against the negative consequences of Western-style development, however, such romantic images have power appeal" ("Gender issues and educational development in Asia," in *The Politics of Women's Education: Perspectives from Asia, Africa, and Latin America.* Jill Conway & Susan Bourque, eds. 1993.) Many Asian women themselves are challenging modernization paradigms and the values that support them. These leaders are utilizing the concepts of women's equal rights while

also inventing new institutions for economic fairness and promoting new approaches to family and community that they believe are more appropriate to their cultures and values.

KOREA: FAMILY PLANNING AND UNIVERSAL EDUCATION

When Japan surrendered to the US in 1945, the Japanese occupation of Korea was at an end. But after communism triumphed in China, communist adherents in the northern part of Korea took over the government and invaded the south. United Nations troops joined the US government in fighting the invasion and secured peace in a divided peninsula. The Japanese had reinforced the existing Confucian patriarchal system, impressed Korean men as workers in Japan, and seized many unmarried women for service as comfort women. The nationalist movement that arose was therefore not directed against European nations or the US.

The cessation of hostilities in South Korea found a small country ravaged by the war, houses were destroyed in both rural and urban areas, the land was nearly devoid of tress, and farming was still largely subsistence. For many years the Korean military governed the country with the complicity of the US. Authoritarian political rule was reenforce by Confucian tradition that made women subservient to men, and men to rulers. To promote rapid economic transformation, the

government determined to reduce population growth and create an educated workforce. Both policies altered the traditional lives of women in Korea.

To carry out efforts at birth control, adult women were formed into Mother's Clubs which met monthly to receive their allocation of birth control pills. All women of the village were required to attend. Dispensing the pills were educated urban women who imparted much more than pills as they taught the women about health and sanitation, and spoke about current events. These clubs responded to the government pleas for tree nurseries in order to reforest the hillsides. Some clubs not only sold the seedlings but planted trees as well. Profits were used by the members as a group. Imagine the liberating emotions of a compound-restricted woman who suddenly has the opportunity to go on a pilgrimage to a Buddhist shrine on a train!

The emphasis on reduced family size was a success: the fertility rate fell from 6 children per woman in 1960 to 1.6 in 1990. But pills are not widely used because those available in the 1960s produced many side effects because of their hormonal strength. Female sterilization is the primary method used; abortion is also high. Recently, ability to predict the sex of a fetus has resulted in a higher ratio of boys to girls born; this male preference is more pronounced after families already have daughters. Thus perversely, the ability of women to control their fertility has reinforced patriarchy, at least temporarily. But the organizing of

women opened worlds for women to explore, particularly as the country rapidly urbanized: 28% of the population was urban in 1960, 75% in 1990.

Government efforts to create an educated workforce began with the 1948 constitution which introduced universal education. Girls had to attend school and so were no longer available to help their mothers with the onerous chores of rural subsistence living – a trend that encouraged urbanization. This literate work force of young women became the foundation of later industrial development despite lower pay than men and deplorable working conditions in many factories. In the 1980s spontaneous rebellions began to break out in free export zones where unions were prohibited. Despite government support for industrialization, reality in the factories was chilly because women were called by derogatory terms by men; once married most were required, and usually anxious, to leave and become a dependent housewife. By the late 1980s, active lobbying by Korean women's groups led to Equal Employment Act; but the intent of this progressive law was subverted by tradition.

Similarly, access to education for women has had mixed benefits. In-ho Lee complains that without women in educational administration and curriculum development, education has stressed conformity so that an inverse relationship exists between the level of education and workforce participation ("Work, education, and women's gains: the Korean experience," in *The Politics of*

Women's Education: Perspectives from Asia, Africa, and Latin America. Jill Conway & Susan Bourque, eds. 1993.) For university graduates, few opportunities are available, especially after the 1998 economic crisis. Many families still see higher education for women as a means to attract a higher status husband.

Women's activism

Korea's constitution, drafted under American tutelage, granted women equality – as did most constitutions of newly independent countries, without any significant demand for this privilege. Previous women's activism was related to nationalist struggles or to rights for practicing Christianity which challenged the Confucian order. The contemporary women's movement in Korea came, according to In-ho Lee, "from imported academic feminism and the political context of grass roots demands to secure basic human rights." (op. cit.) During the 1970s the focus of women's movement was on improving the situation of women in factories. As more women's groups appeared, the government set up Special Commission on Women under the prime minister and created a Women's Development Institute. Judged ineffectual by women activists, the Institute did offer employment to university educated women who wanted to work; studies that emerged fueled the emerging advocacy groups. To gain greater visibility, these groups, in 1989, formed the Korean Women's Associations United and helped ensure

the passage of the Family Law Act in Dec 1989. The law finally brings family law under the constitutional provision of equality by granting women equal inheritance rights and provides for courts to decide custody rights of the parents. Efforts to mitigate the oppressive nature of customary practice took over three decades, a effort spearheaded by Lee Tai Young, a lawyer and founder of the Legal Aid Center for Family Rights soon after independence.

Women's power in Korea is still constrained by Confucian beliefs and traditional practices. The rapid economic transformation of the country from subsistence agriculture to an industrial urban nation did not purposefully liberate women. Cracks in patriarchal control began slowly with the Mother's Clubs but it was the plight of industrial workers that brought international activists to Korea to work on their behalf. Educated women, activated by international contacts and women's studies curriculum, organized rights groups that addressed Korean specific inequities. Their role in formal political institutions remains minimal although since the election of President Kim Dae Jung two women were appointed ministers in the government and In-ho Lee became the first female ambassador, to Russia. Sasha Hampden concludes: "The greatest influence women have on the political decision-making process derives from the activities of pressure groups that have effectively mobilised public opinion on women's issues." ("Rhetoric or reality? Contesting definitions of women in

Korea" in *Women in Asia: Tradition, Modernity, and Globalization*. Louise Edwards and Mina Roces, eds. 2000.)

SOUTH ASIA: DIVERGENT PATHS TO ORGANIZING LOCAL WOMEN

South Asia as a region was conditioned by nearly two centuries of British colonialism. Its society is still highly stratified as a result of the influence of the Hindu caste system which has also permeated both Islam and Buddhism as locally practiced. Many elite women and men were educated in English schools and adopted some of the values of the west, particularly regarding law and governance. While the British granted independence to the sub-continent following World War II, only Sri Lanka escaped riots and killing as India was partitioned into two countries. The remote Himalayan kingdoms of Nepal, Bhutan, and Sikkim had been under different forms of British control which India assumed. Only Sikkim has been integrated into the India state.

Women in contemporary India are active in a panoply of organizations that encompass dam building, land and forest rights, pavement dwellers, home-based workers, wife-burning, and much more. Their skills have been honed by nearly two centuries of involvement, first in efforts to reform Hinduism and then in the nationalist movement that demanded independence from Britain. Early women leaders represented the growing middle class whose members were drawn from the three upper castes; they sought western education as well as reforms of cultural practices such as *sati*, child marriage, and a ban of widow remarriage. Some "modernist" Muslims supported education for Muslim women despite the prevalence of purdah, or the seclusion of women. Schools for girls in Sri Lanka were first started under the Dutch, then renewed by the British, in both vernacular and English languages. In all these countries, education of women was stressed, not to create an equal citizens but to help women fulfill their roles of wife and mother in a household headed by western educated men. Thus schooling for girls emphasized domestic skills and generally stopped at puberty.

By the end of the nineteenth century, South Asian men were enrolling in British universities; soon women followed. Study in England exposed women to the wide range of civil society organizations; on their return some started their own associations with both political and social goals. In 1926, the All India Women's Conference (AIWC) was formed to provide a nation-wide platform for women. By 1930, groups demanding improved working conditions for women workers in textiles factories and mines convinced the AIWC to hold a special session on labor practices. But generally, these elite women emphasized religious reform, education, and suffrage that were of most concern to their own classes. Commenting on this history of women's participation, Kumari Jayawardene writes that "The

most revealing aspect has been the essential conservatism of what on the surface seemed like radical change...women were kept within the structural confines of family and society" (*Feminism and Nationalism in the Third World.* 1986.)

Critical in changing these prevailing attitudes of organized women in South Asia was the influence of Mahatma Gandhi. He questioned many of the values of industrialization, and did so by wearing khadi, or homespun cloth; he lived in villages and among the untouchables and Muslims, countering caste and religious taboos; and he reached out to the entire country with his non-violent protests against the British. Muslim and Hindu women and men, many from abroad, joined Gandhi in his ashram. In the spring of 1930, Mahatma Gandhi launched a salt satyagraha to protest a government tax on salt: women and men walked to the Gujerat coast and began illegally to make salt. The photographs of Indian women being arrested in this and subsequent protests helped create sympathy in Britain for Indian independence. Throughout the 1930s, as demands for self-government escalated, many Indian women withdrew from leading women's groups and focused on non-violent protests. Experiences in jail converted many of these women into strong political figures who took leadership roles in independent India. Equally important, Gandhi's legacy gave moral legitimacy to women and men for working with the poor.

As possibilities for the end of British rule grew, so did communal tensions between Hindus and Muslims. In the AIWC, Muslim women formed their own groups and by 1944 had withdrawn entirely from its membership. Although both India and Pakistan declared themselves secular and passed bills to improve women's rights, because the reason for Pakistan's existence was Islam, religious conservatives grew in power in Pakistan and by 1977 the Islamization of the country had begun. Prior to that time, citizens in East Pakistan had began protesting repressive military actions and their treatment as a colony of West Pakistan. In 1971, the province fought for their own country; the new constitution of Bangladesh granted women equal rights in the public sphere.

Independence and economic development

In independent India, women formed new types of organizations to support women's equality as enshrined in the constitution. The country was suffering from destruction both from World War II and the Partition that created Pakistan out of British India; famines seemed endemic. International agencies poured economic development funds into the country, promoting a paradigm that rendered most women's work invisible. In response, women founded both research centers and activist groups to address the often detrimental impact of development programs on poor rural women. Women's work in subsistence agriculture and household production

was documented; the appropriate technology movement designed small machines such as grinding mills to alleviate drudgery and promoted new cookstoves; to introduce such innovations, women had to be persuaded. Like the community development policies which were designed to increase agricultural production and improve health status in the villages, changes from traditional practices did not work without the inclusion of women. Caste and patriarchal dominance in these villages required the setting up of separate women's groups if women were to participate in the development projects.

Once organized, such groups took on issues of local concern from setting up income producing activities to growing their own fodder for cattle on land they fenced off from cattle of better off villagers. The emergence of the Chipko movement, women in the Himalayan foothills who hugged trees to prevent their harvesting, documented the negative consequences of rapid economic growth not only on the poor, but also on the environment. Recognizing the indigenous knowledge of such women about the sustainable uses of field and forest, women have organized to support traditional agricultural practices in Ladakh, and elsewhere, against high dams that would deprive many peasants of their land, and against "biopiracy" of golden rice or the neem tree. In Bihar, local women organized to obtain land in their own names.

Increased radio and television coverage of such events spread the word, and soon spontaneous groups of village women arose protesting local inequities. Women in hill tribes in Maharashtra shamed husbands who beat their wives by banging kitchen pots outside the offending man's house. Dalit (formerly called untouchable) women joined with devadasis (temple dancers) to protest the dedication of girls to serve in temples as "brides" of the gods – a sort of sanctioned prostitution. In central India local women challenged government sanctioned toddy shops because cheap liquor was increasing domestic violence while encouraging their husbands to spend their paychecks on the liquor; the shops were closed.

In cities, women earning livelihoods as vendors or home-based workers were organized into the Self Employed Women's Association (SEWA) in Ahmedabad (Jhabvala 1994) and in Madras (Chennai) in the Working Women's Forum. These large organizations, which support urban and rural poor women, were started and led by charismatic women. In contrast, similar groups in Bangladesh, Grameen Bank and BRAC, were started by and continue to be run primarily by men. In Sri Lanka the major early community development organization, Sarvodaya, was also headed by a man. While the empowering effect of forming women into groups is similar, the lack of women in provincial and central positions illustrates the different trajectories taken in South Asia outside India and may be traced to the influence of the Gandhian movement that

encouraged elite women to work with the poor. Men trained in the Gandhian tradition worked with rural poor in both Pakistan and Sri Lanka; but their organizations, like that of Gandhi's, remained largely patriarchal. Increasingly, however, women's organizations in Bangladesh and Sri Lanka are forming women-only organizations themselves to work with the urban and rural poor. In India, women activists, legitimized by the Gandhian tradition to work with the poor, were emboldened by the women in development movement to work toward women's empowerment under female leadership.

Parallel efforts for women's rights

In all the countries of South Asia, elite women continued their efforts to reform religious limitations on women's equality that had been guaranteed by their constitutions when secular leadership was dominant In India, violence against women was the roots of campaigns directed against alcohol, the rape of lower caste and tribal women by landlords and police, and wife burning. These abominations occurred among all groups in the society and women of all religions and castes joined efforts to eliminate them. Over time, however, more conservative elements, both Muslim and Hindu, began to influence politics. This trend was evident when, in the mid-1980s, a Muslim woman sued for support payments under civil law and the courts gave precedence to

Muslim family law, effectively removing Muslim women from many protections in the constitution. The rights of Hindu women were challenged by the *sati*, widow immolation, in Rajasthan which appeared to be more like a murder than self-sacrifice. During the 1990s and continuing today, increased communal violence has underscored the range of political and social views held by women as well as men. Identity politics led scholars to deconstruct the categorization of an Indian woman as an urban middle-class Brahmin. They conclude that the deep class and caste divisions in Indian society have inhibited the emergence of a unified feminist movement. But women are making their voices heard throughout the social, political, and religious spectrum; diverse groups took these issues to the Fourth UN Conference on Women held in Beijing in 1995.

In Pakistan, nationalism has led to a resurgent Islam that continues to contend with the modernist educated classes; most active women are both modernist and upper-class creating a chasm between their lives and those of the largely illiterate poor whom the educational system does not serve. The women's movement was energized and radicalized by the *Hudood* Ordinances put in place by the military regime of General Zia ul-Haq in 1979 to placate religious extremists. These ordinances superceded laws inherited from the British and enforced traditional Islamic punishments for adultery, rape, prostitution, etc. Farzana Bari and Saba Gul

Khattak record the difficulties of the largely middle class movement to challenge issues of family law, especially when they are seldom affected by extreme application. Rather, they argue, that the present women's movement in Pakistan "engages with the state to negotiate increased space and rights for women in the public and private arena through affirmative actions but not through direct political activism via party politics." ("Power configurations in public and private areans: the womens movement response," in *Power and Civil Society in Pakistan,* Anita Weiss & S. Zulfiqar, eds. 2001.)

Instead of directly confronting family issues, many women leaders have set up or work with NGOs that are largely foreign funded to reach out to poor rural and urban women with programs about political empowerment, reproductive rights, and violence against women. Terming this flow of talent the "NGOization of the women's movement," Bari and Khattak conclude that these increased services must be weighed against the undermining of the movement's independence (op cit.) The ability of NGOs to provide services is also questioned because a majority of microfinance programs have funded middle and upper class women, not the poor. But Anita Weiss argues that promoting microcredit in the walled city of Lahore has empowered these poor women. ("Within the walls: home-based work in Lahore," in *Homeworkers in Global Perspective: Invisible No More.* Eilene Boris & Elizabeth Prugl, eds. 1996.)

The Bangladesh women's movement gained legitimacy by its visible and significant participation in the war for liberation in 1971 and the movement for democratization in 1980s. Women's NGOs at first were research based; more recently some have begun social outreach programs that mirror those of BRAC and the Grameen Bank, and broadening their membership. Perhaps because men run those and other similar organizations and are working toward women's empowerment, the issue of western influence within the women's movement is seldom raised. Women do have to contend with the Jamaat party which promotes radical Islam and has encouraged attacks on NGO staff and beneficiaries. Citing the growing strength and solidarity of the women's movement in Bangladesh, Roushan Jahan calls the prevailing mood as one of cautious optimism. ("Men in seclusion, women in public: Rokeya's dream and women's struggles in Bangladesh," in *The Challenge of Local Feminisms,* Amrita Basu, ed. 1995.)

In Sri Lanka, feminists started a Center for Women's Research to focus on issues of concern to women. The Mahaweli irrigation scheme found that women were unable to benefit from loan programs if their husband's had defaulted on an agricultural loan. These women lived in the same area where the government was encouraging export production village programs. In 1987 the Women's Chamber of Commerce started the Agromart Foundation to support such activities as exportation of ornamental tropical fish

and cardamom. While these income activities did not alter gender relations, according to Vidyamali Samarasinghe, women in the program increased their self-confidence and had become more self-reliant. ("The last frontier or a new beginning? Women's microenterprises in Sri Lanka," in *Women at the Center: Development Issues and Practices for the 1990s.* Gay Young, Vidyamali Samarasinghe, & Ken Kusterer, eds. 1993.)

ELECTORAL POLITICS

The rising force of women organized at all levels of society throughout the world has given greater impetus to the 30% target for women in political positions originally promoted in 1995. Introducing quotas for electoral seats is considered an important strategy. The low representation of women in national assemblies contrasts with the number of prominent women political leaders in the region. In Bangladesh the heads of the two major, and intensely competitive, parties are women. Both have served as the prime minister, neither espouse feminist causes, and both come from political dynasties: Khaleda Zia is a widow of an assassinated prime minister; Sheikh Hasena is the daughter of a nationalist leader. When Benazir Bhutto, daughter of another martyred prime minister, was in power in Pakistan, her ability to ameliorate the *Hudood* was circumscribed, but she supported women in their preparations for Beijing. Indira Gandhi, as India's prime minister, kept aloof from the feminist movement; after her assassination her son Rajvi became prime minister; after he was also killed, his wife Sonia –albeit an Italian by birth– was made head of the Congress Party and is being groomed for high office should the party win the elections. Sri Lanka is unique in having had both mother and daughter as leaders: Sirimavo Bandaranaika, the widow of an assassinated prime minister, was the first woman prime minister in the world. Her daughter Chandrika Bandaranaika Kumaratunga is Sri Lanka's president but was also a prime minister; her husband was also assassinated. The dynastic succession is obvious. The reason these elite women could replace male relatives as their countries' leaders is due to class/caste identity and strong personalist politics in the region. Women's issues are certainly not privileged by such woman leaders; indeed, the strength of the women's movement is irrelevant.

With independence, the Indian constitutions recognized the intractability of the caste system by providing for representation of disadvantage peoples though a system that reserved specific constituencies for Scheduled Castes [untouchables or *dalits*] and Scheduled Tribes based on their population. Since many women prominent in the nationalist struggle were elected, no special provisions were deemed necessary at the time. Current women leaders, noting that the percentage of women members in Parliament has averaged 5 % since independence, have agitated for a quota without success. While upper

class women have had some representation in elective bodies, this was not the case in local elections for elective bodies at the village, county, and district levels of government when they were set up in the 1960s. This situation was changed by laws passed in 1993 requiring panchayats at all three levels to reserve one-third of their electoral constituencies for women. Furthermore, one third of all panchayats must elect a woman as chair. These quotas are achieved by rotation of constituencies and of electoral bodies. To date over one million women have been elected to local bodies. The southern state of Karnataka actually has 46.7 per cent women members, an indication that women ran for general as well as for reserved seats.

To assist these new legislators to understand their power and responsibilities many women's organizations have begun training courses for them. Activists at the local levels are generally impressed with the visible results of women in the panchayats, but skepticism is widespread among many feminists who question the ability of these women to understand the workings of the panchayats or to take positions independent of their husbands. Srilatha Batliwala agrees with some skeptics who believe that quotas are "so much window-dressing and political gimmickry... in a narrow sense" but argues that such critics miss the potential that such participation has "to empower women and transform traditional gender relations." ("Political representation and the women's movement," lecture for the Women

and Soecity Forum of ASMITA, Hyderabad, India; May 1997.)

In sum, women's movements in the four South Asian countries discussed have at the very least been able to influence their governments for changes in women's rights.[1] Their access to officials is facilitated by their membership in the modernist upper class. Many women in these countries have begun to work with women of other classes though class, class, and religion seriously impede the emergence of a more unified movement. Gradually poor women in both India and Bangladesh are becoming empowered by development projects that reached to the village or community levels and organized them. This process in Sri Lanka was arrested by the years of ethnic conflict and in Pakistan by the increasing power of conservative Islam.

SOUTHEAST ASIA: A MORE EQALITARIAN SOCIETY

The Hindu-Buddhist religions that expanded throughout the region left behind a status hierarchy that put the rulers, their armies, and the priests at the top. Commerce was less valued, and largely left to women or foreigners. More recent overlay of Islam and

1 For greater detail about the policies and politics of the first three women's conferences, see "UN Decade for Women: its impact and legacy," by Tinker & Jaquette, *World Development*, Mar. 1987. Lucille Mair provides an excellent view from the South in "Women: A decade is time enough," *Third World Quarterly* 8/2 (April 1986).

Christianity have not undercut this ranking although in Malaysia the Chinese filled the entrepreneurial niche as a conservative Islam was encouraging women to stay at home. Such displacement did not happen throughout Indonesia because Hindu-Bali beliefs have intertwined with Islam in much of Java. But in contemporary times, women in Indonesia have not achieved the same level of prominence as entrepreneurs as have women in the Philippines and Thailand, perhaps because of the government sponsored campaign to keep women at home which has encouraged upperclass women to participate in social uplift activities through government related women's organizations. Less well off women in Indonesia continue to work as do most women in both Thailand and the Philippines.

Colonial policies in the region influenced women's educational opportunities. In the Philippines, the UN introduced public schools throughout the country in the early 1900s which has resulted in a 95% adult literacy rate for both women and men in 1998, with over one half of all students completing elementary school, a quarter finish high school. Amaryllis Tiglao Torres argues that in terms of gender stereotypes, the new system did not "intrude on the value of male *machismo*" embedded in the culture by four centuries of Spanish rule, but rather reinforced it. (Women's education as an instrument of change: the case of the Philippines," in *The Politics of Women's Education: Perspectives from Asia, Africa, and Latin America.* Jill

Conway & Susan Bourque, eds. 1993.) Reflecting this emphasis on family, women who complete the university and graduate programs at higher rates than for men tend to dominate medical science (87%), food and nutrition (99%), and commerce (67%) – nurturing professions and trading. The abundance of women with college degrees and the lack of appropriate jobs, especially outside of Metro Manila, encourages women to join NGOs, if they can afford it, or to become self-employed. A study of street food vendors in Ilo Ilo found that 92% of the enterprises were headed by women; further 20% of these vendors had college degrees.

Women dominate the street food trade in Thailand as well, running 88% of the enterprises; women's adult literacy rate is 93%. In Indonesia, under the Dutch, education was limited and students were taught in Dutch above the elementary level. Only engineering and medicine were taught at university level in the country. After independence, the trading language Malay was adopted as the national language requiring new textbooks at all grades. Today women's adult literacy rate is 81%. The rapid expansion of the entire education system has allowed women and men to study, but shortages of teachers and books continues to be a problem. Women continue to be prominent in the batik industry even under pressure from larger industry.

In all three countries, women are expected to help support their families. In rural areas the lower income women

work in agriculture, in cities they are engaged in small or micro enterprise. Young women often work in export industries that locate where women are educated. The income that women earn gives them status and relative independence, though women who sub-contract are frequently exploited. In Thailand and in the Philippines, many women were drawn into the sex industry in response to large numbers of US troops and to the special package tours from Japan and Germany. Local women organized against US bases in the Philippines, and found international support that led to the down-sizing or closing of these installations.

Organizing women

Three factors slowed the development of local women's local organizations in Philippines, Indonesia, and Thailand. First was the perception by most women of the region that there was gender equity: women accepted the division of labor within which they had considerable independence. Divorce is uncommon in the Philippines and Thailand, though concubinage/mistresses are widely acknowledged, perhaps giving wives more latitude. Most middle class women are involved in social service organizations that assist the poor; these groups are more likely to focus on societal issues such as housing, human rights, or the environment. Until recently, few groups addressed more feminist issues relating to family law or violence. Only as exploitation

of women in export factories and the abuse of Philippine and Thai women working in Japan, did specifically women's issues appear.

Secondly, authoritarian governments in all three countries inhibited the growth of NGOs. In Indonesia, where women had been organized as part of the nationalist movement, women were "valorized" as mothers and wives. Under President Suharto, women's organizations were absorbed into the government under the control of the Ministry of Home Affairs. Women's groups outside the officially sanctioned ones –known as GONGO or government organized NGOs- were viewed with suspicion. Activist women gravitated to environment and consumer organizations which were considered safe topics, and women headed several influential organizations.

As the democratization movements grew in all three countries, women joined with men in more overtly oppositional activities. In all three countries the oppositional NGOs were instrumental in the overthrow of regimes and the replacement with more democratic governments; spontaneous protests led by women over high prices of basic foodstuffs precipitated more general student strikes.

Political participation

Women in the Philippines have wielded power for many years indirectly through important men; Imelda Marcos was so powerful that she had her own ministry

while the mistress of President Ramos had both visibility and influence. Cory Aquino became president after her husband was assassinated; Gloria Macapagal, daughter of a revolutionary leader, became president in 2001 when the President Estrada was impeached. A 1986 law to limit terms has resulted in some wives replacing their husbands, but many wives have sought political office on their own. Mina Roces concludes "Organized power is still very much the domain of men." ("Negotiating Modernities: Filopino women 1970-2000," in *Women in Asia: Tradition, Modernity, and Globalization.* Louise Edwards and Mina Roces, eds. 2000.) Indonesia has also seen the succession to president of a daughter of the first Indonesian president with Megawati Sukarnoputri. Her election had earlier been blocked by conservative Muslims who objected to having a woman heading the government. The elevation of women relatives as symbols has no more to do with women's issues in Southeast Asia than in South Asia.

The opening of political space for oppositional NGOs in the Philippines resulted in an rapid expansion of women's organizations during the 1980s, prior to that many groups focused on kinship politics even as they dispensed charity. After the overthrown of Marcos, major women's groups, under the umbrella organization GABRIELA, became more feminist in nature. Mina Roces argues, however, that except for nuns, women organizing outside the narrow construct of kinship politics are marginalized. Such groups are often sustained by networks with groups in other countries: ISIS publishes its Asian journal from the Manila and HomeNet, organizing home-based women workers, has enrolled 20,000 members in the country.

The 1997 elections in Indonesia was the first time women's issues were discussed. Middle-class women, both secular and Islamist, have started many overtly feminist organizations that have raised issues of domestic violence, marriage law, and the conditions of women workers. Since then, the tumultuous events revolving around the survival of democratic government have preempted focused action on revising the model of women promoted under Suharto, but "The reform of gender relations is very much on the agenda of contemporary Indonesia." (Kathryn Robinson, "Indonesian women: from *Orde Baru to Reformasi,*" in *Women in Asia: Tradition, Modernity, and Globalization.* Louise Edwards and Mina Roces, eds. 2000.)

DISMANTLING COMMUNIST CONTROL IN CHINA, LAOS, VIETNAM

When the socialist governments were set up in Vietnam, Laos and China, equal right were nominally granted to women, though scholars have pointed to discrepancies in gender treatment throughout the communist era in all the three countries due to persistent patriarchal values and attitudes. Over

the past decade, as leaders in all three countries have issued economic reforms designed to open their economies to the market economy, inevitable gender disparities that accompany rapid socio-economic change are eroding both achieved and theoretical equality.

For example, the countries decided to give land rights to the people though ownership remains with the state. Even though laws provide for land to be registered in the names of both women and men, women often see no reason for registering. Several international NGOs in Vietnam encouraged women to register in order to document their rights in case of divorce or death. In Laos the government sent teams to the countryside to talk to women about registering land especially among the lowland Lao who have matriarchal inheritance. These women did not comprehend that they might not have their traditional rights to land. Under the new laws, equal rights are ineffective if women do not put their names on the documents. Registration for urban housing was a somewhat different issue. Housing had been predominantly provided through the work unit of the husband so that privatizing living quarters often deprived the wife of security of tenure in the case of divorce. In China, women were sometimes allowed to share the tiny housing space—diving the room with a blanket– for a year while they searched for alternative accommodation. Women researchers have publicized these problems, but the lack of locally led women's organizations

means that appeals must be made to the government.

Mass organizations

In communist Asia, workers, women, veterans, etc., each had a separate organization for representation and for control. Today, women continue to be elected to legislatures through women's mass organizations: Women's Union in Vietnam and Laos, Women's Federation in China. In interviews, women in these organizations are often dismissed as having less power than women in the regular party hierarchy. Historically such mass organizations usually functioned as a vehicle for the party to instruct the village women; Carol Ireson argues that in Laos, however, women's concerns were sometimes filtered upwards as well. (*Field, Forest, and Family: Women's Work and Power in Rural Laos.* 1996.) Today, with the vast amount of development assistance flowing to poor women through both the Vietnam Women's Union and the Laos Women's Union and the subsequent training to the cadres in order to implement new programs, the status of union members has been considerably improved.

Yet without a strong voice of women's organizations outside the government, women's concerns are those assigned by the party; but the mass women's organizations are beginning to challenge the narratives and policies in these countries. Communist regimes do not allow organizing outside party structures. In communist Europe, women had not

organized as women and often rejected the concept of a woman's movement as U.S. propaganda. Even today in Laos, Vietnam, and China, restrictions continue on types of organizations acceptable to the party. Professional groups are accepted, but organizations whose goals are to help others, not its own membership, are generally forbidden because social provisioning is the right and responsibility of the government. In Laos and Vietnam, where foreign assistance has focused on organizing poor women for microcredit schemes, international nongovernmental organizations are allowed to promote their programs but only through a official institution such as the Women's Union, universities, or research centers.

In Vietnam, in 1998, only two NGOs run by local citizens groups could be identified by the Ford Foundation as offering assistance to the poor. Both group s are registered under the 1992 decree 35 that allows scientists to set up groups outside the government for social purposes; and neither accepted foreign funding which might make them seem foreign agents in the minds of suspicious bureaucrats. In 1993, a retired female medical doctor whose speciality is gynecology had set up clinics in two villages with a population of 17,000. Her clinic emphasizes educating women about reproductive health and contraception. Because the major problem in these villages is poverty, she uses locally grown medicinal herbs when possible, and collaborates with the Women's Union which she considers "still political." She subsidizes her village work through a private clinic in Hanoi. The second independent program was set up by a man long experienced in working with an international NGO. He earns money for the work by consulting with foreign NGOs, then invests those funds in programs whose design he believes will correct errors made by many of the naive foreign efforts. He trains young volunteers who, like Peace Corps volunteers, receive minimal pay.[1]

These two organizations may predict the future of civil society organizations in Vietnam; today they are constrained by law and party to provide social service activities. However, even the officially organized microcredit groups I visited were receiving information as well as funding from the international NGO sponsors. Through research projects and international contacts with women's centers and local research organizations, the global discourse on

1 Nepal and Bhutan, buffer states to Tibet and China, have emerged from years of isolation only in the last forty years. Both countries continue to be dominated by kings, but with contrasting results. The massacre of Nepal's royal family in 2001 and the continued Maoist inspired rebellion contrast with the honored status of Bhutan's benevolent kingdom. Women status is high among hill tribes in both counties, but in Nepal this position has been compromised by Hinduism. International NGOs have been extremely active in Nepal, and have sponsored women's organizations and community representation. Women in Bhutan see little need for such outside efforts as the government is promoting local decision-making and women's rights.

women's rights is gradually filtering through to women working in government run universities, research centers, and the Women's Union; the internet is expensive but controls are sporadic. Vietnamese women travel abroad to attend international conferences and to study. A growing network of women exist to influence and instruct policy on women. But as with women in the Philippines, most educated women in both Vietnam and Laos feel they have equity and are not yet engaged in feminist issues, while poor women are working hard to survive. But as rapid economic transformation erodes traditional family support mechanisms, women are beginning to realize the need for actions to maintain their status in the society.

In China, feminist issues that were slowly seeping in were given greater visibility by the UN World Conference for Women in Beijing in 1995 despite the government attempts as censorship. As the conference preparations were underway, a Journal *Rural Women Knowing All* was started to inform farm women of their rights as internal migration often left them to run the farms alone. Wu Qing, recent recipient of the Magsaysay award, helped start a hot line in Beijing; today over 200 such hot lines exist. While there is no network among them, the volunteers running them all know each other and refer problems back and forth.

CONCLUSION

Women's power in Asia today is growing from the community level to national and international women leaders in each country. Despite an historic disconnect between the village women and the educated elite, development projects and the global women's movement are providing an agenda that reaches all levels. To date, women's voices have seldom been heard in elected bodies even with quotas and reservations. Thus influence on legislation and policy is more likely to occur through media campaigns or lobbying than by standing for office. International networking, through the United Nations but also through development agencies including NGOs and the World Bank, adds to the pressure on decision makers to respond.

India has by far the most active women's movements at all levels of society, but feminist have not yet been able to achieve a cohesive national organization. Philippines has organizations of working women that exist outside the older women's organizations with their kinship/charity outlook. Throughout this part of Asia, educated women are articulate in global discussions and meetings about the need for recasting gender relationships. Their personal power in the family is often more egalitarian than the traditional stereotypes but legally they are often vulnerable. Women are walking on many paths to power, changing relationships within the family and community are palpable, but national power is elusive – but growing– in societies with strong patriarchal dominance of political institutions.

EMPOWERMENT JUST HAPPENED: THE UNEXPECTED EXPANSION OF WOMEN'S ORGANIZATIONS

EMPOWERMENT JUST HAPPENED. NO ONE, as he planned economic development for the developing countries, intended to empower women. Indeed, leading theorists like Walt Rostow and Edward Banfield, had a negative view of women, assuming their support for traditional values and religion would impede progress. These attitudes were so embedded in US society that on many university campuses women professors, from chemists to psychologists, were forced into Home Economics Departments. In the 1960s, women in the United States began to rebel against their socially constructed roles and demanded passage of the Equal Rights Amendment. "Uppity Women Unite" was our motto. Together we altered policies in the Congress and help shift the development paradigm to include women.

Around the globe, similar groups were forming. Although this was hardly the first time women organized, the crucial difference in the last half of the twentieth century was that male goals for economic transition undermined the sexual division of labor. This in turn required a change in women's roles. Further, development planners provided resources for women in rural areas to encourage this change. To reach them, planners hired educated women to form village women into groups in order to improve health, limit population, alter fuel consumption, or reduce the drudgery of food production. New technologies, new ideas, new credit, all flowed downwards. In turn, the organizers and the women involved observed and critiqued the plans, and began to demand new programs, new policies, new laws. Without resources, social movements are difficult to sustain. This time, the launching of socio-economic transformations led to a shift in gender relations at home and in the world. Empowerment was an unintended result.

Taking this opportunity, women around the globe have made unprecedented gains toward equality and justice within the family and the state. Societies everywhere have been challenged by this most significant social movement of the twentieth century. Like a mighty flood, the movement began in trickles in the rural towns and villages, in suburban homes, in national and international meetings, in legislation, and in flows of economic assistance. The simile gets complicated here. Formerly isolated groups of women would have been inhibited by geography, but in the last quarter of the 20th century, women could connect making use of rapid improvements in communications and

travel. These many groups converge, as streams do into mighty rivers, but they are influenced also by the rain blowing in from distant places bringing new ideas and information. These complex interactions created the intricate cloth of the global women's movement. .

History records how women's status has varied by culture, government, religion, and agricultural systems. Throughout history, women to expanded their societal roles during crises, when wars have left them in charge of farming or running the manor. But when the men returned, patriarchy was reasserted, perhaps under a different guise. This pattern persists today, but because the current epoch has bound the world together as never before, women can no longer be so easily isolated and controlled. The spread of women's organizations and networks, nationally and internationally, have made women everywhere more aware of their human rights and more willing to demand change.

My perspective of these profound transformations has been formed by over fifty years of research and study of the social, economic, and political changes in the global south coupled with organizing and participating in non-governmental organizations in the United States—from think-tanks, to civil rights and women's rights groups, to political parties, salons and university classes. Drawing on these diverse experiences, I wish to analyze two of the many paths to women's personal empowerment, and how they have led

to changes in gender relations within family, community, and country.

The story is not straightforward. Causality is ambiguous and inconsistent; no one path serves all women. But two distinct factors are constant. First, women organized are more powerful than disparate voices. Second, international economic development has undermined subsistence and traditional farming communities, altering the sexual division of labor and opening cracks in foundations of patriarchal control. Development programs not only encouraged women to organize, but also provided them with funding, training, and a broader worldview.

Leaders in developing countries wanted modernization and economic development, but no diminution of their political power. Historically such selective change might have been possible, but not today. As China struggles to expand the market but maintain communism or Iran seeks nuclear power but its mullahs continue to constrain its democratically elected leader, young people hook up on the internet, families watch foreign television, and newscasts show women in high level decision making positions in governments and corporations.

Fifty years ago the communication age had barely begun as rapid economic development began to challenge the social order that kept women in their place. Planners did not intend to alter traditional power relationships. But as women organized to support economic development, empowerment happened

anyway. Advocates, who promoted the inclusion of women in economic development or the recognition of women's human rights at the United Nations and other international agencies, were themselves empowered. At the national level, as employment opportunities in the government and in development organizations expanded, the number and variety of women's organizations soared giving visibility to their leaders and their causes. At the village level, women recipients of economic projects that had been designed to reduce their time burden or increase their income were empowered. The series of UN Conferences for Women brought together representatives of all these women in an explosive mix of jubilation, intellectual ferment, and growing demands for equal human rights.

In this chapter, I trace the growing power of women in these interrelated spheres—international, national, and local—showing how they reinforced each other through organizations and networking. Because rapid socio-economic change can be profoundly distressing, I also take note of the ways women as well as men have challenged the basic premise of equality or deliberated its implications. The first section shows how disparate concerns about the changing roles and status of women in developing countries culminated in the effort to recognize the differential impact of development programming on women in the Plan of Action of the UN First Conference on Women in Mexico in 1975. The second section discusses

three initiatives of this Mexico meeting as they influenced opportunities for women in government, in research, and in development agencies. The final section reviews the much more abundant literature on the consequences of international development programs designed to address the economic activities and responsibilities of poor women with a focus on how the intended and unintended results of such initiatives influenced women's lives.

The chapter asserts that whatever the activities or interventions, organizing women provided the foundation for increases in economic, human, social, and material capital for both the organized and the organizers. How this new capital was utilized varied from country to country, and culture to culture, and in some cases provoked backlash as patriarchal laws were often challenged. Women understood that they needed to secure their new status and possibilities, and that these had to be secured by law. Today, women are flexing the growing power of the women's movement and demanding access to political structures at all levels of government. Marilena Da Souza, a coordinator of a broom factory in the Amazon, captured the importance of groups. "Alone you are nothing. If you think you are nobody, you are nobody. Together, we have courage, we have new ideas. Together we float."

SEIZING THE HISTORIC MOMENT

The confluence of three historic seismic

shifts allowed women to seize the initiative for advancing social justice around the world, causing upheavals in traditional sex-age-race-class hierarchies, to utilize Ester Boserup's formulation: the crumbling of the colonial order; the establishment of the United Nations; and the reinvigoration of both the international and US women's movements.

Developing countries

The post World War II world witnessed the success of nationalist movements in Asia and Africa. In their fight against the imperial powers, nationalist leaders frequently recruited the help of women in their struggles for freedom and equality. With independence, the male leadership could hardly deny women at least formal rights. Thus, the constitutions of the newly independent countries granted equal rights to women and men in civil matters. Significantly, customary or family law remains a source of contention and discrimination. Nonetheless, the right to vote and hold office represented a significant advance. Indeed, France scrambled to allow women to vote only when their former colonies were doing so.

Many women leaders of nationalist movements were appointed to high governmental positions; others began to organize locally to ensure their new freedoms were not compromised. The idea of using development aid money for women was first proposed by Inga Thorsson to the Swedish Parliament in 1963; in her report of visits in Africa

she described women as "an especially ill-fated group." In 1969, the Swedish International Development Agency (SIDA) funded two positions in the recently established United Nations Economic Commission for Africa to ensure a voice for women at the policy level. Margaret Snyder, later the founding director of UNIFEM, was one of the women appointed. As more development agencies adopted such programs, women around the world began to organize in order to secure access to the funds flowing in.

Ester Boserup was among the economists who studied the agricultural systems in former colonies to recommend ways to increase production. Her research in India in the 1950s convinced her that the prevailing theories about agricultural development were inaccurate, and failed to measure women's economic activity on or off the farm. Her ideas were reinforced and expanded by subsequent research in Africa resulting in her ground-breaking book *The Role of Woman in Economic Development,* which appeared in 1970. She discussed the changing sexual division of labor caused by economic development in a radio broadcast meant to popularize her research; the lecture was widely distributed by the International Labour Organization (ILO). Further exposure came in 1971 when the *Development Digest,* a publication of the US Agency for International Development, published an abstract of her book for dissemination around the world. Her identification with women's roles in

economic development was solidified when she acted as rapporteur of the UN Interregional Expert's Meeting on the topic. Ester Boserup had became an icon for the emerging women in development movement.

United Nations

The establishment of the United Nations provided a forum for the newly independent countries, which had considerable interest in economic development. Patterned on the Marshall Plan, the first UN Development Decade magnified income disparities while at the same time increasing the gross domestic product (GDP). The World Bank became concerned with poverty and population growth; the International Labour Organization worried about inadequate industrialization in the developing world and began to study the informal sector; the Food and Agricultural Organization strove to increase food production in face of frequent shortages. Such policies steered development from infrastructure toward people. This shift allowed such questions as who grows food, who is poor, and who makes fertility decisions to enter the development debate.

The UN Commission on the Status of Women (CSW) was concerned from its inception with the advancement of women, passing resolutions that eventually became the influential Convention on the Elimination of all forms of Discrimination Against Women (CEDAW). At its inception women from developed countries dominated the CSW, reflecting the distribution of power in the UN itself; the CSW's primary issues were education and citizenship rights. Not until 1962 was an Arab delegate, Aziza Hussein, appointed to replace an Israeli as the representative for the Middle East. She introduced two new and controversial issues to CSW, including family planning and the status of women in Islam.

Interest in economic development was lodged in the Department of Economic and Social Affairs of ECOSOC; a section on social planning was set up in 1966. The head of this section, economist Gloria Scott, organized a seminar in Sweden to explore new ideas to ameliorate the socio-economic disparities associated with development. Although not on the agenda, women clearly emerged as an issue during the discussion. To capture this insight, Scott inserted the phrase "integration of women in development" in her report. She then collaborated with the CSW to convene another experts meeting, this time specifically about the "Integration of women in development," and invited Boserup to serve as rapporteur.

US women's movement

Political turmoil grew intense in the United States by the late 1960s. The civil rights movement and anti-Vietnam protests activated women as well as men. Rebelling against the dismissive attitude of the male leadership of both groups, women came together

on university campuses, at the workplace, in the suburbs, and in the cities to demand equality. This reinvigorated women's movement created an excitement throughout the country; formal and informal groups of women began to challenge institutions and organizations. Women demanded equal rights to jobs and education; the campaign for an Equal Rights Amendment (ERA) to the Constitution, though unsuccessful in the end, became a rallying point.

Opposition to the ERA was grounded in conservative south and among the religious right. But the ERA's declaration of complete equality also worried some women labor leaders, such as Esther Peterson who was vice chairman to chair Eleanor Roosevelt of the Kennedy Commission, set up in 1960. Peterson believed that the ERA would undermine the long-fought-for special protection for working women. Only subsequent changes in federal laws that expanded health and safety provisions to include men as well made it possible for her to support the ERA.

ERA supporters generally viewed protective legislation, such as restrictions on night shifts or hours worked, as obstacles to increased work opportunities for women. The conviction that women are the same as men was a basic tenet of this new women's activism. In a society where income is often seen as the marker for success, women demanded equal access to work because an outside job was valued over homemaking. Any concessions might undermine the march to equality. Yet, if both parents work, who cares for the children? Or does equality at work translate into double days for women? These points continue to be contentious, affecting both planning and policy in the United States and around the world—to say nothing of women's lives. Many feminists looked at the social support of motherhood in Europe and elsewhere and saw weakness. On campuses, some scholars contested this *essentialism* as a danger to women's equality, but others began to emphasize the value of women's difference and research has shown that some innate differences flow from how the brain is hard-wired differently in women and men. Most women in Europe and Latin America do not perceive a fundamental conflict between being calling for equality and recognizing that women are different from men. Indeed, some women in former communist countries have rejected the idea of equality in the workplace because the result was a greater household burden.

As the women's movement gathered strength in the 1970s, Congress and the administration, pushed by activist groups in Washington, passed laws to guarantee equal treatment in education, sports, credit, employment, pensions, and social security. These are rights of citizenship and easily put into law. Matters related to women's health or to the needs of displaced homemakers required government expenditures, but passed. However, once women began to lobby for legislation that encroached on sexual mores (by asking funds for centers to treat victims of

rape or domestic violence, or legalization of abortion), Congressional support began to wane. As in developing countries, men are reluctant to give up patriarchal control.

Organizing took place on university campuses as well: graduate women and sympathetic women faculty formed caucuses to initiate courses on women and demand recognition of women's studies in the curriculum and within their academic disciplines. Under pressure, professional associations set up committees to explore women's issues at conferences and on campuses. In Washington, DC, I helped form such a group within the Society for International Development that became known as Women in Development or SID/WID. Talks at our brown-bag meetings by members studying development or doing research in the field confirmed what was then a startling indictment: economic development was having an adverse impact on women.

Presentation of this viewpoint at a 1973 Department of State briefing on the upcoming UN World Conference for Women convinced Mildred Marcy, of the US Information Agency, that the issue of women must be included in the pending legislation revising the US Foreign Assistance Act. Through her connections in the Senate, Marcy secured support for an amendment, which she wrote based on UN terminology, to integrate women into development. Senator Charles Percy—a Republican in a Republican administration—was asked to introduce the amendment though he

had little understanding of its import. Once the phone calls and faxes (it was before the age of email) started pouring in, however, he became a champion of WID, introducing a resolution at the UN General Assembly and co-chairing the US delegation to Mexico City.

These three initiatives, the Swedish development assistance in Africa, the UN Experts Seminar in NYC, and the WID amendment to the US Foreign Assistance Act, had an impact on the direction and scope of international economic assistance programs in the 1970s. The original development paradigm was under attack. Funding for infrastructure and industry had increased the disparity of incomes in developing countries prompting the World Bank to make poverty a high priority issue. At the time, little data was sex disaggregated and development programs assumed families were the basic economic unit for planning, ignoring women's needs. Through the American Association for the Advancement of Sciences, where I was the head of international science and whose chair at that time was Margaret Mead, I convened a Seminar in Mexico City prior to the UN Conference for Women which brought together over one hundred women and men who had studied the problem. In preparation, my staff abstracted all available literature on the topic in French, Spanish, and English.

The new direction was championed at the UN World Conference for Women in Mexico City in June 1975 where two new UN agencies were

created specifically for women: the UN Fund for Women—now UNIFEM—and the International Research and Training Institute for the Advancement of Women, INSTRAW. Major bilateral donors searched for programs that could reach poor women in rural and urban settings. Scholars documented the negative impact of many development programs on women, noted women's lower entitlements within families, and showed the perilous existence of many women headed-households. The impact of subsequent Structural Adjustment Programs, initiated by the World Bank in the 1980s to force borrowing governments to contain spending, fell heavily on women as social programs were decimated

WOMEN'S INTERNATIONAL POLICY LEADERSHIP

The women mentioned above, advocates, scholars, and practitioners, not only influenced development policy within the UN and its agencies, bilateral assistance programs, and the burgeoning nongovernmental organizations (NGOs), they were themselves empowered. Including women in development programs meant that agencies created new offices and hired more women professionals; land grant universities with large agricultural projects funded by USAID set up new programs both on campus and in the field. The UN system, bombarded by demands for greater equity among its work-force, increased the number of

women in decision-making positions and promoted Finnish Helvi Sipila as the first Assistant Secretary General when she headed the Mexico City conference. UNIFEM and INSTRAW both provided opportunities for women to rise within the international system.

The World Bank also set up an office for women, one that was minimally funded and soon outpaced by the newer office on environment. Over twenty years later, however, and despite a 2001 publication on *Engendering Development*, a perception persists that the Bank does not support its own poverty reduction or social goals sufficiently. On the contrary, it is argued, many Bank projects add to the immiseration of women. Nonetheless, there are more women in professional positions within the Bank as countries who fund the Bank have pressured it to hire more women. Although not all women professionals support women's programs, the presence of more women (and some men who do) makes advocacy within the institution more acceptable and less likely to hurt one's career.

The resistance to WID in the World Bank and other multilateral economic institutions (MEIs) is examined in a path-breaking study of how global social movements are *Contesting Global Governance*. The authors compare the women's movement to the environmental and labor movements in terms of their impact on the International Monetary Fund, the World Trade Organization, and the World Bank. At a time when MEIs are moving beyond their

interstate mandates to actively engage civil society actors in numerous countries, their analysis of women and the Bank is particularly salient. (*Contesting Global Governance: Multilateral Institutions and Global Social Movements.* Robert O'Brien, Anne Marie Goetz, Jan Aart Scholte, Marc Williams, eds. 2000).

Two issues help explain the difficulty the global women's movements have had in trying to influence the Bank. First, there is no single international women's movement and no agreed upon agenda, although there are women's movements in the plural. Second, there continues to be strong resistance because the gender equality that feminists propose would fundamentally change current approaches to social organization.

The existence of global feminisms presents distinct challenges. Within the women's movement, women in the South and North frequently disagree about the causes of economic injustice. Women in the periphery also have trouble being heard by international development NGOs working in their countries. Because these women often lack the training and sophistication of lobbyists in Washington DC, the male-dominated international NGOs often make policy for them, without their input. Executive Directors of the Bank who represent donor countries also pressure for women's programs, but women in the South, who potentially benefit from these policies, feel marginalized. Even the US women's movement, although it is strong, does not

lobby the Bank on behalf of feminist groups in the South. In contrast to the cooperation that exists among international environmental groups, including those based in the United States, the "US women's movement has not thrown its weight behind the gender and development issues...Gender equity issues are still seen as more controversial, and more 'culturally specific' than are concerns with the environment or even human rights" (O'Brien op cit p.65). *Contesting Global Governance* underscores how radical the women's movements have been around the world, and they are often critical of WID. But without the WID movement, there would have been no issue to study. The conclusions illustrate both the remarkable expansion of women's power, and its limitations. A single solution is impossible; rather advocates for women's empowerment must understand the tremendous variation of cultures in which women live before trying to recommend appropriate programs or evaluate progress.

WOMEN'S STUDIES VERSUS WOMEN IN DEVELOPMENT

The US women's movement grew and formed many streams during the 1970s. Consciousness raising groups exploded in the suburbs, committees on the status of women were formed in cities and states. Courses on women were introduced on most college campuses, largely in the humanities. Women doing research at home and abroad added to the knowledge of women's

subordination and patriarchy. Minority women demanded inclusion of race in the curriculum and called themselves Third World Women. As academic women strove for power and acceptance on liberal arts campuses, they moved away from activism toward theoretical analysis—first Marxist, then postmodern. These critiques took place in a climate of fierce anti-government attitudes, spawned by the Vietnam War, which created suspicion of government actions and programs on campuses, from ROTC (military recruitment) to government sponsored research.

By contrast, the growing WID community was lodged primarily in agricultural universities where government funding was the rule. Research on economic development was applied, not theoretical. USAID funded programs provided scholarships for women from developing countries—real Third World Women. These conflicting perspectives p roduced a confrontation at the first Women's Studies Association meeting in Kansas in 1979, when US minority women accosted women panelists from developing countries and overturned the USAID information table. This confrontation created a gap between WID and women's studies activities and continued to inform women's studies curriculum for two decades. In an effort to heal this breach and encourage a more global viewpoint, in the late 1990s the Ford Foundation offered grants to thirteen women's studies programs to add comparative and international studies to their curricula.

Also caught in the controversies between scholars from the north and the south were area studies women who were writing about the impact of colonialism and development on women. African and Muslim women in particular questioned the right as well as the ability of white Christian scholars to understand their countries. Such a debate had already split the African Studies Association into two distinct professional groups. At a 1976 conference, convened at the Wellesley Center for Research on Women and organized by the women's committees of the area studies associations, the explosiveness of the debate affected further cooperative research for some years.

North-South perspectives

The lack of international perspective and the ethnocentrism of many US women leaders led to clashes at the Mexico City conference as well. Many women from the developing world rejected the feminists' emphasis on individualism at the expense of community and argued that women's problems were due as much to economic exploitation as to patriarchy. This North-South division was exacerbated by US foreign policy that rejected demands for a new international economic order at Mexico City and efforts to include the pro-Palestinian stance of many Third World countries in the final document. These global political issues persisted at the women's conferences in Copenhagen and Nairobi.

The nadir of US foreign policy regarding women came at the second world conference for women held in Copenhagen in 1980. Preparations for the Copenhagen conference included funds for research. Lucille Mair, Secretary-General of the conference, broadened the viewpoints of women and international development by channeling these funds to women from the developing world. As a result, the documentation for the conference inserted women into the three most contentious issues of the period: apartheid, Israel and zionism, and underdevelopment. This material was then incorporated into the conference document. Despite the feminist bent of the US delegation, the State Department insisted that the delegation vote against the conference document, objecting to controversial wording that equated Zionism with racism.

The third World Conference for women in Nairobi in 1985 was held during less contentious times. A Peace Tent fostered dialogue between Israelis and Arabs; apartheid had ended; and women scholars from the South wrote about the relationship between macroeconomic policies and gender issues. The group, called Development Alternatives with Women for a New Era (DAWN), was convened by Devaki Jain in Bangalore, India, in 1984. Through regional meetings and debates, DAWN presented their compelling manifesto, *Development, Crises, and Alternative Visions: Third World Women's Perspectives*, at the NGO Forum. The DAWN network continues to publish on development policy issues.

Clearly, policy leaders in both South and North benefited from the increased funding available to study, organize, and support women. Whether from national or international sources, much of the funding during the 1980s revolved around economic development. Western feminists stressed women's work and control of income: so if a woman used her microcredit loan to buy a pedicab for her husband, Northern feminists criticized this while many Southern writers emphasized family welfare and lauded such action. Lucille Mair, the first woman undersecretary-general of the UN, reiterated the unease of women in the South who argued that poor women already worked and did not need to be "integrated" into development. For them the problem was not *exclusion* but *inclusion* in system that uses the sexual division of labor and class differences to exploit women. ("Women: a decade is time enough," in *Third World Quarterly* 8/2:583-93. 1987.)

By the end of the UN Decade for Women in 1985, a global women's movement existed with many viewpoints and distinct feminisms. The energy of the US women's movement, which had helped propel the inclusion of women in development programming in the 1970s, was splintered; a majority of both scholars and activists focused on national issues and identity politics. Those concerned with international development formed their own professional association, the

Association of Women in International Development (AWID), to unite the women on campuses with those carrying out programs for donor agencies and those conducting action-research. Generally, these women were trying to convince development agencies that their programs would be more effective if they paid attention to women's concerns and de-institutionalized male bias. Confrontation was not considered a useful tactic; rather the most effective approach was to adapt and broaden existing programs. As the World Bank moved to support neo-liberal economic policies in the 1980s, the WID office did not challenge the model but tended to defend the Bank to outside critics. Nor did the women in the Bank, whatever their nationality, consider themselves as part of the women's movement; most considered that too radical. Lacking strong critics pursuing a transformative agenda, the gender unit in the Bank has been unable to alter bank policy appreciably.

Impact Of Un Directives On Governments And Women's Organizations At The National Level

The 1975 Mexico City conference gave international visibility to women's concerns; the recognition of the adverse impact of economic development on women resulted in increased funding for studies and projects by bilateral and international donor agencies, by foundations, and by nongovernmental organizations. The Plan of Action, the conference's major document, passed by acclamation, included three directives for national governments that have continued to influence both development and empowerment strategies. The document instructed governments to set up a focal point for women, 'national machineries' in UN parlance; to prepare a report on the status of women in their country; and to include women to be included in their economic planning.

NATIONAL MACHINERIES

Most governments did in fact set up a focal point somewhere in the bureaucracy: in the prime ministers office, in a ministry charged with welfare, or in a new women's ministry. Foreign donors often provided start up funds, but governments were slow to provide additional resources, a fact that underscores the shallowness of national commitment. The effectiveness of women's advocacy was more related to the attitudes of the men in positions of power than to where the office was placed in the formal government structure. To succeed, these offices needed presidents and prime ministers who were receptive to new policies and supportive of the staff. When this strategy worked, strong women in the ruling political party often provided the political muscle. Peggy Antrobus talked to mein September 2003 of her experience in Jamaica in 1979:

> Yes, Manley was very supportive. I was Director of the Women's Bureau, and it was situated in the

Office of the Prime Minister. But this was in large measure thanks to the effectiveness of the leadership of women in the ruling party. Without these women Jamaica's national machinery would have been as ineffective as those machineries are everywhere, unless women are organized politically.

Many one-party states in Africa established women's ministries, but the goal of such units was more often to enhance party's policies than women's status. In communist countries, women were organized through a mass organization that served both as a communication system for party declarations and as a control mechanism, but rarely advanced women's views of their own needs.

Dorienne Rowan-Campbell [then Wilson-Smillie] writes of her attempts as the first director for the Women and Development Programme at the Commonwealth Secretariat to support the various women's offices in the 54 member countries. Noting that this traditional civil service was quite flexible because rules were few and decisions were made by gentlemen's agreement, she writes: "Not being a gentleman, I felt I was free to challenge the rules... We achieved what we did in part because the organization did not perceive the types of changes being instituted as important or even possible." Her staff analyzed the Women's Bureaus, held workshops on why these offices were not performing, and published resulting case studies in *Ladies in Limbo: the Fate*

of Women's Bureaux. She observed that, although these new offices in developing countries provided opportunity for women, those hired often lacked requisite skills. To address this problem, the Programme initiated training sessions for these women and supported research centers to produce reports they could understand and use. ("Co-ordinating Commonwealth countries for WID," in *Developing Power*, Arvonne Fraser & Irene Tinker, eds. 2004.)

Realizing that without political will and adequate resources, women's machineries were isolated and ineffective, feminists turned to alternative strategies. Embracing the academic concept of gender, critics of WID believed that using a different term that incorporated the many facets of women's and men's lives would more easily gain cooperation of male decision-makers. They also thought that women-only programs marginalized women. The result of this paradigm shift within the donor community was to rename policy offices Gender and Development (GAD) and institute the mainstreaming of women's programs. In the field, gender programs were designed to include men as well as women.

The substitution of GAD for WID had the potential to undercut the political clout of the women's movement; indeed some critics think that was its original purpose. Gender has become a euphemism for women in programming or an alternative to sex in census forms, usage that has dulled the analytical power of the term. Anna Marie Goetz found that its use in the field was

problematic: not only is it hard to translate and but it expresses a "particularly Anglo-America feminist understanding of the social construction of gender." ("Mainstreaming gender equality tonational development planning," in *Missionaries and Mandarins*, Carol Miller & Shahra Razawi, eds. 1998:53.) The confusion is illustrated by the widespread strategy of producing *"Gender Budgets"* of national and agencies expenditures to document the paltry amounts of government budgets are spent on *women*.

Mainstreaming was another attempt to promote women's issues throughout national ministries by setting up focal points and reviewing all government programming. Like so many good ideas, however, its implementation has often weakened women's programming. The WID/GAD units did provide more positions for women and helped this staff develop a capacity for strategic planning; but lack of adequate sex-disaggregated data as well as limited resources undermined attempts to influence program budgets. Budget constraints also impeded WID staff efforts, but because GAD programs (and hence their resources) must be spread through many ministries, their effect is diluted. Women professionals often try to avoid assignment to such marginalized units—GAD and WID alike—for fear these jobs will negatively affect their careers. The need for a central focus for information and research prompted most universities to strengthen their women's studies teaching units, pressured by faculty and students alike. But lack of similar internal

and external pressure means that bureaucracies will fall back into their usual habits, even when there are explicit directives from political leaders.

The most obvious way to increase the pressure is to ensure that women occupy executive and legislative positions. In many countries, the campaign for quotas for women in all execuive and legislative decision-making positions has asked that 30% of seats in parliament be designated for women. 30% representation is deemed necessary to provide a critical mass needed to bring about significant changes in policies and procedures. The political visibility of this demand has escalated in the last decade as both the UN Division on the Advancement of Women and the European Union have supported the concept. The 30% target quickly became a goal at the 1995 Fourth World Conference for Women held in Beijing (UNIFEM 2000:9). The widespread interest in the issue of representation in legislative bodies has now been added to the earlier focus on economic and social issues, as a means for women to protect and expanded their rights.

To date over 25 countries have adopted legal or constitutional quotas for women in legislatures, primarily at the national level but also at the local level. The Inter-Parliamentary Union regularly updates it data on the numbers of women in national legislatures, and posts results on its website (www.ipu.org). The Institute for Democracy and Electoral Assistance in Stockholm also tracks elections globally (www.idea.int).

The latest published data indicates that women hold at least 30 percent of the seats in parliaments in eleven countries; another 23 countries have at least 20 percent of seats occupied by women. Although most of the countries are in developed countries six are in Africa, six in South America and the Caribbean, three are in former communist countries, and four in currently communist countries.

The impact of the quotas on numbers of women elected varies by electoral systems, and understanding the actual impact of more women in the legislatures on policy and laws will be a long term project. Extensive studies of state legislatures and the Congress in the United States suggest that once a critical mass of women is present, they do influence types and direction of legislation. Institutional as well as societal culture loom as major obstacles in most countries, but the view that women's different perspectives should be represented has found broad support along with the call for greater equality. Despite the many hurdles, women are moving into the formerly male bastion of politics; not all of them support feminist agendas, but many do focus on what is happening to women and families.

Reports on the Status of Women

The Plan of Action passed in Mexico called for status of women reports from each country which pressured governments to collect sex disaggregated data for critical indicators such as education, employment, and health. Such data provided, for the first time, a clearer view of women's inferior status that could then be used as an argument for development planning. Government ministries had to alter their census or questionnaire forms to provide the necessary data. Collecting and analyzing these data provided employment for women in the government and universities, and dissemination of the data often sparked local debate.

The starkness of gender inequality revealed in these data was given prominence as the UN and the World Bank included these statistics in their annual reports. Disparities in work, education, health, and income were laid bare. Development programs that had championed GDP growth over the quality of life became a tool for social justice; the Human Development Report uses the status of women as a critical factor for human capacity. At the national level, women's groups offered literacy training or set up income-producing projects. Women lawyers noted the gap between laws and practice and formed groups to teach women about their legal rights. As the conflicts between civil laws and customary/family law became evident, some women's organizations began to challenge patriarchal dominance and demand changes in the privileged traditional practices from inheritance rights to land and home ownership to the application of sharia law within civil society.

Established women's organizations based on charitable contributions and committed to good works were joined by more activist groups. Many more

women were energized by the new opening for action and worked tirelessly as volunteers. All these leaders grew in skill and self-confidence as leaders of women-only organizations. Women in trade unions and in political parties formed caucuses within these male dominated institutions to press for greater attention to women's issues. Frustration with lack of response from these institutions led many national women leaders to form their own organizations. Questions arose about what should be women's highest priority in a given country: survival needs or challenging patriarchy? Work issues of union women, women farmers, and domestic help were often distinct from those of educated feminists in many countries, although in revolutionary Nicaragua, women for a time bridged this gap.

The attempt to form a cohesive national women's movement has been well documented in India. The Committee on the Status of Women in India, operating under the aegis of the Indian Council for Social Science Research (ICSSR), was headed by Vina Mazumdar. Demand for research was so great that grants were often given to independent scholars and newly formed groups. For example, Devaki Jain formed the Institute for Social Studies Trust in 1975 in order to receive funding from ICSSR to conduct time allocation studies. For the next decade she produced an amazing series of reports while providing technical services for grassroots organizations and engaging in advocacy. Jain convened

the meeting where DAWN was established in 1984; DAWN took her views of alternative development to the international level. Tensions between advocacy and research meant that policy reports seldom were published in scholarly journals, a familiar problem of action-research centers. Once the report on the Status of Women in India was completed, the government appointed advisory committee recommended that an autonomous institution be set up with a mandate to continue research on women's issues. In 1980, the Centre for Women's Development Studies was set up with Mazumdar as director.

Such research centers in India and elsewhere relied on the Ford Foundation and European agencies for much of their support. Despite this, Devaki Jain wrote that at many international conferences these policy leaders from the South experienced increased discomfort with the ".. almost tedious reference to 'third world women'. Agendas as well as knowledge bases came from Northern women." ("Building a service station brick by brick: the Institute of Social Studies Trust" in *Narratives from the Women's Studies Family: Recreating Knowledge*, Devaki Jain & Pam Rajput, eds.2003:269-70). DAWN provided an alternative vision for development and established a strong network of women scholars from the South.

In many countries, feminist groups shunned cooperation with governments which were corrupt or authoritarian. For example, under dictatorial regimes in Argentina and Chile,

oppositional women's groups invented new forms of protest that are difficult to adapt to a political process. Tension arose between women choosing to join the new administrations and those who preferred to retain the high ground outside government. Constitutional reforms have provided opportunities for cooperation, especially those in South Africa, Uganda, and most recently in Kenya. Current demands for quotas of women in decision-making positions are designed to bring women into the legislative and executive branches in order to change the predominant male culture of the institutions.

National programming for economic development

Literature assessing the impact of economic development on women focused initially on grassroots or community-level beneficiaries. But the employment opportunities available in development programs are frequently overlooked. Governments and NGOs began to hire educated women as staff both in agency headquarters and in the field. Women riding scooters in Bangladesh or Cameroon while training rural women certainly encouraged young girls to dream of alternatives to a life in the fields. While international development NGOs frequently hired women, the men who headed local NGOs as well as administered government services retained many gender stereotypes. They argued that local culture did not countenance women moving about the countryside alone. Even when efforts were made to protect women from these criticisms, such as the Grameen Bank's special residential centers in rural towns, cultural pressures on the women themselves were often severe.

Special provisions for women were debated in a recent action learning project with the BRAC (Bangladesh Rural Advancement Committee), "the world's largest indigenous private sector development organization" with 15,000 staff and 1.6 million village based members. As donors pressure BRAC to live up to its stated goals of gender equity and women's empowerment, women staff has increased to 20%. Promotion is difficult when constraints on women's mobility contrast with men's freedom to travel night or day by any available means. "While the organization is attempting to accommodate women's needs, it is doing so in an incremental fashion, essentially leaving intact the dominant organizational culture, space and ways of working which are themselves gendered. Thus, women in effect have to fit into a system that was made to fit men." (Rao & Kelleher 1997: 123 & 131.)

Although women staff within male dominated agencies and NGOs were able to affect programming, many joined ranks with the growing number of involved women to set up their own development organizations such as SEWA and Working Women's Forum in India, Proshika in Bangladesh, the Green Belt Movement in Kenya, or the Glass of Milk Program in Peru. The charismatic leaders of such

organizations expounded their innovative programs at international meetings and UN conferences; their ideas led to new policies and programs.

Ela Bhatt's experience with unions led her to start SEWA, a union of workers who had no employers. Her exposure the feminist movement as well as her observation of methods used by community development programs led her to promote a form of organizing poor women that conflated these perspectives: women working at home could be organized and provided with services and protections. When the International Labour Organization decided to promote a Convention on Home Work in the1990s, SEWA representatives found themselves in opposition to many trade union organizers from the global North who condemned homebased work as exploitative, similar to sweatshops. In contrast, women in the global South perceived homebased work as an important source of income that was consistent with their household responsibilities. Yet all of these women workers need protection, and as more women in the North were beginning to work at home with computers, homebased work took on a different connotation. SEWA helped organize HomeNet International, a network of groups supporting homebased work. Together, these women convinced the trade unionist that organizing women in their communities, as SEWA and other development organizations do, provides an alternative to the way traditional unions organize women workers. The

Convention recognizes that homeworkers can be independent or producing for an employer. Governments who ratify the 1996 Convention are expected to pass laws that treat homeworkers the same as other wage earners.

Expanding her work with the informal sector, Ela Bhatt helped form WIEGO: Women in the Informal Economy, Globalizing and Organizing, in 1997. This umbrella group brings together researchers, practitioners, and activists from North and South who are concerned with homebased women workers. Their goal is to put this topic on the international agenda through broad participation in international meetings and by sponsoring action-research projects around the world to expand data on the informal economy and especially women's participation in it. An innovative study is tracing "value chains"—where value is added—for two distinct activities associated with women: garments and processed food and forest products. The hope is that a better understanding of where value is added will allow women lower on the chain to claim more of the market price of the products. At a WIEGO conference in Ahmedabad in 2002, the importance of working with government to address issues faced by informal economy workers was emphasized during the presentation of the Durban, South Africa, plan for street vendors. A multi-racial delegation from Durban discussed their determination to work with the informal economy, to create new markets, and to co-ordinate

services available to them, now that South Africa is a democracy. After this presentation, the mayor of Ahmedabad recounted the various accommodations the city had made to vendors, and then promised to set up a task force modeled on the Durban experience.

Roiling the waters

In this way, the streams of educated activist women at the national level often merged with those in government, in research centers and development groups, working nationally and internationally for empowerment of women at all socio-economic levels. While tensions between women in and outside the government were evident in some countries, in most places symbiotic relationships evolved. Insiders provided contracts and grants to local women's organizations and research centers. Outsiders produced marches, articles, and reports that strengthened the arguments of women in government for new programs. All benefited from funding flowing through development agencies and foundations. These women expanded on the issues raised by women in the field and local women's organizations and led the fight to alter policies and laws inhibiting women's equality at national and international levels. When structural adjustment policies were invoked in the mid 1980s, women documented the effects and influenced their implementation over time.

The series of UN World Conferences on Women with their NGO forums grew impressively in size and complexity from Mexico City to Beijing. They provided space on official delegations and on panels at the forums for bureaucrats, advocates, and practitioners to meet fellow nationals as well as women from around the world. Sectoral issues expanded at each conference, to include health, housing, technology. These issues often reflected North/South disparities, but the view that "women's rights are human rights" enshrined in Beijing unite women everywhere.

Equally important, the parallel NGOs forums allowed women from around the world to meet and exchange ideas. Newly formed women's organizations often challenged older organizations for women. In India the split was between charitable elite women's groups and activist change agents, while in much of Latin American there was a gap between feminist groups of educated women and working women from trade union backgrounds and domestic workers. All the ferment at local, national, and international levels created layers of women organized, interacting, disagreeing, uniting to confront customary constraints, educate themselves and others, or campaign for change laws and practices that limited women's rights.

ALTERING CULTURE THROUGH ECONOMIC DEVELOPMENT – BUT NOT ON PURPOSE

When international development policies began to consider how to empower

people, not merely build infrastructure, programs addressing basic human needs were initiated to provide a safety net as rapid economic transformation resulted in increasing income disparities. Most early programs ignored the gender aspects of these programs. But, women as well as men had to benefit from new programs or old patterns would reassert themselves once funding disappeared. Indoor toilets required buckets of water that women had to carry; improved cook stoves were sometimes less efficient in terms of women's time; literacy programs or health clinics held in midday meant lost time for farming. The fundamental flaw of these programs was ignorance of women's economic importance to family livelihood. Statistical methods introduced by the International Labour Organization in the 1930s defined work as labor for remuneration, effectively making women's unpaid family labor invisible. Early foreign assistance programs, designed by economists, assumed that women did not work.

Women's economic subsistence work

Time constraints helped explain women's sporadic attendance at classes or clinics held during working hours – which for women was 12 to 14 hours per day: fetching water and fuelwood; planting, weeding, harvesting, processing and cooking food; taking care of family members; and maintaining the home. These necessary subsistence activities were invisible to economists and census takers; but these income-substituting chores become income producing in more advanced societies and therefore should be counted as economic contributions to the nation. The appropriate technology community responded to the drudgery by introducing faster ways to grind grain and designing more efficient cook stoves. Such technology was introduced to villagers through community organizations set up by national and international nongovernmental organizations (NGOs). These improved technologies not only reduced time spent, but had nutritional and health consequences such as reducing indoor pollution when cooking. Srilatha Batliwala shows how lowered energy expenditure of women in an Indian village equaled the normal shortfall in their nutritional needs, though not when they were pregnant. ("Rural energy scarcity and nutrition; A new prespective," in *Economic and Political Weekly*, 27/9, 1985). Though these solutions were sometimes inappropriate, the attention and organizing women received was an important step for achieving their capacity.

Income needs grew as the subsistence economy was monetized. Women needed to buy pots and cloth, and pay school fees. Early efforts to form groups for knitting and sewing (skills presumed to be female, even in countries where men are tailors and weavers) seldom produced income. Most craft-based activities such as basketry or pottery do not survive the departure of rural workers

who market the products for free. These efforts to help poor earn income were based on western stereotypes and lacked adequate market studies.

Existing employment

More successful were projects assisting women who were all ready working. SEWA organized women working in the informal sector and doing the most menial jobs—those collecting trash for reselling, carrying loads of wood on their heads, or stuffing cloth with scraps from textile factories to make mattresses. From vegetable sellers to *bidi* rollers; each occupation has its own section. Ela Bhatt notes that the informal economy in India today employs well over 90% of the Indian workforce, provides some 63% of the GDP, 55% of the savings, and 47% of the exports. In its 30 years of existence, SEWA has organized 418,000 women, 92% from minorities and 7% Muslims, seeking the women out in the street or in their homes. ("Self employment as sustainable employment." Keynote speech at the public event on the Social Summit + 5, Berne, Switxerland, 2002.) Without any employers to negotiate with, SEWA lobbies the government for favorable laws and regulations to benefit its members. Because they lacked a regular wage, many women frequently had to take out loans at usurious interest so, in 1974, SEWA established a bank. Additional financial services are now offered including enterprise and health insurance as well as home loans. Literacy classes are offered, and members are recruited to be local and regional leaders, for which they are offered a small fee.

In 2002, I visited Khulsum, a Muslim tea seller in Ahmedabad, India, who had also been a SEWA organizer for 15 years. In return for walking around the nearby slum to check on SEWA members and try to recruit more, she received 35 rupees a day. Shortly after this visit, Hindu mobs burned most of these slums, targeting Hindus. Khulsum's shanty and teacart were both burned; but the insurance offered by SEWA for Rps. 85 /year covered her assets in her home and outside up to Rps. 5000.

Because of caste constraints, few women sell prepared food in India. But in Southeast Asia and in Africa, street food vendors are predominantly female. In 1980, I began a fifteen-year study of women and men who make and sell food on the streets in seven countries. At the enterprise level, three findings stand out: except in Africa, the family cooperates in the enterprise; profits are invested in children not in the business; and income from street food vending is often greater than that earned by local white collar workers. The greatest obstacles to vendors were onerous government regulations that often resulted in "street cleaning" which left their carts and utensils broken. Municipal authorities in the study towns changed these policies once they understood the economic importance of street foods. These authorities also provided

access to clean water because they understood that the major health risk in street foods came from washing hands and dishes in dirty water. The Food and Agricultural Organization (FAO), which issues directives on health safety to governments, works with cities and vendors to improve health standards.

This study underscores the experience of SEWA: negotiations with governments to change regulations may be the best approach to improve the income of poor entrepreneurs. Available credit is most useful when it is not tied to specific productive uses. These observations provide a critical counterpoint to much of the research and policy on microcredit.

Microcredit in perspective

When small funds became available through microcredit schemes in the early 1980s, they allowed women to expand entrepreneurial activities doing what they knew how to do: raise goats and chickens, make or sell food, pound rice, even buy a pedicab for male relatives to use. The rapid adoption of microcredit programs in the developing world showed that there is tremendous demand for credit—at reasonable rates—among the poor. Promotion of microcredit as the answer to poverty among women has become so insistent that many observers fear that spending on this single solution will undercut other needed programs. Clearly, the focus on one particular path to empowering poor women should be suspect

and needs careful evaluation of its advantages and pitfalls.

The Grameen Bank exemplifies the predominant microcredit approach. Participants form small solidarity groups which act as collateral for individual loans. Because of their superior repayment rates, women now comprise over 90% of the bank's membership. Promoted as a minimalist approach that avoids costly social services that were common in earlier poverty programs, the concept of group responsibility for loans to the poor has been introduced in countries as diverse as Nepal, Rwanda, and the United States. The strong social movement foundation of Grameen Bank is frequently overlooked; the bank requires its members to follow Sixteen Decisions designed not only to encourage banking discipline, but also to encourage women to practice social goals such as not paying dowry when their daughters marry, not overspending on weddings and funerals, and limiting family size. In other words, the Grameen Bank trains the poor to reduce traditional social spending as well as to save and utilize credit. Further, members are provided information about health and family planning along with financial and marketing issues at the required weekly meetings. In recent years, in order to increase international support, the Grameen Bank has downplayed this social aspect and claims it is simply a bank.

Although alternative microfinance institutions are now extensively used around the world, the Grameen model

appears to many agencies and NGOs as a panacea for poverty alleviation. International donors sponsored a Microcredit Summit in 1997 in Washington DC to announce a goal of reaching 100 million poor with credit facilities, primarily along the Grameen model, by 2005. This initiative rekindled critics who are worried that concentrating on a single method of assisting poor women the rosy view of microcredit masks serious issues about targeting and commercialization, and confusion about microfinance as a substitute for social welfare. Cynics comment that the Grameen Bank has been lavishly supported by donors because it is an ideal channel for donor assistance, since it is relatively standardized.

Economic complaints center on the profitability of the microenterprises; existing women entrepreneurs are more likely to show a profit than those starting a business the first time. Others claim that women are mere conduits for loans controlled by male family members. Such critics ignore the cultural context of rural Bangladesh where studies show that women's access to funds itself seems to raise their status within the family and reduce domestic violence. Further, research indicates most women use credit both for their own projects and also for family enterprises such as farming and selling the harvest which are typically male activities. Helen Todd, who observed Grameen members in their villages for a year, found that women often serve as family managers and that their ability

to improve the family income increases their status and self-confidence. Their acumen was evident in the ways they circumvented strict rules for use of loans and bought land *in their own names* for their husbands' to farm—bank members are supposed to own no more than .25 hectares of land although they may take out loans to build a house on land they hold in their own name. The Grameen model also rigidly controls the use of loans for productive activities; ignoring the fungibility of cash expenditures between social needs. Yet data indicate that family finances improved, whatever the success of the women's enterprise, simply because loans from the bank, though not negligible, were available at a much lower rate than through local money-lenders. (*Women at the Center: Grameen Bank Borrowers after One Decade.* 1996.)

The highly disciplined Grameen model seems uniquely adapted to Bangladesh. Explaining why India has preferred self-help groups, a study for Women's World Banking opined that Bangladesh has less experience of any form of democracy than India, which has a more diverse and individualist society. Because self help groups set up and run their own banks, members themselves become skilled in finance. This contrasts with a large staff needed to visit and monitor rural Grameen centers. Given the geographic isolation and the traditional culture that persists in rural areas of Bangladesh, most of this staff are men. Training members to run their own banks, a common practice in Latin

America as well as in India, creates an intermediate level of empowered women. Such upward mobility for members, which provides income and leadership opportunities to less educated women, is a feature of organizations led by women. In Bangladesh, empowerment for women awaits the generation of daughters of Grameen Bank and BRAC members who are now in school.

Use and misuse of microfinance programs

Development organizations worry that the Grameen Bank model is too narrow: although it claims to be a bank, members have difficulty withdrawing the money they save as part of each loan. Accumulated assets of members have funded much of its growth. Alternative models put more street on banking functions, which allow easy deposits and withdrawals. SEWA's bank is now located in one of the most modern buildings in Ahmedabad; their members enter confidently, often with their husbands trailing them as they conduct their business. Even street kids in Delhi have launched their own bank under the auspices of the local voluntary agency, Butterflies. Located at the Old Delhi Railway Station, where kids shelter at night, the bank keeps their meager income safe; older children have even started taking loans to start their own enterprises.

As the popularity of microcredit explodes, the danger of offering too much credit to the poor is worrying many observers. One of the most vociferous is Farhad Mazhar, an editor of the Bangla journal *Chinta* (Reflection). In an email to the author on 25 July 1999 she wrote: *Politically we always resisted the bizarre idea that indebting poor contributes to "development". The idea that poor women of Bangladesh are empowered by being indebted to credit institutions run by middle class male patriarchal structures built upon the existing web of patriarchal relations, obligations and oppressions—is the biggest joke of our time.*

Concerns over indebtedness increase when groups offering credit compete for customers, something that might happen as the targets of the Microcredit Summit are reached. Will the poor will run up debts just as so many Americans do with multiple credit cards, paying off one card with credit from another? Something similar happened in Nepal when the rural credit bank allowed a single borrower to have several loans of differing length; the program collapsed with no apparent injury to the borrowers. In Bangladesh, with its tighter group membership structure, neither borrowing too much nor failing to pay back seems likely.

Some academics argue that offering credit to women for work-intensive low profit activities condemns women to continued drudgery. Many microfinance programs have responded by assisting in the development of new opportunities from catering or craft businesses to the Grameen Bank cell phone project. But offering credit to the poor is about more than setting up a

microenterprise. Required group meetings are a font of information and support as regular meetings of otherwise isolated and hardworking women open the world to them. Women exchange ideas about dealing with male violence as well as male interference with loans. Most groups promote literacy and often provide such training. Women members enhance their personal and social skills while learning how to set up and run her enterprises. Increased self-confidence as well as income encourages women to send their daughters to school.

Observers agree that, at least among uses of Grameen loans, violence against women falls as women's economic importance increases, perhaps because access to the loans which are used by the family as well as by the women, are through the women themselves. In many countries, when men's traditional roles as family provider are challenged when men lose their jobs and women return to the labor force, violence in fact increases. A particularly poignant case was recently recorded by Edward Miguel his paper on "Poverty and Witch Killing." (*Review of Economic Studies,* 2003.) In Tanzania "households near subsistence kill (or expel) relatively unproductive members to safeguard the nutritional status of other members," justifying their actions by accusing the old women of being witches. Miguel notes that witch killings in South Africa dropped after old age pensions were introduced in 1990s.

Both SEWA and the Grameen Bank offer home loans to women. The power and sense of control that comes from owning one's own house is incalculable in these patriarchal societies. Houses can be used as a place of work, a source of food, provide income through renting, and protection from being evicted should a husband desert or divorce you. Women's right to own a house is traditional within Islam, and laws have been changed in India to allow it. But in many parts of Africa, the material power that comes from accumulation of assets is still not guaranteed to women. Women throughout the continent are taking on this issue.

Credit is a universal need; the poor are not different in this. Money lenders have prospered giving usurious loans, and traditional loan circles, often based on family, did not reach the poor. When poor women can borrow at a reasonable rate of 16% per year, rather than 40% per month, the standard of living of the household improves even if her enterprise loses money.

Local leading to national political action

Spontaneous protests have erupted in India over government actions that directly affect women's livelihood such as the use of non-timber resources or legalizing of toddy, a cheap local liquor, to increase state taxes. Established women's organizations quickly absorbed and supported these new issues. The emergence of the Chipko movement, women in the Himalayan foothills who hugged

trees to prevent their harvesting, documented the negative consequences of rapid economic growth not only on the poor, but also on the environment. Recognizing the indigenous knowledge of such women about the sustainable uses of field and forest, women have organized to support traditional agricultural practices in Ladakh, and elsewhere, against high dams that would deprive many peasants of their land, and against "biopiracy" of golden rice or the neem tree. In Bihar, local women organized to obtain land in their own names.

Increased radio and television coverage of such events spread the word, and soon spontaneous groups of village women arose protesting local inequities. Women in hill tribes in Maharashtra shamed husbands who beat their wives by banging kitchen pots outside the offending man's house. Dalit (formerly called untouchable) women joined with devadasis (temple dancers) to protest the dedication of girls to serve in temples as "brides" of the gods – a sort of sanctioned prostitution. In central India local women challenged government sanctioned toddy shops because cheap liquor was increasing domestic violence while encouraging their husbands to spend their paychecks on the liquor; the shops were closed.

This ferment was widely reported and helped spur the creation of reserved in local councils. Under laws passed in 1993, one-third of all seats in local councils in India must be filled by women, a goal that is achieved by rotating the reserved constituencies so that no seat is permanently a woman's seat. While such provisions might be seen as preventing continuity, many women become so respected that they are elected to general seats. To date over one million women have been elected to local bodies.

In Argentina and Chile, women led the protests against the "disappeared." Such action under authoritarian governments was dangerous; the women counted on their identity as mothers. In Peru, women organized communal kitchens and organized boycotts against rising prices, and supplied milk to children and communal kitchens in poor neighborhoods during the economic crisis of the 1980s. A similar protest by Indonesian women in 1998 helped precipitate a regime change. "Acting under the cover of the traditional concept of the role of women, young women intellectuals started the sales of affordable milk for infants." Encouraged by widespread support, the women led a demonstration in front of Hotel Indonesia; three women observers were mistakenly arrested. The organizers of the group were very much aware that the shift—*from milk to politics*—was a protest against the government's masculine paradigm of power and violence which had brought the country to economic ruin. (Carla Bianpoen, "Women's political call," in *Indonesian Women: The Journey Continues*. Mayling Oey-Gardiner & Carla Bianpoen, eds. 2002.)

The groups that organize such demonstrations are often evanescent; established organizations are usually

too embedded in the system to contest it. But South Africa offers an example of women countering the party of which they were an integral part. The Rural Women's Movement which had agitated against forced removals and Bantustans, worried that a return of power to tribal chiefs, as proposed in the draft constitution which made the Bill of Rights subordinate to customary law, would legitimize women's subordination. In 1992, Women's National Coalition was formed from 81 groups and 13 regional alliances of women's groups plus the women's caucuses or "gender desks" of all major parties. This coalition declared a Women's Charter for Effective Equality and lobbied successfully for reversing the order and making customary law answer to civil law. The amended constitution was passed in 1997.

Such protests, initiated by small groups, merge local concerns into national and eventually into international policies. The examples presented here merely suggest the activities of hundreds of others. The political climate in a given country is key to the success of such demonstrations: daring authoritarian regimes must be done with care; few protests take place in communist countries. In Eastern Europe as in the Philippines, where gender equality was widely assumed, women tended not to organize separately but rather joined men in contesting government actions.

Accumulating Personal, Economic, Social, Material, and Political Power

In less than four decades, organized women everywhere have coalesced into the dominant social movement that emerged in the late 20th century, the global women's movement. For millenia, women came together to harvesting, worship, and support others in their tribes or villages. In the last 150 years, suffragists formed national and international associations for business, charitable, and educational goals. Many international women's organizations achieved representation in the United Nations, which allowed them to provide guidance and support to the new wave of the women's movement.

What made the quantum leap from disparate organizations to global women's movement possible? My argument is that the recognition by the international development community of women's economic roles made a critical difference, and it is an understanding that has been championed by women around the globe. But recognition without funding would not have had the results inscribed in this chapter. Funds flowed to researchers and activists; women did not have to be wealthy to travel to international conferences or to focus on studies of women, or to write books such as this for an audience created by the rise of the women's movement. Opportunities exist for women to be paid to study or work with women. Funding reached poor rural and urban women through NGOs and community development

projects. Current efforts to ensure that women share in and benefit from the information society are also funded by international agencies, and the spread of rapid global communications has increased the speed by which ideas flow.

When economic aid began to glow, few planners worried about the dislocation of the relations between men and women, which were viewed as established behaviors, firmly embedded in local traditions. Today, theses changes are identified with the West, and nationalists and religious fundamentalists in many countries fulminate against "cultural imperialism." But these leaders do not desire less developed economies, only a return to unchallenged patriarchal control. Thus in many ways, women's status has become hostage to cultural change. Only women in their own countries and societies can counter this trend. But the intellectual support from other countries and examples of women's growing empowerment are essential for their success. The combination of resources available through development and the power of local organizing contributed to women's empowerment at various socio-economic levels through a myriad of channels and organizations. No one planned it, but empowerment happened.

WOMEN'S ECONOMIC ROLES AND THE DEVELOPMENT PARADIGM

WOMEN WERE INVISIBLE IN THE LIB-eral economic development paradigm predominant in the 1950s. This invisibility of women's economic roles reflected the prevailing worldview in Europe and the United States that considered women's work ancillary to the family and economically irrelevant. This assumption allowed to the conceptual modeling of the household as a unit which was benevolently ruled by the patriarch who made decisions that were in the best interests of all family member. Further, this construct effectively ignored women's caring functions globally and obscured women's economic activities in subsistence economies. That such assumptions were seen as culturally biased only proved the need for modernization of economies around the world.

The social construction of gender reflected in development theory was increasingly challenged by women in both developed and developing countries. Scholars documented the work that women did and concluded that many development programs were having an adverse impact on women. Activists agitated in Europe and the United States for their governmental agencies to integrate women into development.[1] The preponderance of early development programs were focused at the community level and designed to improve agriculture, educate the villagers in health and sanitation practices, or teach literacy. These were the very areas where women's work undermined programmatic design. Research documenting the economic activities of women in subsistence economics impelled reconsideration of such programs and suggested the need to organize women separately from men. Increasingly, women activists influenced economic assistance policies at the national and international levels and prompted a broadening of sectors focused on including women in international development.

In order to reach and train women at the village level, programs began to organize them and hired educated women to help. These women soon became advocates for changes in customary laws that affected them as well and founded national women's organizations to lobby their own governments. The series of United Nations World Conferences on Women provided opportunities for these women

1 Based on personal interviews in Hanoi, September 1998.

to meet other activists and scholars at the non-governmental forums. Foundations facilitated this interchange by providing travel. This vast array of women from countries around the world reinforced women's demands for greater equity. By subsidizing women's organizations at all levels, economic assistance agencies in fact helped fund the global women's movement.

In the 21st century, poverty has become the major focus of development agencies which now focus on women as the key. Many projects to assist women to earn money have certainly helped. However, women now argue that the persistence of patriarchy with its inequitable power relationships can only be addressed politically. A woman's right to a house also provides her with power to limit domestic violence but also becomes a site for income activities and the production of food.

This chapter traces the evolution of the development paradigm in response to the recognition of women's economic roles. As the women's movement grew, women demanded greater emphasis on their rights. Rapid socio-economic transitions altered family structure which called for greater attention to gender relationships. Gender sensitive programs and policies further changed development programs. Activists today are working to ensure that rhetoric is matched with expenditures. Finally, recognizing that development is basically political, women are demanding greater representation in legislatures and government globally.

WOMEN'S ECONOMIC ROLES CHALLENGED THE DEVELOPMENT PARADIGM

Women were invisible in early economic development theory for three basic reasons. First, the worldview prevailing in Europe and the United States in the post-World War II era which assumed women did not work was incorrectly perceived as universal. Secondly, the economic constructs based on this assumption proposed the household as an economic unit whose members were well served by its patriarch. Finally, this lack of cultural variability could be traced to some extent to inaccurate information about women's economic roles and gender relationships in developing countries.

The industrialized countries, recovering from World War II craved normalcy as they envisioned it had been before the war: men working and women in the home. This vision ignores how easily appropriate roles for women and men can be manipulated. Traditionally the social construction of gender was influenced by religion and culture. Governments can utilize media and tax policy to encourage change. For example, in the 1930s, women in the US were implored to leave their jobs so that men could work and support their families. So successful was this reordering of women's roles that the regents of the University of California, Berkeley, decided undergraduate women should concentrate on home science and arbitrarily reassigned women professors

from across the disciplines to Home Economics. But once the US entered the war, the government proclaimed women's patriotic duty was to work in the defense industry: the posters of Rosie the Riveter were as ubiquitous as those recruiting soldiers.

Development theorists took as given this transitory view of gender and utilized it for designing the stages of growth that would lead to modernization. Liberal economists wished to counter Marxism with an alternative inevitable path, but they tended to dismiss in importance of women in both the economic and caring economies. Marxist theory does recognize women's importance in reproducing the labor force as well as their work yet provisions for assisting women in their caring functions were seldom adequate in communist countries. Both these economic constructs lacked an understanding of women's reality, especially in developing countries.

Women's activities in the family were, according to the economic construct, part of the household unit whose male head was the benevolent decision-maker. Placing women in the black box of the household obliterates their work in the care economy globally. In subsistence economies which still retained the traditional sexual division of labor as development assistance programs geared up, focus on the patriarch undercut customary responsibilities and tended only to reward the males with rights. Focus on the household

obscured the facts of women's economic contributions.

WOMEN'S RESPONSE

The rhetoric of democracy and equality espoused during the war resonated in both former colonies and in industrial countries. Independence movements brought women to the forefront of struggle, especially when the male leaders were jailed. Many women were given high level positions at home and in the United Nations in the newly independent countries. International women's organizations participated in the Economic and Social Council and lobbied the UN to include social issues in the UN First Development Decade 1960-1970 that focused on infrastructure and industrial projects. In 1964, Sweden became the first western country to alter its development policies explicitly to include women: USSR had initiated a few such projects earlier in the decade. Activists spurred the US Congress to amend the Foreign Assistance Act of 1973 and require the US Agency for International Development to administer its programs with a view "to integrate women in national economies of foreign countries, thus improving their status and assisting the total development effort." A similar resolution was passed by the UN General Assembly in Dec. 1974.

Ester Boserup studied the introduction of cash crops into subsistence economics in Africa in *Woman's Role in Economic Development*. Not only did policies

that privileged cash crops result in increasing women's work in the fields but, since income from these crops flowed exclusively to the men, allowed men to seek higher paying jobs in urban areas with no obligation to support their rural families. In this manner, development programs frequently had an adverse impact on women's work and also contributed to the disintegration of the family which led to increasing poverty among women headed-households.

Research about women's work in subsistence economies recorded the many hours women actually worked doing such survival activities as growing, harvesting, processing, and preparing food as well as carrying water and fuelwood. These time allocation studies clearly show that women work more hours than men; further, while men had some leisure time, women did not. Babies were on their backs as they worked; girls assisted their mothers as soon as they could walk. Many assistance projects failed because they ignored the fact that the real rural energy crisis was women's time.

Time-allocation studies also distinguished between societies that utilized bride price and those that practiced the dowry system. In female agricultural systems, women's work is highly valued and requires a payment to the bride's family to compensate for losing her labor. Where male farming systems predominate, women are a burden on the family and must pay a dowry to the husband. A study in South India showed how one caste switched from bride price to

dowry as irrigation decreased women's work and income allowed an increase in status by taking women out of the fields. Of course, even in male farming systems, women harvested, processed, and prepared the food.

Still, development agencies continued to conceive of programs that ignored variations, political considerations, and women's work demands. Even within a country, similar projects often had opposing consequences on different groups of women. Mayra Buvinic ["Projects for women in the third world: explaining their misbehavior," in *World Development* 14/5, 1986] complained that projects often "misbehave" because elite women benefitted more that the poor. Ester Boserup ["Economic change and the roles of women," in *Persistent Inequalities*, Irene Tinker, ed. 1990] noted how age- class-race hierarchies modify women's roles in different types of societies. Hanna Papanek ("To each less than she needs, from each more that she can do," in *Persistent Inequalities*) and Amarya Sen ("Gender and cooperative conflicts," in *Persistent Inequalities*) both emphasized how women's lower entitlements both within families and society affect the efficacy of development programs. Maruja Barrig recorded the conflict between Northern donors and local NGOs in her study of indigenous women of the Andes. ["What is justice? Indigenous women in Andean development projects," in *Women and Gender Equity in Development Theory and Practice*. Jane Jaquette & Gale Summerfield, eds. 2006] Kristen Ghodsee links

the limited success of WID projects in post-communist Europe to their situation within free-market capitalism rather than a more socialistic welfare state closer to the Scandinavian model. ["And if the shoe doesn't fit, wear it anyway: economic transformation and Western paradigms of women and development programs in post-communist Central and Eastern Europe," in *Women's Studies* Quarterly 32:1/2. 2003]

GLOBAL CONFERENCES AND ALTERNATIVE VOICES

UN World Conferences on Population in 1974 brought together scholars who had been studying population trends with activists trying to implement family planning. Early euphoria over rapid acceptance of birth control methods had been replaced by concern that a plateau had been reached. Margaret Mead lectured about how cultural factors often prevented women from utilizing population programs. Feminists stressed the importance of choice when designing family planning programs and complained that although "improving the status of women and girls of itself was a desirable goal for reaching lower fertility, the motivating force behind population policy" was to reduce family size. Not until the 1994 International Conference on Population and Development in Cairo was the global women's movement "able to help define the parameters of the discourse on population ... [emphasizing that] women's empowerment and

improvement in status are important ends in themselves and essential to the achievement of sustainable development. This is in direct opposition to the prevailing notion in the population field that women are merely a means to reach a preordained target of population growth." [Radhika Balakrishnan, "Population policy revisited: examining ICPD," in *Forum: Health Transition Review* 6. 1966]

This population conference, along with the Conference on the Human Environment held in Stockholm in1972, began a series of official UN world conferences dealing with emerging issues not dealt with in the original UN Charter. Participants in these conferences included national delegations, Non-Governmental Organizations [NGOs] in consultative status to the UN. In addition, all arranged a Forum where a wide range of groups interested in the topic could debate. Women learned to lobby delegates at the UN meeting to include women in pertinent sections of the conference document. For example, at the World Food Conference, held in Rome in 1974, women staff of the FAO ensured that women's roles in food production were recognized.

The 1975 World Conference of the International Women's Year, provided the first opportunity for a discussion about the impact of development on women. An international seminar of women and men scholars, practitioners, and activists concerned with development preceded the official conference. Most participants became advisors to

their country's delegations; others organized panels at the NGO Tribune, as the Forum was called. As a result, many recommendations from the workshops were incorporated into the plan of Action. Delegates argued that one conference was insufficient to address women's inequalities; a decade for women was declared, with conferences in 1980 and 1985. The International Women's Tribune Center was established in New York City which published a newsletter so that activists could keep in touch; they also compiled resource books for women's groups in developing countries.

The IWY conference proved to be an incubator for a global women's movement. It also confronted women with politics of the UN. The General Assembly had proclaimed three themes for International Women's Year as "equality, peace, and development," reflecting the primary preoccupations of the three ideological blocs: the Communist East, the industrialized West and the developing countries. Equality, especially equal voting rights, was also the original focus of the Commission on the Status of Women set up within the UN in 1946. Peace was associated with Socialist women, in the US as well as in Europe, who had united over worker's rights and then, after WWI, on a demand for the end of wars. For years the Cold War mentality made cooperation between women from East and West more difficult.

As with the subsequent women's conferences, political maneuvering by

countries concerning issues outside the purview of the conference frequently conflicted with the desires women to focus on topics more closely related to women's concerns. While some women were convinced that governments used women's conferences as a proxy for global debates because women lacked the political muscle to contest, other women welcomed such debates as an indication that women as citizens needed to be part of such discussions.

The growing disconnect between Northern feminists, especially Americans like Betty Freidan, and women from the South was highlighted at the Mexico City NGO Tribune and caused by the assumption of universality of women's issues by American feminists. Lucille Mair, as secretary-general of the 1980 Copenhagen Conference, funded a series of research papers written by women from the South to balance the dominance of documentation by Northern scholars. Increasingly, the WID approach of integrating women into development was met with the question: into what? Lucille Mair argued in "Women: A decade is time enough" that such integration, far from benefitting women, actually made them work harder. [*Third World Quarterly*, 8:2. 1986] Elise Boulding cautions that integration into the present world order only increases women's dependency. She opts for a "strategic separatism that frees up the potentials of women for economic and social experiments on a small scale, outside the patriarchal social order." ["Integration into what?

Reflections on development planning for women," in *Women and Technological Change in Developing Countries.* Roslyn Dauber and Melinda L. Cain, eds. 1991 Socialist feminists criticized the capitalist project, echoing many of the complaints made by WID advocates about the values and biases in liberal development thought. The women's social movement became a transnational network of diverse groups and interests encompassing class, religious, and geographic variations.

In 1983, Devaki Jain presented a paper at the OECD/DAC women in development group: "Development as If Women Mattered: Can Women Build a New Paradigm?" This concern blossomed into series of meetings among women scholars from the South who drafted the influential *Development Alternatives with Women for a New Era: Development, Crisis, and Alternative Visions: Third World Women's Perspective.* This book was unveiled at the Nairobi Women's conference in 1985. Participants in the project formed a new global organization, DAWN, to continue the presence of women of the South in the development debate.

Challenges to development practices also came from the Caribbean. In 1978, a regional development program was set up within the University of West Indies in Jamaica. WAND [Women and Development Unit] "was to be shaped by its constituency" and to the university with the community. [Peggy Antrobus, "A Caribbean Journey: defending feminists politics," in *Developing Power.* Arvonne Fraser & Irene Tinker, eds. 2004] A Caribbean voice was particularly important since the UN Commission for Latin America was not serving the region which seemed consumed with more radical critiques based on dependency theory.

As the women's movement expanded, women's organizations began to hold world conferences themselves. A 1974 feminist meeting in Frankfurt, Germany, demanded increased surveillance over international prostitution rings and called for a ban on female circumcision. Aware of what they termed the "male dominated transnational-controlled press," *Women's International Bulletin* was started by Isis, a documentation center based in Geneva and Rome, to enable women from North and South to exchange grassroots experiences. Today, Isis operates out of Santiago, Chile; Kampala, Uganda; and Manila.

A World Congress for International Women's Year, convened in East Berlin in October 1975, was a hybrid conference. Organized by the Women's International Democratic Federation to celebrate its 30th anniversary, the meeting was planned with the support of the United Nations and attended by the UN Secretary-General Kurt Waldheim who thanked the WIDF for first suggesting the idea to celebrate IWY. Participants included many Asian and African women and men who had attended workshops in the socialist countries that promoted integrating women into revolutionary causes, as opposed

to the WID model designed to incorporate women into a capitalist model. [Kristen Ghodsee. "Gendering Socialist Internationalism: Communist Mass Women's Organizations and Second World/Third World Alliances during the U.N. Decade for Women, 1975-1985." Journal of Women's History 24(4).2012]

All this activity of women around the world underscored the critical role women played in developing countries while at the same time challenging the WID model.

SHIFTS IN PROGRAMS AND POLICIES BY DEVELOPMENT AGENCIES: 1970 – 1985

Advocates for women in development emphasized programs which recognized women's economic roles. Previous programming for women was concentrated on their roles as mothers and was funded by well-funded population programs. Such programs dealt with women only in their reproductive roles, and then only as mothers, not as women. Health programs, although call Maternal and Child Health, were child focused and gave no consideration to the mother's health. Population programs spoke of women as "targets" of family planning and were surprised when women chose not to become "acceptors." To counter the cultural preference e for large families, the World Bank promoted child spacing to enhance the health of mother and child. Sill, initiatives that focused on women's

health continued to be neglected until the onslaught of HIV/AIDS forced the medical community to respond to indications that women's susceptibility was greater than men's.

To avoid welfare approach to women, WID encouraged separate offices, or machinery in UN parlance, to design new ways to fund, monitor, and carry out programs that would integrate women into the economy of the country. They argued such projects would be both more effective and efficient if women were included. This was a tactical decision given the somewhat chilly attitude toward women's rights help by agency administrators. Activists, in and outside agencies, criticized the development policies and programs being pursued, they felt that working within the system was more important than an overt challenge to the capitalism.

For example, agricultural projects promoted cash crops; research showed clearly that introducing these crops increased women's work. WID proponents stressed women's critical role in food production and lobbied for extension services to improve production. This effort was largely unsuccessful as administrators of agricultural programs were strongly influenced by US land grant colleges which taught women home economics and men to be farmers. This cultural blindness often led to teaching African women to can foods or set a table while teaching men to farm.

Cooperatives were introduced to replace marketing boards under the assumption that producers and land

owners were the same. For three years the coffee production in Kenya fell after women no longer received payment for their crop, the funds going instead to the male who was usually in the city. Only after the coop agreed to fund school fees for their children did the women return to harvesting coffee.

The same misguided assumptions left tractors in the fields when no replacement parts were available. Appropriate technology [AT] became a rally cry for transferring technology to developing countries. The AT engineers soon developed useful technology to improve processing of rice and bring water to villages. Their efforts to provide new improved cookstoves were mired in cultural assumptions about fuel types, efficiencies at the micro level, and women's time constraints. As a result, few of these cookstoves were adopted by rural women.

WOMEN, WORK, AND INCOME

Agencies tended to select women's organizations or church groups to implement economic projects for women despite their lack of familiarity with creating income projects. Rather, their experience running social programs in their own countries led them to set up projects emphasizing women's domestic roles inconsistent with the reality of women's lives in developing countries. In both Asia and Africa women farmers were taught to sew in countries where men were the tailors.

Such programs were conceived in response to the demonstrable need of women for money as monetization expanded. More successful were projects assisting women who were already working. SEWA [Self-Employed Women's Association], started by Ela Bhatt in Ahmedabad, India, set up a bank in 1974 to provide loans for members. A vegetable seller, who collected her produce in the morning from a wholesaler, might have to pay 50% interest in the evening: by paying for the goods, her income immediately increased. Similarly, the impetus for the Grameen Bank came when Mohammed Yunus observed a woman making chairs one at a time. He realized that credit would allow her to increase her output and buy goods in bulk. The Grameen model evolved into organizing women so that the group became collateral for loans to set up microenterprises. Research showed that despite low or no profits from these new microenterprises, family welfare increased because inexpensive credit was available. Experienced entrepreneurs were the most successful borrowers from Grameen. Use of credit to buy a pedicab for a husband or son was widely criticized who complained that women were just a conduit for male family members. Such an emphasis on individualism over family conflicted to values of the local culture.

For feminists, the philosophical distinctions between SEWA and Grameen are critical. SEWA organized women by their existing jobs, insisted they become literate, and trained members

to become leaders. In contrast, the Grameen Bank is headed by men with a largely male staff. While SEWA is organized around a union philosophy, Grameen has a strong social movement foundation. Members are expected to follow Sixteen Decisions that include calisthenics, birth control, and refusal to pay dowry or for lavish weddings. Use of loans are also controlled the bank. Such a "father knows best" approach reflects a patriarchal mentality. Devaki Jain, reviewing income-generating projects in India to assess how the nature of leadership influenced women's agency concludes: "All work did not necessarily empower women... It took something more, and that seemed to be feminist leadership." ["A View from the South: A Story of Intersections." *Developing Power*. Arvonne Fraser & Irene Tinker, eds. 2004]

None of these microenterprises would be considered work under early ILO guidelines. In the 1970s, the ILO did begin a series of studies on the informal sector which it defined as an enterprise with five or more employees. Because women tended to be sole or family workers, this definition once again excluded them. Market women in West Africa had been the subject of studies for years, yet their considerable income fell outside definitions of employment. A seven country study of Street Foods was more influential in influencing policies at the ILO. The study underscored how cultural factors influence the roles women and men in the enterprises. In Nigeria women

ran 94% of all enterprises, 78% in Thailand, 77% in Senegal, and 63% in the Philippines; in contrast women operated only 17% in Egypt and 16% in Indonesia. In Bangladesh, only 1% of the vendors were women although they assisted their husbands in 37% of the enterprises. ILO took note of date showing that many street food vendors made more money than workers in formal sector jobs such as school teachers or military officers.

Gender became even more central to the debate over the informal sector in the 1980s when industries around the world began to "informalize" their workforce. The impact of industrial homework on social relations has been profound. Women were employed in assembly centers; other women made the same goods at home. The line between formal and informal work became convoluted. How to collect data on women's employment in the informal sector is central to United Nations statistical indices, especially as they are utilized in both the Human Development Report and the Gender Inequality Index.

ORGANIZED WOMEN MOVE BEYOND ECONOMICS

Development programs designed to reach village women required local people to organize them. In most societies, educated urban women were hired to work with village women and frequently to collect data on their lives. Many of the issues raised veered from

the programs at hand toward women's powerlessness in face of customary practices concerning marriage, property, inheritance, and domestic violence. Recognizing how these problems were theirs as well, urban women began to organize themselves and lobby their governments to address the legal and constitutional rights of women.

While development agencies continued to follow the WID approach of integrating women into economic programs for efficiency reasons, the expanding women's movement was asserting women's rights as the basis for broadening programs beyond the economic sector. Although women's income was shown to increase women's bargaining power within the family and to diminish the incidence of domestic violence, other research showed that men often reduced family support as women increased theirs. Formal sector jobs pay women less than men; women in the informal sector were often compelled by household responsibilities to work fewer hours. This unequal income particularly affected women headed-households.

As the socio-economic transition continued, poverty increased among female headship households. Structural adjustment policies in Latin America and Africa which decimated social programs and stifled growth tended to exacerbate this trend toward the "feminization of poverty." Research suggests that women's capacity to command and allocate resources is more crucial to empowerment than simply receiving them.

A major resource for women is control of land. Traditional farming systems allocated usufruct rights to women, but the male family controlled ownership and could evict widows. In post-genocide Rwanda, distant relatives often ejected grandmothers caring for grandchildren. The AIDS epidemic had a similar result in Uganda. Although both countries have recently passed laws to remedy this situation, enforcement is lax. The Landesa Center for Women's Land Rights "champions women's secure access to land." [www.landesa.org] This pioneering project in India has arranged micro-plots that include women's names on land titles: the plots are too small to threaten existing landholders. Urban women frequently grow produce on strips along roads or other public lands. These urban gardens contribute to the economic security and nutrition of the poor; in Kampala, half the land in the city is farmed by about one-third of the total population; 70% of poultry and eggs eaten in the city are produced there.

Housing is even more critical for women's empowerment: a home not only provides shelter but a site of income and space for growing or raising food. Further, owning a home allows women to eject abusive partners, reducing not only domestic violence but also lowering the incidence of AIDS. Costa Rica passed a law in 1990 that guaranteed women's ownership rights to any home subsidized by the government: if the woman was married the house was registered under both name, but if

she was not married, the house was in her name alone. In Bangladesh, where floods regularly wash away traditional rural huts with their bamboo poles and matting sides, the Grameen Bank granted loans to its members. Before the loan could be granted, however, her husband had to deed to her the land in this virilocal village where the house was to be built thus ensuring she had rights to stay in her tiny house even if the husband migrated to the city.

The culmination of women's demand for equality came at the 1993 World Conference on Human Rights when the body adopted the statements that the human rights of women are an inalienable, integral, and indivisible part of universal human rights. Essentially, this declaration is a frontal attack on patriarchy because it implies that existing laws which privilege men and maintain the subordination of women must be eradicated. This mantra was reiterated in the Platform of Action which was passed at 1995 World Conference for Women in Beijing despite a concerted effort of the Vatican and several Muslim nations to backtrack on this pivotal assertion that women's rights are human rights

The integration of women into economic development is no longer seen as sufficient. Feminists have injected their arguments for justice into the development paradigm. A woman's right to control her body impacts has required revamping development policies relating to health, population, and HIV/AIDS.

GENDER AND DEVELOPMENT

Participants at a 1978 workshop on "The Continuing Subordination of Women in the Development Process" at the Institute of Development Studies at Sussex University underscored challenges to WID coming from Marxist feminists. Noting that the growing literature on development was largely descriptive, the participants found that this approach, by treating women as a distinct and isolated category, ignored gender relationships within the household and labor force. Papers from the workshop were published in *Of Marriage and the* Market; in this ground-breaking volume, the authors analyze the persistent forms of gender inequality in the processes of development.

An added dimension to this critique has come from transnational feminist scholars who echo the complaint that women are not a universal and homogeneous category as presupposed by Western feminist scholarship. Rather, they argue, Third World women must be viewed through an anticolonial, anticapitalist lens. From this view, the subordination which characterizes these women must include, not only gender relations, but also the "hegemonic imperialism" that describes the present capitalistic system. [Chandra Talpade Mohanty, *Feminism without Borders: Decolonizing Theory, Practicing Solidarity.* 2003] But the DAWN network insists that any struggle against these forms of

oppression must not compromise "the struggle against gender subordination."

Gender refers to the socially constructed roles of women and men and is distinct from biological sex. As such, gender describes what is accepted femininity and masculinity in a particular society. These characteristics are learned behavior and thus changeable over time. Also changing is the gender division of labor but not the fact that women are responsible for most of the unpaid labor in the household. As the development discourse recognized women's economic roles and as commodification required earned income, traditional methods of combining both work in the home and in the field have been increasingly lengthen women's double day. In both developing and developed economies, women's caring work continues to be undervalued and is seldom included in economic data, further disadvantaging women.

Since gender of an individual is the kaleidoscope of all a person's characteristics, the question arises as to what should be considered the predominant attribute. The Marxist discourse had emphasized class as the organizing principle. In the 1980s, social movements organized around ethnic or religious identity gained prominence. While most focus today is on Islamic societies, the break-up of Yugoslavia and the subsequent Balkan wars illustrate the power of cultural identity. Control of reproduction, and therefore of women, is central to identity politics because women are celebrated as

the embodiment of culture and values. Some women see this role an "an onerous burden, one they would just as soon not assume, especially if it is predicated upon control and conformity. But for other women, it is an honor and a privilege...This is why all 'fundamentalist' movements have women supporters as well as women opponents." [Valentine Moghadam. *Identity Politics and Women: Cultural Reassertions and Feminisms in International Perspective.* 1994]

Identity politics, by seeking an idealized past, reasserts customary patriarchal family law. Similarly, Robert Mugabe railed at a new constitution that would give women rights to land; he declared that he did not lead Zimbabwe to independence to undermine patriarchal privilege. Such visions of the past are selective, applying primarily to gender relationships. Modern armaments are never embargoed; the Taliban stand out in their abhorrence of media. All are retrogressive regarding women's rights.

During the 1980s, both scholars and practitioners began to utilize the term gender when discussing household relationships, especially when describing the sexual division of labor. This substitution has led to widespread use on data forms and now encourages transgender groups to request yet a new category for census gathering.

The analysis of gender roles emphasized the distinct socialization of women and men and underscored how a focus on work as economists defined it is an imperfect lens to women's activities.

Feminists turned away from a demand for equality, which set up man as the measure, toward equity, which recognizes difference. By the time of the Women's Conference in Nairobi in 1985, the word gender was in wide currency.

GENDER IN DEVELOPMENT PROGRAMING

Transforming this nuanced concept of gender into programmatic reality turned out to be much more problematical than expected when, during the end of 1990s, many development agencies adopted the terminology. Proponents declared that such programs are less likely to cause a backlash from men who often objected to donor's focus on women. Acknowledging gender relations in planning, they believed, would result in more sustainable projects. They also hoped that a new approach would reinvigorate agencies to improve and increase projects for women.

Not all practitioners were pleased with the change. They pointed out that when translated the term was problematical. In Vietnam, some five words were used and all of them meant physical sex. Others have suggested that men running development agencies were uncomfortable with the growing strength of the women's movement and wished to deflect its power. In practice, however, the term just became a euphemism for woman. IDRC was perhaps the first development agency to adopt "gender" in its policy statements. In 1985, Eva Rathgaber, director of the women's office, listed the technology projects as gender projects and tried to change the office name to Gender and Development. Two years later the name formally changed. CIDA's 2019 publication on *Gender Equity* reiterates the importance of gender analysis in order to identify the different roles played by women and men and concludes that "These different roles usually result in women having less access than men to resources and decision-making processes, and less control over them."

Caroline Moser, who had run training workshops on gender and housing for women from developing counties at the University of London, published *Gender Planning and Development* while she was working at the World Bank. Noting that historically, bureaucratic efforts to introduce WID were often "symbolic," Moser comments on the hypocrisy of many donor agencies because they employed so few staff in relevant offices. The book reviews institutional obstacles to the adopting of any new policy and asks whether the preferable strategy is to create a separate institution or to mainstream gender throughout the institution. Her analysis of different types of projects – welfare, equity, anti-poverty, efficiency, and empowerment – promotes clarity in the goals of planning. Training of staff at all levels is essential to provide methodological tools in order to "simplify complex theoretical feminist concerns... such that they can be translated into specific interventions in planning practice."

Many donor agencies, disappointed

in the limited impact that WID/GAD offices were having on policies or programs, embraced gender mainstreaming as a method to insert the issue of gender throughout the organization. Case studies of UNDP, the World Bank, and ILO, indicate that "to a surprising degree" these multilateral agencies have incorporated mainstreaming into their practices, but in keeping with their organizational goals so that gender equity is only one of their policy objectives. The result is that adoption of gender mainstreaming by the United Nations "turned a radical movement idea into strategy of public administration." [Elizabeth Prugl & Audrey Lustgarten, "Mainstreaming Gender in International Organizations." *Women and Gender Equity in Development Theory and Practice: Institutions, Resources, and Mobilization.* Jane Jaquette & Gale Summerfield, eds. 2006]

A 2011 workshop on mainstreaming organized by Oxfam GB and the UK Gender and Development Network, recorded that some in the women's movement felt "gender mainstreaming has become just part of the technocratic language...devoid of passion." However, participants from the global South hailed mainstreaming as a beacon beyond institutions that is a political statement favoring gender justice and women's rights.

Ultimately, feminists recognized that constant pressure is necessary to ensure that women's issues are not sidelined. Several donor agencies abolished their WID/GAD units when they switched to gender mainstreaming and lost a crucial advocate. Clearly, to affect institutional change, putting gender into all policies and programs must be accompanied by a focal point that lobbies for funding and monitors progress. As chair of Women's Studies at UC Berkeley in the 1990s, I observed the critical role the department played in supporting courses throughout the curriculum that included women's issues. Perhaps an analogy exists in the conceptualization of this volume. All authors were urged to include gender in their chapters, but after a year of planning the editors realized the need for a separate chapter on women, gender, and development.

HOLDING AGENCIES RESPONSIBLE

Ultimately, changing institutions is a political process. The history of including women in development is a history of women organizing. The targets of demanded change have evolved from integrating women into development programs to gender mainstreaming in bilateral and international aid agencies as well as in foundations and NGOs. Methods of collecting statistics have evolved under women's pressure to include sex-segregated data and a broader interpretation of work; their efforts to count women's double day in the caring economy have been less successful.

Women's organizations have lobbied their own governments to live up to the conventions they signed at the four

world conferences for women and to sign and ratify the UN Convention on All Forms of Discrimination against Women (CEDAW). At local and national levels, women continue to monitor government spending to challenge the governments to match their funding on women's projects with official rhetoric.

In 2002, Gender Action was established to extend gender budgeting to the policies and programs of all International Financial Institutions, particularly the World Bank and the International Monetary Fund – two of the largest public sources of development financing in the world. Founder Elaine Zuckerman argues that these institutions routinely undermine their commitment to empower women and promote gender equality through gender-insensitive investments. Gender Action has recently formed a global network of Gender IFI Watchers to help local women's groups document the negative impacts of IFI projects. [www.genderaction.org]

DEMANDING POLITICAL POWER THROUGH QUOTAS

Political participation of women has become a major goal throughout the global women's movement. Frustrated at the slow pace of change, the 1995 women's conference in Beijing Platform of Action demanded that 30% of all decision-making positions in government should be allocated to women. Recognizing that appointed positions are more

difficult to control, women focused on elected bodies, promoting the idea that 30 % of membership is necessary to provide a critical mass that would allow significant changes in policies and procedures. Today, over half the world's countries have some sort of electoral quota system for their legislatures.

Research shows that quotas do not consistently result in increased numbers of women elected. More important, even in countries with significant women representatives, policy change is uneven. The Human Development Report writes that "Quotas are primarily a temporary remedial measure, and are no substitute for raising awareness, increasing political education, mobilizing citizens and removing procedural obstacle to women getting nominated and elected."

Much debate centers on the rational for more women legislators. If the goal is equality, then increased numbers constitutes success. But if the goal is to empower women to implement a more feminist agenda, then outcomes, not numbers is crucial. Thus how women candidates are selected and who supports them must be analyzed before numbers of women in legislatures can be equated with empowerment.

The most efficacious method for ensuring that women are elected to legislatures is through the party list system. Globally, about 35% of countries use a variation of this electoral system. Parties determine who is on the list. In the closed list system, candidates are selected from the list of the winning party's list in seriatim: if every other candidate were

a woman, the party would have elected 50% female legislators. However, many countries utilize an open list system: symbolic men or women may head the list, but voters have no guarantee which candidates will be selected by male party leaders to serve.

Over half of the world's states, or 54% of the 114 that hold direct elections to their legislatures, use an electoral system based on a territorially defined constituency. Another 10% used some combination of these two major systems. Requiring a specific single member constituency in national elections to be reserved for a woman is politically impractical, so in some countries women are elected indirectly, as in Pakistan, or separate districts with only women candidates, as in Uganda or Rwanda. Not surprisingly, women seem to have only minimal influence in either country. One study addresses the confounding problem of how to change the institutional culture. "The case of Uganda is an important one, because it brings to light a dilemma in institutional change: new players - namely women - are brought into the game, but the rules, structures, and practices continue to promote the existing political and social interests." (Aili Mari Tripp. "Women and Democracy: New Political Activism in Africa." *Journal of Democracy* 12(3). 2001) Overall, women's representation has not altered the neoliberal rules of the game.

In Eastern Europe, communist countries utilized the structure of the party with its mass organizations to provide representation for women. These arrangements collapsed when these communist regimes fell; none of these countries has retained quotas. In China, Vietnam, and Laos women's mass organizations continue to exist, but because decision-making power resides in the party, not the legislatures, the women in the mass organizations have little influence and tend to be looked down on by strong women leaders within regular party ranks.

Clearly, the numbers of women in a legislature does not necessarily correlate with women's empowerment. A history of women's attempts to pass laws against domestic violence in Sweden and India illustrate this critical point. In Sweden, as a result of both major political parties deciding in 1972 to alternate women and men on their list of candidates, Sweden has had the highest percentage of women legislators until Rwanda passed them in 2008. Feminists argue that this action moved debate on women's issues into the parties and made a unified voice for women outside parties more difficult. They complain that most social policy legislation such as improved working conditions and pay, affordable child care, and paid maternity – and paternity – leave, drew on a socialist ideology and were passed with little input from independent feminist organizations. Further, legislation passed in 2003 meant to protect women from domestic violence has not been aggressively implemented due to outdated attitudes: incidences of violence are increasing, according

to a 2004 report by Amnesty International. In 2005 a women's party, The Feminist Initiative, was formed to agitate for reform of rape laws, programs to address domestic violence.

India has had active women's organizations for years, but most focused on charitable work or development projects. For ten years, these groups agitated for a law dealing with violence against women. Finally, in 2005, women in 2005 to organize a national lobby, WomenPowerConnect, with full-time lobbyists in New Delhi. This a coalition of women's organizations was instrumental in the passage of the Domestic Violence Bill finally became law in November 2006. [www.womenpowerconnect.org]

The Human Development Reports, when calculating the Gender Inequality Index, measures empowerment as the number of women in parliaments plus women's educational attainment. A more accurate method of indicating empowerment would be to consider the impact of legislation passed by elective bodies, and also the numbers of politically active women's organizations. Similarly, to achieve greater equity in realizing the other two indicators in the Gender Inequality Index, laws and customs that preserve male privilege must be changed. Until women can control their own body, they will be unable to realize their reproductive rights. Also, women's capabilities will not be achievable until women can own their homes and until the care economy is included in economic calculations.

Conclusion

The story of women and international development is a story of women organizing to challenge the development paradigm. Over fifty years, women have influenced development agencies to include women's concerns, and formed a global social movement that has altered gender relations throughout the world. Today women are seeking political power to advance their claims for equity.

To envisage the years to come, an historical perspective refreshingly underlines that tremendous progress has been attained for women's rights and gender justice (although massive work remains to achieve full women's empowerment). In developed countries a century ago, women could not vote and rarely worked beyond the home. Now they do both although globally gender gaps persist in earnings, household responsibilities, asset ownership and decision making. Going forward, countries most resistant to women filling citizen and economic roles will certainly continue to experience an erosion of traditional cultural and religious barriers to women's empowerment in response to citizens' bottom up organizing and government reforms.

While challenges to close gender gaps worldwide remain immense, there is unprecedented energy today toward realizing women's and men's equal rights. The global women's movement has exploded into a myriad of new organizations and networks led by women in every country. Such organizations

also empower women as political, community, and social leaders. As these leaders influence development policies and initiate national legislation, world society and gender relationships will surely become more equitable.

THE CAMEL'S NOSE: WOMEN INFILTRATE THE DEVELOPMENT PROJECT

AFTER WORLD WAR TWO, AMERICA AScendant undertook to assist the newly independent countries around the world to develop their economies. The impetus came from the belief that the political and economic systems in the United States had proved their superiority in winning the war. But the drive was also rooted in the Cold War competition between capitalism and communism. Capitalism could be reached through defined stages and was presented by Walt Rostow as a "non-communist manifesto" to counter the dialectic of Marxism.

Economists who designed development theory were rooted in the 50s culture that sent Rosie the Riveter to the suburbs and assigned her the role of dutiful wife serving martinis to her hard working husband. Oblivious of cultural influences and perceiving economics as a science, these academics promoted a construct they assumed would be applicable globally, a sort of tent that could be erected anywhere, a tent without women.

The desire to emulate the American culture of progress and prosperity was pervasive. Leaders in underdeveloped countries embraced the goals of economic development but not necessarily the capitalist system. During first three of my lengthy research trips to India

(1951 & 1965) and Indonesia (1957), so did I. My studies focused on the transition to democracy at both the national and local level. Women were not a topic.

UNDERSTANDING THE IMPACT THAT SOCIETAL EXPECTATIONS HAVE ON IDENTITY

The second wave of the US women's movement was just taking off when I moved to Washington DC in 1960. Until that time, I had been able to secure funding to support my pursuit of a doctorate at the London School of Economics and travel to India in 1951 for my field research, overland in a Ford Anglia. Instead of selling the car to fund my research, I found a husband: we say that he bought me as well as the car. When his tour at the US Embassy was over, I persuaded him to drive with me from Mombasa, Kenya, to London. My New Yorker style travel book plus this backstory was eventually published in 2010.

After finishing my dissertation, we drove that same Austin A40 across the US to California; I held a research job at the University of California/Berkeley while my husband studied for his PhD. Two years in Indonesia on a joint Ford Foundation grant followed: despite my

apprehension, the funders did not seem upset that I was pregnant. While completing his dissertation at Cal, he was offered a teaching position at American University in DC: no affirmative action at that time.

Discrimination against women was palpable in DC in 1960. Despite having a PhD and a published co-edited book on India, and having won a post-doc fellowship, the personnel officer at the Brookings Institution told me: we hire Radcliffe girls as secretaries and Harvard men as researchers. Eventually I found a job at Howard University, the federally chartered university set up after the Civil War to educate African-Americans: even their pay scales privileged white men, then black men, white women, and finally black women.

In the 1960s, DC was a maelstrom, churning with many groups seeking to change the status quo. President Jack Kennedy had nominated the first national Women's commission which proposed such then-radical ideas as requiring equal pay for women! This commission spawned state commissions on women, expanding women's demands throughout the country. We women marched on the mall to support the Equal Rights Amendment. I took my two young daughters to join supporters outside the Capital Building.

In contrast to the peaceful protests by women, demands to end racial discrimination in education and voting were met with violence in the southern states. Not surprisingly, my black colleagues at Howard University were apprehensive about joining the August 28, 1963, *March on Washington for Jobs and Freedom*. Most watched from the sidelines as I pushed a baby carriage along the mall and sat in the shade above Martin Luther King as he made his stirring address "I Have a Dream." This largest protest march in history, perhaps as many as 300,000 people, included many well-known performers and speakers and was at least a quarter white. And there was no violence.

Black faculty at Howard University came from the black bourgeoisie; society had socially constructed their identity, although at the time I did not know that term. Students at Howard from this group were the most conservative as compared with the activism of students from Africa or the Caribbean. As I began to understand the power of society to mold expectations about people and how they had influenced my Black colleagues at Howard, I gradually realized that socialization had similarly molded women. In post-World War II, Rosie the Riveter was sent home to the suburbs to become the perfect housewife. Educated women were expected to sacrifice their careers for a husband. No wonder so many women were frustrated and angry; Chevy Chase, Maryland, where I lived, was reported to have one of the highest rates of women with drinking problems in the country! Lucky that I had escaped such pressure, I sympathized with women who had acquiesced to the "women in the home" propaganda but were now giving new strength to the women's movement.

My participation in the women's and the civil rights movements reinforced each other: I joined activists in organizing meetings, registering black voters in DC as well as Mississippi, and marching in protest rallies. I even ran for Maryland's legislature. Academe was rife with discrimination; graduate students led the way to protest male dominance in universities and agitate for women as part of panels at annual professional meetings. I helped organize women's groups in political science, Asian studies, and population associations. But I had not connected women to international development.

All this changed when I returned to Indonesia in 1972. Because of my involvement in the US women's movement, I was invited by the US Embassy to lecture about women's issues and goals in the States. To make my talk vivid for the audience, I needed to compare Indonesian women's rights and roles with those at home. Realizing how little I knew about Indonesian women outside their professional roles, I began exploring their lives and civil rights, and how independence was changing them. Far from progress, economic development was having an adverse impact on them. Our economic aid was recreating the same barriers for Indonesian women that we activists in the US were fighting to remove.

ORGANIZING TO CHANGE DEVELOPMENT POLICY

Back in Washington DC, I talked to other women who had done research abroad and heard the same story. A few of us were members of the Society of International Development (SID) but others found the lectures too rarified and the membership fee too high for some to join. As an alternative we formed an independent caucus of women interested in international development (WID) to collect articles and data about how development programs were affecting women. Reading Ester Boserup's recently available book *Woman's Role in Economic Development* provided an authoritative voice to our conclusions.

The next SID international conference was scheduled for April 1973 in Costa Rica. Too late to register for regular daytime sessions, we persuaded the organizers to arrange two evening panels for WID presentations. SID conferences are quite sociable and evening sessions few. Much to everyone's surprise, the rooms were packed with men as well as women. Participants recounted many similar stories about how development was undermining women's traditional roles and ignoring their economic contributions. Clearly this was a global issue that needed greater recognition.

Events moved quickly. I testified at a State Department briefing on the 1975 International Women's Year conference, summarizing the critiques of US development policy. Because the US Senate which was then debating revisions to the Foreign Assistance Act, it was still possible to insert this issue in

the legislation. Using the UN phrasing, an amendment drafted which declared "that women should be integrated into development." Senator Charles Percy was persuaded to introduce this amendment in the Senate as a courtesy and was approved without discussion as a sort of "feel good" idea easily eliminated and would have been discarded by the Congressional Conference Committee except for the barrage of telegrams and phone calls from women representing mainstream women's groups. I spent days on the phone to women staffers explaining the importance of the amendment and emphasizing that no new funds were required, and important factor that helped Congressmen support the amendment.

Appointed as an advisor to the US delegation to the UN Commission on the Status of Women in Jan 1974, I was able to brief participants about the negative effects development programs were having on women in the global South and to urge a refocus of development policy to recognize women's economic contributions, especially in agriculture. The implications for UN agencies were obvious; within a year, women in those agencies had introduced resolutions requiring women the integration of women in all development projects.

My participation in the UN was encouraged by Margaret Mead, then the president of the American Association for the Advancement of Science where I had recently become the Director of International Science. In June 1974, I accompanied her to the UN Conference on Population in Bucharest to help distribute *Cultural Factors in Population Programs* which our staff at AAAS had produced. Margaret Mead spoke at panels in both the governmental and NGO meetings. Her ability to influence participants with this research convinced me to try a similar strategy the following year at the UN World Conference for Women.

1975 UN Women's Conference in Mexico City

Under the aegis of AAAS, and with Margaret Mead's potent support, I convened a Seminar in Mexico City just prior to the Women's Conference. Having the backing of well-regarded scientific institutions from both the US and Mexico gave tremendous legitimacy to our Seminar. Advice and support from women and men in several United Nations agencies in New York helped frame the agenda. Nearly one hundred women and men from 55 countries attended. Each of the five workshops – food production, education, work, health, women's organizations – produced a report identifying problems and suggested actions in each area. These ideas were widely discussed at the NGO Tribune; several were added as amendments to the Plan of Action being debated at the UN governmental conference by seminar participants who were part of their country's delegations and were able to insert

many ideas from the Seminar into the Plan of Action.

The Seminar participants emphasized the need for women to organize in every country around local priorities: access to education and health facilities, civil rights, and the recognition of woman's economic contributions to her country. Over the next decade, the proliferation of civil society organizations addressing these various issues was exponential. Widespread support for these groups came from development agencies, foundations, humanitarian organizations, and churches. Taken together, these groups began to form a global network increasingly able to influence economic development policies.

DECONSTRUCTING WOMEN'S WORK

Because economic theory as then practiced was promulgated by men living in the developed world, they were influenced by prevailing world-view that women did not "work." To question this approach to economic development required a new definition of "work." Most of women's economic activities were based on the sexual division of labor and continue to be uncompensated. The ILO had defined formal work in terms of income thus effectively excluding all subsistence and household activity. Yet time allocation studies showed that women in subsistence societies spent many more hours than men in such survival tasks as growing, harvesting, processing, and preparing food, as

well as carrying water and fuelwood. Child or elder care seldom appeared as a separate activity since women carried the babies on their backs, older siblings watched young ones, and life expectancy was low. None of these activities was counted as "work."

Projects designed to deliver water to a village in Kenya or provide new sources of burnable material in Nepal worked well because they reduced drudgery. In contrast, projects requiring more effort from women, such as cutting wood for the "more efficient" cook stoves, faced women's resistance. Midday literacy classes were poorly attended because women were working in the fields. Indoor latrines, which required women to carry extra water to flush them, remained unused. Synthesizing this research, I wrote "The Real Rural Energy Crisis: Women's Time" in preparation for the UN conferences on Technology (1949) and Energy (1950) as a challenge to existing policies underlying rural projects for women.

Projects aimed at men also needed to be reconfigured. Ester Boserup had documented how introducing cash crops to men living in subsistence economies in Africa had increased women's work by requiring their labor on those crops – which produced income, while still raising food for the family – which did not. Further, the influx of cash allowed men to migrate to urban areas for higher paying jobs, where they often acquired a second wife, leaving their rural wives to labor in the fields.

629

Informal sector

Women's work in the informal sector was also discounted under the ILO's definition: an enterprise that employed five or more people. Individual and family enterprises were not included. Both neoclassical and Marxist theory expected these microenterprises to disappear with the advent of urbanization and modernization. In practice, monetization forced the poor to earn money for their daily needs. Well-intentioned efforts to teach women to knit and sew in countries, where women were farmers and men the tailors were dismal failures.

In Ahmedabad, India, Ela Bhatt decided to form a union among already working as head-loaders, vegetable sellers, mattress-stuffers, among other occupations, and formed SEWA (Self Employed Women's Association.) Her first project was forming a bank: credit allowed these workers to avoid the usurious rates of lenders and so increase their earnings. SEWA also required its members to become literate; many workers have become part of the leadership.

In contrast, the Grameen Bank, in Bangladesh, was run by men at all but the village level. Members of this movement, who could not have access to more than half a hectare, were expected to follow the '16 Decisions:' actions aimed at improving health and nutrition, which included limiting family size, and reducing expenditures on such customary practices as dowry and family rituals. Women were organized into small groups whose members stood surety for loans granted others in the group to start small income producing projects. Because few village women had any entrepreneurial history, many enterprises lost money or failed. However, the availability of low cost credit still improved overall family welfare by providing families with needed cash; as a result, women's status generally improved. Some women earned enough to buy land in the name of their daughters, thus avoiding limitations on landholding and assuring the daughter of a good marriage. Better prospects for young women lead members to send their daughters to school.

A comparison of these two credit programs shows how the different paths led eventually to empowerment. The comparison also underscores the difficulty of categorizing programs between strategic and practical. SEWA, run by women from top to bottom, encouraged members to learn, rise in the organization, and invest in tangible assets. Grameen Bank illustrates the idea that "the patriarch knows best." Empowerment came slowly with members flouting the rules to buy land: daughters were the real beneficiaries. Still the focus on women improved their status despite their experience with enterprises. Many microcredit programs set up in other countries and patterned on the Grameen Bank only copied the loans aspects. By neglecting the basic tenets of changing life style and promoting group support, these programs often had little financial impact and encumbered women in

debt. Research findings emphasize the importance to adapting programs to the local culture; empowerment comes faster when women are given leadership opportunities.

Street Foods

Looking for a microenterprise where women actually made money, I initiated the Street Food Project at the Equity Policy Center (EPOC), a think-tank I started with the object of using research to transform the programs studied. We recruited women researchers in nine countries to follow all food vendors in their city for a year, identifying who makes, sells, and eats food on the street. Findings showed, for example, that although only one widow was a vendor in Bangladesh, women were involved in food preparation and cleaning of the stalls in 37% of the enterprises operated by their husbands. In contrast, 94% of Nigerian vendors were women selling foods throughout the day with help from female relatives. In the Philippines and Indonesia, couples often ran the activity together. Clearly, cultural attitudes affected the number of women street food entrepreneurs. Income from the trade varied both within and among the countries. Where buying street foods is a daily occurrence as in Thailand or Nigeria, many women made more money than university professors or mid-level bureaucrats. But seasonal peanut vendors in Senegal barely cleared expenses. In all countries women, often heads of households,

worked to provide sustenance for their families. Only in Nigeria, with its tradition of polygamous unions and separate budgets, did women not share their income with their husbands: rather they supported their children and kin.

The Street Food project not only illuminated the wide range of gender relations affecting women's income and its use, the study also influenced policies at local, national, and international level. FAO has encouraged vendor associations for teaching about food safety; cities have set up food courts with available water for washing dishes and hands – the main source of contamination. The importance of research for altering policy was once more demonstrated.

Home-based work

Working from home allows women to combine their household responsibilities with a way to earn income. Treated as "egg money," economists ignored home-based production until the 1980s when industries began to "informalize" their workforce in response to globalization. In order to cut labor costs, industries making wearing apparel contracted with local factories abroad that in turn contracted both the assembly and sewing to women at home. This vertical hierarchy for producing garments was largely unregulated leaving these industrial home and factory workers, predominantly women, open to exploitation. Contradicting assumptions by both neoclassical and Marxist

theoreticians, this emergent economic form suggested that labor would not eventually be absorbed into the formal economy. This provides additional evidence that modernization, far from freeing women from drudgery, many simply provide ongoing opportunities for their exploitation.

The assumption that work must be compensated through formal institutions has effectively excluded the bulk of women's economic activities, whether within the household or in the informal sector. Research that underscored the economic benefits of the care economy as well as the critical role played in household survival by income from microenterprise and home-based work has persuaded economists to grudgingly include these activities as "work." Once again, changing the earlier definitions of work required a rethinking of the development tent.

WOMEN IN THE HOUSEHOLD

Among the many questionable assumptions in economic theory is the idea that the household functions as a single unit, a "black box," overseen by a benevolent patriarch. Such a construct obscured women's economic value and undercut women's influence as the subsistence economy was increasingly monetized. Once women began to earn money, they were seldom able to control its use. Research into entitlements, especially for food or education, underscored women's low status.

Game theory showed that women's bargaining position within the family was constrained due to her desire to stay married.

Many women, by choice or desertion, became heads of households. Realizing that women headed households were the poorest of the poor, WID focused early on this trend. Data were sparse, so our group at AAAS decided to estimate the percentage of women headed households overall. At the time, a World Bank research paper had declared that developing countries were better off as soon as per capita income reached $100. Quizzing the authors, they admitted this figure was an educated guess. So we did our own educated guessing, estimating that one-third of all households in developing countries were headed by women. That figure became the standard reference that has proved surprisingly robust. Percentages vary depending on the definition of female headship; nonetheless, the clarity of our declaration helped focus the development agencies on this issue.

Most customary law gives the male overriding power in the household; women must constantly negotiate their position as modernization proceeds. Some WID projects were so focused on increasing women's income that they threatened male prerogatives; enterprises were taken over, fields destroyed, and project staff endangered. Increasingly, WID proponents urged consideration of other family members when designing projects for women. This pragmatic approach was not followed by

all development agencies. For example, in Bangladesh, a Swedish group refused loans to a woman who wished to buy a pedicab for her son who would then earn money for the household, insisting rather that she start her own activity.

Reproduction and women's health

Women's power within the family was particularly limited regarding reproductive decisions. In the 1970s, Western development agencies promoted population programs because economic gains were being negated by rapid population growth. Within the women's movement, family planning programs as then practiced were challenged both for coercive aspects and for racist implications. WID proponents at some donor agencies opposed funding population projects for fear that focus on women as mothers would dilute the argument for recognizing their economic importance. Some population programs saw the importance of increasing women's control over their own reproduction they also began to offer income projects to their clients as a way of providing women an alternative form of social security.

The SID/WID group echoed concerns about women and their health that were angering women in the United States. Male doctors treated women with disrespect; research on critical issues such as breast cancer were conducted on male college students. Population programs embodied the same disregard for women. Organizations were formed to challenge the implementation of population programs and began to urge a focus on women's health by promoting birth spacing and improved check-ups for pregnant women. In preparation for the 1980 women's conference, EPOC convened a global seminar on women's health issues not connected to reproduction and held panels in Copenhagen calling for greater emphasis on women's nutritional needs and testing for sexually transmitted diseases.

Questioning patriarchal and customary rights

If economic programs tended to be top-down and based on theoretical constructs, the ground swell of women's groups challenging their subordination rolled in from village and town. Indeed, development agencies avoided programs that might seem to the recipient countries as an attempt to destabilize the patriarchal order. But even the removal of a pebble from the power structure often had amazing consequences.

An early example comes from South Korea right after conflict ceased. Ruined houses sat on hills bereft of trees; the economy was in tatters. The government launched programs to accelerate economic development coupled with efforts to reduce rapid population growth. To reach women in rural areas who traditionally spent their lives within their husbands' compounds, the government set up family planning programs in villages. Women were required

to meet once a month to receive contraceptives pills distributed by an educated woman who also schooled the women on health issues and the importance of sending their daughters to school. Of course, these young women also talked about the rapidly changing attitudes in the cities. Once organized, the government decided to utilize these women's groups to plant seedling for the reforestation projects. Money earned from selling the saplings back to the government was used by the women to travel to nearby religious sites. Thus women's worldview was expanded from a narrow household focus as they were exposed to new ideas and distance places.

GLOBAL SOCIAL ACTIVISTS

From 1902, when the International Alliance of Women was founded to promote women's suffrage, European women helped organize women globally to reduce poverty and encourage education. These groups became leaders in the UN Commission on the Status of Women which was formed in 1946. Several more sensitive topics were on the agenda of the 1974 First International Feminist Conference held in Frankfurt, Germany, which advocated greatly increased surveillance over international prostitution rings. They also called for a ban on female circumcision in Africa. Fran Hosken became a crusader for the ban and founded the Women's International Network a quarterly journal to distribute information about female genital mutilation and other feminist topics which US media seldom covered.

Feminists in Europe, who were appalled by the lack of media coverage of the 1974 conference, determined to form an alternative communications and documentation center to provide information about women's activities, especially those in the global South. Marilee Karl, in Rome, and Jane Cottingham, in Geneva, started Isis that same year and began collecting everything they could gather about women's organizing. To share this information, they soon began to publish the *Women's International Bulletin* which focused on grassroots experiences. Today, Isis operates out of Santiago, Chile; Kampala, Uganda; and Manila.

This emphasis on communication avenues among women was crucial in the pre-email age. These two groups were joined the following year by a documentation and media organization, the International Women's Tribune Centre, headed by Australian Anne Walker. Located across from the UN building, the centre provided a way for women who attended the NGO conference – termed the Tribune – during the Mexico Women's Conference to stay connected. Their publications included training manuals designed to help women organize at the grassroots.

CHALLENGING THE CAPITALIST MODEL

Shortly after the Mexico City Women's Conference, a World Congress for

International Women's Year, was convened in East Berlin in October 1975. Organized by the Women's International Democratic Federation to celebrate its 30th anniversary, the meeting was planned with the support of the United Nations and attended by the UN Secretary-General Kurt Waldheim who attended and thanked the WIDF for first suggesting the idea to celebrate IWY. Participants included many Asian and African women and men who had attended workshops in the socialist countries that promoted integrating women into revolutionary causes, as opposed to the WID model designed to incorporate women into a capitalist model.

Western feminists challenged governments to address discrimination and violence against women, while the Berlin conference celebrated the success of communist countries in incorporating women in the labor force and the political system, and in organizing women domestically and internationally for development and peace. Although women's rights surfaced as an issue, and women in socialist societies lamented the double day, the top down approach of the socialist countries discouraged grass roots organizing. The socialist model lost both credibility and state support in most of the Eastern bloc after the fall of the Berlin Wall in 1989, but debates over whether capitalist or more statist, "socialist" approaches were better for women continue.

These two European conferences in 1974 and 1975 promoted distinct views about women's needs. While the feminists challenged the governments as well as women to address the abuses inflicted on women, the Berlin conference celebrated the success of communist countries in organizing women for development and peace. Women's rights soon surfaced among groups organized as part of the development practice. The top down approach of the socialist countries tended to promote dependency on the state.

EXPANSION OF CIVIL SOCIETY ORGANIZATIONS

The exponential growth of women's organizations after the Mexico City conference was made possible by the flow of funds from the UN itself, from bilateral and multilateral agencies, from foundations, and through charitable organizations. Most promoted organizing women at the village level, but their approaches were influenced by the administrative and political systems in the recipient countries. In former French colonies, for example, the provincial organization of government services, like that in communist countries, did not encourage local initiatives. Where governments adopted the list system of voting, women had to join a party if they wished to influence policy or instigate new ideas. The most robust growth of women's organizations occurred in countries using a single constituency system where members of the legislature could be influenced by local activists. Funding for women's organizations was sparse before WID. Without someone

paid to organize local women, only a crisis could justify them to use their time on non-survival activities. Development funding was thus critical to the burgeoning of the women's movement. I summarized this unanticipated result of development funding in "Empowerment just happened: the unexpected expansion of women's organizations."

CRITICS OF THE WID APPROACH

Critics of the women and development approach fall into two distinct categories: one questions the types of programs advocated, the other criticizes the ideological assumptions underlying liberal economic theory. Both groups misunderstand or misinterpret the original pragmatic focus to bolster their arguments for change; however, their complaints reflect the unrealistic assumptions of WID advocates about the ease of changing either bureaucratic culture or power relationships within the family.

Putting women into development projects

Since economic development was the goal of agency programming, WID advocates argued that projects would be more efficient if they took into account women's economic contributions. Time allocation studies illustrated this trend; one result was the flurry of appropriate technology projects designed to reduce women's survival tasks. Another result was the introduction of projects for producing income for women. Although some projects were culturally inappropriate and seldom resulted in income for women commensurate with their time spent, microcredit and micro-enterprise programs generally improved women's status, if not their income.

Despite the growing body of data on women's work, WID supporters underestimated bureaucratic resistance to changing projects design which was based more on economic constructs than on an understanding of women's economic roles. Historically, planners understood that the introduction of cash crops in Africa meant increased work by women but nonetheless privileged cash over women's welfare: no surprise that the food production fell as women worked longer hours on less desirable land. Today the debate focuses on land grabbing by foreign corporations that will provide increased production for the country: the impact on women is unclear and widely discounted.

Power in the family

WID proponents also underestimated the persistence of power relationships within families. As more women received cash from jobs in the formal or informal sectors, their income was generally appropriated by their husbands: even when women invested in jewelry, men might rip off their rings or gold chains. When an enterprise employing women to dry fruit for sale became too successful, it was taken over by men. In Nicaragua, women were uninterested

in microenterprises: any income they might earn would just reduce the household funds given her, as customary, by her husband.

In countries where men paid bride price, any income or goods women might have belonged to the man's family. Women in such countries were cognizant of male power and found ways to circumvent tradition. To prevent losing their possessions to extended male family members when their husband died, market women in Dar-as-Salam bought a house in the municipality where women could own property; when family members tried to claim a TV or refrigerator, the women claimed it belonged to someone else. In Kenya, women's groups combined their funds and bought plates and tables which members could borrow for their individual celebrations.

These examples illustrate both the tenacity of customary law, but also how income could empower women. They also underscore the importance of cultural variation and the necessity to adjust programs to local circumstances.

Patriarchy in customary law

The concept that the patriarch in a family knew best for all family members has been discredited. Amartya Sen investigated starvation and found that those with few entitlements, namely women, had least claim on food. Yet Sen also questions the utility of game theory to explain family dynamics because neither party wishes to disband

the marriage. ("Gender and Cooperative Conflicts." *Persistent Inequalities.* 1990.) The issue within the family is how to make power more equitable.

In the landmark publication, *Development, Crises, and Alternative Visions,* Development Alternatives for Women in a New Era (DAWN), the authors stress this approach and criticize WID as too individualistic. Clearly development projects that did not place women within a family context could be disrupting, but projects that reinforced women's subordination were equally undesirable. Such projects reflected "women's needs" according to Caroline Moser. For planning purposes, Moser prefers to identify projects that confront women's inequality as "strategic" while terming projects that reflect women's survival activities as "practical." (*Gender Planning and Development: Theory, Practice and Training.* 1993.) Such distinctions may be useful for planning purposes; actual implementation of projects muddied such divisions as unexpected outcomes often empowered women while not directly confronting family or state power. Just organizing women proved to be amazingly liberating: as women's worldview expanded, they rapidly identified the sources of their oppression. More amazing, women felt empowered to demand more civil and well as economic rights. Despite these new demands, economic aid agencies continued to fund the women's movement.

In retrospect, while the approach of WID, with its premise that offering

the benefits of development to women as well as men would eventually empower women, was too optimistic and seriously underestimated resistance by bureaucrats and patriarchs, its impact cannot be denied. The many efforts initiated to address agency constraints for implementation and to confront male bastions of continued oppression are well documented in this volume.

IDEOLOGICAL CRITIQUES

Economic development was based on modernization theory with is base in capitalism. WID did not contest this theoretical base because its goal was to ensure women's concerns were inserted into all development programs and funding for projects was offered within this parameter.

Still there were critics. Lucille Mair, while recognizing that WID put women into the development project, argued in her 1986 article "Women: A Decade is Time Enough" for reconsideration of the WID approach of integrating women into development by asking: into what? Peace advocate Elise Boulding cautioned that integration into the present world order only increases women's dependency. She opted for a "strategic separatism that frees up the potentials of women for economic and social experiments on a small scale, outside the patriarchal social order." ("Integration into What? Reflections on Development Planning for Women" *Women and Technological Change in*

Developing Countries. Roslyn Dauber & Melinda L. Cain, eds. 1991.)

Marxist feminists attacked the idea of working within the development paradigm and argued that this approach only treated the symptoms of economic inequality, especially women's poverty, but ignored the root causes of class disparity. Since gender of an individual is the kaleidoscope of all a person's characteristics, the question arises as to what should be considered the predominant attribute. Research now shows that women of all classes or ethnicities are subject to male dominance; thus women organizing women *as women* has given strength and reach to the global women's movement. The importance of class and ethnicity has not disappeared, of course, as chapters in the volume show: but sex identity remains the most defining characteristic.

GENDER IN DEVELOPMENT

The impact of substituting *gender* for *women* differs substantially between the academic and development programs. The speed with which this change was embraced by agencies in the early 1980s reflected the disillusionment among some women in the bureaucracies who had expected more rapid implementation of women's projects and so began to question the premise of the programs. The switch also reflected the growing power of the women's movement which was challenging patriarchy on many fronts; the use of *gender*

was less threatening to men: there will never be a *gender movement.*

Marxist feminists also argued that by treating women as a distinct and isolated category WID ignored gender relationships both within the household and with the labor force. Academically, the introduction of gender complexity and of gender relationships has provided a powerful analytical tool for the study of transformative social change. Yet even at universities that have changed the terminology from Women's Studies to Gender Studies, the campus community still tends to conflate the two words, obliterating the nuances inherent in *gender.* Using "Women and Gender Studies" has clarified this issue in several instances.

The confusion about the meaning of *gender* in agency programs has been much more problematical. First, the term is almost impossible to translate into local languages. In Vietnam, two practitioners assigned to lecture about gender in projects were puzzled about the laughter until they realized that all the five Vietnamese words they were using to approximate *gender* in effect referred to having sex. Despite such workshops to clarify the term, most practitioners still assume the programs are intended for women. In contrast, when the Ford Foundation representative in Vietnam interpreted gender to encompass men as well as women for a project funding three month scholarships for foreign study, all recipients were men who were more easily able

than women to leave their family responsibilities to others.

Gender mainstreaming

Women in the development agencies argued that a reason for the slow adoption of programs to aid women was due to the "silo effect" which separated projects by field. By abolishing the silo and agitating for inclusion of gender in all policies and programs throughout the organization, advocates of *gender mainstreaming* hoped for improved outcomes. Case studies of UNDP, the World Bank, and ILO, indicate that "to a surprising degree" these multilateral agencies have incorporated mainstreaming into their practices, but in keeping with their organizational goals so that gender equity is only one of their policy objectives. The result is that adoption of gender mainstreaming by the United Nations "turned a radical movement idea into a strategy of public administration." ["Mainstreaming Gender in International Organizations." Elizabeth Prugl & Audrey Lustgarten. *Women and Gender Equity in Development Theory and Practice: Institutions, Resources, and Mobilization.* Jane Jaquette & Gale Summerfield, eds. 2006.]

Ultimately, feminists recognized that constant pressure is necessary to ensure that women's issues are not sidelined. Clearly, to affect institutional change, putting gender into all policies and programs must be accompanied by a focal point that lobbies for funding and monitors progress. As chair of Women's

Studies at UC Berkeley in the 1990s, I observed the critical role the department played in supporting courses throughout the curriculum that included women's issues. Losing the WID/GAD office in development agencies also meant losing a focal point for women lobbying for programs reflecting women's priorities.

MOTHERIST AND DIFFERENCE IDENTITIES

Gender is the sum of an individual's characteristics. WID emphasized women's economic value as salient rather than women's reproductive or sexual role. When women as mothers became a focal point for action, many feminists felt this reinforced paternalist control. Thus in Argentina, when the Madres de la Plaza became the primary resistance to the military government: accusing them as anti-family and demanding they account for the disappeared, feminists were uneasy. In both Chile and Peru, women's groups confronted those authoritarian regimes by organizing communal kitchens to help the poor women affected by arrests and killings.

Elsewhere, the rise of Islamic parties has injected religious tenets into government policies. In Indonesia, where policies privilege motherhood, formerly robust women's organizations are being steered away from development projects. Islamist parties have not been as successful in Bangladesh with its plethora of women's organizations and other NGOs running projects for women; still the pressure to wear the

burka is increasing. The relationship of motherhood to identity politics, especially in Muslim dominant countries, is illuminated by Valentine Moghadam in her edited book *Identity Politics and Women: Reassertions and Feminisms in International Perspective*, 1994, and reprised in this volume.

A distinct argument has arisen in Europe where feminists reject the idea that women and men are the same; they also reject the thought that men are superior to women. Rather, both have views and experiences that need to be included in setting government priorities. This "difference feminism" has been particularly strong in France. However, Norwegian prime minister Gro Harlem Bruntland echoed this view when she included an equal number of women in her cabinet.

CONUNDRUM: ARE WOMEN THE SAME OR DIFFERENT?

At first, most of us WID proponents felt that because men controlled the levels of power, we had to imitate them to demand more equal treatment for women. I started wearing pants suits and left my earrings at home. Others smoked cigarillos though I never saw a woman with a pipe. I was aghast, however, when a colleague brought her knitting to an important meeting. Wary of using man as a measure, I often noted in my talks that as long as man was the measure, women would always be second class. My action-research center

was called the Equity Policy Center. I wanted justice, not sameness. This is a slippery slope, demanding equal treatment that is different.

Justice: equality, merit, and need

At the height of the suffrage movement, many men argued that giving women the vote would sully their moral precepts thus using the concept of difference to deny women their rights. Women argued for justice, as we do today. Jane Jaquette suggests that three competing ideas of *justice* frame the modern debate and are based on the fairness of resource distribution. *Equality* implies each person has a right to similar resources whether food or income or the vote. Challenges to this approach can come from the difference argument as arguing that distinct attributes of women, such as child-bearing, make equality as sameness irrelevant.

Merit brings in the concept of earning the right to resources and has been the foundation of the economic argument that women earn merit for their role in production of commodities or income. In the modern context, merit implies equality of opportunity but not equality of outcome. People who work harder receive just rewards. Yet utilizing this argument to evaluate the merit of the care economy challenges the economic basis.

Finally, *need* is the moral imperative for altruism toward those without adequate resources: the charity principle. Both religions and governments promote the moral value of providing resources for the poor or for victims of disaster. But recipients of charity are not perceived as equal by themselves or society.

Justice for women must be rethought and reconfigured to include both sameness and difference. Finding a path through the brambles should be a major priority for global feminism.

FEMINIST CONFLICTS IN THE US

Efforts to address this issue must come both from academics and practitioners. Yet there is remarkably little interchange between women's studies and women in international development. In the United States, Women's Studies were spearheaded by graduate students reacting to the cavalier treatment during protests against the Vietnam War and sexist attitudes of civil rights activists. Patriarchy became a salient academic issue and humanities their base. Their anti-government stance collided with women concerned with the impact of development abroad who sought funds from government and foundations to study abroad. To Women's Studies, "Third World Women" were members of US minorities. When women from developing countries participated at a panel during a Women's Studies conference in 1977, their talk was disrupted and their materials trashed.

The ethnocentrism of Women's Studies was still an issue when I was chair of the Women's Studies Department at Berkeley. I introduced several

new courses and encouraged my colleagues to include non-US examples in their teaching. A major grant from the Ford Foundation to 13 universities in the US was predicated on including international in Women's Studies or putting women's issues into international relations courses. Only one other university attempted the latter initiative in which we were moderately successful. But I was astounded at a conference of theses 13 university teams when one exclaimed, after a year of cooperating with a university in Prague, they concluded that patriarchy was different in Europe. This is unfinished business in the US. Since not too many countries have separate departments for the study of women, most studies on women in development take place in research centers. I believe that women need to bring insights from both areas to an understanding of women globally.

SEEKING POWER IN GOVERNMENT

The basis for arguing for more women in decision making positions in government is that women have different views of society which need to be reflected in legislation. Putting women into development programs meant lobbying legislatures, cajoling bureaucrats, and initiating training programs. The creation of WID focal points encouraged more women to enter government service. Follow-up research critiqued projects helping improve women's livelihood, health, and civil rights. All this

activity propelled the women's global movement in all its iterations. But what is granted by government can also be taken away, as Robert Mugabe has done in Zimbabwe.

In order to protect the expansion of their rights and opportunities, women need to embrace political participation. Doing so required a shift in the mind set of many feminists, particularly where oppositional NGOs had been funded by international donors so they could challenge autocratic rule. This hesitation has been largely overcome since the Beijing Women's Conference in 1995 demanded special provisions to enable women to be elected or appointed to high level decision making positions, and promoted the idea that 30 % of membership is necessary to provide a critical mass that would allow significant changes in policies and procedures. Proponents for quotas assert that "women leaders better represent the interests of women citizens, will introduce women's perspectives into policymaking and implementation, and help expand women's opportunities in society at large" (Mala Htun. "Women's political participation, representation and leadership in Latin America." Washington DC: International Center for Research on Women, Issue brief. 1998.)

This global rush for quotas for women in elective bodies is widely supported and little examined. Do numbers of women in legislatures in fact translate into power to implement a feminist agenda? Or is the purpose of more women in elective offices to offer exposure of more citizens to the reality

of compromise and governance? In other words, is this an effort to inculcate women into the male agenda or is it an effort to change the agenda. Are women perceived as same or different? To illuminate this issue, I analyzed the impact of numbers as they impacted on the two widely used electoral systems: proportionate representation and single constituency. Because women in PR systems are beholden to the party if they are chosen candidates, their ability to alter male priorities is limited. Further, activist women tend to focus on party politics rather than seek change through women's organizations. In contrast, candidates in single constituencies are reelected by those where they live. Women's groups have a greater opportunity to influence candidates, and women candidates can push for feminist goals without necessarily going through the party. In 2008, I analyzed the fate of legislation to address domestic violence to show this fact: neither France nor Sweden was able to pass this law, and Rwanda, with the highest percentage of women in the legislature, was able to pass it but unable to persuade its autocratic president to sign it into law. These three countries have variations of PR. Only India, with its single constituency system and robust women's organizations, succeeded.

WOMEN AND DEVELOPMENT IN THE TWENTY-FIRST CENTURY

The persistent inequities that women face globally are rooted in patriarchal customary law but have been included in new constitutions and old laws in most countries. One set revolves around women in the family: marriage, reproduction, inheritance, legal subordination. A second set reflects women's changing roles in the face of rapid socio-economic transitions, from subsistence to the monetization, from defined sexual division of labor to increased work for women. Finally, the conspicuous imbalance of political power slows women's quest for justice. WID proponents have addressed all these issues as I will summarize below.

Many of the WID projections of equity have yet to be realized; even the definition of equity has been challenged. The overriding task for feminist is to agree on the outlines of the world system we seek. A debate on such a future involves applying philosophical precepts and moral reasoning to policies and projects that range from maternity leave and childcare to women's ownership of assets.

Customary practices in a changing world

Governmental manipulation of women's expected roles in post-World War II in the United States ignited the second wave of the women's movement. Educated women sought jobs and working women demanded equal pay. Income was believed to be the first step toward greater equality. For women concerned with development practice, recognizing

women's economic worth seemed like the camel's nose: challenging male-centric bases of the prevailing economic paradigm. And so it proved to be, as recounted in this chapter.

As development programs facilitated women's organizing, women chafed at traditional practice regarding marriage, inheritance, and women's ability to make decisions about her fertility, activity outside the house involving work, education, or joining organizations. Often the only path to greater independence from the family was to eschew marriage altogether, assuming household headship. Soon women were demanding greater access to such newly available opportunities such as education, credit, and property. But contradictions between earning an income and raising a family alone meant that women could work less and so earn less. Not surprisingly, women working as maids in Teheran were pleased, at least at first, to stay home and let their husbands work as decreed by the newly triumphant Islamic government.

Justice for women in the new century

Few women aspire to be a single mom, but persistent gender stereotypes seem to become stronger once a child is added to the working couple. Debates over work in the home and outside escalate. When my three children were young, I was the only working woman on our street. Without a husband who drove carpools, without a mother-in-law who arrived from her own apartment to make dinner three times a week and baby sit as needed, and without the flexibility of university employment, I could not have managed. Still, I was the manager of the household: that was the expectation of society.

What do women want today? How do we reconcile women's distinct role in reproduction with equal opportunity in the workplace? If the tent of patriarchal privilege has been flattened, what sort of family structure should be erected? Designing a just and equitable dwelling for the family in a community which allows choice and difference has become the challenge for women today.

CPSIA information can be obtained at www.ICGtesting.com
Printed in the USA
BVOW09s1002190416

444756BV00017B/253/P